Arts of the Sung and Yüan

Papers prepared
for an international
symposium organized
by The Metropolitan
Museum of Art in
conjunction with the
exhibition *Splendors of
Imperial China: Treasures
from the National Palace
Museum, Taipei*

Edited by
Maxwell K. Hearn
and
Judith G. Smith

Department of Asian Art
The Metropolitan Museum of Art

This volume is issued on the occasion of the international symposium
Arts of the Sung and Yüan, May 10–12, 1996, organized in conjunction
with the exhibition *Splendors of Imperial China: Treasures from the National
Palace Museum, Taipei*.

The Metropolitan Museum of Art, New York
March 19–May 19, 1996

The Art Institute of Chicago
June 29–August 25, 1996

Asian Art Museum of San Francisco
October 14–December 8, 1996

National Gallery of Art, Washington, D.C.
January 27–April 6, 1997

The exhibition has been organized by the National Palace Museum,
Taipei, and The Metropolitan Museum of Art, New York.

It is supported in part by The Henry Luce Foundation, Inc., The Starr
Foundation, the National Endowment for the Humanities, the National
Endowment for the Arts, and an indemnity from the Federal Council
on the Arts and Humanities. Transportation assistance has been provid-
ed by China Airlines.

The symposium is supported in part by The B.Y. Lam Foundation.

Book design and production
Joseph Cho and Stefanie Lew

Printed and bound in the United States of America
by Coneco Lithographics.

ISBN 0-87099-806-4
Library of Congress Cataloging-in-Publication Data
Information is on file at the Library of Congress, Washington, D.C.

Published by
The Metropolitan Museum of Art
1000 Fifth Avenue
New York, New York 10028

Cover and illustrations facing chapter openings
Huai-su (ca. 735–ca. 799), *Autobiographical Essay*, dated 777. Detail.
Handscroll, ink on paper. National Palace Museum, Taipei.

Contents

圖片版權

Contributors to the Symposium

Speakers

Richard M. Barnhart
The John M. Schiff Professor of Art History, Yale University

Maggie Bickford
Associate Professor of History of Art, Brown University

Chang Kuang-yüan
Department Head, Department of Antiquities,
National Palace Museum, Taipei

Craig Clunas
Senior Lecturer in History of Art, University of Sussex

Robert E. Harrist, Jr.
Associate Professor of Art and East Asian Studies,
Oberlin College

Ho Chuan-hsing
Research Associate, Department of Calligraphy and Painting,
National Palace Museum, Taipei

Angela F. Howard
Associate Professor, Department of Art History,
Rutgers University

Anning Jing
Assistant Professor, Department of Art, Michigan State University

Hui-shu Lee
Assistant Professor, Division of Humanities, Hong Kong
University of Science and Technology

Lin Po-ting
Department Head, Department of Calligraphy and Painting,
National Palace Museum, Taipei

Ogawa Hiromitsu
Professor, Department of East Asian Art, Institute of Oriental
Culture, University of Tokyo

Martin J. Powers
Professor, Department of the History of Art, University of
Michigan

Jessica Rawson
The Warden, Merton College, Oxford University

Peter C. Sturman
Associate Professor, Department of the History of Art and
Architecture, University of California, Santa Barbara

Ts'ai Mei-fen
Associate Research Fellow, Department of Antiquities,
National Palace Museum, Taipei

Hsingyuan Tsao
Assistant Professor of Art History, Reed College

Wang Yao-t'ing
Research Fellow, Department of Calligraphy and Painting,
National Palace Museum, Taipei

Wu Hung
Harrie A. Vanderstappen Distinguished Service Professor in
Chinese Art, University of Chicago

Chairs

Richard M. Barnhart
The John M. Schiff Professor of Art History, Yale University

James Cahill
Professor in the Graduate School, History of Art,
University of California, Berkeley

Chang Lin-sheng
Deputy Director, National Palace Museum, Taipei

Fu Shen
Professor, Graduate Institute of Art History,
National Taiwan University

Wai-kam Ho
Former Laurence Sickman Curator of Chinese Art,
The Nelson-Atkins Museum of Art, Kansas City

Kohara Hironobu
Professor of Art History, Nara University

Chu-tsing Li
J. H. Murphy Professor Emeritus of Art History,
University of Kansas

Roderick Whitfield
Percival David Chair of Chinese and East Asian Art,
School of Oriental and African Studies, University of London

Discussants

Richard Edwards
Professor Emeritus of Chinese Art, University of Michigan

Jonathan Hay
Associate Professor of Fine Arts, Institute of Fine Arts,
New York University

Julia K. Murray
Associate Professor, Department of Art History and Chair,
East Asian Studies, University of Wisconsin

Jerome Silbergeld
Professor of Art History, University of Washington

Richard Vinograd
Associate Professor, Department of Art, Stanford University

Marsha S. Weidner
Professor of Art History, University of Kansas

Foreword

Thirty-five years ago, in 1961–62, the exhibition *Chinese Art Treasures* brought a selection of 231 works from the National Palace Museum, Taipei, to five American museums, including The Metropolitan Museum of Art, establishing a new benchmark in Chinese studies and introducing a whole generation of Americans to the highest artistic achievements of Chinese culture. While many of the masterworks included in the present exhibition were also shown in the earlier selection, the goals and methods of this exhibition are considerably different.

Issues of authenticity and connoisseurship were central concerns in the earlier exhibition, which arrived in the West at a time when ascertaining the date and authorship of Chinese paintings through stylistic analysis was still a hotly debated topic. While connoisseurship remains essential to the art historical endeavor, scholarly interest today has shifted to more interpretative approaches that seek to place art objects within their broader cultural context. Questions of patronage, the artist's status, and the shifting social functions of artworks are now being meaningfully explored within the Chinese cultural tradition.

The present exhibition, and its accompanying publication, *Possessing the Past*, is organized thematically and chronologically in order to narrate in as comprehensive a manner as possible the complex history of Chinese art and culture. It traces the foundations of Chinese civilization from the Neolithic and Bronze Ages through a selection of ritual and decorative objects created from the quintessential materials of these ages: jade and bronze. Cultural paradigms established in the Medieval era of Chinese history, brush writing and landscape painting, are introduced with key masterpieces of calligraphy from the fourth to the eighth centuries and monumental landscapes of the tenth and eleventh centuries. The evolution of imperial portraiture is examined in a series of nearly lifesize depictions of Sung, Yüan, and Ming monarchs never before shown outside China. The tension between court-sponsored art and the self-expressive works of scholar-artists is traced through the Sung, Yüan, Ming, and Ch'ing dynasties with major examples of scholar painting and calligraphy of the eleventh through the seventeenth centuries juxtaposed with monuments of court patronage from the same eras. In the installation, different categories of objects are frequently placed in counterpoint to one another to suggest how diverse media or different forms of expression may share a similar aesthetic or reflect a common social context. The full-length portrait of Sung emperor T'ai-tzu (r. 960–76) is juxtaposed with a monumental landscape in the style of Fan K'uan to underline the idealization of both man and nature in Sung China in accord with Confucian principles of a hierarchically ordered society. A grouping of Ju-

ware ceramics and ritual bronzes created under the reign of Emperor Hui-tsung (r. 1101–25) is placed together with a handscroll of the emperor's calligraphy to illustrate the dual aesthetics of archaism and naturalism that shaped that ruler's influential approach to the arts.

The focus of the present symposium, organized to accompany the *Splendors of Imperial China* exhibit, is the art and culture of the Sung and Yüan dynasties. Our understanding of these two eras has expanded and changed dramatically since the 1961 exhibition. Given the presence of so many rare early masterpieces from these periods in the present exhibition and their formative role in shaping the development of later Chinese culture, we have elected to take this opportunity to reexamine with a fresh eye some of the most familiar monuments of China's past. A one-day symposium organized by Princeton University, immediately following the New York symposium, will continue to treat this time period while a symposium examining the arts of the Ming and Ch'ing dynasties is planned by The Art Institute of Chicago and the University of Chicago in conjunction with the exhibition's display at the Art Institute this summer.

This volume, which includes the papers presented at the three-day symposium, is dedicated to furthering the principle of cross-cultural interchange embodied in the exhibition. Just as the 1961–62 exhibition inspired a whole generation of China scholars in the West, the present exhibition offers a fitting occasion for a new group of scholars to participate in the scholarly exchange that such a rare opportunity affords. It is our hope that the papers and discussions engendered by this symposium, which brings together scholars from Asia, Europe, and the United States, will stimulate further insights and interest as well as remind us of the diverse points of view and modes of understanding that works of art engender across the gulfs of space, time, and cultural heritage. Only through such interactions can new perceptions and interpretative structures evolve.

An integral part of the symposium that cannot be included here is the commentary and interchange offered during each of the six sessions. We would like to acknowledge in advance our appreciation for the important contributions offered by the scholars who will serve as chairs and discussants during the proceedings; their names, along with those of the paper givers, are listed on page 7.

In an effort to provide those who attend the symposium with advance copies of the papers, we have made use of the emerging technology of desktop publishing to produce this volume in a few scant months. Even with the technological feats at our disposal, however, this publication would not have been possible without the extraordinary cooperation of all of the contributors as well as the enthusiastic support and hard work of the staff of the Department of Asian Art. While it was our pleasure to assist in defining the scope and direction of the symposium's program, it was Judith Smith who meticulously edited all of the manuscripts, organized all of the details of the symposium, and oversaw every aspect of this publication's design and production. We are all in her debt. We would also like to express our appreciation to the exceptionally talented team of Joseph Cho and Stefanie Lew, who created the design for this volume, produced the typeset copy, and worked tirelessly to

ensure the successful completion of the project. Angela Darling, Mary Chen, Jay Xu, Jennifer Chen, and Deborah Kramer provided invaluable assistance in the preparation of the manuscript for publication. In planning this volume, we also benefitted from the expert advice of Kit Moss, in the Department of Art and Archaeology, Princeton University.

Finally, we acknowledge with gratitude the generosity of the Lam family and The B.Y. Lam Foundation for providing the funding that has helped to make the symposium and this publication possible.

<div align="right">

Wen C. Fong
James C.Y. Watt
Maxwell K. Hearn

</div>

Chronology of Dynastic China

ca. 2100–ca. 1600 B.C.	Hsia Dynasty (unconfirmed)	
ca. 1600–ca. 1100 B.C.	Shang Dynasty	
ca. 1100–256 B.C.	Chou Dynasty	
	Western Chou	ca. 1100–771 B.C.
	Eastern Chou	770–256 B.C.
	Spring and Autumn Period	770–481 B.C.
	Warring States Period	481–221 B.C.
221–206 B.C.	Ch'in Dynasty	
206 B.C.–220	Han Dynasty	
	Western (Former) Han	206 B.C.–9
	Wang Mang Interregnum	9–23
	Eastern (Later) Han	25–220
220–589	Six Dynasties	
	Three Kingdoms	220–265
	Western Chin Dynasty	265–317
	Southern Dynasties	317–589
	Northern Dynasties	386–581
581–618	Sui Dynasty	
618–907	T'ang Dynasty	
907–60	Five Dynasties	
916–1125	Liao Dynasty	
960–1279	Sung Dynasty	
	Northern Sung	960–1127
	Southern Sung	1127–1279
1115–1234	Chin Dynasty	
1272–1368	Yüan Dynasty	
1368–1644	Ming Dynasty	
1644–1911	Ch'ing Dynasty	

I. Ritual, Functional, and Decorative Arts

A New Study of Ancient Chinese Calligraphy: Shang Dynasty Bronze Inscriptions as Standard Script and Oracle Bone Inscriptions as Simplified Script

Chang Kuang-yüan

Since ancient times Chinese legend has credited Ts'ang Chieh, a historiographer of the Yellow Emperor (ca. 28th century B.C.),[1] with the creation of the Chinese written script, thereby placing the origin of Chinese characters more than four thousand seven hundred years ago.[2] Following the discovery of late Shang dynasty oracle bones in 1899, most scholars have placed too great an emphasis on the importance of oracle bone inscriptions,[3] claiming that oracle bone writing constitutes China's earliest script. Moreover, it has been consistently asserted that the bronze inscriptions (chin-wen) found on Shang (ca. 1600–1100 B.C.) and Chou (ca. 1100–221 B.C.) dynasty bronze vessels originate from the same source as oracle bone inscriptions.[4] Oracle bone inscriptions are considered to predate bronze inscriptions; thus, they have been given a primary position in the development of the Chinese written script, while bronze inscriptions have been relegated to a secondary position. This view has been generally accepted without question by scholars in the East and the West, which has created a misconception about the origin of the Chinese written script that is difficult to rectify.[5]

Due to the richness of recent archaeological findings, the legend attributing the creation of the Chinese written script to Ts'ang Chieh is no longer credible. It is now possible to trace the origin of Chinese script back seven to eight thousand years.[6] Therefore, how can we continue to regard the Shang dynasty oracle bone inscriptions, which go back only three thousand years, as China's first written script?

Actually, oracle bone inscriptions are limited in time to the late Shang dynasty and in geographic distribution to the clan temple in the late Shang palace in present-day An-yang, Honan Province. The inscriptions were carved on turtleshells and cattle scapulae which were used solely by the royal clan for divination. In comparison, Shang dynasty bronze inscriptions were not only common to the region of the late Shang capital and its surrounding kingdoms, but also existed in the early Shang period. Thus, bronze inscriptions date earlier than oracle bone inscriptions and have a wider geographic distribution. Today many scholars do not realize that bronze inscriptions already existed by the early Shang period, nor do they understand that the inscribed characters resemble primitive picture writing. Researchers, therefore, often overlook the historical significance of bronze inscriptions. In this study, I have drawn primarily on archaeological materials and the perspective of semantics in an attempt to place Shang dynasty bronze inscriptions in their proper place within the development of the Chinese written script.

1. Hsü Shen, Shuo wen chieh tzu, Eastern Han 121 B.C., preface, chüan 15, part 7.

2. According to the tradition of Hsüan-yüan chiao, the Yellow Emperor was born on the fifth day of the fourth month in 2735 B.C. The modern Ch'ing-ming Festival, on April 5, commemorates the birth of the Yellow Emperor.

3. Ch'en Meng-chia, Yin-hsü P'u-tz'u Tsung Shu, Peking: Science Press, 1956, p. 3.

4. Kao Ming, Ku-wen-tzu Lei-pien, foreword, 1980, p. 2; Li Hsiao-ting, "Yen-chiu han-tzu ch'i-yuan yu yen-pien te chi-tien hsin-te," Ti er chieh kuo-chi Chung-kuo ku-wen-tzu-hsüeh hsüeh-shu yen-t'ao-hui lun-wen chi, 1993, 10, p. 2.

5. John Julius Norwich, British Museum Tour Guide (Chinese edition), 1995, p. 33. In a display of the development of the Chinese written language, oracle bone writing is erroneously introduced as the earliest evidence of Chinese script.

6. "Ho-nan Wu-yang Chia-hu Hsin-shih-ch'i shih-tai i-chih ti er chih liu ts'u fa-chüeh chien-pao," Wen-wu vol. 1, 1989, p. 14. (published colored plates of inscriptions carved on excavated turtleshells); Chang Kuang-yüan, "Tsao Shang te wen-tzu–t'ao-wen p'ien," Ku-kung wen-wu yüeh-k'an vol. 97, 1991.4, pp. 4–21. (Reprints of colored plates of carved inscriptions on excavated turtleshells, two of which contain the identifiable characters mu (eye) and jih (sun). Archaeological data confirm that the shells date back 8000 years; hence these characters are evidence of an eight-thousand-year-old script.); "Kan-su

Ch'in-an Ta-ti-wan i-chih i-chiu-ch'i-pa chih chiu-pa-er nien fa-chüeh te chu-yao shou-huo," Wen-wu 11 (1983), p. 22. (Traces of writing in purplish-red ink are found on the inner wall of a Ta-ti-wan bowl dating back 7500 years.

7. Shih Chih-lien, "Shang Yüeh li," Wen-wu, 1961, vol. 1, p. 42; T'ang Lan, "Ts'ung Ho-nan Cheng-chou ch'u-t'u te Shang-tai ch'ien-ch'i ch'ing-t'ung-ch'i t'an-ch'i," Wen-wu 7 (1973), p. 6; Li Hsüeh-ch'in, "Lun Mei Ao shou-huo te chi-chien Shang Chou wen-wu," Wen-wu. 12 (1979), p. 73; Ts'ao Shu-ch'in, "Shang-tai chung-ch'i yu ming-wen t'ung-ch'i ch'u-t'an," K'ao-ku 3 (1988), pp. 246–52.

8. Chang Kuang-yüan, "Tsao Shang te chin-wen," Ku-kung wen-wu yüeh-k'an, no. 103, 1991.9, pp. 24–35, and "Shuo tsao Shang Fu Chia Chiao," Ku-kung wen-wu yüeh-k'an, no. 108, 1992.3, pp. 24–25.

9. Jung Keng, Chin-wen pien, 1938; Chou Fa-kao, Li Hsiao-ting, and Chang Jih-sheng, Chin-wen Ku-lin fu-lu, vol. 1, 1977, p. 3.

10. Chang Kuang-yüan, "Tsao Shang te wen-tzu–t'ao-wen p'ien," pp. 4-21.

11. Jung Keng, Chin-wen pien; Chou Fa-kao, Li Hsiao-ting, and Chang Jih-sheng, Chin-wen Ku-lin fu-lu, p. 3.

12. Chang Kuang-yüan, "San-ch'ien-nien ch'ien Rung-shih chih tsun," Ku-kung wen-wu yüeh-k'an, no. 117, 1992:12; pp. 66–75, and Shang-tai chin-wen t'u-lu, 1995, pp. 10–16.

In the past thirty years a small number of scholars, including Shih Chih-lien, T'ang Lan, Li Hsüeh-ch'in, and Ts'ao Shu-ch'in, have pointed to the existence of inscriptions on early Shang bronzes,[7] and identified at least eleven recognizable characters on nine ritual vessels and six weapons.[8] Because very few Shang bronze vessels have been excavated, the appearance of eleven recognizable characters cannot be considered an isolated case (fig. 1.1). From these early inscriptions we can discern three types of written characters:

 1. Picture characters (*t'u-hua wen-tzu*), full drawings of objects written with a calligraphy brush.
 2. Graph characters (*t'u-hsing wen-tzu*), outlines of objects created with brushstrokes.
 3. Standard (regular) characters (*cheng-kuei wen-tzu*), characters built with ordered brushstrokes.

In the past, the greater body of strange clan marks has been viewed as graph characters, ignoring a significant number of picture characters which more closely resemble primitive writing.[9] I would like to make the distinction between picture and graph characters in order to clarify the structure of early Shang characters in bronze inscriptions and facilitate further research of the origins of ancient Chinese script and calligraphy.

By the late Shang period, picture, graph, and standard characters are commonly found upon bronze vessels. Improvements in bronze casting technology in this period stimulated the increasing use of bronze vessels by the king and officials in ancestor worship rituals, from which arose the custom of adding bronze inscriptions. Indeed, a large body of characters existed in the late Shang dynasty. The small number of extant early Shang bronze inscriptions does not necessarily indicate that there were fewer characters in use during the early Shang, nor that there was a large-scale production of characters in the late Shang, but that the practice of including inscriptions on bronze vessels had not yet become popular. In addition, at least forty-three characters on early Shang pottery vessels (*t'ao-wen*) have been found, all of which antedate the oracle bone inscriptions of the late Shang.[10]

Conservatively speaking, by the late Shang there were already about five hundred clan marks,[11] which, when added to the number of regular narrative characters then in use, gives us a total of fewer than one thousand characters. In addition to confirming their popularity, the wide geographic distribution of bronze inscriptions indicates that these characters were commonly used at the time.

Using six inscriptions on six late Shang bronzes from the collection of the National Palace Museum, Taipei, I will illustrate that the picturelike characters formed with heavy brushstrokes seen in Shang dynasty bronze inscriptions are not decorative motifs but genuine characters composed with a brush following the principles of calligraphy (fig. 1.2).[12] Shang dynasty bronze inscriptions, in fact, consisted of widely used brushwritten characters, the standard script used throughout Shang society.

Based upon bronze casting methods, it is possible to conclude that bronze inscriptions are in fact evidence of contemporary calligraphy of the Shang dynasty.

The process of bronze casting, known as the "piece-mold" method, involves the following steps:

1. Clay is used to fashion a solid model of the vessel.

2. A pattern is carved on the surface of the clay model.

3. Sections of clay (at least three) are used to reprint the pattern from the model. (This is known as the "mold.")

4. A thin, even layer of the surface is scraped off, leaving a bare core.

5. Using a calligraphy brush, an inverted inscription is written on the mold.

6. The inscription is carved in relief.

7. The core and molds are aligned, and an alloy of copper and tin is poured into the casting spaces.

8. Once cool, the mold is removed, leaving the remaining vessel with a reversed, "correct" inscription in intaglio on the inner side of the body. (If there is no inscription, procedures five and six are omitted.)[13]

Conventionally referred to as "bronze inscriptions" (chin-wen), these inscriptions can be clearly identified as traces of Shang dynasty brush writing, which was the standard form of writing at the time. Therefore, the nearly one thousand characters that have been preserved on Shang dynasty bronze vessels to this day can be taken as evidence of the standard written script of the period. The characters follow the basic rules of calligraphy, much like those in stone tablet inscriptions dating from the Han dynasty (206 B.C.–A.D. 220) onwards reflect the calligraphic style of the time. In executing stone inscriptions, a calligrapher would submit a sheet of ink writing to an artisan, who would then carve the inscription on stone. The sheet of writing was placed upon the stone tablet and the lines carved in relief, following the calligrapher's model. Thus, inscriptions on stone tablets are indeed brush writing. Although they are distinguished by different techniques, both bronze inscriptions and stone tablet inscriptions are evidence of the contemporaneous style of brush writing.

In addition to bronze inscriptions, there are also approximately two hundred characters found on pottery from the Shang dynasty. Pottery inscriptions (t'ao-wen) were carved quickly by common workmen, and consequently can not be appreciated as a model of regular script. Although pottery inscriptions belong to the same category as bronze inscriptions, they are not likely to be representative of the Shang dynasty standard script. Thus bronze inscriptions remain the standard written script of the Shang dynasty.

Returning to the oracle bone inscriptions of the late Shang, I would like to emphasize that, although nearly four thousand five hundred characters have already been identified in these inscriptions, the structure of oracle bone characters from the late Shang is in fact the same as that of characters used in bronze inscriptions. The sole difference between the two types of inscriptions is one of style, attributable to the fact that bronze inscriptions were composed with a brush and oracle bone inscriptions executed with a knife. When examining the method in which oracle bone inscriptions were carved, it is apparent that a calligraphy brush was used to mark the burnt scapulae and turtleshells, and then a bronze knife was used

13. Chang Kuang-yüan, "Chan-kuo ch'u Ch'i Huan-kung chu-ch'i hsü k'ao," Ku-kung chi-k'an, vol. 12, no. 2, (Winter 1977), and "Shang Chou chin-wen chih-tsuo fang-fa te shang-ch'üeh"—yü Jih-pen Sung-wan Tao-hsiung chiao-shou ch'ieh-ts'uo," Ku-kung wen-wu yüeh-k'an, no. 104, 1991.11, pp. 56–71.

14. *Tung Tso-pin,* Chia-ku-wen tuan-tai yen-chiu li, *1965, pp. 105-109, and* Chia-ku-hsüeh liu-shih nien, *1965, pp. 70–71; Chang Kuang-yüan, "Ts'ung shih-yen chung t'an-suo wan Shang chia-ku ts'ai-liao cheng-chih yu p'u-k'o te fang-fa," vol. 2, Han-hsüeh yen-chiu, chap. 2, no. 2, 1984:12, pp. 454–58.*

to carve the characters.[14] The bronze knife could only carve straight lines on the hard surface of the shell or bone, making it difficult to form the round lines and full shapes made with the calligraphy brush, as seen in the full and mellow characters in certain bronze inscriptions. For example, the top part of the characters *t'ien* (originally meaning "person," later borrowed to mean "heaven") and *tzu* (son) found in bronze inscriptions are executed with heavy, round brushstrokes, while their depiction in oracle bone inscriptions is flat and straight. The character *t'ien* is a particularly good example; the round head is replaced by a horizontal line, resulting in a character that resembles regular script of the Han period (*k'ai-shu*) (fig. 1.3). In general, it can be said that oracle bone characters are more linear and, in many ways, more simplified than the characters in bronze inscriptions. From this, it can be concluded that the knife-carved characters in oracle bone inscriptions are simplified characters (fig. 1.4). The oracle bone inscriptions produced exclusively in the Shang palace consisted of these "simplified characters" (*chien-t'i-tzu*) with characteristically abbreviated lines and simplified forms. The craftsmen, diviners, and historiographers who used this simplified written script were undoubtedly aware of and familiar with bronze inscriptions. Oracle bone inscriptions and bronze inscriptions must have influenced each other, as can be seen from the frequency with which the two styles were used interchangeably.

It is important to understand that during the Shang dynasty there was only one type of script, which I refer to as standard script (*cheng-t'i-tzu*). The standard script was the model for the perfectly formed brush-written inscriptions on bronze vessels and the less refined writing on pottery, as well as the simplified characters carved on oracle bones (*chia-ku-wen*) of the late Shang palace. We should not assume that because of the later classification of Shang dynasty script that there existed three distinct types of writing as opposed to three variations of one type of script. Likewise, it would be a mistake to speak of bronze inscriptions as "ancient script" (*ku-t'i-tzu*) and oracle bone inscriptions as "modern script" (*chin-t'i-tzu*). In fact, the differences seen in the various manifestations of the standard script are attributable to differences in media.

15. *Li Hsiao-ting,* Chia-ku wen-tzu chi-shih, *1965, and "Yen-chiu han-tzu ch'i-yüan yü yen-pien te chi-tien hsin-te," p. 2; Kao Ming,* Ku-wen-tzu Lei-pien, *p. 2.*

In the past thirty years it has been accepted that oracle bone inscriptions are evidence of the earliest mature form of the Chinese written scripts[15] and were the precursors of bronze inscriptions. I propose that the relationship between oracle bone and bronze inscriptions is not vertical, but rather a horizontal relationship involving the coexistence of a standard and a simplified script.

In conclusion, we cannot ignore Shang dynasty bronze inscriptions simply because there are only one thousand characters extant today and attach great weight to late Shang oracle bone inscriptions because there exist more than four thousand five hundred characters. We should understand that bronze inscriptions are the manifestation of Shang standard script written with a brush, while oracle bone inscriptions represent the simplified (carved) script commonly used by histo-

riographers and artisans at the palace of the Shang kings. Bronze inscriptions came first, and are the true representatives of the Shang script.

In an earlier paper entitled "A Study of the Written Script of the Shang and Chou and its Place in the History of Chinese Writing," I divided the development of the Chinese written script into three stages:

> 1. A "creation period" (*ts'ao-ch'uang shih-ch'i*),
> represented by pottery inscriptions.
> 2. A "developmental period" (*yen-chin shih-ch'i*), in which
> pottery inscriptions are replaced by bronze inscriptions.
> 3. A "standardization period" (*ting-hsing shih-ch'i*),
> represented by small seal script (*hsiao-chuan*) and
> regular script (*k'ai-shu*).[16]

16. Chang Kuang-yüan, "Ts'ung Shang Chou wen-tzu t'an lung," Lung tsai ku-kung, 1978, pp. 2–6.

Bronze inscriptions, the first written script of the second stage, hold a pivotal position in the development of the Chinese writing system, as they both continue an ancient tradition and serve as a model for future innovation. Oracle bone inscriptions, alternatively, should be considered the first instance of the simplification of the Chinese script. Both bronze and oracle bone writing, nevertheless, influenced each other, leading to a more concise and standardized writing system.

Shang bronze inscriptions are evidence of China's earliest primitive picture characters, and as such a valuable tool for the study of the origins of Chinese characters and the world of their creators. The round and fleshy characters, moreover, suggest that bronze inscriptions were not only the standard written script of the period, but also representative works of Shang calligraphy. Bronze inscriptions can also be considered China's earliest calligraphy. Oracle bone inscriptions are not representative of the earliest form of calligraphy, but a simplified form of carved writing used in the late Shang palace. Oracle bone writing can be appreciated as an artistic style of carving, but not as calligraphy.

The simple theory put forward here should encourage future scholars of Chinese semantics and the history of calligraphy to reevaluate the conventional perspectives.

Figure 1.1
A comparison of the development of Chinese characters inscribed on early Shang bronze vessels with scripts of various periods.

Figure 1.2
A comparison of the stages of development of six clan symbols from late Shang bronze inscriptions.

Early Shang Bronze Inscriptions 早商金文	Picture Characters 圖畫文字				Graph Characters 圖形文字				Regular Characters 正規文字		
Late Shang Bronze Inscriptions 晚商金文											
Late Shang Oracle Bone Inscriptions 晚商甲骨文											
Chou Dynasty Bronze Inscriptions 周金文											
Small Seal Script 小篆											
Regular Script 楷書											

	Picture Characters 圖畫文字			Graph Characters 圖形文字		
Late Shang Bronze Inscriptions 晚商金文						
Late Shang Oracle Bone Inscriptions 晚商甲骨文						
Chou Dynasty Bronze Inscriptions 周金文						
Small Seal Script 小篆						
Regular Script 楷書						

Shang Dynasty Bronze Inscriptions 商代金文	Late Shang Oracle Bone Inscriptions 晚商甲骨文	Late Western Chou Bronze Inscriptions 西周晚期金文	Small Seal Script 小篆	Regular Script 楷書
				天
				子

Figure 1.3
A comparison of picture chracters in Shang bronze inscriptions with later developments in Chinese script.

Figure 1.4
A comparison of late Shang bronze clan symbols (standard script) with oracle bone inscriptions (simplified script).

Changes in the Representation of Life and the Afterlife as Illustrated by the Contents of Tombs of the T'ang and Sung Periods

Jessica Rawson

It is often implied that if we want to understand the thoughts and beliefs of people we must read their words. Substantial official historical, legal, and ritual texts give us some information on the death rituals and burials of the T'ang and Sung periods. Recent studies have indeed used this material to describe T'ang Tai-tsung's burial and the funeral prescriptions given in Chu Hsi's *Family Rituals*.[1] Such texts are obviously important sources for an understanding of medieval Chinese attitudes to death and life. But surprisingly these accounts give us little clue of what we might expect to find underground in actual tombs. Year by year, archaeological discoveries have revealed astonishing arrays of model figures and painted chambers. These materials themselves may prove a route as useful as any official text in understanding the purposes that tombs served.

Here it will be suggested that the tombs of the T'ang to Sung periods present us with pictures of daily life, and that these representations were essential tools for the medieval Chinese themselves in forming, maintaining, and extending their understandings of the afterlife. These representations are visual sources of information, which are apparently independent from official writings on burial rituals of the same periods. But, as we shall discover, popular stories about death and especially about ghosts provide some parallels with the images offered by tombs. Some of these stories give partial accounts of the underworld, and especially its bureaucratic practices. Over some centuries medieval views of the afterlife were elaborated with accounts of higher levels of officials in a celestial bureaucracy. The beliefs are sometimes subsumed under the general heading of religious Taoism.

This paper will examine tombs of the period from the seventh to thirteenth centuries, with a preamble on earlier burial practices. The period of the seventh to eighth centuries is particularly important to the discussion, for during that time replicas, which had been employed over several centuries, were partially replaced by real objects. Such tomb contents will be examined alongside the overall structures and embellishment of tombs. For this latter topic, I will to a large extent be relying on Ellen Johnston Laing's illuminating papers on tomb decoration of the Liao, Sung, and Chin periods.[2] A major objective of the present study is to use the patterns in the overall arrangements of tomb contents and tomb decoration as a context for interpreting medieval Chinese views of the afterlife. Changes in burial practices, such as a move from tombs filled with bronze ritual vessels to ones equipped with ceramic models of farm buildings, must have coincided with changes in social practices and in religious and intellectual interests of the periods con-

1. David McMullen has provided a detailed discussion of the death rites for T'ang Tai-tsung on the basis of material in the T'ung tien; see David McMullen, "The Death Rites of Tang Daizong," to be published in the proceedings of a symposium held at Cambridge University, March 1993. For a Sung period text, see Patricia Buckley Ebrey, Chu Hsi's Family Rituals, A Twelfth-Century Manual for the Performance of Cappings, Weddings, Funerals, and Ancestral Rites (Princeton: Princeton University Press, 1991).

2. Ellen Johnston Laing, "Patterns and Problems in Later Chinese Tomb Decoration," Journal of Oriental Studies 16, nos. 1, 2 (1978), pp. 3–20; "Chin 'Tartar' Dynasty (1115–1234) Material Culture," Artibus Asiae no. 49, 1/2 (1988/89), pp. 73–126.

cerned. The latter are sometimes described in texts, but they are as readily discerned in the physical remains.

Objects recovered from the ground, be they from tombs or from hoards, are often considered one by one—that is to say individual bronze or silver cups or basins—or category by category—for example, figures of camels or of tomb guardians. However, further insights come from reviewing whole groups and the interrelationships between groups within tombs of particular periods. That is the approach adopted here. These groups will be compared with others of similar date, and their changes over time will be described.

The emphasis on wholes rather than on the separate parts arises from the view that tombs present pictures of how the tomb occupant and his or her contemporaries had lived in this world and also how they expected life after death to be. Moreover, that picture was not static; the objects, models, and decoration of buildings and figures were in some "sense" intended to come alive, to live and thus to move or to be inhabited. (How we are to understand that "sense" will be considered a little further at the end of the paper.) We are looking at the objects to be used by the dead in their future lives and we are given glimpses of the settings, especially of the buildings, in which they were expected to live. The future lives envisaged were in effect extensions of the earthly lives of their owners. This view of the afterlife contrasts with the medieval Christian understanding of the dead as passing to other worlds—to Heaven or to Hell. In Europe, people learned what Heaven or Hell would be like from pictures in churches or from plays presented in churchyards or in the streets. It is probably helpful, indeed, to consider the Chinese tomb in part in this light—as portraying in visual terms what the afterlife would be like.[3]

The functions and contents of both the earthly life and the afterworld life were constructed and acted out within the social and intellectual framework of their periods. Social position, indicated by objects and by tomb ornament, implied a network of peers with similar tombs and tomb ornaments, and a ranking of superiors and inferiors with different possessions and buildings or landscapes in their graves. A tomb thus presented not just the fact of how a specific individual expected to live, but by the particular qualities of the tombs related individuals and their supposed lives within their living social context, mapping the society of the dead by reference to the living. But yet more complex, nonmaterial aspects of life can also be discerned from tomb contents and decor. As the tombs were constructed within the intellectual and religious frameworks of the time, their combinations of replicas or real objects, of landscapes or of interiors also indicate how their owners understood the qualities of life and of the afterlife and even suggest some details of their concepts of a universe of ideas. Images of auspicious creatures, the twelve calendrical figures and the stars are all references to specific views of the cosmos.

Burial Patterns in the Pre-T'ang Period

All Chinese tombs contain a mixture of real objects employed in life by the tomb occupant and some measure of representation. The central concern of this paper is with the balance between real objects and representations of them in pictures and

3. The ritual and legal codes are generally silent about the nature of life after death. Anecdotes present an account, as we shall see below. In addition, religious texts give Taoist and Buddhist views, but these hardly coincide with what we see in patterns of burial. Indeed, as the paper will conclude, the burials themselves provide views of the afterlife in visual form.

models. A larger representation embracing a whole tomb might be created from a composition of real objects or from one containing a mixture of real objects and representations—pictures and models. This first section will consider the early development of representation in tombs and the role of replicas within the Chinese pattern of burial.

It seems that objects were buried in large numbers in Chinese tombs from the Neolithic period to the nineteenth century because their occupants believed that such items were essential to a proper life after death. I say "seems," as we have no systematic textual evidence of any period to give a direct indication of what the Chinese actually believed about the character of the life of a person after his or her death. However, the large resources expended on providing the dead with objects and furnishings surely imply that they would be used somewhere. As their owners were the dead, those uses must have been thought to take place in an afterlife.

In the Neolithic and early dynasties of the Shang and Chou, burials consisted of coffins within pits, in which the finest objects of life were interred. Ceramics, jades, and bronzes of exceptional quality have come from tombs ranging in date from 6000 to 600 B.C. Perishable materials, often very difficult to reconstruct, including silks and lacquers, were obviously also buried. Although such objects were real, even these early assemblages were in some sense representational rather than purely real. When packed together with the dead in a coffin, the objects were clearly not arranged precisely as in life. The chosen group was probably selected to provide the owner with essentials proper to his social position and to the functions of ritual sacrifice and of war or military display that he, or she, was expected to perform. Such assemblages were pictures of moments in the lives of their owners. In life Shang or Western Chou nobles would have occupied greater areas of living space and would presumably have owned more than the objects buried. These would have been used, worn out, and replaced.

Indeed, burials changed from the sixth century, if not earlier, to ameliorate some of these shortcomings: the simple stepped pit of the early tomb type developed into tombs comprising, in the most complex examples, several chambers. In the late fifth century tomb of the Tseng Hou I at Sui-hsien, Hupei Province, or the late second century burials of Liu Sheng and Tou Wan, at Man-ch'eng in Hopei, for example, separate sections or rooms represent different functions; we can identify those functions from the room shapes, or, in the case of the later tombs, the materials of the rooms, but above all from the objects. A magnificent set of bells and large and sumptuous bronze ritual vessels mark out the central chamber of the tomb of the Marquis I of Tseng as intended for the performance of ritual music and for presenting offerings to his ancestors; a smaller room, in which his coffin was placed, was obviously the Marquis' private apartment. Here, in the second room, were also musical instruments and offering vessels, indicating distinctions between types of music and offerings, public in one place, private and more personal in another. Other rooms held weapons and the bodies of young women, who presumably played the music. This burial, thus, presents distinct spaces with distinct functions, both with actual physical spaces and with objects in them. We can see the

4. Tseng Hou I mu (Beijing: Wen-wu Ch'u-pan-she, 1989).

5. Man-ch'eng Han mu fajue bao-gao, 2 vols. (Beijing: Wen-wu Ch'u-pan-she, 1980).

6. The picture presented by these tombs, enclosing within stone the royal pair in their jade suits, was discussed by Wu Hung at the colloquy organized by the Percival David Foundation, University of London, June 1995 (publication forthcoming). Wu Hung presented an interpretation of the tomb as providing an image of the literal immortalization of the royal pair. However, if, as we must assume, the couple were to continue their life after death, then it is likely that the use of stone and jade had a metaphorical as well as a literal meaning. The qualities of permanence embodied in stone and jade were perhaps metaphorically applied to the afterlives of the dead occupants. For a discussion of the metaphorical use of objects and groups of objects, particularly in tombs, see Jessica Rawson, "Ancient Chinese Ritual as Seen in the Material Record," presented to a symposium on ritual at Cambridge University, March 1993 (publication forthcoming).

7. K'ao-ku hsüeh-pao 1984.4, pp. 503-30.

8. Lothar Ledderose and Adele Schlombs, Jenseits der grossen Mauer: Der Erste Kaiser von China un seine Terrakotta-Armee (Gütersloh/Munich: Bertelsmann Lexikon Verlag-GmbH, 1990), pp. 164–79 describe and discuss both granary models and ceramic replicas of ritual vessels.

9. For discussion of the terracotta army and other aspects of the Ch'in tomb, see Lothar Ledderose and Adele Schlombs, Jenseits der grossen Mauer: Der Erste Kaiser von China un seine Terrakotta-Armee, pp. 250–324 and Ladislav Kesner, "Likeness of No One: (Re)presenting the First Emperor's Army," Art Bulletin 77, no. 1 (March 1995), pp. 115–32 and references cited in both publications. Robert Thorp, "An Archaeological Reconstruction of the Lishan Necropolis," in The Great

tomb both as a real dwelling and as referring to or depicting a palacelike building.[4]

The tombs of Prince Liu Sheng and his consort at Man-ch'eng are on a larger scale, and the distinctions between the sections are yet more clearly marked.[5] In the tomb of Liu Sheng, a large central room, adorned with tents before which offerings could be made, was equivalent to the central room in the tomb of the Marquis I of Tseng. But here, in the later tomb, the fine vessels and bells of the previous era were replaced by plain bronze and ceramic, the latter especially for small lamps. Indeed, it would seem that copies or replicas were appropriate, because this section of the tomb was less important than the private chambers. By contrast with the larger central chamber, the smaller rear rooms were more elaborate, with fine stone structures and several subdivisions. The main part of the private chamber was intended for banqueting and retiring in the afterlife. The jade suits in which the prince and his wife were buried have attracted a lot of attention and were perhaps intended to immortalize the bodies of the royal pair, both literally and metaphorically.[6] Fine weapons, lamps, and lacquered furniture with gilded fittings convince the viewer that this was the central area of activity. Stone and ceramic figures of servants replace the eighteen real young women who had accompanied the Marquis. Here at Man-ch'eng, the balance between replica—that is to say representation—and real, suggests a picture with the foreground worked out in great detail and the background simply sketched in. The private room in which the prince dwelt in his jade suit was the foreground; the central room and two passages for storage made up the background.

Real and replica had appeared together long before the construction of the Man-ch'eng tombs. Eastern Chou tombs in central northern China, at Ch'ang-tzu in Shansi, contained both bodies of real servants and replicas in wood.[7] Perhaps we should look, however, further west, to the state of Ch'in, where replicas may have been even more important. Small model granaries made of ceramic in Shensi during the Spring and Autumn period are among the very first examples of the pottery models that were to become a staple of Han and T'ang tombs.[8] Ch'in state willingness to develop replicas is seen in its most striking form in the famous terracotta army. This is an elaborate example of a large and essential component of the tomb made in replica, a representation or picture, while other elements of the burial were real. For example, real horses were buried in a stable. The border line between real and replica is here very fine. We know also from texts that other elements of the tomb were pictured also, rather than real. The landscapes of the Ch'in world were reproduced within the tomb, with realistic rivers made of mercury.[9] By comparison with the grand tomb of Ch'in Shih Huang, the burials of Liu Sheng and Tou Wan were conservative.

These various tendencies towards depiction attained a certain degree of standardization in the middle Han period (ca. 100 B.C.) with the simultaneous prevalence of decorated grave chambers and the use of ceramic burial goods, especially those that depicted buildings, granaries, stoves and wells, and other agricultural buildings. At first the ornament of the tomb walls comprised relatively small scenes from the lives of the occupants, including banquets and entertainments by actors

and acrobats. Larger images of the animals of the directions or of dragons and other denizens of the spirit world appeared concurrently.[10] Such pictures were important in showing life in action. No longer were the objects left standing immobile in the tomb. They were accompanied by illustrations of the movements and gestures with which they might be used. Eastern Han tombs in Henan, such as those at Mi- hsien or at Lo-yang, illustrate banquet scenes on a larger scale, preparation of food, farming, and even excursions.[11] Others go much further and represent a whole panoply of activity. Complex images of farming at Chia-yu-kuan, or scenes of farms and manors at Ho-lin-ko-erh, or of genre scenes at I-nan, Shantung Province, all have the same function: to describe and thus to provide for the dead a world in which their afterlives were to take place. Some tombs depict yet more complex sequences of images with political, intellectual, or cosmological significances.[12]

While there is considerable variety region by region, within the main central areas of the two capitals at Lo-yang and Ch'ang-an, the principal images on walls of middle-ranking tombs were fairly stereotyped, being limited in the main to scenes of the preparation and serving of meals and the provision of stables and carts for excursions. In the same way, we find the ceramic models, already mentioned, equally routine. Models in Western Han tombs in Henan comprised various jars and other containers and stoves. By the Eastern Han this group had been expanded to include elaborate models of storied wooden towers, as well as other farm buildings, animal-pens, and granaries and wells. In addition, some spectacular tall lamps were also made in ceramic.[13]

From such evidence we can put forward some general propositions about the situation in the Han. In the first place, a set range of images in pictorial art and models in ceramic was made and deployed in middle-ranking tombs. Such systematic use of similar items, tomb by tomb, suggests a standard against which such burial goods were made, acquired, and deployed. A standard may have been laid down in writing, but, if so, there is today no trace of it. Alternatively the standard may have been enshrined in practice. The second conclusion we can draw is that the wider setting of the house, farm buildings, and excursions available to the dead had broadened the scope of the tomb beyond that of the palaces or houses of the earlier period (although chariot burials had always offered the possibility of war and parades to the dead). Thirdly, while some real items continued to be buried, especially the highly valued personal possessions of weapons, mirrors, and garment fasteners, representations or replicas were now normal in the form of pictorial renderings on tomb walls and ceramic tomb models. We have in due course to come to terms with the notion that such pictorial representations and ceramic replicas must have served the living and the dead in some very significant way. Indeed, they must have been useful. But as I will suggest, that use may have been literal and at the same time intellectual, to enable the medieval Chinese to comprehend how life after death might look and be.

Tomb contents had from very early times encompassed the functions of sacrifice, warfare, eating, and sleeping. Increasing use of pictures and of models made it possible to represent a wider range of activities in a wider space than ever before.

Bronze Age of China, A Symposium, ed. George Kuwayama (Los Angeles: Los Angeles County Museum of Art, 1983), pp. 72–83. For Han dynasty armies in ceramic, see Wen-wu 1977.10, pp. 10–21; 22–26; Wang Kai, "Han Terra-cotta Army in Xuzhou," Orientations 21, no. 10 (October 1990), pp. 62–66.

10. See, for example, Wen-wu 1992.12, pp.1–20; K'ao-ku hsüeh-pao 1964.2, pp. 107–24; Robert Thorp, "The Mortuary Art and Architecture of Early Imperial China," (unpublished Ph.D. diss., University of Kansas, 1979), pp. 206–39.

11. K'ao-ku hsüeh-pao 1965.1, pp. 107–68; Mi-hsien Ta-hu-t'ing Han mu (Beijing: Wen-wu Ch'u-pan-she, 1993).

12. Ho-lin-ko-erh Han mu pi-hua (Beijing: Wen-wu Ch'u-pan-she, 1978); I-nan ku hua-hsiang-shih mu fa-chueh pao-kao (Shantung: Wen-wu-pu wen-wu kuan-li-chu ch'u-pan, 1956). For more unusual tomb decor and its interpretations, see Martin Powers, Art and Political Expression in Early China (New Haven and London: Yale University Press, 1991); Wu Hung, "Beyond the 'Great Boundary': Funerary Narrative in the Cangshan Tomb" in Boundaries in China, ed. John Hay (London: Reaktion Books Ltd., 1994), pp. 81–104.

13. Even substantial Eastern Han tombs, such as that at Ting-hsien, the equivalent of the Man-ch'eng tombs already described for the Western Han, contained ceramic replicas; see K'ao-ku hsüeh-pao 1964.2, pp. 127–59.

But an appeal to function alone cannot explain the development and continued use of representation. For, as we shall see in the middle T'ang and Sung periods, representation continued even when the scope of the tomb was once again restricted to the house and the wider world was omitted. Thus, we need to look at this use of representation from a different angle.

In the first place, replicas and pictures may have been introduced to the tomb simply by extrapolation. As there seems to have been an impetus to make burials ever closer to the spaces and contents of life, replacing some of those contents and some of those spaces by representations may have been inevitable steps if ambition to encompass palaces, landed estates, and the cosmos was to be satisfied. There may, however, have been other reasons why replicas were acceptable or even necessary. For the changes in burial patterns took place concurrently with what seems to be a major expansion, if not change, in the concept of the afterlife.

Anna Seidel has pioneered understanding of this subject.[14] In her discussion of documents found in Han dynasty tombs, she has brought to our view what must have been a commonplace to the Han, that the dead needed the proper credentials for their encounters with the bureaucracy of the underworld. These credentials included land contracts establishing the deceased's ownership of the land in which he was buried; documents, known as chen-mu wen, to act as passports (provided by the highest celestial deity) to introduce the deceased to the netherworld administration; and inventories of the possessions of the deceased, again addressed to the officials of the underworld. These documents were obviously intended for submission to the underworld bureaucracy because, after all, the documents were in the tomb, not retained above ground. The documents alone are convincing evidence that beyond the tomb lay another world that mirrored this one.[15]

But the use of an inventory of burial goods provides an important link between the two worlds. No longer is the tomb simply the home of the deceased, separate from but adjacent to the world he had lived in. Now inventories showed that the tomb and its contents were also essential to the underworld; they had a legal existence for its bureaucracy. Thus, the tomb was simultaneously an extension of the world and an extension of the underworld. The underworld was under the ultimate jurisdiction of the highest deity, the Celestial Thearch. His envoy transmitted his orders to the underworld and kept the demons at bay. In this light, dealings with the underworld are to be seen as part of the good ordering of the afterlife, not simply part of a purgatory and hell as described in Western medieval texts. As Donald Harper has recently shown, such concepts go back to periods before the Han. It can therefore be suggested that they may have guided the shaping of representations in tombs.[16]

For once we see, as the Chinese seem to have seen, the tomb as an extension of a netherworld, the reality of the objects becomes less important that the ability to account for them legally in an inventory. Indeed, in the interests of completeness, replicas were probably highly desirable, demonstrating in incontrovertible terms a tomb occupant's position (or desired position). Further, a growing understanding of an underworld bureaucracy may have demanded some of the standardization that

14. Donald Harper, "Chinese Religions—The State of the Field, part I, Warring States, Ch'in, and Han Periods," The Journal of Asian Studies 54, no. 1 (February 1995), pp. 152–62; Anna Seidel, "Traces of Han Religion in Funeral Texts Found in Tombs," Akizuki Kan'ei (ed.) Dokyo to shokyo bunka (Tokyo: Hirakawa shuppen, 1987), pp. 21–57. There is, in addition, a large literature of the origins and development of early Taoist beliefs.

15. Anna Seidel rejects the view that an ascent to paradise was the primary goal of the afterlife in Han times. She also contests the division often proposed between the p'o and the hun. Her views are therefore at variance with those of Michael Loewe, Chinese Ideas of Life and Death: Faith, Myth and Reason in the Han Period (202 BC–AD 220) (London: George Allen & Unwin Ltd, 1982); and Ying-shih Yü, "Life and Immortality in the Mind of Han China," Harvard Journal of Asiatic Studies 25 (1964–65), pp. 80–120; "'O Soul, Come Back!' A Study in the Changing Conception of the Soul and the Afterlife in Pre-Buddhist China," Harvard Journal of Asiatic Studies 47 (1987), no. 2, pp. 363–95.

16. Donald Harper, "Resurrection in Warring States Popular Religion," Taoist Resources 5, no. 2 (1994), pp. 13–28.

we observed in connection with the middle Han. The need to visualize another world that was separate from but similar to this world probably also made it attractive to present pictures of the afterlife in paintings, sculptures, and tomb models. We can understand these visual representations as helping the people of the time to form and maintain ideas about the physical settings of an unknown world, in the same way as a story about the wanderings of a ghost would also give them information about that world.

The period that is central to this paper shows the development just described in reverse. The T'ang period is famous for tombs with wall paintings that depict the wider outside world and models that show a large range of animals and human figures, among which are troops of soldiers and trains of camels and horses that have to be envisaged as moving beyond the realm of the house or palace. In addition, sets of between two and six large figures act as guardians. These latter figures may take some of the role of paintings within tombs or stone sculptures above them.

When we turn to the Sung and Chin periods, we find the outside world restricted in favor of careful depiction of the inner one. Elaborate architectural detail gives density and conviction to homely settings for the dead. Large-scale ceramic figures and smaller ones were reduced in number, and were often not used; sets of real utensils became the dominant burial goods. Fine porcelain, lacquers, and bronzes were objects for actual use. Moreover, there are interesting changes in the objects employed, which suggest new conceptions as to what were the most essential attributes of élite life.

The T'ang Period and its Predecessors

Between the Han period and the first century of the T'ang falls the period of divided rule. The different kingdoms into which China was carved up followed diverse burial practices. However, some tomb figures were employed in many areas. In addition, other essentials of the afterlife were depicted in wall paintings and impressed bricks and in large stone sculptures above ground.[17] Tombs, whose primary furniture was ceramic tomb models, developed steadily during the century or so between the burial of the Northern Wei general Ssu-ma Chin-lung and his wife in the late fifth century and the founding of the Sui dynasty in the late sixth century. Such burials culminated in the seventh and early eighth century T'ang tombs, with their, by now, renowned figures of animals, soldiers, and servants.[18]

Predecessors of T'ang burials equipped with large numbers of tomb figures are found in the Northern Ch'i and Sui tombs of north China. The tomb of Kao Jun at Tz'u-hsien in Hopei Province and of Hu-lu Ch'e at T'ai-yüan in Shansi represent the period.[19] Both consisted of single domed chambers with access ramps. At the foot of the ramp, just inside the chamber, were epitaph tablets. Kao Jun, who died in 575, was a relative of the Northern Ch'i emperor and had, as might be expected, a sumptuous tomb. Particularly remarkable are the wall paintings. Large numbers of tomb figures, approaching four hundred in all, the majority servants and soldiers, filled the room. Twenty-one of these were mounted and were, by and large, in pairs. They included men and women; the rest were standing. Horses,

17. For discussion of the ways in which these stone sculptures elaborated the narratives of tombs see Ann Paludan, The Chinese Spirit Road: The Classical Tradition of Stone Tomb Statuary (New Haven and London: Yale University Press, 1991).

18. Wen-wu 1972.3, pp. 20–33, 64; Los Angeles County Museum, The Quest for Eternity: Chinese Ceramic Sculptures from the People's Republic of China (London: Thames and Hudson, 1987), pp. 52, 122–24.

19. K'ao-ku 1979.3, pp.234, 235–43; Wen-wu 1992.10, pp. 1–14.

mules, camels, oxen, rams, and pigs were also included. The models of agricultural buildings represented a granary, a stove, a pounder, and a well. Two pottery *hu* and eight dishes were accompanied by seventeen porcelain items, among which were an amphora and three candlesticks. These vessels were probably for offering sacrifices or for meals.

The Sui tomb further west was similar, with a total of three hundred twenty-eight figures, also divided between mounted and standing attendants, soldiers and musicians, and farm animals with some farm models. This tomb too held fine ornamented ceramic vessels for eating and drinking, including pieces that obviously replicated fine metalwork. Both tombs had large guardian figures (*chen-mu-shou*), with standing spines along their backs. As in the Northern Ch'i tomb, there appears to have been a standard repertoire of warriors and musicians on horseback. The laden camels are particularly fine and more impressive than the Northern Ch'i examples.

These two tombs illustrate the sources of the principal structural forms of early T'ang period tombs, which consist of single domed rooms. In the early eighth century royal tombs of the Princes I-te and Chang-huai and the Princess Yung-t'ai, buried near Sian, the main tomb chambers had anterooms in addition.[20] While these royal tombs had long access ramps, with small niches on either side, the majority of the excavated aristocratic tombs had shorter ramps, often—though not invariably—without niches.

Many of these early eighth century burials were adorned with wall paintings that represented formal aspects of aristocratic life. The antechamber was generally painted with wooden columns surmounted by brackets supporting beams. Ellen Laing has suggested that these columns are to be understood as the central section of a large hall extending laterally. The ramp walls were also painted and, in the grander tombs, provided room for depictions of military processions, hunting scenes, figures of soldiers, servants, and even of ambassadors. It can be imagined that these paintings were to extend the representation of soldiers and servants made in ceramic replica. In addition, the paintings could depict buildings and even landscapes. Weapons and banners on racks were emblems of rank. T'ang tomb paintings have two general features: a wide range of subjects, indicating in the case of princes a large universe of interests and influence; and a recurrent reference to scenes in the outdoors.[21]

Tombs with the painted scenes seem to coincide in date with pottery tomb figures. Large numbers of figures were deposited in the niches along the ramps of the princely tombs and of higher level aristocratic tombs in the Sian area. But this fashion did not last long. We can see changes in tomb contents particularly well in a series of six dated tombs excavated at Yen-shih, Honan, which have the advantage of remaining intact, having escaped the tomb robbers.[22] The first three, dated respectively 657, 706, and 709, are all slightly different. The first in the sequence has two ceramic figures of male servants, two of female, and two of horses. In bronze, it holds a hairpin, a basin, and a mirror—in other words, personal possessions of the deceased. The next in date has no ceramic tomb figures, although it

20. Wen-wu 1972.7, pp. 13–25; 26–32; 1964.1, pp. 7–33; see also Wen-wu 1977.10, pp. 41–49, and K'ao-ku 1978.3, pp. 168–78; Wen-wu 1991.9, pp. 16–27; Sian chiao-ch'ü Sui T'ang mu (Beijing: K'o-hsüeh ch'u-pan-she 1966); T'ang Ch'ang-an ch'eng-chiao Sui T'ang mu (Beijing: Wen-wu Ch'u-pan-she, 1980).

21. In areas outside the capital different types of painting were popular, but scenes out-of-doors were also current, as at T'ai-yüan; Wen-wu 1988.12, pp. 50–59,65; 1990.12, pp. 11–15. See also a northern type of tomb in Hupei, Wen-wu 1987.8, pp. 30–42; and one in Ning-hsia, Wen-wu 1993.6, pp. 1–19.

22. K'ao-ku 1986.5, pp. 429–57.

does have a *san-ts'ai* decorated *hu*. A bronze ewer, a pair of bronze candlesticks, and a bronze mirror are obviously of relatively high quality and real rather than representational objects.

The third tomb, belonging to one Li Ssu-pen and dated 709, is of typical early eighth century form (fig. 2.1), with a relatively conventional group of tomb figures, as follows (fig. 2.2):

Two monsterlike tomb guardians (*chen-mu-shou*); two military guardians in the form of guardians of the directions;[23] two civil officials; four women with hair in two bunches; sixteen women with elaborate hairstyles; six women on horseback; twelve male figures; four men on horseback; four men leading horses; two men leading camels; two camels, two horses; two dwarfs; an ox and an ox cart; two cocks, two ducks; one pig; three dogs; one sheep; one pen; one stove; one grinder; one pounder or pestle/hammer; a small *san-ts'ai* cup on a high foot; and a ceramic jar.

In bronze, the tomb held a basin for washing, a jar, and two mirrors. In this instance and, it would seem, in many others, the numbers of ceramic replicas were large and the real objects in precious materials, such as bronze, few by comparison. It is worth remarking here that real weapons are absent, although soldiers are depicted in both painting and figures. It would appear that the definition of the tomb occupant no longer required the personal weapons that had been ubiquitous in the Han period.

Although the complement of ceramic tomb figures varies from tomb to tomb, the categories enumerated are typical. As with the Han tombs, it would appear that the supply of figures and their functions were fairly standardized. But although the supply and use of figures appear set in the first decade of the eighth century, by the fourth decade the situation had changed. In the tomb of Li Ching-yu, dated 738, next in the sequence at Yen- shih, the tomb figures of servants and attendants are absent (fig. 2.3). In place of the complement of tomb figures are various very fine silver wares (fig. 2.4): four silver boxes, three silver dishes, one pair of chopsticks; and two silver spoons. Three jars with pointed, pagoda-shaped lids are in ceramic, but most of the vessels are in bronze: two jars; two pots; five basins, and a candlestick. Also of bronze are three mirrors. The tomb is rich enough to hold jades in the form of two pigs and three notched ornaments. Apparently, new additions are an iron standing figure with an animal head and real coins. Real coins were quite usual in Han tombs, but less general in early T'ang ones. They remained a recurring element of late T'ang and Sung burials. The animal-headed figure is part of a set of twelve representing the calendrical animals (or representatives of the hours). They were placed in niches of the main chamber, thus surrounding the occupants. As these figures were to recur in Sung tombs, this is an important element for the later discussion. The material used is particularly interesting, as iron seems to have been deployed for figures that were felt to have distinct power over the elements, and perhaps these included cosmic forces.[24] In earlier T'ang and pre-T'ang tombs, calendrical figures appear both in ceramic and engraved on epitaph covers. But their popularity increased greatly from the mid-eighth century, at what appears to

23. *For a discussion of these guardian figures, see Mary Fong, "Tomb Guardian Figurines: Their Evolution and Iconography," in* Ancient Mortuary Traditions of China: Papers on Chinese Funerary Sculptures, *ed. George Kuwayama (Los Angeles County Museum, 1991), pp. 84–105.*

24. *For a discussion of calendrical figures, see Judy Chungwa Ho, "The Twelve Calendrical Animals in Tang Tombs," in* Ancient Mortuary Traditions of China: Papers on Chinese Ceramic Funerary Sculptures, *ed. George Kuwayama, pp. 60–83. For later iron figures taking the place of ceramic farm animals, see* Wen-wu *1991.12, pp. 16–32, fig. 31. It would seem likely that iron was sometimes used as a powerful material; see Ann Paludan, "The Tang Dynasty Iron Oxen at Pujin Bridge,"* Orientations *25, no. 5 (May 1994), pp. 61–68.*

25. For tombs in the Sian area, see K'ao-ku yu wen-wu 1992.5, pp. 58–63, 82; 1991.4, pp. 50–95; See also Chung-kuo k'ao-ku-hsüeh yen-chiu lun-chi, chi-nien Hsia Nai hsien-sheng k'ao-ku wu-shih chou-nien (Sian: San Ch'in Ch'u-pan-she), pp. 428–56. For tombs in the Lo-yang area, see K'ao-ku hsüeh-pao 1989.3, pp. 275–304; for southern Sui and T'ang tombs, see K'ao-ku hsüeh–pao 1992.2, pp. 147–84; compare K'ao-ku 1985.2, pp. 131–48. A useful table of tomb contents is given in National Museum of History, The Special Exhibition of Tang Tri-colour (Taipei: National Museum of History, 1995). For further tombs in Hopei and Shansi, see Wen-wu 1990.5, pp. 21–27; 28–33, 53; 1991.9, pp. 28–39; 1993.6, pp. 20–27, 64; 28–33; 1987.8, pp. 43–48, 62; 1989.6, pp. 51–57.

26. Other examples of tombs from Honan Yen-shih show that this development was general: K'ao-ku 1984.10, pp. 904–14. At this site, the early T'ang tomb contained fine tomb figures; the later one, dating to the ninth century, held soapstone carvings, including items intended for writing (see also note 49 below). [For further tombs at Yen-shih see K'ao-ku 1992.11, pp. 1004–1017.] The introduction of fine silver into later T'ang tombs is particularly impressive. See Wen-wu 1995.11, pp. 24–44. The interest in silver, particularly for the burial of women, pre-figures Sung practices.

27. Quoted by Wang Ch'u-fei: K'ao-ku 1956.5, pp. 50–51.

28. Glen Dudbridge, Religious Experience and Lay Society in T'ang China: A Reading of Tai Fu's Kuang-i chi (Cambridge: Cambridge University Press, 1995).

29. Glen Dudbridge, Appendix, no. 99.

30. Glen Dudbridge, Appendix, nos. 111, 97, 87.

31. Glen Dudbridge, Appendix, no. 159.

have been a time of change in burial practice, and they remained significant into the Liao and Sung periods. Other tombs at Yen-shih confirm that the K'ai-yüan period of the 730s and 740s was a time of change in tomb contents.[25]

A mid-ninth century burial at Yen-shih shows the same preoccupation with real objects in fine materials: a silver box; a box in shell; a gilt bronze burner; a gilt bronze ladle or spoon; two bronze mirrors; a bronze candlestick and an earpick. But the contents of this tomb belonging to Cheng Shao-fang takes the development documented here a stage further with the introduction of porcelain in place of low-fired ceramic, including a jar, a flask, a bowl, and a tea slop vessel. Indeed, these items may have been intended for tea drinking. A group of seven pottery figures also appears. Thus, the move away from representations of the afterlife using tomb figures to a tomb set with real objects proceeded unevenly.[26]

At Sian, likewise, a change from tombs primarily equipped with ceramic tomb figures to those holding primarily real items seems to have begun to take place in the third to fourth decades of the eighth century. This change coincides with the promulgation of various ritual codes, but is not referred to in them. Moreover, the change took place somewhat against the direction indicated by regulations in the T'ang liu tien, which ordains the use of specified numbers of tomb figures for individuals of particular ranks.[27] By the time these codes were promulgated, they were in the main describing the past. For these reasons changes in the nature of burials have to be viewed and comprehended with reference to the material contents themselves and cannot be explained primarily from official written sources.

We can, however, gain some understanding of how burials were viewed in the popular imagination from the stories collected in Tai Fu's Kuang-i chi. In his discussion of this late eighth century compendium, Glen Dudbridge has recently drawn together stories whose protagonists cross the boundaries between life and death.[28] Ghosts visit the world of the living and invite the living to visit them in their homes, namely their tombs: "Chu Ch'i-niang is a Lo-yang courtesan, patronized by a General Wang. In K'ai-yüan Wang dies, without her knowledge, but later appears and asks her to join him in a city residence. Against her daughter's advice she goes, spends the night with him, and is found the next day on the general's coffin-stand. Wang's sons are called, and she is taken home."[29]

Another story describes a relationship started in life continuing beyond the grave, with the man opting to enter the grave of his dead lover. Encounters with the dead often involve money changing hands, but as a sign of a ghost's involvement, the coins then turn to paper. The peace of the grave is much prized, and, if disturbed, the dead are likely to cause trouble until reburied.[30] Grave figures are also obviously well known and viewed both as inert and alive. They have a distinctly ambiguous state: "During T'ien-pao, Ts'ai Ssu, a poet living in Ch'en-liu, finds himself attended by a friendly ghost. He has a hut made for it to stay in. But the ghost insists on borrowing Ts'ai's house for a wedding, then wants to borrow equipment for a ceremony. Ts'ai's family go to watch, protected by a Kuan-yin mantra and ritual purification. The ghosts scatter and retreat to a graveyard. They are identified as grave-figurines and burned."[31]

"A traveller in Shang-hsiang meets a ghost who asks him to help control the rebellious grave figurines in his tomb. The man must stand before the tomb and pronounce an order of execution. He does this, sounds of execution follow, and the grateful ghost comes out with some headless figures in gold and silver as reward. Although the authorities suspect him of robbing a tomb, inspection proves his story true."[32]

32. Glen Dudbridge, Appendix, no. 161.

From these stories we can conclude that the boundary between the living and the dead was seen as transparent. The dead could leave their tombs and transact affairs with the world. Two major categories of transaction involved sexual exchange and money, both of which turned out to deceive the living in almost all cases. In addition, the living might find themselves negotiating with the bureaucracy of the underworld and might even gain release from sentence of death: "Wei leaves his post in Mu-chou to live in Chia-hsing. He falls sick in 773, and is summoned before a senior official in the underworld. He goes through bureaucratic formalities and appears in a court like that of a modern county magistrate. The proceedings show that he has been summoned by mistake. Curious about his future career, he finds it blank. Returning home, he meets a nephew just summoned below. This man duly proves to be dead."[33]

33. Glen Dudbridge, Appendix, no. 176.

34. The coins buried in tombs are generally real ones, but occasionally paper money is buried in a fine purse, as in a Southern Sung tomb in Kiangsi Province; see Wen-wu 1990.9, pp. 1–13, color pl. 1:1). See also Stephen Teiser on the development of paper money within the economy of the afterlife; (Stephen Teiser, "The Growth of Purgatory" in Religion and Society in T'ang and Sung China, eds. Patricia Buckley Ebrey and Peter N. Gregory (Honolulu: University of Hawaii Press, 1993), pp. 134–35.

Two levels of life are immediately evident, the world we all know, and the underworld that precisely mirrors the world. In addition, there is a liminal world of the tomb in which dead and living may meet. Tombs are populated by grave figures that may come to life or rest inert (though the stories also mention real objects). Moreover, the money used by the dead in their transactions is like the grave figurines, both real and paper.[34] Thus ambiguity runs through these stories and indeed probably through the ways in which the tombs were understood. Or taking further the suggestion made above, the tomb is both an extension of the world, in which tomb figures are tomb figures, and an extension of the underworld, in which tomb figures are alive.

The stories and the tombs with their furnishings would seem to have complementary functions. Both explain how life is conducted after death. In the case of the tomb, that explanation is given in visual terms. The images provide elements with which the medieval Chinese imagination could work. As the fears expressed in the ghost stories make clear, there was a pressing need to comprehend and to negotiate with the underworld, and all instruments that made that understanding clearer would facilitate the negotiation. Such a desire may have been one of the motives for making representations within tombs ever more explicit.

It is much less clear why later eighth century tombs should have become more intimate, and why they should have been equipped with fewer rather than more replicas. However, it may have been the case that for a good existence in the afterlife, a fuller supply of real goods was now thought to be essential and replicas less useful. As the problems of T'ang society increased with the An Lu-shan rebellion, we cannot look for explanations for enriching tomb contents to economic and social conditions of the later eighth and early ninth centuries. The change must have been produced by change in the view of what would ensure a comfortable path

through the possible hitches in bureaucratic procedure. Perhaps real objects were deemed more secure than replicas when identifying an individual to the bureaucracy of the underworld? Or possibly it was thought that real objects would satisfy the needs of the dead more efficiently than replicas and thus persuade them not to haunt the living? Another factor may have been that the role of the underworld was receding, as Terry Kleeman has suggested, and that in its place other celestial worlds were becoming alternatives to which the dead might aspire. Were white silver and white porcelain now buried more frequently because these were materials that would be appropriate to an afterlife constructed, not in terms of the severe rulings of an underworld bureaucracy, but with the higher celestial levels of administration in mind? By this date the pantheons of the Taoist had been fully elaborated, and celestial realms and bureaucracies described. The whiteness of silver and porcelain may have consciously or unconsciously brought to mind the jadelike colors that feature in scriptural and poetic descriptions of these realms.[35]

The Liao, Sung, and Chin Periods

The tenth to thirteenth centuries took the developments of later T'ang tombs to a new level. In northern China, in particular, tombs that provided rooms for the dead to inhabit were created with ever greater attention to architectural detail and household setting; they were often provided with the finest quality utensils for the occupant to use.

The Liao period is mentioned for two reasons. In the first place, the sumptuous princely burials of Fu-ma Tseng, buried 959, and of the Princess of Ch'en and her consort, buried 1018, illustrate the interment of the very highest quality personal objects.[36] Glass, agate, and porcelain made up the utensils. Silver and gold were used to decorate horse trappings and the personal apparel of these horse-loving people. Such tombs were much more sumptuously equipped than surviving T'ang burials. Wall paintings of the northerly tombs, on the other hand, retained some of the features of T'ang tombs: long access ramps were embellished with paintings of carriages in Liao style, and with bands of musicians and entertainers. The doorways were guarded by painted figures that reproduced features of the ceramic military guardian figures of the T'ang. Inner chambers were painted as rooms with wooden columns and brackets, also seen in T'ang tombs in Shensi. Many Liao tombs have such architectural features modeled in relief, especially at the main entrance to the burial chamber. Some also have the constellations painted on the ceiling of the main chamber.[37] Such painting on the ceiling gives substance to Ellen Laing's suggestion that in the Liao period and later, the very fine representations of dwellings should be understood as being depicted from a courtyard in the center of a house (although, like everything in a tomb, there may be a certain ambiguity about what is outside and what is inside). Indeed the ceiling decoration may be the key to understanding some of the imagery of the tombs and their roles in the afterlives of their owners. For instance, we can link these painted ceilings with the calendrical figures mentioned in connection with the mid-eighth century: in several Liao painted tombs, such figures encircle a star-studded center (fig. 2.6c). While,

35. Terry F. Kleeman, "The Expansion of the Wen-ch'ang Cult," in Religion and Society in T'ang and Sung China, eds. Patricia Buckley Ebrey and Peter N. Gregory, pp. 45–73. Edward Schafer, Mirages on the Sea of Time: The Taoist Poetry of Ts'ao T'ang (Berkeley: University of California Press).

36. K'ao-ku hsüeh-pao 1956.3, pp. 1–31; Che-li-mu po-wu-kuan, Liao Ch'en guo Kung-chu mu (Beijing: Wen-wu Ch'u-pan-she, 1993).

37. Wen-wu 1973.8, pp. 2–18; 1975.8, pp. 31–39; 1975.12, pp. 26–36; 1980.12, pp. 17–29; 30–37; 1990.10, pp.1–19; 1992.6, pp. 1–11; 12–16; 1995.2, pp. 4–28.

as we have mentioned, much of the Han, Six Dynasties, and perhaps early T'ang tomb structure and contents can be understood with reference to a netherworld, the star-studded ceilings and calendrical guardian figures imply a shift towards a view of the celestial levels of bureaucracy just mentioned and the Taoist star deities. In Liao and later tombs, the tomb may have been a dwelling extending this world and also an entrance to the higher levels as much as to the nether ones.

In some Liao tombs the world is divided into two spaces, as in the tomb of Han Shih-hsün (buried 1111) at Hsüan-hua in Hopei Province (fig. 2.5).[38] The outer room displays a traveling carriage and a band of musicians on the east and west walls. The north and south walls are painted with civil and military officials. The inner room gives exceptional detail of food preparation for banqueting. This tomb is partially robbed, but contains pottery replicas of many utensils. These low-fired ceramic replicas are particularly relevant to the contents of both Liao and Sung period tomb painting. For example, another tomb at Hsüan-hua of Chang Kung-yu (buried 1117) contains such replica implements as ceramic scissors and even copies of small items of furniture (fig. 2.6a). These same items often also appear in tomb paintings or modeled in bricks. An eleventh century tomb outside the south gate at Cheng-chou is decorated on the walls with the same household furnishings of clothes racks, candlesticks, and scissors, among many other things.[39] Within Liao tombs, objects to be held and used by the tomb occupant were made of much higher quality materials than the ceramic replicas just mentioned (fig. 2.6b). Many were of finest porcelains, others of colored lead-glazed ceramic; and princes had silver, agate, jade, and exotic foreign glass. As with the later T'ang tombs, mirrors and cash in bronze were common. Iron was also quite usual.[40]

The Liao tombs belong to a continuous series of graves decorated as buildings, which include not only a relatively few Northern Sung examples, but also plentiful Chin and Yüan burials.[41] Chin tombs are primarily to be found in Shansi, while the Yüan ones extend northwards and have been found near Ch'ih-feng and Huehot.[42] In this context, the Sung tombs can be seen as part of an extensive and rich tradition of tomb decoration that had some of its roots in T'ang tomb construction. While tomb decoration varied widely area by area, there was a certain consistency throughout much of central China in the tomb goods supplied.

Sung period tombs in northern China emphasize the centrality of the interior rather than the exterior of the household. Tombs at Pai-sha in southern Honan have been known for a long time, and similar tombs have come from Ching-hsing in Hopei.[43] As with the Liao examples, these Sung tombs often have two rooms with a formal doorway. The outer room of tomb 1 at Pai-sha shows a banqueting scene in modeled painted brick, with musicians entertaining the couple, who are seated at either side of a table. This formal position of the tomb occupants is common in many highly decorated tombs, particularly those of the Chin period in Shansi. The rear room of the same tomb is painted with much more detailed scenes, showing serving and toiletry. The corpse(s) lay at the rear of this tomb in front of a half-open door.

Half-open doors were a feature of tombs of the Han period and reappeared in

38. Wen-wu 1992.6, pp. 1–11, figs. 20, 27.

39. Wen-wu 1958.5, pp. 52–54.

40. Liao tombs do not usually include tomb figures, but may do so. They may be of ceramic, stone, or wood (Wen-wu 1975.8, pp. 31–39, figs. 9–12; 1992.6, pp. 17–23, pl. 3; 1980.12, pp. 30–37, fig. 13).

41. A Liao tomb at Fa-k'u (Wen-wu 1975.12, pp. 26–39, color pls. 1, 2, fig. 4) has an exceptionally fine coffin in the shape of a meticulously executed wooden building. Such fine work takes to a much higher degree of accuracy the stone coffins in the shapes of buildings of the Sui and T'ang periods. In addition, this tomb held real paintings in scroll form. This feature would seem to be related to the Sung practice of decorating tombs with paintings of hanging scrolls, as mentioned below in connection with a tomb at Mang-shan near Lo-yang.

42. For a survey of Chin tombs, see Ellen Johnston Laing, "Chin 'Tartar' Dynasty (1115–1234) Material Culture"; also Wen-wu 1991.12, pp. 16–32. For recently excavated highly decorated tombs of the Yüan period, see Wen-wu 1992.2, pp. 1–23, 24–27.

43. Su Pai, Pai-sha Sung mu (Beijing: Wen-wu Ch'u-pan-she, 1957); K'ao-ku hsueh-pao 1962.2, pp. 31–73.

44. *The question of what the half-open door might signify has been raised by Ellen Johnston Laing, "Patterns and Problems in Later Chinese Tomb Decoration," p. 19. It may simply be what it seems: an entrance or exit for the tomb occupant to move between the several worlds available to him or her. Pillows displaying an open door, likewise, are in the British Museum and Shanghai Museum. Here the same purpose may be indicated. Stories of sleepers who in their dreams enter ghostly worlds through their pillows may have inspired such depictions. The Sung, like the T'ang, had its supply of stories about ghosts.*

45. *The canopies in the Pai-sha tomb can be compared with the painted canopies in the cave temples at Tun-huang, for example.*

46. *For a discussion of purgatory, see Stephen Teiser, "The Growth of Purgatory," in* Religion and Society in T'ang and Sung China, *eds. Patricia Buckley Ebrey and Peter N. Gregory, pp. 115–46; a recent symposium on paradise representations was held at Harvard University (October 20–21, 1995). There is a copious literature on Buddhist and Taoist scriptural accounts of the heavens and their deities.*

47. Wen-wu *1992.12, pp. 37–51.*

48. *Compare the real scrolls from Fa-k'u mentioned above in note 41. The clear depiction of furniture in these northern tombs was matched by small replicas in Sung and Chin tombs.*

49. *See* Wen-wu *1973.4, pp. 59–63 for the tomb of Chang T'ung-chih and his wife. Discussions of this tomb and other material covered in this paper have been presented in several papers by the present author. This account takes advantage of unpublished symposium presentations on T'ang and Liao tombs, as well as papers on T'ang and Sung silver. For the tombs of other women buried with silver utensils, see* Wen-wu *1986.5, pp. 78–80;* K'ao-ku *1992.4, pp. 324–30 (I am indebted for these references to a forthcoming article by Shelagh Vainker on Northern Sung silver). For other Sung finds of related sil-*

Liao and later burials.[44] They would appear to indicate the liminal state of the tomb, with access both to the world of the living and the world of the dead. We can imagine the need for such a door from the ghost stories already mentioned. The ceiling of the rear rooms was painted to represent a series of textile canopies, as if it were the ceiling of a Buddhist cave (fig. 2.7).[45] Such ornament is in contrast with the star patterns described in connection with Liao tombs and seen also on the Sung tombs at Ching-hsing. But both stars and canopies may be references not to the worldly interiors of houses, but of access to heavenly worlds. Not only Taoism but Buddhism also, of course, promised such worlds to the faithful. While Westerners have always sought means to evade Purgatory and Hell and to attain Heaven, the pragmatic Chinese seem to have expected a more ambiguous afterlife. Time might, we can surmise, be spent in several of the worlds available to the dead.[46]

The tombs just described were partially or completely robbed of furnishings. But we can get some impression of the balance between tomb decoration and tomb contents from a painted tomb at Lo-yang Mang-shan dating to the mid-twelfth century, probably before the fall of Pien-liang (fig. 2.8).[47] The tomb has a single large room with a decorated entrance and two side chambers. Such a plan differs from the majority of Liao and Sung tombs in Hopei. But like the tombs already mentioned, the ceiling is domed and was presumably decorated. The small side rooms were modeled and painted with scenes of food preparation. Utensils, such as scissors, tables, and clothes racks, which we have already encountered in Liao burials, were depicted on the walls. An exceptional feature is a display of hanging painted scrolls.[48]

But the tomb is especially interesting for fine silver and ceramic eating utensils, as well as gold and silver jewelry (fig. 2.9). An inscription on one of the dishes indicates that the tomb occupant was a woman with connections to the Imperial family, which may explain the very high quality vessels and their large numbers. However, it is clear from finds from other tombs of the eleventh and twelfth centuries that women of not exceptionally high standing were often given fine silver wares as burial goods. As I have discussed elsewhere, the tomb of the wife of Chang T'ung-chih, buried in the late twelfth century at Huang-yüeh-ling near Chiang-p'u in Kiangsu Province, is interesting for its fine silver vessels accompanied also by very fine white porcelains.[49] This tomb contains a flask similar to the one in the tomb at Mang-shan.

The contents of the woman's grave can be readily compared with that of her husband. Here we find, in place of fine silver and porcelain, writing utensils: two inkstones, two pieces of ink, a small bronze water holder, two scroll or paper weights, a bronze brush rest, and a bronze seal.[50] This same range of utensils appears in other tombs and would appear to be essential equipment for a man. Later T'ang tombs had also held writing utensils, but less regularly, and they were generally confined to inkstones and paper weights. In both the T'ang and the Sung, definition of men in terms of writing rather than in terms of fighting with swords or other military equipment is certainly an important comment on both life and the

afterlife.[51] Again, as with the silverware for women, it is perhaps possible that writing implements were buried so that the deceased could have an appropriate life, either in a netherworld or in a higher celestial sphere, perhaps carrying out official duties.

Although we have mentioned ceramic models of utensils, we have not so far mentioned ceramic tomb figures. In the west of China, where the southern T'ang dynasty perpetuated the T'ang name and some other aspects of T'ang material life, figures continued to be made in the tenth century.[52] In the subsequent Sung period, tomb figures seem to have been particularly popular in Kiangsi Province, often being made in high-fired porcelain produced at Ching-te-chen. In addition, the calendrical figures already mentioned in connection with the T'ang are among the most frequent figure types overall.[53] During the Sung, as in the T'ang, some examples were placed in niches of the tomb walls, thus surrounding the body or bodies of the dead. Other strange, imaginary animals must have had some mythical role. In this respect, the function of Sung ceramic tomb figures was significantly different from those of the T'ang. They were generally intended not to provide the earthly attendants of servants and soldiers, but to represent aspects of the unseen world of the cosmos. Farm animals in iron, especially oxen, are also a feature of Sung and Chin tombs. Iron may have been selected as a particularly powerful material.

We know that the Sung, like the T'ang, had a lively popular literature in which the visits of ghosts to the world were a recurrent element. The dead, while inhabiting their tombs, might pass through the doorways both to the world of mankind and also to other worlds. It is also suggested here that the change in burial goods may reflect a changing balance in an understanding of the realms of the afterlife. A change from a standardized set of tomb figures to the more intimate personal, and often very valuable, possessions of an individual suggests that now the afterlife may have presented fewer fears of accounting to an implacable bureaucracy and greater promises of fruitful service among the higher levels of officials. There was, in addition, a shift from the imagery of a military life and excursions of hunting expeditions to a depiction of men at their desks, either in official life or in retirement, with women elegantly served with silver cups and adorned with jewelry.

Conclusion

This paper has presented information on tombs at three levels. It has been concerned with the facts of what is actually found in tombs and how the tombs and their decoration changed. Secondly, it has emphasized the representational character of tombs and the different media in which that representation took place. Thirdly, it has been concerned with the possible interpretations that we might give to what we see. As the tomb was essential to an afterlife, the explanations have been given in terms of how the afterlife might have been conceived, rather than in terms of how the tombs might have been determined by economic conditions or legal codes. Thus, the tombs are seen here as giving us access to medieval views otherwise difficult to reach.

ver, see K'ao-ku 1991.7, pp. 670–72; Wen-wu 1986.5, pp. 70–77.

50. For tombs holding writing utensils, see Wen-wu 1991.3, pp. 26–38; Wen-wu 1988.11, pp. 48- 54; 55–60; K'ao-ku 1991.7, pp. 670–72, fig. 2:8; Wen-wu 1990.3 pp. 19–23; K'ao-ku 1988.4, pp. 318–28; 329–34, fig. 1:6. For a survey of ceramics in dated tombs, see K'ao-ku 1994.1, pp. 74–93.

51. Although they are conspicuously absent from the tombs discussed in this paper, swords were of course widely used; see K'ao-ku 1988.4, pp. 335–36).

52. Wen-wu 1991.5, pp. 11–26; 1990.3, pp.1–13.

53. K'ao-ku 1993.2, pp. 141–44; K'ao-ku 1988.4, pp. 318–28.

54. Michael Carrithers, Why Humans Have Cultures: Explaining Anthropology and Social Diversity (Oxford: Oxford University Press, 1992).

55. For an account of the value of objects and other items that we see as ways of containing information and as a means to focus our attention and contribute to our comprehension of situations and ideas, see Merlin Donald, Origins of the Modern Mind: Three Stages in the Evolution of Culture and Cognition (Cambridge, Mass. and London: Harvard University Press, 1991); for a discussion of the philosophical implications of representations, see Kendall Walton, Mimesis as Make-Believe, on the Foundations of the Representational Arts (Cambridge, Mass. and London: Harvard University Press, 1993).

As mentioned, the stories of the *Kuang-i chi*, and equivalent tales of earlier and later periods, allow us comparable access to views of the afterlife. Indeed, it has been argued by Michael Carrithers in connection with the tenets of Hinduism that stories provide a particularly useful way for the peoples of any time to express and expound and to understand their own beliefs.[54] Pictures and more elaborate representations including architectural settings and real and replica objects are, I suggest, exactly equivalent. They too express and expound ideas, but they do so visually and do not always, indeed often do not, refer to knowledge or notions expounded in religious texts or even in stories. We have to take them as a source of information in their own right. For they have an important immediacy. They were made and viewed by those who used them. The structures of tombs, their ornament, and their contents were put in place by peoples to whose views of life and the afterlife they conformed. Moreover, the ways in which these tombs could be altered over time or from place to place also made it possible to accommodate differing concepts. Indeed, the changes in physical appearance may have formed part of a dialectic by which those very ideas were changed.[55]

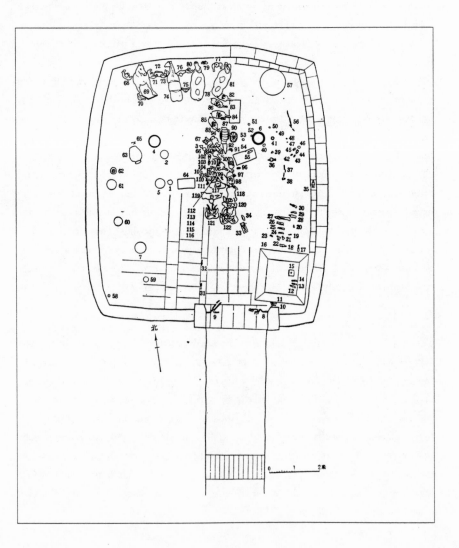

Figure 2.1
Plan of the tomb of Li Ssu-pen, buried in 709 at Yen-shih, Honan Province, showing large numbers of ceramic tomb figures. After K'ao-ku 1986.5, p. 435, fig. 13.

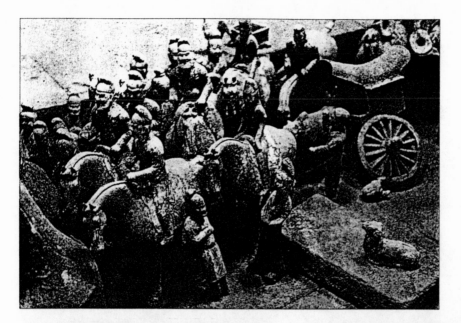

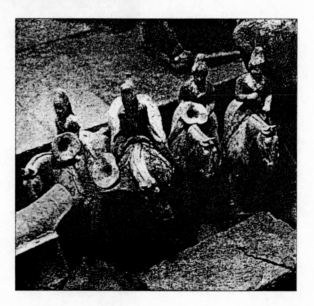

Figure 2.2
Three views of ceramic tomb figures from the tomb of Li Ssu-pen. After K'ao-ku 1986.5, pl. 6.

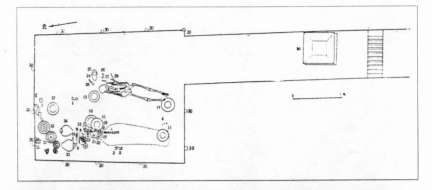

Figure 2.3
Plan of the tomb of Li Ching-yu, buried
in 738 at Yen-shih, Honan Province.
After K'ao-ku 1986.5, p. 443, fig. 23.

Figure 2.4
Silver from the tomb of Li Ching-yu.
After K'ao-ku 1986.5, pl. 8.

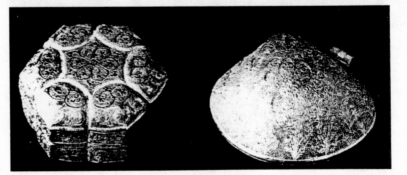

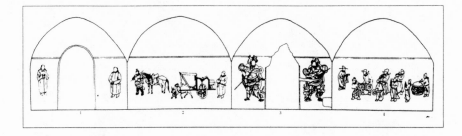

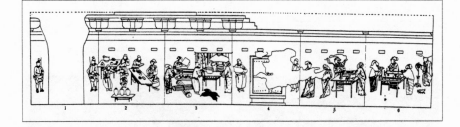

Figure 2.5a, b
Drawings of wall-paintings in the two
rooms of the tomb of Han Shih-hsün,
buried 1111 at Hsüan-hua, Hopei
Province. After Wen-wu 1992.6, p. 7,
fig. 20, p. 8, fig. 27.

Figure 2.6a
Utensils from tomb 2 of Chang Kung-yu,
buried 1117 at Hsuan-hua, Hopei
Province; a) earthenware replicas. After
Wen-wu 1990.10, p. 3, fig. 4.

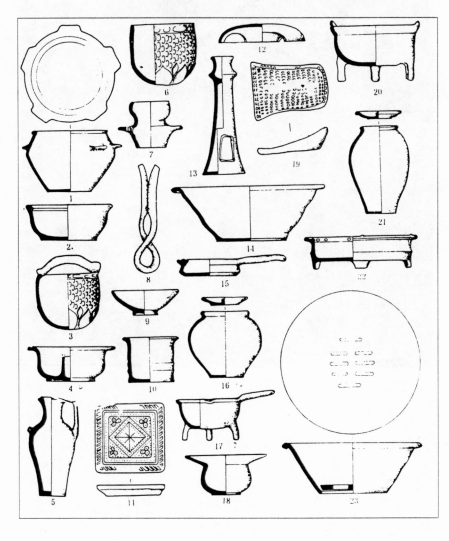

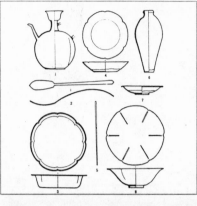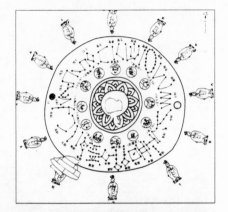

Figure 2.6b, c
Utensils from tomb 2 of Chang Kung-yu,
buried 1117 at Hsuan-hua, Hopei
Province; b) porcelain vessels; c) ceiling
ornament of constellations and the twelve
calendrical figures. After Wen-wu
1990.10, 5, fig. 10, and p. 9, fig. 17.

Figure 2.7
Ceiling ornament of a painted canopy in
Buddhist style from tomb 1 at Pai-sha,
Honan Province. After Su Pai, Pai-sha
Sung mu, *pl. 14.*

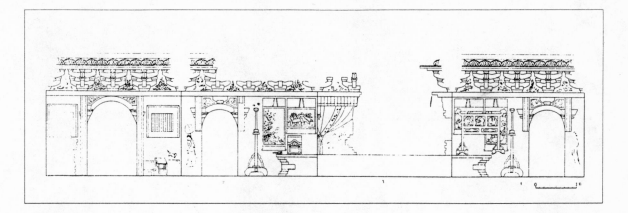

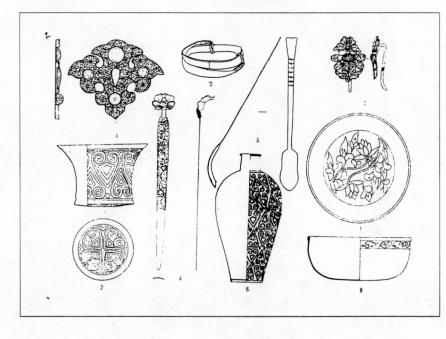

Figure 2.8
Drawing of the decoration of the walls of
a twelfth-century tomb at Lo-yang
Mang-shan. After Wen-wu 1992.12,
p. 42, fig. 11.

Figure 2.9
A selection of silver vessels and jewelry
from the tomb at Lo-yang Mang-shan.
After Wen-wu 1992.12, p. 46, fig.
22.

Commodities, Collectables, and Trade Goods: Some Modes of
Categorizing Material Culture in Sung-Yüan Texts

Craig Clunas

The importance of systems of categorization has long been recognized within Chinese painting studies, with particular reference to the categories of subject matter found in historical catalogues and to what they tell us about changes in the conceptualization of the realm of visuality through time. Lothar Ledderose's 1973 article "Subject Matter in Early Chinese Painting Criticism"[1] paid exemplary and meticulous attention to shifts within these categories in surviving texts down to the Sung period, while, in a more recent example, Lin Po-ting has used changes within this field over a shorter period of the eleventh and twelfth centuries to draw attention to the rise of the "intimate landscape" subject as "a distinct and separate category in the hierarchy of painting subjects."[2]

1. Lothar Ledderose, "Subject Matter in Early Chinese Painting Criticism," Oriental Art 19, no. 1 (1973), pp. 1–15.

2. Lin Po-ting, "Birds in Waterscapes: The Emergence of Intimate Landscapes and Water Birds as Themes in Song Dynasty Painting," Orientations 26, no. 9 (October 1995), p. 59.

These studies, however, focus their concern on the contents of the categories they study. Yet it is impossible for many now to read a list of categories, any list of list of categories, without being dimly aware of the sardonic presence of that mythical Chinese encyclopedia, laid before us with a poker-face by the Argentinean writer Jorge Luis Borges, that moved Michel Foucault to laughter in the introduction to *The Order of Things*, originally written in 1966. This preposterous list of categories of animals, which runs from "(a) belonging to the Emperor," through "(n) that from a long way off look like flies," foregrounded for Foucault in an instant the limitations of his own, hitherto seemingly rational procedures of division and sorting.[3] Since that moment, the contingent nature of all categories has been inescapable for many, but so has the central importance of their operations to ways in which different historical and social moments have configured meaning out of the otherwise uncontrollable and promiscuous profusion of things, natural and unnatural. And if even those most seemingly innocent of categories, "natural" and "unnatural," can be shown to be precise historical constructions, how much more must we alert ourselves to the problematic nature of those that our profession as museum curators and art historians relies on for its very legitimacy: "art," "decorative art," "painting," and, perhaps most insidiously of all, "material culture," that recent and feeble attempt to evade the issue altogether. Foucault has further contended, with regard to the history of Western Europe, that changes in the history of categorization are not randomly distributed, but accompany more profound changes at the level of what he calls the "episteme," the entire system of the possibility of knowledge. The position of Foucault's work with regard to studies of China seems to me to be analogous to a remark of G.K. Chesterton on Christianity: it is not that it has been tried and found wanting, rather, it has been found difficult and (with a few very honorable exceptions) not tried. In one of the

3. Michel Foucault, The Order of Things: An Archaeology of the Human Sciences (London: Tavistock Publications Limited, 1989), p. xv.

most thoroughly argued of those exceptions, John Hay has aptly stated:

> When one reads *The Order of Things* from a sinological perspective, it is as though one is constantly seeing its images reflected brilliantly in a pile of mirror shards. So many of the same issues are to be seen, but in fragments that need to be rearranged, often but perhaps not always differently, in the reconstruction of another history.[4]

4. John Hay, "Subject, Nature, and Representation in Early Seventeenth-century China," in Proceedings of the Tung Ch'i-ch'ang International Symposium, ed. Wai-ching Ho (Kansas City: The Nelson-Atkins Museum of Art, 1991), p. 4–6.

This paper will therefore try, in a rather tentative and unsatisfactory way, to suggest that an attention to systems of categorization in the Sung and Yüan periods, studied as systems in themselves and not purely for the content they embody, can play a role in the larger question of the nature of thought and the construction of meaning at this precise historical period. Such change will be sought for here, not in the pronouncements of philosophers, but in the practices whereby lists of things were written into a range of Sung and Yüan texts, to a number of ostensible purposes, although, as we shall see, perhaps to one common end.

I intend to look at the accounts of material objects, some of them at least now categorized as works of art, in three particular texts dating from the hundred years spanning the mid-thirteenth to mid-fourteenth centuries. These are, in the probable order of their composition: first, one of the earliest examples of the genre of guides to the total accoutrements of the scholarly interior, the *Tung-t'ien ch'ing-lu chi* (Collected Pure Favors of the Cavern Heavens), by Chao Hsi-ku, written about 1242; second, Chou Mi's memoir of the fallen Southern Sung capital of Lin-an (modern Hangchow), the *Wu-lin chiu-shih* (Old Affairs of Wu-lin), written between 1280 and 1290; and, finally, the major Yüan dynasty account of maritime Asia and of China's trading links with it, Wang Ta-yüan's *Tao-i chih-lüeh* (Brief Account of the Island Barbarians) of 1349. The linking together here of these three texts, each of which has its separate place in traditional bibliographical practice, is an act of arbitrary and contingent categorization by me that should not go unnoticed, even if it can for the time being be accepted as a deliberate strategy of reading.

Another arbitrary act of reading in which I wish to engage is taking the texts backwards in the presumed order of their composition, beginning, therefore, with that of Wang Ta-yüan.[5] The *Tao-i chih-lüeh* is today viewed as one of the most important of the geographical treatises that flourished in the high period of maritime exploration and trade, spanning the years of the Sung to early Ming. It takes an honored place in modern studies of that trade, in between the earlier *Chu-fan chih* of Chao Ju-kua and the accounts of the early-fifteenth-century voyages of the eunuch admiral Cheng Ho.[6] The biography of its author has been reconstructed from internal evidence by recent scholarship that has in general supported Wang's claim to have had firsthand knowledge of at least some of the countries discussed, in two major voyages made from Ch'uan-chou, in 1330–34 and 1337–39.[7] This, of course, does not mean that we are dealing with some sort of "raw" unstructured data, but in fact (as Roderich Ptak has trenchantly pointed out) with a highly crafted literary text that deploys in its prefaces and postface overlapping and comple-

5. The edition I have used is Wang Ta-yüan and Su Chi-ch'ing, eds., Tao-i chih-lüeh chiao-shi, Chung-wai chiao-t'ung shih-chi ts'ung-k'an (Beijing: Chung-hua shu-chu, 1981).

6. The former is the best known of these texts in English, thanks to the pioneering early translation, Friedrich Hirth and W.W. Rockhill, Chao Ju-kua: His Work on the Chinese and Arab Trade in the Twelfth and Thirteenth Centuries, Entitled Chu-fan Chi (St. Petersburg: Imperial Academy of Sciences, 1911).

7. See the introduction by Su Chi-ch'ing to Wang Ta-yüan, Tao-i chih-lüeh, pp. 9–10.

mentary world views cited in a number of discourses, including discourses of the state and cosmology.[8] Particularly important is the numerology that underlies the ordering of the text's segments, and that is based on the numbers nine and three: there are ninety-nine independent country segments containing information on places visited by the author, with a hundredth chapter giving hearsay information on nine more, making a total of one hundred eight places. A particular importance is attached to the eighty-first (nine times nine) chapter, as the symbolic nadir of geography.[9] The importance of number as an organizing principle at this period cannot, it seems to me, be overstated. Number (*shu*) took any educated reader back almost directly to the most prestigious of all classical texts, the *I-ching* (Book of Changes), central to any sort of epistemological formation of the period.[10] Consequently, it is never a bad idea to be aware of the numerical relationships between categories in any type of activity, the visual arts of the period not excluded. What is striking in this light about the categories of painting subject discussed by Ledderose is the fact that number appears at first sight to play no part in the expansion or contraction of the system of categories, although it still seems a worthwhile future exercise (that will not be pursued here) to look at some of the classic texts of painting criticism with a numerologically sensitized eye.

The *Tao-i chih-lüeh* is arranged, as noted above, geographically. It is therefore a text that maps things onto places, an ordering principle, which in the Chinese written record goes back a very long way, at least to the *Yu kung* or "Tribute of Yu" section of the canonical *Book of Documents* (Shu-ching), and is central to the type of chorological writing we know as gazetteers. This seems such a "natural" way of doing things that it passes without comment, but even it has a history. The structure of the individual country segments within the *Tao-i chih-lüeh* follows a standard pattern that has been described as falling broadly into three areas. In modern terms these are the geographic (information about locations and distances); the ethnographic (the customs, or *feng-su*, of the place, its laws and government), and the economic.[11] I want to focus on the last of these, and in particular not on the list of the products of the various regions of Asia described, but on the trade goods that Wang asserts from experience that Chinese merchants take and sell. In reading through the text and extracting every mention of these goods, some of them raw materials, some of them goods from other parts of Asia that were simply transshipped in Chinese vessels, and some of them manufactured goods from China itself, I have consciously tried to remain at the level of the text. That is to say, I have paid close attention to the precise phrasing of the lists, never conflating two very similar sounding items into one category, even when "common sense" would encourage one to do so. "Common sense" is here a very false friend. On these terms, then, I count 204 separate items of trade goods.

Several things stand out. First, there is no visible hierarchy of objects, in the sense that types of thing are not always mentioned in the same order. This may be clearer with a few examples. The goods deemed suitable for Chiao-chih (now the northern part of Vietnam) are "various colors of bolts of twill damask silk (*ling*) and silk gauze (*luo*), blue cotton, ivory combs, sheets of paper, bronze and iron."[12]

8. These are discussed in Roderich Ptak, "Image of Maritime Asia in Two Yüan Texts: Daoyi Zhilue and Yiyu zhi," Journal of Sung-Yüan Studies 25 (1995), pp. 52–54).

9. Ibid.

10. On this, see "Chapter Four: Shao Yung and Number," in Kidder Smith, Jr., Peter K. Bol, Joseph A. Adler, and Don J. Wyatt, Sung Dynasty Uses of the I Ching (Princeton: Princeton University Press, 1990), pp. 100–35.

11. Ptak, "Image of Maritime Asia in Two Yüan Texts," p. 57.

12. Wang Ta-yüan, Tao-i chih-lüeh, p. 51.

13. Ibid., p. 102.

14. Ibid., p. 106.

15. Ibid., p. 148.

16. Ibid., p. 353.

To Ting-chia-lu (Trengganu in Malaysia) go "blue and white patterned porcelain vessels, Champa cloth, fine red plain silk (*chuan*), pewter, wine,"[13] while Jung (Chumphorn, Malaysia) will take "bronze and lacquer wares, blue and white patterned bowls, porcelain ewers and vases, floral silver, purple fired beads, Wu-lun cloth."[14] Borneo welcomes "white silver, red gold, colored satin of silk (*tuan*), small caskets, iron wares."[15] In the far west, Mecca, on the Arabian peninsula takes "silver, five-colored satin of silk, blue and white patterned wares, iron tripods."[16] There is no visible pattern here as to the order in which things are mentioned. The relationship, for example, between textiles and ceramics is not fixed; and, instead, sometimes one comes first in the list, sometimes the other. Gold and silver, which feature relatively frequently, do not always come before other less precious materials, but nor do they invariably come last. It looks totally, and lamentably, random.

Perhaps even more worrying to the tidy-minded is the way things are themselves described. The number of entities is multiplied to an infuriating degree, and one that made the task of compiling a list very much lengthier than I had imagined when I sat down to do it. As mentioned above, there are 204 items mentioned, distributed across the 108 countries discussed in the text (though it should be noted that some places are silently categorized as too primitive to be interested in the goods of China at all). Most of these appear only once. There is only one mention of *ch'in* zithers and of *juan* (a stringed instrument like the *p'i-p'a*), said to be exported to Chi-lan-tan (Kelantan, Malaysia).[17] There is only one mention of "yellow oiled umbrellas," destined for Hsu-wen-na (the location is disputed, but is certainly somewhere in India).[18] These are not isolated instances. In fact, 132 out of the total 204 categories have only one mention. Very many get only two mentions. Only two categories make it into double figures, these being simply "silver" (*yin*), with thirteen mentions, and "iron wares" (*tieh-ch'i*), with ten. An analysis of the list in full would be tedious, but my point about what looks like an almost manic multiplication of categories is made by extracting all the mentions of ceramics, and simply listing them, in the precise wording in which they appear in the *Tao-i chih-lüeh*, and with the number of mentions they receive following. They are:

17. Ibid., p. 99.

18. Ibid., p. 314.

19. This is generally accepted as being a reference to what current practice would call Lung-ch'uan ware. Wang Ta-yüan, Tao-i chih-lüeh, p. 22.

20. See Ibid., p. 31, for Su Chi-ch'ings arguments as to why ch'ing-pai in this text refers to porcelain painted in underglaze cobalt blue, rather than to what has been also called ying-ch'ing ware. The precise identification is not, in any case, germane to my argument.

> ceramics (*tz'u-ch'i*): 1
> porcelain from Ch'u-chou[19] (*Ch'u-chou tz'u-ch'i* or *Ch'u-chou tz'u*): 2
> Ch'u wares (*Ch'u ch'i*): 1
> Ch'u vats (*Ch'u weng*): 1
> Ch'u vats (*Ch'u weng ch'i*): 1
> blue porcelain (*ch'ing tz'u-ch'i*): 2
> blue porcelain patterned bowls (*ch'ing tz'u hua wan*): 1
> blue ware (*ch'ing ch'i*): 6
> blue dishes (*ch'ing p'an*): 1
> blue vats (*ch'ing weng ch'i*): 2
> blue and Ch'u ware (*ch'ing Ch'u ch'i*): 1
> patterned bowls (*hua wan*): 1
> blue and white patterned bowls[20] (*ch'ing-pai hua wan*): 8
> blue and white bowls (*ch'ing-pai wan*): 1

blue and white ceramics (*ch'ing-pai tz'u*): 1

blue and white patterned ceramics (*ch'ing-pai hua tz'u-ch'i*): 1

blue and white patterned wares (*ch'ing-pai hua ch'i*): 6

blue and white and Ch'u[-chou] ceramics: 1

porcelain ewers and vases (*tz'u hu p'ing*): 1

porcelain vases (*tz'u p'ing*): 1

porcelain dishes (*tz'u ch'i p'an*): 1

coarse bowls (*ts'u wan*): 9

black vases (*wu p'ing*): 1

small jars (*hsiao kuan*): 1

earthenware vases (*wa p'ing*): 1

earthenware jars (*wa t'an*): 1

earthenware vats (*wa weng*): 1

water jars (*shui t'an*): 1

water jars (*shui ch'eng*): 1

large and small water jars (*ta hsiao shui ch'eng*): 2

large and small water jars (*ta hsiao shui kuan*): 1

large and small jars (*ta hsiao ch'eng*): 1

large and small jars and vats (*ta hsiao ch'eng weng*): 3

jars and vats (*ch'eng weng*): 1

large vats (*ta weng*): 1

vats (*weng ch'i*): 1

jars (*ch'eng ch'i*): 1

The view might be advanced that I am wasting my time for two reasons. It could be argued, on the one hand, that these very precise distinctions are accurate reflections of highly specialized trading conditions in different ports, that it was, for example, possible in the fourteenth century to sell porcelain ewers, but not porcelain vases, in Chumphorn, while exactly the opposite conditions prevailed in Kanmai-li (possibly Kerman in the Persian Gulf).[21] This view would see the minute division of the broader category of "fired beads" (*shao chu*) according to color (we hear of fired beads, five-colored fired beads, five-pattern fired beads, four-color fired beads, blue-colored fired beads, blue fired beads, purple fired beads, red fired beads, red-colored fired beads, red and green fired beads, red and blue fired beads, yellow fired beads, yellow and red fired beads) as reflecting very particular customer preferences. This view should not be set aside lightly, but I think in the end it can be discounted. The multiplication of entities is too great, and their distribution too random. Another view would see the exercise above (which could easily be repeated with regard to the textile descriptions) as being pointless in that it attempts to impute too great a level of systematization to casual jottings. Why should one expect coherence in such a text? There is in fact no "real" difference between "porcelain from Ch'u-chou" and "Ch'u wares." All one needs to do is collapse the minor variations of wording, and get on with work on the larger and more manageable units that thereby result.

This, I would argue, would be to commit a seductive error. I would submit

21. *Wang Ta-yüan*, Tao-i chih-lüeh, *pp. 106, 364.*

that the size of the number of categories for material goods embodied in the *Tao-i chih-lüeh* is not the result of sloppy thinking or loose drafting on the part of Wang Ta-yüan. The multiplication of terms is so great that one is almost tempted to see it as hard to achieve by mere accident—someone who did not care would repeat themselves more often. Rather, I want to argue, it is a manifestation at the level of text of a discourse of things that structures them quite differently from the European intellectual tradition. It is not, and never has been, in the long shadow thrown by Plato's ideal Forms, the notion that beyond the multiplicity of observed phenomena lies a set number of immutable, eternal, and unchanging Forms of the "really" real. Beyond all the bowls we can see and touch and hold lies the Form (the Platonic word is *eidos*) of "bowl." Such ideas, at however distant a remove and whether they are raised to the level of consciousness by practitioners or not, under-pin all the notions of taxonomy by which the modern museum, the modern art market, and the practices of scholarship and connoisseurship in the decorative arts operate. However, to read them back into Sung and Yüan texts, particularly into Sung and Yüan lists of things, is to risk missing the point of such lists at the time of their creation. It is the multiplication of categories, not their reduction, that "makes sense" in the epistemology of the age. A sense of the plenitude and com-plexity of things, the richness and diversity of the made material world, pervades much of the writing of the period, and, I shall go on to argue, much of the visual culture too. The central position of China as disburser of things to the outer world is underlined by what is to us the verboseness and imprecision of Wang's categories (I have not counted them with the same rigor, but I have the impression that the number of categories of products of the outside world is very much smaller). What is also underlined is China's central role as maker of meaning, maker of sense, through its ability to multiply and to put forth categories of things, of *wu*. This mul-tiplication, beyond the traditional "ten thousand things" (*wan wu*) of pre-Ch'in phi-losophy, is also seen in the writing of the Sung philosophers we now call for conve-nience the Neo-Confucians. Their thought was becoming normative at the precise period we are looking at, spreading beyond a narrow elite to provide a wider way of "making sense" within Chinese culture. As Shao Yung (1011–1077), numerolog-ical builder of "a world-system of enormous scale and complexity" put it:

> There is a thing of one thing. There is a thing of ten things. There is a thing of a hundred things. There is a thing of a thousand things. There is a thing of ten-thousand things. There is a thing of a million things. There is a thing of a billion things. Isn't man the thing of a billion things?[22]

22. *Kidder Smith Jr., et al.,* Sung Dynasty Uses of the I Ching, *pp. 100, 134.*

This steadfastly nonreductionist system of things was manifested not only in the highly technical and arcane writings of a Shao Yung, but by the fourteenth century also in the categorizing practices of the far-voyaging Wang Ta-yüan. If we now move back slightly in time to the very beginning of the Yüan, what is the world of things as it appears in Chou Mi's *Wu-lin chiu-shih*? This text is one of a group of more or less nostalgically read accounts of the fallen Southern Sung capital, all of

them to a degree epigones of the unique text on its Northern Sung predecessor at K'ai-feng, the *Tung-ching meng Hua lu*, (A Record of Dreaming of Hua [Hsu] in the Eastern Capital), first published in 1187.[23] Of the four principal descriptions of Hangchow, *Wu-lin chiu-shih* is distinguished as being the only one written by an identifiable member of the scholarly elite, and has been recognized both by the editors of the *Ssu-k'u ch'uan-shu* and by the leading modern scholar of the subject as "by far the most comprehensive and well written of the journals."[24] It is accepted as having been compiled between about 1280 and 1290, when Chou Mi (1232–ca. 1308) was living in retirement under Mongol rule in Hangchow.

The work is in ten chapters.[25] It is distinguished from the other texts by its inside information on court ceremonial, which Chou Mi was in a position to have witnessed firsthand, but it shares with them a fascination with lists, above all with lists of things. There are lists of the categories of objects forming the dowry of imperial princesses (p. 30), of the structures that make up the imperial palace (pp. 53–57), of markets (p. 116), foodstuffs (pp. 122–27), and many other categories, including a list of 280 titles of the type of variety show known in the Sung as *tsa-chu*.[26] Some of these lists can be quite long. I count forty-one types of fruit, twenty types of vegetables, seventeen types of non-alcoholic cold drinks, and fifty-four types of alcoholic ones. Plurality, multiplicity, the enlargement of terms are what is on offer here. It seems inescapable that the Sung and Yüan reading public on at least some occasions liked reading lists. (And it should be remembered that the formal layout of Sung or Yüan texts often made the reading of such lists less easy on the eye than it is in the present age of punctuated and annotated editions.) Perhaps an echo of this in popular culture is the presence of lists in drama, such as the patter of the fruit merchant in one Yüan play, with its extensive roll-call of mouth-watering delights.[27]

One entire chapter of the *Wu-lin chiu-shih* is made over to a single enormous list of things and people, describing as it does the items consumed and displayed, and the officers and officials present, on the occasion of the Sung emperor Kao-tsung's visit in the tenth month of the twenty-first year of the Shao-hsing era (equivalent to 1151) to the mansion of the Commandery Prince of Ch'ing-ho, sur-named Chang, an imperial relative by marriage.[28] Obviously Chou Mi had not witnessed this event, which had taken place a century before his own time, and unless he invented the whole thing in all its plethora of detail, we are forced to surmise the reality of the quoted inventory or account in manuscript form, written by a certain member of the favored family named Chang Kuei or Chang Ch'ing (the early editions differ), to which he appears to have had access. What is striking about the description of foodstuffs is the vast elaboration of categories again present, dividing the huge meal served into more than thirty courses, with individual named dishes running well into three figures. These are carefully graded according to the rank of their recipient. Thus, here things fit people, social rank being privileged as the pre-existent "natural" category (the role played by geography in the *Tao-i chih lüeh*) onto which made objects have to be mapped. This is, of course, the organizing principle behind sumptuary regulations, those laws designed to restrain

23. *The following discussion is heavily indebted to Stephen H. West, "The Interpretation of a Dream: The Sources, Evaluation and Influence of the Dongjing meng Hua lu,"* T'oung Pao 71 (1985), pp. 63–108.

24. Ibid., p. 101. *The other texts are:* Tu-ch'eng chi-sheng *(preface dated 1247),* Hsi-hu lao-jen fan-sheng lu *(ca. 1250), and* Meng-liang lu *(1274, 1304, or 1334).*

25. *The edition I have used is the one with simplified characters, published in one volume together with* Tung-ching meng Hua lu *and the other three descriptions of Hangchow, as part of the* Chung-kuo p'eng-jen ku-chi ts'ung-k'an *(Beijing: Chung-kuo shang-yeh Ch'u-pan-she, 1982), hereafter referred to as Chou Mi.*

26. *Stephen H. West, "Mongol Influence on the Development of Northern Drama," in* China under Mongol Rule, *ed. John D. Langlois, Jr. (Princeton: Princeton University Press, 1981), p. 445, n. 2.*

27. *Frederick W. Mote, "Yüan and Ming," in* Food in Chinese Culture: Anthropological and Historical Perspectives, *ed. K. C. Chang (New Haven and London: Yale University Press, 1977) p.235, quoting a translation by Stephen H. West.*

28. Chou Mi, *pp. 168–80.*

29. Craig Clunas, "Regulation of Consumption and the Institution of Correct Morality by the Ming State," in Norms and the State in China, eds. Chun-chieh Huang and Erik Zurcher, Sinica Leidensia 28 (Leiden/New York/Koln: Brill, 1993), pp. 39–49.

30. Chou Mi, pp. 177–78.

31. Michael Freeman, "Sung," in K. C. Chang, pp. 166–67.

unbridled and inappropriate consumption that were an enduring concern of imperial governments both before and after the Sung.[29]

Following the lists of foodstuffs and participants in the event come lists of Dishes and Boxes Presented to the Emperor (*Chin-feng p'an-ho*),[30] which are then further subdivided according to what they contained: Precious Vessels (*Pao ch'i*), Antique Vessels (*Ku ch'i*), Ju Ware (*Ju yao*), Boxes (*Ho chang*). Then Calligraphy and Painting (*Shu hua*) is divided into "Ten scrolls bearing the imperial seal," "Nine scrolls with no seal but with imperial calligraphy," and "Two scrolls without imperial seals or calligraphy," before this broad category of Dishes and Boxes Presented to the Emperor ends with Bolts of Silk. It then moves on to accounts of the huge amounts of bounty disbursed by the emperor, before closing with a list of members of the Chang family who were favored by the imperial presence.

I want to concentrate on the internal organization of the category Dishes and Boxes Presented to the Emperor. In his discussion of this banquet, Michael Freeman assumes these are the vessels in which the food was served, but this is impossible for several reasons.[31] The subsection Precious Vessels opens with "Imperial medicine belt: 1 item," which is clearly not a food vessel at all, and also contains such explicitly nonculinary objects as "Jade incense-tripod: 1 item." It is highly unlikely that by Kao-tsung's time food was taken out of putatively Shang and Chou bronze vessels. The description of the Ju ware pieces reads as follows:

> wine bottles (*chiu p'ing*): 1 pair
> brush washer (*hsi*): 1 item
> incense burner (*hsiang lu*): 1 item
> incense box (*hsiang ho*): 1 item
> incense ball (*hsiang ch'iu*): 1 item
> cups (*chan*): 4 items
> basin (*yu*): 1 item
> incense emitters (*ch'u hsiang*): 1 pair
> large dressing box (*ta lien*): 1 item
> small dressing box (*hsiao lien*): 1 item

The specific nature of the names makes it impossible that these are vessels for eating. Rather, they are gifts made to Kao-tsung by the Chang family, and particularly appropriate gifts in that, as physical testimony to the material culture of the lost northern capital whose glories he was attempting to re-create, they bolstered his claim to an undiminished legitimacy of rule over the whole space of the empire.

Is there a hierarchy of types of object within the larger categories in this chapter of *Wu-lin chiu-shih*? I would argue that there is. The order is: precious vessels, antique vessels, *Ju* ware, lacquer boxes. The simple principle behind this list is that things mentioned first are more important, just as pictures with the imperial seal outrank those without it but with imperial calligraphy, and they in turn outrank those with neither. (The hierarchy is not to do with artists, since sealed and unsealed works by the Northern Sung master I Yüan-chi occur in more than one subcategory.) We can follow this principle down to a lower level of analysis. Within Precious Vessels, the order is: the imperial medicine belt, jades, gold, pearls, king-

fisher feathers, white (clear?) glass, glass, and agate. Within the eight Antique vessels, all the Shang pieces come before the Chou ones, and first of all comes the sole *ting*, the most prestigious and hallowed of all shapes. These might not be the order in which we would place things today, or even the order in which we might casually assume they would have been ranked in the Sung. Archaic bronzes were not the cynosure of admiration in every context. Nor do works of painting and calligraphy necessarily of themselves enjoy the preeminence that the discourse of "fine art" later accords them. In the specific context of imperial magnificence, gold and pearls and even kingfisher feathers and glass enjoyed a luster they did not possess. The notion of *ku*, "antique," might indeed be a powerful structuring discourse, and one getting more powerful in the Sung, but the complementary notion of *pao*, "precious" or "treasure," should not be set aside as a result of either puritanism or positivism (the gold vessels are all gone, but the bronzes, not to mention some of the calligraphy and paintings, are with us still).[32] The ranking of objects follows the structuring principle of the whole event, in which notions of hierarchy are paramount. There is, however, a transference going on, in which objects that are important because they are appropriate to people of a certain rank come to take on some of that rank in and of themselves. This creates the possibility of a move towards the fully autonomous commodity culture, where the person will gain by association with the thing, rather than the other way round.

The role of the Sung court as a center of cataloguing and listing is so obvious that it may pass unremarked. Both activities are closely bound up with the notion of a canon, and are as important for what they exclude as for what they embrace. Northern Sung emperors understood this from the very beginning; decisions were made about what to include and what to keep out in the case of Confucian texts and calligraphic specimens alike. In both cases, this was enforced by a technology of reproduction, either by printing or by the rubbings of the *Ch'un-hua-ko t'ieh* collection, that was at least as much about control as about dissemination.[33] The cataloguing activities of the court of Hui-tsung are a continuation of this: the *Hsuan-ho hua p'u* of 1120 and the *Hsüan-ho po-ku t'u-lu* of 1123 are but two of the best known examples. Another catalogue, or list of things, dating from this era, and one that remains more firmly within the visual realm, has been the subject of an excellent study by Peter Sturman.[34] He draws attention to the now dispersed and largely lost *Hsüan-ho jui-lan ts'e*, hundreds of fifteen-leaf albums containing visual and textual records of auspicious phenomena conveying Heaven's blessing on the by then beleaguered Northern Sung polity. As Sturman sensitively shows, these shed an intriguing light on the whole question of "realism" in Sung painting, the role still accorded to the accurate transcription of observed phenomena through art, at a time when advanced aesthetic theory explicitly challenged the validity of such activity, seen as being enthralled to the inferior category of "form-likeness" (*hsing-ssu*). I would wish in the context of the present discussion simply to draw attention in addition to the quality of extensiveness that these albums share with some of the other texts discussed here. There are (or rather were) a lot of these pictures. It is once again the multiplicity of these phenomena, irreducible to broader categories or neater pat-

32. The comments of Julian Raby and Michael Vickers in "Puritanism and Positivism," in Pots and Pans: A Colloquium on Precious Metals and Ceramics in the Muslim, Chinese and Graeco-Roman Worlds, *Oxford 1985*, Oxford Studies in Islamic Art 3 (Oxford: Oxford University Press, 1986), pp. 217–23, remain highly relevant here.

33. Peter K. Bol, "This Culture of Ours": Intellectual Transitions in T'ang and Sung China *(Stanford: Stanford University Press, 1992), pp. 152–53.*

34. Peter C. Sturman, "Cranes above Kaifeng: The Auspicious Image at the Court of Huizong," Ars Orientalis 20 (1992), pp. 33–68.

terns, which is their testimony to the workings of cosmological principles of the greatest significance and moment.

The author of the *Wu-lin chiu-shih*, Chou Mi, was also himself the author of an important catalogue of works of art he had seen, the *Yün-yen kuo-yen lu* or, *Record of That which has Passed the Eyes like Floating Clouds*. It discusses paintings, calligraphy, bronzes, jades, ceramics, and musical instruments, and is one of the earliest such private compilations to survive.[35] It lists things, not people, unlike most earlier catalogues whose structuring principle is by artists. It also lists individual items the author claims to have seen (and there is no reason to doubt him on this). As such, it differs from the third and final text I wish to discuss, the *Tung-t'ien ch'ing-lu chi*, of Chao Hsi-ku.

This work has had a complex textual history that has not yet been fully elucidated. It remained unpublished until the second half of the Ming, and then is confused with another text of almost exactly the same name (simply *Tung-t'ien ch'ing-lu*) that contains a very high proportion of post-Sung material.[36] The Chao Hsi-ku text was highly praised by the *Ssu-k'u ch'uan-shu* editors, however, and described in this century by Robert van Gulik as "the oldest 'guide for the scholar of elegant taste.'"[37] The divisions of the text are as follows:

1. Antique *ch'in* zithers (*ku ch'in pien*)
2. Antique inkstones (*ku yen pien*)
3. Antique bells, tripods, and [bronze] vessels (*ku chung ting i-ch'i pien*)
4. Curious stones (*kuai shih pien*)
5. Inkstone screens (*yen ping pien*)
6. Brush stands (*pi ko pien*)
7. Water droppers (*shui ti pien*)
8. Ancient calligraphic specimens (*ku han-mo chen-chi pien*)
9. Ancient and modern rubbings (*ku chin shih-k'o pien*)
10. Ancient paintings (*ku hua pien*)

The last three chapters have been extensively mined and translated for their material on painting and calligraphy, and are well known within the field.[38] The first seven have been rather less studied, as has the text as a whole. Little is known about its enigmatic author, save that he was a member of the Sung imperial family, who held office in Ch'ang-sha in the Ch'ing-yüan era (1195–1201), and that he returned to I-ch'un in Kiangsi province in 1242.[39]

The title, here translated as "*Collected Pure Favors of the Cavern Heavens*," could scarcely more explicitly proclaim a Taoist framework for the text, even if the implications of this are not always clear. The *tung-t'ien* (cavern, or grotto, heavens), beneath the great mountains of China, were numinous places, the homes of holy Taoist adepts and the source of potent mineral elixirs. In at least some accounts there were principally ten of these marvels, that is, one for each chapter of the *Tung-t'ien ch'ing-lu chi*.[40] The trope of the infinitely huge contained within the seemingly small is repeated in the preface, more particularly in the idea that things offer a way out of the mundane, a route of access to higher realms; Chao speaks of how, on studying antique objects, "I no longer knew that my body was lodged in

35. Hin-cheung Lovell, An Annotated Bibliography of Chinese Painting Catalogues and Related Texts, Michigan papers in Chinese Studies 16 (Ann Arbor: University of Michigan Press, 1973), p. 11.

36. Ma Ling-ch'un and Li Fu-t'ien eds., Chung-kuo wen-hsüeh ta tz'u-tien, 8 vols (Tien-chin: Tien-chin ren-min Ch'u-pan-she, 1991), 6, p. 4517.

37. R. H. van Gulik, Chinese Pictorial Art as Viewed by the Connoisseur (New York: Hacker Art Books, reprint 1981), p. 489.

38. In van Gulik, and also in Susan Bush and Hsio-yen Shih, Early Chinese Texts on Painting (Cambridge, Mass. and London: Harvard University Press, 1985), whose extracts are based on translations by Sarah Handler.

39. Bush and Shih, Early Chinese Texts, p. 295.

40. A classic account is Edward H. Schafer, Pacing the Void: T'ang Approaches to the Stars (Berkeley / Los Angeles / London: University of California Press, 1977), pp. 249–53.

the realm of men."[41] Things are proclaimed here as a means to an end, in a way that recalls the famous formulation of Su Shih (1037–1101): "The superior man may visit his intention (*yu i*) on things, but he may not leave his intention behind (*liu i*) with things."[42]

The bulk of the text contains some very different messages. Above all, it is shot through with an anxious concern with authenticity, as the use of the word *pien*, "to discriminate," for the chapter headings would suggest. The fear of fraud, which permeates the connoisseurship texts of the late Ming, all of them in turn in a sense epigones of this one, is everywhere, expressed in the distinction between the terms *chen* and *wei*. Thus the discussion on *ch'in* focuses on the connoisseurship of the various types of cracking in the lacquer as a guide to the instrument's age, while the section on bronzes begins a long tradition of accounts of the faking of patinas in an attempt to simulate the effects of burial.[43] What is, of course, implied here is a commodity context for the objects discussed, not one of gifts or of trade but a setting in the marketplace, where accurate information is as hard to come across as authentic goods. There are, in fact, no great lists of individual things in the *Tung-t'ien ch'ing-lu chi*. Nor is there a great multiplicity of objects; in fact, the range of things discussed is, on the contrary, very tightly circumscribed. In place of lists, there are statements such as "Antique *ch'in* are the hardest thing to obtain, beyond fine gold or beautiful jade,"[44] looking very much like part of a project to reorder (if not consciously or explicitly) the sort of priorities seen in the *Wu-lin chiu-shih* list. It is tempting to see this as an attempt to assert control over the plethora of things, not by listing or cataloguing them *in extenso*, but by cutting back on the number of things that can be discussed at all. It would be even more tempting, but probably extremely rash, to see this as a phenomenon allied in some way to the often-observed fact that the subject matter available to painters of elite social origins was also undergoing a circumscription at broadly the same period. The phenomenon we now call "literati painting" certainly involved a rejection of, or at least a drawing away from, certain kinds of subject matter. To draw a neater conclusion would be premature.

Attempts to control things through categories are always in the end attempts to control the people who may deploy those things, to sustain hierarchies of class or gender or age, which inappropriate and indiscriminate use of things threatens to subvert. Such risks are greatest at times of market expansion, when more people can get their hands on more things and more types of things. The urban culture of Southern Sung Lin-an was undoubtedly such a setting. Chao Hsi-ku is moved to remark:

> When a Taoist plays the *ch'in*, that *ch'in* is pure even if it is not [of itself] pure. When a vulgar person plays the *ch'in*, that *ch'in* is sullied even if it is not [of itself] sullied. How much more is this the case for women, girls, professional entertainers, and the lower rabble![45]

Sumptuary laws will not do the job here, only taste (in Susan Stewart's trenchant phrase, the "code-word for class varieties of consumption"[46]) will provide the necessary social technologies of control.

41. *Chao Hsi-ku, Tung-t'ien ch'ing-lu chi, 10 chuan, Mei-shu ts'ung-shu ch'u chi ti-chiu chi, p. 1a.*

42. *Bol, "This Culture of Ours," p. 277.*

43. *Chao Hsi-ku, Tung-t'ien ch'ing-lu chi, p. 2a & 11a.*

44. Ibid., *p. 2a.*

45. Ibid., *p. 10a.*

46. *Susan Stewart, On Longing: Narratives of the Miniature, the Gigantic, the Souvenir, the Collection (Durham and London: Duke University Press, 1993), p. 35.*

Although the earliest of the three texts rather arbitrarily yoked together in this essay, the *Tung-t'ien ch'ing-lu chi*, is therefore in a way the most "modern," the manner in which it responds to the unprecedently rich and various material world of the Southern Sung points forwards to another such moment of crisis in the relationship of people and things, the later sixteenth and early seventeenth centuries, when it was finally published and took its place as a classic of a genre that it anticipated by some three hundred years. However, much further work remains to be done before we can answer with any conviction the bigger question of whether shifts within the meaning of categories, or changes in the operation of categorization itself, brought it into being. John Hay's general suggestion that "we can recognize a number of aspects of Foucault's classical era in Sung dynasty Neo-Confucianism" has not been taken up by specialists in Sung thought, either for confirmation or refutation.[47] I certainly do not claim to have engaged fully with it here, lacking as I do the necessary familiarity with the material of this period. Nor would I wish to be understood as saying that the sorts of constructions of meaning in things that I have been discussing represent some "soft underbelly" of Chinese thought, a way in which avoids the painful necessity of engagement with the very complex writings of Sung and Yüan philosophers. However, if we are to advance to a more firm grounding for the widely shared, and undoubtedly correct, view that the China of 1400 is not the China of 1000, and that some major if unquantifiable shift in meaning and representation takes place in China over those centuries, then the sorts of material I have been dealing with are not trivial and not peripheral to this wider enterprise.

47. Hay, "Subject, Nature, and Representation in Early Seventeenth-century China," p. 4–5.

II. New Directions in Northern Sung Culture

The Revival of Calligraphy in the Early Northern Sung

Ho Chuan-hsing

Between 960 and 979, the Sung emperors T'ai-tsu (r. 960–76) and T'ai-tsung (r. 976–97) reunited the empire after a period of political division known as the Five Dynasties and Ten Kingdoms, defeating the previously independent states in the north and the south. The region where T'ai-tsu was born, the large central plains region north of the Yangtze, had once served as the center of T'ang political and cultural life. Beginning in the mid-T'ang period, from the second half of the eighth century on, however, the economic and cultural center of the empire gradually moved south, so that by the tenth century, when northern China was ravaged by incessant warfare, the relatively stable southern states such as the Later Shu (934–65), the Southern T'ang (937–75), and Wu-yüeh (907–78) became both a refuge for northerners, and a place where art and culture still flourished. The unification of the empire under the Sung not only ushered in an era of political and economic stability, but also enabled artists from the rich cultural centers in the south, to make a major contribution to the newly emerging culture of the Sung. In particular, the art of calligraphy, after nearly a century of stagnation, underwent a major renewal. When Northern Sung critics of calligraphy discussed the achievements of this period a century later, they generally gave most of the credit for the revival to Emperor T'ai-tsung's active encouragement.[1] It can be said that his efforts determined the main direction of the early Sung revival of calligraphy, and exerted a direct influence on the works of court calligraphers and scholar-officials in later generations.

The Search for Works by Ancient Masters, and the Creation of Model Rubbings

Shortly after he ascended the throne in 976, T'ai-tsung completed the reunification of the empire by easily defeating the kingdom of Wu-yüeh in Chekiang and the Northern Han (951–79) in Shansi. The first step he took in reviving calligraphic traditions was to initiate a search for ancient works of calligraphy scattered in local collections, especially those in the south. Historical records indicate that between 977 and 995, T'ai-tsung repeatedly offered financial rewards and official positions to anybody in the southern provinces who could offer calligraphic relics from past masters. As a result, the imperial collection gained original manuscripts or rubbings of works by such figures as Chang Chi (active second half of 2nd century), Chung Yu (151–230), Wang Hsi-chih (ca. 303–ca. 361), Wang Hsien-chih (344–388), Emperor Hsüan-tsung of the T'ang (r. 712–56), Yü Shih-nan (558–638), Ou-yang Hsün (557–641), Ch'u Sui-liang (596–658), and Huai-su (725–785), gathered from collections in places such as Jing-hu, in Hupei, T'an-

1. See Chu Ch'ang-wen, Mo-ch'ih-pien (Taipei: Han-hua, 1970), chüan 3, pp. 429–32, "Ch'en han-shu" (On the Calligraphy of the Emperors); Huang T'ing-chien, Shan-ku t'i-pa, I-shu ts'ung-pien (ISTP), comp. Yang Chia-lo (Taipei: Shih-chieh, reprint 1967), vol. 22, chüan 4, p. 31, "T'i T'ai-tsung huang-ti yü-shu" (Colophon on the Calligraphy of Emperor T'ai-tsung); Mi Fu, Shu-shih, in ISTP, vol. 2, p. 56.

2. See Kuo Jo-hsü, T'u-hua chien-wen-chih in Hua-shih ts'ung-shu (Taipei: Wen-shih-che Ch'u-pan-she, 1974), vol. 1, chüan 1, p. 2, "Hsu kuo-ch'ao ch'iu-fang"; Li T'ao, Hsü Tzü-chih t'ung-chien ch'ang-pien (Taipei: shih-chieh, 1974), chüan 31, p. 334; Wang Ying-lin, Yü-hai, in Ching-yin Wen-yüan-ko ssu-k'u-ch'üan-shu (SKCS) (Taipei: Shang-wu, 1983), vol. 944, chüan 45, p. 233; Hsü Sung, ed., Sung hui-yao chi-kao, in Sung hui-yao chi-pen (Taipei: shih-chieh, 1964), vol. 5, p. 2238. Wu Jen-ch'en, Shih-kuo ch'un-ch'iu, in SKCS, vol. 466, chüan 83, pp. 123, 125.

3. See Ou-yang Hsiu, Chi-ku-lu-pa-wei in Shih-k'o shih-liao ts'ung-shu, Yan Keng-wang, ed. (Taipei: I-wen, n.d.) part two, vol. 77, chüan 10, p. 6b, "Shih-pa-chia fa-t'ieh" (Copybook of Eighteen Calligraphers); Lin Chih-chün, T'ieh-k'ao (Taipei: Hua-cheng shu-chu, 1985), p. 33, "Ch'un-hua ko-t'ieh k'ao-hsü" (Continued Research into the "Ch'un-hua ko-t'ieh").

4. On the Southern T'ang engravings, see Lin Chih-chün, T'ien-k'ao, pp. 1-14, 23–26. Lin holds that the ten chüan of the Ch'un-hua ko-t'ieh were created on the basis of revisions made to the Southern T'ang Sheng-yüan-t'ieh, the stone engravings of which were obtained from Chiang-nan in the Sung period, and that the Ch'un-hua ko-t'ieh was itself engraved on stone. However, there have been no extant Southern T'ang engraved calligraphic models since the Sung, so the Ch'un-hua ko-t'ieh is still regarded by most scholars as the progenitor of the genre of calligraphic model collections. For a comparison of the works of Wang Hsi-chih in the Ch'un-hua ko-t'ieh and in T'ang T'ai-tsung's collection, and a discussion of the question of authenticity, see Nakata Yujiro, O Gishi o Chushin to suru Hojo no Kenkyu (Research into the Copybook with a Focus on Wang Hsi-chih) (Tokyo: Nigensha, 1960), chap. 5, "Ch'un-hua ko-t'ieh," pp. 79–81.

chou, in Hunan, Yüan-chou, in Kiangsi, and Sheng-chou, in Kiangsu. Also among these new acquisitions were gifts presented to the throne by Ch'ien Yü (943–999), a descendent of the king of Wu-yüeh, and Ch'ien Wei-yan (962–979).[2]

T'ai-tsung ordered Wang Chu (d. 990), court calligrapher in the Hanlin Academy, to sort through the imperial collection, with the result that, in 992, the Ch'un-hua ko-t'ieh collection of rubbings was published, in 10 chüan, with a total of 419 works by 105 calligraphers. This set of rubbings was presented to officials in the Bureau of Military Affairs and the Secretariat as an expression of the emperor's high regard for calligraphy. It is said that only a small number of sets were made since the original woodblocks kept in the imperial library were later destroyed by fire.[3] Due to private and official copies and recarvings,however, the Ch'un-hua ko-t'ieh exerted a powerful influence on later scholars and calligraphers. It is the earliest extant anthology of model rubbings, and hence the prototype for all later model calligraphy collections. Part of its contents come from the imperial collection gathered under the direction of T'ang T'ai-tsung in his campaign to exalt the calligraphy of Wang Hsi-chih. According to the Hsüan-ho shu-p'u (Catalogue of Calligraphy in Emperor Hui-tsung's Collection), some of these works were still in the collection of Emperor Hui-tsung (r. 1101–25) at the end of the Northern Sung. Although some of the works collected in the Ch'un-hua ko-t'ieh were taken from engravings made in the Southern T'ang or from private collections, thus leading some later connoisseurs to doubt their authenticity,[4] these calligraphic models can be viewed as the choicest selections from the imperial collection at that point in history, and representative of the official standard of ancient calligraphy at that time.

The Ch'un-hua ko-t'ieh is divided into four sections, according to the status of the calligraphers—namely, Emperors, Famous Officials, Ancient Masters, and Wang Hsi-chih and Wang Hsien-chih. The first two categories accord with traditional concepts of the exalted status of emperors, placing imperial works at the beginning of the collection, as was to become the practice in official collections thereafter. The third category, Ancient Masters, was arranged chronologically. The high regard traditionally accorded Wang Hsi-chih is evidenced by the creation of the final category. An examination of the contents reveals that they consist mainly of epistolary works, called "Southern Exemplars," dating from the Eastern Chin (317–420) and later. Aristocrats, like Wang Hsi-chih, who had fled south to the Eastern Chin in the mid-fourth century created a vast quantity of private letters in running script style. Valued for their spontaneity and naturalness, these letters were collected and copied by the emperors of the Southern Dynasties and by T'ang T'ai-tsung becoming one of the most important traditions in the history of calligraphy. In later times, artists studied Wang Hsi-chih's epistolary works both because they expressed the refined cultivation of a true literatus and because they had come to represent the orthodox tradition of Chinese calligraphy.

The Search for the Ancient Techniques: Emperor T'ai-tsung's
Running, Cursive and Flying White Scripts

What is the relationship between the establishment of the model rubbing (*fa-t'ieh*) tradition, with Wang Hsi-chih at its center, and the calligraphy of the early Sung dynasty? In his *History of Calligraphy* (*Shu-shih*), Mi Fu (1052–1107) says of the officials in T'ai-tsung's court that "because of the emperor's likings, they all studied the works of Chung [Yu] and Wang [Hsi-chih]."[5] Huang T'ing-chien's *T'i T'ai-tsung huang-ti yü-shu* (Colophon on the Calligraphy of Emperor T'ai-tsung) states that after the emperor had unified the empire, "he hung up his bow and arrow, and, in his leisure time, after attending to affairs of state, concerned himself with calligraphy, marvelously getting to the bottom of all eight methods; all the literati of the time personally took instruction from him."[6] Southern Sung sources also mention that when the emperor had some spare time he would often call together the calligraphers from the Hanlin Academy and work with them in imitating the works of Chung Yu and Wang Hsi-chih.[7] From this we can see that the main force behind the study of Wang Hsi-chih and Chung Yu (who had had an important influence on Wang) at the court in this period was T'ai-tsung's personal admiration for this tradition.

The courtly preference for studying Chung Yu and Wang Hsi-chih continued through the reign of Emperor Chen-tsung (r. 998–1022). It is recorded that in the year 1008, Prime Minister Wang Ch'in-jo made the following statement to Emperor Chen-tsung about his predecessor's achievements in reviving calligraphy:

> It is because T'ai-tsung was so expert in calligraphy that nowadays everyone throughout the empire applies himself to the study of calligraphy. The Five Dynasties had so-called court calligraphy, but no works showing the proper methods are to be found among them. The current situation has been achieved because everyone now studies Wang [Hsi-chih], Ou[-yang Hsün] and Liu [Kung-ch'üan].[8]

Although the historical sources state that T'ai-tsung was skilled in all calligraphic scripts, that he often gave his works to high ministers as gifts, and that a large number of these works were collected in the imperial archives,[9] no original works are extant. The only evidence of T'ai-tsung's writing that survives is a rubbing, the *Chih-tao yü-shu fa-t'ieh*, in the National Palace Museum, Taipei (fig. 4.1). This work consists of thirty-two leaves, in standard, running, and running-cursive scripts, and bears a colophon dated to the fifth year of the Ch'un-hua era (994); it must have been engraved sometime during the Chih-tao era (995–97). The contents are mainly copies of proverbs from the Classics. At the end of each selection, the character *ch'ih* (used to mark imperial decrees) is added, just as is in the thirty-two calligraphic works by the T'ang emperor T'ai-tsung (r. 626–49) in the first part of the *Ch'un-hua ko-t'ieh* (fig. 4.2). In fact, the calligraphic styles of the two emperors is quite similar. The Ch'ing collector Pi Lung added a postscript, in which he notes that Emperor T'ai-tsung's calligraphy in this work is similar to the

5. *Mi Fu, Shu-shih, p. 56.*

6. *Huang T'ing-chien, Shan-ku t'i-pa, chüan 4, p. 31.*

7. *Wang Ying-lin, Yü-hai, chüan 33, p. 775.*

8. *Ibid., p. 772.*

9. *Chu Ch'ang-wen, Mo-ch'ih-pien, chüan 3, p. 429. Similar accounts can be found in many sources on Sung history, for example, the Hsü Tzu-chih t'ung-chien ch'ang-pien, Sung hui-yao chi-kao, Yü-hai, Hsüan-ho shu-pu Huang-sung shu-lu, and the Shu hsiao-shih, as well as the early Yüan work Shu-shi hui-yao (1376) by T'ao Tsung-i, and many letters and colophons from the later Northern Sung. Some of these testimonials can perhaps be viewed as flattering exaggerations of the emperor's achievements, but what mainly concerns us here is the manner in which early Sung calligraphy was influenced by the imperial court.*

standard script in the *Kuan-nu t'ieh*, attributed to Wang Hsi-chih. When we recall Sung T'ai-tsung's emulation of T'ang T'ai-tsung, and the tradition of esteem for Wang Hsi-chih underlying it, the relationship between the three is quite obvious.

Also extant, in the *Wu-kang t'ieh*, engraved in the Southern Sung, is a work by Emperor T'ai-tsung done in cursive script, *Four Poems by the T'ang Poet Ts'ui Hao* (fig. 4.3). The brushstrokes are even and smooth, with a special emphasis on well-rounded curves and interconnections between the characters. A style similar to this interconnected cursive script can be found in the works of the Han calligrapher Chang Chih and the T'ang calligrapher Chang Hsü (active early 8th century) collected in the *Ch'un-hua ko-t'ieh* (fig. 4.4). However, due either to errors in the engraving or to a deliberate emphasizing of the interconnective style, the brushstrokes in T'ai-tsung's work seem rather oversimplified, giving a flat and smooth feel, which lacks the inner tension found in the melodiously rising and falling brushstrokes of the earlier calligraphers.

Another possible source of this cursive script style is Huai-su's famous *Tzu-hsü t'ieh* (*Autobiographical Essay*), dated 777 (fig. 4.5). In the early Northern Sung, this work was part of the personal collection of Su Shun-ch'in (1008–1048), grandson of Hanlin scholar Su I-chien (957–995), who was treated well by T'ai-tsung. When Su I-chien was at his official post in the south, he acquired a large quantity of paintings and calligraphies from the imperial collection of the fallen Southern T'ang dynasty;[10] Huai-su's *Autobiographical Essay* was perhaps among them. It would then have been passed down to his son Su Ch'i and his grandson Su Shun-ch'in; in any case, the distinctively powerful and vigorous interconnective style of Huai-su's work, renowned for its freedom and abandon, was certainly an influence on Su Shun-ch'in's own work.[11] Although it is impossible to say for certain whether the *Autobiographical Essay* in Su I-chien's collection had a direct influence on the emperor's large cursive script style, T'ai-tsung's fluent and mature mastery of cursive script suggests a firm grounding in the styles of the High T'ang masters.

Although T'ai-tsung's *Four Poems by the T'ang Poet Ts'ui Hao* may have lost some of its original spirit in the course of repeated recopyings and engravings, it is still possible to feel its smoothly rounded gentleness, free from any trace of haste or anger. This is a common stylistic feature of calligraphies produced by artists connected with the imperial court. Even if T'ai-tsung had intended to emulate the freedom and abandon of the cursive script of the late T'ang, he was unable to escape the restrictions of the rules for cursive script that he himself advocated and the influence of the tastes common to the imperial court, and thus he produced this fluent and gentle work.

T'ai-tsung's efforts to revive ancient calligraphy were not restricted to his study of Wang Hsi-chih's running and standard script styles. He was also interested in the nearly vanished decorative calligraphic style known as "flying white script" (*fei-pai*). In his appraisal of T'ai-tsung's achievements in the field of calligraphy, the Northern Sung calligraphic critic Chu Ch'ang-wen (1039–1098) pointed out that the origins of the flying white script could be traced to Ts'ai Yung (132–192), and was in the repertoire of Wang Hsi-chih and his son Wang Hsien-chih, as well as that

10. *Kuo Jo-hsü, T'u-hua chien-wen-chih, chüan 6, p. 86, "Su-shih t'u-hua" (Su's Collection).*

11. *The only extant original of Su Shun-ch'in's cursive script is the Nan-p'u t'ieh, in the Tokyo National Museum. A rubbing of his work can be found in the Ch'i-lan-t'ang fa t'ieh (1805), chüan 5, "Huai-su tzu-hsü-t'ieh pa" (Postscript to Huai-su's Autobiography). The six lines of calligraphy at the head of the original Autobiographical Essay may also be by Su Shun-ch'in.*

of Hsiao Tzu-yün (486–548). Chu added that the technique flourished in the T'ang dynasty but gradually began to disappear, until T'ai-tsung "re-established what had been in decline and displayed its glory to all future times."[12]

Historical sources repeatedly mention T'ai-tsung creating works of calligraphy in the flying white script and giving them to officials. Among these are works written in large characters, as well as pieces for engravings over the entrances of buildings (such as the four large characters *Yutang zhi shu* [Hanlin Academy] he had engraved for the Hanlin Academy in the year 991, or the inscription he had done for the renovated Imperial Archives in 992); the zenith of this activity was probably his bestowal of eighteen such pieces to Manager of Affairs K'ou Chun in 994.[13] Thereafter, Emperors Chen-tsung and Jen-tsung inherited T'ai-tsung's interest in the flying white script.[14] The sources also report that they did not use an ordinary brush for this style, but a special flat brush made of bark.[15]

Despite clear evidence in the written records, no example of flying white calligraphy by any of the three emperors has survived, so we have no way of knowing what the writing looked like. There was already a long tradition of this style of calligraphy before the Sung dynasty; many references to it are found in works on calligraphy from the Southern Dynasties to the mid-T'ang (late 5th to mid-8th centuries).[16] These works treat flying white script as one more type of calligraphic script, on an equal footing with standard, cursive, seal, and clerical scripts. The T'ang calligraphic theorist Chang Huai-kuan believed that the flying white script was invented by Ts'ai Yung and was often used for inscriptions over palace halls in the late Han and early Wei periods. Chang also listed third- and fourth-century calligraphers who excelled at the flying white script, such as Wei Tan (179-253), Wang Chi (276–322), Chang Hung (active mid-3rd century), Wang Hsi-chih, Wang Hsien-chih, Liu Shao (d. 352), Wang Seng-ch'ien (426–485), and Hsiao Tzu-yün.[17]

In the T'ang, flying white calligraphy was prized by Emperors T'ai-tsung and Kao-tsung (r. 649–83), as well as Empress Wu Tse-t'ian. The "Biography of Liu Chi," in the *T'ang shu*, tells the following story of officials at court fighting over Emperor T'ai-tsung's flying white calligraphy:

> Policy Advisor Liu Chi had a disposition that was distant and uncompromising. T'ai-tsung was skilled at calligraphy in the style of Wang Hsi-chih, especially the flying white script. Once when the emperor was having a party for the ministers of the third rank and above in the Hsüan-wu Gate, he wrote some pieces in the flying white style to give to them. The ministers, perhaps emboldened by drink, were fighting over who would get them from the emperor's hand; Liu Chi approached the throne and took them from the emperor's hand. They all advanced, saying, "Liu Chi has ascended to the imperial throne, a crime worthy of death; please apply the law!" The emperor laughed and said, "I have heard that in ancient times Chieh Yü declined the imperial carriage; now I see the policy advisor ascending" the throne.[18]

12. *Chu Ch'ang-wen, Mo-ch'ih-pien,* chüan 3, p. 432.

13. *Li T'ao, Hsü Tzu-chih t'ung-chien ch'ang-pien, chüan 27, p. 3–4; chüan 32, p. 343; chüan 36, p. 372; chüan 40, p. 388.*

14. *See Ou-yang Hsiu, Ou-yang Wenchung-kung ch'üan-chi, in Ssu-pu tsung-k'an ch'u-pien, Wang Yun-wu, ed. (Shanghai: Shang-wu, n.d.), vols. 49–50, chüan 40, p. 305, "Jen-tsung yü-fei-pai chi" (On Emperor Jen-tsung's Flying White Script), chüan 126, p. 981; Tung Shih, Huang-Sung shu-lu, in Chih-pu-tsu-chai ts'ung-shu (Taipei: I-wen, 1966), vol. 107, part 1, pp. 5b–6a; Wang Ying-lin, Yü-hai, chüan 27, pp. 664, 660; chüan 33, pp. 771–75, 778; Ko Sheng-chung, Tan-yang-chi, in SKCS, vol. 1127, chüan 8, p. 484, "Ch'ung-mu T'ai-tsung Huang-ti yü-shu fei-pai yü-t'ang-chi" (Retracing the Jade Hall Record Written by Emperor T'ai-tsung in Flying White Script).*

15. *Li T'ao, Hsü Tzu-chih t'ung-chien ch'ang-pien, chüan 98, p. 980; the entry for the third month of the first year of the Ch'ien-hsing period of Jen-tsung's reign (1023), records the following: "The emperor had originally never tried to write in the flying white script, but one day he went to Chen-tsung's shrine and saw the flying white brushes laid out there, so he picked one up and tried writing with it. The characters were forceful and vigorous, as if he had been writing in this style all his life, so he started to give these away as gifts." Hsü Sung, ed., Sung hui-yao chi-kao, vol. 56, chüan 1753, p. 2271, states, "The brushes were made from bark."*

16. *For example, Wang Yin's "Ku-chin wen-tzu chih-mu" of the Southern Dynasties Sung (420–79), and Yü Yüan-wei's "Lun-shu" of the Liang (502–57); and, from the T'ang dynasty, Sun Kuo-t'ing's "Shu-p'u hsü" (687) and Chang Huai-kuan's "Shu-tuan" (727).*

17. *Chang Huai-kuan, "Shu-tuan" (Opinions on Calligraphy), part 1, in Chang Yen-yüan, Fa-shu yao-lu, in*

ISTP, vol. 1, chüan 7, pp. 111–12.
For recent discussions of the flying white
style, see Fujiwara Sosui, *Zokai
Shodoshi (Illustrated History of
Calligraphy)* (Tokyo: Seishin Shobo,
1975), chap. 3, pp. 372–91; Mori
Soko, *Zusetsu Shoron (Illustrated
Discourse on Calligraphy)* (Tokyo: Seito
Shobo, 1988); Tseng Yu-ho, *A History
of Chinese Calligraphy* (Hong Kong:
The Chinese University Press, 1993),
pp. 69–71.

18. Liu Hsü, *Chiu T'ang-shu (Taipei:
Ting-wen, 1983, revised edition)*,
chüan 74, p. 2608.

19. Wang Ying-lin, *Yü-hai*, chüan 33,
pp. 775–76.

20. Ibid., p. 776.

21. See Nishikawa Nei, "Shichiso-zo
San no Hihakusho," *Shohin*, no. 6
(June 1950), pp. 42–43.

Similar incidents are said to have occurred repeatedly in Sung T'ai-tsung's court; we do not know whether the ministers acted in this way deliberately to flatter the emperor by re-enacting the story about the T'ang court, or if it was a coincidence. The *Yü-hai* (Sea of Jade), an encyclopedia edited by Wang Ying-lin (1223–1296) of the Southern Sung, records the following incident:

In the second year of the Chih-tao period (996), on the *ping-wu* day of the fifth month, the emperor [T'ai-tsung] showed several of his flying white works to his close ministers; the characters were all broad, full, and measured. First he gave one to Lü Tuan, the prime minister, causing the other officials to come forward, clamoring that they wanted one too. The emperor said, "This is just like when Liu Chi ascended the imperial throne."[19]

According to the records, T'ai-tsung had strong feelings about the flying white style:

The flying white script follows the form of characters used in small cursive script; it differs from clerical script. As the emperor of All under Heaven, why do We bother with the study of calligraphy? It is just that in Our heart We love it, and cannot easily give it up. It has been so for many years now, and thus We have been able to fully penetrate the method.[20]

T'ang T'ai-tsung's famous engraving in running script, the *Chin-tz'u ming*, engraved in 646, has the nine characters *chen-kuan nien-nien cheng-yüeh nien-liu jih* (twenty-sixth day of the first month of the twentieth year of the Chen-kuan period) in the upper margin (fig. 4.6). The style used is probably what is traditionally called "flying white." The strokes used to finish the characters are similar to those found in standard script, but the other strokes show the strong influence of clerical script; the character *kuan,* in particular, finishes with an upward flying final stroke, like a billowing sash, which is quite decorative. The twisting strokes, leaving traces of uninked white paper within them, create a dynamic visual effect, reminding one of the description of Wu Tao-tzu's portraiture, in which there was said to be a great variation between the roughness and refinement of the various strokes, which created an upward flying, floating effect, described as "Wu's sashes billowing in the wind."

At the end of the eighth century, this style was transmitted to Japan. The colophon by Kukai (774–834) to the painting *The Seven Patriarchs of Shingon,* now in the Fukoku-ji, Kyoto, is a classic example of flying white script.[21] In 699, the characters written by Empress Wu Tse-t'ien in the upper colophon to the *Shen-hsien T'ai-tzu pei* (fig. 4.7) were shaped to look like birds, or like bird-insect script; the addition of bird-shaped decorations creates an even more graphically schematic form. Although there are no longer any extant examples of the flying white calligraphy of the Sung emperors T'ai-tsung, Chen-tsung, and Jen-tsung, we can infer

from Sung T'ai-tsung's emulation of T'ang T'ai-tsung, and his statement about the relation between this style and the cursive and clerical scripts, that the style of these works may have been close to the type seen on the *Chin-tz'u ming*. In any case, it is clear that the Sung emperors were deeply influenced by T'ang imperial tastes, and were greatly interested in this ancient style.

However, the flying white style, with its use of bark-made or hard brushes, its imitation of clerical and cursive scripts, and its decorative appearance when written on paper, was not able to "shed its glory on future times," as Chu Ch'ang-wen had expected. After the Northern Sung, there are almost no records of great calligraphers expressing interest in this script; it has only survived in popular culture as a form of folk art.

An "Academy Style" of Calligraphy: The Imperial Calligraphy Academy and Court Calligraphers

Sung T'ai-tsung's fondness for the calligraphy of Chung Yu and Wang Hsi-chih and his advocacy of a revival of this tradition had a direct influence on court calligraphy. As Chu Ch'ang-wen wrote, "At this time the calligraphy commanded in the inner court underwent a major change; the Five Dynasties styles were abandoned in favor of the old methods used in the High T'ang, a clear transformation."[22] The calligraphy "commanded in the inner court" was given the disparaging title "Academy Style" by late Northern Sung critics. As Huang Po-ssu (1079–1118) wrote, in his discussion of the T'ang calligrapher Huai-jen's (active early 7th century) stele *Chi Wang Hsi-chih tzu sheng chiao hsü* of 672:

22. Chu Ch'ang-wen, Mo-ch'ih-pien, chüan 3, p. 430.

> In recent times, most of the calligraphers in the Hanlin Academy have imitated the style of this stele, but have not been able to equal it, so their works are complete without any lofty resonances. Thus, this style is called the Academy Style. This name has been around since the time of Wu T'ung-wei and his brother, in the T'ang dynasty; these days very few scholar-officials bother to try their hand at this style.[23]

23. Huang Ch'ang-jui, Tung-kuan yü-lun, *in SKCS, vol. 850*, chüan hsia, p. 361.

Wu T'ung-wei, Drafter of the Hanlin Academy in the Chien-chung period (780–83), under the T'ang emperor Te-tsung (r. 780–804), was skilled at running and cursive scripts; all the Hanlin scholars imitated his style, and it was this style that in the early Sung was called the Academy Style.[24]

The Southern Sung calligraphic critic Ch'en Yu (active late 12th century), quoting Huang Po-ssu's critique of the Academy Style, compared the calligraphy of Wang Chu, the influential calligrapher who compiled the *Ch'un-hua ko-t'ieh*, to that of Wu T'ung-wei, calling it "Little Wang's calligraphy" and stating that "the shape of the characters is lofty and charming, but there is no true structural force to them." However, by the late Northern Sung, Hanlin scholars imitated this style in writing their memorials to the throne.[25]

Wang Chu had come to the early Sung court from the Later Shu kingdom, claiming to be a descendent of Wang Fang-ch'ing, who had given the *Wang-shih i-*

24. Chang Chi, Chia-shih t'an-lu, *in Pi-chi hsiao-shuo ta-kuan (Taipei: Hsin-hsing, n.d.) section 16, vol. 1, pp. 214.*

25. Ch'en Yu, Fu-hsüan yeh-lu, collected in ISTP, vol. 2, chüan 1, pp. 254–55.

26. For Wang Chu's biography, see T'o T'o, et al., comp., Sung shih (Taipei: Ting-wen, 1983, revised edition), chüan 296, pp. 9872–73. Li T'ao and Wang Ying-lin both give detailed accounts of calligraphy-related activities in the court of T'ai-tsung, but do not tell of the compilation of the Ch'un-hua ko-t'ieh, nor is it mentioned in the Sung shih biography of Wang Chu; see Li T'ao, Hsü Tzu-chih t'ung-chien ch'ang-pien, and Wang Ying-lin, Yü-hai. It is not clear whether historians deliberately refrained from mentioning this important incident in Wang's life, or if there is some other reason for this omission.

27. Wang Ying-lin, Yü-hai, chüan 33, p. 778.

28. Tung Shih, Huang Sung Shu-lu, section 2, p. 4b. See also Chu Ch'ang-wen, Mo-ch'ih-pien, chüan 3, p. 485.

men *fa-shu* to Empress Wu Tse-t'ien. He had held the post of Recorder in P'ing-ch'uan, Pai-chang, and Yung-k'ang under the Shu government, and, after coming over to the Sung, was given the position of Recorder in Lung-p'ing, Hopei. After eleven years, in the year 978, he took the post of Historiography Institute Usher, and participated in the work of editing philological works. After working in the Historiography Institute for four years, he was promoted to Editorial Director, then to Hanlin Court Calligrapher and finally to a position in the Hanlin Calligraphy Academy. His most famous work was the imperially commanded editing and compilation of the ten *chüan* of the *Ch'un-hua ko-t'ieh,* based on a review of all the works in the imperial collection.[26] The work was engraved in the year 992, two years after Wang Chu's death. From the late Norhern Sung on, Wang was severely criticized by model rubbing experts for his selection. The appropriateness of these criticisms is a question we cannot answer here, but it is clear that after the turmoil of the end of the T'ang and the Five Dynasties, when many of the works of the old masters were destroyed or scattered among the populace, it was extremely difficult to re-create accurately the ancient calligraphic tradition.

Wang Chu was well known as a calligrapher in the court of T'ai-tsung, as noted in the following exchange between the emperor Chen-tsung and his prime minister, Li Tan:

> The emperor Chen-tsung said to Li Tan and the others, "When the former emperor [T'ai-tsung] had some leisure, after dealing with the affairs of state, he always wanted to look at calligraphy and apply himself to writing it; whenever he saw a particular exquisite work, he would certainly try to study and imitate it, and he always succeeded." Li Tan and the others said, "The calligraphy of the former emperor was divine and heroic, beyond comparison to that of ordinary mortal ministers; for example, the Court Calligrapher Wang Chu was famed for his calligraphy at that time, but he was still far from matching the late emperor." The emperor said, "And there were none among the court calligraphers or editorial assistants who were a match for Wang Chu."[27]

None of his ink works survive, but it is generally believed that the titles in the *Ch'un-hua ko-t'ieh* were written by Wang (fig. 4.8). Although impossible to know the original appearance of these characters, since they have undergone repeated copying and recutting, the shape of the characters shows a close relationship to the ancient Wang Hsi-chih tradition, just as is seen in Emperor T'ai-tsung's *Chih-tao yü-shu fa-t'ieh.* Wang's claim that he was a descendent of Wang Hsi-chih[28] would also seem to have perfectly suited the emperor's high esteem for that ancient master.

Wang Chu did not remain in high favor for long, probably only for the short time between 982, when he took his post in the Hanlin Academy, and his death in 990. By the late Northern Sung, his works were rarely seen; Huang T'ing-chien mentions only three: *Lin Lan-t'ing hsü, Shu Yüeh I lun,* and *Pu Chih-yung ch'ien-tzu wen.* The *Hsüan-ho shu-p'u,* which lists all the works in the imperial collection of

Emperor Hui-tsung, mentions no works by Wang Chu. Huang T'ing-chien criticized him as "fettered by rules like a little monk" and "pretty but defective in his lack of resonance,"[29] an indication of the late Northern Sung literati's attitude toward court calligraphers. They strictly observed the rules of calligraphy, but in doing so they lost the resonance and true flavor of good calligraphy.

The early Sung government adopted the T'ang practice of establishing a Calligraphy Academy under the Hanlin Academy, thus relegating all work relating to calligraphy to one specific agency.[30] We know from Wang Chu's biography that the Calligraphy Academy was created in the year 982, but this agency does not appear in the "Chih-kuan chih" (Record of Official Posts) of the Sung shih, so we can assume that it, like the Hanlin Painting Academy, established two years later, was an unofficial, intramural organization. The rank of calligraphers assigned to this agency was not high, equivalent to that of a petty official "not of official status," which is to say, according to the results of recent studies, between the sixth and ninth ranks.[31] To ensure that there would be no inappropriate mixing between these persons and the more official ministers at court, a system of slow transferal and promotion from non-official to official posts was adopted. The entry for the Calligraphy Academy in section nine, "Promotion of Ministers Not of Official Status," of the "Chih-kuan chih," in the Sung shih, states: "Those who had served as Hanlin Attendants for five years were placed in the Palace Eunuch of the Left Duty Group; those who had been working as Court Calligraphers for ten years were placed in the Palace Eunuch of the Right Duty Group; after fifteen years, calligraphic Ushers were put in a temporary official post, but only later would they be given their official titles."[32] Judging from these rules, it took a relatively long time even to make it to the rank of a petty official.

Although their rank in the Calligraphy Academy was low, the calligraphers enjoyed a close association with the emperor within the court, often acting as his personal advisors. Wang Chu had many occasions for close contact with the emperor. The entry for the seventh year of the T'ai-p'ing Hsing-kuo era (982) in the Ch'ang-pien records an instance where Wang Chu candidly and eloquently criticized T'ai-tsung's calligraphy:

> When the emperor had some leisure, after dealing with the affairs of state, he always wanted to look at calligraphy and apply himself to writing it, hoping to capture the marvel of each kind of script used by the masters. He sent the Imperial Commissioner Wang Jen-jui to show one of his letters to Wang Chu. Wang Chu said, "It is not yet perfect." The emperor applied himself to further study and practice, and again showed his work to Wang Chu, but Wang gave the same verdict as before. The messenger, Wang Jen-jui, asked why, and Wang Chu said, "When emperors are just starting to study calligraphy, and people flatteringly praise it, they no longer apply themselves to improving." After a long while, the emperor showed Wang Chu another work, and this time Wang said, "His skill is now perfect, beyond my own capabilities."[33]

29. Huang T'ing-chien, Shan-ku t'i-pa, chüan 4, p. 38; chüan 5, pp. 51–52.

30. For the T'ang court calligraphy system, see Huang Wei-chung, "Tu Liu Kung-ch'üan chuan lüeh-shu shih-shu er san shih" (Incidental Notes on the Court Calligraphy System Gleaned from a Reading of Liu Kung-ch'üan's Biography), in I-chiu-chiu-i-nien shu-fa lun-wen cheng-hsüan ju-hsüan lun-wen-chi (Taipei: Hui-feng-t'ang, 1992), p. 6–1–7.

31. See Shimada Hidemasa, "Kiso-cho no Gagaku ni tsuite" (On Painting in Hui-tsung's Reign), in Suzuki Kei Sensei Kanreki Kinen Chugoku Kaigashi Ronshu (Festschrift of Essays on the History of Chinese Painting for Professor Suzuki Kei) (Tokyo: Yoshikawa Kobunkan, 1981), pp. 117–25.

32. T'o T'o et al., Sung shih, chüan 122, p. 4044.

33. Li T'ao, Hsü Tzu-chih t'ung-chien ch'ang-pien, chüan 23, p. 263.

Nevertheless, it was usually the emperor who directed the calligraphy of his ministers. Moreover, during the reigns of Chen-tsung and Jen-tsung the appreciation of the calligraphy of former emperors was considered a solemn and important duty, which the ministers had to undertake with the utmost respect and carefully flattering rhetoric. Mi Fu writes, "Emperor T'ai-tsung was born at a time when the cultural artifacts of the Five Dynasties were already gone, and Heaven gave him a disposition that loved the works of the ancients. His standard script creatively used the eight methods, his cursive script entered a state of Samādhi, his running script was matchless, his flying white entered the realm of the divine, so that for a time all the officials applied themselves to the study of Wang Hsi-chih and Chung Yu, because the emperor loved them so much."[34] Although this is undoubtedly excessive praise, it is very likely true that the officials at court studied and practiced the calligraphy of Wang Hsi-chih and Chung Yu because of the emperor's advocacy of that tradition.

Calligraphy Engraved on Steles and the T'ang Calligraphic Tradition

In addition to the tradition of model rubbings in the south, another factor that influenced the development of calligraphy in the early Sung was the writing found on the steles remaining in the northern plains, especially in the area around Ch'ang-an and Lo-yang, the political and cultural centers of the T'ang. The calligraphy used in inscriptions from the Hanlin Academy and other official offices in the early Sung generally resembled that of the T'ang steles.

Let us first examine three famous steles in seal script, from the Forest of Steles (Pei-lin), in Sian. The monk Meng-ying's *Chuan-shu ch'ien-tzu wen,* engraved in 965 (fig. 4.9); Kuo Chung-shu's *San-t'i Yin-fu-ching,* engraved in 966 (fig. 4.10); and Hsü Hsüan's copy of the *I-shan pei,* engraved in 993 (fig. 4.11).

Meng-ying (active second half of 10th century) was a monk from Heng-chou, in Hunan, skilled at the minor miscellaneous scripts (of which there were eighteen) and the small seal script. He was once called to court and given a purple robe by Emperor T'ai-tzu. In the Ch'ien-te (963–67) and K'ai-pao (968–75) periods, he had a great deal of interaction with the famed literati of the capital, and was called a reincarnation of the T'ang seal-script calligrapher Li Yang-ping (active 759–80). His status as a Buddhist cleric and his skill at the decorative seal script style probably endeared him to T'ai-tsung, who was also a Buddhist and skilled at the flying white style.[35]

The *Chuan-shu ch'ien-tzu wen* was probably originally written in 964 for Wu T'ing-tso (918–971) of Ching-chao (modern Sian, Shensi Province), in gratitude for Wu's support of Buddhism. It has a colophon in the upper margin by Yüan Cheng-chi, former prefectural judge of Ching-chou, Shensi, together with an explanation that the engraving was done in 965 by An Jen-yü. In the Ming and Ch'ing periods this stele was in the prefectural school in Sian. Wu may have had this stele made not only for religious reasons, but also to provide a model for students of calligraphy in the future.

Kuo Chung-shu (d. 977) was a native of Lo-yang, and had served in the gov-

34. Mi Fu, Shu-shih, p. 56.

35. Chu Ch'ang-wen, Mo-ch'ih-pien, chüan 3, p. 489, records the emperor's call to court and bestowal of the purple robe; also see Wang Ch'ang, Chin-shih ts'ui-pien, in SKSLTS, part 1, vol. 22, chüan 124, p. 3b. From this stele and the poems of contemporaries, we can conclude that the emperor in question was T'ai-tsu. At that time, Meng-yin was nineteen years of age. For T'ai-tsung's Buddhism, see Huang Ch'i-chiang, "Sung T'ai-tsung yü Fo-chiao," (Sung Emperor T'ai-tsung and Buddhism), National Palace Museum Quarterly (November 1994), pp. 107–33.

ernment of the Later Han (947–50). After the destruction of the Later Chou (951–60), he came to the Sung court, taking the posts of Erudite of the National University and Erudite of Calligraphy during T'ai-tsu's reign, and later serving in posts in Shensi, Kuangtung, and modern Ningsia Provinces. During T'ai-tsung's reign, about 976, he was given the post of Recorder in the Directorate of Education. In his later years he became a Taoist, and the accounts of his eccentricities in those years read like legendary tales. He published his research on the characters used in ancient writing, and was famous for both painting (boundary painting or *chieh hua*) and calligraphy (seal, clerical, and standard scripts). Like Meng-ying, his seal script is often mentioned together with that of Li Yang-ping.[36] The *Yin-fu-ching* (Scripture on Unseen Harmony) is a Taoist text that interested many T'ang scholars. It is said that Ch'u Sui-liang (596–658) once copied a hundred rolls of this scripture on imperial order; and there existed carvings of the scripture written in small seal script, attributed to Ou-yang Hsün and Ch'u Sui-liang.[37] This work is obviously connected to Kuo Chung-shu's Taoist faith, but from a calligraphic point of view (it is written mainly in small seal script, with ancient and clerical script also used), it, like Meng-ying's *Ch'ien-tzu wen,* expresses an interest in the transformations of the shapes of characters over the centuries.

These two works were created within a year of each other, and they are similar both in script type and style. Each seems to be intended as a model of the correct way to write seal script. Early Sung scholars placed a high value on the epigraphy of stone and bronze inscriptions, which served as a basic element in Confucianism; Hsü Hsüan (917–992) of the Southern T'ang and early Sung, along with other philologists of the time, was ordered by the emperor to re-edit Hsü Shen's Han dictionary, the *Shuo-wen chieh-tzu.* Even before this, Li Yang-ping had made a study of this text, and added a new explanation, differing from Hsü Shen's, on the origin of many seal script characters. In his preface to the new edition of the *Shuo-wen,* Hsü Hsüan says that, although the editors respect Li Yang-ping's accomplishments in the area of seal script, they do not agree with his arbitrary and unfounded personal opinions and new explanations of the text.[38] The seal script of Meng-ying and Kuo Chung-shu does not show any obvious differences in style that might be attributed to their different positions and backgrounds. What these two works show us are how the seal script tradition was continued, and how models were set up, under the influence of the contemporary enthusiasm for the study of ancient scripts.

Hsü Hsüan was a high official in the Southern T'ang court of Li Yü (r. 961–75). He excelled in epigraphy as well as philology, including small seal and clerical script calligraphy, and his elegance and erudition were much respected by his contemporaries. After the Southern T'ang fell, he surrendered to the Sung with Li Yü; during T'ai-tsung's reign he worked on calligraphy as an official in the Institute of Academicians, where he was well regarded. In 983, he was promoted to Policy Advisor of the Right, and came to be known as Policy Advisor Hsü.[39]

Hsü Hsüan had few political achievements after the fall of the Southern T'ang, devoting himself instead to seal script calligraphy and philology. The *Hsüan-ho shu-p'u* records that he wrote out the entire *Shuo-wen* using small seal script characters

36. For Kuo Chung-shu's biography, see Hsio-yen Shih, "Kuo Chung-shu," in, Sung Biographies: Painters, Herbert Franke, ed. (Weisbaden, 1976), pp. 69–76. Ou-yang Hsiu was a great admirer of Kuo's standard script; see Ou-yang wen-chung kung ch'üan-chi, chüan 10, p. 12.

37. Wang Ch'ang, Chin-shih ts'ui-pien, chüan 124, p. 8a.

38. Hsü Shen, Shuo-wen chieh-tzu, with additional explanations by Hsü Hsüan, in SKCS, vol. 223, p. 380.

39. For Hsü Hsüan's biography, see Ou-yang Hsiu, Ou-yang Wenchung kung ch'üan-chi, chüan 143, p. 1147; Chu Ch'ang-wen, Mo-ch'ih-pien, chüan 3, p. 457; T'o T'o et al., Sung shih, chüan 441, p. 13044.

40. Hsüan-ho shu-p'u, chüan 2, p. 66.

(a total of several tens of thousands), as a model for future students. His seal script calligraphy was regarded as the best since that of Li Yang-ping.[40] Hsü Hsüan was dissatisfied with Li Yang-ping's amendments to the *Shuo-wen,* and so it is not surprising that he was less than satisfied with Li's seal script. For this reason, he sought traces of an older tradition; in his later years he obtained a rubbing of the *I-shan pei,* said to have been written by Li Ssu in 217 B.C., and thereby sought to carry on the Ch'in dynasty seal script tradition exemplified by Li Ssu.

In 993, Hsü Hsüan's disciple, Cheng Wen-pao, engraved Hsü's copy of the *I-shan pei* in stone, after which it was placed in the Ch'ang-an School for the Sons of State, also to be used as a model for future students of calligraphy. This work shows the extent of the efforts made by early Sung scholars to recapture the ancient calligraphic traditions. The original *I-shan pei* was said to have been destroyed by the T'ang period and later re-engraved from a rubbing, in both stone and wood.[41]

41. Wang Ch'ang, Chin-shih ts'ui-pien, chüan 4, pp. 7b–8b.

Whether Hsü Hsüan's copy was made from the stone or the wood recarving, it was most likely already a reproduction, so we can expect that Cheng Wen-pao's engraving may have lost some of the flavor of the original. However, because this work was one of the means by which the first Ch'in emperor standardized the small seal script after unifying the empire, the restoration of the *I-shan pei* by Hsü Hsüan, a high-ranking official in the new Sung regime who was also a philologist and a calligrapher, may have had not only an artistic meaning, but also political significance.

Some ancient stone engravings of standard and running script also existed in the early Sung, and these were stylistically quite consistent. Meng-ying's *Chuan-shu ch'ien-tzu wen,* discussed above, has appended to it a preface composed by T'ao Ku (903–970), written by Huang Fu-yen in standard script, and dated 965 (fig. 4.12). The characters have a rectangular structure and a neat and even appearance, a shape that is easily recognizable as the style originating with Ou-yang Hsün, court calligrapher under the T'ang emperor T'ai-tsung. Huang Fu-yen is otherwise unknown in calligraphic history; his title is given in the inscription as "formerly acting prefectural delegate of Chung-wu chün," but we do not know to what school of calligraphy he had allegiance. The author of the text, T'ao Ku, on the other hand, was famous for his erudition in the early Sung. When he wrote this preface, he was Hanlin Academician Recipient of Edicts in the imperial court,[42] so we can perhaps assume that this engraving was in some way connected to the Hanlin Academy.

42. For T'ao Ku's biography, see T'o T'o et al., Sung shih, chüan 269, pp. 9235–38.

A similar calligraphic style appears on a stone engraving from 968, which bears passages from both Buddhist and Taoist scriptures, in the Pei-lin, Sian (fig. 4.13). The calligrapher, Yüan Cheng-chi, had written the annotations and the colophon at the beginning of Meng-ying's *Chuan-shu ch'ien-tzu wen* (fig. 4.9). More conservative calligraphic critics in the Ming period tended to speak well of Yüan's work, calling it "classically restrained, at ease and elegant," with a flavor reminiscent of T'ang calligraphy. They even ranked his accomplishments ahead of those of such advocates of stylistic innovations as Ts'ai Hsiang (1012–1067), Su Shih (1037–1101), and Huang T'ing-chien (1045–1105).[43] This tablet was originally erected in the School for the Sons of State in Ching-chao prefecture, perhaps with the intention of encouraging Buddhist and Taoist beliefs, but its calligraphic style

43. An Shih-feng, Mo-lin k'uai-shih (Taipei: Han-hua 1970), chüan 7, pp. 443–44.

no doubt also influenced many students destined for government posts. It reflects the importance at that time of the continuation of the High T'ang court calligraphy style, which was based on the work of Ou-yang Hsün.

This style was still in vogue during the reigns of T'ai-tsung and Chen-tsung, as can be seen from a stele, dated 980, in the Pei-lin, Sian, which bears three Taoist scriptures engraved in small standard script in the Ou-yang Hsün style (fig. 4.14). Nothing is known of the calligrapher, P'ang Jen-hsien; the stele does not list any official titles, so it is possible that he was simply a common citizen with no official post, but an accomplished calligrapher. A Ming critic praised his work, saying, "Placed side by side with famous T'ang works, there would be no way to tell the difference."[44] Perhaps T'ang calligraphy was influential at this time not only in the imperial court, but among calligraphers without government affiliation. The same calligraphic style is seen on the *Hsüan-sheng wen-hsüan-wang tsan pei*, a stele erected in the Confucian Temple in Ch'ü-fu to commemorate Chen-tsung's ceremonial visit to Mount T'ai (fig. 4.15). Some Ming scholars proposed that the calligraphy was by I Hsi-ku, Editorial Assistant in the Imperial Calligraphy Academy, noting that "although it is still basically the Academy Style, there are traces of the sacred spirit of the sages left in it."[45] I was the chief court calligrapher during Chen-tsung's reign. His works include the *Hsieh-t'ien shu-shu kung-te ming*, erected in T'ai-an prefecture and praised as "unparalleled standard script calligraphy," and the *Feng-shan ch'ao-chin t'an-sung pei*, also in T'ai-an.[46] Both may be considered representative of the court standard for calligraphy during this period.

Ou-yang Hsün's standard script did not have an exclusive monopoly over the calligraphic world at this time. Hsü Hsüan's disciple, Cheng Wen-pao, added a long postscript to the previously mentioned copy of the *I-shan pei*. It is written in standard script, with broad characters and rather heavy retractions of the brush on the dottings and cross-strokes, somewhat similar to the early standard script of Yen Chen-ch'ing (709–785). Cheng's postscript can be regarded as a harbinger of the new stylistic tendencies that were to appear after the middle of Jen-tsung's reign (r. 1023–63). But whatever the origin of their style, the characters in this postscript, as in the steles discussed above, show the same general early Sung stylistic trait of strict evenness and accuracy.

With regard to running script, the Academy calligraphers, as mentioned earlier, took Huai-jen's *Chi-tzu sheng-chiao-hsü* as their model. This style was already apparent in the works of Hanlin Editorial Assistants at court during T'ai-tz'u's reign; it was still in vogue during Chen-tsung's reign, as can be seen from the *Chung-yüeh chiao-kao wen*, written at imperial command by Liu T'ai-ch'u in 1019 and erected in the Chung-yüeh temple, in Teng-feng prefecture, Honan (fig. 4.16). This style was also influential among literati at the time, as illustrated by two rarely seen early Sung calligraphies now in the National Palace Museum, Taipei, Li Chien-chung's *T'u-mu t'ieh* (fig. 4.17) and Lin P'u's *Shou-cha er t'ieh* (fig. 4.18).[47]

The *Chi-tzu sheng-chiao hsü* (fig. 4.19), which was to become the standard for the early Sung Academy Style and exert a strong influence among the newly arisen scholar-official class, was intimately connected to T'ang T'ai-tsung. This work was

44. Chao Han, Shih-mo hsi-hua, in SKSLTS, vol. 83, chüan 5, p. 5b.

45. Ibid., pp. 7b–8a.

46. Wang Ch'ang, Chin-shih ts'ui-pien, chüan 127, pp. 1a, 36b.

47. For discussions of these two works, see Wang Yao-t'ing, "Lin Pu shou-cha" (Letters of Lin Pu) and Ho Chuan-hsing, "Li Chien-chung tzu," in Sung-tai shu-hua tse-yeh ming-p'in t'e-chan (Famous Album Leaves of the Sung Dynasty) (Taipei: National Palace Museum, 1995), pp. 232–34.

written at the emperor's command as a preface to Buddhist scriptures translated by Hsüan-tsang (active mid-7th century), and as a confirmation of the crown prince who would later become Emperor Kao-tsung. It was compiled by the monk Huai-jen of Ch'ang-an's Hung-fu monastery in 648 (the twenty-second year of the Chen-kuan period) from tracings of Wang Hsi-chih's running script calligraphy in the imperial collection. The stele was erected in 672, and its influence became increasingly widespread. Because it is composed entirely of tracings from Wang Hsi-chih's calligraphy, and thus preserves the appearance of a relatively large number of his original characters, the *Chi-tzu sheng-chiao-hsü* has been highly valued by later critics. Thus it is not difficult to understand why this work became a model for the early Sung court calligraphers, who so intently emulated the High T'ang style and shared the esteem for the Wang Hsi-chih tradition. Moreover, the Buddhist leanings of the early Sung emperors would naturally have encouraged a high estimation of this work, which is itself a text in support of Buddhist beliefs. The Northern Sung critic, Huang Ch'ang-jui, after first stating flatly that the works of the Hanlin calligraphers who imitated this stele "never attained any loftiness or resonance whatsoever" and that their work was ridiculed by literati as "vulgar calligraphy," goes on to explain, "The imitators who failed to match it were of course vulgar; but as for the characters on the stele itself, these were not vulgar in the least."[48]

48. *Huang Ch'ang-jui*, Tung-kuan yü-lun, chüan *hsia, p. 361.*

Conclusion: The Limitations of the Revival

The calligraphy of the early Sung drew severe criticism from calligraphers of the late eleventh century. For example, in a colophon, Ou-yang Hsiu (1007–1072) laments, "The literary models of the Confucian learning were completely scattered and lost in the turmoil and warfare at the end of the T'ang. In the first hundred years of the Sung, heroic writers and great Confucians of all kinds appeared one after another; it has only been in the area of calligraphy that there has been no revival; none have appeared who can equal the calligraphers of the T'ang."[49] In the same spirit, he says to Ts'ai Hsiang, in a discussion of calligraphy, "Calligraphy has never been in better shape than it was in the T'ang, and never worse than it is now."[50]

49. *Ou-yang Hsiu*, Ou-yang Wen-chung kung wen-chi, chüan *139, p. 1081.*

50. Ibid., *p. 1106.*

In the preface to his *Hsü-shu-tuan* of 1074, Chu Ch'ang-wen listed a number of major early Sung calligraphers and their specialties, but in the end admitted that the calligraphy of that period could not match the achievements of the Tsin and T'ang. The reason he gives is that the calligraphic tradition was no longer intact:

After the turmoil of the Five Dynasties, few calligraphic students were able to receive the transmission of the techniques from teachers, and those who did kept them secret and did not pass them on; so even if scholars of the time were determined to learn calligraphy, they had no tradition to follow; thus the intended revival was cut off in the middle.[51]

51. *Chu Ch'ang-wen*, Mo-ch'ih-pien, chüan *3, p. 423.*

Su Shih, in a postscript written for the calligraphy of Ou-yang Hsiu and Ts'ai Hsiang, in the collection of a Mr. Yang, also mentions the paucity of calligraphers in the late T'ang, Five Dynasties, and early Sung:

Since the demise of Yen [Chen-ch'ing] and Liu [Kung-ch'üan], brush technique has been in a baleful condition. On top of this, there was added the turmoil of the late T'ang, when talented men were killed off in great numbers, so that by the Five Dynasties the literary patterning and lively spirit were completely scattered and lost. Only the works of Yang Ning-shih [873–954] are heroic; capturing what was left of the flavor of the two Wangs, Yen, and Liu, he can truly be called a hero of calligraphy who would not allow the times to submerge him. At the beginning of this dynasty, Li Chien-chung [945–1013] was famed for being a good calligrapher, but his style and rhyme are common and turbid, still exuding that sad and sorry flavor of the late T'ang and later; among the others, there have also been none excellent enough to compare with their predecessors.[52]

52. Su Shih, Tung-p'o t'i-pa, in ISTP, vol. 2, chüan 4, p. 82.

Criticisms aimed at the shortcomings of individual calligraphers were also quite common; in addition to the remark by Su Shih that Li Chien-chung's work was "common and turbid" in its style and rhyme, "still exuding that sad and sorry flavor of the late T'ang and later," we have already seen Huang T'ing-chien's criticism of Emperor T'ai-tsung's favorite court calligrapher, Wang Chu, as "fettered by rules like a little monk" and "defective in its lack of resonance." Mi Fu shows great disdain for the style of renowned early Sung scholars and authorities, ridiculing it as "calligraphy following in the footsteps of the aristocrats of the time." He goes on to give harsh critiques of both the "fat, flat, rustic, and turbid" characters of Li Tsung-o and the "court style" of Sung Shou (991–1040).[53] These criticisms reflect the fact that the concepts of tradition and innovation embraced by the newly arisen scholar-officials and other calligraphers of the late eleventh century had already undergone some very obvious changes since the early Sung, in spite of the fact that those changes were actually only made possible by the foundation created in the early Sung.

53. Mi Fu, Shu-shih, pp. 56-57.

The *Ch'un-hua ko-t'ieh* established the genre of the calligraphic model rubbing anthology, and the literati calligraphers of the late eleventh century, with their esteem for spontaneity and personal expression of individual character, were very interested in this development. Ou-yang Hsiu wrote:

Model rubbings began as collections of funeral condolences, get-well greetings, farewells, and informal letters of no more than a few lines, exchanged between family members and friends. Initially, there was nothing deliberate about it, just letting the brush go where it wished, splashing and waving around the ink, with results that were sometimes lovely and

sometimes ghastly, all different shapes arising in tandem, spread out or rolled up, far flung or held back, all brilliantly unfolded before one's eyes. A quick look through it would astonish, while a slow examination would reveal that the meanings extended without end. Thus, they were passed on to later generations, who took them as extraordinary sources of pleasure and wished they could meet their creators.[54]

54. Ou-yang Hsiu, Chi-ku-li pa-wei, chüan 4, pp. 9b–10a.

However, it would appear from the samples collected in the *Ch'un-hua ko-t'ieh* that the calligraphy in the imperial collection at that time was no match for the collection of the High T'ang, in either quality or quantity. Emperor T'ai-tsung's search for ancient calligraphic works in the south and receipt of gifts from surrendering states failed to make the imperial collection complete; in the late Northern Sung, Mi Fu was still able to find quite a few ancient works in private collections.[55] The real completion of the model rubbing tradition, and the beginning of its more extensive reverberations, had to wait for the efforts and discoveries of later calligraphers like Mi Fu.

55. Mi Fu, Pao-chang tai-fang lu: "When Emperor T'ai-tsung of our dynasty put down a pretender state, he collected all its calligraphy, but there was still quite a bit in private collections..." See Nakata Yujiro, Bei Futsu (Tokyo: Nigensha, 1982), Kenkyu pen, pp. 31–125.

As for steles and inscribed tablets, the early Sung artists had access to T'ang relics in the Ch'ang-an and Lo-yang areas, where the old T'ang capitals had been located. From our discussion of the several steles referred to here, we can see that this led mainly to the inheritance of the T'ang calligraphic style, centering around Ou-yang Hsün's standard script and Huai-jen's running script. The literati of the late eleventh century, with their broad knowledge and overbrimming self-confidence, were unimpressed by these limited achievements. Between 1061 and 1069, Ou-yang Hsiu systematically assembled rubbings of ancient steles, adding his own colophons, and published them in the *Chi-ku lu pa-wei,* in ten *chüan.* The collection, which included a total of 177 items, among them rubbings of both inscriptions on ancient bronze vessels and Sui and T'ang stone steles, became an important historical source for the study of ancient writing and steles. While the extent of this work's immediate influence may be questioned, we can safely say that it expressed the breadth of knowledge that scholars of the period possessed about ancient calligraphy, which had already far exceeded the limitations set by the leadership of court calligraphers, and paved the way for the blossoming of literati calligraphy in the late Northern Sung.

Translated by Brook Ziporyn

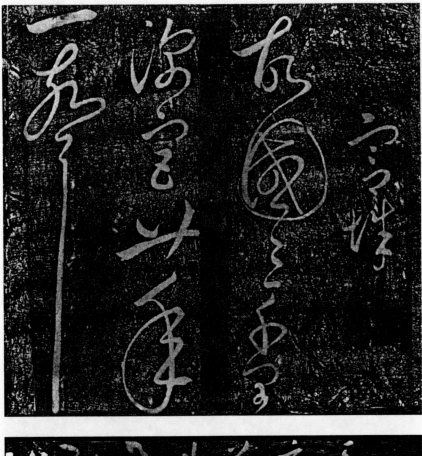

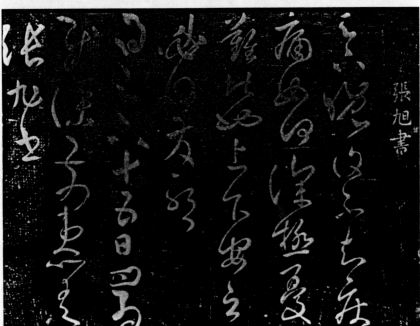

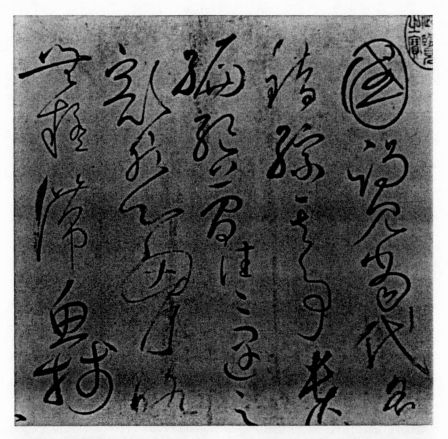

Figure 4.5
Huai-su (ca. 735–ca. 799), Tzu-hsü
t'ieh (Autobiographical Essay), dated
777, detail. Handscroll, ink on paper,
28.3 x 755 cm. National Palace
Museum, Taipei.

Figure 4.6
Emperor T'ai-tsung (r. 626–49), Title
to the Chin-ts'u ming (Chin Shrine
Engraving). Detail. Rubbing, engraved
646. Chin Shrine, T'ai-yüan, Shansi
Province.

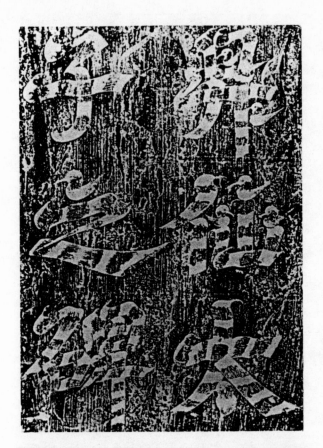

Figure 4.7
Empress Wu (r. 690–704), Title to
Shen-hsien T'ai-tzu pei *(Stele of*
Crown Prince Shen-hsien). Rubbing,
dated 699. Yen-shih, Honan Province.

Figure 4.8
Wang Chu, (?–990), Title to Ch'un-
hua ko-t'ieh. *Rubbing from the*
Ch'un-hua ko-t'ieh, *engraved 992,*
26.4 x 31 cm. National Palace Museum,
Taipei.

Figure 4.9. Meng-ying (active late 10th
century), Chuan-shu ch'ien-tzu wen
(Thousand-character Essay in Seal
Script). Detail. Rubbing, mounted as an
album, engraved 965. National Palace
Museum, Taipei.

Figure 4.10
Kuo Chung-shu (?–977), San-t'i Yin-
fu ching (Scripture on Unseen Harmony
in three Scripts), detail. Rubbing,
engraved 966, 143.3 x 84.6 cm.
National Palace Museum, Taipei.

Figure 4.11
Hsü Hsüan (917–92), Mo I-shan Pei
(Copy of the Stele of Mount I), detail.
Rubbing, engraved 993, 163 x 84 cm.
National Palace Museum, Taipei.

Figure 4.12
*Huang Fu-yen (active second half of
10th century), Chuan-shu ch'ien-tzu
wen hsü (Preface to Thousand-character
Essay in Seal Script). Detail. Rubbing,
dated 965, 276.1 x 106.3 cm.
National Palace Museum, Taipei.*

Figure 4.13
*Yüan Cheng-chi (active second half of
10th century), Fo-shuo mo-li-chih-
t'ieh ching (Marici Sutra). Detail.
Rubbing, engraved 968. Pei-lin, Sian.*

Figure 4.14
P'ang Jen-hsien (active second half of
10th century), T'ai-shang lao-chün
ch'ang-ch'ing-ching ching *(Lao-tzu's
Classic of Purity and Quietude), detail.
Rubbing, dated 980, 122.4 x 65.5 cm.
National Palace Museum, Taipei.*

Figure 4.15
Emperor Chen-tsung (r. 988–1022),
Hsüan-sheng wen-hsüan-wang tsan
pei *(Stele of Eulogy to Confucius).
Detail. Rubbing, engraved 1008, 250 x
99.8 cm. National Palace Museum,
Taipei.*

Figure 4.16
Liu T'ai-ch'u (active first half of 11th
century), Chung-yüeh chiao-kao wen
*(Text to the Chung-yüeh Oblatory).
Detail. Rubbing, engraved 1019, Teng-
feng, Honan Province.*

Figure 4.17
Li Chien-chung (945–1013), T'u-mu
t'ieh. *Album leaf, ink on paper, 31.2 x
44.4 cm. National Palace Museum,
Taipei.*

Figure 4.18
Lin P'u (997–1028), Letters. Album
leaf, ink on paper, 31.2 x 38.2 cm.
National Palace Museum, Taipei.

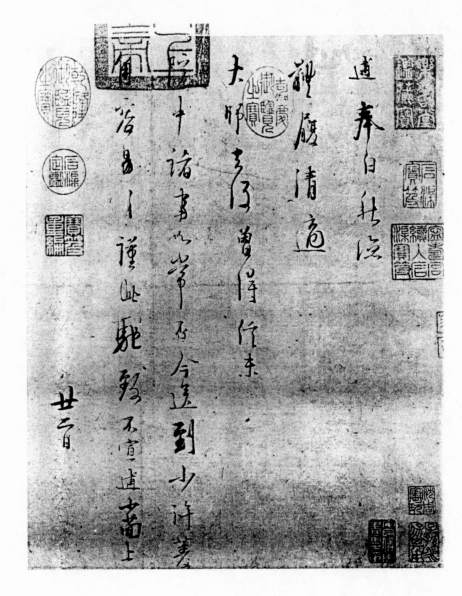

Figure 4.19
Huai-jen (active early 7th century),
Chi-tzu sheng-chiao hsü *(Preface to*
the Saintly Characters of Wang Hsi-
chih). Detail. Rubbing, engraved 672,
29.1 x 15.4 cm. National Palace
Museum, Taipei.

The Relationship Between Intimate Scenery and Shoal-and-Waterfowl Paintings in the Sung Dynasty

Lin Po-ting

In the early history of Chinese painting, the classification into different subject matter did not appear to exist. However, accompanying the development of painting through the ages and the accumulation of works in collections, the need arose to order and classify works on the basis of subject matter. The Sung dynasty proved to be a critical period in the formation of the nomenclature for categories of painting.

In the Northern Sung, Kuo Juo-hsü's *Record of Experiences in Painting* (ca. 1074) includes four categories, those of figures, landscapes, birds-and-flowers, and miscellaneous subjects. Liu Tao-ch'un, in *Critique of Famous Painters in the Present Dynasty* (ca. 1086), mentioned six categories; figures, landscapes-and-forests, animals, fur-and-feathers, spirits, and architecture. Approximately forty years later, the editors of *Hsüan-ho hua-p'u* (ca. 1120) created ten distinctions for the subject matter of paintings in the imperial collection—religious figures, figures, palace architecture, barbarians, dragons-and-fish, landscapes, animals, birds-and-flowers, ink bamboo (including intimate scenes), and fruits-and-vegetables (including herbs and insects). And Teng Ch'un, in his *Hua-chi* (ca. 1167), includes eight categories; spirits-and-religious figures, figures-and-portraits, landscapes and trees-and-rocks, birds-and-flowers and fur-and-feathers, animals and insects-and-fish, architecture and boats-and-wagons, fruits-and-vegetables, and herbs-and-grasses, as well as intimate scenery and miscellaneous subjects.

In *Hsüan-ho hua-p'u*, paintings of intimate scenery (*hsiao-ching*) are grouped with those of ink bamboo, while in *Hua-chi* they are linked with miscellaneous subjects. This pairing of the two subjects, however, may not have been accidental. The theme of bamboo done in monochrome ink was advocated by such scholar-official painters as Wen T'ung (1018–1079) and Su Shih (1037–1101), reaching a peak in popularity during the late Northern Sung at exactly the same time that intimate scenes emerged and were taken up by the same group. Intimate scenery, did not become a prominent subject in painting at that time, however, so examples of this theme were grouped together with ink bamboo. By the Southern Sung, however, intimate scenery and miscellaneous subjects were grouped into the same category, reflecting its emergence as a new mode of expression in the art of the time.

Documentary Evidence for "Intimate Scenery"

The definition of "intimate scenery" is somewhat enigmatic. In the "Ink Bamboo" section of *Hsüan-ho hua-p'u*, the following statement is found: "In the arrangement of scenery, one does not need to fill [the composition] in order to describe a thousand *li*. From the Five Dynasties to the present [Sung] dynasty, there have been only

1. Hsüan-ho hua-p'u, chüan 20, in Hua-shih ts'ung-shu (Taipei: Wen-shih-che Ch'u-pan-she, 1974), vol. 1, p. 621.

2. Kuo Hsi, Lin-ch'üan kao-chih; shan-shui hsün, in Sung-jen hua-hsüeh lun-chu, in I-shu ts'ung-pien, ed. Yang Chia-lo (Taipei: Shih-chieh shu-chu, 1967), vol. 2, no. 7, p. 6.

3. Han Cho, Shan-shui chüeh ch'üan-chi, chüan 1, in Sung-jen-hsüeh lun-chu, vol. 4, no. 10, p. 199.

4. Yonezawa Yoshiho believed that "The idea behind the scenery in small paintings is what is meant by 'small scrolls.' But it also implied the depiction of ordinary landscapes commonly seen, not grand or famous ones"; quoted in Suzuki Kei (Wei Mei-yueh trans.), Chung-kuo hui-hua shih (Taipei: National Palace Museum, 1991, vol. 1, p. 230. His idea of intimate scenery as a theme emerging at the beginning of the decline of monumental landscape painting is similar to that of the author's.

5. Chu Ching-hsüan, T'ang-ch'ao Ming-hua chi, in Mei-shu ts'ung-shu, eds. Huang Ping-hung and Teng Shih (Taipei: I-wen yin-shu-kuan, 1975), vol. 2, no. 6, p. 30.

6. Chang Yen-yüan, Li-tai Ming-hua chi, chüan 9, in Hua-shih ts'ung-shu, vol. 1, pp. 117, 123.

7. See Mi Fu, Hua-shih, in Sung-jen hua-hsüeh lun-chu, vol. 2, no. 9, p. 25.

8. Huang T'ing-chien, Shan-ku pieh-chi, in Ying-yin Wen-yüan ko ssu-k'u ch'üan-shu (Taipei: Shang-wu yin-shu-kuan, 1983), vol. 1113, p. 547.

9. See Mi Fu, Hua-shih, vol. 2, no. 9, p. 12.

10. See Kuo Juo-hsü, T'u-hua chien-wen chih, chüan 4, in Hua-shih ts'ung-shu, vol. 1, p. 199.

11. See Huang T'ing-chien, Shan-ku chi, vol. 1113, p. 287; Ch'ao Pu-chiu, Chi-lei chi, in Ying-yin Wen-yüan ko ssu-k'u ch'üan-shu, vol. 1118, p. 556; and Shen Kua, T'u-hua

twelve artists of ink bamboo and intimate scenery."[1] "Intimate scenery" here probably refers to the small scale of the paintings, which is also indicated in the following record from Kuo Hsi (ca. 1000–ca. 1090): "Of those who arrange grand and unlimited scenery, many reduce them to intimate scenes."[2] An overview of landscape painting from the first half of the Northern Sung indicates that artists tended to portray "complete scenery" (ch'uan-ching).[3] As this mode reached its peak in popularity, another one—more refined and simplied—emerged as an alternative, in what became known as "intimate scenery."[4] A similar development also occurred in the theme of birds-and-flowers during the T'ang dynasty, where paintings of entire plants became increasingly popular until Pien Luan supplanted them with his "broken branch" approach.[5] Thus, perhaps "intimate scenery" can be understood in relation as a counterdevelopment to its predecessor—"complete scenery."

Early documentary evidence related to intimate scenery points to the term "small paintings" (hsiao-hua) found in Chang Yen-yüan's Record of Famous Painters Through the Ages.[6] Chang was most likely referring to the refined brushwork that was used for relatively small paintings of the time. The intimate scenes in the works of Chao Ling-jang (active ca. 1080–1100) have also been described as delicate "small scrolls" (hsiao-chou).[7] For example, Huang T'ing-chien (1045–1105) once wrote an inscription on an intimate scene by Chao which read, "Ta-nien [Chao Ling-jang] excelled at 'small brushwork' (hsiao-pi)."[8] The term "small brushwork" is also found in the writings of Mi Fu (1052–1108); "The landscapes of Li [Ssu-hsün] and Wang [Wei] are rare and elegant while the feathers-and-fur in small brushwork by Huang Ch'üan are very popular."[9] The so-called "small brushwork" here evidently refers to the extremely refined brushwork of small-scale paintings. The works of another artist who depicted intimate scenery, Kao K'o-ming (ca. 1007–1049), were also noted for their "cleverness."[10] Thus, perhaps two definitions were associated with intimate scenery in the latter half of the Northern Sung; one referred to the size of the work in which refined brushwork was used, and the other dealt with a more pure and simple quality. I believe that intimate scenery as a new mode of expression deals with this latter definition, because of its importance in Sung thought and art.

But where does the term "intimate scenery" actually come from? A passage in Record of Experiences in Painting notes that "Hui-ch'ung and Kao K'o-ming did paintings of intimate scenery," indicating that by the latter half of the Northern Sung "intimate scenery" had already come into existence as a term for subject matter. Many other references to such scenery are also found in the literary writings of such scholar-officials as Huang T'ing-chien, Ch'ao Pu-chiu (1053–1110), and Shen Kua (active between 1086 and 1093).[11] And in Hsüan-ho hua-p'u, "intimate scenery" is indicated in the titles of many works of tenth-century artists, including Hsü Hsi's Intimate Scenery of Wild Ducks, Chü-jan's Intimate Scenery in a Misty Pass and Intimate Scenery of Woods and Rocks, and Huang Chü-ts'ai's (933–993?) Intimate Scenery of Waterfowl, Bamboo, and Rocks. Two possibilities exist concerning the interpretation of "intimate scenery" in these titles. One is that intimate scenery had already existed in the Five Dynasties-early Northern Sung period, which is reflect-

ed in these titles presumably copied faithfully from the works in Emperor Hui-tsung's collection. The other is that court editors and connoisseurs renamed the works based on contemporary notions of intimate scenery. If the latter view is assumed, it would suggest that paintings of intimate scenery can be documented from at least the latter half of the Northern Sung. However, the origins of intimate scenery still need to be researched further.

Based on the above records concerning the content and names of paintings depicting intimate scenery, the notion behind "scenery" appears to be closely related to that of "landscape." However, the names of works by Hsü Hsi, I Yüan-chi (such as *Scene of Gibbons*), and others point to subject matter dealing with waterfowl and other animals.[12] Since such motifs make up a significant part of the compositions, they have been classified accordingly as animal or bird-and-flower paintings. The present paper deals in part with an examination of the relationship between bird-and-flower painting and intimate landscape scenery.

Intimate Scenery and Level-Distance Landscapes

Although landscape developed into an independent theme in the T'ang dynasty, too few works have survived from that period to allow closer study. Nonetheless, landscape elements can still be seen in wall paintings from Tun-huang and the lacquered *p'i-p'a* in the Shoso-in repository, where the so-called "three distances" are clearly evident in the compositions. But it was not until the Sung dynasty that the "three distances" were fully exploited.[13]

In the early Northern Sung period, such hanging scrolls as *Landscape* (ca. 959–986), excavated from the Liao tomb at Yeh-mao-t'ai, and Fan K'uan's (active ca. 990–1030) *Travelers among Streams and Mountains*, in the National Palace Museum, Taipei, datable to around 1000, incorporate "high distance" as the structural focus of the composition. In both of these works, trees and mountain forms fill the painting surface. *Serried Peaks and Dense Woods* (fig. 5.1), in the National Palace Museum, Taipei, attributed to Chü-jan, is a landscape which appears datable to before 1100, and it incorporates a combination of deep and high distance schemas.[14] *Pines in Level-distance* (ca. 12th to 13th century), attributed to Li Ch'eng (916–967), as its title suggests, is a level-distance landscape. Even by the eleventh century, it is interesting to note that in Kuo Hsi's *Early Spring*, in the National Palace Museum, Taipei, dated to 1072, all three distances appear to have been combined effectively into a unified compositional formula.

In terms of handscrolls dating from the Northern Sung, the compositions of *The Hsiao and Hsiang* (ca. 11th to 12th century) in the Palace Museum, Beijing, and attributed to Tung Yuan, (d. 962), and *Summer Mountains* (ca. 1030) in The Metropolitan Museum of Art, attributed to Ch'ü Ting (active first half of 11th century) consist of water and bank in the foreground and hills in the middleground dominated by a high distance composition. The compositions of *Pavilions among Rivers and Mountains* (ca. 1050) in the Osaka Municipal Museum of Art by Yen Wen-kuei (active ca. 970–1030), and *Fishermen* (ca. 1050) in the Nelson-Atkins Museum of Art by Hsü Tao-ning (ca. 970–1053) also incorporate a river bank and water in

ko, *in* Chung-kuo hua-lun lei-pien *(Taipei: Hua-cheng shu-chu, 1984), vol. 1, p. 45.*

12. *See* Hsüan-ho hua-p'u, chüan *17 and 18, in* Hua-shih ts'ung-shu, *vol. 1, pp. 581, 597.*

13. *Kuo Juo-hsü,* Lin-ch'uan kao-chih, *vol. 2, no. 7, p. 17. Kuo Hsi already had identified the "three distances" as follows: "Mountains have three distances. On a mountain looking up is called high distance. On a mountain looking out at a vista is called deep distance. From someplace close and looking at distance mountains is called level distance."*

14. *This painting bears a ssu-yin half seal impression and a Hsüan-ho pao-tien seal impression, making it an important Northern Sung landscape.*

the foreground, but the middle- and background are dominated by a combination of high-, deep-, and level-distance vistas. Although all three distances were employed in early Northern Sung landscapes, high-distance alone or combined with deep-distance provided the most appropriate mode for representing the monumental quality popular in landscape painting at the time.

Concerning bird-and-flower painting from the early Northern Sung, Huang Chü-ts'ai's *Sparrows and Pheasant* (ca. 990) in the National Palace Museum, Taipei, is an exceptional example. Behind the pheasant in the foreground are a rock, flowers, leafless shrubs, and sparrows perched or in flight. The composition appears balanced on the central axis of the hanging scroll and the motifs are arranged accordingly. This type of composition is based on the decorative formula of bird-and-flower painting derived from the T'ang dynasty. Such late T'ang paintings as the wall paintings at the Astana tombs and decorative arts from the Shoso-in appear to share many of the same compositional features as the tenth-century *Bamboo, Pheasant, and Rabbits* hanging scroll excavated at Yeh-mao-t'ai, thus documenting the conservative nature of Huang's work. Likewise, Kuo Hsi's *Early Spring* and Fan K'uan's *Travelers Amid Mountains and Streams* also involve numerous motifs (such as mountain peaks, rocks and trees) arranged along the vertical axis of the hanging scroll. Thus, such compositional affinities suggest that parallel developments occurred in different subject matter during Northern Sung painting.

The latter half of the Northern Sung was also marked by the emergence of a group of scholar artists, such as Ou-yang Hsiu (1007–1072), Su Shih, Huang T'ing-chien, and Mi Fu, all of whom advocated revolutionary new ideas in art. They were unimpressed by the opulent, grand styles of landscape painting popular at the time, seeking the opposite qualities of purity, clarity, and simplicity of style and subject. Ou-yang Hsiu, for example, wrote, "Elegance and simplicity are difficult to convey visually, and even if an artist is successful in transmitting these qualities, observers may not necessarily recognize the achievement."[15] To this statement can be added the following comments by Su Shih, "I often discuss calligraphy. The works of Chung Yu [151–230] and Wang Hsi-chih [303–361] are characterized by understated elegance and exquisite simplicity, and these qualities exist beyond the brush and ink."[16]

Of the many styles prevalent in the Northern Sung, the one associated with Li Ch'eng appears to come closest to the ideal of purity, clarity, and simplicity. Kuo Juo-hsü, in *Three Landscape Artists*, stated: "The one whose atmosphere is desolate, whose misty forests are pure and vast, whose peaks stand out, and whose ink wash is refined is Ying-ch'iu [Li Ch'eng]."[17] Huang T'ing-chien also recorded that "In arranging a natural painting, the sense of water should be distant, the activities of waterfowl should be leisurely, and reeds should be in wind or frost.... The six scrolls of Li Ying-ch'iu's *Sudden Rain* embody these ideals."[18] In fact, of the scholars who mention the qualities of clarity and distance, most associate it with Li Ch'eng. In terms of the three distances, each has a different quality, which Kuo Hsi considered as such; "High distance is powerful and forceful, deep distance has multiple mountain ranges, and level distance is diffused and vague" and "As for figures in the

15. *Ou-yang Hsiu*, Wen-chung chi, chüan *130, in* Ying-yin Wen-yüan ko ssu-k'u ch'üan-shu, *vol. 1103, p. 313. Translated by Dora C.Y. Ching.*

16. *Su Shih*, Tung-p'o t'i-pa; Pa Huang Tzu-ssu shih hou, *in* Sung-jen t'i-pa shang, *in* I-shu ts'ung-pien, *ed. Yang Chia-luo, vol. 1, no. 23, p. 45. Translated by Dora C.Y. Ching.*

17. *Mi Fu*, Hua-shih, *p. 158.*

18. *See Huang T'ing-chien*, Shan-ku pieh-chi, *p. 287.*

three distances, those in high distance are clear, those in deep distance are minute, and those in level distance are hazy."[19] Thus, of the three distances, the diffused, hazy, and vague features of level-distance landscapes most closely corresponded to the idea of pure and vast distance advocated by literati.

Unfortunately, practically no works by Li Ch'eng survive today. The influence of his painting, however, is undeniable. After the reign of Emperor Shen-tsung (r. 1068–85), the style of Li Ch'eng had already become associated with the "wintry forests and level distances." For example, Kuo Juo-hsu mentioned that "The marvels of misty woods and level distances began with Ying-ch'iu [Li Ch'eng]."[20] Mei Yao-ch'en (1002–1060) also indicated that "By the time Fan K'uan reached old age, his learning was insufficient, but Li Ch'eng [was able to advance] by doing level-distance [landscapes]."[21] Such landscapes are characterized by vast, extensive space that does not include imposing, monumental mountains. Isolated trees and rocks also are suitable for expressing the desolate, pure, vast space. Thus, rolling slopes, small hills, and shoals dominate such famous level distance landscapes as *Pines in Level Distance*, attributed to Li Ch'eng, and *Temple in Autumn Mountains* (ca. 1050), attributed to Hsü Tao-ning, in the Fuji Yurinkan Collection, Kyoto.

In the latter half of the Northern Sung, some artists who advocated a sense of clarity and distance in their works were also associated with Li Ch'eng. Wang Shen (ca. 1048–after 1104), for example, recorded, "Those who depict intimate scenes and use ink for level distances all follow in the style of Li Ch'eng."[22] Sung Ti (active 11th century) and his brother, Sung Tao, were linked to the Li Ch'eng style[23] and were said to have excelled at painting "Landscapes and wintry forests with a leisurely and elegant feel—the embodiment of peace and harmony."[24] In fact, it was Sung Ti's efforts at depicting the level-distance scenery of the Hsiao and Hsiang river area which led to the *Eight Scenes of Hsiao and Hsiang* emerging as a new subject in painting. Unfortunately, his paintings of the Eight Views no longer survive, but several related works survive from the Southern Sung, including *Hsiao and Hsiang* (attributed to Tung Yuan), *Dream Journey on the Hsiao and Hsiang* (ca. 1170), attributed to a certain Master Li, in the Tokyo National Museum, and *Eight Views of Hsiao and Hsiang* (ca. 1150?), by Wang Hung (active ca. 1131–61), in The Art Museum, Princeton University.[25] A compositional feature they all share is the presence of a prominent expanse of water. These works help us imagine what Sung Ti's works might have looked like and see how important his contribution was to the development of level- and deep-distance landscapes. In fact, one of his Eight Views, *Wild Geese Descending to a Sandbar*, probably would have best expressed the long, level distance of the lake and river region.

Sung artists who painted the Eight Views, especially *Evening Bell from Mist-Shrouded Temple* and *Night Rain on the Hsiao and Hsiang*, often attempted to capture the poetic essence of the scenes rather than render mere illustrations. Teng Ch'un, writing in the twelfth century, aptly described the nature of Sung Ti's works:

The Eight Views by Sung Fu-ku [Ti] are all evening scenes. Among them, *Evening Bell from a Mist-shrouded Temple* and *Night Rain on the Hsiao and*

19. *Kuo Hsi*, Lin-ch'üan kao-chih, p. 17.

20. *Mi Fu*, Hua-shih, p. 12.

21. *Mei Yao-ch'en*, Wan-ling chi, chüan 50, in Ying-yin Wen-yüan ko ssu-k'u ch'üan-shu, *vol. 1099, p. 364.*

22. *Mi Fu*, Hua-shih, pp. 117, 123.

23. Ibid., p. 24: "*The artists…Yen Mu-chih,…Sung Ti, and…Liu Ming-fu all followed after Li Ch'eng.*"

24. Ibid., p. 182.

25. *See Richard Barnhart, "Shining Rivers: Eight Views of the Hsiao and Hsiang in Sung Painting," Inter-national Colloquium on Chinese Art History (Taipei: National Palace Museum, 1991), vol. 1, painting and calligraphy, pp. 45–97 (esp. pp. 60–70).*

26. *Teng Ch'un*, Hua-chi, chüan 6, vol. 1, p. 317.

Hsiang are the most difficult to describe, for such aspects as the sound of a bell and the appearance of rain at night cannot be rendered visually. As a result, Fu-ku first did the paintings and then created the titles....[26]

Teng went on to mention that later, less creative artists made the mistake of composing paintings based upon the titles. In addition, Sung's theory of painting and his inspiration are also evident in a monologue directed at another artist:

You have the ability to paint, but lack inspiration.... You ought to first find an old wall and then drape a bolt of silk over it. Sit in front of the wall from morning to night and observe...[the shapes and forms] suggested by the mind's eye.... Not appearing artificial, they will mysteriously, yet naturally, emerge from your brush.[27]

27. *Shen Kua*, Meng-hsi pi-t'an, chüan 17, *in* Ying-yin Wen-yüan ko ssu-k'u ch'üan-shu, *vol. 862, p. 799.*

And turning to Mi Fu, we find an artist specializing in painting cloudy mountains, evoking, like Sung Ti, the essence of the landscape rather than the description of the forms. Concerning Mi, it was stated:

Mi Nan-kung [Fu] often moved among the rivers and lakes. Divining where to live, he needed a place with luminous mountains and clear water. At the beginning, he could not paint, but later he copied what his eyes saw [visually], gaining a source of inspiration.[28]

28. *Chao Hsi-ku*, Tung-t'ien ch'ing-lu, *in* Mei-shu ts'ung-shu, *vol. 1, no. 9, p. 272.*

By his own account Mi Fu, already advanced in age, only started to paint after Li Kung-lin (ca. 1041–1106) had fallen ill for three years. Furthermore, he preferred painting in an untrammelled style with unusual materials in what he called "ink plays."[29] Mi Fu sought such ideals in both practice and theory, which influenced contemporary and later writers, such as the authors of *Hsüan-ho hua-p'u* and *Hua-chi.*

29. *Kuo Jo-hsü*, Tu-hua chien-wen chih, *vol. 1, pp. 265–69.*

Northern Sung scholars from Ou-yang Hsiu to Su Shih and Huang T'ing-chien rejected ornate styles of poetry as well, seeking purity and "blandness" instead. They attempted to break from established methods and go back to the origins; in effect, seeking poetry beyond poetry itself.[30] Ch'ao Pu-chiu once wrote a poem in which he praised poetry for being able to express ideas beyond objects themselves, claiming that painting was confined to them. His attitude toward art, however, is somewhat conservative. Thus, when taking into consideration Sung Ti's comments about gaining inspiration from the surface of an old wall, the two scenes of his from the *Eight Views of Hsiao and Hsiang* mentioned above, and Mi Fu's cloudy mountains, we find a new concept of painting that points to the essence of the painting itself; in other words, it becomes "painting beyond painting."

30. *See Kuo Shao-lu*, Chung-kuo wen-hsüeh p'i-p'ing shih *(Taipei: Wen-shih-che Ch'u-pan-she, 1982), vol. 1, p. 372.*

Bird-and-flower painting in the Northern Sung is epitomized by the tradition of such Szechwan artists as Huang Ch'üan and Huang Chü-tsai, father and son, during the reign of Emperor Shen-tsung. However, the art of Hsü Hsi must also be given due consideration: Kuo Juo-hsü, for example, considered Huang and Hsü to be of equal stature. Kuo admired Hsü Hsi as a scholar-recluse of the Chiang-nan

area who specialized in depicting rivers, lakes, shoals, flowers, wild bamboo, waterfowl, and fish of the region.[31] Moreover, Hsü was an important artist in the development of waterfowl painting. In the latter half of the Northern Sung, when scholar-artists became increasingly influential, such figures as Mi Fu and Shen Kua praised the style of Hsü Hsi and disparaged that of Huang Ch'üan.[32] As a result, the Chiang-nan style associated with Hsü's works gained in popularity at the same time that pure and vast water scenery gained momentum. This trend's influence was especially strong on artists in the painting academy under Emperor Hui-tsung (r. 1101–1125). Thus, not surprisingly, bird-and-flower painting of this period came under the influence of scholar-artists.

The importance of poetic imagery in painting is found in the frequent mention of pure, desolate, and vast distances in the descriptions of the following artist's works in *Hsüan-ho hua-p'u*: Li Kung-nien, Lo Ts'un, Wang Tsung-han, Chao Chung-ch'uan, Chao Shih-t'ien, Chao Shih-lei, and Ts'ui Ch'üeh.[33] Li Kung-nien (active 11th to 12th century) and Lo Ts'un were known as landscape painters, while the others listed here were classified as bird-and-flower artists. All of their works have been lost over the centuries, with the fortunate exception of Li Kung-nien's *Winter Landscape* (ca. 1120), now in The Art Museum, Princeton University. The foreground of this work is punctuated by a slope of wintry trees; the middle-ground is a vast, empty expanse of land and water; and misty clouds and tall mountains dominate the background. Of the places in the composition which deserve special attention, the foreground appears elevated, taking up almost half of the composition, and the open space in the middle of the scroll is aligned with the vertical thrust of the background mountains. Stylistically, although this work resembles that of Li Ch'eng and Kuo Hsi, the fine texture and washes appear like axe-cut strokes; they may, in fact, be similar to what the style of a young Li T'ang (ca. 1070s–ca. 1150s) might have been.[34]

The description of Li Kung-nien's painting in the present essay can be seen to accord with the account of his style in *Hsüan-ho hua-p'u*. Though *Hsüan-ho hua-p'u* is reliable to a certain extant, some parts may be biased toward the artistic tastes of the imperial family. Nonetheless, they are informative of the ideals and practices at the time. Chao Tsung-han, Chao Shih-lei, Chao Hsiao-i, Chao Ling-jang, and Wang Shen were all painters of intimate scenery or vast, clear level-distance landscapes who were members of or related to the imperial family. The scenery associated with desolate expanses of water was quite unique at the time, and the uninhabited scenery of rivers and lakes—punctuated perhaps only by a few waterfowl—formed the essence of shoal-and-waterfowl painting. A record of Kao Tao (active late 11th century) documents this relationship between pure and vast landscapes and shoal-and-waterfowls: "Kao Tao...did intimate scenery, forming his own style. His *Clear Distance and Silent Depth* is both pure and harmonious..."[35]

Scenery of Shoals and Waterfowl

The interaction between humanity and waterfowl in everyday life has ancient origins, the traces of which can be found in ancient Chinese art. Though documenta-

31. *Mi Fu*, Hua-shih, pp. 158, 159.

32. In Hua-shih, Mi Fu stated that T'eng Ch'ang-yu (?–930), Pien Luan, Hsü Hsi, and Hsü Ch'ung-ssu (active 11th century) all did paintings of flowers that were lifelike. The only exception was Huang Ch'üan, whose works Mi called "opulent but vulgar" (Ibid., p. 12). Shen Kua believed that the "spirit harmony" of Huang Ch'üan's flowers did not match those of Hsü Hsi (see Shen Kua, Meng-hsi pi-t'an).

33. References to the intimate landscape scenery of these seven artists are found in the respective entries in Hsüan-ho hua-p'u, chüan 12, 16, 18, pp. 506–605.

34. See Wen C. Fong, et. al., Images of the Mind: Selections from the Edward L. Elliott Family and John B. Elliott Collections of Chinese Calligraphy and Painting at The Art Museum, Princeton University (Princeton: The Art Museum, Princeton University, 1984), p. 55.

35. Teng Ch'un, Hua-chi, p. 291.

tion of early waterfowl painting is scanty, some cultural artifacts have survived. Looking back to the rise of bird-and-flower painting in the T'ang dynasty, waterfowl in a secular context was accompanied by the increasing representation of birds and lotus ponds in a Buddhist one. The theme of birds-and-flowers flourished in the Sung dynasty, when waterfowl as a subject appeared frequently in painting, ceramics, and other arts. The waterfowl in Sung art includes the following: geese (e.g., bean geese, white-fronted geese, domestic geese, and ruddy shelduck), swans (e.g., whistling swans and whooping swans), ducks (e.g., green-winged teal, mallards, and mandarin ducks), egrets, wagtails, kingfishers, red-crowned cranes, and moor hens. Of these, geese, ducks, and egrets are the most common.

Paintings of waterfowl often carry auspicious meanings. Geese, for example, are said to possess the Four Virtues (Sincerity, Propriety, Integrity, and Wisdom). Mandarin ducks symbolize marital bliss, while the character for egret (*lu*) is a homonym for rank in office (*lu*). These symbols and allusions were well understood by commoners and scholar-officials. Other allusions include waterfowl swimming under lotus blossoms, which symbolize the Pure Land in Buddhist thought. A waterfowl with a fish in its mouth alludes to the idea of profit (*yu-li*). But of all the allusions in paintings of waterfowl, one of the most important ones is that of the fisherman-recluse. The concept of reclusion appears early in Chinese history, but its association with fishing can be said to have begun with Chang Chih-ho (active ca. 730–ca. 810), a scholar-official who became a fisherman-recluse and composed a series of poems celebrating life on the rivers and lakes. Numerous later poets and painters took up the theme, even emperors like Emperor Kao-tsung (r. 1127–62), who wrote of "ripples extending over rivers and lakes" and the "infinitesimal emptiness" in his *Fisherman's Ode*.[36] Among Northern Sung scholars, Su Shih was moved by *Hui-ch'ung's Reeds and Geese* to write an inscription stating that he wanted to purchase a skiff and visit the lake region evoked in Hui-ch'ung's imagery. In another inscription by Su on *Ch'en Chih-kung's Geese*, he also expressed a desire to visit the rivers and lakes and keep company with geese and ducks in a scene he felt was reminiscent of those described in Chang Chih-ho's poetry.[37] And the remarks on Lo Ts'un's painting in *Hsüan-ho hua-p'u* indicate that although he lived in the bustling capital, his heart was in the waterscapes dominated by rivers and lakes and inhabited by birds and fish.[38] Thus, the writings by literati that expressed ideas of "infinite scenery of rivers and lakes" and "comings-and-goings of birds and fish" represented their desire for seclusion in the realm of desolate waterscapes away from the "dusty" world.

Birds-and-flowers had already become an independent theme in painting by the T'ang dynasty, and representations often appear to have been based on designs in the decorative arts. Accompanying developments in landscape painting, the compositional formulae for bird-and-flower painting followed both a conservative tradition emphasizing decorative treatments and a new trend which focused on more natural expressions of the main motif and background. With the rise of "sketching from life" in Northern Sung painting, increasing attention was placed on the observation of the natural movements and appearances of animals in their environ-

36. *The inscription on* Awakening under a Thatched Awning, *attributed to Emperor Kao-tsung and currently in the National Palace Museum, may have been written by emperor Hsiao-tsung, but originally composed by Kao-tsung.*

37. *See Su Shih,* Su Tung-p'o chi, *chüan 13, in* Su Tung-p'o chi *(Taipei: Shang-wu yin-shu kuan, 1967), vol. 2, p. 26; and* Su Tung-p'o hsü-chi, *chüan 1, in* Su Tung-p'o chi, *vol. 4, p. 88.*

38. Hsüan-ho hua-p'u, *chüan 12, p. 511.*

ment.[39] Combined with the advocation of pure and vast distance on the part of scholar-artists, painters began to pay particular attention to the shoals and level-distance in the background of waterfowl painting.

Surviving paintings of shoals-and-waterfowl are few, especially from the Northern Sung. For example, though *Reeds and Goose* (fig. 5.2), attributed to Ts'ui Po (active ca. 1060–85) and in the National Palace Museum, can be dated on the grounds of style to the mid-fourteenth century, the composition appears to follow a late Northern Sung formula.[40] The painting does not qualify as an "intimate scene," but it provides evidence for the nature of waterfowl painting in general. In the painting, the centrally-positioned goose and the reeds in the background follow the central axis of the hanging scroll in a manner similar to that in Huang Chü-ts'ai's *Sparrows and Pheasant*, which I have already indicated as following in a conservative tradition dating back to the T'ang dynasty. *Reeds and Goose,* however, captures the natural attitude of the subject, conveying the idea of "sketching from life" popular in the Sung. The only element lacking, however, is the expression of a clear and vast realm.

The shoals-and-waterfowl painting which comes closest to the ideal of a pure, vast realm is *Reeds and Shore in Snow* (ca. 1120) by Liang Shih-min (ca. 11th to 12th century), now in the Palace Museum, Beijing (fig. 5.3). This short handscroll has a *Hsüan-ho* mounting with a title in the script of Hui-tsung and half-impressions of the *Hsüan-ho* and *Cheng-ho* seals in the four corners. The title also appears in the *Hsüan-ho hua-p'u*, further testifying to its authenticity. The opening of the handscroll is dominated by a riverbank in the foreground with a withered tree, bamboo, stones, and a wagtail. This is followed by a wide expanse of water, in which only a pair of mandarin ducks are seen swimming. A layer of snow rests on the reeds of the distant shore, where a pair of ruddy shelduck are sitting. The desolate winter scene has a feeling of expansive, silent distance, to which the waterfowl add a touch of life and auspiciousness. In the *Hsüan-ho hua-p'u*, a record of a painting of the same title by Lo Shih-hsüan (active 11th–12th century), a contemporary of Liang Shih-min, suggests a very similar scene. It reads:

> Lo Shih-hsüan, an official in the inner court, was skilled in painting intimate landscapes in his old age. He painted many works on silk, but in his compositions he depicted only several smartweeds and a pair of water birds floating on a watery expanse. His paintings are visual renderings of Tu Fu's [771–770] poetry. When literati saw his paintings, there was not one who did not praise them.[41]

This work, too, reveals the influence of the new painting style advocated by literati of the time.

Although *Reeds and Shore in Snow* is classified as a bird-and-flower painting, the composition is closely related to that of landscape painting. For instance, Wang Shen's *Rivers and Tiered Peaks* (ca. 1100) in the Shanghai Museum is similar to Liang's work in several ways. The compositional formula of both involves two banks divid-

39. For more on this term, see Lin Po-ting, "Changes in the Meaning of Hsieh-sheng," National Palace Museum Bulletin *vol. 28, no. 6 (January–February 1994).*

40. Reeds and Goose *bears a* ssu-yin *half-seal impression of the early Ming dynasty in the upper left corner, which is an unusual location for this seal. However, it does appear on Chü-jan's* Layers of Peaks and Dense Woods *(see fig. 5.1). Thus, the author believes that* Reeds and Goose *does not date later than the latter half of the fourteenth century.*

41. Hsüan-ho hua-p'u, chüan *19, p. 617. Translated by Dora C.Y. Ching.*

ed by a broad river, forming a large open space in the middle. The "void" in these two landscapes takes up more than half of the composition, and the dominant shore in both is the distant one towards the end of the scrolls. The distant bank in *Rivers and Tiered Peaks* in particular forms the "solid" area of the work. Of particular note is that in this traditional Northern Sung landscape, the foreground is dominated by a waterscene with less attention to the riverbank. Moreover, the boundary between water and land parallels the edge of the handscroll, and the opposite shore in the background is described with relative detail and occupies an important position in the painting. The foreground and distant shores establish for the viewer the near and far elements, giving a sense of depth to the scenes. Although the scrolls have a concrete opening and ending, the artists of both add some variation by suggesting a line of vision which moves diagonally from fore- to background. This may be said to be the beginning of the "one-corner" composition that epitomizes Southern Sung landscape painting.

To sum up the development of compositions in Northern Sung handscroll paintings in the present paper, I would like to address, in particular, the works *The Hsiao and Hsiang Rivers*, attributed to Tung Yuan, *Fishermen*, attributed to Hsü Tao-ning, *Temple in Autumn Mountains* and *Summer Mountains*, attributed to Ch'ü Ting, *Pavilions Among Rivers and Mountains*, attributed to Yen Wen-kuei, Wang Shen's *Rivers and Tiered Peaks*, and Liang Shih-min's *Reeds and Shore in Snow*. I have arranged these works in chronological order, though some of them remain attributions that await further research (figs. 5.4 and 5.5).

The majority of Northern Sung landscapes incorporate distant vistas of grand mountains, in which artists developed a clear sense of the relationships between the fore-, middle-, and backgrounds based on the observation of actual landscape scenery. The foregrounds at the opening and end of the handscrolls in figures 5.4a, 5.4b, 5.4c, and 5.4d are composed of shoals and river banks. Looking over an expanse of water, the viewer encounters mountains in the distance. The vantage point of the artist in figure 5.4e is slightly higher, however, resulting in a sense of deep distance. The opening and closing of the scroll features foreground banks, while rocks and hills are found in the middleground. Since the vantage point is high, the view of the water and the mountains is not obstructed by the large rocks and small hills of the middleground. These five works illustrate how artists of the Northern Sung developed a clear sense of how the foreground, middleground, and background of landscape paintings should be composed. This is most clearly evident in figure 5.4f, in which the foreground bank, expanse of water, and distant mountains form a balanced composition that consciously parallel the edge of the handscroll itself.

Turning to figures 5.5a and 5.5b, only the foreground at the opening of the scrolls is dominated by a river bank. Skipping over an expanse of water, the viewer encounters the opposing bank in the upper part at the end of the scroll. Thus, the viewer's line of vision proceeds diagonally from the bank in the lower right foreground to the background in the upper left, thereby omitting the left foreground element. As in figure 5.4, though the painter has shifted the point of view, a cen-

tralized position has been assumed. In figure 5.4, the viewer's position is outside of the handscroll, towards the middle, with a balanced view of foreground elements at right and left. However, in figure 5.5, the viewer's position shifts to a spot inside the painting on the right foreground bank looking out diagonally to the background shore. Thus, from the early to the late Northern Sung, important changes in the vantage point of the artist/viewer appear to have occurred which foreshadow the development of the "one-corner" composition in landscape paintings of the Southern Sung.

Reeds and Shore in Snow is a handscroll, but to learn more about how the theme was treated in a vertical format, we may examine the "painting-within-a-painting" found in Scholar (fig. 5.6), in the National Palace Museum, Taipei, a work by an anonymous Sung artist.[42] Scholar, which appears to date from the first half of the twelfth century, includes a depiction of a short hanging scroll (originally an album leaf?) hung over a screen painting which is similar to Reeds and Shore in Snow. By imagining the screen painting in Scholar compressed into a horizontal handscroll format, the two images would appear even more alike. Despite their similarity, however, Reeds and Shore in Snow reflects the pure and vast distance appreciated by literati, whereas the screen painting in Scholar emphasizes the beauty of autumn combined with auspicious imagery that appears more related to the academic tradition.

Orange and Tangerine Groves (fig. 5.7), also in the National Palace Museum, Taipei, is attributed to Chao Ling-jang.[43] Dated to approximately the mid-twelfth century on the basis of style, the album leaf appears to describe the following lines by Su Shih:

> Wilted lotus are already without cover from the pelting rain,
> Faded chrysanthemums still have branches that can survive the rude frost;
> Of a year's beautiful scenes, you, Sir, should remember
> Especially the time when oranges and tangerines were yellow and ripe.

The groves of citrus trees bear fruit, as two pairs of wild ducks (mallards) and a pair of wagtails add an auspicious note. No outlines were used to render forms; ink washes and texture strokes dominate. The delicate and elegant air of the work indicates that it belongs to the academic tradition, which contrasts with the slightly awkward quality evident in a genuine example of Chao's work in the Boston Museum of Fine Arts, entitled River Cottage in Clear Summer (dated 1100). Thus, the amateur brushwork and style differs from that of Orange and Tangerine Groves, despite some stylistic similarities in the river banks and rocks.

The composition of Orange and Tangerine Groves is clearly composed of two opposing banks divided by a stream. Compositionally, the diagonal thrust of the stream scenery follows in the tradition of Northern Sung landscape handscrolls, but with one major difference. Looking back to other Northern Sung landscapes, the two shores are also emphasized, but with greater attention placed on the foreground one. The foreground shore and trees in River Cottage in Clear Summer take up a large proportion of the composition, but that of the opposing shore is even greater. In Orange and Tangerine Groves, so much weight is given to the foreground

42. For more on the Scholar, see Lin Po-ting and Ts'ai Mei-fen, "Sung-jen 'jen-wu,'" in Sung-tai shu-hua ts'e-yeh ming-p'in t'e-chan (Taipei: National Palace Museum, 1995), pp. 276–79.

43. Orange and Tangerine Groves is one leaf from a pair. It and the accompanying leaf with calligraphy by the Sung emperor Kao-tsung each bear a nei-fu shu-yin seal impression, indicating that they date no later than the early Southern Sung.

elements that the foreground bank almost touches the background one. This emphasis on the trees and landscape elements in the foreground is frequently found in late Northern Sung works, and even more so in the Southern Sung, when the foreground triumphs over the background. Thus, a mid-twelfth century date for this leaf seems plausible.

Autumn Woods and Waterfowl (fig. 5.8) (ca. 12th–13th century) an album leaf in the National Palace Museum, Taipei attributed to Kao K'o-ming, also belongs to the Chao Ling-jang tradition. The scenery in the work focuses on the foreground bank, almost to the exclusion of the background one. Ducks (perhaps ruddy shelducks) are flying and swimming. The brushwork is relaxed and the composition approaches the "one-corner" type found in the Southern Sung.

Pair of Mandarin Ducks on an Autumn Bank (fig. 5.9) is another twelfth- to thirteenth-century painting in the National Palace Museum, Taipei, but attributed to Hui-ch'ung. The painting depicts a pair of small ducks resting on a shore next to withering lotus and reeds. The composition already reflects a typical Southern Sung "one-corner" organization, suggesting that the painting probably bears little relation to Hui-ch'ung. However, since he was well known for painting intimate scenery, many such works have been attributed to him.

A painting-within-a-painting which is similar to *Pair of Mandarin Ducks on an Autumn Bank* and represents another format of late Northern Sung shoals-and-waterfowl painting is found in Hui-tsung's *Copy of Chang Hsüan's 'Ladies Preparing Silk'* (fig. 5.10) in the Museum of Fine Arts, Boston, datable to around 1120. Illustrated on a fan held by one of the figures is an intimate scene of a pair of ruddy shelducks, reeds, and shoals in snow. The fan painting and *Pair of Mandarin Ducks on an Autumn Bank* illustrate a pair of waterfowl on a riverbank, but the composition is arranged in a different manner. The emphasis in scenery in the Northern Sung was on distant vistas, where shores and banks occupied important parts of the composition. By the Southern Sung, the foreground became emphasized, thereby placing the focus on the waterfowl in the foreground to the exclusion of elements in the background. In the transition to the Southern Sung, artists had already mastered the depiction of space and concentrated on simplifying and focusing their vision. For example, Liang Shih-min represented shoals and plants by the water's edge, expressing the pure and vast distance with the surface of the river, the sky, and shoals. The artist of *Orange and Tangerine Groves*, however, emphasized shoal scenery, filling half the composition with it. And in typical Southern Sung works, artists tended to work towards expressing the expansive vistas of shoals and water, but reducing or simplifying the representation of water in the process.

Conclusion

Although research materials are more plentiful for Sung than T'ang painting, much still remains unknown. The present study of Sung painting analyzes the development of the theme of intimate scenery from desolate, pure, and vast level-distance scenes to scenes featuring shoals-and-waterfowl. In the course of the discussion, I have touched on the issues of level-distance scenery, pure and vast realms of shoals-

and-waterfowl painting, and compositional devices employed by artists.

Northern Sung landscape painters emphasized the appearance of rocks and mountains, so that by the time Kuo Hsi described the "three distances" in a concrete fashion, he was discussing the spatial relationships between mountains (i.e., land masses).[44] What is worth noting about Kuo Hsi is that he followed in the inkwork tradition of Li Ch'eng, specializing in the exceptionally refined use of brushstrokes and ink washes to represent many forms of trees, rocks, space, clouds and mist. Furthermore, he was especially gifted at depicting space not simply as a void, but as a moisture-suffused atmosphere. In the latter half of the Northern Sung, scholars such as Ou-yang Hsiu and Su Shih appreciated paintings that expressed the ideal of pure, vast, and desolate distance. Following in this trend, artists began to experiment with different techniques in order to emphasize the beauty of empty space, sometimes leaving up to half of the composition empty. They found that one of the best ways to do so was to incorporate shoals, water, clouds, mist, and sky. Of these elements, the issue of "water" and "shoals" was particularly important. Han Cho, in the early twelfth century, stated:

> I would like to continue the discussion of the "three distances." The boundary between the foot of mountains and the edge of water which extends far into the distance is called "wide distance." When the water's edge extends even beyond one's sight, this is called "hazy distance." When the scene is cut off and everything seems to float, this is called "silent distance."[45]

Here, Han takes the spatial relationship of water, rather than that of land masses, as his starting point. His discussion, moreover, must have been based on available works of artists from Kuo Hsi to his contemporaries. His observation of developments in contemporary paintings must have also prompted him to reevaluate the "three distances." Thus, the late Northern Sung was an important period in the development of "void" in landscape painting. And, by the Southern Sung, these tendencies and forms became codified and established.

One of the reasons why Northern Sung literati advocated pure and vast realms as ideals in painting is their strong association with the area and style of painting found in the Chiang-nan region. The editors of the *Hsüan-ho hua-p'u* in the late Northern Sung and Teng Ch'un, author of *Hua-chi*, in the Southern Sung also advocated pure and vast realms in landscapes, establishing "intimate scenery" as an important category of painting. But after this period, no authors or critics gave such emphasis to intimate scenery until its reevaluation by modern scholars.[46] The initial direction of intimate scenery in the Northern Sung may be said to have been unclear. However, by the late Northern Sung, the trend towards pure and vast realms became recognizable. This tendency, in turn, was a major influence on the development of Southern Sung painting, which many scholars note for the "one-corner" composition and the importance of "emptiness." These characteristics, as we have seen, were already advocated by Northern Sung scholar-artists, who seem

44. *Kuo Hsi*, Lin-ch'üan kao-chih, vol. 2, no. 7, p. 17.

45. *Han Cho*, Shan-shui ts'un ch'üan-chi, vol. 4, no. 10, p. 198.

46. *See Yonezawa Yoshiho's article in* Chugoku kaigashi kenkyu *(Tokyo: Institute of Oriental Studies at Tokyo University, 1961); John Hay,* Chinese Fan Paintings: A Colloquy, June 23–25, 1975, *University of London, Percival David Foundation of Chinese Art; Toda Teisuke, "Kachoga ni okeru Konan teki no mono,"* Chugoku no kachoga to Nihon—kachoga no seikai *(Tokyo: Gakkushu kenkyusha, 1983); and Teng Ch'un,* Hua-chi, *pp. 228–32.*

to have paid particular attention to the treatment of void. But it was only in the Southern Sung that such tendencies matured and became established, which led to their subsequent simplification. Thus, in the Southern Sung, paintings in small formats, such as album leaves, became increasingly popular and closely associated with pure and vast scenery. Under these circumstances, it was perhaps deemed unnecessary to mention intimate scenery by name. The term "intimate scenery" was used in the titles of later paintings, however, such as Huang Kung-wang's *Intimate Scene of Streams and Mountains*, Ni Tsan's *Intimate Scene of Rocks and Trees*, Wen Cheng-ming's *Album of Intimate Scenery*, Ch'en Shun's *Intimate Scene of Pines and Fungus*, Wu Li's *Intimate Scene with Kao Yu-tao*, and Wang Yuan-ch'i's *Imitation of Ni [Tsan's] and Huang [Kung-wang's] Intimate Scenes*.[47] But after the Sung dynasty, few developments took place with regards to intimate scenery. Since it was no longer considered innovative, the term, for all intents and purposes, appears to have fallen out of use.

Translated by Donald E. Brix

47. See Fu K'ai-shen (James Ferguson), Li-tai chu-lu hua-mu *(Taipei: Wen-shih-che Ch'u-pan-she, 1982).*

Figure 5.1
Attributed to Chü-jan (ca. 960–995),
Serried Peaks and Dense Woods,
Northern Sung period (before 1100).
Hanging scroll, ink on silk, 144.1 x
55.4 cm. National Palace Museum,
Taipei.

Figure 5.2
Attributed to Ts'ui Po (active
1060–1085), Reeds and Goose,
Yüan Dynasty (ca. mid-14th century?).
Hanging scroll, ink and color on silk,
138.1 x 52.3 cm. National Palace
Museum, Taipei.

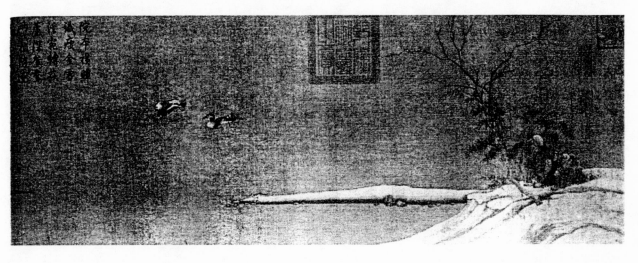

Figure 5.1
Attributed to Chü-jan (ca. 960–995),
Serried Peaks and Dense Woods,
Northern Sung period (before 1100).
Hanging scroll, ink on silk, 144.1 x
55.4 cm. National Palace Museum,

Figure 5.4
Schematic drawings of selected early Northern Sung landscape paintings in handscroll format.

Figure 5.4a
Attributed to Tung Yüan (d. 962), The Hsiao and Hsiang rivers, *(ca. 11th–12th century), Palace Museum, Beijing.*

Figure 5.4b
Attributed to Hsü Tao-ning (ca. 970–1053), Fishermen, *Northern Sung (ca. 1000). The Nelson-Atkins Museum of Art.*

Figure 5.4c
Attributed to Hsü Tao-ning (ca. 970–1053), Temple in Autumn Mountains, *ca. 1050. Fuji Yurinkan Collection, Kyoto.*

Figure 5.4d
Attributed to Ch'ü Ting (active ca. 1023–ca. 1053), Summer Mountains, *ca. 1030. The Metropolitan Museum of Art.*

Figure 5.4e
Attributed to Yen Wen-kuei (active ca. 970–1030), Pavilions among Rivers and Mountains, *ca. 1050. Osaka Municipal Museum of Art.*

A

B

C

D

E

Opposite shore and background scene

對岸及山景,

Water

水域

近岸及水域 Foreground shore and water

Figure 5.4f
Schematic drawing of the parallel compositional relationship between foreground, expanse of water, and background in figures 5.4a to 5.4e.

A

B

Opposite shore and background scene

對岸及山景,

Water

水域

近岸 Foreground

C

Opposite shore and background scene

對岸及山景

Water

水域

Foreground

近岸

D

Figure 5.5
Schematic drawings of selected late Northern Sung landscape paintings in handscroll format.

Figure 5.5a
Wang Shen (ca. 1048–after 1104), Tiered Peaks and Rivers, ca. 1100. Shanghai Museum.

Figure 5.5b
Liang Shih-min (active 11th–12th century), Reeds and Shore in Snow, ca. 1120. Palace Museum, Beijing.

Figure 5.5c
Schematic drawing of the diagonal compositional relationship between foreground, expanse of water, and background in figure 5.5a.

Figure 5.5d
Schematic drawing of the diagonal compositional relationship between foreground, expanse of water, and opposite bank (background) in figure 5.5b.

Figure 5.6.
Anonymous, Scholar, *ca. first half of 12th century. Album leaf, ink and color on silk, 29 x 27.8 cm.*
National Palace Museum, Taipei.

Figure 5.7
Attributed to Chao Ling-jang (active 1080–ca. 1100), Orange and Tangerine Groves, *ca. mid-12th century. Album leaf, ink and color on silk, 24.2 x 24.9 cm. National Palace Museum, Taipei.*

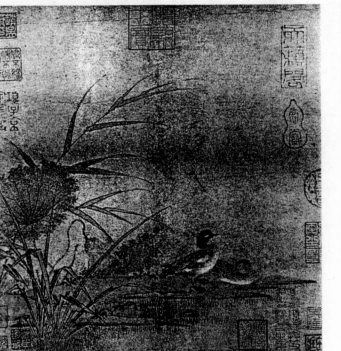

A Discussion of Ting Ware with Unglazed Rims and Related Twelfth-Century Official Porcelain

Ts'ai Mei-fen

Were the changes in the manufacture of porcelain during the Sung dynasty due to influences generated by the interaction of such factors as clays, glazes, kilns, and artisans, or were they the result of outside influences and expectations? Did these outside influences indirectly affect the products of the kilns, through interest shown when purchases were made, which then manifested itself in constraints on the market? Or, did they directly affect the techniques and decorative designs used at the kilns? These are fundamental questions that concern the production of porcelain. However, scholars of porcelain have had difficulties answering these questions. Even if we believe that the transmission of an artisan's skills and the individual artist's creativity naturally lead to the evolution of porcelain production, we must also consider that consumers, such as merchants, scholars, and emperors, have influenced production as well. Some historians have attempted to address these questions through statistics and data gathered from archaeological material, but the results seem only to demonstrate the quantity, appearance, and popularity of certain products during a given period, and which ware was preferred by which social group. Therefore, in writing this essay, I have examined the motives behind the historical records, especially whether the politically powerful emperors and the central government strongly intervened when policies regarding the manufacture of porcelain were made.

In the history of porcelain, the most highly acclaimed wares come from the Sung dynasty. They are renowned for their beauty and jade or silver-like appearance. From the Yüan dynasty down to the present, Sung wares have been continually imitated with little success. Yet the factors influencing how these wares evolved have rarely, if ever, been studied. An important factor has been the lack of recorded material. Among the records on Sung dynasty porcelain, apart from the book *T'ao-chi lüeh*, by Chiang Ch'i, dated possibly to the Southern Sung, the longest written passage concerning this subject is found in both the *T'an-chai pi-heng* and the *Fu-hsüan tsa-lu*.[1]

In this passage, it is strongly emphasized that the court had a significant influence on the production of porcelain. This included preferences and orders given by the central government, the inner court, and emperors. For instance, secret-color (*mi-se*) ware of the tenth century was made exclusively for members of the inner court—not for officials or the common people. Moreover, because the inner court did not like the *mang k'ou* (literally, "rough mouth" or unglazed rim) of Ting ware, it was not considered good enough to merit imperial patronage, and so the Ju kiln was ordered to produce its classic celadon ware. This trend influenced production

1. *Yee Chih, T'an-chai Pi-heng, recorded by T'ao Tsung-i, Ch'uo-keng-lu* (Wen-yüan-ke Ssu-k'u-chüan-shu) *(Taipei, 1983), V. 1040, chüan 29, p.13. Ku wen-chien, Fu-hsüan Tsa-lu, compiled in T'ao Tsung-i, Shuo-fu (Han-fen-lo ed.), chüan 18.*

in the Hopei, T'ang-chou, Teng-chou, and Yao-chou kilns in the north, and the Lung-ch'üan kiln in the south, all of which specialized in celadon ware. During the Cheng-ho period (1111–18), "the capital had kilns to make porcelain"; these were called Kuan or "Official" kilns. At the beginning of the Southern Sung, the previous policy of the Northern Sung was continued and celadon ware was produced in a newly established official kiln under the direction of the Hsiu-nei-ssu, which was also referred to as the Nei kiln. The ware produced in this kiln was said to "have a body made of refined clay (ch'eng-ni) and a brilliant and clear glaze." The Chiao-t'an-hsia kiln, which was built later, was not equal to this kiln. From the viewpoint of the inner court, however, Yüeh secret-color ware, Ju ware, Kuan ware, and Nei ware were all of comparable quality. Ting ware, however, because of its unglazed rim, was rejected.

The reliability of the passage mentioned above has been questioned by a large number of people. This passage was based on accounts transmitted from memory after the fall of the Southern Sung. As a result, the name of a man who built a kiln in the early Southern Sung was confused, and the description of conditions under the Northern Sung is even more inaccurate.[2] Thanks to recent archaeological excavations of kiln sites, however, certain facts regarding the history of porcelain have become clearer. Yao-chou ware, for example, was produced since the T'ang dynasty, well before Ju ware was produced. Such new evidence makes us want to more thoroughly investigate the reliability of this passage. For instance, are the Ju kiln and the northern Kuan kiln two separate kilns, or the same? Is there any difference between wares produced by the Hsiu-nei-ssu and the Chiao-t'an-hsia kilns? Was the legendary Kuan kiln situated in both the north and the south? Was the Ju kiln established after the Cheng-ho period (1111–18), and was its ware made solely for the imperial family? All of these questions have been raised before, but no consensus has been reached. Drawing primarily on historical documents, this essay will attempt to discuss the development and relationship between the court and porcelain production. The questions addressed here include: (1) Was the *mang k'ou* Ting ware really not acceptable to the twelfth-century court? (2) What was the reason behind firing Ju ware for official use? (3) Was the reason for producing Kuan ware in the Southern Sung the same as that in the late Northern Sung? In other words, during the twelfth century, in the period between the Northern Sung and the establishment of the Southern Sung, what kinds of factors influenced officials with regard to porcelain production?

Mang K'ou Ting Ware and the Imperial Taste for Gold and Silver Ware

The Ting kiln, well known as one of the suppliers of porcelain to officials during the Sung dynasty, was also a commercial kiln whose products were sold throughout the country and to other parts of the world. The kiln was located in Chien-tz'u village, Chü-yang county, Hopei Province. Situated nearby were two steles, from which we know the following:[3] at the end of the Five Dynasties period, in 957, the government established a position entitled Tz'u-yao shang-shui-wu shih, which was held by a local official as part of his many duties. The duties of this position, which

2. The question is whether Shao Cheng-chang or Shao Erh built the Hsiu-nei-ssu official kiln. Furthur discussion can be found in Sha Meng-hai, "Nan-sung Kuan-yao Hsiu-nei-ssu-yao chih Wen-ti te Shang-chüeh," Kaogu Yu Wenwu no. 6 (1985), pp. 105–6; Li Hui-ping, Sung dai Kuan-yao ts'u-ch'i (Beijing, 1992); Li Minju, "On the Official Kiln of the Sung Dynasty," Wen Wu no. 8 (1994), pp. 47–54.

3. Ch'ung-Hsiu Ch'u-yang hsien-chih (Recompiled Local Gazetteer of Ch'u-yang County, in 1904), chüan 11, p. 135; chüan 12, p. 125.

still existed in the Northern Sung, included the management of kilns and the responsibility of sending levies of porcelain to the Tz'u-ch'i k'u, or Porcelain Storehouse.[4] Another important responsibility of this position was the collection of commercial taxes. During the Hsi-ning period (1068–77), the entire country had 1,793 commercial or related tax offices.[5] The taxes collected went into the Left Storehouse, to cover the country's general expenses. Up until 1120, Chien-tz'u village still kept records of its vendors' transactions.[6] Therefore, Ting ware not only served an official purpose, but was also a commercial product.

With regard to the porcelain entering the Porcelain Storehouse, it was either used to supply the government offices and inner court, or, if it was not immediately needed, was sold, which enriched the national treasury. Some porcelain was delivered to the finance organization, and its price was set by merchants; some was sold by the officials of the inner court, who were in charge of the country's border territories.[7] This may be one reason why a considerable amount of first-rate porcelain has been discovered in nobles' tombs of the Liao and Hsia. The task of maintaining the required amount of items in the Porcelain Storehouse (later referred to as the Miscellaneous Storehouse), fell to either the officials who made orders to artisans to produce the required amount, or to local officials who went out to inspect available material and then acquired that which was necessary.[8] In the tomb of Emperor T'ai-tsung's empress (d. 1000), which is situated in Kung county, Honan Province, there were unearthed thirty-seven Ting ware pieces,[9] demonstrating that early Northern Sung Ting ware merited imperial patronage. Among those pieces found, sixteen are incised with the character *kuan*. From the end of the T'ang dynasty to the Northern Sung, more than one hundred fifty pieces have been unearthed with this mark.[10] Explanations regarding the interpretation of the mark vary, but many tend to describe it as meaning "official," "imperial family," or "noble family." Although these unearthed objects do not have unglazed rims, they do possess banded rims made of gold or silver. From this, we can conclude that porcelain with metal rims was not excluded by the imperial family.

The term "rough mouth" (*mang k'ou*) in the line of text "[the court] cannot bear to use Ting ware which has a rough mouth," relates to the coarse rim, which does not have any glaze. The reason for this feature is the practice of firing shallow vessels upside down on their rims, bringing them into contact with the saggars and making it necessary to leave the rims unglazed.[11] Scholars believe that *mang k'ou* Ting ware appears to have been first produced during the middle of the Northern Sung (Jen-tsung [1023–63] and Shen-tsung [1068–85] eras) and reached its peak at the end of the Northern Sung.[12] Moreover, some scholars believe that it was because the rim was unglazed that it was banded with metal; but, on the contrary, the reason for the unglazed rim was that the metal-banded rim was the popular taste of the time.

From both archaeological discoveries and recorded material, it can be seen that during Shen-tsung's reign the country's ceramic industry was thriving. For instance, Ching-te chen, in the fifth year of the Yüan-feng period (1082), established a Tax Office for Kilns. During the decline of the Yüeh and Hsing kilns, in the

4. Sung Hui-yao, *compiled from the Yung-le ta-tien in 1809 by Hsü-sung and entitled* Sung hui-yao chi-kao *(Taipei, 1964 reprint),* chüan Shih-huo p. 52:37.

5. *Kawakami Koichi,* Economic Life of Sung Dynasty *(Tokyo, 1976),* p. 242.

6. Ch'ung-hsiu Ch'ü-yang hsien-chih *(as in note 3).*

7. Sung hui yao, chüan *Shi-huo, pp. 52:36, 52:8;* Sung shih, chüan *165, pp. 10, 11.*

8. Sung hui yao, chüan *Shi-huo, p. 52:8.*

9. Huaxia Archaeology *3 (1988).*

10. Hsieh Ming-liang, *"Some related problems on the meaning of the Kuan character on the white ware,"* The National Palace Museum Research Quarterly *Vol. 5, no. 2 (Winter 1988), pp. 1–38.*

11. *The Hopei Bureau of Culture Archaeological Team,* "Reconnaissances and Trial Diggings Conducted on the Ting Yao Kiln Site at Chien Tz'u Village, Ch'ü Yang County, Hopei Province," *K'ao-ku 8 (1965), pp. 394–412.*

12. Yü Yung-ping, *"Porcelain from Dated Tombs and Pagoda-foundations of the Sung, Liao and Chin Periods,"* K'ao-ku 1 (1994), pp. 74–93.

13. Sung Shih, chüan *186*; chüan *86*;
Yüan-feng chiu-yu chih, chüan *2*, p.
13; chüan *3*, p. *7*; chüan *5*, p. *13*;
Sung hui-yao, chüan *Shih-huo*,
p. *41:41*.

14. Chen Wan-li, "O Tuei-yü Yao-tzu
te Chu-pu Jen-shih"; Shang Chien-
ching, "Yao-tz'u Chih-i," Wen-wu
ts'an-kao tsu-liao *4 (1955)*, pp. *72–4*,
75–8.

15. Sung shih, chüan *165*, p. *10*.

16. Sung hui-yao, chüan *Fan-i*,
pp. *7:4–10*.

17. Ibid., chüan *Fang-yu*, p.*4:2*.

18. Sung shih, chüan *153*, pp. *14–5*.

19. Ibid., pp. *13–4*.

first year of the Hsi-ning period (1068), and during the Yüan-feng period (1078–85), these kilns still submitted taxes in kind to the court.[13] During the Yüan-feng period, Yao-chou used porcelain as its form of tax in kind, and during the same period in 1084, a "spirit" stele for the kiln was erected.[14] These actions clearly indicate the importance of the porcelain industry in the eyes of the officials. This flourishing industry can be attributed to the prosperous society, the spread of skills, and Emperor Shen-tsung's policies for enriching the national treasury. It is written in the official history of the Sung dynasty that this emperor sought to increase the national treasury in order to raise an army to recover territory lost to the barbarians.[15] He established a new treasury, called the Yüan-feng Treasury, and strongly promoted the collection of riches of all kinds to fill it. The national treasury relied on tax collection, and accordingly, needed vast financial resources. The local officials, as a result, worked hard to promote all kinds of commercial industry, and on their own initiative requested the establishment of offices for the levying and collecting of taxes. The rise and prosperity of the porcelain industry is consequently not unrelated to these factors. It was during this period of increased taxes on kilns and fierce market competition that *mang k'ou* Ting ware first appeared. From an economic point of view, Ting ware that was fired upside down and stacked in saggars to save space, enabling large amounts to be fired at once, saved costs. From a decorative point of view, the upside-down firing process contributed to the development of the techniques for adding metal bands to the rims and the use of mold impressed decoration.

The custom of increasing the beauty of wares by adding gold or silver to the edges had been practiced since the Han dynasty. After the tenth century, tens of thousands of ceramic, hawksbill turtle, ivory, rattan, and other items sent from the Wu-Yüeh Kingdom were decorated on their edges with gold or silver.[16] Clearly, this was to satisfy the tastes of people from the upper strata of Sung society. It was recorded that during Jen-tsung's reign, an incident occurred in the inner court, where a kitchen hand took the silver off all the edges of the kitchen utensils, stealing over 3,600 taels of silver.[17] This event illustrates how extravagant the emperor's silver-inlaid eating utensils were. The common people were also interested in imitating this practice of adding gold or silver to their ware, with the result that in 1036 it was decreed that for "all utensils...only officials of the third grade and above could use wares decorated with gold bands...or, only if the ware was a gift from the emperor."[18] From this, it can be seen that laws prohibiting the spread of the practice of decorating items with precious metals were necessary. During this period, more than ten thousand taels of gold and silver were used annually for this decorative purpose.[19] The practice of covering edges obviously began well before the Ting kiln started firing its ware upside down. The practice was not introduced to cover up the unglazed rim, but, on the contrary, the unglazed rim was possibly instituted because of the popular practice of decorating edges.

Decorating the edges of wares with gold or silver was a specialized artistic skill. Within the government organization there was a Crafts Institute (Wen-ssu yüan), which was under the jurisdiction of the court. It had forty-two workshops,

one of which was the Leng-tso workshop (Decoration of Edges Workshop). Besides this, there was the Hou-yüan tsao-tso so, which was controlled by the inner court, and had seventy-four workshops employing between three hundred and four hundred thirty artisans. This department also had a Leng-tso workshop.[20] The Ting ware submitted as taxes in kind was sent from the Porcelain Storehouse to these workshops, where the metal rim was added. It was then either presented to the emperor or used as a form of reward for officials or ambassadors. In fact, so as to avoid the metal band slipping off the smooth rim, the edge was ground to make it coarse, enabling the band to be firmly fastened to the rim.

The National Palace Museum's Ting bowl with sculpted lotus petals, incised with the *kuan* character (fig. 6.1), follows the style of the early Sung dynasty. It is fired upright, and there is no glaze on the foot. However, the foliated rim has been ground away, and the indented sections of the rim have traces of white glaze. The glaze was applied but ground away before the metal band was added. It may be that the upside-down-firing method used for Ting ware was designed to save time in the work process, in that it produced a coarse rim to which the band could be conveniently added. Therefore, whether it was fired upside down was irrelevant; as long as the trend of adding metal bands persisted, the rim would have to be roughened. Meng Yüan-lao's *Tung-ching meng-hua lu*, which records aspects of daily life during Hui-tsung's reign (1101–25), notes that when the inner court celebrated a birthday "lacquer utensils banded in gold and silver were used."[21] In other words, Emperor Hui-tsung's court still used food utensils that were banded with metal. Thus, it is not possible that Ting ware was forbidden from entering the court because it had a banded rim.

The upside-down-firing method also benefited the development and implementation of the technique of impressing molded decoration onto Ting ware. By utilizing the stacked-saggar process, it was possible to produce many objects of a similar design. The exterior decoration was reduced, and ornamentation was concentrated on the interior. The point of support for ware fired upside down was entirely on the rim, in order to ensure that the ware did not warp. Consequently, wares with everted mouths, small feet, and thin bodies were possible; and after they were coated with a thin layer of glaze and fired, a brilliant, transparent effect was achieved. Compared with the same mold technique used at the Yao-chou kiln, whose wares had thick bodies and viscous glazes and could only be fired upright, the advantage of firing the thin Ting ware upside down was undeniable. The molded ware of Yao-chou and Ting-chou both appeared around the middle of the Northern Sung period. The arrangement of the decoration and the decorative themes were often similar. This was probably related to the official practice of requesting designs, in which requests for specific motifs were made by the relevant central government agency.[22] In addition, because of the large quantity of pieces required, many kilns often used molds to save time in carving. The intricacy and complexity of the mold reflected the imperial family's aesthetic point of view towards gold and silver ware, tapestry, and embroidery.[23] Tapestry and embroidery are flat, but the embossed effect of gold and silver ware is very similar to that of molded porcelain.

20. Sung hui-yao, chüan *Chih-kuan*, pp. 29:1, 36:72.

21. Meng Yüan-lao, Tung-ching meng-hua lu *(1147 published; Taipei ed., 1975)*, chüan 9, p. 55.

22. Hsieh Ming-liang (as in note 10).

23. Feng Hsien-ming, Ting Yao, (Shanghai and Kyoto, 1981).

In the beginning, the natural method of decorating porcelain was not through impressing molds, as clay is easier to cut after it is half dried. The Yüeh kiln used thin and pointed tools to incise designs, while the Yao and Ting kilns preferred a slanted knife, and were also adept at using combs of bamboo to draw waves, flower petals, and shadows. The effect that was achieved on the soft clay cannot be compared with any other materials. After glazing, the color filled and deepened in the incised grooves, thereby increasing the feeling of smoothness and fluidity. The Ting kiln, however, abandoned incising for molding, and thus forsake fluidity for orderliness and intricacy. The reason for this is that the Ting kiln was guided by a different aesthetic taste. Molds were commonly employed to impress designs onto metal objects and small seal-shaped molds had also been used on bricks, tiles, and early porcelain. In the case of Ting ware, the use of a single, patterned, mushroom-shaped mold meant that a piece's shape and decor could be created at the same time. This technique was probably related to the repoussé technique employed on gold and silver ware, which was popular in the T'ang and Sung dynasties.

Sung emperors were very particular about their gold and silver wares. For example, thirty gold belts produced by a highly skilled artisan from the Tzu-yün-lou, during Sung T'ai-tsung's reign (976–97) were still regarded as palace treasures in the time of Hui-tsung (1101–25).[24] During the Sung dynasty, the Hou-yüan tsao-tso so, located in the Tzu-yün lou, was the largest workshop.[25] This workshop was similar to the inner court's Craft Institute, but its divisions were even more specialized. Half its work involved producing gold and silver ware. Generally speaking, items made or decorated with gold and silver as accessories for the emperors' and officials' costumes, nobles' marriage items, and gifts presented by officials to the Khitan Tartars were produced in these two workshops. All pieces that were decorated with silver and gold—for example, ornaments, rhinoceros hairpins, saddlery, belts—were embellished with such motifs as fruits, treasures, the Guardian Kings, the Eight Immortals, rhinoceros, paired deer, stalking lions, wild horses, playing children, phoenixes, and flowers.[26] All of these motifs were approved by the emperor, and similar decorations could be seen on the clothing of court and military officials. Many of the surviving gold and silver wares unearthed from Sung and Liao tombs and storage cellars bear these kinds of motifs (fig. 6.2). The designs of gold and silver made for the inner palace are related to the molded motifs on Ting ware—such as lions playing, children playing, and paired deer (fig. 6.3). At Ting the kiln site there have been discovered sherds with dragon and phoenix designs—imperial symbols, the misappropriation of which could be considered a crime.[27] The molded ornamentation of Ting ware is unquestionably related to its official function. The *Sung hui-yao*, which contains records related to porcelain from the late Northern Sung, further supports this, recording that until the end of the Northern Sung, mold impressed Ming K'ou Ting porcelain was still requisitioned as a tax in kind by the Imperial Palace.

The *Sung hui-yao* states that in the sixth month of 1125, the last year of Hui-tsung's reign, the emperor decreed that the number of items levied for the Shang-shih chü (Palace Food Service) be decreased. This included "the medium-sized,

24. *Ts'ai T'ao*, T'ie-wei-shan ts'ung-t'an *(compiled in* Pai-pu ts'ung-shu chi-cheng *[Taipei, 1966]),* chüan 6, *p. 1.*

25. Sung hui-yao, chüan *Chih-kuan,* pp. 29:1, 36:72.

26. Sung shih, chüan *150–3.*

27. *Chou Mi,* K'uei-hsin tsa-shih, hou-chi, *p. 14.*

short-legged porcelain *t'ang-chan* (soup bowl) with coiled dragon decor on the inside, made at Chung-shan fu [known as Ting-chou after 1113], which was reduced by ten."[28] The Shang-shih chü was a division of the Liu-shang chü (Six Palaces Services), originally created as a temporary office but changed into a permanent institute in 1103). This office used the name of the emperor to indiscriminately levy tens of thousands of luxurious items. This led to numerous revolts, until 1126, when the empire was under siege by the Chin and Emperor Ch'in-tsung (r. 1126–27) decreed that this office should be eliminated to appease the people.[29] Porcelain *t'ang-chan* were available in different sizes with the same design. They were also produced with the upside-down firing method described earlier. A sherd discovered at the Ting kiln has the same kind of molded dragon design described in Hui-tsung's decree (fig. 6.4a), and is coincidentally, from a short-legged bowl.[30] A complete dish found in a cellar near the Ting kiln (fig. 6.4b),[31] has a similar molded dragon design. The wares requested by the Shang-shih chü, were evidently not limited to one kind. At the Ting kiln, a sherd was found with the characters Shang-shih chü, (fig. 6.5),[32] which came from a vessel that was short legged, wide mouthed, with curved sides and a narrow foot. This piece must have been fired upside down. The outside is plain, but the inside is filled with complicated designs. In the center are two fish-dragon (fish depicted like flying dragons), which was a prescribed design for civilians.[33] This further shows that the *mang k'ou* Ting wares with molded designs were produced in large quantities to supply the inner court during the Hui-tsung era (r. 1101–25). This was the luxurious and wasteful side of the late Northern Sung court, and it ended with the demise of the Northern Sung.

The influence of gold and silver wares were not limited to Ting wares with molded designs. When the common wineshops began to use silver vessels,[34] the shapes of objects in other media, such as porcelain and lacquer, were also influenced. For instance, wares with foliate rims, lobed vessels, and wares with sprigged relief were all probably based on gold and silver shapes. The Ting ring-handled cup (fig. 6.6), referred to as the *ch'ü-chih*, imitates the court's celebrative gold and silver ware.[35] Broken parts of molds of this cup have been found at the Ting kiln site,[36] proving that it was produced in large quantities. The Ju bowl in the shape of a lotus is also based on a gold or silver prototype. However, was Ju ware really only produced to imitate the style of gold and silver wares? The court could have had an unlimited supply of pure gold, so why spend the time and effort creating a kiln to produce such an imitation?

The Rise of the Ju Kiln and the Imperial Kiln

During the twelfth century, glass was deemed a precious article in Japan, Korea, and China. The people of the Sung dynasty had substantial knowledge of glass, and there was more than one process for smelting it. A kind of glass called *yao-yü* was made to imitate the opaqueness and warm, smooth feeling of jade. In the Sung dynasty, the clothing worn by officials for sacrificial rites was decorated with *yao-yü*.[37] During this period, the use of glass was widespread, and the large amount unearthed is proof of this.[38] In archeological excavations, it is common to find glass

28. Sung hui-yao, chüan *Ch'ung-ju*, p. 7:60.

29. Sung shih, chüan *117*, p. 13.

30. The Hopei Bureau of Culture Archaeological Team, op. cit., fig. 2:21.

31. Miao Chi-hao and Hueh Tseng-fu, "Ting ware Porcelains discovered in Pei-chen, Ch'ü-yang county, Hopeh Province," Wenwu 5 (1984), pp. 86–8, fig. 7,8. The same one is the pl. 69 in Feng Hsien-Ming, op. cit.

32. The Hopei Bureau of Culture Archaeological Team, op. cit., fig. 10:9.

33. Sung shih, chüan *153*, p. 15.

34. Meng Yüan-lao, op. cit., chüan 4, p.26; chüan 5, pp.29, 32.

35. Meng Yüan-lao, op. cit.., chüan 9, p. 55.

36. The Hopei Bureau of Culture Archaeological Team, op. cit., fig. 13:3.

37. Sung shih, chüan *152*, pp. 6, 10.

38. An Chia-yao, "Early Glass Vessels of China," K'ao-ku hsüeh-pao 4 (1984), pp. 413–48.

39. *Meng Yüan-lao, op. cit., chüan 4, p. 27.*

dating to the Sung dynasty, fortuitously preserved in the secret stone compartments of the foundations of Buddhist temples. Another kind of glass that was popular during the Sung is mentioned in Meng Yüan-lao's *Tung-ching meng-hua lu*. He noted that a scholar like himself would prefer a *pi-wan* (blue-green) glass bowl to a silver one.[39]

Glass existed in China as early as the Chou dynasty, and during the Six Dynasties period, its basic composition was known. By the Sung dynasty, it had become a common commodity and could be purchased anywhere. It was also understood that the most valuable glass came from foreign sources. Chinese glass in bright colors was available, but it was very fragile and would crack if hot water came into contact with it. Foreign-made glass was, in comparison, duller in color, but could withstand boiling water, and was as strong as porcelain or silverware. Islamic glass contained borax, which imparted certain qualities to the glass, such as low expandability, high heat resistance, and resistance to cracking under high temperatures. Chinese glassware for Buddhist reliquaries contained lead, with the result that the glass was thin, bright, and attractive. In comparison, the carved glass bottles made by the Arabs were thick, practical, and durable.[40] Because of the Sung peoples' preference for Islamic glass, much of it entered China along with spices and perfume. It even became an item of tribute. Records show that on various occasions from 39 to 189 pieces of glass were used in this way.[41]

40. *Chang Lin-sheng, "Liu-li Kung-i Mien-mien Kuan," (On the craft of glass) The National Palace Museum Monthly of Chinese Art Vol. 1, no. 58 (1988), pp. 14–29.*

41. *Sung hui-yao, chüan Fan-i, pp. 7:32, 33, 48, 55.*

Locally made thin and fragile glass was in abundant supply, while the Islamic tribute glass was mainly found at the court. There were no artisans in the court, however, to shape the glass. Ts'ai T'ao's *T'ieh-wei shan-ts'ung t'an* records that in 1114, Emperor Hui-tsung inspected the Feng-ch'en Storehouse himself and found two glass vessels and two large containers filled with glass matrix that resembled iron slag in lumps about the size of a fist. No one knew what it was for or where it came from. The inner court had the glass matrix smelted and molded, making glass pebbles of green, red, yellow, and white, but they could not form them into other shapes.[42] In the West, the raw material of glass was often first smelted into a glass matrix before being shipped to foreign markets. Local artisans would then further shape the matrix into objects that reflected local characteristics. Clearly, the Sung court did not know how to deal with the glass matrix. After it is smelt, glass can only be shaped by blowing and modeling with the proper tools.

42. *Ts'ai T'ao, op. cit., chüan 5, p. 19.*

43. *Inner Mongolia Institute of Archaeology, "Excavation of the Tomb of the Princess and Her Husband of Liao's State of Chen," Wenwu 11 (1987), pp. 4–24, fig. 35.*

44. *Henan Institute of Cultural Relics, "Investigations and Trial Diggings of the Site of Ru Yao at Qingliang Si Temple in Baofeng, Henan," Wenwu 11 (1989), p. 1.*

45. *Hsieh Ming-liang, "The Discussion on two Ju Ware Mallet-shaped Vases in the National Palace Museum," The National Palace Museum Monthly of Chinese Art Vol. 1, no. 58 (1988), pp. 58–63.*

Sung Hui-tsung evidently appreciated the beauty of glass and tried to shape it, but failed. In the tomb of a princess from the Ch'en State of the Liao dynasty, dated 1018, numerous Islamic glass items were found. One of the pieces was a transparent vase with carving on it (fig. 6.7b), known as a mallet-shaped vase, because of its dish-shaped mouth, long and narrow neck, sloping shoulders, and almost perpendicular barrel-shaped body with a slightly concave base.[43] This vase is very similar to the celadon-glazed Ju vase with a dish-shaped mouth, which was unearthed in Pao-feng county, Honan Province,[44] except that the bottle has a flatter base and a straighter neck (fig. 6.7d). The National Palace Museum's two Ju ware mallet-shaped vases are similar to these glass vases (fig. 6.8), aside from the fact that the mouth is ground away and they have metal rims.[45] This kind of vase with a dish-

shaped mouth, long neck, and perpendicular barrel-shaped body has been found in Egypt, Iran, Serce Limani, and Hopei. Scholars believe that this shape was influenced by tenth and eleventh century Islamic glassware (fig. 6.7a), which was popular during that time. The body of the ware gradually became more tubular and the outer decor plainer. In China, several similar vases have been unearthed, the oldest dated to 1058 (fig. 6.7c).[46] The emperors of the Sung dynasty undoubtedly admired the imported glassware, and the National Palace Museum's two Ju ware vases seem to have been influenced by this preference.

Although the shape of these glass vases and Ju ware vases is very similar, the surface of the glass is, in comparison, shiny and smooth, even on the rim and the base. It has been repeatedly recorded by Sung scholars that the emperor did not like Ting ware because of its unglazed rim, although, in fact, the Ting kiln continued to manufacture ware for the court. Perhaps what was passed down in these records is only partially true. Emperor Hui-tsung may have used this as an excuse to order the Ju kiln to make fully glazed porcelain with sesame seed-shaped spur-marks. Firing porcelain on spurs did not begin at the Ju kiln; this technique was already in use in the early Northern Sung at the Yao-chou kiln complex and the so-called Ju kilns, which were numerous and spread over Pao-feng county and other areas of Ju-chou, and produced wares that were closely related in appearance to those of Yao-chou. It is also possible that, with the addition of new kilns established under the emperor's orders, neighboring artisans were hired to create and study a new ware with a smaller spur and an even glaze, which led to the establishment of the Ju and Kuan kilns, which sent their wares to the palace.

Another reason for the possible connection between glass and Ju ware is that Ju-chou had large deposits of agate. Coincidentally, during the fourth and fifth years of the Cheng-ho period, two large batches of agate were listed as taxes in kind, which was at that time an important news item and led to the elevation of Ju-chou's status.[47] As pointed out by other scholars, the location of the Ju kiln at the Ch'ing-liang temple in Pao-feng county, was under the jurisdiction of the Ch'ing-ling-chen township, Ju-chou, an area that was known for its agate production in the Sung dynasty.[48] The chemical composition of agate is silica dioxide; after it is fired, it becomes glass. After it is fired and the colors become unevenly distributed, a glass matrix can also resemble agate. According to the Ch'ing-po ts'a-chih, the Ju kiln used agate as its glaze.[49] The inner court, which was unable to make glassware, ordered the Ju-chou kiln, which sent agate as tribute and was also able to make celadon ware, to take the glass or agate and fire it onto the surface of the porcelain. They also requested that the porcelain be round and smooth, without mang k'ou or unglazed rims. Therefore, a sequence of events can be reconstructed, beginning with the discovery of the glass matrix, and moving on to the court's failure to make glassware, the presentation of agate as a tax in kind, and the order to make glazed porcelain without unglazed rims at Ju-chou. Soon after the fifth year of the Cheng-ho period (1115), the world famous and treasured Ju ware was first made.

The above discussion has explored the possibility that the Ju kiln's fully glazed celadon porcelain resulted from an official request to make imitation glassware. It is

46. An Chia-yao, "On the Early Islamic Glasses Discovered in China in Recent Years," K'ao-ku 12 (1990), pp. 1116–26. See also, Sakurai Kiyohiko and Kawatoko Mutsuo, "A Preliminary Report of Excavations at Al-Fustat in Old Cairo—Ruins of the Old Capital of Islamic Egypt," Museum no. 341, pp. 25–38.

47. Sung shih, chüan 185, p. 16. It was recorded that agate was discovered at Ch'ing-ling-chen in 1114; Sung hui-yao, chüan Jui-i, p. 1:22, recorded that agate from the Shang-yu mountain of Ch'ing-ling-chen was discovered again in 1115. These incidents have also been recorded by Chou Hui, Ch'ing-po tsa-chih (Wen-yüan-ke Ssu-k'u-chüan-shu, ed.V. 1039), chüan 8, p. 8; chüan 6, p. 8.

48. Wang Ch'ing-cheng, Fan Tung-ch'ing, and Chou li-li, The Discovery of Ru Kiln (Shanghai, 1987), pp. 21–2.

49. Chou Hui, Ch'ing-po tsa-chih, chüan 5, p. 10.

not meant to resolve whether the celadon ware was originally made in the area around the Ju kiln, or whether it became a regular kiln at a later point, or even whether the renowned Ju kiln was for official or civilian use. The conclusions that I have reached from my research on the subject are set forth below.

First, there were multiple sources for the Sung court's porcelain ware. Besides receiving the local tax in kind from the Ting and Yüeh kilns, the national treasury might have ordered artisans from other parts of the country to manufacture the required ware. Some examples include sherds with the reign marks Ta-kuan and Cheng-ho, found at the Yao kiln. These wares were known to have been supplied to officials during Hui-tsung's reign. Furthermore, from sherds inscribed with *chin-chan* (tribute bowl) and *kung-yü* (supplied for imperial use) found at the Chien kiln, it is known that these wares were sent as tax in kind to the court for tea drinking.[50] But these finds do not mean that these two kilns did not have a long history of supplying porcelain to the general public. Near the location of the Ch'ing-liang temple, were the old kilns of Lu-shan, Hsia-hsien, Lin-ju, and Pao-feng. The Ch'ing-liang temple kiln might have had an even longer production history, and might also have supplied official wares. Moreover, this kiln is believed to be one of the Ju kilns. In the fifth year of the Cheng-ho period, under orders from the central government, local agate was added to the glaze. It is, therefore, also possible that because of the agate tax in kind, the Ching-liang temple was established as a new kiln for temporary experimental production.

Second, a Northern Sung Kuan kiln existed, but it was not necessarily the Ju kiln. It was under official or government jurisdiction, utilizing the artisan system, and had been producing celadon for a long time. For instance, the workshops referred to as Ch'ing-yao tso and Yao-tsu tso were listed as offices under the Tung-hsi pa-tso ssu (East and West Eight Workshops),[51] which was involved mainly in construction within and outside the capital. There was also an office known as the Yao-wu (Kiln Office), that was in existence before 1007, whose duties included the supply and management of clay for the production of vessels.[52] Under this office, aside from the regular artisans involved in the production of bricks and tiles, there was the Ch'ing-tso chiang (celadon artisans) and Ho-yao chiang (glaze artisans), who were apparently involved in the production of celadon ware. The Ch'ing-yao tso and the Ch'ing-tso chiang are compared with the Ch'ing-ch'i yao in the books *Hsien-ch'un Lin-an chih* and *Meng-liang lu*, which concerned Hangchow.[53] All of them produced celadon ware. The Ch'ing-ch'i kiln was recorded as the Southern Sung's Chiao-t'an-hsia Kuan kiln; thus, the Ch'ing-yao tso and the Ch'ing-tso chi-ang should be the Northern Sung's Kuan kilns and artisans, respectively. The Kiln Office of the Northern Sung was only utilized when it was required, and ceased to function when not needed. For instance, Emperor Chen-tsung, in 1009, re-established the Eastern and Western Kiln Office for the purpose of building a palace; construction began in February and stopped in October.[54] This is a typical example of an official gathering of resources and artisans as needed; the resulting products were apparently exclusively for official use, a characteristic of Kuan wares recognized by later generations. Although in 1009 the Kiln Office was recognized for its

50. The Ch'ing-shui Vally Archaeo-logical Team of Shensi Institute of Archaeology, "The Sung Dynasty Kiln Site of Yao-chou ware at T'ung-chuan, Shensi," K'ao-ku 12 (1959), pl. 7:9.

51. Sung shih, chüan 165, p. 22; Sung hui-yao, chüan Chih-kuan, p. 30:7.

52. Sung shih, chüan 165, p. 22; Sung hui-yao, chüan Shih-huo, p. 55:20.

53. Wu Tzu-mu, Meng-ling-lu (com-piled with Meng Yüan-lao, op. cit.), chüan 9, p. 209; Hsien-ch'un Lin-an Chih (Wen-yüan-ke Ssu-k'u-chüan-shu, ed. V. 490), chüan 10, p. 4.

54. Sung hui-yao, chüan Shih-huo. p. 55:20.

porcelain production, before and after this date there is no clear record as to whether the Kiln Office at the capital actually made celadon ware. The only thing that was recorded by this office was the quantity of wood and coal used in the kilns.[55] Although the Kiln Office may have been responsible for production, and could have built the kilns to make the porcelain, it is also possible that these functions were performed by the Tz'u-yao shui-wu (Tax Office for Kilns), since this office is often referred to in historical documents as the Kiln Office.[56] Or, during the early Sung, the Western Kiln Office may have only been a collection place, gathering products from the various celadon kilns.[57] Therefore, it may not be the case, as is often surmised that there were porcelain kilns built in the capital. From the *Sung hui-yao*, it is known that the East and West Eight Workshops did not necessarily order wares from the capital, but made orders to various provinces.[58] If it is true that during the Cheng-ho period, "the capital had kilns to make the wares," then the manufacture of the wares could have been overseen by the East and West Eight Workshops, or the Eastern Kiln Office, and it is possible, but not necessarily the case, that the kilns were built in the capital. Perhaps it is when the Ju kiln was established, around the fourth and fifth years of the Cheng-ho period (1114–15), when the agate taxes in kind from Ju-chou were used to make imitation glassware. Or, it could be in the fifth to seventh years of the Cheng-ho period (1115–17), when the Ming-t'ang (Hall of Enlightened Rule) was built and kilns were needed to make new ceremonial wares. For the same reasons as when Emperor Chen-tsung built a palace, the Eastern Kiln Office was requested to make a new supply of ceramics. Since the dates of these two events were very close, they could have been two separate events or the same. It is also possible that after these events, the Liu-shang chü asked for additional taxes in kind and the Kiln Office therefore continued production. Unfortunately, when the Chin soldiers invaded some ten years later, the records were lost before they could be entered into the archives. From records of the Yüan-feng period (1078–85), it is known that the Eastern and Western Kiln Offices were situated beside the Pien River, which was prone to flooding;[59] perhaps these sites are under present-day K'ai-feng.

Third, the characteristics of Ju ware were already well known during the Northern Sung. In 1124, on a visit to Korea, the emissary Hsü Ching saw examples of Korean celadon and said that it was similar to the new porcelain of Ju-chou.[60] "New" referred not only to the age, but to the new style, such as that of the ceremonial wares awarded to Korea by the imperial court in 1117. The style, color, and technique of these wares were unanimously recognized as a new and creative achievement of the period, and must have been something Hui-tsung was very proud of. The twelfth-century Korean celadons seen today, aside from the similarity in glaze style, were also manufactured using the sesame-seed-shaped spur technique, which has also been confirmed as a characteristic of Ju ware. These wares had a limited production to begin with, and after the ravages of war, the Southern Sung court treated them as treasures. During the twenty-first year of the Shao-hsing period (1151), a powerful official, Chang Chün, gave Emperor Kao-tsung sixteen pieces of Ju ware, twelve pieces of glassware, and other treasures, such as

55. Sung hui-yao, chüan Shih-huo, p. 55:20.

56. Liao Shih, chüan 75, "Wang Yü" chüan.

57. Sung hui-yao, chüan Shih-huo, p. 55:20.

58. Sung hui-yao, chüan Chih-kuan, p. 30:8.

59. Sung hui-yao, chüan Fang-yü, p. 16:17.

60. Hsü Ching, Hsüan-ho feng-shih Kao-li t'u-ching (Wen-yüan-ke Ssu-k'u-chüan-shu, V. 593), chüan 32, p. 2.

bronzes, paintings, and jade. These were all things that were prized by Emperor Hui-tsung. In the imperial garden, both the glass bottles and the Ju ware were used for holding flower arrangements,[61] a fact that suggests that these items were cherished equally for their splendid beauty.

Southern Sung Kuan Ware and Ritual Wares for Sacrificial Rites

Another important factor influencing the manufacture of porcelain was its use in sacrificial rites. State ceremonies took place often during this time. Traditionally held for the purpose of worshipping heaven, earth, and the ancestors; they also helped to reinforce the emperor's authority. Sung scholars studied in detail the historical records of various sacrificial ceremonies, especially the important ones performed in the Chiao-ssu (Suburban Sacrifices), the Ming-t'ang (Hall of Enlightened Rule), and the T'ai-miao (Imperial Ancestral Temple). An examination of these studies can also shed light on the ritual uses of porcelain.

These ceremonies were complicated and a large quantity of ceremonial wares was required. In the second year of Emperor T'ai-tsu's reign (961), the emperor decreed that the San-li-t'u, by Nieh Ch'ung-i, was to be the authoritative book on all rituals.[62] This began a trend in the Sung imperial palace to "return to the proper rituals of ancient times," but as seen from the taxes in kind sent to the capital from the Southern T'ang and Wu-Yüeh kingdoms, including gold, silver, rhinoceros horn, elephant tusk, and Yüeh and Ting porcelain,[63] the early Sung Court was not very particular about the items they used for rituals. After Sung Jen-tsung decided to perform personally the ceremonies at the Ming-t'ang,[64] however, close attention was given to the form and rules governing ceremonial wares. Because of Jen-tsung, scholars and officials began to discuss the importance of rituals, even though the rituals were based on the San-li t'u. This book is a compilation of works based on the illustrative books San-li, by scholars of the Eastern Han, Sui, and T'ang dynasties. The illustrations were made according to what the scholars thought ritual vessels should look like based on their traditional names rather than on excavated examples. In the seventh year of the Ch'ing-li period (1047), the vessels used in the Suburban Sacrifice were gourd chüeh, ceramic teng, and ceramic lei;[65] the ceramics used in the state ceremonies were based on the San-li t'u. Only a recent edition of this book survives today, so the cups, bowls, and plates illustrated there may only bear an approximate relationship to the actual vessel types used in the ceremonies of the early Sung, which included i, kuei, tui, and p'an. Ritual containers, such as t'ai-tsun, cho-tsun, hsi-tsun, hsiang-tsun, hu-tsun, and shan-tsun, were probably large vessels.

For the purpose of studying all types of ancient sacrificial ceremonies, and in order to correct any errors of the past, Emperor Shen-tsung (r. 1068–85) established a new bureau called Hsiang-ting li-i so (Office of Editing for Ceremonies of Etiquette).[66] In 1083, the emperor ordered that pottery, which symbolized the nature of Heaven and earth, be used in ceremonies in order to conform to the simplicity of ancient rituals.[67] This may be one of the reasons that, from the Shen-tsung period onwards, porcelain was produced in large quantities. The kind of

61. *Chou Mi*, Wu-lin chiu-shih (compiled with Meng Yüan-lao, op. cit.), chüan 9, p. 502.

62. Sung shih, chüan 151, p. 10.

63. Sung hui-yao, chüan Fan-i, p. 7:1

64. Ku-chin t'u-shu chi-ch'eng (Ting-wen published, Taipei, 1976), V. 717, chüan 173, p. 64; V. 718, chüan 178, p. 19.

65. Yung-le ta-tien (Shih-chieh published, Taipei, 1962), chüan 5454, p. 17.

66. Ku-chin t'u-shu chi-ch'eng. V. 716, chüan 155, pp. 42, 43.

67. Ibid.

ware used for rituals depended on the kind of ceremony performed, which could have been simple, or colorful and decorative. The simple ceremonies did not use gold or silver wares, but a plain ware which was not to be banded with precious metals. Therefore, the line of text "[the court] cannot bear to use Ting ware which has a rough mouth" may have been used in reference to wares used in certain ceremonies. Shen-tsung's desire to make each ceremony proper and exact resulted in their becoming extremely detailed and complicated. The scholar-official and poet Su Shih (1037–1101), who was at this time officially engaged in work related to rituals, recommended a simplification of this practice and a reduction in the number of ceremonies,[68] but his appeal was not needed. Instead, in the Hui-tsung era, ceremonies became more luxurious and wasteful.

68. Ibid., p. 45.

The emperors of the mid-Northern Sung recruited scholars to discuss ancient rituals, believing the previous rituals were impractical and contrary to the meanings in the books. Scholars raised numerous questions, and this is probably the reason why antiques were studied avidly beginning in this period. Scholars involved in literary research and the collecting of antiques promoted the study of antiquities, etymology, and ancient regulations governing rituals. Their purpose was to investigate the origins of production, to fill in missing parts of classical texts, and to eradicate earlier misinterpretations.[69] There were also numerous collectors, who published catalogues and essays based on their own collections. Even the imperial family became involved in this trend. Besides publishing books of regulations on rituals, in the Ta-kuan period (1107–9), Emperor Hui-tsung ordered the compilation of the *Hsüan-ho po-ku t'u-lu* (Catalogue of Antiquities in the Hsüan-ho Collection), which included over five hundred objects. By the Cheng-ho period (1111–18), there were over 6,000 pieces in the collection, which illustrates the great interest in excavating antiques. These books may have been incomplete, but the spirit of textual research deeply influenced the rules concerning ritual wares.

69. Lü Ta-lin, Preface of K'ao-ku-t'u (Wen-yüan-ke Ssu-k'u-chüan-shu, V. 840).

The emperor's adherence to "returning to the ancient" ceremonies was deepened through the establishment of the I-li chü (1107) and the Li-chih-chü (1112).[70] The former office was concerned with discussing rituals, and the latter was related to the establishment of ceremonies. During the Ta-kuan era (1107–10) many of the old ceremonies were still followed. The I-li chü was already aware of the fact that the official ceremonial wares, including *tsun, chüeh, fu,* and *kuei,* were different from the antiques collected by aristocrats, and so recommended changes in the vessel forms. The office ordered local officials to gather drawings of the ancient vessels from antique collectors to serve as a reference.[71] For the ceremony for worshipping the earth in 1114, for worshipping heaven in 1116, and, for conducting a grand ceremony at the Ming-t'ang in 1117, the ritual vessels already showed a "return to the ancients."[72] From 1115 to 1117, Emperor Hui-tsung established the Ming-t'ang and sought to hold a grand ceremony that matched that recorded in the classics. In the grand Ming-t'ang ceremony of 1117, therefore, in addition to worshipping heaven, earth, and the ancestors, the number of spirits worshipped increased to 690. Hui-tsung insisted that the rules be different from previous ones, and ordered that the inner court's designs be followed in establishing the Ming-

70. Sung shih, chüan 149, p. 2.

71. Sung hui-yao, chüan Li, p. 14:62; chüan Shih-huo, p. 69.

72. Sung hui-yao, chüan Li, p. 14:66; Chai ch'i-nien, Chou Shih (Wen-yüan-ke Ssu-k'u-chüan-shu, V. 681).

73. Ku-chin t'u-shu chi-ch'eng,
V. 717, chüan 173, p. 66.

74. Ibid.,V. 718, chüan 174, p. 2.

75. Sung hui-yao, chüan Yü-fu,
p. 6:14.

76. Ku-chin t'u-shu chi-ch'eng,
V. 718, chüan 174, p. 2.

77. Sung hui-yao, chüan Li, p. 15:21

78. Jung Keng, Shang-Chou i-chi
t'ung-kao (Yen-ching hsüeh-pao,
1941), pp. 183–90.

79. Ts'ai Mei-fen, "Cheng-ho Ting",
The National Palace Museum
Monthly of Chinese Art no.104, p. 1.

80. Ibid., chüan Li, p. 14:70.

81. Ibid., chüan Li, p. 14:84.

82. Ku-chin t'u-shu chi-ch'eng,
V. 718, chüan 174, p. 2; V. 716,
chüan 156, p. 47.

t'ang.[73] The ceremonial wares used in these major ceremonies were referred to in the Southern Sung as new ceremonial wares of the Cheng-ho era (Cheng-ho hsin-ch'eng li-ch'i).[74] These wares became the new style after the publication of the *Hsüan-ho po-ku t'u-lu*.

The new ceremonial wares of the Cheng-ho era were mainly bronzes, and the court of Hui-tsung had substantial experience in manufacturing this kind of ware. In the fourth year of the Ch'ung-ning period (1105), nine tripod vessels (*ting*) were produced and in the seventh year of the Cheng-ho period (1117), another nine such vessels were made, as a reference to King Yü of the Hsia dynasty, whose state was composed of nine kingdoms and who, therefore, made nine tripod vessels to symbolize his rule over all nine regions.[75] On one occasion, a state ceremony required approximately 6,000 to 9,000 ceremonial pieces.[76] It is difficult to calculate what proportion of these were bronze, although the records show that at one time in the Southern Sung 2,172 ceremonial bronzes were in need of repair.[77] Although most of the ritual objects used by the court of Hui-tsung were probably bronzes, few examples are extant. Only about thirty inscribed bronzes manufactured between 1115 and 1121 are known. The inscriptions on these bronzes are eloquent, and the shapes are dignified. Even during Emperor Kao-tsung's reign (1127–62), less than forty years later, scholars of bronze and stele inscriptions mistook these wares for antiques.[78] The exterior and shape of the Cheng-ho tripod vessel (fig. 6.9) in the National Palace Museum, which was given to the powerful eunuch T'ung Kuan in 1116 for a family ritual,[79] accurately imitates prototypes of the late Shang or early Chou dynasty, and the animal masks and motifs on the vessel properly follow ancient designs. Furthermore, in 1117, as noted earlier, Hui-tsung presented Korea with a new set of ceremonial wares, in order to ensure that the proper style was followed.

Although the new ceremonial wares were given to many, and written information was given for reference, the wares produced were still not uniform. In the first year of the Hsüan-ho period (1119), the Li-chih chü ordered local officials to follow the rules that it drafted and the colored drawings it printed in the manufacture of ceremonial bronze, lacquer, and wooden wares.[80] Under Emperor Hui-tsung, ceremonial wares were produced in large numbers; in the Suburban Sacrifices, they used drinking cups (*chüeh*) of gourd as well as various porcelains that followed the new stylistic dictates.[81] Northern Sung porcelain kilns under the jurisdiction of the government made archaic wares, and their degree of similarity to antiques can be used as evidence of the change in style which occurred during the Cheng-ho period (1111–18).

During the early Southern Sung, the imperial court continued to use the newly established ritual vessels and musical instruments. After the Chin invasion of the capital, in the second year of the Chien-yen period (1128), Emperor Kao-tsung made a simple altar at Yang-chou for the Chiao-ssu (Suburban Sacrifices), and all of the wares used were Hui-tsung's new ceremonial wares.[82] A year later, however, when the court fled the capital across the Yangtze River to the south, all of its ritual vessels and musical instruments were lost. Hence, in the first year of the Shao-hsing

period (1131), Hui-tsung's grandiose Ming-t'ang ceremony was greatly simplified with only a short list of subjects to be worshipped: heaven, earth, and a few select ancestors. For this ceremony the emperor ordered ceramic vessels to be made at Yüeh-chou following bamboo and wooden models.[83] In 1134, after the political situation was more stable and Kao-tsung had established the capital at Lin-an, the grand Ming-t'ang ceremony was revived, but only 443 spirits were worshipped— two-thirds of the number worshipped in the north. Nonetheless, the ceremony still required more than 7,000 ceremonial wares, which were made in Yü-yao county, Shao-hsing fu.[84] After the ceremony, the official Wang Pu criticized the grand Ming-t'ang ceremony, claiming that many aspects of it were not in accordance with the rules. He asserted that the ritual vessels roughly imitated those illustrated in the San-li t'u and that this was not proper. He suggested that the court should look to antiques for the proper style and to the new wares of the Cheng-ho era, such as the fu, kuei, tsun, and lei, using lacquer and wood instead of bronze.[85] The emperor seemed to accept most of these comments and so in 1137, the grand Ming-t'ang ceremony used the antique-style bronze chüeh instead of the vessels shaped like a bird with a cup on its back which had been used earlier. In 1142–43, the palace treasury obtained a copy of the Hsüan-ho Po-ku t'u-lu and gave it to the official of rituals,[86] initiating a large-scale alteration of ceremonial wares to their proper forms. In 1143, the new ceremonial wares for the Suburban Sacrifices imitated the Po-ku t'u-lu; the pottery was made at Ping-chiang fu, the bronze chüeh were made at Chien-k'ang, and the bamboo and wooden wares were ordered from Lin-an fu.[87] By 1146, the grand Southern Suburban Sacrifice was regarded by Prime Minister Ch'in K'uai (1090–1155) as one that properly followed the ancient rules.[88] It was recorded that, apart from bronze, bamboo, and wooden ceremonial wares, the Suburban Sacrifices needed to use ceramic. The tsun, lei, fu, kuei, and tou were all made of ceramic, referring to the shapes in the Hsüan-ho Po-ku-t'u-lu, and, if not found in this book, taken from depictions in the San-li t'u,[89] which also qualified as a source for proper archaic styles.

In other words, in the first year of Kao-tsung (1127), there was a shortage of ceremonial wares, with the result that the ceremonies were simplified and porcelain, lacquer, and bamboo were used instead of bronze. As to the regulations governing vessel styles, they were similar to those for the bamboo and wooden ritual vessels used by the general populace, which, in turn, were influenced by the San-li t'u. Ceremonial porcelain was manufactured at Yü-yao, or Yüeh-chou, and so are known as Yüeh wares. By 1143, ceremonial wares were made according to the Hsüan-ho Po-ku t'u-lu, and ceramics were made at Ping-chiang-fu in the Soochow area. It seems that the wares from the Kuan kiln in Hangchow had still not shown up in the historical record.

Official history records that until 1149, the ceramic, bronze, bamboo, and wooden wares for the T'ai-miao (Imperial Ancestral Temple) were supplemented by the Lin-an fu in modern Hangchow.[90] Lin-an township, which was able to accommodate the production of other wares made of different materials, flourished. After this period, we know that the Kuan kiln at the Lin-an kiln center had

83. Chung-hsing li-shu (Compiled from Yung-le ta-tien by Hsu Sung in 1809, unpublished), see Li Minju, op. cit., p. 54, n. 34.

84. Ibid.; see also Ku-chin t'u-shu chi-ch'eng, V. 718, chüan 174, p. 2.

85. Ku-chin t'u-shu chi-ch'eng, V. 718, chüan 174, p. 2.

86. Sung hui-yao, chüanLi, p. 14:80; Chai Chi-nien, op. cit., the author got the Hsüan-he po-ku t'u-lu from the emperor in 1142.

87. Chung-hsing li-shu, see Li Minju, op. cit., p. 54, n. 35.

88. Sung hui-yao, chüan Li, p. 14:81

89. Li Minju, op. cit., p. 50, It was recorded that Wang Chin-hsi was responsible for overseeing the manufacture of ritual vessels, and was the manager of the Hsiu-nei-ssu; but according to Sung hui-yao, chüan Li, p. 15:19, Wang had left his position in the Hsiu-nei-ssu to become the "Ju-nei nei-shih-sheng tung-tou kung-feng-kua hsuan-ssu-tien chih-hou" in 1145.

90. Chung-hsing li-shu, see Li Minju, op. cit., p. 54, n. 37.

definite deadlines for production.

The above discussion indicates that the Southern Sung need for official porcelain originated with ceremonial functions; the designs were related to bronze and jade forms, and sentimentally followed the old rules of the Northern Sung, particularly those established by Hui-tsung. About 1149, the Kuan kiln in the town of Lin-an purposely made porcelain that resembled Ju ware. In the last fifty years, large quantities of sherds, including a *hu-tsun* with tubular handles, a *ku*, and censers in the shape of *ting, li,* and *kuei*, have been unearthed around the Kuan kiln at Hangchow. From these finds and what has been transmitted above ground, such as a Chou-style *kuei* (fig. 6.10), a Warring States-style *hu*, and a *fu*, we know the general characteristics of the ceremonial wares supplied by this Kuan kiln.

What is of great interest and deserves consideration, however, are the styles and features of the official porcelain used before 1149. Some scholars believe that the Hsiu-nei-ssu was only an institute and that the Hsiu-nei kiln did not exist at all. Others have insisted that the Hsiu-nei kiln existed, but that it was destroyed in one of several fires in Hangchow. Some advance the theory that the Ke kiln was in fact the Hsiu-nei-ssu kiln while others believe the Ke kiln was a product of the Lung-ch'üan kiln. Taking into consideration these divergent views, I believe that two other viewpoints can be added. First, from the book *T'an-chai pi-heng*, we learn that in the early Southern Sung, the system probably imitated that of the Northern Sung. In other words, the Southern Sung reestablished the Ch'ing-yao tso and the Ch'ing-tso chiang, which worked under special requirements, hiring groups of artisans to make porcelain and, when the work was completed, disbanding the operation. The official Ju kiln had, to some extent, these same arrangements. Therefore, the Southern Sung officials reestablished the Hsiu-nei-ssu, whose duties, as recorded in the official history of the Sung, included construction and the manufacture of porcelain, both of which overlapped with the work of the Tung-hsi pa-tso ssu. Although official porcelain production was under the direction of the Hsiu-nei-ssu, the kilns did not necessarily have to be located in Hangchow. Furthermore, because the capital of the early Southern Sung moved from Yang-chou to Yüeh-chou to Chien-k'ang (Nanking) before settling in Hangchow, the official kilns could not always have been in Hangchow. All the sherds of celadon excavated in recent years at Hangchow, therefore, were probably products of the Ch'ing-ch'i-yao or the Chiao-t'an-hsia Kuan kilns, which were probably already established kilns. The kilns not only made specific wares for officials and the court, but also sold wares, which were traded by street vendors, to commoners.

Second, some scholars have proposed that the Ke kiln was a Kuan kiln before the Chiao-t'an-hsia kiln (previously known as the Hsiu-nei-ssu kiln).[91] This proposal is not completely convincing because Ke ware is characterized by a variety of shapes, bodies, glazes, colors, and firing techniques, which have confused many scholars of porcelain. Nevertheless, the numerous products made by the Ke kiln also include such pieces as *ting* tripod censers, *i* in the shape of a *kuei*, and *hu*, all of which could have fulfilled an official function. Because these wares were for official use, similar to the Kuan and Ju wares, and so were rarely used in burials, we do not

91. *Li Hui-ping,* op. cit.

have any specific dates for when they were made. As described earlier, before 1149, official wares were not made at a particular location, and there is still no report of finds at the Yüeh kiln that match the ceremonial wares of the Southern Sung. With regard to Soochow, the modern site of Ping-chiang fu, no excavation has been attempted. Therefore, it is not known whether in the early Southern Sung, the Yüeh-chou or Soochow kilns had Ke-type porcelain. Interestingly, the Lu-mu area of Soochow was known for its fine and strong clay (ch'eng-ni). Cricket containers made of this clay were famous in the Ming and Ch'ing dynasties. During the Ming dynasty, the kilns of the Ministry of Works would take the clay from Soochow to make wares.[92] Is this related to the clay used for the body of the celadon ware at the Nei kiln, which was described in the T'an-chai pi-heng as having "a body made of fine clay [ch'eng-ni] and a bright and clear glaze?" During the Southern Sung, glass made at Soochow was also very famous.[93] Scholars of glass believe that in the beginning glass was made at the same place as porcelain,[94] a theory that has further increased my interest in porcelain production in Soochow during the Southern Sung. Interestingly, in 1131, the scholar Chou Chih-kao (1094–1170) was promoted to an official position at Ping-chiang fu, and later became Chamberlain for Ceremonies, responsible for organizing material for the production of ritual musical instruments.[95] It was, therefore, not impossible for him to introduce this clay as material for making the body of the ware at the Kuan kiln in Soochow. A question which is also worth considering is whether it was the Kiln Office of Ching-te chen (established as early as the period of Emperor Shen-tsung) or the Lung-ch'üan kilns of the Northern Sung era (which also supplied celadons) that imitated the Northern celadon wares and supplied them to the imperial court as a tax in kind during times of urgent need.

Conclusion

From the above discussion, it is apparent that the porcelains produced by the famous Sung dynasty kilns were strongly influenced by the demands of the inner court and government. However, the recorded statement that "[the court] cannot bear to use Ting ware which has a rough mouth, and so ordered Ju-chou to produce celadon ware" is inconsistent with actual circumstances.

First of all, the *mang k'ou* Ting porcelain was still used by the court in the twelfth century, and the use of metal bands and production of thin bodies were influenced by the molding techniques of gold and silver wares. The decor is also clearly consistent with the court's taste. Therefore, the belief of the Southern Sung people that Ting ware was not used in the court because it had an unglazed rim is incorrect.

Second, perhaps the statement "[the court] cannot bear to use Ting ware which has a rough mouth," was an official excuse, which led to the appearance of celadon Ju ware with sesame-seed-shaped spur marks. The inspiration for this ceramic style may even have been related to the contemporary preference for glassware. Using the unglazed rim as an excuse, the kiln in Ju-chou was established to imitate the smooth outer body of glassware. However, this type of celadon kiln,

92. *Wang Au,* Ku-su chih *(the local gazetteer of Soochow, 1479),* chüan *14, p. 33.*

93. *Ibid.,* chüan *14, p. 30.*

94. *Su Pai, "Conversation by writing on Relics Unearthed from the underground palace of Fa-men-ssu Pagoda,"* Wenwu *10 (1988), pp. 29–30.*

95. *Sung shih,* chüan *388, p. 1.*

which was under the direct supervision of the court, was clearly in existence as early as the eleventh century, and the Ju kiln was only one, and not the first, of the kilns to produce this ware. These kilns, established by the *ching-shih* or "capital," may have existed in the capital, but could also have existed at different places at different times. Furthermore, the kiln officer of the capital may have collected kiln taxes or accepted taxes in kind. The official kilns of the Northern Sung could have possessed a multitude of characteristics during the one hundred fifty years of this period.

Third, although the precious metal bands on the *mang k'ou* Ting ware were preferred by the Sung people, if there was one place where they could not be used, it could have been in court ceremonies, which required simplicity. The Northern Sung court placed great emphasis on ceremonies, which led to the rise in the study of antiquities and the production of archaic bronze ritual vessels. At the beginning of the Southern Sung, the ceremonies for worshipping Heaven and earth were conducted in order to calm the people. The critical need for ritual vessels resulted in the manufacture of celadon ceremonial wares, which were produced by the official Kuan kilns. In the early Southern Sung, the Kuan kiln could have been at Yüeh-chou, Soochow, or any other officially appointed kiln. It was only after 1149, however, that the official site was established in Hangchow. This clearly calls into question the Southern Sung official history of the Kuan kiln.

Sung emperors were certainly involved in changing the face of porcelain production: Shen-tsung, apart from his desire for archaic ceremonial wares, might have viewed porcelain as an industry; Hui-tsung seems to have tried to create unique works of art; and Kao-tsung used porcelain to resolve the embarrassing situation of lacking the proper, traditional ceremonial wares. They ensured that the official wares were made according to specific rules, and that these wares were vastly different from the lively and unrestrained ceramics used by the populace.

Figure 6.1
Bowl with sculpted lotus petals, Early
Northern Sung dynasty, (10th century).
Porcelain, Ting ware, diam. of mouth
19.2 cm, h. 11 cm. National Palace
Museum, Taipei.

Figure 6.2
Silver plaque with design of a lion for an
inlaid lacquer box, from tomb of Wang
Chien. Five Dynasties, (10th century).
L. 23 cm.

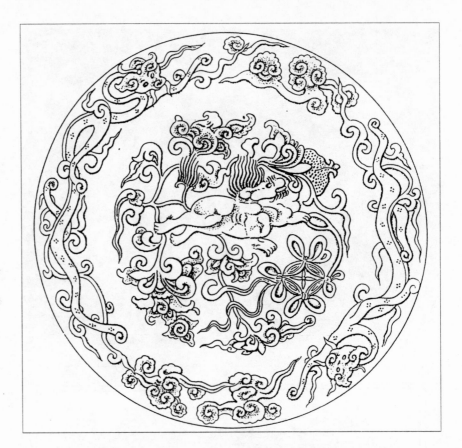

Figure 6.3
Bowl with impressed design of a lion,
Late Northern Sung dynasty, (12th cen-
tury). Porcelain, Ting ware, diam. 17.8
cm, h. 4 cm. National Palace Museum,
Taipei.

Figure 6.4b
Dish with impressed design of a dragon
from Pei-chen, Ch'ü-yang County,
Hopei Province, Northern Sung dynasty,
(12th century). Porcelain, diam.
23.2 cm, h. 5 cm.

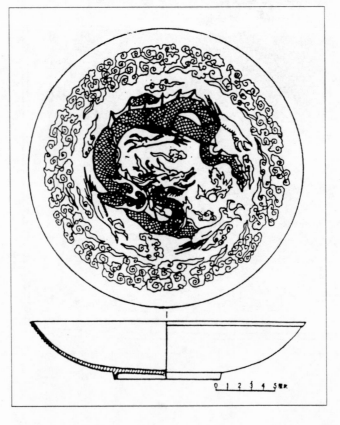

Figure 6.4a
Shard with design of a dragon from Ting
kiln site, Ch'ü-yang County, Hopei
Province. (After K'ao-ku, no. 8 [1964]).

Figure 6.5
Shard with design of fish-dragon and
incised characters Shang-shih-chü from
Ting kiln site, Hopei Province.

Figure 6.6.
Porringer with handle, Northern Sung
dynasty, (960–1127). Porcelain, Ting
ware, diam. of mouth 16.9 cm, h. 4.2
cm. National Palace Museum, Taipei.

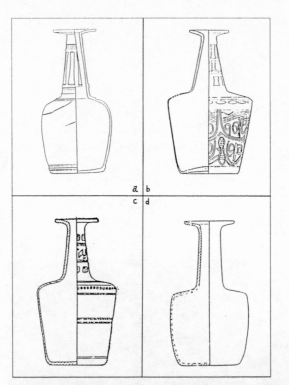

Figure 6.7a
Glass vase, from Fustat, Egypt,
(10th–12th centuries), h. 18 cm.

Figure 6.7b
Glass vase, from the tomb of a princess of
the Ch'en State of the Liao dynasty,
dated 1018, h. 25.2 cm.

Figure 6.7c
Glass vase, from the stupa of the Tu-le
Temple, Chi County, Tianjin, dated
1058, h. 26.4 cm.

Figure 6.7d
Celadon vase, from Ju kiln site, Ch'ing-
liang-ssu, Pao-feng County, Honan
Province, h. 33.5 cm.

Figure 6. 8
Mallet-shaped vase, Northern Sung
dynasty, (12th century). Porcelain, Ju
ware, h. 22.6 cm. National Palace
Museum, Taipei.

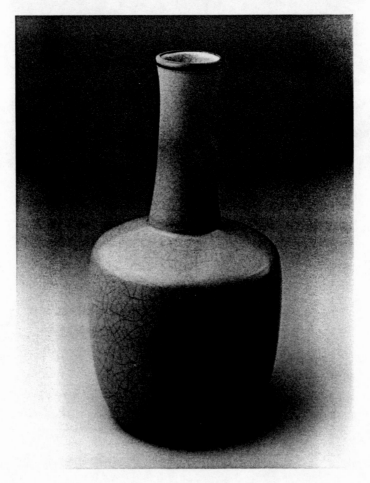

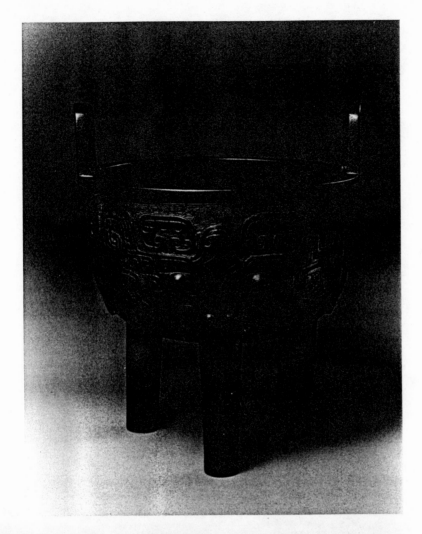

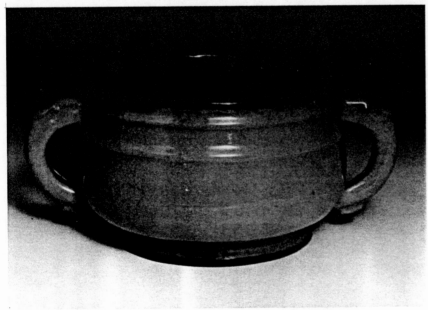

Figure 6.9
Tripod vessel (Cheng-ho ting), Sung
dynasty, dated 1116. Bronze, diam. of
mouth 18.9 cm, h. 23.2 cm.

Figure 6.10
Kuei-shaped censer, Southern Sung
dynasty, (12th century). Porcelain,
Kuan ware, h. 12.7 cm. National
Palace Museum, Taipei.

III. Politics, Society, and Culture

Humanity and "Universals" in Sung Dynasty Painting

Martin J. Powers

Throughout history it has been the most privileged groups who usually define what counts as most characteristically "human." In Confucius' time the term *jen*, "humaneness," was an attribute of the well-born gentleman. Likewise, the notion that the heroic ideal embodied the most noble of human qualities was deeply rooted in European thought, so much so that, when the nineteenth-century painter Delacroix portrayed common soldiers performing noble deeds, the critics protested in outrage. But eventually both East and West would develop discourses in which even the poor were admitted into the ranks of humanity. In this paper, I would like to examine the development of such a discourse in China. We can begin with Li Sung's (active ca. 1190–ca. 1230) famous fan painting of the knickknack peddler in the National Palace Museum, Taipei, dated 1210 (fig. 7.1).

At first sight, the *Knickknack Peddler* appears perfectly transparent. The peddler, coming from afar, brings all the items necessary for a peasant family's domestic economy: pots and brushes for mom, hoes and tools for dad, toys for the kids, and religious figurines for family religious needs. A ragged-looking peasant mother with child at her breast beams benignly as her progeny—even the suckling baby—rush to grab toys. The peddler, with torn trousers, can hardly afford to lose merchandise, yet he smiles indulgently as the children give reign to their desires. The children's poverty is apparent in their clothing, but a doting mother's care is equally evident in their cutely trimmed hair and in their creased, pudgy thighs. In fact, Li Sung missed few opportunities to thematize "cuteness" in these toddlers. He observed closely their large heads and short limbs, and seems to have accentuated everything that might warm a parent's heart, from their mischievous smiles to their round little bottoms.

What could be more universal than cute kids and toys? But historians of society and culture know very well that a discourse of childhood is a far-from-universal phenomenon. Jacques Gèlis, in the popular history of private life, traces the enjoyment of children as children to roughly the seventeenth and eighteenth centuries. One telltale sign of this change in consciousness is the appearance of paintings portraying children. As an example, Gèlis reproduces Marguerite Gerard's painting of children, albeit upper-class children, with the bodily proportions and pudgy limbs typical of toddlers. Other related developments of this period include early forms of public school for children, the beginnings of pediatric literature, a growing sense of private space, and a "literature of intimacy," what Yves Coirault referred to as "frank and indiscreet confessions."[1] Any responsible account of Li Sung's *Knickknack Peddler* requires that we bear such studies in mind, for the painting was produced at

1. Jacques Gélis, "The Child: From Anonymity to Individuality," in A History of Private Life: Passions of the Renaissance, ed. Roger Chartier and trans., Arthur Goldhammer (Cambridge, 1989), pp. 309–25; Yves Coirault, cited in Madeliene Foisil, "The Literature of Intimacy," in A History of Private Life: Passions of the Renaissance, p. 329.

a time when public schools, pediatric manuals, and movingly intimate poetry were beginning to appear in China. What makes the unavoidable comparison of interest, however, is not so much the similarities as the differences.

As soon as we consider the social conditions under which such paintings would be viewed, much that seemed natural suddenly becomes problematic. Paintings of peasant life had been popular among educated collectors since the tenth century, but Li Sung was a court artist and so most likely painted this for the court.[2] Therefore, those who owned and viewed such fans enjoyed much higher social status than those portrayed on it. This makes Li Sung's sympathetic portrayal of the rural poor somewhat puzzling. In this painting, the central theme seems to be an itinerant stranger's permissive response to the children's exuberant naughtiness. But such a theme cannot be taken for granted. Gèlis notes that, in Europe, "moralists became critical of parents who indulged their children. 'For he that has been used to have his will in everything as long as he was in coats, why should we think it strange that he should desire it and contend for it still when he is in breeches.'"[3] If Li Sung's painting seems indulgent of childhood innocence, we must ask why?

The unassuming pair of magpies perched on the peddler's pack are also puzzling, once we understand their meaning. Recently, Ellen Laing has shown that the magpies are, in effect, a rebus for joy and worldly success. The Chinese word for magpie is pronounced *hsi* and is homophonous with the word for joy. Laing has traced images of children fishing or catching magpies on ceramic pillows and on paintings. Catching fish is another rebus meaning to get "profit." The willow with its new shoots signifies the new year season. Two magpies and a willow therefore represent a wish for joy, or success, in the new year.[4] In Sung times and later, the rebus was a typical feature of peasant visual culture, an adaptation to the fact that most peasants were illiterate. But the owners of this fan were surely literate. Why would an official or courtier admire a painting sporting symbols for the literacy-impaired?

The magpies raise other puzzles as well. One assumes it is the peasants who are to obtain joy in the new year, and let us accept Laing's point that joy was understood mainly in terms of success—profit, official rank, or many children.[5] How should the owner of this fan suppose that a peasant family could aspire to profit or official rank? In the late twentieth century we easily forget that such wishes require a social order tolerant of upward mobility. This was not the case for much of world history. In Tudor England, social mobility among peasants was not the norm. Richard Moorison, for example, held that "a common welthe is then welthy and worthy his name, when everyone is content with his degree," where "degree" refers to an inherited social station. George Whetstone, during the same period, maintained that "plowmen and inferior people were 'the feete, which must run at the comaundement of every other member...where this Concorde is, peace and prosperytie floorysheth in their Citties.'"[6] In short, there are many elements in Li Sung's painting that beg placement within some discourse of poverty and childhood.

As it happens, both topics are richly represented in the memorials, essays, and

2. Kuo Jo-hsü's remarks on such artists as Mao Wen-ch'ang and Ch'en Tan presuppose a lively market for genre subjects by the tenth century. See A. C. Soper, trans., Kuo Jo-hsü's Experiences in Painting (Washington, D.C., 1951), pp. 54–5; 3.18b, 19b. See also Ellen Laing, "Auspicious Images of Children in China: Ninth to Thirteenth Century," Orientations 27, no. 1 (January 1996), p. 51.

3. Gèlis, "The Child," p. 320.

4. Laing, "Auspicious Images," p. 50.

5. Ibid.

6. Stephen L. Collins, From Divine Cosmos to Sovereign State: An Intellectual History of Consciousness and the Idea of Order in Renaissance England (Oxford, 1989), pp. 19, 17.

especially the poetry of a tradition of major writers associated with the so-called *ku-wen* movement. Among the *ku-wen* advocates we find some of the brightest names in the history of Chinese literature, art, and politics: Han Yü (768–824), Po Chü-i (772–846), Su Shih (1037–1101), and many more. The chief literary ideals of these poets have been summarized as follows: (1) a critique of highly ornate, courtly styles; (2) the use of vernacular diction and phrasing; (3) an emphasis on practical themes, including social and political commentary. Clearly, these literary ideals were not merely aesthetic, but packed a social agenda as well. According to Ronald Egan, Su Shih "held that the highest moral standards are rooted in actions that are simple and commonplace." Mei Yao-ch'en before him wrote that the essence of poetry lay in the ability to "make the old, fresh, and to make the common, elegant" (*i ku wei hsin, i su wei ya*).[7] The most consistent feature of this agenda seems to have been the insistence that human worth is not determined by wealth or by birth. Consequently, these poets tend to maintain that dignity and profound emotion can be discovered in the most ordinary people or things, including even barnyard animals.

7. *Ronald C. Egan*, Word, Image, and Deed in the Life of Su Shi *(Cambridge, 1994), p. 8; Ch'en Shih-tao, Hou shan chi (Canton, 1886), chüan 23:13b.*

There was much more than populist rhetoric at stake here. Po Chü-i, born into an impoverished scholar family in 772, wrote many poems on the plight of the poor, for example, "Watching the Wheat Reapers":

> *Farm families have few leisure months,*
> *In the fifth month chores double up.*
> *When south wind rises at night,*
> *Fields and dikes are covered with golden wheat.*
> *Women old and young carry baskets of food,*
> *Children and toddlers bring out porridge in pots,*
> *Following each other with food for the farm hands,*
> *Those stout fellows on the southern knoll.*
> *Their feet steamed by the sultry vapor from the soil,*
> *Their backs baked by the sun's burning light;*
> *Drained of all strength to feel any heat,*
> *Their only regret, summer days are too short.*
> *Then there are those poor womenfolk,*
> *Their children clinging to their side.*
> *With their right hand they pick up leftover grains;*
> *On their left arm dangles a broken basket.*
> *To hear their words of complaint—*
> *None who hear them could fail to grieve:*
> *Their family land stripped clean to pay taxes,*
> *They now glean the field to fill their stomachs.*[8]

8. *Translation with minor changes by Irving Yucheng Lo, in* Sunflower Splendor: Three-thousand Years of Chinese Poetry, *Liu Wu-chi and Irving Yucheng Lo, eds. (Bloomington, 1976), p. 202; K'uei yeh chi (Bloomington, 1976), p. 89.*

By the tenth century, the theme of rural suffering was so well established that we must assume this discourse served as the ground for a number of paintings addressing conditions of rural poverty. Chao Kan's (active ca. 961–75) handscroll

Early Snow on the River in the National Palace Museum, Taipei, provides a sympathetic view of fisher children on a snowy day. Likewise, Li Ti's (active ca. 1113–after 1197) album painting of a peasant with a captured foul takes cold and suffering as its primary theme.[9] The bird dangles before the rider triumphantly, as if in procession. But there is irony in this triumph, for the erstwhile "hunter" is huddled on the water buffalo's back, clad in thin cloth. From this we know that this bird means the difference between having a meal and going hungry another night. The portrayal of cold and suffering in such paintings is reminiscent of some lines by Po Chü-i:

> The north wind was sharper than the sword,
> And homespun cloth could hardly cover one's body.

Several *ku-wen* poets championed the plight of the poor in official life as well as in poetry. Han Yü, for example, in the early ninth century, wrote a memorial against the custom of allowing men and women to become bonded if they could not pay their debts. In his memorial against this practice, he wrote, "Though it might go by another name, the system was no different from slavery with its flogging and harsh treatment, ending only with death. This is not only against the law, but contrary to good government."[10] As a result of his efforts, more than seven hundred individuals were released in that prefecture. Liu Tsung-yüan and other *ku-wen* advocates undertook similar actions.[11]

At this time, the social and economic status of peasants was very much a topic of debate. In mid-T'ang times, most peasants probably held a status similar to serfdom in Europe. By the Northern Sung, the majority had become either tenants or small freeholders. This change in the status of peasants threw into question all the old social rules. The debate can be detected at the legal level, with some officials introducing laws to protect tenants, and others promoting laws favoring landlords.[12] All such debates were in reality battles about the definition of human worth.

Why should the magistrate Han Yü, with his official's background, risk his career to champion the poor? One reason may lie in the fact that many of the *ku-wen* advocates did not come from upper-class families, but from lower official background. As the historian Chao Kang has noted, "Many eminent scholars or high ranking officials [had] worked as tenants at some point in their lives."[13] What made it possible for such men to acquire political power was the examination system, which largely replaced the hereditary system of official recruitment between the ninth and eleventh centuries.[14] By the eleventh century, most officials entered government through the competitive civil service examination system. It is important not to romanticize these developments. We would not expect the Sung bureaucracy to be staffed with hordes of former peasants. The poems of the *ku-wen* advocates, filled as they are with expositions of social inequities, would be sufficient warning against utopian accounts of Sung society. But the fact that such poems were routinely published, and the fact that so many of these poets did rise from

9. *For an illustration, see Osvald Sirén, Chinese Painting: Leading Masters and Principles, 7 vols. (London, 1956), vol. 3, p. 254.*

10. *The memorial and a translation can be conveniently consulted in Shih-shun Liu, Chinese Classical Prose: The Eight Masters of the T'ang-Sung Period (Hong Kong, 1979), pp. 52–3.*

11. *Jo-shui Chen, in Liu Tsung-yüan and Intellectual Change in T'ang China, 773–819 (Cambridge, 1992), pp. 149–58, surveys many of Liu's more liberal sentiments. Liu was by no means alone in his views.*

12. *Chao Kang, Man and Land in Chinese History (Stanford, 1986), pp. 177–82.*

13. *Ibid., p. 177*

14. *Peter K. Bol, "This Culture of Ours": Intellectual Transitions in T'ang and Sung China (Stanford, 1991), p. 33. See also John Chaffee, The Thorny Gates of Learning in Sung China: a Social History of Examinations (Cambridge, 1985), especially pp. 66 ff.*

undistinguished backgrounds, is also not to be lightly dismissed.

We are now in a position to reconsider how the peasant boys in Li Sung's painting might aspire to achieve success. In the late eleventh century, Su Shih was shown a painting of herd boys and so wrote a colophon for it in response. This colophon assumes peasant mobility as an underlying theme:

> Long ago I lived in the country,
> Knew only sheep and cows.
> Down smooth riverbeds on the cow's back,
> steady as a hundred-weight barge,
> a boat that needs no steering—while banks slipped by,
> I stretched out and read a book—she didn't care.
> Before us we drove a hundred sheep,
> heeding my whip as soldiers heed a drum;
> I didn't lay it on too often—
> only stragglers I gave the lash to.
> In lowlands, grass grows tall,
> but tall grass is bad for cows and sheep;
> so we headed for the hills, leaping sags and gullies
> (climbing up and down made my muscles strong),
> through long woods where mist wet my straw coat and hat...
> But those days are gone—I see them only in a painting.
> No one believes me when I say I regret
> not staying a herdsman all my life.[15]

15. Translation, with minor changes, by Burton Watson, The Columbia Book of Chinese Poetry: From Early Times to the Thirteenth Century (New York, 1984), pp. 308–9. Su Tung-po ch'üan-chi (Taipei, 1974), vol. 1, p. 489.

In this poem, Su Shih clearly reveals that he once lived as a peasant. His vernacular diction, practical knowledge, and open admiration for the muscles of his rustic boyhood profess an appreciation for peasant values. On the other hand, his compassion for the animals, and his ability to lead them wisely, suggest an aptitude for official life—they suggest, in other words, the possibility of a herd boy becoming an official. Su was no destitute peasant, nor does he claim to be one in this poem. But it is also difficult to imagine a Pope or even a Wordsworth boasting about manly muscles from his rustic youth. Su's professed sentiments are comprehensible only in reference to an ideology tolerant of upward mobility. Not surprisingly, a comparable sentiment can be found in Su's essays, where he argues that every dynasty which chose a feudal, or hereditary, social system, inevitably fell.[16] In the context of the time, that essay, and this poem, were political statements.

16. Su Tung-po, vol. 2, pp. 258–9.

Su's poem, and others like it, provide the discursive context for a number of paintings of rural children. Li Ti's painting of herd boys caught in a summer shower is perhaps the best-known example, but a small fan painting in Beijing (fig. 7.2) resonates deeply with the sentiment of Su's poem. In this painting, a herd boy, heading home at dusk, has just forded a river on his water buffalo's back, comfortable and dry thanks to her patient obedience. This mother's obedience, however, was not without cost. Just as he turns back, the boy realizes her calf is stranded on the far

shore, hesitant to cross. Its distress is visible in its rigid neck and its helpless gaze after its mother. With but one foreleg bent, the artist makes visible the calf's inner state, its feelings of indecision and anxiety. Seeing the boy hesitate, we now know that he, like the calf, is unsure of what to do. The artist does not tell us how the little drama will end; he leaves us suspended in an unresolved state.

The boy's sensitivity to the calf's feelings reminds us of Su's sympathy for his water buffalo. If we take the *ku-wen* tradition of poetry as the discursive ground for this painting, it would be easy to cite many sensitive poems dedicated to animals, not only pet cats and dogs, but even faithful roosters or wounded geese. This painter, like so many *ku-wen* poets, has captured a fleeting moment when feelings of uncertainty surface, revealing an imperfect yet compassionate humanity.

This interest in liminal feelings, those maladroit moments most typical of human fraility, is part of the *ku-wen* discourse of *min* and *jen-ch'ing*. Both terms offered an important source of justification for non-aristocratic intellectuals. As the aristocracy lost its ability to define the true nature of humanity, articulate men of lower background began to forge a vision of high culture in opposition to those traditions seen as privileged, for a pompous style of justification was of little practical use to men of humbler origin. For such men, exclusionary modes of justification were not an option. The only viable alternative was to appeal to universal values. The closest thing to a universal source of justification in the Chinese tradition was the classical concept of the *min*.

Since classical times, *min* meant those people who generated society's wealth and for whose welfare the government was responsible. In the classical Mandate of Heaven theory, Heaven's pleasure or displeasure is interpreted as identical to the mood of the *min*. When the ruler is tyrannical, he loses the support of the *min*, and thus his mandate to rule.[17] Thus, by portraying themselves as defenders of the *min*, scholars had found a source of authority that no Chinese emperor could ever openly deny.

One quality scholars claimed to share with the *min* was *jen-ch'ing*, or universal human feelings. From the third century B.C. onward, the term *jen-ch'ing* had designated the entire range of distinctively human emotions, including the desire for food or sex, and the fear of cold or danger, but embracing as well nobler sentiments, such as sympathy for others or familial love. In T'ang times, the poet Tu Fu (711–770) began using the term to describe a spontaneous kindness for others based on the recognition of a shared, human condition.[18] In one poem Tu Fu, a stranger in the district, takes a morning walk. He meets a farmer who invites him in, treats him to wine, and shares with him his family's joy at the release of his son from the army. Tu Fu reflects, "A newcomer needs *jen-ch'ing*, so I will not decline it when offered. My host shouts for more to eat; I get up to go, he pushes me down, village fashion, not really rude. Then, when the moon has risen, he still invites me to stay on." Tu Fu, bard of the common man and inspiration for all *ku-wen* poets, gives us a finely textured taste of village hospitality, the *jen-ch'ing* a newcomer should not decline.

In the Sung dynasty, the term could still connote that kindness local people

17. *The* Kuo-yü, *compiled around the third or fourth century B.C., says that "Whatever the people (min) desire, Heaven is certain to grant it";* Kuo-yü, *ed., Shanghai Normal University Classical Texts Collation Group (Shanghai, 1978), 16.515. For a general discussion see Benjamin I. Schwartz,* The World of Thought in Ancient China *(Cambridge, 1985), p. 47.*

18. *Tu Fu Yin-te, pp. 134–5. Translation based on Rewi Alley with minor revisions,* Tu Fu, Selected Poems *(Hong Kong, 1974), pp. 118–9.*

offered to strangers. Meng Yüan-lao, for example, in his famous essay about the capital K'ai-feng, praised the local customs (*minsu*), claiming that "the *jen-ch'ing* is honest and friendly. If the people see that an outsider is being cheated by some local, a crowd will certainly step in [to save the unwary traveler]."[19] What made *jen-ch'ing* universal was the fact that the most typically human feelings were not limited to members of the upper classes.

19. *Meng Yüan-lao (1110–60)* Tung-ching meng hua lu, *ed., Teng Chih-ch'eng (Beijing, 1982), 5.131.*

This theme underlies another *Knickknack Peddler* painting by Li Sung in the Cleveland Museum (fig. 7.3). In this painting, the mischievous peasant boys have gathered with sticks and stones to attack a striped snake. One child, perhaps aware of the danger, prefers to hide behind the peddler's pack. The peddler, a stranger, has abandoned his pack and has rushed forward to scatter the boys, thus risking his own safety. It is difficult to imagine that a native Chinese could view this fan and not think of Mencius' anecdote illustrating the universality of human compassion. In maintaining that human nature is basically good, Mencius argued that any person, seeing a child in danger, would surely rush to its aid, even if a stranger. Li Sung's painting presumes that such compassion can be found in all social orders and, therefore, is universal.

"Humanity" in such a painting refers not to the posturing of heroic largesse, but to those secret blessings granted to others in moments of vulnerability. A poem that illustrates well this facet of *jen-ch'ing* describes an intimate yet compromising moment in the life of Su Shih. The poem is entitled "Children":

> Children don't know what worry means;
> I get up to go and they tug at my clothes.
> I'm about to scold them,
> but my wife only eggs them on in their silliness.
> "The children are silly, but you're much worse!
> Never happy, always worried; what good does it do?!"
> I return to my chair, shamed by these words.
> She rinses a wine cup, sets it down before me.
> How far superior to Liu Ling's wife,
> always bitching at the cost of his drinking![20]

20. *Watson,* Chinese Poetry, *pp. 300–1;* Su Tung-po, *vol. 1, p. 111.*

In this poem, Su makes a frank confession of his character flaws—his short temper, his inability to indulge the children's innocence. Indeed, it is he who is silly, not the children. He gets an honest scolding, which sets him straight; he retreats to his chair, perhaps to pout. His wife says nothing, merely setting a wine cup before him. This simple act signifies her intimate knowledge of his habits and feelings, the kind of knowledge only a wife could possess.

I know of no painting precisely addressing this theme, but there is a fan painting in Beijing which conveys a similar tone of domestic intimacy (fig. 7.4). We are offered an interior view into the private life of a lower official's family. We know he is a lower official because of the thatched roof, the unhewn posts, and the donkey at the wicker gate. The pines and bamboo outside, whether planted by the official or

simply painted by the artist, reassure us that this is not a corrupt official. But then, this would have been obvious from the humble standard of living. It is morning, and he must travel. A lone servant has set his bags beside the donkey at the wicker gate. In the house, his wife is busy preparing breakfast. But junior tugs at mom's skirt, pointing at dad, puzzled by his slumber. This is the moment before dad leaves the house; he should be saying good-bye to his wife and child, but instead he is caught at a vulnerable moment—he is fast asleep. We smile indulgently at both child and father, having experienced such moments ourselves. In this way the artist draws us, too, into the circle of *jen-ch'ing*. What kind of man would carry around such a fan? Perhaps the sort who might appreciate Su Shih's poem on "Children."

For Su, *jen-ch'ing* was far more than a term for the human condition. Su went so far as to argue that *Tao*, or the right principles for government, had its origins in *jen-ch'ing*.[21] As Ronald Egan shows, this was a radical posture to take. Prior to Su, the dominant moral view had it that human emotions were basically at odds with morality. Egan's research reveals that, for Su, the seven classical emotions were not obstacles to virtue, but unavoidably part of life: "There is no person alive who does not feel uncomfortable when hungry or cold and who has never experienced sexual desire." Without these emotions, virtues such as humaneness would not exist: "it is only when first there is pleasure or anger that there can be humaneness and justice." Remember that, in Su's poem, his humanity revealed itself only after his temper erupted. In this way, the weaker emotions became politically charged for Su, because they were inseparable from human nature: "That which the educated and the common man have in common, and which no person can escape, is human nature."[22] In such statements, Su collapses the boundary between rich and poor, the privileged and the marginalized, just as he does in his poems.

The discourse of *min* and *jen-ch'ing* was developed by *ku-wen* advocates at a time when the court still relied heavily on pomp and circumstance. But there is evidence that, by the twelfth century, the imperial court had begun to adopt the rhetoric of *jen-ch'ing*. This would help to explain a painting such as Li Sung's *Knickknack Peddler*. Unlike so many poems about the peasants' suffering, Li Sung's painting suggests that rural poverty is perhaps not so bad, after all, and that peasant women can raise fat, frisky children the same as anyone else. Perhaps this message would have appealed to the court. But there are further nuances, which color the ideological construction of poverty. In its touching narrative and its loving enumeration of childhood's charms, this painting asserts that even the poor possess feelings of *jen-ch'ing* in common with people of all classes. The notion "all classes" is underscored by reference to the culture of the lowest classes. The use of the rebus, for instance, authorizes the work by incorporating a supposedly authentic trope of the *min*. This pictorial trope recalls the literary device of mimicking Chinese folk poetry, a stratagem practiced by Sung poets such as Fan Ch'eng-ta.

With its valorization of shared, human feelings across different economic groups, there can be no doubt that this discourse is profoundly humanistic; but this humanism should not be confused with that of early modern Europe, for its concept of "humanity" is not heroic. Clearly the social implications of such ideals as the

21. Egan, Word, Image, p. 8.

22. Ibid., pp. 9–11.

"beautiful," the "heroic," or the "sublime" differ sharply from such concepts as *min* and *jen-ch'ing*. Only by bearing this in mind do we realize that the sentiments expressed in these paintings appear universal only to a modern consciousness.

In closing, what do we really learn from the emergence of "cute children" as a topos in painting? Is it the case that European parents did not find children cute until the seventeenth century, or the Chinese until the eighth? I suspect not. We must be cautious not to confuse discourse with belief. It is difficult to imagine that Medieval parents, or parents of almost any society, did not love their children. The emergence of a discourse of children in the art and literature of China need not signal a change in felt emotions; all we know for certain is that it signals a change in the discourse of emotions. By "discourse" I mean the way talking about emotions can affect the distribution of authority in society. Members of T'ang aristocratic families did not need to appeal to universal human qualities—quite the contrary, they were justified by such exclusive qualities as heredity, wealth, or an aristocratic bearing. Tu Fu, Po Chü-i, Su Shih, and others elevated feelings of family and neighborly warmth to the status of a defining feature of the *min*. Because the people were a source of political legitimacy, and because the scholars set themselves up as constructors of the true nature of the *min*, they acquired a source of legitimization quite independent of the court or even the bureaucracy. It is this discourse of *jen-ch'ing* that informs the portrayal of family feelings in Sung fan paintings. This tradition of rhetoric, and the issues of human dignity it addressed, are the necessary ground for understanding Sung paintings of the rural poor.

Figure 7.1
Li Sung (active ca. 1190–ca. 1230),
Knickknack Peddler, dated 1210. Fan
mounted as an album leaf, ink and light
color on silk, 25.8 x 27.6 cm. National
Palace Museum, Taipei.

Figure 7.2
Herd Boy, Cow, and Calf. Fan
mounted as an album leaf, ink and color
on silk Palace Museum, Beijing.

Figure 7.3
Li Sung (active ca. 1190–ca. 1230),
Knickknack Peddler, *dated 1212. Fan*
mounted as an album leaf, ink and light
color on silk, 24.2 x 26 cm. The
Cleveland Museum of Art.

Figure 7.4
Departure at Dawn. *Fan mounted as*
an album leaf, ink and color on silk.
Palace Museum, Beijing.

Art and Identity in the Northern Sung Dynasty: Evidence from Gardens

Robert E. Harrist, Jr.

The scholar in his garden: is there any more familiar image in Chinese painting (fig. 8.1)? Portraits of real people in real, named sites, as well as generic visualizations of hermits or wealthy dilettantes—all these incorporate garden settings as the proper environment for a certain type of learned, accomplished person and a certain way of life emblematic of high culture in China. Even images of unoccupied gardens conjure up these associations.

The popularity and durability of this imagery is not surprising, given the long and distinguished history of garden building as an art form in China. What tends to get lost in accounts of both actual gardens and their representation in art are the ways in which these sites changed over time. It is true that certain basic elements, such as open pavilions, rockeries, and ponds, remained essential elements of garden design for many centuries. But as Craig Clunas reminds us in a recent article, there was no one set of architectural practices that produced a timeless configuration of spaces or artificial landscapes constituting "the Chinese garden."[1] Sung dynasty gardens looked different from those of the Ming, and, however insistently tour guides may tell us otherwise, most of the gardens we can visit in Soochow today are modern reconstructions that bear only a passing resemblance to the Ming dynasty sites they replaced.

The ideological significance and the meanings generated by gardens also changed over time. The idea of reclusion seems to have always hovered about garden sites, be they rustic mountain cottages or imperial villas (was there anybody in the old days who did *not* want to be a hermit?), but the concept of reclusion itself meant different things in different periods.[2]

Judging from research I have done over the past few years, I have become convinced that the Northern Sung dynasty was a critical, formative period in the history of Chinese gardens. Given what I said earlier, I do not wish to suggest that after this time ideas about gardens or the way they were built remained static. I will argue, however, that what might be termed the "garden culture" of the Northern Sung arose in conjunction with certain social and political transformations and permanently inflected the ways in which gardens were understood and the meanings they conveyed when represented in the visual arts. Above all, the Northern Sung bequeathed to later periods the conviction that a garden, like a piece of calligraphy or a painting, was in some essential way an extension of the identity of the person who created it.

1. Craig Clunas, "The Gift and the Garden," Orientations 26, no. 2 (February 1995), pp. 38–45.

2. The classic study of eremitism in China remains Frederick Mote, "Confucian Eremitism in the Yüan Period," in The Confucian Persuasion, ed. Arthur Wright (Stanford: Stanford University Press, 1960).

Northern Scholars and their Gardens

More sources describing gardens have survived from the Northern Sung than from any earlier period. Even when we allow for the fact that textual evidence of all kinds survives in greater quantities as we approach our own time, it still seems clear that more gardens were built during the Northern Sung, and more was written about them than ever before in Chinese history.[3]

Although imperial, aristocratic, and merchant patronage supported the construction of many of the gardens documented in Northern Sung texts, scholar-officials were the most prolific garden builders. The many poems and essays about gardens that appear in the literary collections of Ou-yang Hsiu (1007–1072), Mei Yao-ch'en (1002–1062), Su Shih (1037–1101), Su Ch'e (1039–1112), Huang T'ing-chien (1045–1105), and other less famous Northern Sung men reflect the importance of these sites in their lives. Scholars also compiled specialized texts on the history of gardens, such as Li Ke-fei's (d. 1106) *Record of the Famous Gardens of Lo-yang* and Chu Ch'ang-wen's (1039–1098) *Further Records of the Geography of Wu Commandery*, which discusses gardens in Soochow.

The physical traces of gardens built by Northern Sung scholars vanished centuries ago, but some features of their design can be surmised from literary sources and, to a lesser extent, from paintings. In his study of Sung gardens, Liu T'uo has noted a preference for sparse, uncluttered ground plans.[4] Buildings tended to be simple, isolated structures, often with thatched roofs; some were fashioned from stalks of living bamboo tied together to form tentlike enclosures. Although some gardens, especially in Lo-yang, contained terraces or multi-storied buildings for viewing distant scenery, most buildings were of one story only. Extensive areas of water in streams and ponds added to the sense of spaciousness. The use of boulders to form artificial mountains (*chia-shan*) seen in extant Chinese gardens was well known, especially in the Soochow area, but the construction of earthen mounds was more common.

The activities pursued in these gardens ranged from simple relaxation and wine drinking to serious cultivation of the arts. At the conclusion of an essay describing the "Dream Brook," his own garden in Chen-chiang, the polymath Shen Kua (active between 1086 and 1093) lists activities appropriate to a garden: playing the zither, chess, meditation, calligraphy, painting, tea, chanting poems, and conversation.[5] Gardens also were sites where bonds of friendship and political alliance were forged and strengthened. Retired conservative statesmen living in Lo-yang formed a group known as the Lo-yang Elders Club, which held meetings in the garden of Fu Pi (1004–1083).[6] The guest list of the much-discussed *Elegant Gathering in the Western Garden* was like a preview of the infamous "Yüan-yu Party Stele," on which names of men associated with a conservative political faction, including those of Su Shih and Huang T'ing-chien, were inscribed and denounced. Although this famous gathering may never have taken place, accounts of the event, and paintings of it attributed to Li Kung-lin (ca. 1042–1106), whatever their origins, were vividly imagined representations of what countless sources prove was the natural habitat of eleventh-century literati.[7]

3. For studies of Sung dynasty gardens, see Liu I-an, "Pei Sung K'ai-feng yüan-yüan de k'ao-ch'a," in Sung-shih lun-chi, ed. Chuang Chao (Hsü-ch'ang: Chung-kuo shu-hua she, 1983), pp. 558–78; Liu T'uo, "Sung-tai yüan-lin de i-shu feng-ke," Mei-shu shih-lun, no. 4 (1986), pp. 39–49; and James Hargett, "The Pleasure Parks of Kaifeng and Lin'an During the Sung (960–1279)," Chinese Culture 30, no. 1 (March, 1989), pp. 61–78.

4. Liu T'uo, "Sung-tai yüan-lin," pp. 42–44.

5. Shen Kua, "Meng-hsi chih chi," in Chung-kuo li-tai ming-yüan chi hsüan-chu, eds. Ch'en Chih et al. (Ho-fei: Anhui k'e-hsüeh chi-shu Ch'u-pan she, 1983), p. 35.

6. See Kida Tomo'o, "The Literati of Lo-yang under the Northern Sung," (in Japanese) Toyoshi kenkyu 38, no. 1 (June 1979), pp. 69–73, and Michael Dennis Freeman, "Lo-yang and the Opposition to Wang An-shih: The Rise of Confucian Conservatism, 1068–1086" (Ph.D. diss., Yale University, 1973).

7. Ellen Johnston Laing, "Real or Ideal: The Problem of the 'Elegant Gathering in the Western Garden' in Chinese Historical and Art Historical Records," Journal of the American Oriental Society 88 (1968), pp. 419–35. For a polemical defense of the "Elegant Gathering" tradition, see Hsü Chien-jung, "Hsi-yüan ya-chi yü mei-shu hsüeh—tui i chung ke-an yen-chiu fang-fa de p'i-p'an," To-yün, no. 4 (1993), pp. 5–21.

Why Gardens?

Aside from the fact that gardens were surely very pleasant places for anybody who owned one or for anybody who could visit a friend who did, how do we account for this flurry of garden building and the outpouring of texts that describe gardens? Several modern scholars have argued that garden building was encouraged by the rise of landscape painting during the Northern Sung.[8] As everybody knows, this period witnessed the emergence of landscape as the most revered and the most spectacular genre of Chinese painting (fig. 8.2). Gardens, in which artificial landscapes were composed, presumably satisfied the same taste for viewing representations of scenery that landscape painting served.[9]

Behind these appealing accounts of how painting and garden building seemed to move, at least during the Northern Sung, in a satisfying historical parallelism there lurks the great question of why landscape painting became so important in the tenth and eleventh centuries. Various learned and compelling explanations have been offered: among them, that the collapse of the T'ang dynasty fostered a retreat to nature; that the rise of Neo-Confucian thought and its commitment to the "investigation of things" in the phenomenal world inspired landscape painters; that the appropriation of landscape imagery as a symbol of imperial order focused new attention on this genre of painting.[10]

All of these phenomena surely did contribute to the rise of monumental, monochrome landscape painting, and perhaps, though less directly, to the fluorescence of garden building in the Northern Sung. I have no grand new explanatory theory to add to those I have summarized, but I do think we can profit by giving more attention to a historical phenomenon that might at first seem unrelated to landscape: the extraordinary change in urban life that occurred during the tenth and eleventh centuries (fig. 8.3).

It is true that the development of monochrome landscape painting would have been unthinkable without the achievements of rustic painter-hermits, mountain men like Ching Hao (active ca. 870–ca. 930) and Fan K'uan (active ca. 990–1030); but this genre achieved its triumphant dominance of Chinese painting in urban environments during the very period when Chinese cities began to resemble more than ever before in history the cites of the modern world.

K'ai-feng, the Northern Sung capital, was the city in which these urban transformations were most noticeable and most intense. (It was also, we should note, the city in which Chü-jan [active ca. 960–995], Yen Wen-kuei [active ca. 970–1030], Kao K'o-ming [ca. 1000–33], Ch'ü Ting [active ca. 1023–ca. 1050], Kuo Hsi [ca. 1000–ca. 1090], and Li T'ang [ca. 1070s–ca. 1150s] lived and worked.) Owing to the imperial court's demand for services and luxury goods, the presence of large numbers of well-paid civil and military officials in the city, and the vastly expanded economic life of the entire empire, K'ai-feng became the richest city in China. By the end of the eleventh century its population had swelled to around one million.[11]

Changes in municipal administration profoundly affected life in the city. Under the T'ang dynasty, both its capitals, Ch'ang-an and Lo-yang, were divided by a

8. See Liu T'uo, "Song-tai yüan-lin."

9. Bird and flower paintings, more numerous if not more prestigious than landscapes, also achieved great popularity during the Northern Song dynasty and depicted fragments of garden scenery.

10. See Wen C. Fong et al., Images of the Mind: Selections from the Edward L. Elliott and John B. Elliott Collection of Chinese Calligraphy and Painting at the Art Museum, Princeton University (Princeton: The Art Museum, Princeton University, 1984), chapter 1.

11. This figure is an estimate made by E. A. Kracke, Jr., "Sung K'ai-feng: Pragmatic Metropolis and Formalistic Capital," in Crisis and Prosperity in Sung China, ed. John Winthrop Haeger (Phoenix: University of Arizona Press, 1975), p. 66. For a survey of K'ai-feng's economy see, Laurence J. C. Ma, Commercial Development and Urban Change in Sung China (960–1279), Michigan Geographical Publication No. 6 (Ann Arbor: Department of Geography, University of Michigan, 1971).

12. Ma, Commercial Development, pp. 78–82.

13. Kracke, "Sung K'ai-feng," p. 75.

14. Translation adapted from Susan Bush and Hsio-yen Shih, Early Chinese Texts on Painting (Cambridge: Harvard University Press, 1985), pp. 153–54.

15. James S. Ackerman, The Villa: Form and Ideology of Country Houses (Princeton: Princeton University Press, 1990), p. 9.

16. See Liu I-an, "Pei Sung K'ai-feng," and Hargett, "The Pleasure Parks of Kaifeng and Lin'an."

17. E. A. Kracke has discovered a correlation between a suburban address and high official status. See Kracke "Sung K'ai-feng," p. 75.

18. Wu Tseng, Neng-kai chai man-lu (Ts'ung-shu chi-ch'eng ch'u-pien ed.), 14.351–52.

19. Hsüan-ho hua-p'u (I-shu ts'ung-pien ed.), 7.201.

dense system of walls into *fang* or wards. Commerce was restricted to central markets and limited to certain hours each day; curfews kept citizens indoors after dark. In Sung dynasty K'ai-feng, the *fang* system was abolished and a much freer street plan and zoning regulations allowed trade and commerce to flourish in all parts of the city and its burgeoning suburbs.[12] Restaurants, wineshops, inns, bookshops, and brothels sprang up throughout the city and conducted business at all hours of the day and night. This commercial boom also created a market for craft and luxury goods among a large segment of the population.

In spite of the urban pleasures K'ai-feng offered, there was another, less attractive side to its rapid development. E. A. Kracke, Jr. has argued that K'ai-feng's residents were forced to endure "a pervasive atmosphere of competition, conflicting aims, utilitarian plainness, if not ugliness, neglect of cherished social patterns and norms, and inequities arising from untried ways."[13] In addition to these psychological disturbances, residents of K'ai-feng, like city-dwellers today, coped as best they could with crowds, dirt, and stench. It was in this environment, not on a mountain-side kissed by fresh breezes, that Kuo Hsi said that "one sees cliffs by lucid water or streams over rocks and longs to wander there...this is the wonderful power of [landscape] painting beyond its mere mood."[14]

Recognizing that what are arguably the greatest landscape paintings in Chinese history were produced, viewed, and collected in a city that was the Sung dynasty equivalent of New York, and probably smelled even worse, we do not have to posit a simple cause and effect relationship: it is too simple to argue that new patterns of urban life made people long for wilderness scenery. But there are recurring examples in world art of extremes of refinement or rusticity, complexity or simplicity, generating the conditions in which opposing or complementary phenomena came into being. For example, James Ackerman has noted that in Europe the history of the villa "has been intimately tied to that of the city: villa culture has thrived in the periods of metropolitan growth (as in ancient Rome, eighteenth- and nineteenth-century Britain and the twentieth-century West)."[15] Whatever the other factors that made landscape painting so important to people in the Northern Sung, it is hard to believe that the urban realities of their everyday lives did not intensify the pleasure of looking at images of unspoiled natural scenery, and, to return to my main topic, the pleasure of visiting gardens.

Although garden building flourished in Soochow, Lo-yang, and other cites, K'ai-feng was the site of the most activity.[16] Scholar-officials on active duty in the capital were especially eager to own or visit gardens both within the city and in its burgeoning suburbs. The availability of land for gardens in the eastern suburbs of K'ai-feng probably accounts for the high concentration of officials who had homes there.[17] For example, the veteran official Fan Chen had a garden in this area, which was visited by Su Shih and Su Ch'e. While he held office in K'ai-feng in the 1080s and 1090s, Li Kung-lin also lived east of the city near the Rainbow Bridge.[18] According to his biography in the *Hsüan-ho hua-p'u*, during these years Li spent his leisure days visiting gardens in the company of one or two friends.[19]

Place and Persona in Northern Sung Gardens

Although it is easy to understand that the growth of Chinese cities and the urban woes they inflicted on their residents encouraged the building of gardens, trying to discover how people thought about gardens is a more complex task. The historians Stephen Daniels and Denis Cosgrove have cautioned that to understand a built landscape such as a garden, "it is usually necessary to understand written and verbal representations of it, not as 'illustrations,' images standing outside it, but as constituent images of its meaning or meanings."[20] A close reading of Northern Sung texts reveals that the physical spaces of a garden—its buildings, ponds, and plantings—were perceived not only as the private property of garden owners but also as self-representations of these men, as spatial and architectural manifestations of their identities. Concluding his account of the garden of Fu Pi in Lo-yang, Li Ke-fei writes that "The pavilions, platforms, flowers, and trees all emerged from the design of his own eyes and the craft of his own heart. Therefore, the [places] that are winding or straight, spacious or dense, all [display his] profound thought."[21]

Li Ke-fei's assumption that a garden was an expression of its owner's mind is echoed in many other Northern Sung texts. Viewed within the context of ideological, political, and social transformations that occurred during the Sung dynasty, this association between gardens and the scholars who built them acquires further significance.

Consider Li Kung-lin's illustration of Chapter 17 from *The Classic of Filial Piety* (fig. 8.4). The text for this chapter speaks of the scholar's duty to exert himself to the utmost while serving in government and to reflect on his shortcomings while in retirement. In the upper left, an official bows as he addresses an impressive figure, surely the emperor himself, seated on an ornate couch; a diagonal band of clouds separates this scene from another image in which the same man seen speaking to the emperor now sits quietly in his garden.

Interpreted within the Confucian rhetoric of *The Classic of Filial Piety*, this images shows that even when he is alone and off duty, the scholar-official single-mindedly reflects on his obligations to the state. But Li Kung-lin's painting can also be read as an illustration of dualities in the lives of Chinese scholars: the complementary, but just as often conflicting, ideals of service to the world and longing for detachment from it, of winning public renown and achieving private contentment. These dualities may be as old as the Chinese state itself, but they took on a new character in the Northern Sung dynasty.

As Peter Bol and others have demonstrated, the Sung witnessed important changes in the composition and status of the class of men we generally refer to by the vague but still useful term "scholars," the common English translation of the Chinese terms *shih* or *shih-ta-fu*.[22] From the Han through the T'ang dynasties, these men, who staffed the Chinese government and dominated its culture, were generally members of powerful, aristocratic families. Under the Northern Sung dynasty, the composition of the scholar class was transformed by the vast expansion of the civil service examinations. At least in theory, any man of talent and ambition who could secure an education in the Confucian classics could also hope to pass the

20. *Stephen Daniels and Denis Cosgrove, "Introduction: iconography and landscape,"* The Iconography of Landscape: Essays on the symbolic representation, design and use of past environments *(Cambridge: Cambridge University Press, 1984), p. 1.*

21. *Li Ke-fei, "Lo-yang ming-yüan chi,"* in *Chung-kuo li-tai ming-yüan chi, p. 39.*

22. *For an extensive discussion of the changing nature of the* shi *during the T'ang and Sung dynasties, to which I am much indebted, see Peter K. Bol,* This Culture of Ours: Intellectual Transitions in T'ang and Sung China *(Stanford: Stanford University Press, 1992), "Introduction" and Chapter One, "The Transformation of the Shih," pp. 1–75.*

examinations and become a government official.

Although the examination system introduced new potential for social mobility, it also meant that a scholar's position in the world depended upon the patronage of the state: it was the emperor and the government operating in his name, not their family origins, that conferred prestige and material well being on scholar-officials who held public office.[23]

At this same time, however, there are signs that men who participated in public life, who placed themselves within the complex network of political and social obligations generated by the state, cultivated with new intensity an independent domain of private life. The boundaries between public and private life in Sung dynasty China, or in earlier periods, are not always easy to distinguish. As we noted, even in Li Kung-lin's illustration, the man sitting at home is still thinking about his public duties. We should recognize also that certain virtues or types of behavior, such as filial piety, displayed primarily within the private, domestic spaces of family life, could be means through which people achieved public renown. Nevertheless, during the Sung dynasty family, friends, personal property, and leisure activities constituted what Robert P. Hymes and Conrad Schirokauer have called "a private domain or sector" with its own legitimacy and demands for serious consideration.[24]

Intellectual life of the Northern Sung also encompassed activities that reflected private concerns and enthusiasms. For example, the Northern Sung was a great age of independent scholarship, notable for the production of historical treatises, scientific texts, and catalogues dealing with an astonishing range of material culture.[25] In addition to poetry and calligraphy, which had long been favorite leisure pursuits of Chinese scholars, art collecting and painting also became subjects of intense interest.

Although not all Northern Sung scholars engaged in them, these pursuits did become a significant part of what defined these men as a distinct group within Chinese society. These cultural activities, as well as private religious practices, also were means through which Northern Sung scholars defined themselves as individuals and constructed unique, self-chosen identities. By "self-chosen identity" I mean the total configuration of those things that one does, self-consciously or not, that make one person different from another—a serviceable, if not a sophisticated, definition of this concept.

In their gardens, Northern Sung scholars created environments that spatially, legally, and psychologically were their own. Their positions in the world outside the garden might depend upon political and ideological structures generated by the state, but their gardens, and the identities these sites articulated, were self-generated and unique. It was no accident that Li Kung-lin chose to represent his meditating scholar in a garden in order to signify the domain of this man's private thoughts. The siting of the pavilion and willow, the placement of the garden rock, can be understood, to borrow a phrase from Li Ke-fei quoted earlier, as "the design of his own eyes and the craft of his own heart."

In addition to a garden's physical design, its name expressed a powerful bond between the actual place and the persona of its owner, especially when the owner

23. *Many scholars achieved official rank through the* yin *privilege that allowed office holders to recommend sons or other relatives for government service. See Charles Hucker,* A Dictionary of Official Titles in Imperial China *(Stanford: Stanford University Press, 1985), p. 50. Nevertheless, the examination system remained the most powerful engine of upward social mobility and the surest path to high social status.*

24. *See Robert P. Hymes and Conrad Schirokauer, eds.,* Ordering the World: Approaches to State and Society in Sung Dynasty China *(Berkeley: The University of California Press, 1993), "Introduction," p. 54.*

25. *See Jacques Gernet,* A History of Chinese Civilization, *trans., J. R. Foster (Cambridge: Cambridge University Press, 1987), pp. 337–42.*

used the name of his garden, or the name of a studio or a related site, as his *hao* or style name.[26] Circulating as signatures on paintings or calligraphy, in literary collections, or simply in the conversations of scholars, these names could project alter egos, sometimes seemingly frivolous roles into which men could retreat when they wished to distance themselves from the lineaments of their public selves. Serious Confucian gentlemen could become "The Old Drunkard," "Master Returning Home," "Mr. Joy Garden," or "The Hermit of the Lung-mien Mountains"—names used by Ou-yang Hsiu, Ch'ao Pu-chih (1053–1110), Chu Ch'ang-wen, and Li Kung-lin for places they owned and for their style names.

The names of individual sites a garden contained also stamped it with the personal, sometimes eccentric, character of its owner.[27] Inscribed on plaques or stelae in a garden, or simply carried in the mind of the owner and known to visitors, these names could display flashes of poetic imagination or playful wit. They could reveal also a garden owner's sense of his position in historical and literary traditions, and in so doing reveal the nature of political, moral, or philosophical beliefs with which he wished to be allied.

Gardens and their Owners

The means through which scholars constructed distinct, self-chosen identities in their gardens can be seen best by exploring a few individual cases. Although the gardens of Ssu-ma Kuang, Ch'ao Pu-chih, Chu Ch'ang-wen, and Li Kung-lin shared many features that were characteristic of scores of recorded gardens built by Northern Sung scholars, the activities that took place in these gardens, the names given to the sites they contained, and their representations in texts and images evoked four different identities.

The leader of political conservatives during the middle of the eleventh century, Ssu-ma Kuang withdrew from office after unsuccessfully opposing the reform policies of Wang An-shih. He settled in Lo-yang in 1071 and vowed to "close his mouth and say no more about affairs."[28] Two years after he arrived in Lo-yang, Ssu-ma Kuang built the Garden of Solitary Enjoyment (Tu-le yüan) on a plot of land he purchased in the northern section of the city. In this garden he spent the next twelve years waiting for a change in the political climate that would facilitate his return to the capital. Although he distanced himself from government affairs during these years, he was far from idle. It was in his garden that Ssu-ma Kuang compiled his massive survey of Chinese history, the *Comprehensive Mirror for Aid in Government*, widely considered to be the finest historical work written in China after Ssu-ma Ch'ien's (145–ca. 90 B.C.) *Historical Records*.

Ssu-ma Kuang devotes the opening section of an essay about his garden to a thorough explication of its name, Solitary Enjoyment or *tu-le*.[29] These two Chinese characters appear in a famous passage from the book of Mencius (372–289 B.C.). Admonishing King Hui to share his riches with his people, Mencius argued that "solitary enjoyment" was not as good as enjoyment shared with other people. But this, Ssu-ma Kuang claimed, applied only to kings and princes, or to sages like Yen-tzu, a disciple of Confucius whose enjoyment of life was not diminished by his

26. For a discussion of this phenomenon, see Jan Stuart, "Ming Dynasty Gardens Reconstructed in Words and Images," Journal of Garden History 10, no. 3 (July-September 1990), pp. 162–72. There are examples of comparable identification between places and the personae of their owners in earlier periods—one thinks of T'ao Ch'ien calling himself "Mr. Five Willows" after the trees that grew in front of his house—but this type of hao is far more common in the Sung and in later periods.

27. For a discussion of names in Chinese gardens, see Robert E. Harrist, Jr., "Site Names and their Meaning in the Garden of Solitary Enjoyment," Journal of Garden History 13, no. 4 (November, 1993), pp. 199–212.

28. Ku Tung-tao, Ssu-ma Wen-kung nien-p'u (Hsü-ch'ang: Chung-kuo ku-chi Ch'u-pan she, 1987), 6.186, cited by Freeman, "Lo-yang and the Opposition," p. 47.

29. Ssu-ma Kuang, "Tu-le yüan chi," Wen-kung Wen-cheng Ssu-ma wen-chi (SPTK ed.), 66.494. A translation of this essay appears in Osvald Sirén, Gardens of China (New York: The Ronald Press, 1949), pp. 77–78, and, in a slightly altered version, on which my own translation is based, in Edwin T. Morris, The Gardens of China: History, Art, and Meanings (New York: Charles Scribner and Sons, 1983), pp. 80–81.

30. *James Legge, trans., The Chinese Classics, 7 vols. (Oxford: The Clarendon Press, 1893-1895), I, p. 188.*

31. *Ssu-ma Kuang, "Tu-le yüan ch'i t'i,"* Wen-kuo Wen-cheng Ssu-ma wen-chi, *4.81–82.*

32. *Li Ke-fei, "Lo-yang ming-yüan chi," p. 52.*

extreme poverty.[30] Like a "bird who takes no more than one branch for his nest, or a rat who, drinking from a river, fills his belly and takes no more," such was the humble enjoyment Ssu-ma Kuang claimed for himself.

Despite his seemingly light-hearted intentions in building his garden, Ssu-ma Kuang selected names for its sites with the utmost care and intended a reader of his essay, or a visitor to the garden, to be aware of the special meanings the site names conveyed. In a set of poems devoted to the seven principal sites in his garden, Ssu-ma Kuang begins each with the exclamation "I love" followed by the name of a person from Chinese history.[31] According to Li Ke-fei, it was the poems, more that the garden as an actual site, that aroused the admiration of Ssu-ma's contemporaries.[32]

Through reading Ssu-ma Kuang's essay and poems it is possible to reconstruct the following sequence of sites and historical figures for whom they were named. The Reading Hall was associated with the Han dynasty Confucian scholar Tung Chung-shu, who immersed himself so deeply in his studies that for three years he never glanced out at his garden. This is the site as it was visualized by Ch'iu Ying (ca. 1495–1552) in his painting of Ssu-ma Kuang's Garden (fig. 8.5). The Fishing Hut honored Yen Kuang, the eremitic friend of Emperor Han Kuang-wu (r. 25–57) who turned down high office to live as a fisherman. The Plot for Picking Herbs alluded to Han K'ang, a virtuous herb seller of the Eastern Han who fled to the mountains to avoid being corrupted by his reputation for honesty. Terrace for Viewing Mountains alluded to a line of poetry by T'ao Ch'ien. Pavilion for Playing with Water commemorated Tu Mu, a poet of the T'ang dynasty who once built a pond with a similar name. Studio for Planting Bamboo recalled the life of Wang Hui-chih (d. 388), who said he could not endure a single day without seeing the plant he called "this gentleman." The Pavilion for Watering Flowers alluded to Po Chü-i (772–846), the great T'ang dynasty poet, garden owner, and lover of flowers.

Like the biographical chapters of a Chinese dynastic history, the sites in Ssu-ma Kuang's garden were a sequence of monuments, each devoted to a figure from the past whose life he admired. The image of himself that Ssu-ma Kuang created through building, inhabiting, and writing about his garden linked his own identity with those of the men his garden honored. Like Ssu-ma Kuang, each of these men had spent part of their lives in voluntary or forced retirement—frequently, like Ssu-ma himself, in retreat to avoid political situations they deplored.

Instead of a gallery of heroes who collectively defined an ideal persona, the garden of Ch'ao Pu-chih was a monument to a single figure, the Six Dynasties hermit and poet T'ao Ch'ien. Although Ch'ao Pu-chih enjoyed a successful official career, his close association with Su Shih had grave political consequences. In 1102 Ch'ao and other men loyal to Su Shih, who had died the year before, were charged with factionalism and dismissed from office. The following year, the printing blocks for their literary works were destroyed and their names were inscribed on the "Yüan-yu Party Stele." In the face of these attacks, Ch'ao Pu-chih retired to a garden in Chin-hsiang prefecture in modern Shantung. Although he was granted a government sinecure, from 1102 to 1109 he remained in the political wilderness.

The Hut of Master Returning Home, as he called his garden, and the style name "Master Returning Home" that he derived from it, both alluded to T'ao Ch'ien's prose-poem, "Returning Home."[33] Like his mentor Su Shih, Ch'ao Pu-chih loved T'ao Ch'ien's poetry; but his intense identification with T'ao went beyond mere literary preferences.[34] After years of reading about ancient worthies, poets, strategists, and religious adepts in search of a spiritual and intellectual model, Ch'ao Pu-chih discovered his ideal in T'ao Ch'ien's "Returning Home." Although he must have known this famous piece of literature from the time he was a child, reading it again, after his arduous years of involvement in political life and factional struggles, Ch'ao claimed to have experienced a revelation. He began calling himself "Master Returning Home" and resolved to model his life on that of the Six Dynasties poet.

Ch'ao Pu-chih's passionate identification with T'ao Ch'ien was expressed through his garden. As Ch'ao carries the reader of his long essay about his garden on a tour of its sites, he explains that the name of each one was taken from passages in "Returning Home." A hall named Pines and Chrysanthemums alluded to T'ao's "pines and chrysanthemums are still there." A pavilion named Whistling Long alluded to "ascending the eastern slope and whistling long." A pavilion named Lingering and Composing alluded to "lingering by clear water and composing poems." After introducing six more sites named with phrases from T'ao Ch'ien's poem, Ch'ao Pu-chih summarizes the effect of living among them, claiming that as he moved about the garden he felt as if he were in the company of the poet himself.

In Ch'ao Pu-chih's garden, as in Ssu-ma Kuang's Garden of Solitary Enjoyment, physical sites and daily activities, as well as verbal descriptions, expressed the garden owner's vision of himself and a set of ideals with which he wished to be associated. For Ch'ao Pu-chih, his identification with T'ao Ch'ien—his self-declared model—was so intense that his garden became the setting for total immersion in the world of a man who had lived six hundred years earlier.

The Joy Garden (Le-p'u) of Chu Ch'ang-wen shared many features with the gardens of Ssu-ma Kuang and Ch'ao Pu-chih, but the identity his garden evoked was very different. A native of Soochow, Chu Ch'ang-wen earned his *chin-shih* degree by the unusually early age of twenty and seemed destined for a fine career.[35] He chose, however, to remain at home for most of his life, a choice made possible by his family's wealth. Although he suffered from a deformed foot that was said to have discouraged him from seeking office, this handicap did not keep him from frequently climbing up an artificial hill in his garden. Whatever the true nature this affliction, it provided a convenient excuse for distancing himself from political life during the period of Wang An-shih's ascendancy in the 1070s.

In his long essay, "Record of the Joy Garden," dated 1081, Chu Ch'ang-wen reports that the land his garden occupied had been acquired by his grandmother and that his father and uncle had lived there as young men.[36] Reflecting on his own quiet life in the garden, Chu Ch'ang-wen cites other men, from antiquity down through T'ao Ch'ien and Po Chü-i, who, at various times, lived in retirement and devoted themselves to fishing, farming, or gardening. The circumstances of their

33. T'ao Ch'ien, Ching-chieh hsien-sheng chi (SBBY ed.), 5.6a–8b.

34. Ch'ao Pu-chih, "Kuei-lai tzu ming Min-ch'ang so chü chi," Chilei chi (SPTK ed.), 31.208–209.

35. For a succinct modern biography of Chu Ch'ang-wen, see Liu Shih, Kiangsu li-tai shu-fa chia (Nanking: Kiangsu ku-chi Ch'u-pan she, 1984), p. 44.

36. Chu Ch'ang-wen, "Le-p'u chi," in Wu-tu wen-ts'ui (SKCS ed.), 4.46–7b. Although the basic meaning of the word p'u is "flowerbed," Chu Ch'ang-wen uses it in the larger sense of "garden."

lives were different, Chu argues, but their joy or *le* was the same.

The body of Chu's essay tells us little about the actual appearance of his garden; what he does clarify are the functions and activities for which the various garden sites were built:

> Although my rooms are lowly and lack ornament, and my rundown kiosks are untiled, the scenic atmosphere is simple and rustic, as if set among cliffs and valleys. This can be admired. In the garden is a hall of three bays. At its side are wings for housing my family. To the south of this is another hall, also of three bays. I call it "Penetrating the Classics." This is where I discuss the Six Arts.[37] To the east of the Hall for Penetrating the Classics is also the Milin Granary for storing the year's savings. There is a Crane Chamber for raising cranes and the Studio of Childish Innocence for instructing my children. At the northwest corner of the Hall for Penetrating the Classics is a high slope that I named Viewing Mountains Slope. On the slope is the Zither Terrace, and at the western corner there is the Studio for Chanting. These are the places where I strum my zither and compose poems, hence the names. Beneath the Viewing Mountains Slope is a pool...[In its center] is a kiosk called Ink Pool. Here I have gathered the masterpieces of the hundred masters [of calligraphy] and unroll them for my pleasure. On the bank of the pool is a pavilion called Brush Stream. I use its pure [water] to moisten my brush.[38]

37. The "Six Arts," refers to the following classics: Book of Changes, Book of Documents, Book of Odes, Spring and Autumn Annals, Book of Rites, *and* Book of Music.

38. Chu Ch'ang-wen, "Le-p'u chi," 4.5b-6a.

Chu's essay continues with a description of the various trees and flowers cultivated in his garden and voices his pleasure in sharing these: "With the fruits and products of these plants one can amuse guests and friends and pour wine for relatives."

Although it is cast in the form of a record of his garden, Chu Ch'ang-wen's essay is actually a self-portrait of the writer engaged in the intellectual and aesthetic pursuits that defined his world as a scholar living in retirement. Portraying himself, near the close of the essay, in daily study of classical texts and histories, or instructing his children in the Studio of Childish Innocence, Chu asserts his commitment to the great enterprise of transmitting Confucian learning. Other sites in Chu Ch'ang-wen's garden, and the activities he pursued there, gave his garden certain aesthetic dimensions that were unique to his own life and interests, especially music and calligraphy. The Zither Terrace was a monument to the instrument Chu Ch'ang-wen made the subject of his *History of the Zither* (*Ch'in-shih*), a six-chapter text, completed in 1084, that includes a discussion of notable players from the Chou through the Sung dynasties and offers a practical guide to playing the instrument, on which Chu himself was an expert performer.[39] The Ink Pool and Brush Stream in Chu Ch'ang-wen's garden commemorated his passion for collecting and practicing calligraphy; it was among these garden sites devoted to calligraphy that Chu composed another scholarly treatise, the *Ink Pool Discussions* (*Mo-ch'ih pien*).[40] This work comprises Chu Ch'ang-wen's own topical essays on philology, brushwork, collecting, epigraphy, and other subjects, as well his transcriptions of earlier texts on calligraphy that

39. See the entry by Yamauchi Mashiro in Yves Hervuet, ed., A Sung Bibliography (Hong Kong: The Chinese University Press, 1978), p. 276.

40. See Liu Shi, Kiangsu li-tai shu-fa chia, pp. 44–45.

have been transmitted only through his book.

But it is not only as a scholar and aesthete that Chu Ch'ang-wen presents himself in his garden. This was also a site in which Chu fulfilled the roles of filial grandson and son, grateful for his grandmother's foresight in buying the land and eager to improve the garden so that his father could enjoy it during his retirement. After his father died unexpectedly and Chu Ch'ang-wen himself became master of the garden, he devoted one site, the Studio of Childish Innocence, to educating his own children. In addition to members of his family, friends also were invited to enjoy the garden's pleasures, which Chu Ch'ang-wen, perhaps in a mild rebuke to Ssu-ma Kuang, specifically refused to keep to himself. A place of security, comfort, and family continuity, the Joy Garden was worthy of its name.

Although many Northern Sung scholars wrote extensively about their gardens, Li Kung-lin appears to have been the only one who made a painting of his (fig. 8.6). This famous work, titled *Mountain Villa*, is known today in several copies of the same composition. In a series of vignettes, Li depicts himself and his companions among the individual, named sites of his rambling, unwalled garden, which was located in the Lung-mien Mountains of Anhui Province.

We see the artist and his companions sitting by waterfalls and pools, gazing at landscape, sequestered in a cave, and working in a thatched building called the Hall of Ink Meditation (fig. 8.7). In addition to this building, several of the other sites bore names derived from the vocabulary of Buddhism, a religion to which Li Kung-lin was deeply devoted.

Li made this painting in the late 1080s or early 1090s, while he was serving as an official in K'ai-feng. The contrast between his everyday life at the time he painted *Mountain Villa* and the life depicted in the painting could scarcely have been greater. He had been away from his mountain retreat since 1079 and had held two provincial posts, but he was still a relative newcomer to life in the metropolis and to service in the central administration of the Sung government. There is good reason to believe that during this period, memories of his life in the Lung-mien Mountains were more attractive than ever. According to Li's biographer in the *Hsüan-ho hua-p'u*, "not for a single day did he forget the hills and mountains."[41] And in one of his own poems, written during the fall of 1087, while he was grading examinations papers in K'ai-feng, Li wrote "Lung-mien indeed is a carefree land!"[42]

Seen retrospectively, his years of private life in the mountains had taken on new meaning through their contrast with his life in government service, when the painting was actually made. Rhetorically, *Mountain Villa* asserted that it was *this* place, his garden in the mountains, and *this* mode of life that most vividly embodied Li's conception of his own identity.[43] In the eyes of his great friend Huang T'ing-chien, Li was "a man of hills and streams."[44] This is precisely the way Li Kung-lin presented himself in *Mountain Villa*, as he wished to be known and as he called himself in his artistic cognomen, The Hermit of Lung-mien.

But Li Kung-lin's motives for depicting himself in his garden probably were more complex and more ambiguous than can be accounted for simply by his desire to indulge himself in pleasant memories of life in retirement or to show off to his

41. Hsüan-ho hua-p'u, 7.201–202.

42. Recorded by Chang Lei, K'e-shan chi (SKCS ed.), 28.8b–9a.

43. Stephen Owen has described a similar impulse in autobiographic poetry in China, which "begins in apology, in the need to 'explain oneself.' Such a need arises only under certain conditions: the poet feels that the self and its motives are more interesting, more complicated, or simply different from what they appear to be; he is pained at the discrepancy, seeks to rectify it, show what is truer and more worthy." Stephen Owen, "The Self's Perfect Mirror," in The Vitality of the Lyric Voice, eds. Shuen-fu Lin and Stephen Owen (Princeton: Princeton University Press), p. 75.

44. Huang T'ing-chien, colophon for Li Kung-lin's Five Horses, recorded by Chou Mi, Yün-yen kuo-yen lu (MSTS ed.), shang, p. 40.

friends who viewed the painting the excellence of his land in the mountains. Although Li's relative obscurity, and his apparent ability to maintain good relations with men in opposing political camps, may have shielded him from direct attacks, the factionalism of the Yüan-yu period (1086–93), when *Mountain Villa* was painted, vexed the lives of many of his closest associates and surely added tension to Li's own. Rather than interpreting his painting of his garden as an act of self-revelation, we can also see *Mountain Villa* as an elaborate work of artistic and intellectual camouflage. Retreating into the identity conjured up by his painting, Li could distance himself and his role in the world from the frustrations and dangers faced by men close to him whose involvement in political debate was more open and direct than his own.

Conclusion

There is a striking continuity between the ways in which Northern Sung scholars built and interpreted gardens and their practiceof other arts. On the two-dimensional surfaces of their calligraphy and painting, just as in the three-dimensional spaces of their gardens, these men produced works of art charged with autobiographic and self-referential meaning. The history of all three arts, as well as other pursuits such as art collecting, shows that although the imperial court was the unquestioned center of both political and artistic authority during the Northern Sung, scholars created independent cultural domains of their own.

The activities and writings of these men helped to shape the course of much of later Chinese art. Above all, the tradition of what came to be known as literati painting would be hard to imagine without the foundation laid by Su Shih and his associates. In the later history of gardens, ideas expressed in Northern Sung writings, and visions of gardens conjured up in paintings like Li Kung-lin's *Mountain Villa*, fixed in Chinese cultural memory the concept that building a garden, a thatched hut, or a studio and giving it a distinctive name were acts of self-representation through which the garden owner constructed an identity and projected it to the world. Representations of a garden, in writing or in the visual arts, whether by the garden owner or by someone else, continued this process in media that could outlive both the garden owner and the physical sites he had built.

Although gardens and their representations in art changed continuously in later centuries, the bond between places and the personae of their owners, forged during the Northern Sung, was never forgotten. In the Yüan dynasty, "landscapes of property," to borrow Richard Vinograd's memorable phrase, became an important genre of painting in which images of gardens, retreats, and studios signified that these private environments, like the minds of their owners, remained inviolate in the face of dynastic upheavals, invasions, or conquest.[45] In the Ming and Ch'ing dynasties, gardens were associated with increasingly aestheticized modes of life enjoyed by scholarly gentlemen of comfortable means or by others who followed their lead in cultural matters. Building a garden, and having it represented in painting, expressed commitment to literati ideals while at the same time showing off wealth in a culturally prestigious investment.[46]

45. Richard Vinograd, "Family Properties and Personal Context in Wang Meng's Pien Mountains of 1368," Ars Orientalis 13 (1982), pp. 1–30.

46. The economics of garden building are discussed briefly by Clunas, "The Gift and the Garden," pp. 38–45.

Perhaps no one understood the visual authority of garden imagery better than the Ch'ien-lung emperor (r. 1736–95). In a painting of him dated 1753 (fig. 8.8), the open-air setting, the emperor's pose and costume, and even the servant who attends him create a scene so like those in Li Kung-lin's *Mountain Villa* that it would not be hard to imagine Ch'ien-lung rambling about with Li on an excursion in the artist's mountain garden. After all, by choosing to have himself portrayed in this benevolently informal guise in his private garden, Ch'ien-lung was asserting his rightful place in a tradition that Northern Sung scholars had helped to create.

Figure 8.1
Sun K'o-hung (1532–1610), The
Stone Table Garden. *Section of a
handscroll, ink and color on paper,
height, 31 cm. Asian Art Museum, San
Francisco.*

Figure 8.2
Kuo Hsi (ca. 1000–ca. 1090), Early
Spring. *1072. Hanging scroll, ink and
light color on silk, 158.3 x 108.1 cm.
National Palace Museum, Taipei.*

Figure 8.3
Chang Tse-tuan (active first quarter of
12th century), Going up the River at
Ch'ing-ming Festival. *Section of a
handscroll, ink and color on silk, 24.8 x
528 cm. Palace Museum, Beijing.*

Figure 8.4
Li Kung-lin (ca. 1042–1106), Chapter
17 from The Classic of Filial Piety.
*Section of a handscroll, ink on silk, 23.2
x 477.3 cm. The Metropolitan Museum
of Art.*

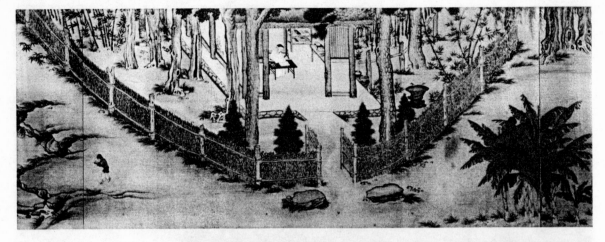

Figure 8.5
Ch'iu Ying (ca. 1495–1552), The
Garden of Solitary Enjoyment.
*Section of a handscroll, ink and light
color on silk, 27.8 x 381 cm. Cleveland
Museum of Art.*

Figure 8.6
*Copy after Li Kung-lin (ca. 1042–
1106)*, Mountain Villa. *Section of a
handscroll, ink on paper, 27.7 x 513
cm. Palace Museum, Beijing.*

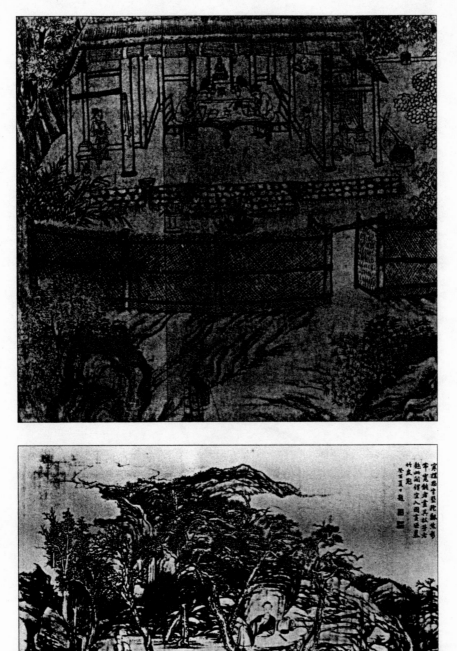

Figure 8.7
Copy after Li Kung-lin (ca. 1042–1106), Mountain Villa. *Section of a handscroll, ink on paper, 27.7 x 513 cm. Palace Museum, Beijing.*

Figure 8.8
Anonymous, The Ch'ien-lung Emperor in a Garden. *1753. Section of a handscroll, ink on paper. Collection unknown.*

In the Realm of Naturalness: Problems of Self-Imaging by the
Northern Sung Literati

Peter C. Sturman

In mid-summer of 1101, Su Shih (1037–1101) passed through the city of Chen-chiang on his return from exile on Hainan Island. Although he was fatigued, suffering from malaria and the heat, and in fact close to death, Su Shih found the energy to visit the Buddhist temple on Chin-shan, the Yangtze River island just off the city's shore. Here he encountered his own portrait, painted sometime earlier by his close friend Li Kung-lin (ca. 1041–1106). Confronting himself, Su Shih inscribed a short poem on his portrait and addressed a pressing question:

> A mind already like wood turned to ash,
> This body like an unmoored boat:
> I ask of your accomplishments in life—
> "Huang-chou, Hui-chou, and Tan-chou."[1]

1. Su Shih, "Tzu-t'i Chin-shan hua-hsiang," Su Shih shih-chi (Beijing: Chung-hua shu-chü, 1987 reprint ed.), chüan 48, pp. 2641–42.

Huang-chou, Hui-chou, and Tan-chou are the three places of exile to which Su Shih was banished during his checkered career as a prominent official, and his likeness's response to the question he poses thus sounds ironic, resigned, even bitter. Before demonstrating that there is, in fact, neither irony nor bitterness in Su Shih's voice, let us begin with some of the broader questions Su Shih's poem raises with regard to the art of portraiture in Chinese painting. When Su Shih looked at his portrait, he had a very specific reaction. There was no comment on Li Kung-lin's artistry, nor on the circumstances that may have led to the making of the painting and its enshrinement in the Chin-shan Temple. Rather, Su Shih was interested in two questions of much broader significance, which he believed, no doubt, would be asked again by other viewers. Who was this person and what were his accomplishments?

Su Shih's short poem reminds us that portraiture is an art of presentation as well as representation. Representation presumes truthfulness, an attempt to re-engender a subject as it exists. But presentation can be artifice. It assumes the voice of truthfulness but often to exaggerate, to edit, perhaps to create fiction. In China, where there was particular concern about how one would appear to future generations, the artifice of presentation can dominate—to the degree that one wonders if the term for portraiture in Chinese, *hsieh-chen*, "sketch one's trueness," is less an accurate description than a chimerical ideal.

This paper will look at problems related to that ideal raised by Su Shih and other Northern Sung literati figures associated with his circle in the latter half of the eleventh century, focusing in particular on images they made of themselves. At

root is the conflict between the long-standing practice of casting a subject in the guise of recognizable, historically sanctioned archetypes and the "trueness" of the individual. More than physical likeness, trueness involved the idea of naturalness, and naturalness, as we shall see, was intrinsically associated by Su Shih and others with exile. An important point to be made from the outset is that the discussion will not be limited to portraits, of which extremely few exist, but must also include paintings of objects that would be construed metaphorically as self-images. In addition, certain examples of calligraphy, an art that was broadly recognized as a medium of self-expression, will provide an important point of reference.

The Scholar's Image

We begin with a poem Su Shih wrote to thank the scholar-artist Ho Ch'ung for having painted Su's portrait.[2] Ho's painting is no longer extant, but a couple of the images that Su Shih mentions can be illustrated. A running commentary will explain the allusions.

> Presented to the Portraitist and Cultivated Talent Ho Ch'ung
> *Have you not seen, Sir, the Mounted Escort of Lu-chou with eyes like lightning,*
> *Left hand suspending a bow, sideways fingering an arrow?*
> *And have you not seen Meng Hao-jan riding a donkey in the snow,*
> *Brows knit, chanting a poem, shoulders hunched like a mountain?*

Commentators to Su Shih's poem explain that the T'ang dynasty emperor Ming-huang (r. 713–56), who served as Mounted Escort of Lu-chou while enfeoffed as the Prince of Lin-tz'u prior to ascending the throne, was an excellent archer. Ming-huang holds the arrow sideways, apparently because one of his eyes was slightly crooked.[3] This painting of Ming-huang that Su Shih describes is unknown today, but the image of Ming-huang's contemporary, Meng Hao-jan (689–740), chanting a poem on his donkey, can still be seen in *Travelers in a Wintry Forest* (fig. 9.1). Meng Hao-jan is Ming-huang's antithesis: the failed scholar who departs from the capital, with its connotations of worldly success, and rides his donkey in the wintry forest of reclusion at Hsiang-yang (Hupei Province), singing about the marvels of landscape that he experiences firsthand.[4] Su Shih's next lines question the point of these two archetypes, contemplating at the same time where his own portrait may fit:

> *Hungry and cold or rich and ennobled, how is it these two exist?*
> *Needlessly, their leftover images remain in the human realm.*
> *This body of mine always seeks to converge with outside objects,*
> *Floating clouds, changing, transforming, leave no traces.*
> *I ask milord, why trouble yourself to sketch my likeness?*
> *You respond that it is your pleasure, suiting your inclination.*
> *With coarse yellow cap and rustic clothes, [you give me] a mountain man's appearance;*
> *The intention is to situate me amidst mountains and cliffs.*

2. Su Shih, "Ssu hsieh-chen Ho Ch'ung hsiu-ts'ai," Su Shih shih-chi, chüan 12, pp. 587–88. The Ch'ing dynasty commentators of Su Shih's poem date it to 1075.

3. Ibid., p. 587, citing Shang-shu t'an-lu.

4. This is epitomized by a story told in Meng Hao-jan's official biography. During an impromptu meeting with Emperor Ming-huang, the emperor inquired of Meng's poetry. Meng responded with a poem that included the line, "Because I lack talent, the illustrious ruler has rejected me." Ming-huang was offended and upbraided Meng with the remark, "You have not sought office, and we have never rejected you." Meng Hao-jan was ordered to return home to Hsiang-yang, his one shot at an official career blown. Sung Ch'i, Ou-yang Hsiu, Hsin T'ang shu (Beijing: Chung-hua shu-chü, 1975 reprint ed.), chüan 203, p. 5578. See also Hans H. Frankel, Biographies of Meng Hao-jan, Chinese Dynastic Histories Translations, no. 1 (Berkeley: University of California, 1952), pp. 4–5; Peter C. Sturman, "The Donkey Rider as Icon: Li Cheng and Early Chinese Landscape Painting," Artibus Asiae, vol. 55, 1/2 (1995), p. 51.

The rank and fame of generals and ministers—why be limited to those today?
In the past were sketched Dukes Pao and O.[5]

5. Duke Pao and Duke O refer to the T'ang dynasty generals Tuan Chih-hsüan and Wei-ch'ih Ching-te. Hsin T'ang shu, chüan 89, pp. 3752–55, 3762–64.

Allusion to the painting of the T'ang dynasty generals Tuan Chih-hsüan (d. 643) and Wei-ch'ih Ching-te (585–658) in the last line of Su Shih's poem reveals that the whole verse is modeled after a famous earlier poem titled "Song of the Reds-and-Blues" that the T'ang poet Tu Fu (711–770) wrote for the painter Ts'ao Pa in the eighth century.[6] Much of Tu Fu's poem comments on Ts'ao Pa's lack of concern for worldly gain, choosing to paint despite the profession's low social status. Su Shih also adopts this theme, making a point to show that Ho Ch'ung only paints to suit his own pleasure. Su Shih emphasizes the naturalness of Ho Ch'ung's motivation, and he would like to believe that the subject, himself, is equally natural—not tied to conventional role models such as represented by the impoverished, poem-chanting donkey rider Meng Hao-jan, but literally traceless, like a floating cloud. But this is where a certain irony enters. In order to paint Su Shih "natural," Ho Ch'ung found it necessary to adopt the conventions of "naturalness": he painted Su Shih in the rustic garb of a mountain man and set him among hills and valleys, which had been a well-established archetype since the fourth century, when Ku K'ai-chih painted Hsieh K'un in such a setting to portray his true unceremonial nature.

6. Tu Fu, "Tan-ch'ing yin," Tu shih hsiang-chu (Beijing: Chung-hua shu-chü, 1979 reprint ed.), chüan 13, pp. 1147–52. David Hawkes, trans., A Little Primer of Tu Fu (Oxford: Clarendon Press, 1967), pp. 143–44.

The final two lines of Su Shih's poem for Ho Ch'ung specifically allude to Ts'ao Pa's repair of the famous set of twenty-four portraits of meritorious officials and generals that T'ang T'ai-tsung (r. 626–49) had ordered Yen Li-pen (d. 673) to paint on the walls of the Ling-yen Pavilion in 642.[7] It is with these celebrated images that Su Shih contrasts his portrait painted by Ho Ch'ung. Su Shih's rhetorical question at first appears to be little more than a limp justification for Ho Ch'ung's choice of archetype, or perhaps justification for himself, painted as something less than a weighty contributor to the nation, but there are reasons to believe that Su Shih was genuinely disinterested in the kinds of portraits that the Ling-yen Pavilion gallery represented. Official portraiture demanded adherence to principles of uniformity and convention; the individual is subsumed by the broader context—in this case, the building of the great enterprise of T'ang. Perhaps the point can be made with images from the scroll *Eight Noble Officials* attributed to Ts'ao Pa's contemporary Ch'en Hung (8th century) (fig. 9.2).[8] Postures, hand positions, and expressions are identical among the subjects. Although there are some distinctions of facial characteristics, a pronounced effort is made to present these figures as uniform types—if a civil official, pale skinned, neatly groomed, and refined; if a general, swarthy, bristling, and wide-eyed (just as Tu Fu describes Dukes Pao and O in his poem for Ts'ao Pa).

7. Chin Wei-no, "Pu-nien-t'u yu Ling-yen-ko kung-ch'en t'u" ("The Palanquin Bearers" and "The Meritorious Officials of the Ling-yen Pavilion"), Wen-wu 10 (1962), pp. 13–16.

8. In the collection of the Nelson-Atkins Museum, Kansas City. Eight Dynasties of Chinese Painting (Cleveland: The Cleveland Museum of Art, 1980), pp. 6–8. There is uncertainty concerning the identity of these figures because the labels above the figures may have been added at a later date. They are generally associated with officials from the Northern Wei period to the Sui dynasty. The attribution to Ch'en Hung is hopeful at best, but the style of the painting is reflective (if not representative) of T'ang painting. A number of the issues discussed below are explored with intelligence by Richard Vinograd in Boundaries of the Self: Chinese Portraits, 1600–1900 (Cambridge: Cambridge University Press, 1992), especially pp. 6–14, 23–27.

Even if this were a genuine painting by Ch'en Hung, the eight noble officials would still be imaginary recreations (their labels identify them as considerably earlier historical figures), so their relative lack of individuality is to be expected. However, the "trueness" of a portrait does not rely solely upon lifelikeness. We turn to a painting made while the sitter was alive that Su Shih himself saw and

9. *The Five Old Men of Sui-yang were Pi Shih-ch'ang, whose portrait is now in The Metropolitan Museum of Art, New York. Chu Kuan and Tu Yen, whose portraits are in the Yale University Art Gallery; and Wang Huan and Feng P'ing, whose portraits are in the Freer Gallery. See Li Lin-ts'an, "Sui-yang wu-lao t'u" (The Five Old Men of Sui-yang), Ta-lu tsa-chih, vol. 12, no. 9, pp. 272–75; "The Five Old Men of Sui-yang," National Palace Museum Bulletin, vol. 8, no. 5 (1973), pp. 1–21; Chuang Shen, "Sui-yang wu-lao t'u pu-shu" (Addendum to the Five Old Men of Sui-yang), Ta-lu tsa-chih, vol. 13, no. 3, pp. 83–90; Thomas Lawton, Chinese Figure Painting (Washington, D.C.: The Freer Gallery of Art, 1973), pp. 165–70; Mary Gardner Neill, ed., The Communion of Scholars: Chinese Art at Yale (New Haven: Yale University Art Gallery, 1981), pp. 97–100; Wen Fong, Beyond Representation (New York: The Metropolitan Museum of Art, 1994), pp. 44–47. Most of the inscriptions to the scroll are recorded in Pien Yung-yü, Shih-ku-t'ang shu-hua hui-k'ao (Taipei: Cheng-chung shu-chü, 1958 reprint ed.), chüan 15, 45a–63b.*

10. *Pien Yung-yü, chüan 15, 45a.*

11. *Ibid., 45b.*

12. *Ibid., 46a–b.*

13. *Chou Hsun, Kao Ch'un-ming, Chung-kuo fu-shih wu-ch'ien nien (Hong Kong: Shangwu, 1984), p. 106; Chou Hsi-pao, Chung-kuo ku-tai fu-shih shih (Beijing: Chung-kuo hsi-chü Ch'u-pan-she, 1984), p. 265.*

inscribed, a portrait of the retired official Pi Shih-ch'ang (ca. 960–before 1056) by an anonymous painter. This is one of five such images, extant though now separated, that comprised a famous scroll titled the *Five Old Men of Sui-yang* (fig. 9.3).[9] The paintings commemorated the retirement and friendship in Sui-yang (Honan Province) of five respected octogenarians centered around the important statesman Tu Yen (978–1057). As one would expect from portraits commissioned for a contemporary event, the painter worked hard to capture the distinctive individual physical features of his subjects, such as Mr. Pi's droopy nose, moon-cheeks, and pronounced upper lip.

In the original format of the scroll, the portraits were followed by a preface written by Ch'ien Ming-i in 1056, and poems apparently written by each of the five old men. These were followed by an astounding eighty-one admiring inscriptions, including poems by some of the most notable scholars of the Northern Sung. Of particular interest to us is the fact that many of these writers, beginning with Ch'ien Ming-i, chose to emphasize the relative carefree joys of retirement. "In those days, having hung up their caps, they spent much time traveling throughout the countryside, passing leisurely days feasting and drinking," writes Ch'ien.[10] In Tu Yen's poem we read of "hidden delights of forest and stream," where the old men take their leisure, "flowered morns and moonlit nights, pleasures taken by season."[11] Then there is the poem following Chu Kuan's portrait, which begins,

> When each returned to court, they encountered the times of a sage like Yao;
> Now with crane-white hair, all feel ready to prepare the Taoist's cap.
> Suddenly arriving among forests and streams, they are able to let themselves go;
> Having thrown away hair clasps and sashes, they esteem leisure-wandering.[12]

One might assume that the paintings of the Five Old Men of Sui-yang would accord with their new carefree existence, and it is true that the gentlemen each don the scholar's layered headgear, sometimes referred to as *kao-shih ching*, "lofty scholar's wrap," sometimes as *hsiao-yao-ching*, "carefree wandering wrap," which together with their plain robes signify removal from the formality of the court.[13] Yet, with the possible exception of Tu Yen, who tugs at a few hairs on his chin, each gentleman is portrayed in the stiff formal manner we associate with T'ang dynasty images of honorable officials. One senses from these portraits that whatever fun Pi Shih-ch'ang and company were having "letting themselves go" among forests and streams has been rudely interrupted so that the painter could pose them in a manner he thought appropriate to their weighty station as senior statesmen. Compare Pi Shih-ch'ang's portrait to Kuo Hsi's contemporary rendering of two old scholars (who easily could be two of Five Old Men of Sui-yang), stooped and shuffling off to a rustic pavilion where they will enjoy themselves with music, food, and wine, and the point is clear (fig. 9.4). The portrait's emphasis on formality compromises Pi Shih-ch'ang's individuality, subsumes it into a neat package of Confucian propriety: "the meritorious official." Su Shih was bothered by the artifice of such packaging because naturalness was lost. In an essay titled "Record of the Transmittal of the

Spirit," he wrote:

> If one wishes to capture the naturalness of the spirit then one should use
> the method of observing secretly from within a crowd. Today's artists
> make their subjects dress up in gowns, and caps and sit down, having them
> concentrate on a single object and in that direction keep a solemn counte-
> nance and bearing of integrity. [Like this] how will one ever again see their
> natural state?[14]

14. Su Shih, "Ch'uan-shen chi," Su
Shih wen-chi (Beijing: Chung-hua shu-
chü, 1986), chüan 12, pp. 400–1.

This strikes me as a pretty good description of how Pi Shih-ch'ang was probably
painted. One can faintly hear the anonymous portrait painter's polite orders to
keep on staring at that celadon vase in the corner of the room.

Su Shih's recommended technique of spying from the crowd is echoed in a
poem that he wrote for the scholar Ch'en Chih-kung. The subject of Ch'en's paint-
ing was a wild goose, and he does not exactly hide in a crowd, but the principle is
the same:

> When the wild goose spots a human,
> It's bearing changes before it even takes off.
> From where did you do your observing,
> Able to capture this manner of "no humans about"?
> It must be that your form was of withered wood,
> So that both man and bird were at ease...[15]

15. Su Shih, "Kao-yu Ch'en Chih-kung
ch'u-shih hua yen erh-shou," Su Shih
shih-chi, chüan 24, pp. 1286–87. Su
Shih's commentators date this poem to
1084. This poem and the following are
both translated and discussed by Susan
Bush in The Chinese Literati on
Painting: Su Shih (1037–1101) to
Tung Ch'i-ch'ang (1555–1636)
(Cambridge: Harvard University Press,
1971), p. 41

Ch'en Chih-kung, in other words, made himself invisible—not by hiding among
the reeds, but by assuming a stance of such quiet detachment that the bird ignores
him. Su Shih is not referring to some masterful demonstration of body control but
rather Ch'en Chih-kung's attainment of a kind of enlightened state where all ego-
consciousness disappears. An anonymous Southern Sung album leaf titled *Resting in
the Shade of Willows* provides a useful pictorial counterpart to Su Shih's poem (fig.
9.5).[16] A Taoist immortal-like recluse sits with such remarkable stillness that the
waterbird across the stream ignores his presence. Detachment is rewarded with the
power of vision to see the world in its natural state. Su Shih elaborates in another
poem, this time for a painting of bamboo by his close friend Wen T'ung
(1018–1079):

16. In the collection of the Palace
Museum, Beijing. The album leaf was
formerly attributed to Wang Shen.

> When Yü-k'o painted bamboo,
> He saw bamboo but not himself.
> Not only did he not see himself,
> Transfixed, he left his body behind.
> Body and bamboo transformed,
> And inexhaustable freshness emerged.
> Chuang-tzu is no longer of this world,
> So who can understand such concentration?[17]

17. Su Shih, "Shu Chao Pu-chih suo
ts'ang Yu-k'o hua chu san-shou," Su
Shih shih-chi, chüan 29, pp.
1522–23. Su Shih's commentators
date this poem to 1087.

18. Chuang-tzu chi-shih, *edited by Kuo Ch'ing-fan (Beijing: Chung-hua shu-chü, 1961), p. 43. Translation by Burton Watson, The Complete Works of Chuang-tzu (New York: Columbia University Press, 1968), p. 36.*

19. *"The clever man wears himself out and the wise man worries, but there is nothing that the man of no ability seeks—he eats his fill and wanders idly about, drifting like an unmoored boat, emptily and idly wandering along."* Chuang-tzu chi-shih, p. 1040. *Translation by Burton Watson, with modifications, p. 354.*

20. Old Tree, Rock, and Bamboo *(whereabouts unknown) should be considered the one genuine painting by Su Shih likely to be extant today. The painting is followed by a poem and inscription by Liu Liang-tso and a poem by Mi Fu, all of which are datable to ca. 1090. In addition, the seals of Wang Hou-chih of the Southern Sung are found on both the painting and the inscriptions. The painting possibly dates from the period of Su Shih's exile in Huang-chou (1080–84).*

21. Chuang-tzu chi-shih, p. 39–40. *Translation by Burton Watson, p. 35.*

Su Shih's model for both Ch'en Chih-kung and Wen T'ung is the story told in *Chuang-tzu* of how Tzu-ch'i sat staring up at the sky, "vacant and distant, released from his body," prompting this question from his friend: "What is this? Can you really make the body like a withered tree and the mind like dead ashes?"[18] A mind like dead ashes, we are reminded, is one of the two images Su Shih used to describe his portrait painted by Li Kung-lin in the temple on Chin-shan. The other, a body like an unmoored boat, also comes from *Chuang-tzu*.[19] Both metaphors refer to the superior man of no ability who, unencumbered by worldly ties, transcends the caprices of emotion to realize a natural existence in accordance with the Tao. Su Shih adopted one other image from *Chuang-tzu*, this time for his own painting: the tree whose trunk is so gnarled and whose branches are so twisted that the carpenter would never give it a second look (fig. 9.6).[20] Told of this useless tree, Chuang-tzu responds, "Why don't you plant it in Not-Even-Anything Village, or Broad-and-Boundless Field, relax and do nothing by its side, or lie down for a free and easy sleep under it? Axes will never shorten its life, nothing can ever harm it. If there's no use for it, how can it come to grief or pain?"[21]

Not-Even-Anything Village, Broad-and-Boundless Field...Chuang-tzu's whimsical names must have struck Su Shih as remarkably appropriate to describe the destinations of political banishment, just as Chuang-tzu's man of no ability, unclever, unwise and thus living free and easy, provided an attractive way of referring to oneself, the exile. Of course, the reality of banishment, whether in its most extreme form as exile or as the more common demotion or forced retirement, was undoubtedly a harsh experience, but there was this long-standing perspective in China that provided it with a positive spin. The exiled official was often acclaimed for uncompromising integrity—punishment was the consequence of personal virtue. Detached from the political center, the journey to the wilderness, to landscape, symbolically represented an opportunity to pursue the Taoist ideal of self-cultivation and naturalness. It is for this reason that Su Shih, confronting his portrait at Chin-shan, speaks of the "accomplishments" of his exiles. They represented Su Shih in his trueness.

Calligraphy, Naturalness, and Exile

According to Su Shih, the painter captures the trueness of the subject by erasing his own presence from the scene. The bird will act naturally, strutting among the reeds, and the human will not strike stiff poses. Equally important, the painter, by forgetting his or her own ego, will not attempt to impose a constraining interpretation on the subject—a preconceived notion of propriety, for example, as one sees in the images of the Five Old Men of Sui-yang. When the painting is a self-image, however, Su Shih's recommended method of spying from the crowd encounters obvious difficulties. Naturalness is compromised by self-consciousness—ironically, the consciousness of trying to appear natural, both as subject and portrayer.

The problem can be explored by looking at Su Shih's response to Huang-chou, the site of his first exile. He arrived at this small town on the Yangtze River with a suitcase of expectations. Preceding him was the well-established model of the failed

scholar who journeys to the hinterlands and writes genuine, hence superior poetry precisely because he no longer enjoys the privileges of officialdom. When the hard-luck poet Meng Chiao (751–814) was dispatched to a lowly post in 803, his friend Han Yü (768–824) consoled him with the reminder that it is when one is in a state of disequilibrium that one sounds forth, *pu-p'ing erh ming*, or, in other words, creates great literature.[22] Northern Sung scholars, considering such earlier figures as the reclusive landscape poet Meng Hao-jan, Tu Fu, Meng Chiao, or Mei Yao-ch'en (1002–1060) from their own dynasty, associated the suffering of poverty with direct experience of landscape and good poetry.[23] Expectations of one's artistic performance could thus be heightened during periods out of office.

Su Shih provides confirmation of this awareness with his most famous work of calligraphy, *Poems Written at Huang-chou on the Cold-Food Festival*, datable to 1082 (fig. 9.7). In the first of the two poems, Su Shih uses the dreary image of mud-splattered crab apple blossoms under a heavy night rain to call attention to his miserable lot. "The tree is like a sickly young man who rises from his illness to find his hair gone gray," read the final two lines of the poem, suggesting that Su Shih's own youth is fading as he wastes away in exile.[24] But Su Shih's advertisement of his misery proves to be a ploy, for the second poem negates all sense of emotion with a declaration of Taoist detachment:

> The spring river is about to enter the window;
> The rain's force comes without cease.
> A small hut like a fishing boat,
> Lost amid water and clouds.
> In an empty kitchen I boil cold vegetables;
> In the broken stove I burn damp weeds.
> How do I know it is the Cold-Food Festival?
> Crows are seen carrying paper money in their beaks.
> My lord's gates are nine layers deep;
> My family tombs are ten-thousand li away.
> Will I, too, weep that the road is at an end?
> Dead ashes, blown, will not reignite.[25]

"Dead ashes," "small hut like a boat lost in water and clouds"—there can be little question that Su Shih is echoing Chuang-tzu's metaphors, and by doing so he betrays the fact that poems and calligraphy are a deliberate attempt to present himself as Chuang-tzu's man of no ability who transcends emotion to realize a natural existence. Su Shih's handwriting provides a fascinating counterpart. There is nothing quite like it in his considerable extant oeuvre. Beginning with the misshapen character *tzu*, eccentric forms move along in quirky pulses, yet always with a strong sense of organic flow. By the end of the second poem, just as Su Shih asserts his quiet detachment, the calligraphy crests in vigor and vitality. It may seem strange that the calligraphy of detachment is not quiet and understated, but this is precisely the point. Detachment means naturalness, and the graphic correspondent of natu-

22. Han Yü, "Sung Meng Tung-yeh hsu," Wu-pai-chia chu Ch'ang-li wen-chi, Ssu-k'u ch'üan-shu *edition (Shanghai: Ku-chi shu-chü, 1987 reprint ed.), chüan 19, 12a–14b. Translated by Charles Hartman,* Han Yü and the T'ang Search for Unity *(Princeton: Princeton University Press, 1986), pp. 230–32.*

23. I discuss this at length in "The Donkey Rider as Icon: Li Cheng and Early Chinese Landscape Painting."

24. This first poem is translated and discussed by Ronald C. Egan, Word, Image and Deed in the Life of Su Shih *(Cambridge: Harvard University Press, 1994), p. 254.*

25. Collection of the National Palace Museum, Taipei. The two Cold-Food Festival poems are included in Su Shih's collected works under the title "Han-shih yü," Su Shih shih-chi, chüan 21, pp. 1112–13.

26. Su Shih, "Sung Ts'an-liao shih," Su Shih shih-chi, chüan 17, pp. 905–7. This poem is translated and discussed by Ronald Egan, "Ou-yang Hsiu and Su Shih on Calligraphy," Harvard Journal of Asiatic Studies, vol. 49, no. 2 (December 1989), pp. 407–8. Su Shih's poem focuses on a well-known essay that Han Yü wrote for the wild-cursive calligrapher Kao-hsien, in which Han accuses the monk of using too much passion to write his exuberant cursive—unbefitting a Buddhist monk. Su Shih takes issue with this view, insisting that it is precisely the Buddhist's non-attachment and calm heart that allows him to write so forcefully.

27. The inscription to this essay, now in The Art Museum, Princeton University, has been extensively studied by Fu Shen, "Huang T'ing-chien's Calligraphy and his Scroll for Chang Ta-t'ung: A Masterpiece Written in Exile" (Ph.D. diss., Princeton University, 1976).

28. Ibid., pp. 20, 21.

ralness is writing that is absolutely free—able, as Su Shih writes elsewhere, to capture "the world's myriad movements and ten-thousand scenes."[26]

Awareness of heightened expectations for calligraphy in the wilderness can also be deduced in the work of Su Shih's close friend and pupil, Huang T'ing-chien (1045–1105). During his exile in Jung-chou, Huang transcribed an ancient prose essay for his nephew, Chang Ta-t'ung.[27] In his surviving colophon (the essay is lost) (fig. 9.8), Huang presents himself as an old, discarded survivor—one to be contrasted with the ambitious young men of the village who seek his tutelage in matters of composition and calligraphy, "still preserving the habits of those exam candidates in the capital area." As it was for Su Shih, Huang T'ing-chien advertises his wretched conditions. He suffers from stomach and chest pains; foot trouble keeps him from bending over. His home is to the south, near a butcher's slaughterhouse, "where weeds grow as high as the roof and wild rats share the narrow path." And yet, as Fu Shen's careful research has shown, in other documents Huang describes his life at Jung-chou as almost bucolic, enjoying the landscape, growing vegetables and eating simple but nourishing food. At Jung-chou, Huang T'ing-chien calls his studio Jen-yün-t'ang, Studio of Accepting One's Fate, and in explaining its name writes, "Today fate rises me up; tomorrow I'll rise above fate...My body is like dried-up wood and my mind like dead ashes."[28] Huang T'ing-chien's clear message is that he has transcended his surroundings and ill health. By emphasizing the misery of his lot he signals the viewer of his calligraphy to marvel at his transcendence, just as Huang does, writing at the end of his colophon, "I don't know if on a later day I could ever write such characters again." The correlation between the fact of Huang T'ing-chien's exile and this magnificently gaunt and powerful writing would have been even clearer had the original text that preceded this inscription survived. It was the same essay Han Yü had written for the long-suffering Meng Chiao, in which we learn that one sounds forth from a state of disequilibrium.

Both Su Shih and Huang T'ing-chien present themselves as models of naturalness. They do so by first recalling the Han Yü-Meng Chiao model of crying out and then disavowing it, rising above their circumstances and emotions. The corresponding writing—the calligraphy of naturalness—is bold and unfettered. The calligrapher sets in motion his customary habits of brush movements but amplifies them, thus allowing personal idiosyncrasies to become accentuated. The result is a powerful assertion of the individual—the writer's "trueness."

Calligraphy perhaps offers a way around the conundrum produced by self-consciousness of naturalness. The constant practice that the art demands, and the fact that it is unidirectional—no going back or touching up—promotes an association with automatism. Su Shih and Huang T'ing-chien can advertise their naturalness and then simply turn it on; the viewer is hard-pressed to deny it. But could painting offer a similar solution? Su Shih argues that it can with his *Old Tree, Rock and Bamboo*. It is not simply a matter of Su Shih employing calligraphic brushwork; more important, he imitates calligraphy's unidirectional flow. This trick is accomplished by creating circular patterns in the rock which seem to compress and then erupt into the twisted tree to the right. One stumpy branch abruptly ends. The trunk contorts

upward and out, leading to Su Shih's graphic brushstrokes descriptive of smaller flamelike branches. Because the painting seems to move in one direction, there is an uncanny sense of Su Shih's process of painting, and because the image is so roughly stylized and amateurish (especially by Northern Sung standards), one readily believes that the painting was spontaneously made.

The problem with Su Shih's painting is that it is virtually unique; the solutions it offered, based on the model of calligraphy, were limited and difficult to coordinate with the traditions and general practice of painting as they were known in the eleventh century. But if the problem of naturalness in self-imaging could not be readily solved, it could at least be confronted, and in a way that made the painter's confrontation with the issue transparent. I will offer one example here—a painting of some controversy that perhaps was made by a member of Su Shih's circle. If my argument is correct, then this painting provides a fascinating glimpse of the Northern Sung literati's interaction with the problem of self and naturalness.

The Ear-Picker

The painting is a handscroll attributed to the Five Dynasties Period painter Wang Ch'i-han (fig. 9.9). The attribution, along with a title, *Collating Books,* are written directly on the painting in inscriptions that purport to be from the hand of the Northern Sung emperor Hui-tsung. A seal on the painting is said to be that of Li Yü (r. 961–75)), ruler of the Southern T'ang kingdom where Wang Ch'i-han was active. After the painting follow three important though puzzling inscriptions written by Su Ch'e (1039–1112) dated the first lunar month, 1091, Su Ch'e's brother, Su Shih, dated six months later, and the Su brothers' friend Wang Shen (ca. 1048–after 1104). Following Wang Shen's inscription, on a connecting piece of silk mounting, is a short notation by Shih Kung-i, dated 1210 (Chin dynasty), in which he refers to the painting as Wang Ch'i-han's *Picking One's Ear.*[29]

From the outset it should be stated that the title and attribution written in Hui-tsung's style of calligraphy inspire no confidence. The weakness of the writing and its idiosyncratic placement on the painting compel us to discount it. As for Li Yü's seal, *Chien-yeh wen-fang chih yin* (seal of the Chien-yeh Library), as there is no standard by which one can measure its authenticity, this too cannot be considered proof of a tenth-century date. No other painting by Wang Ch'i-han is known today, and so little exists by his contemporaries that stylistic analysis is unlikely to decide the date of the painting. Shih Kung-i's inscription is important early documentation, but it is not conclusive. The earlier inscriptions by Su Ch'e, Su Shih, and Wang Shen do not identify the painter, but they speak at length about contemporary events, and these are what interest us.

Su Ch'e:

The feather-robed gentleman leans on his bed, picking his ear. With breast unhampered by cares, he can really enjoy himself! Recently, Ting-kuo [Wang Kung], with no matters to worry about, could be just like this. But he is about to begin dashing about and will not be able to return to this

29. The painting is in the collection of the History Department of Nanjing University. Han Ko, "Wu-tai Wang Ch'i-han K'an-shu t'u" (The Five Dynasties Period Painter Wang Ch'i-han's "Collating Books"), Wen-wu 10 (1960), p. 61; Ma Hung-tseng, Wang Ch'i-han, Chung-kuo hua-chia ts'ung-shu series (Shanghai: Jen-min mei-shu Ch'u-pan-she, 1982). See also Thomas Lawton's entry for a copy of this painting in Chinese Figure Painting (Washington. D.C.: Smithsonian Institution, 1973), pp. 78–79.

relaxed state. Seen by Tzu-yu, 10th day of the first lunar month, 6th year of Yüan-yu (February 1, 1091).

Su Shih:

In the past, Wang Chin-ch'ing [Wang Shen] suddenly became deaf in his ear. He couldn't bear it and thus sought a cure from me. I answered with these words: "You, Sir, are the descendant of a military general.[30] If your head were to be severed or your breast pierced it should be of no concern. So are these two ears of such use that you cannot bear to part with them? Within three days your illness will pass. If it does not, you can cut off my ear and take it. Alarmed, Wang Shen suddenly understood, and after three days his illness was cured. He wrote the following poem to inform me:

30. Wang Shen's ancestor was Wang Ch'üan-pin, whose martial heroics helped to establish the Sung dynasty. T'o-t'o, Sung shih (Beijing: Chung-hua shu-chü, 1977 reprint ed.), chüan 255, pp. 8919–24. For a fine study of Wang Shen, see Weng T'ung-wen, "Wang Shen sheng-p'ing k'ao-lueh" (Study of the Life of Wang Shen), Sung-shih yen-chiu chi, tome 5 (Taipei: Chung-hua ts'ung-shu pien-shen wei-yuan-hui, 1970), pp. 135–68.

> With a ninny's anxious heart, I repeatedly exhorted you,
> But you were tough, and allowed me only three days time.
> I have already replaced my ears, so there's no need for you to hack away,
> I am just happy that our two families remain at peace without any problems.

Today I see that Ting-kuo owns this ear-picking painting, which he says he received from Chin-ch'ing. I randomly record this matter. Written by Shih, 2nd day of the 6th lunar month, 6th year of Yüan-yu (June 21, 1091).

Wang Shen:

> I hear from the wise and sharp fellow
> That recently he's acquired a "three excellences" painting:
> Brightly colored—a Chiang-nan screen,
> My poem and Su Shih's calligraphy.
> He brings it here and I unroll the scroll,
> Yesterday's dream—I am startled awake.
> With illness forgotten there's certainly no distress;
> Deafness can be enjoyed—like being dumb.
> I nagged you to work hard at a cure,
> The drilling of holes began from here.
> Marvelous words at root are traceless;
> One hundred years from now who will understand?
> But one night the east wind will blow through the willow tendrils,
> And out it will leak, worth cherishing, the news of spring.

On the basis of Su Ch'e's short description of a gentleman in a feathered robe leaning against a bed, which is at minor variance with the white-robed gentleman of the painting seated on a high chair, some have presumed that these inscriptions originally belonged to a different painting.[31] I disagree. Su Ch'e is not being literal. Rather, he is having fun with Wang Kung (1048–1104), whom Su Ch'e identifies with the figure in the painting. Feathered robe suggests the garb of an immortal, a free-and-easy sort who enjoys perfect naturalness, slouching at rest and picking at

31. Ma Hung-tseng, Wang Ch'i-han. p. 16.

his ear. The particular wording of Su Ch'e's inscription here suggests an allusion from *Chuang-tzu*, in which Hui-tzu, "leaning on his desk," is described as having attained perfect knowledge.[32] Substituting bed for desk would emphasize the utter informality of Wang Kung, his having attained the perfect knowledge of relaxation.

32. Chuang-tzu chi-shih, *pp. 74-75;* Watson, *p. 42.*

On the basis of Su Ch'e's inscription alone, one would presume that this is a portrait of Wang Kung, who received the painting from Wang Shen. When we read Su Shih's inscription, however, the implication seems to be that the ear-picker is Wang Shen, who is reported as having had ear problems in the past. The Ming dynasty scholar Ch'en Chi-ju thought this as well when he saw the painting in the late sixteenth or early seventeenth century.[33] Su Shih's inscription would lead one to believe that the painting was by Wang Shen—a self-portrait, in other words— but then there is Wang Shen's poem. The "wise and sharp fellow" would have to be Wang Kung, who brings the painting to Wang Shen for an inscription. Wang Shen obliges, but only refers to his poem, no painting. This would imply that he did not paint it. Ch'en Chi-ju seems to have picked up on this, suggesting instead that the painter was their mutual friend Li Kung-lin.

33. Ch'en Chi-ju, Ni-ku lu, *cited from* Lawton, op. cit., *p. 79.*

Inscriptions and documentation present a perplexing picture, but when all of the possibilities are explored, I believe that the most likely painter of *The Ear Picker* is Wang Shen. The only other viable possibility is an earlier painter of the Southern T'ang, such as Wang Ch'i-han. For this to be the case, however, there would have to have been a most extraordinary coincidence between the earlier painter's subject and the context of Su Shih's, Wang Shen's and Wang Kung's circumstances in the late eleventh century. This will be clear presently. First, I present a hypothetical reconstruction of events.

Wang Kung, a noted collector, acquired a large screen with a landscape painting that was of Southern T'ang date. Wang Kung's close friend, Wang Shen, paints a comical portrait of Wang Kung seated in front of his screen, with open robe and bare feet. Wang Kung shows the painting to Su Ch'e, who comments on Wang Kung's relaxed state, but he also reveals that Wang Kung is about to be saddled with official duties; his fun is about to end. Six months later Wang Kung shows the paint- ing to Su Shih, who had just arrived in the capital, Tung-ching (K'ai-feng). Su Shih, no doubt, understood that Wang Shen had painted Wang Kung, but because the image of the ear picker had particular significance to something that had happened in the past between he and Wang Shen, he chooses to speak about this in his inscrip- tion, though in coded language. Lastly, Wang Kung brings the painting back to Wang Shen to show him what the Su brothers had written. Wang Shen begins his verse by reporting that Wang Kung is bragging about his "three excellences" painting, which consists of the Southern T'ang screen, Su Shih's calligraphy, and Wang Shen's poem that Su Shih recorded in his inscription. His role as the painter is left unmentioned because he prefers to keep this a secret; as he suggests at the end of his poem, there are secrets here that may never be known. I suspect that at this point Wang Kung's scroll of the ear-picker had attained some notoriety among members of Su Shih's circle in the capital. If Wang Shen was the painter, there would have been good rea- sons to hide the fact, for the ear-picker proves to be an extremely politically charged

image in the context of Su Shih's, Wang Shen's and Wang Kung's lives.

Years earlier, in 1079, Su Shih fell victim to party politics at the court. Supporters of Wang An-shih's New Policies, of which Su Shih had been a vocal opponent, brought forward a legal case in which Su Shih was charged with having written poems that contained unrestricted censures of government policy. Additional indictments broadened the accusations to include defamation of the emperor, which was a capital offense. Su Shih was arrested in late August 1079, interrogated, and eventually found guilty. There was genuine fear that Su Shih would be executed. Instead, he was sentenced to two years of penal servitude and banished to Huang-chou to serve his sentence. More than thirty other individuals were found guilty because of their involvement with Su Shih, and some were also exiled. These included Wang Kung, a close friend to whom Su Shih had sent questionable poems, and especially Wang Shen, who was the most deeply implicated because he had arranged for the publication of Su Shih's poetry, including those judged seditious.[34] Wang Kung was sent to administer a minor tax collecting post at Pin-chou (Shansi Province), where he remained for three years. Wang Shen was exiled to Chün-chou (Hupei Province).[35]

Su Shih alludes to their communal misfortune in his inscription on *The Ear-Picker*, though he explains little besides the fact that whatever their difficulties, he and Wang Shen had managed to remain friends. The key to understanding the image is a remarkably bold poem that Su Shih wrote for another mutual friend, Ch'in Kuan (1049–1100), in the midst of Su Shih's political difficulties in the first half of 1079.[36] Ch'in Kuan had first written a "playful" poem for Su Shih on the subject of deafness. Su Shih rhymed it, and in so doing clarified that deafness was being used as a trope for political ineptitude. Others are incredibly sharp of hearing, he writes, such as the person who thought ants moving under his bed were fighting bulls,[37] but to Su Shih the howling wind and thunder barely sound like a whisper. He is, of course, referring to the racket taking place at the Censorate, which at that very moment was preparing its case against Su Shih. His hearing is totally finished, he continues, so there is no need even to wash his ear clean with the clear flowing stream (alluding to the ancient hermit Hsü Yu, who did this after listening to Yao's invitation to serve). Sharpness of hearing was commonly understood as a mark of sageliness. Su Shih turns this around by alluding to Chuang-tzu's mythical ruler Hun-tun (Chaos), who lacked the seven openings necessary for eating, seeing, hearing, and breathing; when they were drilled into him he died.[38]

> But I fear that in the end this heart will never cease;
> Not seeing, not hearing—obstructions still remain.
> You, Sir, suspect that my deafness is an act,
> So I purposely write this jesting verse to plumb the depths of the dangerous and strange.

So ends his poem. Su Shih remained defiant to the eve of his arrest. Deafness and political ineptitude are reflections of moral integrity, of a willingness to ignore the obvious dangers of outspoken criticism. Had the censors been aware of this

34. *Wang Shen's troubles with the court were complicated by the licentious behavior he pursued while his wife, the Princess of Wei (1051–80, one of Sung Ying-tsung's daughters), lay deathly ill. Sung shih, chüan 248, pp. 8779–80.*

35. *Su Shih's problems with the Censorate in 1079 and the involvement of Wang Shen are well described in Charles Hartman's study, "Poetry and Politics in 1079: The Crow Terrace Poetry Case of Su Shih,"* Chinese Literature: Essays, Articles, Reviews, *vol. 12 (1990), pp. 15–44. See also Ronald C. Egan,* Word, Image, and Deed in the Life of Su Shi, *pp. 46–53.*

36. *Su Shih, "Tz'u-yün Ch'in T'ai-hsü hsien hsi erh-lung," Su Shih shih-chi, chüan 18, pp. 950–51. The poem still exists in manuscript form in the collection of the National Palace Museum, Taipei. It is reproduced in Shodo geijutsu (Tokyo: Chuo koronsha, 1980), vol. 6, pl. 18–19.*

37. *This is from the official biography of the Chin dynasty figure Yin Chung-k'an. Cited from the commentary to Su Shih's poem, p. 950.*

38. *Chuang-tzu chi-shih, p. 309; Watson, p. 97.*

poem, it would probably have been added to the case they were building against him. Charles Hartman has shown in his survey of this episode in Su Shih's life that at least one of the poems Su Shih admitted as being critical of men employed by the court refers to "opinions that are narrow-minded and make a raucous din like the sound of cicadas, not deserving to be heard."[39] That sentiment is certainly implied in his poem for Ch'in Kuan; it is also implied by the imagery of The Ear-Picker.

39. This was a poem written for Tseng Kung in 1070. Hartman, "Poetry and Politics," pp. 26–27.

Could this be a painting by Wang Ch'i-han or some other earlier painter? Consider the image more closely. According to Ma Hung-tseng and Han Ko, who I presume examined this painting in detail, the figure not only picks at his ear, he also deliberately closes one eye. "Not seeing, not hearing—obstructions still remain," wrote Su Shih. Could the coincidence of the ear-picker's actions and Su Shih's description of being half-blind and half-deaf in political affairs not be directly related? It is true that figures were commonly portrayed in front of screens in paintings of Southern T'ang date, and on occasion old paintings were contemporized by Northern Sung inscriptions to fit the writer's circumstances,[40] but I have seen no evidence that this particular subject of ear-picking had been painted at any time prior to the late eleventh century. Conversely, the painting so closely fits the circumstances of Su Shih, Wang Shen and Wang Kung that it is difficult to conceive of it not being painted at this time. The ear-picker attempts to clean his ear, bore a hole, unplug it, cure this deafness and get smart! He could be Su Shih, Wang Shen or Wang Kung, but I suspect that it was originally painted for Wang Kung's benefit. Wang Kung is said to have been rigidly principled and uncompromising. One writer describes him as "untrammeled and proud, with a penchant for criticizing others and with a tongue that was to be feared."[41] His numerous enemies made certain that he never made much progress in his career as an official, though he was often recommended to serve. Presenting him as the untrammeled scholar who attempts to unplug his ear would have been particularly suitable, especially around 1091, when Wang Kung was again being recommended for office. As for the painter, if it were Wang Shen, he would not have wished to advertise his authorship; the political situation remained highly charged throughout this period, and this mode of secretive discourse using "much shadowy language and skillfully shooting off ingenious barbs,"[42] as one later scholar described it, could have attracted considerable trouble once the Yüan-yu Party's political fortunes changed.

40. One "seditious" poem singled out in the Crow Terrace poetry case was originally inscribed after a set of paintings by the T'ang dynasty artist Han Kan. The paintings were owned by Wang Shen. Ibid., p. 34.

41. Sung shih i (Taipei: Wen-hai Ch'u-pan-she, 1967 reprint ed), chüan 26, p. 23a.

42. Wang Fu-chih (1619–92), cited from Hartman, "Poetry and Politics," p. 43.

If my theory of the ear-picker is correct, this painting represents a new and innovative image of the scholar. It is a self-conscious presentation of the problem of siting oneself between two worlds—the naturalness of landscape, represented by the Southern T'ang screen behind the ear-picker, and the dusty marketplace of officialdom. The ear-picker aligns himself obliquely, no doubt reluctant to forsake the purity of the landscape and the enjoyable activities with which it is associated—art, reading, and music as represented by the items on the bed adjacent to the screen. The screen-and-figure format was particularly well-suited to this problem of presentation, for there is strong evidence that a painting like that attributed to Chou Wen-chü, Playing Wei-ch'i by a Double-Screen, was similarly intended to present different alternatives of lifestyle, different layers of existence from landscape to court

service (fig. 9.10). In the foreground are four gentlemen enjoying a game of *wei-ch'i*. They are informally dressed and relaxed, but not in comparison to the bearded fellow portrayed in the painting behind them, who is well attended to by four lovely maidens. A poem written by Po Chü-i (772–846) on a related painting confirms the contrast:

> ...*In my old age I am fond of pondering sleep,*
> *So indolently I am constantly nodding.*
> *My wife urges me to take off my black hat,*
> *And the servant girls spread the green coverlet.*
> *Then the scene is like that on a screen,*
> *Why take the trouble to paint an ancient sage?*[43]

The last line in Po Chü-i's poem recalls the archetypes that underlie Ch'en Hung's *The Eight Noble Officials.* Replacing their noble image is the happy fellow on the bed. From the *wei-ch'i* players to the indolent old man to the landscape on the screen within the screen, there is a progression of desirability leading to the realm of naturalness. Most, like the Five Old Men of Sui-yang and the figures in the foreground of Chou Wen-chü's painting, are situated somewhere in between the two extremes of true hermetic living and officialdom. The ear-picker, too, occupies a middle ground, but in contrast to the other figures he demonstrates awareness of his choices and the consequences of his decisions. He questions the place that he occupies, and in so doing establishes an archetype of a different nature. Self-reflective, based on personal experience, he embodies the complexity that accompanies the attempt to make oneself the subject of a painting that was intended to embody the Taoist ideal of naturalness.

43. Translation by Thomas Lawton, who introduces the pertinent information regarding this composition in his discussion of another version in the Freer Gallery, Chinese Figure Painting, pp. 34–37 (the translation is on p. 36). The poem was said to have been inscribed by Sung Hui-tsung on a painting related to this composition. Wang Ming-ch'ing, Hui-ch'en san-lu, Ssu-k'u ch'üan-shu edition, chüan 3, 17a–b. The main figure in the foreground of Chou Wen-chü's painting is sometimes identified by traditional commentators as Li Yü, ruler of the Southern T'ang, and sometimes as his father, Li Ying, surrounded by his three brothers.

Figure 9.1
After Li Ch'eng (919–967), Travelers
in a Wintry Forest, *early 12th centu-*
ry. Hanging scroll, ink and color on silk,
161.6 x 100 cm. The Metropolitan
Museum of Art.

Figure 9.2
Attributed to Ch'en Hung (active ca. 725–50), The Eight Noble Officials. *Detail. Handscroll, ink, color, gold and silver on silk, 25.2 x 82 cm. The Nelson-Atkins Museum of Art, Kansas City.*

Figure 9.3
Unidentified artist (11th century), Portrait of Pi Shih-ch'ang. *From the set* Five Old Men of Sui-yang. *Album leaf, ink and color on silk, 40 x 32 cm. The Metropolitan Museum of Art.*

Figure 9.4
Kuo Hsi (ca. 1010–1090), Old Trees,
Level Distance, *ca. 1070–80. Detail.
Handscroll, ink and color on silk 35.9 x
104.8 cm. The Metropolitan Museum of
Art.*

Figure 9.4a
Detail of figure 9.4.

Figure 9.5
Unidentified artist (13th century),
Resting in the Shade of Willows.
Album leaf, ink and color on silk, 29.4 x
29 cm. Palace Museum, Beijing.

Figure 9.6
Su Shih (1037–1101), Old Tree,
Rock, and Bamboo, ca. 1080–85.
Handscroll, ink on paper, measurements
unknown. Collection unknown.

Figure 9.7
Su Shih, Poems Written at Huang-
chou on the Cold-Food Festival, *dat-*
able to 1082. Handscroll, ink on paper,
34 x 119 cm. National Palace Museum,
Taipei.

Figure 9.8
Huang T'ing-chien (1045–1105),
Colophon to an Essay Transcribed
for Chang Ta-t'ung, 1100.
Handscroll, ink on paper, 34.1 x
552.9 cm. The Art Museum,
Princeton University.

Figure 9.9
Attributed to Wang Ch'i-han (10th cen-
tury). (new attribution to Wang Shen,
ca. 1048-after 1104), Collating
Books (The Ear Picker), ca. 1091.
Handscroll, ink and color on silk, 28.4 x
65.7 cm. Nanjing University.

元符三年
正月丁酉曉
錫雅州張
歸來毛
大同治任將
書適余有
復心之象

Figure 9.10
Attributed to Chou Wen-chü (10th century), Playing Wei-ch'i by a Double Screen. *Handscroll, ink and color on silk, 40.3 x 70.5 cm. Palace Museum, Beijing.*

IV. Religion and Cross-Cultural Influences

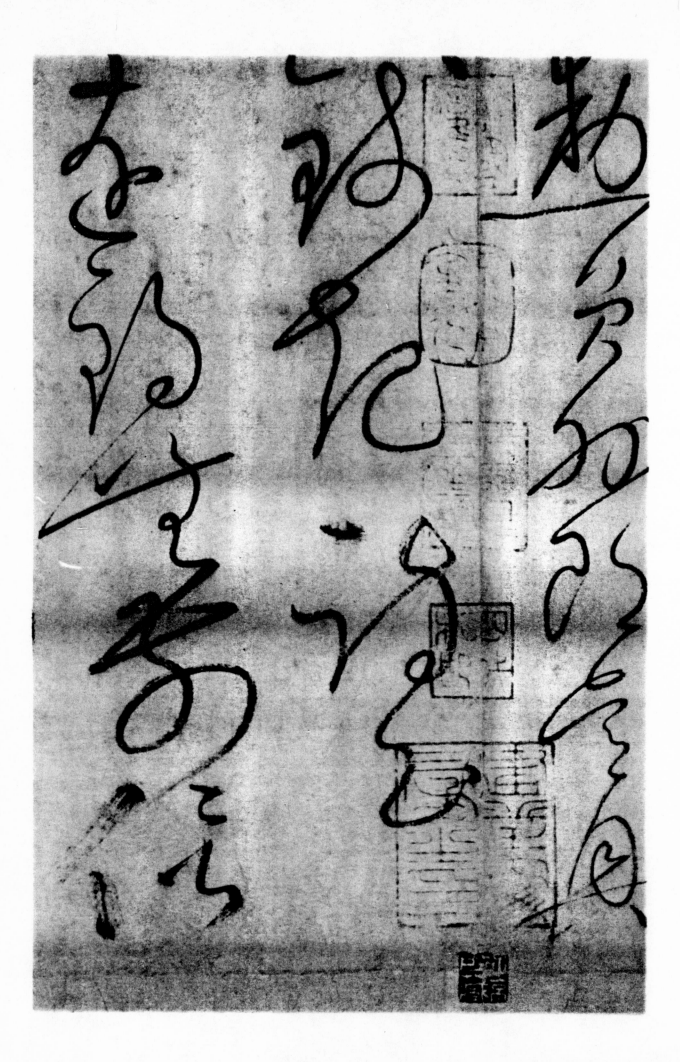

Deer For the Palace: A Reconsideration of the Deer in an Autumn Forest Paintings

Hsingyuan Tsao

A group of eight deer, seen in profile facing toward the left side of the painting, is led by a large stag, crowned by a pair of antlers. Around them is a richly polychrome autumn forest, with a myriad of leaves carefully portrayed in a maple-leaf pattern, making up a resplendent fore- and background. A stream, set off by dark green bushes, zigzags down through the picture from left to right. This is one of a pair of hanging scrolls in the collection of the National Palace Museum, Taipei, entitled *Deer among Red Maples*, painted in the tenth to early eleventh century (fig. 10.1). The other painting of the pair, *Deer in an Autumn Forest*, depicts nine deer, most of them looking into the space to the right of the painting (fig. 10.2).

Apart from an essay by Li Lin-ts'an, of the National Palace Museum, where the works are kept, these two paintings remain essentially unstudied.[1] Even the transmission of the works is not very clear. The earliest seals on the paintings are from the Yüan imperial court, and read *k'uei-chang* and *t'ien-li*. The two scrolls passed into the Ch'ing court collection, where they were traditionally attributed to an anonymous artist of the Five Dynasties. Since the 1960s, however, most scholars have come to believe that the paintings are the work of an unidentified Liao dynasty artist. Li Lin-ts'an begins his essay with a passage from Kuo Jo-hsü's (active early 1080s) *Experiences in Painting* (T'u-hua chien-wen chih),[2] which records a set of five hanging scrolls depicting a thousand-horned stag, painted by the Ch'i-tan or Liao Emperor Hsing-tsung (r. 1031–55) and presented to the Northern Sung court. From this record, and the kind of silk that the works were painted on, Li concludes that these paintings must be two of the five scrolls referred to by Kuo Jo-hsü (fig. 10.3). According to Li's reconstruction, they are numbers two and four of the set of hanging scrolls.[3] His reason for this ordering of the paintings is that they do not have either the inscription that Kuo Jo-hsü recorded as being on the last panel of the set or the low hillocks that are a conventional beginning for a landscape painting. Since the two paintings do not appear to be contiguous, the possibility of either of them being the middle panel is also ruled out.[4]

The composition of both paintings does indeed seem incomplete, as if they belonged to a much larger composition. Judging from their content, it appears that they might have been left and right parts of a work from which the middle section is now missing.[5] The stags in both paintings face outward—contrary to compositional logic—toward the less spacious sides. The narrow spaces in front of the stags have always been interpreted as the result of trimming when the panels were remounted as scrolls. More importantly, it has been suggested that these works were originally mounted on a screen.[6] One factor to keep in mind in considering

1. Li Lin-ts'an, "T'an feng yu lu tu he ch'iu lin ch'ün lu tu." (On Deer Among Red Maples and Deer in An Autumn Forest), Ku-kung wen-wu yüeh-k'an vol. 1, no. 2, pp. 51–4.

2. Kuo Jo-hsü, Experiences in Painting (T'u-hua chien-wen chih), Alexander C. Soper, trans.(Washington, D.C.: 1951), p. 94.

3. Li Lin-ts'an, op. cit.

4. Ibid., p. 53.

5. James Cahill, writing about these paintings in his essay "The Imperial Painting Academy" in the catalogue of the present exhibition argues that the deer appear to be facing inward from each side, toward something, perhaps some source of sound that has startled them.

6. Michael Sullivan, "Notes on Early Chinese Screen Painting," Artibus Asiae vol. 27 (1965), p. 252. Sullivan argues that because of "their obvious decorative quality and the fact that they are so perfectly matched, if placed side by side, the Autumn Forest on the right, they seem to fit naturally together, though they may originally have been parts of a much larger multi-panel screen." Also see: James Cahill, "The Imperial Painting Academy." The argument here is that heavy applications of pigment originally on the leaves and other elements of the composition, a technique typically used on a flat, rigid surface, have flaked off since the paintings were remounted as scrolls and rolled, leaving areas where only underdrawing remains.

this compositional incompleteness is that we can only analyze works of art by our own standards. I suggest in this paper that in order to understand these works better, we should use unearthed works of art from the Liao, in addition to the traditional art-historical analysis of the works. I want to assert, for the Ch'i-tans, that the "incompleteness" of these works, though possibly true, may also reflect how the Ch'i-tan people's visual conceptions in art differ from the ethnic Han Chinese conceptions. My objective is to seek out the traces of a distinctive Liao-Ch'i-tan art style, free from modern preconceptions or cultural prejudice. Any reconsideration of the paintings should be from the viewpoint of the ethnic-cultural discourses around them, or evoked by them. Iconographically, they fit the general range of the "Autumn" section in the murals of the Four Seasons found in the Ch'ing-ling Imperial mausoleum of the Liao dynasty, in the Pa-Lin Right Banner, Chao-wu League, Inner Mongolia (fig. 10.4).[7]

A Reconstruction of the Painting

As Li Lin-ts'an has pointed out, these works may be two of the five scrolls presented to the Sung court by the Liao emperor in the Ching-li era (1041–48), as recorded by Kuo Jo-hsü:

> In the Ch'ing-li era…[the Liao ruler] painted a picture of a thousand-horned deer on five scrolls as a present [to the Emperor]. A title along the side reads: '[Such-and-such a] year, month, and day, Imperial painting [fu].'[8]

In this passage, the crucial word for reconstructing the format of the work is *fu*, which has been translated as "scroll." What Li Lin-ts'an proposed is a single composition that was depicted across five scrolls. There is no early extant work in this format, nor are there examples from tomb or temple mural paintings. However, a few existing paintings that are now mounted as separate hanging scrolls are believed to have originally been parts of such sets. One of them is *Buddhist Retreat by Stream and Mountain*, attributed to the tenth-century landscapist Chü-jan, now in the Cleveland Museum of Art and identified as one part of a recorded six-panel screen. The eighteenth-century collector An Ch'i wrote in his catalogue *Mo-yüan hui-kuan*: "Two of the Chü-jan paintings recorded in the Hsüan-ho catalogue, namely, *Buddhist Retreat by Stream and Mountain* and *Distant Peaks Floating in the Mist*, are each on six panels. On the upper right corner of the present scroll, an accession or inventory number, 'Chü 5,' [Chü-jan No. 5?] definitely suggests that this painting is numbered fifth in the original set of screens or hanging panels."[9]

The word *fu* could also be understood as "the width of a piece of fabric"; when it is used as a unit of measure, it means either a scroll or a piece of fabric. Another reading of the passage, therefore, could be "[the Ch'i-tan] ruler used five *fu* of *ch'ien* silk to paint a thousand-horned deer [to offer] as a present [to the Emperor]." In this reading, the words "five *fu*" modify *ch'ien*, a kind of silk, rather than *hua* (to paint or a picture); so the meaning of the sentence should be, a picture painted on five pieces of *ch'ien*, or, a painting five *fu* in width. This interpretation of the format

7. *Jitsuzo Tamura and Yukio Kobayashi*, Tombs and Mural Paintings of Ch'ing-ling Liao Imperial Mausoleums of Eleventh Century AD in Eastern Mongolia: Detailed Report of Archaeological Survey Carried out in 1935 and 1939. *English summary by Shinobu Iwamura and Wilma Fairbank, 2 vols. (Kyoto: 1953).*

8. Kuo Jo-hsü, op. cit.

9. *Quoted by Wai-kam Ho in his entry for this painting in* Eight Dynasties of Chinese Painting: The Collections of the Nelson Gallery-Atkins Museum, Kansas City, and the Cleveland Museum of Art *(Cleveland Museum of Art, 1980), p 15.*

as a single painting on five attached pieces of silk is supported by similar usages of *ch'ien* and *fu* throughout Kuo Jo-hsü's book. Kuo uses the terms *chüan* and *chou* to refer to horizontal and vertical scrolls, respectively, and uses *fu* to mean "piece."[10] Li Lin-ts'an has offered a somewhat different interpretation: that the composition was painted on five separate pieces of fabric, that is, five separate scrolls forming one continuous composition. In this case, each individual scroll would consist of a single *fu* of silk. If the two works from the National Palace Museum are to be equated with the recorded set, they should each be painted on a single piece of silk. But from the works themselves and Li Lin-ts'an's study of them, we learn that both are painted on a little more than a whole piece. In each case, a narrow strip has been added, making each scroll about twenty percent wider than one *fu* of silk. Obviously, the size of each scroll does not fit the definition of a *fu*. I will return to this point later.

Another entry in Kuo Jo-hsü's *Experiences in Painting* describes a certain Duke of Chin who was given a painting on eight *fu* of silk: "A painting of 'Yüan An Lying in Snow' painted on eight *fu* [joined pieces of fabric] forming a single surface." Kuo goes on to note that this painting was later mounted on a screen, and a pavilion built to house it. Here again, the term *fu* means a width of fabric.[11] The passage suggests that large-scale paintings presented as gifts might sometimes be unmounted, so that the recipient could mount the work in whatever fashion was best adapted to his space.[12]

Thus, even though the two extant paintings of deer might have been segments of the work presented by the Liao emperor, the original format cannot have been five scrolls. They might also be totally unrelated to the work recorded by Kuo Jo-hsü. At any rate, I believe that the original work was in one large composition and that the two extant paintings are all that survive from this original work.

If this hypothesis about the format of the paintings is plausible, then these works could be parts of a large screen. The Ch'i-tan people inherited many elitist cultural tastes from the Five Dynasties, especially from the Later Ch'in dynasty (936–946), including the use of screens in their living chambers, as is seen in *Han Hsi-tsai's Night Banquet*.[13] Such free-standing screens are often depicted in mural paintings from Liao tombs. A recorded Liao screen painter, and the only female artist known from this period, was Lady Hsiao (d. 1069), wife of Yeh-lü Tsung-cheng, Prince of the Ch'in and Chin States. She was not included in the *Liao History* (*Liao-shih*), but is recorded in the epitaph that was found in her and her husband's tomb. The epitaph describes with clarity and specificity her competency in painting:

> She has an elegant taste for painting in *fei-pai* [flying white] style, and she is especially good at colorful painting. Screens (*p'ing*) in her residence are mostly by her.[14]

Apart from the implications of this earliest use of the term *fei-pai*, which must be dealt with on another occasion, the epitaph informs us for the first time that the

10. *Kuo Jo-hsü, op. cit., p. 85.* Under the subtitle "Cheng Tsan," we read: "One day there was [brought before Cheng Tsan] for judgment a man who had been accused of theft. Tsan ordered that the stolen articles be brought for inspection, and [found] three or four rolls of old, smoke-blackened silk, backed with wool cloth and with lizards' skin covering the rollers. [At the sight] he exclaimed, 'Why, these are paintings which the Grand Marshal, Duke Li, used to treasure!'" The word "roll" in Chinese in this passage is *fu*.

11. *Ibid., p. 92.* For the text quoted here, see Kuo Jo-hsü's original text in the Appendix to Soper's translation

12. In Teng Ch'un's mid-twelfth century *Hua chi* (Beijing, 1963, reprint), p. 123, we read that the writer's father, serving in Hui-tsung's court, saw a mounter using a piece of old silk with a landscape painted on it to wipe a table; when he took a close look, he realized that it was a painting by Kuo Hsi, and was told that it was one of a series of paintings by the artist that had hung in a certain hall under the previous emperor. Kuo Jo-Hsü records a similar story from the ninth century in which a certain Li Cho, looking over old objects in a temple storehouse with monks, suddenly came across something like a piece of sheet that was torn, stained, dusty, and dirty. Upon examining it carefully, he realized that it was a painting more than ten feet long. (Soper trans., p. 82; original text in appendix, vol. 5, p. 13a). From these two incidents, I speculate that these were unmounted paintings, and would remain unmounted until it was decided whether to put them onto a wall or a screen, or mount them into scrolls.

13. This painting, in the Palace Museum, Beijing, is attributed to Ku Hung-chung. See Osvald Sirén, Chinese Painting, vol. 6, pls. 120–23.

14. Ch'en Shu, ed. Ch'üan Liao wen (Complete collection of Liao writings), (Beijing: Chung-hua shu-chü, 1982), p. 194. The tomb was discovered in 1970, in Lung-kang-tzu, Pei-chen county,

Liaoning, when the Cultural Revolution
was at its height and it was not possible
to carry out thorough research. The
archaeologists simply copied the text of
the epitaph and reburied it. I have com-
pared this text in Chen Shu's Chüan
Liao Wen with the text as published in
Hsüeh Ching-p'in and I Nan, "A
Collating of Epitaphs in Liaoning
Provincial Museum Collections," includ-
ed in Ch'üan Liao wen, Liao-hai
hsüeh-k'an (1986): 2: pp. 94–111,
and confirmed that there is no mistake in
this quotation as I present it here.

15. Hsingyuan Tsao, "Shaved Heads as
Marks of Cultural Identity," paper pre-
sented in the Annual Seminar at the
Center for Chinese Studies, University of
California, Berkeley, March, 1995. Also
see Yeh Lung-li (ca. 1127–1279), Liao
chih (Shanghai: Commercial Press,
1936), p. 11.

16. Jitsuzo Tamura and Yukio
Kobayashi, op. cit., color plate.

17. T'o-t'o (Tocto), Liao shih (Beijing:
1973), p. 212.

Ch'i-tan people lived with screens or dividing walls (the walls that divided space in interiors were sometimes also called p'ing or p'ing-feng) of the kind that we often see in paintings of the Sung dynasty.

I want first to consider the possible interpretation of the term p'ing as a divid-ing wall and that the original form of the works we are concentrating on was part of a large wall painting, painted on pieces of silk and attached to or hanging on the wall. I will consider later the possibility that they were originally mounted as a free-standing screen.

The Ch'ing-ling Mausoleum and Deer Hunting

The close relationship between the Four Seasons landscape paintings in the Liao Imperial mausoleum at Ch'ing-ling and the Deer in an Autumn Forest paintings has been noticed by scholars, but no contextualization of either set of paintings has been achieved. The first things to be lost when the Liao History was composed dur-ing the Yüan dynasty (1272–1368) by the Mongol scholar Tocto (T'o-t'o) were the markers of the Ch'i-tan people's ethnic identity.[15] We should not, therefore, read the Liao History without being aware of the discrepancy between the written history and the material evidence of archaeological finds. That is to say, we cannot assume that Liao paintings are to be read in the same way as paintings produced for and by the ethnic Han people. Previous discussions of the Deer in an Autumn Forest paintings have given them readings based on Han Chinese associations of the images of deer: autumn, melancholy, the sad cry of the deer familiar from Chinese poetry. The sig-nificance of deer and deer hunting for the Ch'i-tan people is still ambiguous, but it certainly differed from traditional Chinese views. Questions such as when, where, why, and how the deer were hunted remain little understood. To what degree did the Ch'i-tans use these subjects to assert their ethnicity and cultural identity in works of art? Indeed, there have been few studies on Liao art, until recently, when numerous Liao tombs have been excavated.

The eastern tomb of the Ch'ing-ling mausoleum has a dual function: it is both Emperor Sheng-tsung's dwelling in the afterlife, and a reflection of the style and scale of his surroundings during his lifetime. As a dwelling, it should be an under-ground palace for the deceased ruler, in which his officials and objects would still accompany him—the officials and guards are depicted in the tomb mural paintings with their names written above their shoulders.[16] A building that sheltered the emperor's portrait along with portraits of Sheng-tsung's favorite officials was ordered to be built among the aboveground constructions at the eastern tomb.[17] These portraits and the tomb structure itself seem to suggest that the Ch'i-tan peo-ple believed the afterlife to be an extension of this life. If that is the case, the land-scape paintings of the four seasons painted on the walls of the central chamber must reflect the scale and style of wall paintings in palaces that Emperor Sheng-tsung inhabited in his lifetime, just as the portraitlike images of his officials represent the living people.

The Liao, a dynasty of nomadic origin, was established in 916 by Yeh-lü A-pao-chi (872–926), who was very fond of the cultures of the sedentary Han

Chinese; in a certain sense his nation was built upon the combination of nomadic and sedentary cultures.[18] We read in the account by the Chinese writer Li T'ao (1115–1184):

> The Ch'i-tan [people] inhabit a grand desert, [their territory] covers the Liao-tung [Peninsula] and some tens of prefectures of the Yen region. In the east they conquered Kao-ku-li, in the west they subjugated Yüan-hao [Li Yüan-hao, a ruler of Hsi-hsia, 1038–1227.] During the more than one hundred years from the Five Dynasties to the present time, [their] confrontation with the Chung-yüan [the central region, the origin of the Han political power] intensifies every day. Even their decrees, regulations, culture, material culture, diet, costume, and entertainments follow the Han styles. Therefore, their self-confidence has expanded arrogantly; they consider that they are better than the [Northern] Wei. The relationship between the Huns and the Han dynasty, or the Turks and the T'ang dynasty, was that they accepted their position as ti and i [both words mean barbarian], and [acknowledged that] they share no commonality of social values with the Central Kingdom.[19]

The core of Li T'ao's account is the statement that "During the more than one hundred years from the Five Dynasties to the present time, [their] confrontation with the Chung-yüan intensifies every day."[20] A cultural confrontation must be built, not on mere words, but on the solid, everyday cultural practice of the nation. The impact of this confrontation between the Liao and the Northern Sung can be read from the murals in the Ch'ing-ling Imperial mausoleum, which was built after the death of the Emperor Sheng-tsung (r. 983–1030), Yeh-lü Lung-hsü, by his first son, emperor Hsing-tsung (r. 1031–54). Later, Hsing-tsung and his son Tao-tsung were also buried in the mausoleum.

The eastern tomb of Emperor Sheng-tsung was excavated by Japanese archaeologists in the 1930s and published in 1953. Among its richly colored murals, the four large seasonal landscapes have especially drawn the attention of scholars to Liao art and its pictorial tradition. Little has been contributed to the study of this subject since then, however, because the number of reliable paintings from the period has, until recently, been so small. Texts that might cast light on these landscape paintings have also remained largely unexplored.

The eastern tomb is a multi-chambered underground structure; the aboveground constructions originally associated with it have long been destroyed (fig. 10.4).[21] Among the five chambers and one hall of the eastern tomb, the four landscape paintings are found on the walls of the hall, which has four doorways leading into the other chambers; one panel of the paintings is located between every two doors. The order of these four paintings, starting from the door to the far north, rear chamber, and moving clockwise, is: Winter, Spring, Summer, and Autumn (fig. 10.5). There is a clear thematic program in these four paintings. In the Spring and Autumn scenes a few flights of wild geese appear as sub-themes of the paint-

18. When A-pao-chi had to vacate the position of Khohan of the Ch'i-tan Eight Tribe Federation, he made a suggestion to another: "I have been in the position for about nine years, and have obtained a large number of ethnic Han people. I would like to be independent from [the other seven units] and be the head of the Han city of Han-ch'eng." See Hsin wu-tai shih, vol. 72, Ssu-i fu-lu (Beijing: 1974), p. 889.

19. Li T'ao, Tzu-chih t'ung-chien ch'ang-pien (A Continuation of the Comprehensive Mirror as an Aid to Government), vol. 142, pp. 16b–17a.

20. Ibid.

21. The aboveground buildings have been reduced to mere rubble now, and one knows of their existence only from reading the Liao shih. See Liao shih, pp. 212–13.

ings. These migratory birds fly south at the beginning of autumn and return north when spring turns the northern land green. A subtle visual play is seen in the different ways the geese are arranged between the Spring panel and the Autumn one. In the Spring panel, which takes these birds as its main subject, two groups of birds fly strictly toward the north (figs. 10.5 and 10.6). They shoot diagonally into the northern sky with no hesitation but with joy, as though they are celebrating their return from Sung territory to the Liao homeland. The birds in the Autumn scene, by contrast, linger in the northern region as the weather turns cold and autumn arrives. One group of wild geese flies in a circle, as if to delay their departure. The tarrying of the birds almost implies the words of Confucius: "If a man is tolerant, he will win the multitude."[22] The Liao regime, one might read into it, attracts not only birds from the south, but people as well. For the Ch'i-tan, the migratory birds meant still more; these birds announced the beginning of a new year. Birds are creatures with potency; therefore, the ceremony of hunting the leader of a flock of swans and presenting it as a sacrifice to the Ch'i-tans' ancestors might signify the transmission of this mysterious potency from the birds. This is one way, at least, to explain the Ch'i-tans' spring hunting of the swans as a part of their seasonal activities.[23]

To fulfill both ceremonial and practical needs, the Ch'i-tan carried out annual seasonal activities: in spring and autumn, the *nabo* ceremony (a term of uncertain meaning, except that it involved both fishing and swan hunting);[24] in summer and winter, camping. From the frequent records of swan hunting in the *Liao History*, both spring and autumn hunts were significant ceremonial outings. About the spring outing it says:

> Spring, *nabo*. It was set in Duck River. The emperor departed from his royal yurt... A flag would be raised when somebody saw a swan to inform other people, then they would beat drums and stir the swans into flying up. At this moment all the flags were up waving and a falcon would be given to the Emperor for him to catch the swan... The emperor, as usual, used the swan as a sacrifice to offer to Heaven.[25]

As for the subjects of the other three panels, they are the same: stags and does among groves of trees and bushes, with at least two stags in each panel. Deer hunting usually began in the fourth month of each year, when the spring activities had come to an end; it could last as long as the twelfth month.[26] The changes in season in the summer, autumn, and winter panels, therefore, can be seen in the differences in tree foliage.

Throughout the *Liao History*, deer hunting was recorded numerous times, but most of the records are of hunts carried out during and after the Mu-tsung era (951–69), when an important change in ritual practice occurred. In particular, it was at this time that the practice of ancestral worship was transformed from its original ethnic Han agricultural-related form into one that was related to nomadic traditions. Thus, the seasonal offering of fresh fruits (*chien-shih-kuo*) and newly har-

22. D.C. Lau, trans. and introduction, Confucius: The Analects *(Penguin, 1979), p. 159.*

23. *This ceremony is discussed in Hsingyuan Tsao, "On the Subject of the Tso-hsieh t'u or 'Tartars Resting' Scroll Attributed to Hu Kuei," presented at the Second International Symposium on Art and Archaeology of the Northern Regions, at Chifeng, Inner Mongolia, 1993. The essay is published in Sung-chou hsüeh-kan (1993), 11, pp. 42–44.*

24. *Nabo is a transliteration from the Ch'i-tan language. Scholars have focused on the problem of its meaning, but no one has yet arrived at a convincing definition of the term. According to the Liao shih, nabo was an imperial ceremony involving fishing and the hunting of the wild goose (or swan).*

25. *Liao shih, 32: 374.*

26. *Ibid., "Diagram Sixth-Outings," pp. 1037–76.*

vested grains (*chien-hsin*) to deceased ancestors was replaced by seasonal hunting. Often, hunting was combined with paying homage at the imperial mausoleums when preserved deer meat was sometimes used as an offering.[27] From T'ai-tsu's era (916–27) to the beginning of Mu-tsung's reign, which is to say at the end of the Five Dynasties era, the political situation had not been stabilized and the main task of the newly raised regime was to establish and stabilize the state. By the tenth year of Mu-tsung's reign (960), the Northern Sung dynasty (960–1127) had been established and the designs of the Liao military became focused on the Sung alone, instead of on multiple states. Politically, the Sung and the Liao became the dominant powers of the time.

27. Ibid., p. 111.

Before the Sung was established, the Ch'i-tan empire had tried to become the hegemon of the Chinese Central Plain, and the need for the Ch'i-tan to assert their own cultural identity was not crucial. In fact, adopting ethnic Han cultural practices may also have been a conscious policy for reassuring the Han world of the level of cultivation attained by the nomadic Ch'i-tan people. The Ch'i-tan, for example, worshiped their ancestors with agricultural products in almost the same manner as the sedentary Han people. We read in the *Liao History*:

The Seventh Month of the Fifth Year of T'ien-hsien (929): seasonal fruits were offered to the temple of T'ai-tsu (*Yeh-lü A-pao-chi*).[28]

28. Ibid., p. 32.

The Seventh Month of the Sixth Year of T'ien-hsien (930): seasonal fruits were offered to the temple of T'ai-tsu.[29]

29. Ibid., p. 33.

The Seventh Month of the Seventh Year of T'ien-hsien (931): newly harvested products were offered to the temple of T'ai-tsu.[30]

30. Ibid., p. 34.

After the tenth year of T'ien-hsien (934), the offering of fruit and grain to the ancestors in the Seventh Month was replaced by hunting and hunting-associated ways of paying homage. At least, after that year, fruit and grain offerings do not appear again in the *Liao History*. All through the Mu-tsung and Sheng-tsung eras, the four seasonal hunts were recorded in detail, and deer hunting is the most frequent. The replacement of fruit and grain for deer hunting and the presentation of preserved deer meat as the ancestral offering in the Seventh Month marks the growing revival of nomadic cultural practices among the Ch'i-tans as their dualistic culture, a mix of nomadic traditions and customs adopted from the Han, began to give way to more purely nomadic practices as the Ch'i-tan elite sought to reassert their cultural identity. It even became necessary for them to domesticate deer, as the demand for deer meat increased.[31]

31. Ibid., pp. 84 and 1391. Deer meat was used not only as a ceremonial offering, but also as a culinary ingredient.

Stags played a very meaningful role in this deer-associated culture. According to a Liao regulation, "antlered stags may only be hunted by emperors."[32] Specialists in luring stags by imitating the sound of a doe were employed to call the stag close enough for the emperor to shoot it. The Jurchen people even sent a specialist in stag-calling as tribute to the Liao emperor Sheng-tsung in 991.[33] Little information

32. Ibid., p. 1265.

33. Ibid., p. 141.

is available about the worship of deer, but it must have existed. In the eleventh month of 986, for example, Emperor Sheng-tsung held a ceremony for the God of Large Deer (fig. 10.7).[34]

34. Ibid., p. 126.

Among the nine emperors of the Liao dynasty, Mu-tsung and Sheng-tsung seem to have been more interested in deer hunting than others, according to the *Liao History*. It should not come as a surprise, therefore, to find deer hunting depicted in three of the four seasonal murals in Sheng-tsung's tomb. These two emperors occupied two very important historical moments: the establishment of the Sung dynasty during the reign of Mu-tsung, and the conclusion of the Ch'an-yüan treaty, which inaugurated about a century of peace between the Sung and the Ch'i-tan, during Sheng-tsung's reign.[35] The Ch'an-yüan treaty was signed after the Liao had fought a number of battles against the Sung under Sheng-tsung's leadership; the significance of the treaty is that it was the first time in history that an ethnic Han regime submitted to a nomadic government by offering tribute to it in exchange for peace. The replacement of the *chien-hsin*, offering of harvested grains, with seasonal hunting and deer worship during Mu-tsung's reign, therefore, was not merely a religious practice, but a mechanism for the Ch'i-tan to declare their cultural difference from the Sung. To make a further, if not yet entirely sound claim, this nomadic form of ancestral worship was a way to reassert their non-agrarian identity at the moment when the Ch'i-tan had defeated the Sung. They also changed their name from the Liao dynasty to the Ch'i-tan Nation as a further means of asserting their ethno-political identity. Ultimately, it was a way of asserting the triumph of the nomadic peoples, who had always been considered an inferior group, over the ethnic Han, the "ultimate superiors" of the Asian continent (fig. 10.8).

35. There are two accounts of this treaty, in Sung shu (Sung History), and Liao shih, p. 160.

It was in the context of this triumphant mood that the eastern tomb was built by Hsing-tsung, the son and successor of Sheng-tsung. Art was highly developed in both Hsing-tsung's and Sheng-tsung's reigns, judging from the frequent appearance of records on art in these periods. Sheng-tsung himself was very fond of painting;[36] he once ordered an artist of his painting academy named Ch'en Sheng to work on a painting in his palace at the Upper Capital on the theme of the "Triumphant Southern Expedition."[37] One of the most successful emperors in all of Liao history, Sheng-tsung succeeded to the throne when he was only twelve years old, and he ruled the country for forty-nine years. During his long reign, he launched successive campaigns against the Northern Sung, until the winter of 1004, when he concluded the famous Ch'an-yüan treaty mentioned above.[38] The painting *Triumphant Southern Expedition* is believed to have been a representation of Sheng-tsung's conquest of several cities on the northern borders of the Northern Sung territory. After his death, his crown prince and successor had craftsmen build him the eastern tomb as the first step in the creation of the Ch'ing-ling mausoleum; it was also the culminating achievement of mural painting in the Liao dynasty.

36. Liao shih, p. 107.

37. Li T'ao, op. cit., p. 184.

38. Ibid., p. 160.

The interpretation of the tomb structure and mural paintings in the eastern tomb is crucial for this paper. The five chambers are symmetrically arrayed around a central axis: two on each side and one at the upper end (fig. 10.9). The structure and mural paintings might stand for elements of Sheng-tsung's surroundings during

his lifetime, because there are no conventional indications of the otherworldly.[39] On both side walls of the corridor, figures and horses are depicted;[40] that the figures are dressed mainly in dark green robes suggests that they are engaged in outdoor rather than indoor activities. Clothes of this color were preferred for the seasonal hunts as well.[41] This might be a scene of an outing for a hunt, of the kind that are sometimes depicted—the outing scene in tomb six at K'u-lun, for instance, is presumably a spring outing, because one of the figures is checking an awl which was used as part of a ceremony in which the brain of the lead swan of a flock was removed after it was caught (fig. 10.10).[42] As we move through a short vertical construction on both side walls, we are drawn into the depths of the corridor, where we encounter two figures with ku-t'o cudgels in their hands flanking the entrance.[43] Beyond these guards are orchestras made up of people dressed in ethnic Han-style robes and hats. These musicians are inside a building indicated by painted bracket sets, columns, beams, and an ornately painted ceiling (fig. 10.11). Passing between another pair of guards, we come to two ante-chambers, in each of which ten or more images of people who appear to be officials are painted on the walls. A few things catch the viewers' attention immediately: none of these figures holds a weapon of any kind, and namelike characters are written above their shoulders in Ch'i-tan script. My reading of these two chambers and the paintings in them is that these are portraits of Sheng-tsung's officials who accompanied him in his lifetime. The first character of the namelike inscription written above the left shoulder of the figure wearing a non-Han looking cap on the east wall of the corridor can be identified as Yelü, the imperial surname. Among the figures in the two chambers, four appear to be either ethnic Han or high-level Ch'i-tans: they wear hats, and there is no indication that any of them have shaved hair, as do the rest of the figures. We cannot see any strands of hair hanging down beneath their hats or along their cheeks, as there would be if they had shaved heads like the others (fig. 10.10). The Ch'i-tan people usually were not allowed to wear hats, except for the rich and noble, partly in order to express their ethnicity.[44] I propose that these figures represent the officials from the southern and northern courts who went on the four seasonal hunts each year with Sheng-tsung.

It must have been a common practice to paint officials' portraits around the image of an emperor. Kuo Jo-hsü notes:

> When the first Wang prince [i.e., Wang Chien] went to the metropolis of Shu, he paid his respects to the august portrait of Hsi-tsung [of the T'ang, r. 874–88]. At the time the walls were painted with the [figures of the emperor's] body of officials, all there except T'ien Ling-tzu and Ch'en Tai-shih."[45]

The *Liao History* provides us with the similar information that in 1031, after the death of Sheng-tsung, his successor ordered that his portrait be painted, and later commanded that two portraits depicting the prime ministers of both the Southern and Northern Courts be made to put in the ancestral hall to accompany

39. There are no known images of this kind in Liao tomb murals, but it is possible that, in the Ch'i-tan culture, some of the images depicted in the tomb stand for eternity.

40. According to the latest archaeological report by Kuo Chi-chung, an archaeologist in Inner Mongolia who worked on the re-excavation of the eastern tomb at Ch'ing-ling, delivered at the Conference on Northern Archaeology and Culture held in Ch'i-feng, Inner Mongolia, August 1993, the Japanese archaeologists excavated only part of the corridor in the eastern tomb. There were still 23 meters of the corridor untouched until 1993. In this newly excavated part, more figures and horses were uncovered. In addition, camels were also found depicted in the mural.

41. Hsingyuan Tsao, "On the Subject of the Tso-hsieh t'u or 'Tartars Resting' Scroll Attributed to Hu Kuei," in Sung-chou hsüeh-kan and Liao shih 32:374.

42. Liao shih 32:374.

43. Ku-t'o is a garlic-shaped object attached to a stick, which is often held by guards in tomb mural paintings.

44. Yeh Li-lung, Liao-chih, Southern Sung text (Shanghai: 1936 reprint), p. 11. See also, Hsingyuan Tsao, "Shaved Heads."

45. Kuo Jo-hsü, Soper trans., p. 87.

46. Liao shih, *18:212*.

47. Liao shih, *32:375*.

48. Ibid.

49. Ibid.

Sheng-tsung's posthumous portrait.[46] Although underground and aboveground portraits might have different audiences, their significance was similar: to commemorate the late emperor and his officials and extend their relationship into the other world.

In the Liao regime, there were two administrative systems: a northern court that was in charge of Ch'i-tan affairs, and a southern court that was the government for the ethnic Han people under this regime. Two sets of officials were needed, therefore, in the two sets of offices. Officials from both southern and northern courts would accompany the emperor on all four of his seasonal hunts.[47] In cold winters, the Liao emperors usually went to camps in relatively warm places, where tents were erected and officials came from both courts to discuss national affairs with him.[48] A tent on the scale of a palace was usually used for the emperor, called *shou-ning tien* (*tien* means a hall, even though in this case it refers to a big tent). This tent was "[erected] using wooden columns and bamboo beams; felt was applied on the roof or ceiling; columns were painted, and the walls of the tent were covered with brocade; the tops [of the walls] were trimmed with embroidered pink lace."[49] If a reconstruction were done based on the description of this *shou-ning* hall in the *Liao History*, its appearance would match that of the central chamber of the eastern tomb.

Meeting in the center of the dome, eight archlike beams of the chamber are supported by eight columns, between which are the four seasonal landscape paintings. The central chamber, the core of the tomb, is divided, that is, into eight sections by columns and archlike beams; among the eight sections of wall, four are entrances to other chambers and the others are painted with the four seasonal landscapes. Beautiful patterns of clouds, phoenixes, and dragons decorate the ceiling, which is in the shape of a dome and is also divided into eight parts by painted arch-shaped beams. I believe that this dome represents the upper part of the Ch'i-tan yurt. The dragon and cloud decorations on the columns echo those on the dome. Between columns and the dome are representations of brackets, *tou-kung*, which hold the dome in place (fig. 10.12); they represent an adaptation of the Han style of construction. This combination of dome and brackets represents a compromise between the Ch'i-tan's acceptance of the Han style of architecture and their preservation of their own cultural values. The Liao tomb of Han Yi (dated 997) excavated in Beijing shows a similar tomb chamber (fig. 10.13). Turning back to the recorded description of the *shou-ning* hall in the *Liao History*, the central chamber of the eastern tomb can be seen as reproducing the real palace-scale tent, except that the four seasonal paintings replace the brocade hangings or linings on the walls. This chamber, then, is an underground replica of the *shou-ning* hall, where Sheng-tsung could receive in the afterlife his officials and diplomats, as he did in his lifetime during his regular seasonal outings.

This interpretation of the central chamber in the eastern tomb of the Ch'ing-ling Imperial mausoleum sheds new light on the function of the chambers' four seasonal landscapes. The theme of the whole tomb, from the outing scene to the landscape paintings in the central chamber, is focused on the royal activities of the four

seasons, and the stags in three of the paintings overtly pronounce the majestic position of Emperor Sheng-tsung.

Palace Halls and the Deer in An Autumn Forest

When the Ch'an-yüan treaty was signed, the Sung finally agreed to establish an "imperial brotherhood" with the Ch'i-tan as a recognition of the Ch'i-tan's legitimate ownership of portions of northern China. Sending generous tribute every year, the Sung government managed to maintain territorial peace with Ch'i-tan from Sheng-tsung's reign onward. The political and military confidence of the Ch'i-tan then grew to the point of raising the need for reestablishing their cultural identity. Following the renaming of their nation from Liao to Ch'i-tan and the triumph achieved in the Ch'an-yüan treaty during Sheng-tsung's reign, this nomadic empire launched a cultural campaign, as indicated unequivocally by records in the Liao *History* of artistic activities that occurred during Sheng-tsung's and Hsing-tsung's reigns. Some records even suggest a kind of cultural brinkmanship with the Sung.[50] In the twelfth month of 1053, for example, both the *Sung History* and the *Liao History* record that the Liao emperor Hsing-tsung issued an edict in which he expressed his wish to obtain a portrait of the Sung dynasty ruler.[51] In the *Sung History* we read a matching report in which a diplomat came to the Sung "and his master ordered him to present three portraits of three [of their] emperors [to us], asking for the portrait of our emperor [in return.]"[52] Hsing-tsung's reign, as recorded in the *Liao History*, saw more artistic activities than any other period throughout the Liao dynasty. The most recorded subject in painting of this period is portraiture, which explains the quantity and quality of the portraits painted in the ante-chambers of the eastern tomb in the Ch'ing-ling mausoleum.[53]

The most important record of this sort in Hsing-tsung's era, however, is the one we find in Kuo Jo-hsü's account of paintings that were used as presents to the Sung court by the Liao emperor. This is the event that inspired Li Lin-ts'an's argument discussed above. Associating this event as we have with the building of the Ch'ing-ling mausoleum, one can see it as a more tangible cultural assertion by the Ch'i-tan. The presentation of the painting of thousand-horned deer, a subject heavily packed with nomadic imperial symbolism, to the Sung emperor would seem to betray a strong quest for being understood and recognized. At the same time, the Ch'i-tan explicitly used this work to pursue an equation between the emperors of the two nations.

By erecting a tent and naming it the *shou-ning tien* during their winter royal outing, the Ch'i-tan people asserted their imperial power in ceremonial practice. They also accomplished this by making paintings that embodied their own cultural and political significance, rather than borrowing painting genres from the sedentary Han culture. It is also true, however, that the Ch'i-tan often appropriated ethnic Han cultural styles, mainly inherited from the states of the Five Dynasties, the Ch'i-tan's neighbors before the establishment of the Sung—to serve their own cultural practices. Traditionally, scholars have viewed this appropriation as part of the process of sinicization, in which the "barbarians" were passively absorbed into the

50. *In 1018, Sheng-tsung issued an edict ordering the academy painter Ch'en Sheng to paint the event of the* Triumphant Southern Expedition. *The Southern Expedition was an event that happened prior to the signing of the Ch'an-yüan treaty. Two readings can be drawn from this passage: the political and military triumph of the Liao; and that the Liao had, like the Sung dynasty, established an imperial academy of painting.*

51. Ibid., p. 246.

52. T'o T'o, Sungshih, (Beijing: Chung-hua Shu-chü, 1977), p. 238.

53. Liao shih, pp. 1420–22.

Han Chinese cultural sphere; as a result, they have not investigated the Ch'i-tan's own intentions. *Tien*, for instance, is a word that usually designates a permanent architectural structure used by an emperor; the Ch'i-tan employed the name for their palace-scale yurt or tent, thereby endowing it with imperial associations. At the same time, the scenery that surrounded the tent was also given a ceremonial function. The significance of the seasonal landscape paintings, in which this scenery was depicted and installed within a burial chamber, is thus indisputable.

Returning to the problem of the reconstruction of *Deer in an Autumn Forest* raised earlier, it seems appropriate to consider these two works as parts of a larger painting that was once used in a hall like the *shou-ning tien,* or the central chamber of the eastern tomb. To the question of how such paintings could have been hung in the yurtlike *shou-ning tien,* I propose two possible answers. The first is that a work of this kind was mounted on a large-scale screen that stood free from the walls. Considering the nature of the nomadic style of indoor life, in which people sat on the floor, it is unlikely that any very tall composition could have been used in a private space for the emperor. It might have been a screen of about 150 cm. in height and a length of 3 meters or more, perhaps a three-part screen, with the middle part longer than the side pieces, of a kind seen in early paintings. The second possibility is that the painting was intended for use in a public space, such as a hall in the palace, in which case two formats can be considered: the free-standing vertical screen, and a painting on joined pieces of silk with some kind of backing that allowed it to be attached to a wall. In either case, as previous scholarship has suggested, these works must originally have been in a flat form, not rolled, and only later were they converted into scrolls, which led, in turn, to the flaking off of the thick applications of pigment as a result of the scrolls' repeated rolling and unrolling.[54] It is even possible that such paintings were, as van Gulik puts it, "nailed or stuck to the wall. In other words, a kind of superior wall paper."[55] We find a similar practice of using paintings during the Five Dynasties:

> Hsü Hsi...took a roll of double-thread silk and painted thereon a great multiplicity of beauties.... [The work] was presented to the Li prince, who had it hung as [part of] the furnishings of his palace; it was referred to as 'flowers to spread over a hall,' or 'flowers to deck out a hall.'[56]

The Ch'i-tan may have employed such large-scale paintings in their palaces not only to fulfill a decorative function, but also to serve a ritual or didactic purpose. Examples have been found in excavated Liao tombs of paintings on silk mounted on the inside wall of the *hsiao-chang*, a house-shaped outer coffin. A painting of this kind with large figures, for example, done on two or three pieces of silk making up a single composition depicting a food offering, was found mounted on the wall of such an outer coffin excavated from a Liao tomb in the Right Pa-lin Banner of the Chao-wu-ta League, Inner Mongolia.[57]

Works such as *Deer in an Autumn Forest* may well have been used as mural paintings in the Liao court, presumably with the aim of creating a seasonal atmosphere

54. See James Cahill, "The Imperial Painting Academy."

55. R.H. van Gulik, Chinese Pictorial Art as Viewed by the Connoisseur (Rome: 1958), p. 179.

56. Kuo Jo-hsü, Soper trans., p. 102.

57. This is an unpublished excavation, so I am unable to reproduce the painting here.

within the realm of the palace, as part of their ceremonial observance. In reading Kuo Jo-hsü's *Experiences in Painting*, we realize that the practice of using both wall paintings and free-standing screens was extremely popular in this period. Recognizing the need for both permanent and mobile lifestyles after the nation was founded, the Ch'i-tan may have adopted the two different types of large-scale paintings—murals and screens. What we see most often in tomb paintings are murals, but screens were also sometimes represented on the walls, and among Liao tomb finds, actual small-scale screens are one type of object that frequently appears. While most Liao tomb murals show the same repertoire of subjects, seasonal landscape paintings such as those in the eastern tomb of the Ch'ing-ling mausoleum are unique. This suggests that paintings of this subject were monopolized by the Liao emperors; and if so, it is evident that paintings such as *Deer in an Autumn Forest* symbolize the very position of the Ch'i-tan emperor, and that the presentation of them to the Sung emperor ascribes a corresponding status to him.

Whether or not the Sung emperor realized the nomadic symbolism of the stag is beyond our knowledge, but in his respectful viewing of the painting, the Sung emperor implicitly recognized the Liao empire as an independent cultural entity. According to Kuo Jo-hsü's account: "[after the painting was presented to the Sung court] the All-highest commanded that the picture be spread out in the ground floor of the T'ai-ch'ing Tower, and summoned his families among the courtiers to look it over at their leisure. On the following day, moreover, it was inspected by the ladies of the palace. This done, it was treasured in the Heaven's Sign Pavilion."[58] In the period when the ruler of a dangerous enemy on the northern frontier was being transformed into an imperial brother, it was appropriate that military engagements between these two nations were being transformed into artistic exchanges. Despite the fact that the painting was from a nomadic state, the emperor ordered that it be given a high-level reception.

58. Ibid., p. 94.

Two further observations may also be made on the basis of a deep reading of Kuo Jo-hsü's information about how a Liao painting was received in the Sung court. First, a painting of one of the four seasons themes might also be viewed individually as an independent genre. The "thousand-horned stag," which for the Ch'i-tans stood for autumn hunting, for example, might have been differently understood by Han Chinese viewers in the court. Second, if paintings of deer are related to the Ch'i-tan's autumn hunt rather than with the traditional Chinese associations of deer, such as those derived from the *Book of Odes*, then paintings of wild geese on a river shore—another of the Liao seasonal themes, which first appears in painting during the Northern Sung period—may also have to be reevaluated. Such river scenes with wild geese have been considered as a lyric subject by the highly cultivated Sung literati, but it might also be possible to interpret them, at least in their origin, as related to the Ch'i-tan spring hunt.[59] The dualistic nature of acculturation thus promotes multiple readings of works with the subjects of deer and wild geese. At any rate, the image of a stag, whether a wall painting in an imperial tomb or a gift presented to the Sung court, has to yield ultimately to a reading based on its nomadic connotations.

59. The rise of pictures of wild geese and other water birds on river shores as a new genre in the early Sung, and their reception as a poetic theme, are discussed by James Cahill in his forthcoming book The Lyric Journey: Poetic Painting in China and Japan *(Harvard University Press, 1996).*

Within the spacious living quarters of an imperial palace, multi-panel paintings far larger in scale than that of the extant *Deer in an Autumn Forest* paintings can easily be imagined. The so-called incompleteness of the composition, arising from the fact that the two stags face toward the narrow side of the work instead of in the opposite direction, as they would in typical Chinese paintings, indicates only that we are viewing these two segments with sinicized eyes and criticizing them with insufficient consideration for their cultural context. In the compositions of the four landscape panels in the eastern tomb of the Ch'ing-ling mausoleum, some of the stags are also facing the narrow side of the composition. If we imagine ourselves standing in the middle of that central chamber and contemplating the activities taking place in the four paintings around us, they become dynamic rather than static. Skipping over the columns and the doors to the side chambers, the four paintings almost appear to be a gigantic horizontal scroll, interrupted only by the columns and doors. Sitting in this chamber and viewing the landscape moving and changing seasonally before his eyes, the deceased Sheng-tsung was perpetuated in his role as emperor by the offering of these landscapes, the spatial extension of his nation, and the seasons, the temporal extension of his empire.

It is thus possible that the works on silk in the National Palace Museum, Taipei, are segments of a much larger painting, comparable to one of the panels in the Ch'ing-ling mausoleum. They might also be parts of a separate multi-panel painting; whether it was the one that was presented to the Sung court is a matter on which I have no further evidence. In any event, it must have been a painting directly related to the Autumn panel of the eastern tomb murals. If this is the case, a reconstruction of the whole composition can be easily achieved. To be complete, the original work needed to have some sky, and better yet, some wild geese flying toward the south. If we include the sky and an upper part representing mountains and forest, the scale of the work becomes almost that of a piece of wall, or a big screen (fig. 10.14).

We may conclude by making a suggestion, based on our study of the murals in the Ch'ing-ling mausoleum and the pair of paintings in the National Palace Museum, that the Ch'i-tan had already established their own cultural identity and cultural achievement by the beginning of the Northern Sung, through their incorporation and adaptation of influences from both nomadic and sedentary cultural traditions. Two societies in this middle period of Chinese history, sedentary and nomadic, had met between encounters on the battlefield on the common ground of culture. Even though it was short-lived, the Ch'i-tan and Sung model of artistic exchange later enriched Chinese culture. We do not know to what degree, however, the Sung understood how the Ch'i-tan could on the one hand appropriate the forms of Chinese culture, while on the other hand replace their contents with those

from their own nomadic heritage. The Ch'i-tan nobles never became totally sinicized; on the contrary, the Sung accepted Ch'i-tan nomadic art without being conscious of doing so. The fate of such paintings as the *Deer in an Autumn Forest* within Chinese art history exemplifies this phenomenon: deprived of their original context, in which they stood for the very essence of nomadic ceremonial practice, they have long been misplaced and misunderstood. This paper has been an attempt to reconstruct their format and meaning by relating them to other examples of nomadic material culture afforded by recent archaeology, as well as by the careful re-reading of old texts.

Figure 10.1
Anonymous (10th–early 11th century),
Deer Among Red Maples. *Hanging
scroll, ink and color on silk, 118.5 x
64.6 cm. National Palace Museum,
Taipei.*

Figure 10.2
Anonymous (10th–early 11th century),
Deer in an Autumn Forest. *Hanging
scroll, ink and color on silk, 118.4 x
63.8 cm. National Palace Museum,
Taipei.*

Figure 10.3
Reconstruction of A Thousand-Horned
Stag. *Based on Li Lin-ts'an (see note 1
in this essay).*

Deer Among Red-leafed
Maples

Deer in an Autumn Forest

5 4 3 2 1

Figure 10.4
Autumn *section from* Four Seasons
*mural paintings. Ch'ing-ling Imperial
Mausoleum. Liao Dynasty (916–1125).
After Jitsuzo Tamura and Yukio
Kobayashi,* Tombs and Mural
Paintings of Ch'ing-ling Liao
Imperial Mausoleums of Eleventh
Century AD in Eastern Mongolia.

Figure 10.5
Drawing of figure 10.4.

Figure 10.6
Drawing of Spring. *After* Keinyo no hekiga *(Mural Painting of Ch'ing-ling Imperial Mausoleum) (Tokyo: 1977).*

Figure 10.7
Stag. *Detail of figure 10.1.*

Figure 10.8
Stag. Detail of figure 10.4.

Figure 10.9
*Structure of the east tomb, Ch'ing-ling
Imperial Mausoleum. Liao Dynasty
(916–1125).*

Figure 10.10
Detail of a figure from a mural paint-
ing, east tomb, Ch'ing-ling Imperial
Mausoleum. Liao Dynasty (916–1125).

Figure 10.11
Dome of the east tomb, Ch'ing-ling Imperial Mausoleum. Liao Dynasty (916–1125). After Jitsuzo Tamura and Yukio Kobayashi, Tombs and Mural Paintings of Ch'ing-ling Liao Imperial Mausoleums of Eleventh Century AD in Eastern Mongolia.

Figure 10.12
Brackets of the east tomb, Ch'ing-ling Imperial Mausoleum. Liao Dynasty (916–1125). After Jitsuzo Tamura and Yukio Kobayashi, Tombs and Mural Paintings of Ch'ing-ling Liao Imperial Mausoleums of Eleventh Century AD in Eastern Mongolia.

Figure 10.13
Dome of the tomb of Han Yi (dated 997).

Figure 10.14
Reconstruction of a yurtlike palace and
the use of paintings like the Deer in an
Autumn Forest.

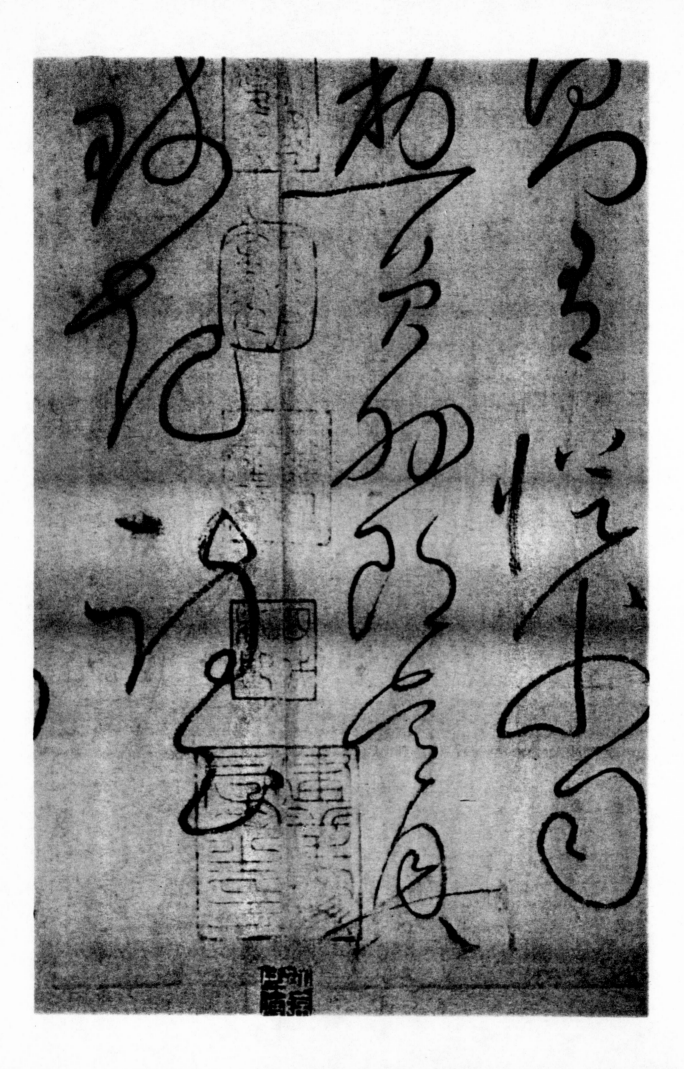

*The Eight Immortals: The Transformation of T'ang and Sung Taoist
Eccentrics During the Yüan Dynasty*

Anning Jing

An eternal life in a merry and carefree world is the final goal of Taoism, and those
who attain that goal are immortals. In traditional China, not only Taoists but people
in general were fascinated by stories about immortals. Many were in constant
search of immortals, hoping that they could help them achieve immortality. They
were also interested in portraits of immortals, which could both help them to iden-
tify immortals and bring them good luck. Although portraits of immortals were
very popular, only a few such portraits have survived to this day. Extant works of
various periods present immortals differently. Prior to the Yüan dynasty, immortals
are mostly portrayed as individuals. In contrast, popular immortals from the Yüan,
Ming, and Ch'ing periods appear mostly in groups. This phenomenon of individu-
als versus groups reflects a fundamental change in the Taoist practice of the search
for immortality. In pre-Sung times, consumption of certain plants, animals, and
minerals, which individuals could set out on their own to acquire, was the major
means to achieve immortality. But the effect of such an external elixir (*wai-tan*)
often proved deadly, leading practitioners to focus more on mental and physical
exercise and regimens known as the internal elixir (*nei-tan*). This new method
often required decades of rigorous training under experienced masters. A close
relationship between masters and pupils was essential to learn this new way to par-
adise. This led to the rise of various Taoist schools, such as the Northern and
Southern schools of the Ch'üan-chen sect, the dominant Taoist organization during
the Yüan. Since novices depended on their teachers in order to become immortals,
renowned masters had themselves to be recognized as immortals first. This recog-
nition could not prevent the masters from dying, but it could at least offer an
explanation for death: immortals would sometimes pretend to die and abandon
their physical bodies in order to return to their Taoist paradises. Unlike the trace-
less immortals of earlier periods, they often visited this world, usually in the dis-
guise of ordinary people. They loved worldly places such as markets, wine shops,
and restaurants. Being immortals, they were not always accustomed to established
social norms or traditional patterns of life. Therefore, their behavior at times
would appear odd or unconventional. But it was precisely their eccentricity that
often betrayed them. Once recognized, some of them would readily acknowledge
their identity. Others might deny it; but they could still be approached, coaxed,
observed, and documented, even in portraits, sometimes without their knowledge.

From the Yüan period onwards, immortals were more tightly organized in
hierarchical groups according to the master-disciple relationship of the various sec-
tarian movements. Thus, immortals of the later periods are mostly patriarchal fig-

1. W. Perceval Yetts, "More Notes on the Eight Immortals," The Journal of the Royal Asiatic Society (1922), p. 397.

2. Here, I borrow Richard M. Barnhart's comment on immortals, who are members of the group. See Barnhart, Painters of the Great Ming (Dallas: Dallas Museum of Art, 1993), p. 117.

3. For modern studies and discussions on the subject, see Ph. de Harlez, Le livre des Esprits et de Immortals—Essai de mythologie chinoise (Paris, 1893), pp. 241–51; W. Perceval Yetts, "The Eight Immortals," The Journal of the Royal Asiatic Society (October, 1916), pp. 773–807; W. Perceval Yetts, "More Notes on the Eight Immortals," pp. 397–426; E.T. Chalmers Werner, Myths and Legends of China (London: George G. Harrap and Co., 1922), pp. 288–304; C. A. S. Williams, Outlines of Chinese Symbolism (Peking: Customs College Press, 1931), p. 124; Chao Ching-shen, "Pa-hsien ch'uan-shuo," Tung-fang tsa-chih, vol. 30, no. 21 (November 1933), pp. 52–63; Ferdinand Lessing, "Über die symbolsprache in der chinesischen Kunst," Sinica (1934), pp. 21–53; Henri Doré, Researches in Chinese Superstitions, trans. D. J. Finn (Shanghai, 1931), pp. 35–68; P'u Chiang-ch'ing, "Pa-hsien k'ao," Ching-hua hsüeh-pao, vol. 2, no. 1 (January 1936), pp. 89–136; V.R. Burkhardt, Chinese Creeds and Customs (Hong Kong: South China Morning Post, 1953), p. 158; Richard F.S. Yang, "A Study of the Origin of the Legend of the Eight Immortals," Oriens Extremus, vol. 5 (1958), pp. 1–22; Echo, vol. 5, no. 2/3 (February/March 1975) (a special issue devoted to the subject); Rene Q. Bas, "The Eight Immortals of the Taoist Cosmos," Orientations, vol. 10, no. 7 (July 1979), pp. 50–57; Stephen Little, Realm of Immortals: Daoism in the Arts of China (Cleveland: The Cleveland Museum of Art and Indiana University Press, 1988), pp. 10–12; Robert J. Poor et al., Ritual and Reverence (Chicago: The David and Alfred Smart Gallery, The University of Chicago, 1989), p. 97.

4. W. Perceval Yetts, "More Notes on the Eight Immortals," p. 403; P'u Chiang-ch'ing, "Pa-hsien k'ao," p. 90.

ures; and the main reason for their rise to popularity was the new trend toward the internal elixir.

The most famous assemblage of patriarchal immortals during the Yüan, Ming, and Ch'ing dynasties was a group of eight figures. They often enliven visual art, drama, literature, and other forms of popular culture. This ubiquitous group is the well-known "Eight Immortals." Juniors in the society of immortals, they nonetheless overshadowed almost all the senior members. Beginning in the late Yüan, they became an "important national cult,"[1] and were as popular as our Santa Claus.[2] Even today, their images can be seen in temples and homes, and in public buildings.

The Eight Immortals have attracted the attention of scholars since the Ming dynasty.[3] Previous studies have centered mostly on issues concerning the individual members, such as their origins in T'ang and Sung literary sources. Such research has greatly increased our knowledge of the eight individuals, but it has provided little information on the Eight Immortals as a distinct group. The sum total of the eight figures is not equal to the whole; once an individual joins the group, that individual's image is changed due to a new relationship within the group. In other words, the individual is transformed. The transformation of individual immortals into the group of the Eight Immortals is the main concern of this paper.

There is uncertainty as to the date of the first appearance of the Eight Immortals. Some studies propose the Sung period; others, the Yüan. The disagreement about the origin of the group is complicated by numerous seemingly inconsistent sources. One of the difficulties in clarifying the issue is that there were several senior groups of Eight Immortals prior to the formation of the junior coterie, and each could be easily confused with the other. The term pa-hsien or the "Eight Immortals" emerged as early as the Eastern Han (25–220), in a Chinese Buddhist text, in which the term may refer to Taoist immortals in general.[4]

One early group is associated with Liu An (179–122 B.C.), a Western Han prince who, according to tradition, was once visited by eight mysterious elders who demonstrated various supernatural miracles. This clique was called the "Eight Worthies of Huai-nan." Another early group, known as the "Eight Immortals of Shu," included the reputed founder of Taoism, Lao-tzu, the Celestial Master Chang Tao-ling (34–156), and, oddly enough, the Confucian scholar Tung Chung-shu (179–104 B.C.). All the members in this group were associated with the Shu area either by birth or because they lived there. Yet another senior coterie consists of the great T'ang poets Li Pai (701–762) and He Chih-chang (659–744), who were famous for their indulgence in wine. Alcohol not only aroused their poetic creativity, but also earned them the title "Eight Immortals of Wine." During the Sung period, pa-hsien became a familiar term, and was often used in the names of buildings, tea shops, bridges, and flowers.

The proliferation of groups of Eight Immortals has provided scholars with ample material to disagree with one another. The two current views about the date of the origin of the junior group (Sung or Yüan) are the result of speculations based on such inconclusive sources. The difficulty of resolving this issue has led at least one scholar to declare that a "scientific, historical approach will be out of

question."[5] Since the beaten path has led nowhere, it seems sensible to find a different way.

5. Richard F. S. Yang, "A Study of the Origin of the Legend of the Eight Immortals," p. 10.

The difficulty may be resolved by analyzing the inner structure of the group: its organizational principle, hierarchy, members, evolution, and belief system. It should be examined in the light of the history of Taoism, in order to determine when the formation of the structure was possible.

Among the several extant versions of the junior group of Eight Immortals in literature, drama, and the visual arts, the earliest dates to the early Yüan. The individuals in the different versions vary. Some appear in all versions, and can therefore be called "regulars"; others are present in only some versions, and can be labeled "irregulars." The regulars are Chung-li Ch'üan, Lü Tung-pin, Li T'ieh-kuai (Iron Crutch Li), Han Hsiang Tzu (Master Han Hsiang), and Lan Ts'ai-he; the irregulars include He-lan Hsien (Immortal He-lan), Hsüan-hu Tzu (Master Dangling Pot), Hsü Shen-weng (Immortal Hsü), Ts'ao Kuo-chiu (Emperor's Uncle Ts'ao), Chang Kuo Lao, Chang ssu-lang, and He Hsien-ku (Immortal Lady He). The total number of individuals is twelve, but the group itself never grows larger than eight. This indicates that the organizational structure of the group follows strictly the model of the senior groups of Eight Immortals, in which only eight figures from a larger pool of candidates were selected at one time. The development of the group is well illustrated by four works of art from the Yüan dynasty: two hanging scrolls in the Chion-in, a Pure Land Buddhist temple in Kyoto (figs. 11.1, 11.2); a mural from the Yung-le Palace, Shansi (fig. 11.3); and a k'e-ssu textile scroll, in the Palace Museum, Beijing (fig. 11.4).

The Chion-in Paintings: Formation and Function

The two Chion-in scrolls (figs. 11.1, 11.2), which apparently form a pair, are by Yen Hui, who was active from the late Southern Sung to the Yüan Ta-te era (1297–1307). It is not clear when and how the paintings found their way to the temple in Japan. Neither work is dated, but one of the scrolls (fig. 11.2) bears two seals of the painter: Yen Hui and Ch'iu-yüeh.

The painting shown here on the right (fig. 11.2) portrays Li T'ieh-kuai or Iron Crutch Li, whose real name is Yüeh Shou in the Yüan play "Li T'ieh-kuai." This play is essential to our understanding of Li and his role in the group. In the play, Yüeh Shou was a typical petty clerk in a local government who abused his power. One day he victimized an elderly man, who turned out to be an imperial censor investigating abusive local officials. Li was scared literally to death. In the netherworld, he was about to be thrown into a cauldron filled with hissing oil when Immortal Lü Tung-pin came to his rescue. He was allowed to return to the human world, but his corpse, which he would need as the abode for his returning soul, had already been cremated by his wife. Fortunately, the corpse of a butcher, lame in one leg, was found as a substitute, and Li returned to this world in the donated body of the butcher. In the painting, Iron Crutch Li sits on a rock, resting his newly appropriated body. He looks up to the upper left, where his incarnated soul is departing on a wisp of air issued from his mouth.

The other Chion-in scroll (fig. 11.1) shows another immortal seated in the foreground. His left arm and hand support a three-legged toad, who hugs him on his right shoulder and rests its third leg on his head. In his left hand, the immortal holds a large peach.

The two paintings have not been identified as part of an Eight Immortals set or as derivatives from such a set; nor has the identity of the immortal with the three-legged toad been established. In Japanese publications, the figure is usually called the "Toad" or the "Toad Immortal." The misshapen toad is regarded as an evil creature, and the immortal associated with it is consequently suspected of "black magic."[6] No immortal in China is known by either of these names. The validity of the modern titles rests on the declaration that there is no known literary source for the image.[7]

Among the candidates who might be identified with the "Toad Immortal," the leading contender has been Liu Hai-ch'an, because his name means literally "Liu, the Sea Toad." This connection created a new iconography for Liu. He was given a new symbol: a string of coins (fig. 11.5), which was misappropriated from one of the Eight Immortals, Lan Ts'ai-he, who was known for dragging a string of coins casually on the ground when begging in streets. The act symbolically shows Lan's utter contempt for money, which immortals do not need anyway. Once the string of coins changed hands, however, its significance also changed. It was reassigned to Liu Hai-ch'an to signify Liu's enlightenment by Immortal Chung-li Ch'üan, who allegedly succeeded in stacking up ten eggs on one coin to allude to the precariousness of human existence. In later images, the toad grew much larger in size than Liu himself, and Liu's name was also shortened to "Liu Hai" or "Liu, the Sea." When the new name became popular and the original was forgotten, Liu Hai gained independence from Liu Hai-ch'an. The new incarnation is best known as the subject "Liu Hai Playing with the Toad." But he is now twice removed from the original "Toad Immortal."

The mysterious "Toad Immortal," who since Ming times has been shrouded in layers of innovative interpretation and imaginative re-creation, is actually He-lan Hsien or Immortal He-lan, an almost forgotten irregular in the group of Eight Immortals. His full name is He-lan Ch'i-chen (also known as He Tzu-chen). A Taoist master of the late Five Dynasties (907–60) and early Northern Sung (960–1127), he was a friend of a Sung prime minister, and, in 1005, a guest of Emperor Chen-tsung (r. 998–1022), who wrote two poems for him and granted him a title and various gifts. He died in 1010. His biography in the official Sung history, written by Confucian historians less influenced by rumor and legend, presents him as a Taoist eccentric, not an immortal.[8] But in Yüan popular belief, he was indeed an immortal, and he achieved immortality by devouring a three-legged golden toad:

In White Deer Abbey on Mount Li, there is a Toad Well, in which there was a three-legged toad of golden color. 'This is a meat fungus,' exclaimed Master He-lan when he saw it. He cooked and ate it, whereupon he flew up to the sky in broad daylight.[9]

6. See Fujita Shin'ya, "Yen Hui fude 'Gama Tetsukai zu' to sono Nihon ni okeru tenkai," in Nihon bijutsushi no suimyaku (Tokyo: Pelikan sha, 1993), pp. 844, 847.

7. Ibid., p. 843.

8. See T'o T'o et al. comp., Sung shih (Beijing: Chung-hua shu-chü, reprint 1977), chüan 462, p. 13515.

9. Chih-i, quoted in Lo T'ien-hsiang, Lei-pien Ch'ang-an chih (preface dated 1298) 7, reprint (Beijing: Chung-hua shu-chü, 1990), vol. 1, p. 344.

The story of He-lan Hsien's devouring a golden toad might have been a literal interpretation of a Taoist practice in the internal elixir, in which "golden toad" represents the "essence" (chen-ching). This practice is mentioned by the Southern Sung scholar-official Li Shih (1108–1181) in a poem:

> I have heard that the delicacy of old toad is a drug
> That can turn even grass into golden bud;
> But would it be better to close [my] mouth and nourish internally
> To replace your [toad's] ugly substance and nurture [my internal] bud.
> Riding you, I shall fly to the palace in the moon
> And descend to see the mulberry sea that reaches the clouds beyond the sky.[10]

10. Li Shih, Fang-chou chi 2.14a, reprint in Ssu-k'u ch'üan-shu (Taipei: Shang-wu yin-shu kuan, 1983) (hereafter SKCS), vol. 1149, p. 551b.

According to Li Shih, the toad came from the Palace of Ch'ang-e on the moon. Both Ch'ang-e and the toad are familiar subjects in Han art, as seen, for example, in the famous banner painting from the Ma Wang Tui tomb no. 1. The toad is a regular member in the paradise of the Queen Mother of the West. On an Eastern Han (25–220) carved pictorial tile depicting life at the court of the Queen Mother of the West, the toad is given a central role: it stands erect on one leg, performing a dance before the entire court assembly (fig. 11.6). The dance is being watched attentively by a crow, on the left, who stands on not two but three legs. Since three legs were regarded as a true sign of the supernatural, the four-limbed toad soon sacrificed one of his legs in order to display his divine nature.

In the Chion-in painting, Immortal He-lan holds a large peach in his left hand, which is referred to in a poem by the early Sung Taoist poet Ch'en T'ao:

> Riding a phoenix, Tzu-chin flew over the ancient Lo Valley,
> Once again, Immortal He-lang's [He-lan's] peach turns ripe.
> The music of Three Pure Ones was played at Sung Mountain,
> The Five-colored cloud descended before the imperial garden.[11]

11. Quoted in Shen Fen, Hsü hsien-chuan 1.13b-14a, in Tao-tsang (Shanghai: Han-fen lou, 1923–26) (hereafter TT), p. 138.

He-lan's membership in the group of Eight Immortals is corroborated by literary sources. He is listed with seven other immortals in a poem in a Yüan collection by an anonymous Ch'üan-chen Taoist. Together, they form the earliest known congregation of the Eight Immortals:

> Chung-li of Han times is the leader.
> Lan Ts'ai-he is an actor.
> Dangling Pot [Hsüan-hu Tzu] does not fetch wine.
> Iron Crutch Li's body is consumed in a fire.
> Immortal He-lan converts Emperor's Uncle Ts'ao.
> Master Han Hsiang Tzu can make instant wine.
> Drunken three times at the Yüeh-yang Tower,
> Lü Tung-pin converts the spirit of a green willow.[12]

12. Tzu-jan chi 11a, in TT, p. 787.

13. Tuan Ch'eng-shih, Yu-yang tsa-tsu 19.4b-5a, in SKCS, vol. 1047, p. 760; also see Liu Fu (c. 1040–after 1113), Ch'ing-so kao-i ch'ien-chi (after 1077) 9, reprint in Pi-chi hsiao-shuo ta-kuan (Taipei: Hsin-hsing shu-chü 1985) (hereafter PHT), series 9, vol. 5, p. 3034.

Wine is the unifying theme of the poem. In order to conform to this theme, the immortal Han Hsiang Tzu is portrayed as a magician of wine. According to some T'ang and Sung literary sources, Han was a nephew of the great T'ang official and writer Han Yü (768–824).[13] He had been known since the late T'ang period for his magical power of making flowers grow and bloom instantly. During the T'ang, the appreciation and cultivation of flowers, particularly the peony, were in vogue, especially in Lo-yang, the eastern capital, where even Buddhist monks were enthusiastic gardeners and Buddhist temples more famous for their peonies of rare colors than for their "Three Jewels" (the Buddha, the clergy, and Buddhist teaching). This love of flowers provided fertile ground for the growth and spread of rumors about Han Hsiang Tzu's ability to conjure up "instant flowers." But in the Yüan poem quoted above, Han is praised instead for his ability to brew "instant wine." Whether or not they are directly associated with wine, all the Eight Immortals in the poem are alluded to as drunkards, as suggested by the poetic format chosen for the poem, known as tsui-t'ai-p'ing ("drunk with peace"). The poem's allusion to wine seems to infer that the direct historical model for the Yüan group of Eight Immortals is the T'ang assembly of the Eight Immortals of Wine.

The Chion-in scrolls, each featuring a single immortal, follow the traditional format used for depicting immortals as individualists. During the Sung dynasty, portraits of immortals were often hung in wine shops and sold in painting stores in markets and in fortunetellers' stalls in Taoist temples. Sales were particularly brisk on major holidays. Portraits were bought and collected by people from all social classes, including scholar-officials like Su Hsün (1009–1066), who is numbered as one of the Eight Great Writers of the T'ang and Sung periods. He had two famous sons, Su Shih (1037–1101) and Su Ch'e (1039–1112). Like him, both were scholar-officials and were counted among the Eight Great Writers. Su Hsün believed that his good fortune of having two extraordinary sons came from the blessing of a portrait of an immortal:

In the Keng-wu year of the T'ien-sheng reign (1030), on the ninth day of the ninth month, I went to Wu-ai Tzu's fortunetelling stall in the Jade Bureau Abbey, and saw a portrait whose brushwork was pure and unusual. [Wu-ai Tzu] said that it was the portrait of a certain Immortal Chang, who would always answer the needs of the worshiper. Therefore, I took a jade ring off [my gown] and exchanged it for the picture. At that time, I did not have a son, so every morning I would offer incense and pray before the portrait. After a few years, I got not only Shih but also Ch'e, and both of them by nature loved books. This made me realize how helpful the immortal can be, and that Wu-ai Tzu's words are true. Therefore, I record my story so that later worshippers will pay due respect to this immortal.[14]

14. Su Hsün, Chia-you chi 15.11a-b, in SKCS, vol. 1104, p. 962b.

The compositions of the two Chion-in paintings suggest that the scrolls were originally intended as a pair. One painting appears to be a reflection of the other in

the orientation and complementary postures of the figures, the diagonally parallel positions of the head and hands, and the placement of the foreground boulders. Literary sources, however, record no special relationship between the two subjects of the paintings, Li T'ieh-kuai and He-lan Hsien. Why, then, are they paired in these paintings? And why in a Buddhist temple? Since they have been transmitted in the Pure Land sect, a Pure Land Buddhist view may shed light on their pairing.

The two scrolls highlight the two most important aspects of salvation in Pure Land Buddhism, redemption and paradise. From the Buddhist point of view, among the Eight immortals, only Li can symbolize redemption because he alone has experienced Hell; and only He-lan can show the way to paradise because he is the only one equipped with symbols of paradise, such as the toad and the peach, which originally were part of the paraphernalia of the Queen Mother of the West.

It is not clear who made the match first—Taoists or Buddhists. According to the Taoist poem quoted above, He-lan would be more reasonably paired with Emperor's Uncle Ts'ao; but from the Pure Land point of view, He-lan and Iron Crutch Li are a perfect pair for salvation. I suspect that the two immortals were first appropriated by Pure Land Buddhists to serve in Buddhist funeral rites. Their strong Buddhist affiliation is also seen in a Ming painting, *Four Immortals Honoring The God of Longevity,* by Shang Hsi (active 2nd quarter of 15th century), in the National Palace Museum, Taipei (fig. 11.7). Here, the two immortals, at the right, are accompanied by the two Buddhist saints Han-shan and Shih-te. The employment of the two immortals is a Buddhist contribution to the function of the group. As Tanaka Issei's study on modern Chinese local theater illustrates, Taoist plays featuring the Eight Immortals are often performed to help ensure salvation and redemption for the deceased.[15] This practice probably began from the pairing of the two immortals to symbolize salvation. But the original function of the group, as we shall see below in the Yung-le Palace mural, was to celebrate immortality.

15. Tanaka Issei, Chûgoku gôson saishi kenkyû *(Tokyo: Tôkyô Daigaku, Tôyô Bunka Kenkyûjo, 1989), pp. 780–96.*

The Yung-le Palace Mural: Mural, Drama, Ritual, and Language

The Yung-le Palace was the foremost ancestral temple of the Ch'üan-chen Taoist sect. Dedicated to the patriarchal immortal of the sect, Lü Tung-pin, the temple was originally constructed at, Lü's reputed birthplace, the town of Yung-le, in southern Shansi, in the late 1240s and early 1250s. It consists of three major halls: the San-ch'ing Hall for the Taoist triad, the Three Pure Ones; the Ch'un-yang Hall for Lü Tung-pin; and the Ch'ung-yang Hall for the founder of the sect, Wang Che, and his six major disciples, known as the Seven Perfected. In front of the first hall is a gate, built in 1294, which also served as a makeshift stage for theatrical performances. Taoist plays, such as "Lü Tung-pin Drunken Three Times at the Yüeh-yang Tower" and "Lü Tung-pin Converts the Willow Spirit," were performed on the stage, as depicted in a mural, part of an Eight Immortals composition, in the temple.

The Eight Immortals painting is in the second hall (fig. 11.3). Painted by pupils of the famous Shansi painter Chu Hao-ku, in 1358, it is part of the mural program in the hall celebrating Immortal Lü Tung-pin. The painting is the climax of the entire program, and occupies a space of special significance on the pilgrim route—

the area above the rear door of the hall. It is the final scene viewed by the pilgrim before he or she completes worship in the hall and exits from the rear door to proceed to the third hall.

The subject of the concluding scene of the mural is the Eight Immortals crossing a billowing sea. The group is led by Chung-li Ch'üan, who keeps himself above water by gliding on a bamboo branch. The other immortals manage to stay afloat by converting their attributes or aquatic creatures into means of transportation: Lü Tung-pin slides on his sword, Iron Crutch Li skates on his crutch, Emperor's Uncle Ts'ao navigates a turtle, Immortal Hsü sails on a fish, Lan Ts'ai-he drifts along on a drum, and Han Hsiang Tzu treads on floating flowers. Standing behind Lan Ts'ai-he is Chang Kuo Lao. Their destination is the western paradise, where they will attend the Queen Mother of the West's Banquet of Peaches.

Beneath the mural of the Eight Immortals are two painted figures: a willow spirit and a pine spirit. They serve as attendants of Lü Tung-pin in the Eight Immortals group above; the willow spirit is the hero in the two Taoist plays "Lü Tung-pin Drunken Three Times" and "Lü Tung-pin Converts the Willow Spirit." The mural and the plays share many similarities. In both, the Eight Immortals appear in the final scene, the group leaders are Chung-li Ch'üan and Lü Tung-pin, and the composition of the group is the same.

The influence of Ch'üan-chen plays on the mural is partly attributable to the fact that the Yung-le Palace was once a center for the performance of such plays. Most Ch'üan-chen plays with the Eight Immortals ended with the presentation of the group, a popular theatrical conclusion that is explicitly evoked in the mural. The depiction in the painting suggests that in live performances actors moved across the stage from east to west on an imaginary sea.

Why was the theme of the immortals crossing a sea adapted as the concluding scene of the mural program? What was its significance, and why was it so popular? The theme is often understood as a narrative description of the immortals' display of their magical powers, reflected in the Chinese characters used to describe the scene—*kuo* (passing), as in the phrase "Pa-hsien kuo-hai" (the Eight Immortals crossing the sea), or *p'iao* (floating), as in "Pa-hsien p'iao-hai" (the Eight Immortals floating on the sea).

I would propose that the theme is a ritual statement, a depiction of a ritual act, rather than a narrative. Yüan Taoist plays with the Eight Immortals can be seen as a series of symbolic acts that culminates in the ritual act of the Eight Immortals crossing a sea. No matter how different their plots may be, the plays usually end with the presentation of the Eight Immortals, as if it were a prescribed act. Since the mural is inspired by the ritual act in the plays, it should be understood as a depiction of the ritual act.[16] But what is the significance of this ritual act?

The ritual act of crossing a sea has a linguistic root. The mural is a pictorialization of a type of linguistic symbolism that may be called "homophonic symbolism." It has a surface meaning and an underlying meaning, each of which is expressed verbally with the same sound but is written with different characters. Unlike a pun, whose multiple meanings are intended to be appreciated all at once, in homophonic

16. For the relationship between ritual and play, see Piet van der Loon. "Les origines rituelles du théâtre chinois," Journal Asiatique, vol. 265 (1977), pp. 141–68.

symbolism the surface meaning is explicitly pronounced while the deeper meaning is subtly hidden. The surface meaning is only a camouflage, whereas the deeper meaning conveys the true message for the initiated.

In China's elite culture, the written word is more highly valued than the spoken word, as evidenced by the fact that the Chinese writing system is ideographic, as opposed to alphabetic systems of writing which are transcriptions of sound. But in homophonic symbolism, the sound, which can be understood even by the illiterate, is given precedence over the written word. The phonocentric nature of the symbolism, or its emphasis on sound, indicates that its usage should be identified with popular culture.

Homophonic symbolism can be enacted in speech, in prescribed ritual, in drama, and in visual art. Among these forms, symbolism in speech and in drama is easier to observe, since both use language, the foundation of the symbolism. In visual art, it is more nebulous because language is withdrawn.

A homophonic symbol that was particularly popular during the Yüan is *tu*. Its surface meaning is "crossing water," while its hidden message is "salvation through conversion." The expression of this symbol in speech, ritual, and drama is best illustrated in the play entitled "Ch'en Chi-ch'ing is Intrigued to Embark on a Bamboo-Leaf Boat," by the late Yüan playwright Fan Tzu-an. In the play, Lü Tung-pin converts the failed scholar Ch'en Chi-ch'ing by helping him across a body of water. The word ferry (*tu*) is used in a conversation between the two:

> Ch'en Chi-ch'ing: *Please ferry me across the river.*
> Immortal Lü: *Who are you who asks me to ferry? If you don't tell, I won't ferry.*[17]

The word *tu* used by the immortal is a homophonic symbol; his act of ferrying is also symbolic, and the whole play is an elaboration of the symbol up until the last scene, when Imperial Lord Tung-hua pronounces the Jade Emperor's order that the Eight Immortals and Ch'en Chi-ch'ing go to the West to attend the Queen Mother's Banquet of Peaches.

The symbolic act of ferrying also appears in the play "Lü Tung-pin Drunken Three Times," in which Lü persuades his prospective convert to embark on a boat: "You and I row the boat and hoist the sails/Till we reach the P'eng-lai Palace and Fang-chang Mountain."[18] The symbolism is clearly revealed in Lü's song, although the word *tu* is not used.

The symbol *tu* occurs in both speech and ritual in the play "Lü Tung-pin Converts the Willow Spirit," in which the neophyte asks Lü Tung-pin to ferry him across a river:

> The Convert says: *Please ferry me across the river.*
> Lü Tung-pin answers: *To ferry you is easy. But you must first extinguish the Fire of Ignorance in your heart. Then I will ferry you across.*[19]

In normal situations one does not have to extinguish one's "Fire of Ignorance" in order to cross a river; obviously the word "ferry" (*tu*) is used here symbolically.

17. Fan Tzu-an, Ch'en Chi-ch'ing wu-shang chu-ye chou tsa-chü, reprint in Yüan-ch'ü hsüan, comp. Tsang Chin-shu (Beijing: Chung-hua shu-chü, 1961), vol. 3, p. 1052.

18. Ma Chih-yüan, Lü Tung-pin san-tsui Yüeh-yang Lou tsa-chü, reprint in Yüan-ch'ü hsüan, vol. 2, p. 624.

19. Ku Tzu-Ching, Lü Tung-pin san-tu ch'eng-nan liu tsa-chü, reprint in Yüan-ch'ü hsüan, vol. 3, p. 1195.

Since the two plays are direct textual sources for the Eight Immortals mural in the Ch'ung-yang Hall, their symbolic use of the word *tu* helps us to understand the mural. The image of the group crossing the sea is a pictorial rendition of the homophonic symbol *tu*, whose real meaning is to offer the proselyte the way to the Taoist paradise. The common linguistic root gives the same meaning to the mural, the spoken word, the ritual act, and the dramatic performance, and makes the different forms of expression compatible.

The Eight Immortals mural, which is located on the pilgrim route at the rear of the hall, creates a ritual space that involves the worshiper in the symbolic act of *tu* before he or she leaves the hall. The treatment of allows the worshiper to become a part of the action. This effect is achieved by limiting the depiction of the shore to the two extreme corners of the foreground, thereby blocking the horizontal extension of the space to stress the depth of the seascape, which encompasses both the immortals and the worshiper. In other words, width is sacrificed for depth, so that the pictorial space in the mural opens up, inviting the worshiper to become, in effect, a witness or even a member of the group.

For those unaware of its concealed message, the picture may seem only amusing. But for the initiated, the painting offers a promise—if one is devoted to the immortals, one will someday be able to join them on P'eng-lai Island:

> Visiting the Seven Perfected,
> I travel to the Blissful Island;
> Following the Eight Immortals,
> I am going to the P'eng-lai Isle.[20]

The Textile Scroll in the Palace Museum, Beijing: the Eight Immortals and the Ch'üan-chen Sect

The subject of the Eight Immortals on the paradisiacal island of P'eng-lai is portrayed in a beautiful k'e-ssu textile scroll in the Palace Museum, Beijing (fig. 11.4). Once regarded as a Sung work, it is now believed to be a product of the late Yüan, based upon the weaving technique.[21] The reappraisal of the date seems reasonable from the standpoint of the iconography, as the selection of the immortals is typical of the late Yüan and early Ming.

The immortals' island is strewn with flowers, plants, and garden rocks, all stylized to suggest their rarity and otherworldliness. A spotted deer watches with curiosity as the immortals gather to greet the God of Longevity, who descends on a crane from the clouds above. The immortals stand in two groups: on the left are Lü Tung-pin, carrying a sword; Han Hsiang Tzu, holding a flower; and Lan Ts'ai-he, with a clapper. On the right is Hsü Shen-weng, with an iron flute, and behind him are Immortal Lady He, Chung-li Ch'üan, Chang Kuo Lao, and Iron Crutch Li. The group is identical to the one portrayed in the Yüan play "A Bamboo-Leaf Boat."

The combination of irregulars in this third version of the development of the Eight Immortals group—Chang Kuo Lao, Hsü Shen-weng, and Lady He is different from that in either the second version, the Yung-le Palace mural—Chang Kuo Lao,

20. *Yüeh Po-ch'uan, Lü Tung-pin tu T'ieh-kuai Li Yüeh tsa-chü, reprint in* Yüan-ch'ü hsüan, *vol. 2, p. 510.*

21. Chung-kuo mei-shu ch'üan-chi, kung-i mei-shu pien 7, yin-jan chih-hsiu 2 (Beijing: Wen-wu Ch'u-pan she, 1987), p. 7.

Hsü Shen-weng, and Emperor's Uncle Ts'ao—or in the first version—Dangling Pot, Immortal He-lan, and Emperor's Uncle Ts'ao. Their presence or absence in the different versions of the junior group of Eight Immortals does not simply reflect a waxing and waning of their fortunes, but more importantly, the expressions of religious thinking that constantly redefined the function and purpose of the group. The evolution from the early to the late versions can be generalized as the continuous reinforcement of the leadership and prestige of two core members, Chung-li Ch'üan and Lü Tung-pin.

Emperor's Uncle Ts'ao, who in the first version is the disciple of Immortal He-lan, becomes the convert of Immortal Lü in the second version, as depicted in a Yung-le Palace mural. He-lan is consequently released from the second version; Dangling Pot, who is not associated with the two core members, is also discharged. They are replaced by Chang Kuo Lao and Hsü Shen-weng, who are more frequently mentioned in Sung sources, and thus more popular.

Chang Kuo Lao was known as a Taoist recluse active in southern Shansi during the reign of the T'ang emperor Hsüan-tsung (r. 712–56). During a visit to the court in 733, he dazzled the emperor and baffled court magicians with his miraculous feats. He is customarily identified with his white donkey, which could travel thousands of miles a day and, when not in use, could be folded up like a piece of paper and stored in a box. Chang's visit to Hsüan-tsung's court was recounted in several T'ang period books, including one by Prime Minister Li Te-yü (787–850), and is the subject of several recorded Sung and Yüan art works. An extant painting by the Yüan scholar-official Jen Jen-fa (1255–1327) shows a meeting between the emperor, seated on a throne in the center, and the Taoist, seated on a stool on the right (fig. 11.8). During the meeting, the donkey unexpectedly escapes from the box and runs toward the emperor, who is more startled than amused. The incorporation of the magician into the Eight Immortals brought much charm, prestige, and popularity to the group.

Hsü Shen-weng, or Immortal Hsü, whose original name was Hsü Shou-hsin (1033–1108), was probably the most famous late Northern Sung prophet. According to his Southern Sung hagiography, in 1051, at the age of nineteen, he became a temple sweeper at a local Taoist temple in Hai-lin, T'ai-chou (modern T'ai-chou, Kiangsu Province). When he was about forty, he became a disciple of a Taoist master in the temple and began fortunetelling, but he declined to be ordained as a Taoist priest and continued to sweep the floor for the temple.[22] However, his job was then viewed symbolically as one of spiritual purification, and he was believed to be a true prophet. Emperor Che Tsung (r. 1086–1100) consulted him about the choice of an imperial heir, and, as reported by the Hanlin Academician Ts'ai T'ao, he predicted Hui-tsung (r. 1101–25).[23] He was given a Taoist title by Hui-tsung in 1103; he was frequently summoned to the court,[24] and was known as one of the emperor's closest Taoist advisors.[25] His admirers included Ch'in Kuan (1049–1100), a great Sung literary genius, and Ch'in's even more famous friends, Su Shih and Su Ch'e. Ch'in Kuan and Su Shih visited him personally, as we are told by Su Ch'e.[26]

22. Hsü-ching ch'ung-he hsien-sheng Hsü Shen-weng yü-lu (prefaces dated 1158,1187) 1.1a-2b, in TT, p. 997.

23. Ts'ai T'ao, T'ieh-wei shan ts'ung-t'an (ca. 1130), 1.1b–2a, reprint in SKCS, vol. 1037, pp. 553b–54a.

24. Hsü-ching ch'ung-he hsien-sheng Hsü Shen-weng yü-lu, 1.1a, in TT, p. 997.

25. Hsüan-he i-shih (ca. 1300?), 1.10a–b, in PHT series 14, vol. 1, pp. 209–10.

26. Su Ch'e, Lung-ch'uan lüeh-chih, 10.3a–b, in PHT series 8, vol. 2, pp. 841-42.

In Sung sources, Immortal Hsü is never said to have any relationship with Lü Tung-pin. However, in the Yüan play "Lü Tung-pin Drunken Three Times," he becomes Lü's assistant, and in a mural in the Ch'un-yang Hall at the Yung-le Palace, he is portrayed as Lü's disciple. His inclusion in the Eight Immortals, like the exclusion of He-lan, strengthens Lü's leadership role in the group.

The third version of the Eight Immortals Group is based on the second version, with the replacement of Emperor's Uncle Ts'ao, a shadowy figure unrecorded in Sung legend, by the Immortal Lady He, who was well known as a prophet in Yung-chou or Heng-chou (southern Hunan Province) during the Sung. In her childhood she was believed to have met a mystic with a peach, a taste of which gave her the insight to tell people's fortune. Villagers built a temple for her and called her Immortal Lady He.[27] She was active probably in the second quarter of the eleventh century, and attracted the attention of many scholars and officials, including the prominent statesman, historian, and writer Ou-yang Hsiu (1007–1072). Writing sometime between 1054 and 1072, Ou-yang Hsiu recounted that he had recently seen a report from her native prefecture, Heng-chou, informing the court that she had died without any supernatural sign. His guests from Heng-chou also told him that in her last years she looked thin, dark, and fragile, with many wrinkles. She and another so-called immortal had been closely observed by the local authorities.[28] About a century later, it was reported that her portrait still hung in a temple dedicated to her.[29]

In the late Northern Sung, Lady He was known as an acquaintance of Lü Tung-pin, but in the Yüan she became Lü's pupil. The mystic who enlightened her in her childhood was identified with Lü in Ch'üan-chen sources, including one of the murals in the Ch'un-yang Hall of the Yung-le Palace. Even though she is depicted in one of the paintings in the hall, she is not included in the second version, the Eight Immortals mural. Her final elevation into the third version was probably to make the group more balanced in terms of the yin and yang principle.

Among the five regulars, Chung-li Ch'üan and Lü Tung-pin are the masters; the other three, like the irregulars in the second and third versions, are their followers: Iron Crutch Li is saved from Hell by Lü; Han Hsiang Tzu is enlightened by Lü, according to Han's "autobiography," which is no doubt an early Yüan work;[30] and Lan Ts'ai-he becomes a convert of Chung-li Ch'üan, in a Yüan play.[31] The belief system and hierarchy of the group from the early to the late versions belong strictly to the Ch'üan-chen sect. Therefore, the group was no doubt created and developed by Ch'üan-chen followers.

The group's association with the Ch'üan-chen sect is supported by another fact: while in all the Yüan versions the group leaders are always Chung-li Ch'üan and Lü Tung-pin, in the Sung sources, there is no group, to say nothing of group leaders. Lü Tung-pin is by far the most popular figure in Sung sources, but there he is associated with only two of the other figures to be found in the later group: Chung-li Ch'üan and Immortal Lady He. Chung-li Ch'üan is occasionally said to be his teacher, but they are rarely mentioned together; Lady He is described as his acquaintance, but becomes a member of his circle only after the formation of the

27. Wei T'ai (ca. 1050–1110), Tung-hsüan pi-lu (ca. 1090), 14.7a–b, in SKCS, vol. 1037, p. 497b.

28. Ou-yang Hsiu, Ou-yang Hsiu ch'üan-chi, reprint (Taipei: Shih-chieh shu-chü, 1961), p. 1213.

29. Tseng Ming-hsing (1120?–1175), Tu-hsing tsa-chih (1175), 4.8b–9a, in SKCS, vol. 1039, p. 548.

30. Han Hsien chuan, in T'ao Tsung-i (active 1360), Shuo-fu 112b.1a–22a, in SKCS, vol. 882, pp.468b–79a.

31. Han Chung-li tu-t'o Lan Ts'ai-he tsa-chü, reprint in Yüan-ch'ü hsüan wai-pien (Taipei: Chung-hua shu-chü, 1967), vol. 3.

group. In Sung sources, all other immortals operate independently from each other, except Iron Crutch Li and Emperor's Uncle Ts'ao, whose legends had yet to be created or recorded. Evidently, the group could not have been formed during the Sung. All clues seem to point to Yüan drama as the source of its creation.

The ascendance of Chung-li Ch'üan and Lü Tung-pin began when the founder of the Ch'üan-chen sect, Wang Che (1112–1170), claimed Lü Tung-pin as his teacher and Chung-li Ch'üan as his ancestral teacher. (Wang and his major disciples never mention the group in their writings, however). As the sect became increasingly influential, its two patriarchs consequently became the leading immortals. They were promoted particularly in Yüan drama, which Ch'üan-chen Taoists used ingeniously and successfully for mass proselytizing. Since drama was the national pastime, the Ch'üan-chen immortals rapidly gained prominence throughout the country.

The evolution of the group can be described as an appropriation and transformation of popular T'ang and Sung immortals into a vernacular Ch'üan-chen Taoist pantheon. Compared with the formal Ch'üan-chen pantheon depicted in the first Hall of the Yung-le Palace, the popular pantheon in the second hall is colorful, humorous, and entertaining. While the formal pantheon was used in ritual and meditation by the clergy, the popular pantheon was painted for the masses to show them the road to the P'eng-lai paradise.

The popular and entertaining nature of the group finally led to the secularization of the pantheon, as seen in the textile scroll in the Palace Museum, Beijing (fig. 11.4). In Yüan Taoist plays, the popular pantheon takes its orders from the Jade Emperor, Imperial Lord Tung-hua, and the Queen Mother of the West, who are part of the formal Ch'üan-chen pantheon. In the textile scroll, the immortals hail the God of Longevity as their new chief, although he has no place in the Ch'üan-chen thearchy. With the appearance of this presiding deity from popular culture, the Eight Immortals have been reshaped into a group of comic entertainers whose new role is to celebrate birthdays and longevity.

Since the Ming dynasty, the Eight Immortals have been so thoroughly absorbed into popular culture that the group's original status as a Ch'üan-chen pantheon has been completely forgotten. It is even asserted that their gathering is entirely random (luan-tien), and has nothing to do with Taoism. On the other hand, it is precisely because of their reintegration into the popular culture that they have been ensured true immortality, outlasting the decline of the Ch'üan-chen sect at the end of the Yüan dynasty.

Figure. 11.1
Yen Hui, (active late 13th–early 14th century) He-lan Ch'i-chen. *Hanging scroll, ink and color on silk, 191.3 x 79.6 cm. Chion-in Temple, Kyoto. From Torao Miyagawa ed.,* Chinese Painting, *pl. 69.*

Figure 11.2
Yen Hui, (active late 13th-Early 14th century), Li Tieh-kuai. *Hanging scroll, ink and color on silk, 191.3 x 79.6 cm. Chion-in Temple, Kyoto. From Torao Miyagawa ed.,* Chinese Painting, *pl. 69.*

Figure 11.3
Anonymous, The Eight Immortals, *1358. Wall painting, Yung-le Palace, Jui-ch'eng, Shansi.*

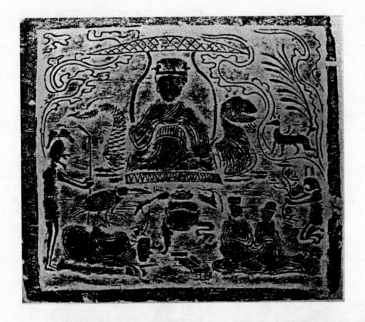

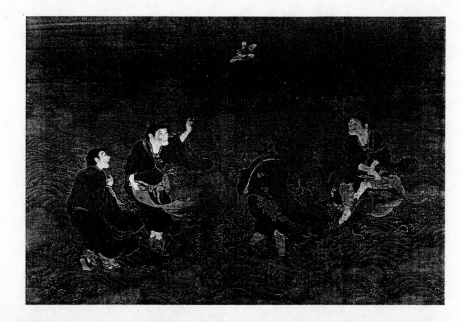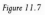

Figure 11.7
Shang Hsi (active 2nd quarter of 15th century), Four Immortals Honoring the God of Longevity, *1430s.*
Hanging scroll, ink and color on silk, 98.3 x 143.8 cm. National Palace Museum, Taipei.

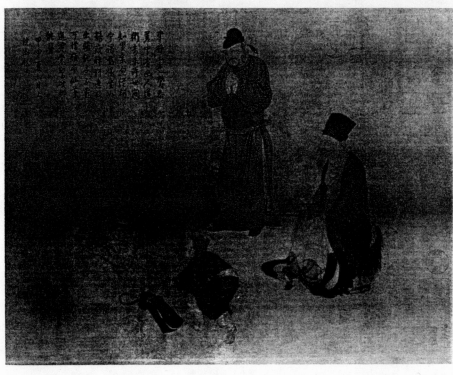

Figure 11.8
Jen Jen-fa (1255–1327), Ch'ang Kuo Lao Meeting Emperor Hsüan-tsung. *Handscroll, 28.8 x 134.7 cm. Palace Museum, Beijing. From Chung-kuo mei-shu ch'üan-chi, Hui-hua pien 5, pl. 36.*

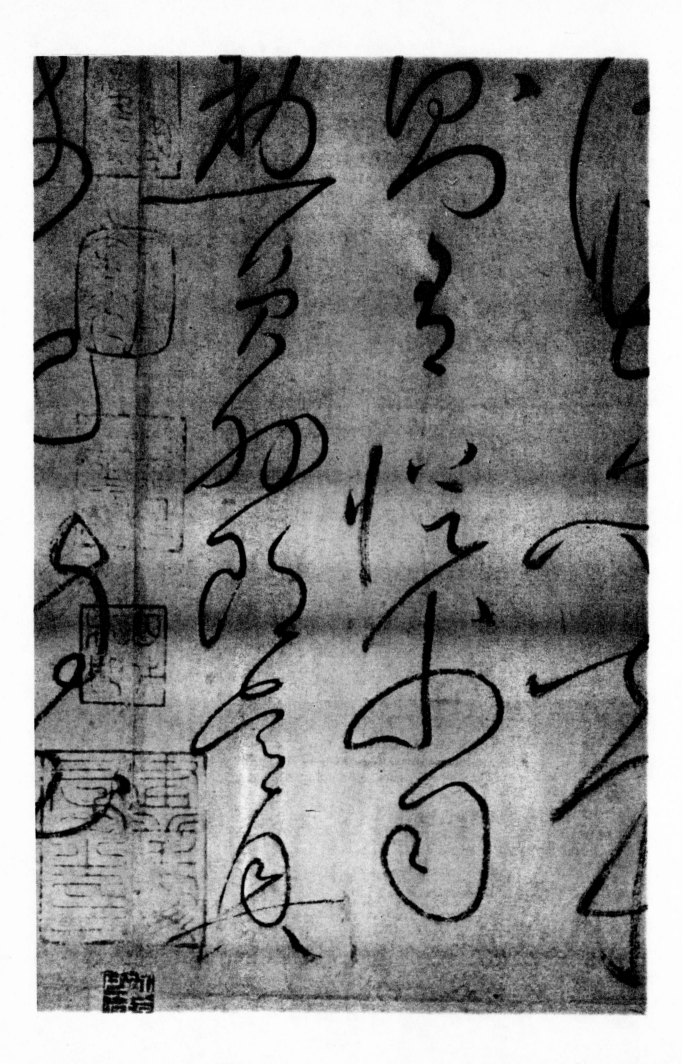

Buddhist Monuments of Yunnan: Eclectic Art of a Frontier Kingdom

Angela F. Howard

The selection of Chang Sheng-wen's *A Long Scroll of Buddhist Images* as one of the paintings in this exhibition offers the opportunity of scrutinizing the celebrated masterpiece of the twelfth century Ta-li Kingdom (modern Yunnan province). With its one hundred thirty-one remaining representations of Buddhist deities, the painting is a staggering visual inventory of devotional icons based on the different doctrines which found favor in Yunnan.[1] In Chang Sheng-wen's grand synthesis, quite a few of the images resemble those venerated in the Sung empire, but several display a disquieting "otherness," both in content and style. They are Yunnanese creations. I argue that this border state under the Nan-chao and Ta-li local monarchy, during approximately six centuries (650–1250), was wide open to not only the influence of China, but that of its peripheral Southeast Asian and Himalayan cultures. Especially in matters of Buddhism and Buddhist art, Yunnan appropriated from these cultures elements that were then transformed to look indigenous.

Using the evidence afforded by the *Long Scroll* and that present in other equally important Buddhist monuments of Yunnan, chiefly sculpture, I will explore the origin and mechanism of transmission of a number of icons, and the political implications of adopting foreign effigies. I am also interested in throwing light on the special content of Yunnanese Esoteric Buddhism, called A-cha-li Esoteric Buddhism, and its imagery. This aspect of the investigation will point to Tibet as a possible model, but also reveal how the foreign teaching was grafted onto native beliefs predating the spread of Buddhism.

I will conclude by introducing a tri-dimensional monument, the Dharani Pillar of Kunming, another complex work of synthesis contemporary with the *Long Scroll*. In the pillar, the use of Esoteric deities locked in a mandalic schema stresses once more the Tibetan link. The organization of the deities in a vertical progression with cosmological overtones reveals, however, possible connections with the monumental complexes (Buddhist and Hindu) created by Southeast Asian royal patrons, and suggests that Yunnan may have shared similar concerns in its monuments.

A comparative study of the *Long Scroll* and of the other extant Buddhist monuments of the Nan-chao and Ta-li kingdoms reveals a pattern of development in which certain factors are consistently present. These factors are the focus of my investigation.[2]

Buddhist Palladia and the Legitimacy of Power

In Yunnan, concepts involving the role of Buddhism in empowering a sovereign, and in legitimizing and guaranteeing the continuity of his rule, surfaced at the very

1. Major studies on the Long Scroll are by Helen B. Chapin, A Long Scroll of Buddhist Images, revised by Alexander C. Soper (Ascona: Artibus Asiae, 1971); Li Lin-ts'an, A Study of the Nan-chao and Ta-li Kingdoms in the Light of Art Materials Found in Various Museums (Taipei: National Palace Museum, 1982); Matsumoto Moritaka, Chang Sheng-wen's Long Scroll of Buddhist Images: A Reconstruction and Iconology (Ph.D. diss., Princeton University, 1976).

2. Li Lin Ts'an, A Study of the Nan-chao and Ta-li Kingdoms, p. 151. Yunnan's Buddhist monuments are investigated in Angela F. Howard, Li Kunsheng, and Qiu Xuanchong, "Nanzhao and Dali Buddhist Sculpture in Yunnan," Orientations vol. 23, no. 2 (February 1992), pp. 51–60; Angela F. Howard, "Buddhistische Monumente der Nanzhao-und der Dali-Konigreichs in Yunnan," in Der Goldschatz der Drei Pagoden, ed. Albert Lutz (Zürich: Museum Rietberg Zürich, 1991), pp. 40–67; Albert Lutz, Der Tempel der drei Pagoden von Dali (Zürich: Museum Rietberg Zürich, 1991).

inception of the Nan-chao monarchy. In Yunnanese art, these grounding principles are manifested in different ways. First, in the major Buddhist monuments (painting and sculpture), the rulers and his court are always portrayed. The royal presence signifies not merely the faith of the patrons, but expresses, above all, the recognition by the monarch that Buddhism was the source of his political power. Thus, the opening of the *Long Scroll* displays against the Ta-li landscape of the holy Tien-tsang Mountains the grand procession of warriors, high dignitaries, minor officials, and clergy led by the Emperor Tuan Chih-hsing (r. 1172–200) (fig. 12.1). At Shih-chung-shan, the Buddhist site 100 km. north of Ta-li opened by the Nan-chao dynasty in the ninth century, there are three representations of Nan-chao kings. As one example, King Ko-lo-feng (r. 748–79) is shown in full regalia and wearing a native "dragon-cage" ceremonial headdress as he presides over the court from his dragon throne (fig. 12.2). How fitting that Ko-lo-feng's posture and demeanor are not different from those of a Buddha. Furthermore, the presence in the group of two officials in T'ang court costume, on either side of the niche, recalls a similar arrangement in a Buddhist paradise setting, where the seated lateral figures are Bodhisattvas. Second, from the Nan-chao outpost of Po-shen-wa-hei (now in southern Szechwan) originates the royal pageant of King Shih-lung (r. 859–77) and his retinue (fig. 12.3). As in every other Buddhist site of Yunnan, the cavalcade is one among a majority of religious representations incised on large boulders.[3] In all three groups, the proximity of the king to the deities and the fact that his portrayal, in some instances, is reminiscent of a Buddhist gathering, may even allude to the coexistence in the king's persona of his temporal and divine nature, although this inference is not supported by textual sources.

The legitimation of royal power by Buddhism took shape far beyond the inclusion of royalty in Buddhist monuments. While the Chinese emperor based his legitimacy on the Mandate of Heaven, the Yunnan monarchs, instead, grounded theirs on the will of Avalokitesvara (in Chinese, *Kuan-yin*). The possession of a special image, a palladia, conferred legitimate power on the ruler. As it is narrated in the scroll *Nan-chao t'u-chuan* (Illustrated History of Nanzhao), dated 947 (but actually a copy of a lost original painted in 899), an old monk, none other than Kuan-yin incarnate, arrived among the Meng tribe in the mid-seventh century, predicted their rise to the status of monarchs, and bestowed a special effigy of *Kuan-yin* as their tutelary deity.[4]

The *A-tso-yeh* "All Victorious" *Kuan-yin,* fashioned in gold during the Nan-chao period and found in 1978 inside the Ch'ien-hsün Pagoda of the Ch'ung-sheng Temple, Ta-li, is the most prominent example of the tutelary deity of the Nan-chao and Ta-li kingdoms (fig. 12.4). As the enduring objectification of sanctioned power, this effigy of Avalokitesvara was replicated through the successive dynasties (as late as the Ming dynasty), always retaining its distinctive stylistic traits. Examples are carved on Yunnan's mountainside, for instance, at Shih-chung-shan, and painted on the *Long Scroll*, in the frames 99 and 89 (a seated example).[5] Indeed, what mattered most was the continuity of that original myth.

A talismanic image as the symbol of royal empowerment, the deification of

3. Liang-shan Po-shen-wa-hei shih-k'e hua-hsiang tiao-ch'a tsu, "Liang-shan Po-shen-wa-hei shih-k'e hua-hsiang tiao-ch'a chien-pao," Chong-kuo li-shih po-wu-kuan kuan-li, no. 4 (1982), pp. 128–36.

4. A facsimile of the scroll is in Li Lin-ts'an, A Study of the Nan-chao and Ta-li Kingdoms, pp. 128–41.

5. Helen B. Chapin, "Yunnanese Images of Avalokitesvara," Harvard Journal of Asiatic Studies vol. 8 (1944), pp. 131–86; Li Yu-min, "Portraits of Kuan-yin in Chang Sheng-wen's Fan hsiang-chuan," Soochow University Journal of Chinese Art History, vol. 15 (July 1986), pp. 227–64. The Shih-chong-shan relief of A-tso-yeh Kuan-yin is in Angela F. Howard, "Buddhistische Monumente," p. 50.

kings, and the divine nature of power are concepts widespread among the cultures of the southeast Asian continent and archipelago. These beliefs and the worship of potent images, Hindu and Buddhist, were practiced (contemporaneously with the Kingdoms of Nan-chao and Ta-li) in the Khmer kingdom of Cambodia, in the Champa kingdom of Vietnam, and in the kingdoms of Indonesia, to single out the major cultures of the area.[6]

In the pre-Khmer period of Cambodia, under King Bhavavarman II (r. mid-seventh century), the palladia of Lokesvara or Avalokitesvara, the Lord of the World, was set up as the king's deity from which his power derived. Several stone and bronze images of this deity originated in Chen-La. In the Khmer period, the king, after his death, became one with his tutelary Hindu deity. There exists a splendid group of sculptures portraying Indravarman with his two wives, from the great mountain temple of Bakong, built in 881.[7] The Khmer king has now become Shiva with his wives Uma and Ganga.

In the Champa kingdom of south Vietnam, the worship of Avalokitesvara was particularly intense under the Indrapura kings (ca. 875–920). In 875, King Indravarman II set up a vihara in honor of this deity, most likely his personal protector, since the building was called Sri Laksmindralokesvara, blending the king's name with that of the deity.[8] This practice became widespread in Yunnan during the Ta-li monarchy; Pai people, the ethnic majority of Yunnan, inserted a Buddhist appellation between their given name and surname. The merging of temporal with divine power was also taking place in tenth-century Java. There are numerous examples, supported by textual sources, of kings turning into an avatar of Vishnu upon their death. Similarly, there are instances of members of the royal house becoming one with Buddhist deities. For instance, according to oral tradition, Prajnaparamita, the Bodhisattva of Transcendental Wisdom, ascribed to 1300, is the first queen of Singasari.[9] The kings of Yunnan, eager to enhance their political status, appear to have imported from Southeast Asia these attitudes and practices towards kingship.

The style adopted by Yunnanese craftsmen for the *A-tso-yeh Kuan-yin* points also to Southeast Asia. The pervasiveness of the cult of Avalokitesvara in this region, and the sharing of formal characteristics by several cultures, have made it harder to distinguish which one of these styles Yunnan appropriated. Helen Chapin, who began the investigation of Yunnanese art about half a century ago, favored Srivijaya as the source of this image. Other scholars believe in the prevailing influence of the Dvaravati culture of Thailand. Indeed, there seem to be points of contact with more than one culture, however, as indicated by Nandana Chutiwong, the similarities between the Yunnanese *A-tso-yeh Kuan-yin* and the Avalokitesvara executed in Champa during the eighth to ninth century are the most frequent and convincing.[10] I believe that the stylistic transmission happened between this culture of Vietnam and Yunnan.

The comparison of the aforementioned Yunnanese ninth century *Kuan-yin*, executed in gold, with a number of well-known Cham Avalokitesvara bronzes, dated to the seventh to ninth century and published by Boisselier, convincingly

6. Stanley J. Tambiah, "Famous Buddha Images and the Legitimation of Kings," Res no. 4 (Autumn 1982), pp. 5–19.

7. Philip Rawson, The Art of Southeast Asia (London: Thames and Hudson, 1990), pp. 36–39, 52–53.

8. Nandana Chutiwongs, The Iconograph of Avalokitesvara in Mainland South-E: Asia (Ph.D. diss., University of Leiden, 1984), p. 427.

9. Paul Debjani, "Deity or Deified King? Reflections on a Unique Vaisnavite Sculpture from Java," Artibus Asiae vol. 40, no. 4 (1978), pp. 311–33; Jan Fontein, The Sculpture of Indonesia (New York: Harry N. Abrams Inc., 1990), pp. 51, 160–61.

10. Helen B. Chapin, "Yunnanese Images of Avalokitesvara," pp. 182–83; Philip Rawson, The Art of Southeast Asia, pp. 136–41; Nandana Chutiwongs, The Iconography of Avalokitesvara, pp. 477–83.

points to Champa as the chief source of inspiration. The bronzes share the same slender, completely frontal, and rigid stance, the same arrangement of clothing (the dhoti gathered to form a median fold, the girdle tied in two knots at the sides), and the same ornaments (diadem, earrings, necklace, armlets, and udarabandha or stomach band). The transmission likely occurred during the ninth century, which was marked by the most forceful political expansion of Nanchao towards the Southeast Asian region.[11]

A-cha-li Esoteric Buddhism and the Link to Tibet

The prominence of Esoteric deities in the *Long Scroll* (for instance, the Vidyarajas in frames 118–21) alerts the viewer to the prominence of Esoteric teaching in Yunnan. The origins of Esoteric Buddhism in this region are still unclear; nevertheless, it may have spread from neighboring Tibet. Furthermore, the Esoteric Buddhism that developed in Yunnan was a local brand called *A-cha-li,* due to the prominent role played by the *acharya,* a Sanskrit term for a spiritual teacher. The key role played by these figures strongly points to a Tibetan transmission.

Such spiritual teachers were not required to respect fundamental monastic rules, such as celibacy; thus, they carried on with their family life alongside their religious activity. Endowed with extraordinary powers, they often performed magic feats, such as delivering people and places from the threat of dragons or drying up bodies of water that had overflown cultivated fields. All these miracles, and more, were performed by the *acharya* Candragupta, the fountainhead of Nan-chao Esoteric Buddhism. In 839, this native of Magadha, India, came to Yunnan from Tibet.[12] Candragupta is shown in frame 56 of the *Long Scroll;* in Po-shen-wa-hei, an *A-cha-li* master identified as Candragupta by Chinese scholars is incised on a large boulder (fig. 12.5).

Yunnanese *A-cha-li* masters vividly recall the personality of *mahasiddhas,* or great adepts, who, with their unconventional mysticism, have prominently contributed to the development of Tibetan Buddhism. Representing all social classes as well as genders, some being historical personages and others legendary, and originating from India as well as from other Himalayan countries, these perfected beings, altogether eighty-four, are essentially a Tibetan product. Some of the earliest extant Tibetan representations of *mahasiddhas* are those in the Alchi frescoes from the mid-eleventh century Sumtsek Temple. The figures are inventively painted on Manjusri's garment: some are shown as monks, others as ascetics, and still others with their female partners on their lap.[13]

Buddhist *A-cha-li* masters became influential in Yunnan because of their compatibility with indigenous Shamanism, which was widespread among the Pai and other local tribes. When spiritual teachers, such as Candragupta, became active in Yunnan, it was neither their yogic skills nor their Tantric knowledge that impressed the local people, but their magic skills, which were so similar to those of the indigenous shamans. Thus, the Yunnanese acceptance of Esoteric teaching came about by grafting the foreign onto the indigenous religious beliefs. The Yunnanese *A-cha-li* became a *sui generis* version of the Tibetan *mahasiddha.* Forming lineages

11. J. Boisselier, La statuaire de Champa: Recherches sur les cultes et l'iconographie *(Paris: Ecole Francaise d'Extreme Orient, 1963), pp. 77–83, figs. 35–38, especially fig. 37. On Nan-chao ninth-century international policy, see Charles Backus,* The Nan-chao Kingdom and T'ang China's Southwestern Frontier *(Cambridge: Cambridge University Press, 1981), pp. 131–58.*

12. Regarding Candragupta, I have relied on Nan-chao ye-shih *(Unofficial History of Nan-chao), compiled by the Ming scholar Yang Shen, in 1550, and revised by Hu Wei, in 1775; it has been translated by C. Sainson,* Nan-tchao ye-che: Histoire particuliere du Nan-tchao *(Paris, 1904), pp. 60–62.*

13. On the mahasiddhas, see Marilyn M. Rhie and Robert A.F. Thurman, Wisdom and Compassion: The Sacred Art of Tibet *(New York: Harry N. Abrams Inc., 1990), pp. 146–55;* Pratapaditya Pal, A Buddhist Paradise, The Murals of Alchi Western Himalayas *(Hongkong: Visual Dharma Publications Ltd., 1982), figs. S15–18.*

and transmitting their religious role from generation to generation, these spiritual masters (some are still active in the area of Ta-li) lead unconventional lives in the midst of their community, which they serve with written spells when administering burial rites, or with their supernatural power when communicating with native gods, or by performing initiation ceremonies.[14]

Tibetan Esoteric Buddhism also provided Yunnan with devotional icons, such as the demonic Mahakala, seen in another mid-eleventh-century fresco from the Dhukang Temple of Alchi (D25). In the western Himalayan kingdom of Ladakh, Mahakala was most likely the tutelary god of the monarchy. It may not be a mere chance that the Great Black God (in Chinese, *Ta-hei-t'ien*), was also a major tutelary deity of Nan-chao and Ta-li, second only in importance to Kuan-yin. According to the local pseudo-history *Chi-ku Tien-shuo*, the King Sheng-lo-p'i (r. 712–28) had an effigy of Mahakala made as tutelary deity of the eastern capital, modern Kunming.[15] The record suggests that Mahakala's cult originated in Ta-li, the main capital of Nan-chao, and then spread to Kunming.

Mahakala is the Hindu god Bhairava, the angry manifestation of Siva, lord of the cemeteries. Thus, at Sha-teng-ch'ing, in the Shi-chung mountains of Chien-ch'uan, a snarling triple-eyed Mahakala, probably executed during the ninth century, is shown wearing garlands of skulls and chopped heads, with a crown of skulls and snakes tightly coiled around his upper arms and ankles (fig. 12.6). With his many hands, he grasps numerous implements appropriate for a Vajrayana deity (a sword, a three-pronged spear, and a lasso). It is worthwhile to draw attention to the technique used at Sha-teng-ch'ing—a combination of intaglio and incision, which is similar to that employed in early Tibetan cliff reliefs, for example, the allegedly eighth-century Nyethang Buddha outside of Lhasa.[16] Additional Mahakala examples are in frame 124 of the *Long Scroll*; in frame 118 the same deity is shown with a plurality of heads and limbs. The type is repeated in the twelfth-century gilt bronze originally from Yunnan and now in the British Museum.[17] This horrific embodiment of uncommon aggressiveness has nine heads, eighteen arms, and three legs. Besides the Tantric implements, he also holds an outstretched body on his shoulders, sports the skin of a flayed head at the waist, and tramples three skulls.

The geographic transmission favors Tibet over other areas, since Mahakala's presence is sporadic in the art of Central Asia, and nonexistent in northern China, leaving Tibet as the only other alternative. The existence of active Tibetan-Yunnanese exchanges is supported by the historical fact that, during the eighth century, the area around Chien-ch'uan (about 100 km. north of Ta-li), where the Sha-teng-ch'ing Mahakala is located, was under the administration of the Shih-lang principality, who paid allegiance to the Tibetans. Similarly, the already mentioned Po-shen-wa-hei site on the Liang mountains, where another image of Mahakala was etched on a boulder, remained also under Tibetan influence until the ninth century. Finally, a very important factor in proving the crisscrossing of influences between the two countries is the route (still in use) that links northwest Yunnan to central Tibet via Li-chiang. The dangers it poses to travelers are vividly described in the ninth century *Manshu* or *Book of the Barbarians*.[18]

14. Chang Hsu, "Ta-li Pai-tsute A-cha-li-chiao," Yunnan min-tsu he tsung-chiao tiao-ch'a *(Kunming: Yunnan People's Press, 1985), pp. 59–62.*

15. Pratapaditya Pal, *A Buddhist Paradise, fig. D25. The Chi-ku Tien-shuo (Collection of Legends of Ancient Tien) was compiled in 1265 by Chang Tao-chung, a native of Kunming. This text is in the anthology* Yunnan pei-cheng-chih, part 5, *(Taipei: Ch'eng-wen Ch'u-pan-she, 1966).*

16. Liu Lizhong, ' ' of the Tibetan Plateau *(Ho.. .ong: Publishing Co., 1988), p. 134.*

17. W. Zwalf, ed., Buddhism: Art and Faith *(New York: Macmillan Publishing Co., 1985), p. 210, calls the god "Lokapala."*

18. The Po-shen-wa-hei Mahakala is likely the three-headed and four-armed image on boulder number 81-401, "Liang-shan Po-shen-wa-hei shih-k'e hua-hsiang tiao-ch'a chien pao," p. 130. The Manshu was written in 862–63 by Fan Ch'o, secretary of the Chinese governor in southeast China. I used the translation by G.H. Luce. Manshu (Ithaca: Cornell University Press, 1961), pp. 9–10. On the routes linking Tibet to southwest China, see Yoshimi Fujisawa, "Todai nyu Unro no shiteki kosatsu," Iwate shigaku kenkyu vol. 29 (1958), pp. 16–30.

19, Angela F. Howard et al., Nan-chao and Ta-li Buddhist Sculpture in Yunnan, p. 56.

In unique fashion, Yunnanese Buddhism paired the image of Mahakala to that of Vaisravana, as in the intaglio relief on San-t'ai-shan, Wu-ting, about 150 km. northwest of Kunming.[19] According to the accompanying inscription, these imposing images (the Vaisravana, 2.3 meters in height, and the Mahakala, 4 meters in height) were executed during the Ta-li administration. As to why the two are represented together, the hypothesis is offered that Vaisravana, the guardian *par excellence* of the North, was transmitted to Yunnan from China, while Mahakala, as argued above, reached Yunnan from Tibet. By combining the two deities, the Yunnanese stressed their diametrically opposed provenance, thereby expressing their desire to receive the gods' protection from dangers stemming from either direction.

The Dharani Pillar of Kunming

Made of red sandstone and over eight meters tall, this burial monument, which richly combines architecture and sculpture (300 images), is the most important work of the Ta-li period (fig. 12.7). According to the historical record inscribed on the pillar, the establishment of the monument involved the loftiest officials and clergy of the Ta-li administration in the years 1200–20. The name "Dharani pillar" derives from the magic spells incised on the pillar's surface. One of the most powerful is the spell included in the "Sutra of the Honored and Victorious Dharani of Buddha's Usnisa," which is also carved on the pillar. The same scripture explains that the building of such a pillar enables one to be saved from evil reincarnations.[20]

20. Angela F. Howard, "The Dharani Pillar of Kunming, Yunnan: A Legacy of Esoteric Buddhism and Burial Rites of the Pai People in the Kingdom of Ta-li (937–1253)," forthcoming in Artibus Asiae.

The pillar is comparable to the *Long Scroll* in the complexity of its theological content and the excellence of its art. The theological content of the two works is, however, different, even though the *Long Scroll* and the pillar were executed less than fifty years apart. The divergence leads to the conclusion that they were inspired by the teaching of different Esoteric schools. The combined wealth of imagery of the *Long Scroll* and of the monument reveals the extent to which Buddhism flourished in this frontier kingdom.

Since I have discussed elsewhere the iconographic program and patronage of the pillar, I focus in this presentation on the cross-cultural character of some of its component parts. The nine levels of the pillar are organized according to three major schemes (fig. 12.8). The lowest, comprising tiers I, II, and III, interprets notions of cosmology within Esoteric Buddhism, for example, the phenomenal world, with Mount Sumeru at its center, rises from the waters of the Great Ocean, which is inhabited by the Nagas. On the slopes of Mount Sumeru are placed the four Lokapalas or guardians of the four directions.

The second scheme, comprising tiers IV, V, and VI, is a mandala (fig. 12.9). To express the drastic break with the phenomenal world below, these three tiers are set up as a truncated pyramid whose corner figures (Vajrapani, Devas, and Bodhisattvas) are not aligned with the Lokapalas. Tiers IV, V, and VI undoubtedly form a mandala, because their numerous deities respond to specific canonical rules governing their place in space. Most of the Buddhas and Bodhisattvas are identifiable. As members of Esoteric "families," they are all bound by a complex system,

working both on a vertical and horizontal direction, and, moreover, are assigned a specific cardinal point. For instance, in tier IV are shown the four Jina Buddhas: Aksobya in the East, Ratnasambhava in the South, Amitayus in the West, and Amoghasiddhi in the North. As members of a mandala, all the deities of the three tiers are emanations of Vairocana, not shown, but alluded to in the central axis of the pillar.

The third scheme of the pillar comprises the remaining tiers and interprets local burial practices of the Pai people, who were so influential in the administration. It is revealing that in this monument, as in the *Long Scroll*, the Yunnanese patrons mingled their local deities with "orthodox" Buddhist deities, thereby proudly acknowledging their roots and proclaiming unabashedly their sense of self-identity.

To indicate precisely the scripture or combination of scriptures that served as sources of the vertical mandala shown in the pillar is close to impossible, since we are unable to reconstruct the work of exegesis of local ecclesiastics. One can, however, postulate that Yunnanese Esoteric teachings were in this, as in previous instances, responding to Tibetan developments. The cloth Vajradhatu mandala, dated to the twelfth century, with a depiction of the Attainment of Buddhahood Assembly (a portion of the Diamond Mandala of the Two Worlds), found in the Treasury of the Ch'ien-hsün Pagoda of the Ch'ung-sheng Temple, is an additional proof of Yunnan ties to Himalayan cultures. Instead of using the canonical thirty-seven images, this mandala refers to them by using *bija* or "seed" letters and the deities' name. More importantly, these symbols are placed in a space shaped like the mandalic scheme used in the frescoes of the Alchi temples in the Western Himalayas. I have not found this peculiarity in the mandalas used in northern China, nor in those exported from China to Japan.[21]

Although one cannot determine a specific Tibetan source for the pillar's mandala or the effigy of the Yunnan Mahakala, or assert that a lineage transmission existed between Tibet and Yunnan, it is nevertheless correct to state that Yunnan was part of a wider geographic area surrounding Tibet. Tibet's doctrinal and artistic achievements had a great influence on the cultures within this area. As one of these cultures, Yunnan manipulated and recreated the received influence. Thus, in the doctrine and the art of the two countries, we find common but not identical factors.

Final remarks are offered on the type of spatial organization of the pillar and its possible link to the Southeast Asian building "boom" tradition, in Java, in particular. The ingenious and well-knit construction of the pillar is made clear by the overhead view (fig. 12.10). The craftsmen used an interesting alternation of superimposed shapes, chiefly variations of an octagon and circle, with the exception of the double-cross layout of tier VII. This intricate arrangement, and the fact that the monument is a compendium of ongoing Buddhist beliefs, recalls the sophisticated spatial conception and theological concerns of Borobudur (about 800), sponsored by the Sailendras of Java.[22] Yunnan appears to have had knowledge of this grand project, since the Kunming Dharani pillar does embody, as at Borobudur, a monumental

21. *The Yunnanese cloth mandala is in* Albert Lutz, Der Goldschatz der Drei Pagoden, *pp. 208–10. The related Alchi mandala is in Roger Goepper,* Alchi, Buddhas, Gottinen, Mandalas: Wandmalerei in einem Himalaya-Kloster *(Köln: 1982), pp. 34–40, pl. 1. I am aware of the diffusion of Esoteric Buddhism in Java under the Sailendra (778–864), but I find it nearly impossible to justify its transmission to Yunnan.*

22. *Philip Rawson,* The Art of Southeast Asia, *pp. 224–35.*

iconographic synthesis organized in a spatial vertical progression. It is undeniable that Sung China did not offer a comparable model.

In the title of the present essay, I used the adjective "eclectic" to express the idea that the art and practice of the Buddhist religion of this frontier state, because of geographic and historical circumstances, were influenced in varying degrees by several neighboring countries. Of course, China, as the most powerful neighbor, exercized a very strong influence, but the role of Tibet, which we are now beginning to grasp, should not be underestimated, especially in the transmission of Esoteric Buddhism. Similarly, we have become aware that several major Southeast Asian cultures (those of Java, the Malay peninsula, Vietnam, and Cambodia) entertained active cultural exchanges with Yunnan. The exchanges are tangibly manifest, for instance, in the shaping of the Avalokitesvara icon and in the role of palladia it assumed for the Nan-chao and Ta-li monarchy.

It is now clear that this frontier kingdom was able to take advantage of what each civilization had to offer in order to enrich its own heritage and shape its own aesthetic. There is also no doubt that the Kingdoms of Nan-chao and Ta-li exercized an intense process of acculturation on the doctrines, rituals, iconography, and style they had appropriated from abroad. It is interesting to note that while the style of the *Long Scroll* is aligned with the Sung aesthetic, in the Dharani pillar the transformation of influences, is so radical in the style of the sculpture as to hinder recognition of the original model. There is no doubt that the sculpture does not look like contemporary Sung works, yet one is equally unable to link it stylistically to the sculpture of any one of the neighboring cultures. The formal appropriations have indeed become a purely Yunnanese style.

The richly textured process of acculturation included the merging of indigenous pre-Buddhist beliefs. In the *Long Scroll* and in the Dharani pillar—two summits of artistic creation—one beholds a distinctly Yunnanese synthesis, which has come into a complete maturity of form and content.

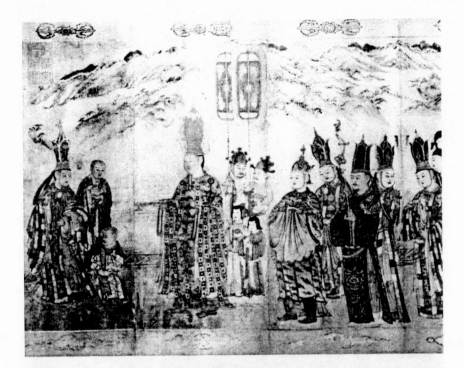

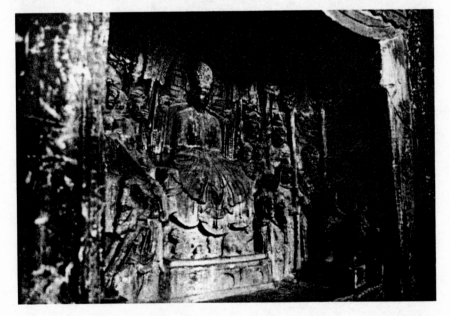

Figure 12.1
Chang Sheng-wen, active late 12th cen-
tury, A Long Scroll of Buddhist
Images, *inscribed in the year 1180,*
Procession of Ta-li Emperor Tuan Chih-
hsing, detail. Handscroll, ink, color and
gold on paper, National Palace Museum,
Taipei.

Figure 12.2
Cave Temple at Shih-chung-shan,
Yunnan, King Ko-lo-feng and his court,
9th century. Relief, sandstone, 1.34 x
1.70 m. Photograph by the author.

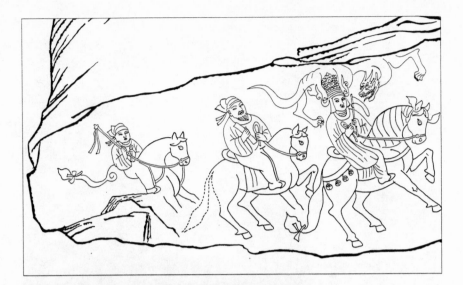

Figure 12.3
Po-shen-wa-hei site, Szechwan, King
Shih-lung's Pageant, *9th century.*
Drawing of petroglyph, sandstone,
8 x 17.2 m.

Figure 12.4
A-tso-yeh Kuan-yin, *from the pagoda*
treasure of Ch'ung-sheng Temple of Ta-
li, Yunnan, possibly 9th century. Gold
with silver aureole, overall height 31
cm, height of figure 24 cm. Photograph
after Albert Lutz, Der Tempel der
Drei Pagoden, *p. 119.*

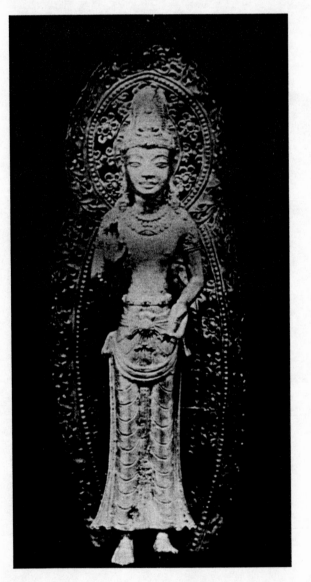

Figure 12.5
Po-shen-wa-hei site, Szechwan, The A-cha-li Candragupta, 9th century. Drawing of petroglyph, sandstone, 2.1 x 3.24 m.

Figure 12.6
Sha-teng-ch'ing site, Yunnan, Mahakala, 9th century. Relief, sandstone, height 2.7.m. Photograph by the author.

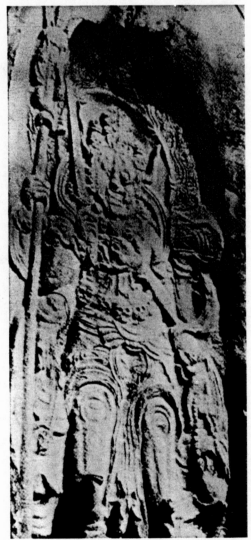

Figure 12.7
Dharani Pillar, Kun-ming, Yunnan, Ta-
li Kingdom 1200–20. Sandstone,
height approximately 8 m. Photograph
by the author.

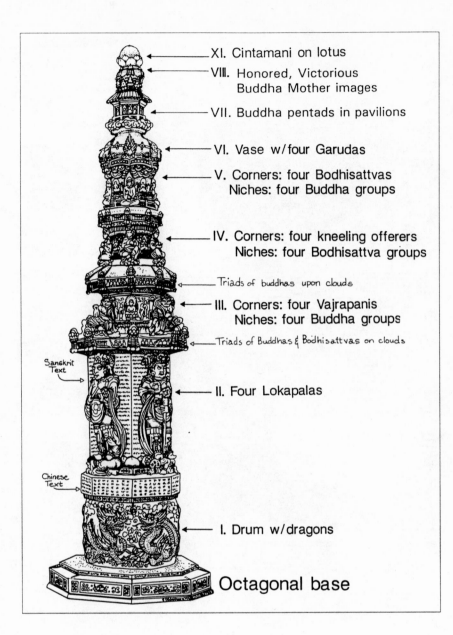

XI. Cintamani on lotus

VIII. Honored, Victorious
 Buddha Mother images

VII. Buddha pentads in pavilions

VI. Vase w/four Garudas

V. Corners: four Bodhisattvas
 Niches: four Buddha groups

IV. Corners: four kneeling offerers
 Niches: four Bodhisattva groups

Triads of buddhas upon clouds

III. Corners: four Vajrapanis
 Niches: four Buddha groups

Triads of Buddhas & Bodhisattvas on clouds

Sanskrit
Text

II. Four Lokapalas

Chinese
Text

I. Drum w/dragons

Octagonal base

Figure 12.8
Drawing of Dharani Pillar.

Figure 12.9
*Dharani Pillar, drawing of mandalic
schema of tiers IV, V, and VI.*

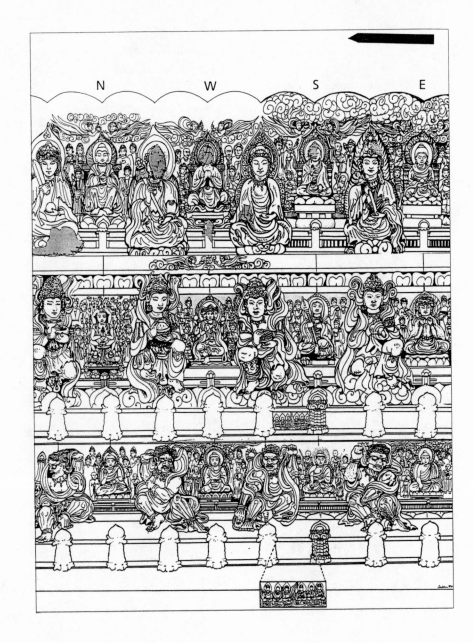

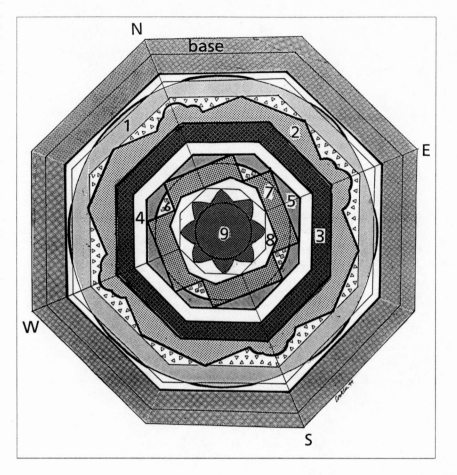

Figure 12.10
Dharani Pillar, plan, overhead view.

V. Interaction of Literati and Court Ideals

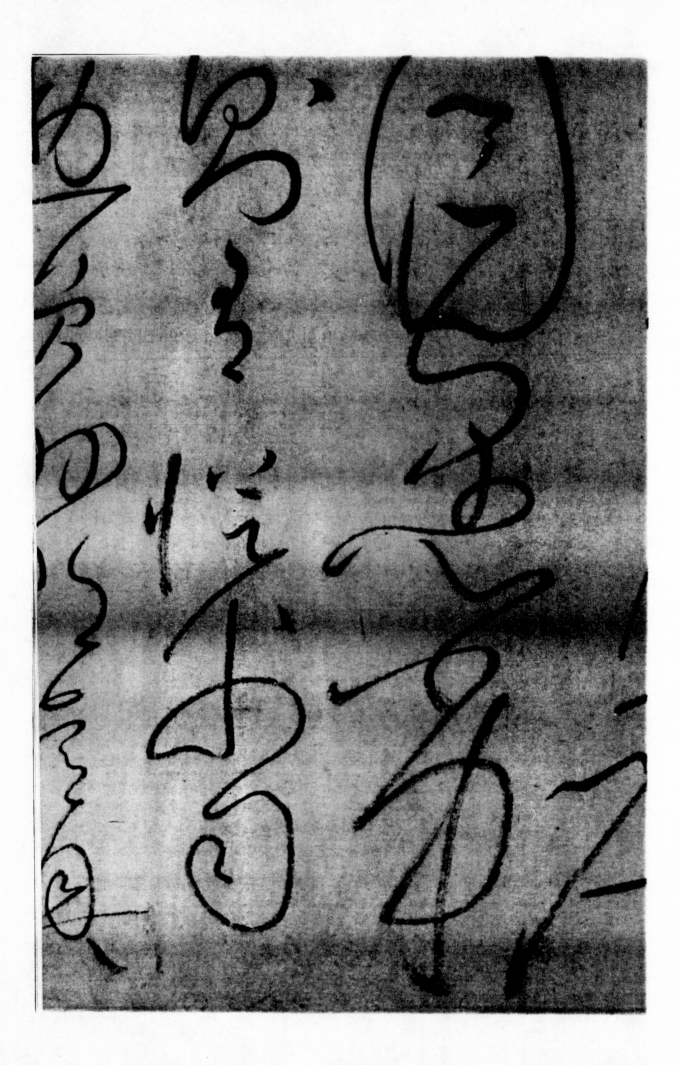

Art and Imperial Images at the Late Southern Sung Court

Hui-shu Lee

According to historical records, long before imperial portraiture was established as a genre of painting at the Northern Sung court, Chinese emperors had been cast in images that defined their positions as the ultimate secular rulers. These were images that were intentionally borrowed from existing religious and historical traditions. In 452, for example, the Wei emperor Wen-ch'eng (r. 452–65) is said to have had his image carved as a Buddha.[1] Three years later, the project was expanded to the five ancestral emperors of Wei—cast as five images of the historical Buddha Sakyamuni.[2] A longstanding tradition presumes that the T'ang empress Wu-tse-t'ien (624– or 627–705) had her likeness serve as a model for the main Vairocana Buddha image at the Feng-hsien Temple, at Lung-men. The association is encouraged both by the feminine elegance of the monumental image and the fact that Empress Wu attempted to establish herself as a reincarnation of Maitreya, the Buddha of the Future, in order to legitimize her status as female ruler.[3]

During the Northern Sung, in addition to sponsoring a specialized practice of painting imperial portraits,[4] to which the set in the National Palace Museum, Taipei nobly attests, emperors occasionally had themselves portrayed as Taoist deities. According to the Northern Sung imperial catalogue Hsüan-ho hua-p'u, for example, Wu Tsung-yüan once painted the thirty-six deities of heaven in the Taoist temple Shang-ch'ing-kung and included the visage of the T'ang emperor T'ai-tsung (r. 976–97) on two of them.[5] Emperor Hui-tsung (r. 1101–25) had his favorite imperial concubine, An-fei, portrayed as a female Taoist deity.[6] Li Hsin-ch'uan (1167–1244) records that this practice continued during the Southern Sung. During Emperor Hsiao-tsung's reign (1163–89), with the completion of the Taoist temple Yu-sheng-kuan, in 1176, the Southern Sung guardian deity Yu-sheng chen-wu ling-ying chen-chun (The Almighty Efficacious Deity who Blesses the Sagely [Realm]) was modeled after the image of Hsiao-tsung.[7]

Considering this background, we should not be surprised to discover that an image strikingly similar to the late Southern Sung emperor Li-tsung (r. 1225–64) appears as the face of the legendary culture-hero Fu-hsi, in a painting from a series illustrating China's sage kings sponsored by Li-tsung (fig. 13.1). Fu-hsi sits clothed in rough animal skins, barefoot, unkempt, exceedingly hairy and with long nails on both feet and hands—characteristics, we assume, that were associated with China's pre-history at the late Southern Sung court and in contrast to Li-tsung's formal portait of a properly groomed sovereign (fig. 13.2). Yet, there is no mistaking the shared facial features: square face, broad forehead, goatee, and, most distinctively, Li-tsung's long "phoenix" eyes. What may be surprising is that these same features

1. Wei Shou, Wei shu (Beijing: Chung-hua shu-chü, 1979), chüan 114, p. 3036.

2. Ibid., chüan 114, p. 3037.

3. R.W.L. Guisso, Wu Tse-t'ien and the Politics of Legitimation in T'ang China (Bellingham: Western Washington University Press, 1978); Yen Chüan-ying, "The Tower of Seven Jewels and Empress Wu," National Palace Museum Bulletin vol. 22, no. 1 (March–April 1987).

4. References to this are found in many places, including Kuo Jo-hsü's T'u-hua chien-wen chih; Liu Tao-ch'un's Sheng-ch'ao ming-hua p'ing, Hsüan-ho hua-p'u; and Teng Ch'un's Hua chi.

5. Hsüan-ho hua-p'u, chüan 4, 46, in Hua-shih ts'ung-shu, ed. Yü An-lan (Shanghai: Renmin meishu, 1982).

6. T'o-t'o, comp., Sung shih (Beijing: Chung-hua shu-chü, 1979), chüan 243, pp. 8644–45.

7. Li Hsin-ch'uan, Chien-yen i-lai ch'ao-yeh tsa-chi (Taipei: Wen-hai Ch'u-pan-she, 1967), chia chi, chüan 2, p. 126.

can be seen on the face of the noble scholar seated under a windblown pine tree in Ma Lin's well-known *Listening to the Wind in the Pines*, of 1246 (fig. 13.3). Imperial images, in fact, appear much more often and in many more guises in court-sponsored Sung painting than has generally been recognized.

It is to be expected that the products of the court-sponsored Painting Academy would reflect imperial taste and requirements: the painters would have been attuned to the likes and dislikes of their imperial patrons, and, conversely, their patrons could freely utilize the services of the Academy. However, it is easy to overlook the fact that the imperial court at any given time was defined by individual personalities, and that these individual emperors and empresses, if so inclined, might utilize the Academy to produce paintings that would express ideas and convey messages meaningful to them. This paper examines two such imperial art patrons of the late Southern Sung. The first is Empress Yang (1162–1233), consort to Emperor Ning-tsung (r. 1195–1224); the second is Ning-tsung's successor, Li-tsung. These two imperial patrons were particularly skilled at using art to promote personal agendas, and they helped to define the nature and content of Southern Sung imperial art for three quarters of a century.

There is much that ties Empress Yang to Emperor Li-tsung. They shared the same environment, the beautiful, cultured city of Hangchow and West Lake, and to a certain degree the same painters: Empress Yang worked primarily with the noted Academy master Ma Yüan (active ca. 1160–after 1225), Li-tsung with Ma Yüan's son, Ma Lin (ca. 1180–after 1256). Moreover, Li-tsung largely owed his ascension to the imperial throne to Empress Yang's patronage. In this regard, the study of these two imperial patrons is really the study of two parallel collaborative teams from one generation to the next. Because of their ties and continuity, Empress Yang and Li-tsung present an ideal contrast, as the gender difference of empress and emperor naturally led to the adoption of different images, models, and voices in the collaborative works they produced with their chosen painters. Another parameter of imperially sponsored art that should be kept in mind is function: were the images overtly public in nature, or were they more private and personal? Broadly speaking, the former tend to be political and didactic, while the latter are more self-expressive. Yet, in these paintings there is often a mingling of these two seemingly distinct spheres. We then must ask, what is the nature of this duality? How can boundaries be determined? To answer these questions, we will look closely at the poetic inscriptions that these two imperial patrons added to the paintings they sponsored, and consider them in the context of their public and private lives.

Empress Yang

Empress Yang was a remarkable woman who managed to rise from humble origins to the throne by relying on beauty, talent, and political savvy (fig. 13.4). In contrast, her husband, Ning-tsung, is described by historical sources as both physically and mentally weak. Empress Yang was always careful to position herself in the proper, conventional role as the nation's supreme lady and the emperor's subordinate. Yet a careful study of Empress Yang's role at the Southern Sung court reveals

that she was a formidable force behind the curtain, one who helped determine the major events at the court for more than a quarter of a century.[8]

Empress Yang's origins are obscure, and no official records exist concerning the early incidents of her life. Unofficial (though reliable) sources state that as a youth she was brought as an entertainer into the palace of Empress Wu, consort to Emperor Kao-tsung (r. 1127–62), because the empress had once favored the young girl's mother, a former court musician. Empress Yang's given name is never mentioned; she is commonly known as Yang Mei-tzu, which literally means "Little Sister Yang." In all likelihood, this is a pet name that she kept from her early days in the palace, where she was greatly favored by the empress. Empress Wu, the most influential and cultured lady of the court, must have provided Yang Mei-tzu with a remarkable role model. She nurtured Yang Mei-tzu into a palace lady "accomplished in history and calligraphy, familiar with the past and present," as her official biography reads.[9] Actively patronized by Empress Wu, Yang Mei-tzu became one of Ning-tsung's concubines. She eventually worked her way to the position of supreme lady of the empire.

Evaluation of Empress Yang's art is largely reliant on her extant poetic inscriptions, many of which still accompany paintings. Although only three such inscriptions are dated, it is possible to suggest a chronological order based upon the stylistic development of her calligraphy and the content of the inscriptions.[10] A progressive chronological sequence of theme and function in these collaborative works is also suggested—a discernible pattern of image-casting that coordinates Empress Yang's art with the facts of her life as we understand them. These provide a clear picture of how an imperial figure could utilize art as both private and public modes of communication.

One of the prevailing patterns in Empress Yang's extant work is the dominant role played by "objects" as subject matter. These consist primarily of flowers, but include willow branches and water as well. Empress Yang's focus on specific, isolated objects corresponds to a genre known in Chinese literature as yung-wu, "celebrating objects." Three of Empress Yang's poetic inscriptions on objects are closely related: Flying Catkins of the Weeping Willow, by an anonymous Academy painter, Apricot Blossoms Leaning Against Clouds, by Ma Yüan (fig. 13.5), and Peach Blossoms, which is unsigned but attributed to Ma Yüan. In comparison with Empress Yang's late dated inscriptions, the calligraphy on these album leaves is less assertive, almost fragile. All three paintings describe blooms of the second lunar month (spring). As the content of the inscriptions is particularly suited to the concerns of a younger woman, we are prompted to recognize the three album leaves as representing an early stage in Empress Yang's collaboration with the Academy painters.[11]

The willow catkins are described as graceful and winsome—the image of fleeting youth.[12]

Threadlike tendrils are tenderly green,
Golden they hang, flittering yellow.

8. See my dissertation, "The Domain of Empress Yang (1162–1233): Art, Gender and Politics at the Late Southern Song Court." (Ph.D. diss., Yale University, 1994).

9. Sung shih, chüan 243, p. 8656.

10. There has long been confusion concerning the calligraphy of Yang Mei-tzu and Emperor Ning-tsung. For a detailed discussion of the problem, see my dissertation, "The Domain of Empress Yang," pp. 152–73.

11. Ibid., pp. 186–199.

12. A "palace verse" that Empress Yang wrote on the same subject reinforces these observations. Yang t'ai-hou kung-t'zu, 1b, in Er-chia kung-t'zu, Pai-pu ts'ung-shu chi-ch'eng, ed. Mao Chin (Taipei: I-wen Ch'u-pan-she, 1964–70).

This couplet reads like an invitation to a husband tempted by other beauties in the palace. For Yang Mei-tzu, the primary means to securing her position in the palace would have been to bear a son, and it is precisely her fertility that is advertised in *Peach Blossoms*:

> For a thousand years she spreads her seed,
> In the second month she starts to bloom.

The couplet's allusion to a poem from the *Shi ching* leaves little doubt that the implicit message for the flower lover Ning-tsung is to cherish this time when the flower blooms, so that an imperial heir can be born.[13] Certainly, the most explicit of the three, however, is *Apricot Blossoms*, which stretches to the limit the subtlety of suggestion that characterizes the art of "celebrating objects":

> Receiving the wind, she presents her unsurpassing beauty;
> Moistened with dew, she reveals her red charms.

Flowers are commonly associated with women, and wind and dew can be considered symbols of male favor and sexual love, so there is little question concerning the content of the underlying message. Yang Mei-tzu's explicit couplet is matched by an equally provocative image: Ma Yüan's apricot spreads its arms in erotic welcome, a thinly veiled invitation to the one person for whom this could have been intended, Emperor Ning-tsung. Coincidentally, the only extant *tz'u* poem by Ning-tsung is titled "Appreciating Apricot Blossoms," and it reads like a response to Yang Mei-tzu's couplet, especially the following lines:

> Her blossoms are like a drunken flush on jade-white flesh,
> But it is time for discussion of current affairs, so I refuse my consorts.[14]

The placement of Empress Yang's seals between her couplet and the splayed ends of the blossoming apricot branch accentuates the suggestiveness of this particular album leaf. Such artistry, on the part of both Empress Yang and Ma Yüan, must surely have tested Ning-tsung's resolve to address the business of the court.

There are precedents of palace ladies utilizing literary talent as a means of regaining the wayward heart of a husband,[15] but they display none of the subtlety exhibited in these collaborative works by Empress Yang and Ma Yüan. What is most striking about the works is the manner in which the *yung-wu* mode is made to correspond so beautifully to the personal circumstances of Empress Yang's life. This pattern can be discerned in a later phase of her life, in fans with poems that she inscribed on the subjects of crab-apple blossoms and autumn cassia (presumably, these were once paired with paintings).[16] The poem on the autumn cassia was composed by the slightly earlier poet Han Chü (ca. 1086–1135), but it takes on added significance when transcribed by the empress. The poem celebrates the virtue of the cassia, standing alone in the fall with fragrant dignity, rather than competing in

13. "T'ao yao," from Shi ching, "Chou nan" 6. Translated by Hans Frankel, The Flowering Plum and the Palace Lady *(New Haven: Yale University Press, 1976), p. 18. This poem uses the peach tree's beauty and fecundity as a metaphor for a new wife.*

14. Ch'üan Sung t'zu *(Taipei: Wen-kuang Ch'u-pan-she, 1973), vol. 4, p. 2311.*

15. Empress Ch'en, consort of the powerful Emperor Wu-ti (r. 140–87 B.C.) is said to have commissioned the writing of the "Ch'ang-men Rhapsody" by Ssu-ma Hsiang-ju (ca. 179–117 B.C.) to attract Wu-ti's notice. Lady Pan composed the "Song of Sorrow" after losing Emperor Ch'eng-ti's (r. 33–7 B.C.) favor to the famous beauty Chao Fei-yen. Hsiao T'ung, Wen hsüan (Taipei: Wen-chin Ch'u-pan-she, 1987), chüan 16, p. 712; chüan 27, p. 1280.

16. The calligraphic style of the two poems referred to here emulates the style of Emperor Ning-tsung and probably dates to the empress's middle period, sometime between the three album leaves described above and the later works of 1216 and 1222. See Hui-shu Lee, "The Domain of Empress Yang," pp. 152–84.

showy color with the crowd of spring's flowers, and enjoying the favor of the moon, which in this context can be understood as representing the emperor. In another poem on the same subject, which Empress Yang composed to be paired with a painting by Ma Yüan, the same theme of enjoying imperial favor appears again:

> Golden milletlike blossoms bloom in clusters on the emerald tree;
> Under the bright moon, dew wettens the jade-step terrace.
> Still some traces of lingering fragrance remain
> From the previous time he came visiting the K'un-ning Palace.[17]

The K'un-ning Palace refers to the residence of Empress Yang, who is likened to the cassia bathing in the light of the moon. The moon dampens the fragrant cassia with his nourishing dew.

Both cassia poems suggest the winning of imperial favor, as opposed to inviting it, and, unlike the couplets and poems described earlier that celebrate the sensuous beauty of spring flowers, the poem on the autumn cassia shifts the emphasis to the flower's virtue. These poems perhaps reflect a stage in Empress Yang's life when her status and power had stabilized. The transition of her projected image is seen in the description of the lightly fragrant crab-apple blossoms, which are portrayed as bearing only a light dusting of rouge. The image accords with the lines of another poem by Empress Yang: "Since assuming the proper seat, I manage literary affairs.... To transform the palace ladies, I apply only light rouge."[18] In her accompanying poem to a painting of plum blossoms by Ma Lin, written rather late in her life (1216), Empress Yang describes the wintry blossoms as chaste and resolute (fig. 13.6), confirming that throughout her life she was constantly seeking the proper image for self-presentation.

Empress Yang also spoke as a public figure, following the notable precedent established by her patron, Empress Wu.[19] Empress Yang performed the traditional imperial role of transcribing representative classical texts celebrating female virtue, such as Pan Chao's (ca. 49–120) Nü chieh (Precepts for Women) and Nü hsiao ching (Ladies' Classic of Filial Piety), which were then illustrated by Ma Lin.[20] She also inscribed small-scale fans and album leaves whose subjects celebrated secular festivities, and her inscriptions are found on religious paintings that reflect the court's involvement with important Buddhist institutions around West Lake.[21] A number of these paintings designate specific recipients, an act that marks the public nature of the Empress's inscriptions.

It is with some of these paintings designated for individuals that we find the line between Empress Yang's public and private voices to be unclear. Perhaps it is more accurate to say that while the paintings are ostensibly public forms of communication, it is still possible to recognize Empress Yang's private voice and image behind the public facade. This arises from knowledge of who the recipient was and the nature of the individual's relationship with Empress Yang. Among Empress Yang's extant works for designated recipients, all but one were intended for mem-

17. Recorded in Yüan Hua, Keng-hsüeh-chai shih-chi, chüan 10, pp. 9b–10a, in Ssu-k'u ch'üan-shu (SKCS) (Shanghai: Ku-chi Ch'u-pan-she, 1987).

18. Yang t'ai-hou kung-tz'u, p. 4b.

19. Empress Wu acted as ghostwriter for Emperor Kao-tsung's ambitious project of transcribing the Stone Classics. Yeh Shao-weng, Ssu-ch'ao wen-chien lu, i-chi, 52, in T'ang Sung shih-liao pi-chi ts'ung-k'an (Beijing: Chung-hua shu-chü, 1989). She also actively promoted the sericulture theme in collaborative works with Academy painters. Lou Yao, "Pa Yang-chou po-fu keng-chih t'u," Kung-k'uei chi (SKCS), chüan 76, pp. 187–202. The contents of many of Empress Yang's palace poems reveal her to have been an active participant in all the public functions expected of an empress.

20. Sun Ch'eng-tse, Keng-tzu hsiao-hsia chi (SKCS), chüan 8, pp. 97–98.

21. Empress Yang collaborated with Ma Yüan in a painting-poetry set of album leaves celebrating the Mid-Autumn Festival, in the Tianjin Museum of Art. Another set of album leaves, long separated from one another, celebrate the Double-Ninth Festival (one is in The Art Museum, Princeton University, the other was formerly in the collection of Huang Chün-pi). Empress Yang's Yang t'ai-hou kung-tz'u includes many poems on secular annual events, festivals, and special occasions, such as the emperor's birthday, banquets, and the greeting of foreign envoys. Paintings of three of the founders of the Ch'an schools of Buddhism bear Empress Yang's encomia. The scroll portraying Tung-shan Liang-chieh (807–869) of the Ts'ao-tung school is in the Tokyo National Museum; those of Yun-men Wen-yen (866–949) and Fa-yen Wen-i (889–958) of the Yun-men and Fa-yen schools are in the Tenryu-ji Temple, Kyoto. There were probably five paintings originally, one for each of the Five Houses of Ch'an. Though unsigned, the paintings are usually attributed to Ma Yüan. Hui-shu Lee, "The Domain of Empress Yang," pp. 211–43.

22. Sung shih, chüan 243, p. 8656. Chou Mi, Ch'i-tung yeh-yü (Shang-hai: Shang-hai shu-tien, 1990), chüan 10, p. 3a. Chou Mi is mistaken in calling Yang T'zu-shan Empress Yang's nephew; all other sources refer to him as an elder brother. For Yang T'zu-shan's biography see Sung shih, chüan 465, pp. 13, 595–96. See also Chiba Hiroshi's entry in Sung Biographies, ed. Herbert Franke (Wiesbaden: Franz Steiner, 1976), pp. 1235–38.

23. For the honor of being invited to imperial banquets, see Sung shih, chüan 113, pp. 2691–97; Wang Ying-lin, Yü hai (Taipei: Hua-wen shu-chü, 1964), chüan 34, pp. 17a–38b.

24. I have argued this in "The Domain of Empress Yang," pp. 152–64. Chiang Chao-shen also believes that the inscription was ghostwritten by Empress Yang; see "The Identity of Yang Mei-tzu and the Paintings of Ma Yüan," The National Palace Museum Bulletin vol. 2, no. 2 (May 1967), pp. 9–10.

25. Ch'ien-lung's comment on the term fu-tzu is found in his inscription on the mounting of the scroll.

bers of her adopted family, the Yang clan. These included her foster brother, Yang T'zu-shan (1139–1213), and her two nephews, Yang Ku and Yang Shih. Empress Yang had entered the palace of Empress Wu as a virtually anonymous young girl; years later, when it was apparent that her family background would be a factor in her attempts to better her position, it was conveniently found that the well-established Yang T'zu-shan was in fact a long-lost older brother.[22] Predictably, Yang T'zu-shan became one of Empress Yang's most trusted allies, helping her win the empress's crown in 1202 and eliminate Empress Yang's primary political rival, Han T'ou-chou (1152–1207) in 1207. Conversely, the Yang clan enjoyed a constant series of promotions and honors as Empress Yang solidified her power. In addition to titles and promotions, favor was customarily demonstrated in the form of imperial gifts, including paintings and calligraphy, and invitations to imperial banquets.[23] Ma Yüan's Twelve Scenes of Water, of 1222 (fig. 13.8), presented to Yang Ku is one example. But before looking at this extraordinary set of paintings, we will consider a hanging scroll reliably attributed to Ma Yüan, titled Banquet by Lantern Light, in the National Palace Museum, Taipei (fig. 13.7).

The calligraphy of the poetic inscription is in Ning-tsung's style but not by Ning-tsung. I believe it was written by Empress Yang, acting as Ning-tsung's ghost-writer:[24]

> Returning from the morning audience, the Imperial Commissioner
> proclaims the official summons:
> Father and sons together are to enjoy the honor of attending the imperial banquet.
> A toast is offered with small wine goblets to pray for great blessings;
> Music is heard in the Han Hall, moving with joyful sounds.
> Like precious vials—plum blossom buds, one thousand branches blooming;
> Like jade and coral—splendid lanterns, ten thousand brightly lit.
> People say that to urge a poem forward one must await the rain;
> A piece of cloud, a chamber in the rain, and the poem is already written.

Ma Yüan's subtle painting draws us deeply into the composition, where we discover female musicians in the courtyard, servants, and six central figures framed by the raised curtains of the central bay of the lit palace hall. These are three men and three women. The men wear offical robes and hats; the women, deeper inside the hall, are dressed in red. One of the three men, slightly larger and more prominent, stands in front and offers a toast. The two behind him echo with salutations of their own. Ever since Emperor Ch'ien-lung (r. 1736–95) collected this painting, and another that is almost identical in composition, it has been assumed that the term fu-tzu in the second line of the inscription refers to a father and his single son (conveniently explaining why there were two paintings: one presented to each!).[25] But it is almost certain that the figures represented are Yang T'zu-shan and his two sons, Yang Ku and Yang Shih, especially as these three were celebrated for their literary talents, which is the subject of the last lines of the painting's poetic inscription.

The painting carries on a little-known tradition of the Southern Sung. In the previous generation, Empress Wu's talented brother Wu I (1124–1171) was a frequent guest at Kao-tsung's banquets and the recipient of paintings with imperial inscriptions. Wu I's son, Wu Chü, equally talented in literature and calligraphy, was similarly feted, this time by Emperors Hsiao-tsung (r. 1163–89) and Kuang-tsung (r. 1190–94). The close relationship between the Wu family and the imperial family must have established a notable model for Empress Yang and her adopted clan, who regenerate this pattern of bestowal of imperial favor, banqueting, and the appreciation of literary and calligraphic talent. This is precisely the subject of *Banquet by Lantern Light*.

Banquet by Lantern Light idealizes its subject. It is a public image intended to present the sagacity of imperial rule and honor the recipients, who partake in its benevolence. Painting and inscription appear cooly objective. The poem, probably composed by a writer in attendance to the court, speaks in the public voice of the emperor, just as the calligraphy presents the public appearance of the emperor's hand. Underneath, however, we recognize the personal directing efforts of Empress Yang, who probably played the role of ghostwriter herself. Together with her favorite painter, Ma Yüan, she resurrects for her adopted family the self-confirming pattern inherited from role models of the previous generation. In this regard, *Banquet by Lantern Light* implicitly projects the image of Empress Yang.

Twelve Scenes of Water, the last dated collaboration between Ma Yüan (to whom the album is reliably attributed) and Empress Yang, is dedicated to the "elder of the two administrators," who can be identified as Yang T'zu-shan's son Yang Ku (fig. 13.8).[26] Each of the twelve scenes carries a four-character descriptive title written by Empress Yang and her date seal of the *jen-wu* year (1222). The subject of the album, as Empress Yang's titles reveal, is the varying moods of water seen in different conditions; and Ma Yüan's superb brushwork, as commentators have long pointed out, is unparalleled for its ability to present "true living water."[27] This is a paramount example of what Su Shih (1037–1101) called a subject of inconstant form but constant principle.[28] Our interests extend beyond the subtleties of Ma Yüan's painting to the reasons why Empress Yang chose this particular subject.

Water, as Su Shih wrote, could serve as a metaphor for the creative act, spontaneously erupting, like Su Shih's own writing.[29] But water could also serve as a self-image, and as records of relevant paintings by Ma Yüan's predecessors reveal, when combined with the dragon, it could serve as an imperial image.[30] As stated in *Hui-tsung's Hsüan-ho hua-p'u*, the dragon represents unbounded transformations, a suitable metaphor for the great person.[31] This would not have been an appropriate image for an empress, but water alone could suggest a similar concept, and in a way that perfectly suited a powerful female figure. This is apparent in Yü Yen-wen's inscription to this album:

> Water's nature is rooted in pliability, and for this reason it is able to move
> or halt with the things [it encounters]. Its physical substance is rooted in
> quietude, and for this reason it is able to grow and diminish with time.

26. Twelve Scenes of Water *has been attributed to Ma Yüan ever since Li Tung-yang (1447–1516) wrote his inscription to the scroll. Stylistic similarities between details of this set of album leaves with other Ma Yüan paintings supports the attribution. Wang Shih-chen (1526–1590), in another inscription following the paintings, correctly points out that "the two administrators" (*liang-fu*) should refer to Yang Ku and Yang Shih, but he mistakenly identifies the elder as Yang Shih.*

27. *An allusion to Su Shih's well-known* "Record of Painting Water" (Hua shui chi), Su Shih wen-chi *(Beijing: Chung-hua shu-chü, 1986), chüan 12, p. 408. See also Robert J. Maeda, "The Water Theme in Chinese Painting,"* Artibus Asiae *vol. 33, no. 4, pp. 247–90.*

28. *Su Shih, "Ching-yin-yuan hua chi,"* Su Shih wen-chi, *chüan 11, p. 367.*

29. *Su Shih, "Tzu p'ing wen,"* Su Shih wen-chi, *chüan 66, p. 2069.*

30. *The tenth-century painter Tung Yü, a dragon specialist, painted the image of water on a screen that backed the Southern T'ang ruler Li Yü (r. 961–75) in one of his pavilions. Liu Tao-ch'un, Sheng-ch'ao ming-hua p'ing, chüan 2, pp. 138–39, in Yü An-lan, Hua-p'in ts'ung-shu (Shanghai: Jen-min mei-shu Ch'u-pan-she, 1982). After entering into the service of Sung T'ai-tsung, Tung Yü received important public commissions to paint dragons and great bodies of water for the Sung court. Kuo Jo-hsü, T'u-hua chien-wen chih, chüan 4, pp. 64–65, in Hua-shih ts'ung-shu, Hsüan-ho hua-p'u, chüan 9, pp. 94–95. Hsü Hsin and Jen Ts'ung-i, painters of the courts of Chen-tsung and Jen-tsung respectively, continued this tradition, decorating imperial screens with images of dragons emerging from water; see Hsüan-ho hua-p'u, chüan 4, p.64.*

31. *Ibid., chüan 9, p. 91.*

32. This and the other ten inscriptions that follow Ma Yüan's painting are recorded in Shih-ch'ü pao-chi ch'u-pien (Taipei: Kuo-li Ku-kung po-wu-yüan, 1971), pp. 978–81.

Calm and bland, empty and yielding, soft and weak, clear and pure...it possesses the virtue of ultimate benevolence, venerated under heaven.[32]

Yü Yen-wen's description is derived from Lao-tzu's *Tao-te-ching*, where water is likened to the Tao itself:

> Highest good is like water. Because water excels in benefitting the myriad creatures without contending with them and settles where none would like to be, it comes close to the Way.
>
> In the world there is nothing more submissive and weak than water. Yet, for attacking that which is hard and strong nothing can surpass it. This is because there is nothing that can take its place.[33]

33. Translation by D. C. Lau, Lao Tzu, Tao Te Ching (Baltimore: Penguin Books, 1963), pp. 64, 140.

Water can thus serve as the ultimate female image—*yin*—and the perfect self-image for a powerful but discreet woman at the court like Empress Yang. Our understanding of how these paintings may have functioned, however, only comes into focus with a closer look at the empress and her family, especially the recipient of the set of paintings, Yang Ku.

In his official biography, Yang T'zu-shan is praised as "wise, able to avoid struggles for power, one who would not interfere with the affairs of the nation."[34] Concrete examples are recorded concerning how Yang repeatedly petitioned to decline imperial honors, thus presenting himself in a pose of humility.[35] Yang Tz'u-shan's younger son, Yang Shih, is recorded as being by nature calm and unassuming, forcibly declining promotions and honors whenever they were offered. Yang Shih was the one who encouraged Empress Yang to retire from the position of regent to Li-tsung, and he even forcefully admonished his older brother when Yang Ku hesitated in declining the tempting award of a high position.[36] The wise and virtuous brother Yang Shih reveals himself to be a true practitioner of the philosophy of yielding. Perhaps Empress Yang's presentation of this album to Yang Ku, one who seems by nature less inclined to intuit the wisdom of water's principle, was intended to serve as a subtle reminder that the greatest power is realized by the softest material, and that their clan could only survive and prosper by adapting to circumstances, just as water adapts to the terrain it covers.

34. Sung shih, chüan 465, pp. 13, 596.

35. Lou Yao, Kung-k'uei chi, chüan 46, pp. 116–22.

36. Sung shih, chüan 465, pp. 13, 596–97.

Ma Yüan's *Twelve Scenes of Water* is an object that is at once public by virtue of the fact that it is an honorary gift, dedicated to an individual, yet personal because of the subtle intentions it conveys. Water, the ultimate image of feminine power and virtue, was the perfect correspondent to the remarkable Empress Yang.

Emperor Li-tsung

In contrast to the vigorous, if largely hidden, activism of Empress Yang, Emperor Li-tsung was known as a withdrawn ruler. In 1224, when Ning-tsung died, there was no officially designated crown prince, and this gave rise to a controversy at the court. To the surprise of many, Chao Hung (also known as Prince Chi), Ning-tsung's assumed successor, was not supported by Empress Yang, and another impe-

rial nephew, Chao Yun (1205–1264), was chosen to succeed the throne as Li-tsung. Chao Hung was removed from the capital and died under mysterious circumstances in 1225. Most historical sources suggest that these were premeditated incidents arranged by the chief councilor, Shih Mi-yüan (1164–1233), but, as Richard Davis points out, it is inconceivable that such actions could have taken place without the approval of Empress Yang. The youthful Li-tsung, nineteen years old in 1224, must have been extremely dependent on his two able patrons. Both Empress Yang and Shih Mi-yüan were power brokers behind the throne until their deaths in 1233.[37]

37. Richard Davis, Court and Family in Sung China (Durham: Duke University Press, 1986), pp. 129–33.

Emperor Li-tsung is described by historical sources as being exceptionally serious, mild-mannered, even wise before becoming emperor, but his reputation did not remain so exemplary.[38] There are signs of laxity early in his tenure as emperor: Li-tsung is criticized for beginning court audiences later than his predecessors, for being too enamored with fancy dress and food, and for excessive interest in entertainment and sex—all while he was supposedly in mourning for his father. As Davis writes, the implication is that Li-tsung had already begun to lose his former discipline and was rapidly sinking into dissipation. In addition, the first two decades of Li-tsung's reign were beset with every natural calamity imaginable, and there was an ever-growing threat presented by the Mongols to the north. For much of his reign, Li-tsung is reported to have grossly neglected administration of the empire in his pursuit of lechery. In fairness to him, however, it is understandable how so young a ruler—inexperienced, "mild-mannered," and dominated by Empress Yang and Shih Mi-yüan—would seek solace in withdrawl.

38. Sung shih, chüan 41, p. 784.

Probably the earliest examples of extant paintings with Li-tsung's inscriptions is the set of Confucian Sages and Worthies, of which the aforementioned Fu-hsi is a prominent example (fig. 13.1). Li-tsung is known to have composed his thirteen encomia on "The Orthodox Lineage of the Tao" (Tao t'ung) in 1230.[39] This was an important, well-publicized event, and it is natural to assume that these paintings by Ma Lin that carry Li-tsung's encomia were done around the same time (five are now extant, all in the National Palace Museum collection).[40] The portraits begin with Fu-hsi, the legendary culture-hero, who is credited with revealing the eight trigrams (seen at his feet), and continue with other sage rulers and philosophers, down to Mencius. The idea was to establish a series that promoted tradition and orthodoxy, reaching back to the beginnings of Chinese culture. Such public displays were not uncommon during the Southern Sung—Kao-tsung's transcription of the Confucian classics is a notable example—but it is important to consider how this particular project fit into the context of Li-tsung's life. This was only five years after his succession to the throne, and there had been continued criticism by Confucian scholars concerning the legitimacy of his rule, the mysterious death of Prince Chi, and Shih Mi-yüan's extended power at the court. There was, in addition, a growing threat from the Mongols, who were engaged in a cultural propaganda war with the Southern Sung in the early 1230s.[41] The Tao-t'ung project should be recognized as a political strategy formulated, in all likelihood, by Empress Yang, Shih Mi-yüan, and Emperor Li-tsung to counter the mounting criticism.

39. Shih Shou-ch'ien, "Nan Sung te liang-chung kuei-chien hua,"I-shu hsüeh no. 1 (1987), pp. 14–19.

40. Eleven years later, in 1241, Li-tsung's encomia were engraved in stones that were established at the National University. Wang Ying-lin, Yü hai, chüan 31, p. 37a.

41. See Liu Tzu-chien, "Sung-mo suo-wei Tao-t'ung te ch'eng-li" (Establishment of the so-called Tao-t'ung in the late Sung), in Liu Tzu-chien, Liang Sung shih yen-chiu hui-pien (Taipei: Lien-ching Ch'u-pan-she, 1987), p. 279.

As the first of the series of portraits, the image of Fu-hsi includes Li-tsung's preface for the entire set, as well as the encomium for this specific image. The first part of the preface, written in four-character lines, reads:

> I succeed the tradition of my ancestors in promoting civil virtues (*wen*). In order to follow this marvelous plan, I daily follow the lessons of my ultimate benevolent mother [Empress Yang]. During the leisure moments away from my numerous obligations, I widely search through the recorded words of the past in order to trace the transmission of the lineage of Tao.

We note how Li-tsung repeatedly draws attention to himself in the preface, which is centered directly over the image of Fu-hsi, thus pushing the encomium for Fu-hsi to the side. We are left with a vivid image of Li-tsung speaking about himself, the legitimacy of his position, and the grandeur of his project with respect to previous Sung emperors right above an image that bears a striking resemblance to Li-tsung himself. The resemblance could hardly be coincidental. In fact, all of the surviving images of the series, while certainly idealized, bear some of Li-tsung's distinctive features, especially the long "phoenix eyes," but there is no question that the Fu-hsi portrait occupies a distinct position in the series. As we note from Li-tsung's encomium to the portrait, this initial image makes a particularly suitable counterpart to the emperor:

> Inheriting from Heaven to establish the ultimate [model],
> He becomes the ancestor to the Hundred Kings.
> Rules and measures are thus established,
> Virtue and morality are pure and complete.
> The eight trigrams are revealed,
> The ancient texts are no longer seen.[42]
> Without words, the people are still transformed,
> The perfect rule is to be natural [without action].

42. The term san fen *in this line refers to the ancient writings of Fu-hsi, Shen-nung, and Huang-ti, three legendary culture-heroes.*

Fu-hsi is cast as the original Taoist, one who teaches without words or actions and thus leads the people in perfect governance. It is an image that would resonate with Li-tsung's own tendency to follow the Taoist way and withdraw from active rule.

The portraits are monumental in scale, 250 cm. or about eight feet in height, and by virtue of their size alone they make a very public statement. The same can be said of Ma Lin's *Listening to the Wind in the Pines*, which is 225 cm. tall. As we noted earlier, this painting, too, strongly suggests the presence of Li-tsung, this time cast as the romantic scholar, chest bared to the wind, seated under a pine and intensely listening to the refined sounds of the whistling wind. Ma Lin's signature is seen at the lower left; Li-tsung titled the painting at the upper right and added two seals, one of which establishes the painting's date as 1246. The painting also bears the seal of the Chi-hsi Palace (*Chi-hsi-tien pao*), suggesting that it may have been displayed in this particular hall. It is, in any case, remarkable as a public image.

Li Lin-ts'an has identified the figure in the painting as the sixth-century Taoist T'ao Hung-ching, who was known to delight in the sound of the wind whistling among the pines.[43] To this we add the observation that, in the Sung dynasty, another early role model, T'ao Yüan-ming (365–427), was also commonly portrayed admiring the wind in the pines.[44] In any case, the figure's headgear, chu-wei (whisk), and relaxed attitude clearly signify the idealized world of the Six Dynasties period, with its associations of Taoist naturalness, ch'ing-t'an (pure talk), and feng-liu (élan) spirit. We note how the posture of the figure is almost identical to that of Fu-hsi. Li-tsung, it would appear, has now fully adopted the Taoist way, casting himself publicly as the undisciplined and untramelled individualist who communes with the mysteries of nature.

43. Li Lin-ts'an, "Tsung Ma Lin te ching-t'ing sung-feng t'an-ch'i" (On Ma Lin's "Quietly Listening to the Wind in the Pines"), Ku-kung wen-wu yüeh-k'an no. 6 (September 1983), pp. 95–97.

44. Sun Shao-yüan, Sheng-hua chi (SKCS), chüan 1, pp. 2b–3a.

There is one last interesting note concerning Listening to the Wind in the Pines. Chou Mi records that there was an extraordinary pine tree planted by a brook near the Te-shou Palace in the imperial precincts. Acquired from Wu (Soochow), it was huge and twisted, like a winding dragon.[45] Perhaps this real-life pine tree served as Ma Lin's model; he certainly would have been familiar with it.

45. Chou Mi, Hao-jan-zhai ya-t'an, middle chüan, p. 21a, in Pai-pu ts'ung-shu chi-ch'eng.

According to historical records, Li-tsung was heavily involved with both Ch'an Buddhism and Taoism, patronizing numerous religious institutions and individuals, and often presenting his calligraphy (sometimes with paintings) as gifts. It is thus not surprising to discover among Li-tsung's extant small-scale fan and album leaves many whose contents reflect Ch'an ideals and Taoist withdrawl. For example, one Li-tsung fan in The Metropolitan Museum of Art rewrites the Meng Hao-jan (689–740) poem "Passing the Meditation Hall of Master Jung":

> In the meditation hall atop the mountain hangs a priest's robe.
> No one outside the window; only birds fly by the stream.
> As evening partly covers the mountain path below,
> I hear the bell sounding over the endless greenery.[46]

46. Translation based on that of Wen C. Fong, Beyond Representation: Chinese Painting and Calligraphy 8th–14th Century (New York: The Metropolitan Museum of Art, 1992), p. 239.

Typically, Li-tsung alters slightly Meng Hao-jan's poem. In this case his editing (four changed characters) emphasizes the stillness and Ch'an flavor of Meng Hao-jan's scene.[47] Li-tsung also changed two characters in a Ch'an-flavored poem by Huang Fu-jan (714–767) on a fan in the Museum of Fine Arts, Boston, "Sent to Master Chen at his Residence of Non-Attachment." The famous Wang Wei couplet on watching clouds similarly possesses a quality of Buddhist detachment. Li-tsung's transcription, together with Ma Lin's illustration, are on fans in the Cleveland Museum of Art. More specifically Taoist are two matching album leaves, a poem with Ma Lin's painting, in the Museum of Fine Arts collection (fig. 13.9). Again, Li-tsung alters slightly an earlier poem—this time by switching the order of two characters in the first line. The original verse is one of the "Small Roaming Immortal Poems" of Ts'ao T'ang (active 847–73). Here is Li-tsung's rewritten version, as based on a translation by Edward Schafer:

47. The last two lines of Meng Hao-jan's original poem read, "As dusk half covers the road while I descend the mountain, I hear the sounds of pines lingering in the greenery." Meng Hao-jan shih-chi (Shanghai: Ku-ji Ch'u-pan-she, 1982), chüan 3, p. 9a.

> Riding a dragon, layered with jade, I pass the stream's source.
> Red leaves have reverted to spring, and the green water flows.

But I realize now that a Heaven and an Earth can be seen within a pot:
Heaven and Earth within a pot—but not once an autumn![48]

Li-tsung alters the poem to fit his circumstances: a jade-layered person emerges (Li-tsung) while far-away Jade Spring becomes the environs of Hangchow—all by simply moving the character for jade. It is, in any case, very much a mundane (if royal) immortal who wanders through this West Lake scene: Li-tsung's dragon is an antlered deer, who ambles through the landscape slowly enough so the emperor can appreciate the spring blossoms and a servant can attend with a large fan. The message of Ts'ao T'ang's poem, and one that Li-tsung no doubt could appreciate, is that a paradise—eternal spring—can exist if one only knows how to look. According to historical records, Li-tsung looked by frequently sneaking out of the palace in search of wine and women (including, on at least one occasion, a Taoist nun).[49]

A new aesthetic in Sung painting emerges in Li-tsung's collaboration with Ma Lin. His interest in Taoism and Ch'an Buddhism is expressed through an awareness of the transience of the human world. He laments the passing of spring, the loss of youth, the ephemerality of beauty. In one poem celebrating spring that Li-tsung presented to his favorite concubine, he writes of how the flowers (and his concubine) have no intention of bidding farewell to the god of spring.[50] In another, he laments the loss of spring, and in so doing manages to repeat the character *ch'un* (spring) in every line.[51] Li-tsung and Ma Lin made an art of exploring that ephemeral moment of mystery and beauty as things come to an end. No better example exists than the pair of album leaves, titled *The Evening Sun*, in the Nezu Museum, that describe an autumn sunset over West Lake and the late crossing of flitting swallows.

A last example of the collaboration between Li-tsung and Ma Lin is the fan in the National Palace Museum titled *Waiting for Guests by Candlelight* (fig. 13.10). There is no matching poetic inscription by Li-tsung extant, but Ma Lin's signature includes the character *ch'en* (servitor), implying that it was painted for the emperor. As Li Lin-ts'an's research has determined, this was almost certainly an illustration of a poem, one that we can assume was once paired with the painting. The poem was composed by Su Shih on the subject of crab-apple blossoms. The key lines read:

One only fears, when the night turns deep, the flowers would fall into sleep;
The silver candles, thus, are brightly lit to shine on these red beauties.[52]

The subject of poem and painting is the delicacy of the spring crab-appple blossoms, and their ephemerality. A seated figure within the hall is surrounded by servants, marking his elevated status. He gazes out at the blossoming trees, which are lit by candles and moon. He is reluctant to let the blossoms go, fearful that by morning they will have fallen from the trees. His central position attracts our attention. He is too small for facial features to be clarified, but dressed in a loose white

48. Li-tsung changes the order of two characters in the first line, which in Ts'ao T'ang's original poem reads in Schafer's translation, "Mounted on a dragon, he crosses the head of the jade gorge once more." Schafer, Mirages on the Sea of Time: The Taoist Poetry of Ts'ao T'ang (Berkeley: University of California Press, 1985), pp. 62–63.

49. Pi Yüan, Hsü tzu-chih t'ung-chien (Beijing: Ku-chi Ch'u-pan-she, 1957), chüan 174, p. 4756.

50. "Quatrain on a Spring Garden," in The Metropolitan Museum of Art. Reproduced and discussed in Wen C. Fong, Beyond Representation, p. 242. This was presented to concubine Chia, sister of the chief councilor Chia Ssu-tao.

51. See Wen C. Fong, Beyond Representation, pp. 241–42.

52. Su Shih, Su Shih shih-chi, chüan 22, pp. 1186–87. Li Lin-ts'an, "Ma Lin ping-chu yeh-yu t'u," in Chung-kuo ming-hua yen-chiu (Taipei: I-wen yin-shu-kuan, 1973), pp. 187–91.

robe and leaning slightly to his left with one leg drawn up, the figure echoes the images we have seen of Li-tsung as Fu-hsi, and especially the Six Dynasties Taoist listening to the wind in the pines. There should be little doubt that we are looking at Emperor Li-tsung: romantic and self-indulgent—an emperor who preferred the night to day, and the pursuit of ephemeral pleasures to the responsibilites of the court.

Conclusion

The contrast between the self-images of Empress Yang and Emperor Li-tsung are in part determined by gender. We note Empress Yang's preference for the tangible, sensuous objects of flowers, and her utilization of the *yung-wu* tradition to present herself indirectly through both poem and image. In contrast, Li-tsung commonly presents himself as a figure in landscape, enjoying seasonal felicities and the profundities of nature. Empress Yang did not compose poems exclusively for objects, and emperors did not shy away from the subject of flowers, but the male imperial patron did not identify with flowers as a self-image when he wrote about them, and Empress Yang, similiarly, remained aloof when writing on subjects outside the woman's accepted domain. As long as the image is presented self-reflectively, the gender distinction is maintained.

There is irony in the fact that a woman as strong and intelligent as Empress Yang could only speak indirectly through metaphor and association, while an emperor as disinterested in active governance as the decadent Li-tsung inherits a tradition in which he can be shown more or less as he is in any number of guises or roles. But both imperial figures manage over time to adjust their respective traditions of image-casting to suit their own particular needs. Empress Yang repeatedly shows how the *yung-wu* tradition, if used with skill, could communicate specific ideas reflective of her changing position. Similarly, Li-tsung finds in the persona of the Taoist ruler a model flexible enough to suit the interests that develop from his natural attraction to withdrawal.

It is often hard to detect the private or personal sides of Chinese imperial figures, and for the most part we do not expect to find them in the art that they sponsored. As these two imperial patrons reveal, however, imperial art was not necessarily restricted to a formal promotion of public values. In fact, even the ostensibly public images can prove to be complicated and personal once we piece together the circumstances under which they were produced. Art provided the means by which talented figures such as Empress Yang and Emperor Li-tsung could reveal the individuals behind the imperial images.

Figure 13.2
Anonymous, Portrait of Emperor Li-
tsung, *(13th century). Hanging scroll,
ink and color on silk, 189 x 108.5 cm.
National Palace Museum, Taipei.*

Figure 13.3.
Ma Lin (ca. 1180–after 1256),
Listening to the Wind in the Pines,
*1246. Hanging scroll, ink and color on
silk, 226.6 x 110.3 cm. National
Palace Museum, Taipei.*

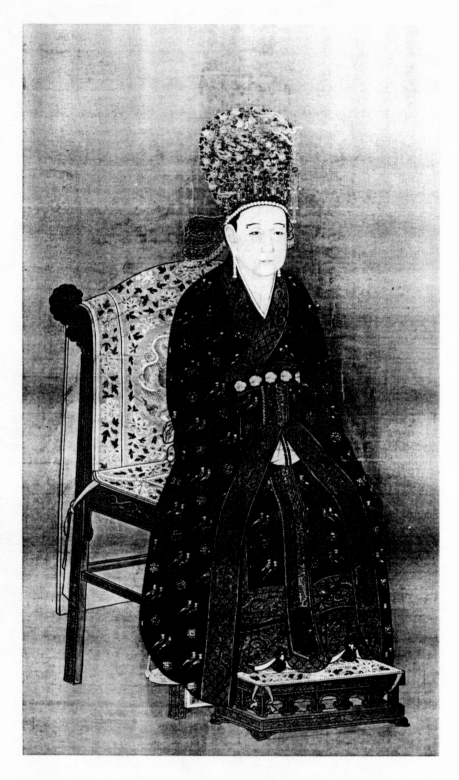

Figure 13.4
Anonymous (13th century), Portrait of
Empress Yang. Hanging scroll, ink
and color on silk, 160.3 x 112.8 cm.
National Palace Museum, Taipei.

迎風呈巧媚
泥露逞紅妍

渾如冷蝶宿花房
擁抱檀心憶舊香
開到寒梢无可愛
此般必是漢宮粧

眉愛水綃

Figure 13.5
Ma Yüan (active ca. 1160–after 1225),
Apricot Blossoms Leaning Against
Clouds, *with poetic inscription by*
Empress Yang. Album leaf, ink and color
on silk, 25.2 x 25.3 cm. National
Palace Museum, Taipei.

Figure 13.6
Ma Lin (ca. 1180–after 1256), Layer
On Layer of Icy Thin Silk, *1216.*
Hanging scroll, ink, color, and gold on
silk, 101.7 x 49.6 cm. Palace Museum,
Beijing.

朝回中使傳宣命
父子同班侍宴榮
酒捧俄驚祈景福
樂闌漢殿動雛聲
簫韶福寧示枝紋
玉棚芊綏裹簽明
人道催詩須待雨
片雲閣雨詩成

Figure 13.7
Ma Yüan (active ca. 1160–after 1225).
Banquet by Lantern Light. *Hanging
scroll, ink and color on silk, 111.9 x
53.5 cm. National Palace Museum,
Taipei.*

Figure 13.7a.
Detail of Figure 13.7

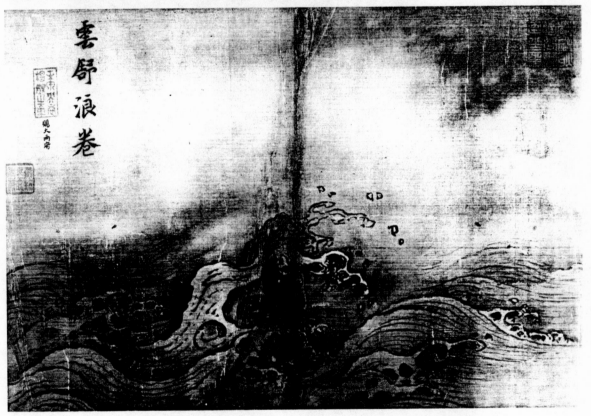

Figure 13.8
Ma Yüan (active ca. 1160–after 1225),
Twelve Scenes of Water, with
inscription by Empress Yang (Clouds
Unfurling, Waves Rolling). 1222.
Album leaves mounted as a handscroll,
ink and color on silk, each 26.8 x 41.6
cm. Palace Museum, Beijing.

Figure 13.9
Ma Lin (ca. 1180–after 1256), The
Wandering Immortal, *with inscription*
by Emperor Li-tsung following Ts'ao
T'ang's "The Little Wandering
Immortal." Pair of album leaves, ink and
color on silk. Museum of Fine Arts,
Boston.

Figure 13.9a
Inscription.

Figure 13.10
Ma Lin (ca. 1180–after 1256),
Waiting for Guests by Candlelight.
Fan mounted as an album leaf, ink and
color on silk, 24.8 x 25.2 cm. National
Palace Museum, Taipei.

From Spring Fragrance, Clearing After Rain *to* Listening to the
Wind in the Pines: *Some Proposals for the Courtly Context of Paintings
by Ma Lin in the Collection of the National Palace Museum, Taipei*

Wang Yao-t'ing

Words, unlike painting, are inadequate to describe meritorious behavior
or record events of great significance. Therefore, portraits of worthy offi-
cials and military heroes were painted and displayed just as in the famous
halls and pavilions of the Han dynasty [206 B.C.–A.D.220]. Paintings
depicting exemplary behavior served as exhortations to viewers, and
paintings of evil actions served as warnings.[1]

1. *Preface to* Hsüan-ho hua-p'u, *dated
1120.* See Yu An-lan, ed., Hua-shih
ts'ung-shu, *vol. 2 (Shanghai: Jen-min
mei-shu Ch'u-pan-she, 1959), p. 4. The
passage quoted here has been translated
by Dora C.Y. Ching. All other transla-
tions are those of the translator, unless
otherwise indicated.*

One of the main functions of the Imperial Painting Academy in the Sung dynasty
(960–1279) was to espouse the official views of the imperial family and the court.
Didactic themes abound among the surviving works associated with the Sung
court, such as *Duke Wen of Chin Recovering his State* by Li T'ang (ca. 1070s–ca.
1150s), in The Metropolitan Museum of Art. Although court artists certainly were
involved in producing official works with didactic functions, they also executed
paintings to fulfill the more informal demands of the royal family and court. In this
paper, I would like to take the works of the Southern Sung (1127–1279) court
painter Ma Lin in the National Palace Museum, Taipei, as examples of how such an
artist worked within the context and surroundings of the court.

Ma Lin (ca. 1180–after 1256) served as a court painter during the reigns of
emperors Ning-tsung (r. 1195–1224) and Li-tsung (r. 1225–64). Like many other
court artists, little biographical material about Ma Lin was recorded, forcing art
historians and connoisseurs to learn more about him through study of his painting
style and the inscriptions and seals on his works added by members of the imperial
family.

Album Leaves by Ma Lin
The first painting by Ma Lin that I would like to discuss is *Spring Fragrance, Clearing
After Rain,* the title of which is derived from a four-character inscription attributed
to Emperor Ning-tsung (fig. 14.1). Next to the calligraphy is the *k'un-kua* seal of
Empress Yang (1162–1232; empress from 1202). The calligraphy here is unlike
that attributed to Ning-tsung on Ma Yüan's (active 1190–1225) *On a Mountain Path
in Spring,* in the National Palace Museum, Taipei. The horizontal brushstrokes, hav-
ing been applied with a heavy hand which was then lifted quickly, produce a con-
trast between heavy and light. The slanted brushwork suggests the hand of an older
calligrapher who no longer had complete control over wristwork. Although it is
stated in *Matters of Calligraphy* that the calligraphy of Empress Yang was "similar to
that of Ning-tsung,"[2] the appearance of an authentic *k'un-kua* seal here would sug-

2. *T'ao Tsung-i,* Shu-shih hui-yao,
chüan 4. Yin-ying Wen-yüan-ko ssu-
ku ch'üan-shu, *vol. 814 (Taipei:
Shang-wu yin-shu-kuan, 1983), p. 45a.*

gest, rather, that this is a cooperative work. I believe the calligraphy is from the hand of the Elderly Emperor Ning-tsung, to which Empress Yang applied her seal.

This painting is a visual rendering of a spring rainstorm at dawn, which has suddenly cleared, with rays of sunlight filtering through; the "clearing after rain" in the title is evoked by the slowly rising mist and the view of the distant mountains through the haze. The first two words of the title, "spring fragrance" (*fang ch'un*), also appear to be simply a straightforward description of the blossoming trees. However, an investigation into Southern Sung court life reveals another layer of meaning to these two characters, for the subject matter here possibly refers to the pavilion of the same name within the palace grounds (Fang-ch'un t'ang) mentioned in the "Halls and Palaces of the Imperial City" section of *Old Matters of Wu-lin*.[3] In another part of this text, "Viewing Blossoms," the author, Chou Mi (1232–1308), states that designated sites existed for viewing particular kinds of blossoms, and that "One views...apricot blossoms from the Spring Fragrance Pavilion."[4] As I believe this painting to represent a view from this pavilion, I think it is not coincidental that all the flowers depicted in the painting are blossoming apricots.

Another work by Ma Lin, the round fan painting entitled *Waiting for Guests by Candlelight,* can be similarly situated within the Southern Sung imperial and poetic context (fig. 14.2). In the previous passage quoted, Chou Mi goes on to say that one views "crab-apple blossoms from the Pavilion of Reflections (*Chao-chuang t'ing*)."[5] The character for "reflections" (*chao*) here acts as a metaphor for viewing crab-apple blossoms, since it seems likely that a couplet by Su Shih (1037–1101) served as inspiration for the name of the pavilion:

> *Fearful that the flowers will be unnoticed in the depth of night,*
> *Tall candles are lit to reflect the red blossoms.*[6]

In this work, light radiates from the doorway of the pavilion, where a scholar, or perhaps even the emperor himself, is seated on a large chair inside. Outside, servants are in attendance, and two rows of tall candles flank the path. Contrary to the imagery implied by the title of the painting, nobody is holding a candle, nor is anybody seen walking. Rather, the static scene seems to reflect the mood suggested by Chou Mi in the passage on "Viewing Blossoms" mentioned above, which continues:

> Within the palace, there are many occasions for viewing different kinds of
> blossoms. At the beginning of the season, preparations are made in the
> palace gardens, and the work is divided up. Every pavilion and hall is
> refurbished... Servants are stationed everywhere.[7]

Although the bustling activity implied by this text does not accord with the image, the elegant setting and serenity of the scene certainly do. Thus, the pavilion in this painting by Ma Lin could very well be the same Pavilion of Reflections found at the Southern Sung court.

At the upper left of *Waiting for Guests by Candlelight* is the partial impression of a

3. Chou Mi, Wu-lin chiu-shih, chüan 4 (Beijing: Chung-kuo shang-yeh Ch'u-pan-she, 1982), p. 53.

4. Ibid., chüan 2, p. 41.

5. Ibid.

6. Shih Yüan-chih and Ku Ching-yüan, eds., Tseng-pu tsu-pen Shih Ku chu Su shih, chüan 20 (Taipei: I-wen yin-shu-kuan, 1978), p. 3. Professor Li Lin-ts'an had earlier pointed out the relationship between this painting and Su Shih's poem in "Ma Lin 'Ping-chu yeh-yu,'" Ta-lu tsa-chih, vol. 25, no. 7 (October 1962), pp. 108–20. The lines here were translated by Dora C.Y. Ching.

7. Chou Mi, Wu-lin chiu-shih, chüan 2, p. 41. Translated by Dora C.Y. Ching.

seal, which the editors of the *Catalogue of the Collection of the Ch'ien-lung Emperor* (*Shih-ch'ü pao-chi*) have read as *fu*.[8] Since Ma Lin's signature is preceded by the character for servitor (*ch'en*) and the painting was undoubtedly done for the court, the character *fu* would appear to be part of one of the Southern Sung imperial seals in which the character is found, such as *nei-fu shu-yin, nei-fu t'u-shu, nei-fu shu-hua,* and *yü-fu t'u-shu.* Of these four seals, only the first can be ruled out with any certainty, due to the difference in size and the last stroke in the *fu* character. In addition to the remaining three seals, two other possibilities exist. If it is not from the Southern Sung, the seal may bear some similarity to the *chin-fu t'u-shu* Ming imperial seal of Chu Kang (?–1398) and the *yü-fu t'u-shu* seal of the Hsüan-tsung emperor (r. 1426–35). However, these last two may be ruled out on the basis of differences in the impression of the seal paste, the strokes, and the size of the characters.

If it is an imperial seal, as it plainly appears to be, which one is it? The answer is suggested by a fan of cursive style calligraphy from *Album Leaves of the Sung and Yüan,* in the National Palace Museum, Taipei, which bears a poem by Su Shih, "Presented to Liu Ching-wen," and the *Te-shou* seal associated with Emperor Kao-tsung (r. 1127–62):

> Wilted lotus is already without cover from pelting rain,
> Faded chrysanthemums still have branches that can survive the rude frost;
> Of a year's beautiful scenes, you, Sir, should remember
> Especially the time when oranges and tangerines were yellow and ripe.[9]

The style of the calligraphy here is closer to that of Emperor Kao-tsung's successor, Hsiao-tsung (r. 1163–89), which may indicate that the Te-shou seal refers to Kao-tsung's retirement palace or that it was used interchangeably by both emperors.[10] Accompanying this fan on the right is a painting attributed to Chao Ling-jang (active 1070–1100) entitled *Orange and Tangerine Groves.* Overlapping the upper middle portion of both painting and calligraphy, the seal *nei-fu shu-hua* appears prominently displayed on the mounting. Considering that the mounting paper is one often associated with Sung works, that there is no difference between the impression on the mounting and the painting, and that the subject matter of the two fans matches, it seems reasonable to assume that we have an example of an original Sung dynasty mounting of album leaves. In addition, the partial impression of this seal is also found, in the same location, on the anonymous Sung painting *Sparrows, Bamboo, and Plum Blossoms,* in The Metropolitan Museum of Art. This work perhaps was produced during the reign of Emperor Hsiao-tsung, and then later in the Sung (perhaps as late as the reign of Emperor Ning-tsung),[11] was, for reasons to be discussed shortly, mounted as an album leaf to which the above seal was affixed. These examples suggest how imperial seals were used in the mounting of fans in albums. Furthermore, even though particular seals might be associated with a specific emperor, they could be handed down to and used by the succeeding emperor.

Returning to the *fu* seal mentioned previously, the lower right corner of this seal that appears at the upper left of *Waiting for Guests by Candlelight* is also found in

8. *See* Shih-ch'ü pao-chi ch'u-pien *(Taipei: National Palace Museum, 1971), p. 726, and* Ku-kung shu-hua lu, *vol. 4, p. 247.*

9. *Translated by Dora C.Y. Ching.*

10. *The calligraphy in this leaf is more pliant, and unlike that of Kao-tsung's* T'ien-shan shih *leaf in The Metropolitan Museum of Art; it is more similar to that in the* Ts'ao-shu Hou ch'ih-pi fu, *in the Liaoning Provincial Museum, which was attributed to Hsiao-tsung by Chang Shou, and is now recognized as his work.*

11. *The* nei-fu shu-hua *seal also appears on Liu Sung-nien's* Three Paintings of Lohans, *in the National Palace Museum, Taipei, and Lu Leng-chia's* Eighteen Lohans, *in the Palace Museum, Beijing. Chiang Chiao-shen believed that this seal was used between 1207 and 1295; see National Palace Museum,* Ku-kung Sung-hua ching-hua, *vol. 2, notes, p. 17.*

exactly the same place on three other round fans of the Southern Sung mounted as album leaves: *Ancient Pines and Buildings* (fig. 14.3) and *Retreat by a Lakeshore,* both anonymous works from the *Ming-hsien pao-hui* album in the Osaka Municipal Museum of Art, and Ma Lin's (?) *Moon-viewing Terrace,* in the Shanghai Museum. In the case of *Ancient Pines and Buildings,* we are indeed fortunate that the accompanying leaf of calligraphy survives (fig. 14.4). This leaf, which bears the calligraphy and *Ch'i-hsi-tien shu* seal relating it to the hand of Emperor Li-tsung, displays the lower left corner of a seal at the upper right. The partial reading here, *chi,* is, I believe, part of the character *shu,* judging from scripts associated with seals. In terms of its position, the seal on this leaf forms a mirror image with that on the leaf of painting. What appears to be the identical partial impression is found in the same location on a fan of calligraphy by Emperor Li-tsung, entitled *Quatrain on Late Spring,* in the collection of the Metropolitan Museum, along with the seal *yü-shu-chih-pao.* In the same collection is another leaf of calligraphy by Emperor Li-tsung, *Quatrain by Meng Hao-jan,* with the same partial impression in the same position. Based on our observations of the above pair of painting and calligraphy leaves in the National Palace Museum, we may assume that the partial impressions we have been examining in the upper left and upper right corners of these fans are from the same seal. If so, it is evident that the second and fourth characters of this partial impression read *fu* and *shu,* a hypothesis borne out by the appearance of the lower half of these two characters in the seal impression on *Taking a Lute to Visit a Friend,* an anonymous square album leaf in the Shanghai Museum. Judging from the similarities between the features of this impression and that on the National Palace Museum pair, I believe that the partial impressions point to the late Southern Sung custom of mounting paintings as album leaves and then impressing them with imperial seals.

Judging from my experience in reading seals, I believe this partial impression is from the connoisseurship seal *yü-fu t'u-shu* of Emperor Li-tsung. The three examples of this seal that I have found so far include the impressions on the upper right corners of the first leaf of Wang Hsi-chih's *Essay on General Yüeh I* and the *Lan-t'ing Pavilion* from *Sung Rubbings of T'ang Engravings of Eight Kinds of Tsin and T'ang Regular Script Writings,* in the Metropolitan Museum, as well as that on the seam between the mounting and Ch'u Sui-liang's (546–658) *Copy of Wang Hsi-chih's "Lan-t'ing t'ieh" from The Eight Pillars of the Lan-t'ing t'ieh* (second version), in the Palace Museum, Beijing (fig. 14.5). Although I have not personally viewed these works, they appear to have impressions from the same seal. But how do we know that this seal was used during the reign of Emperor Li-tsung? Given the fact that we can attribute the aforementioned fans of calligraphy to Li-tsung, we can start by analyzing the rubbings of the Lan-t'ing engravings.

T'ao Tsung-i (ca. 1316–1402), in *chüan* 6 of his *Cho-keng lu,* stated:

There are 117 engravings of the Lan-t'ing Pavilion [preface] bound into 10 volumes from the imperial collection of Emperor Li-tsung. Each impression bears the *nei-fu t'u-shu* seal at the beginning (*yü-ch'ih*).[12]

12. T'ao Tsung-i, *Cho-keng lu,* chüan 6 (Taipei: I-wen yin-shu-kuan, 1966), p. 1, Pai-pu ts'ung-shu-chi-ch'eng, part 20, no. 20.

In this case, even though the first character of the imperial seal mentioned by T'ao and that of the *yü-fu t'u-shu* seal is different, the meanings of the two seals are almost the same. To find out if this is a transcription error on the part of the author or publisher, we may consult another catalogue entry. In his *Keng-tzu hsiao-hsia chi,* under the entry "Reduced Version of the Ting-wu Lan-t'ing," Sun Ch'eng-tze (1592–1676) records:

> I once saw an album of works by the ancients that was in the imperial collection of Emperor Li-tsung of the Sung. The workmanship was extremely refined and each rubbing had the *yü-fu t'u-shu* seal impressed at the beginning (*yü-ch'ih*). Altogether, there were 117 engravings in this complete edition.[13]

13. Sun Ch'eng-tze, Keng-tzu hsiao-hsia chi *(Taipei: Han-hua wen-hua kung-ssu, 1971), (facsimile of 1761 edition), p. 193.*

T'ao Tsung-i and Sun Ch'eng-tze both were writing presumably about the same set of rubbings, and both mention the presence of imperial seals impressed on the so-called yü-ch'ih, or the opening of the work. When we examine the Beijing Palace Museum work mentioned earlier, we note that the *yü-fu t'u-shu* seal (like that mentioned by Sun Ch'eng-tze) straddles the work and the mounting at the beginning of the work in much the same way defined by these texts, the only obvious difference being that the work in the Beijing Palace Museum is a written version and the other two, in the Metropolitan Museum collection, are rubbings. The position of the *yü-fu t'u-shu* seal on the Metropolitan rubbings would suggest that they were once mounted as a handscroll.

Even though *Ancient Pines and Buildings,* in the Osaka Municipal Museum of Art, bears no signature, it still retains the accompanying leaf of calligraphy by Emperor Li-tsung.[14] On the other hand, *Waiting for Guests by Candlelight* has the signature of Ma Lin, but has been separated from its accompanying leaf, which almost certainly was a calligraphic couplet from Su Shih's "Cherry-Apple Poem" (*Hai-t'ang shih*) from the hand of Li-tsung. The other two leaves, *Retreat by a Lakeshore* and *Moon-viewing Terrace,* based on the presence of their partial seal impressions, probably also once had accompanying leaves of calligraphy by Li-tsung. Taken as a whole, these four leaves, although of different but approximate size, perhaps once formed part of an album that was subsequently separated and remounted. Just as the calligraphy by Li-tsung on the leaves is consistent, so are the seals. Thus, to take my analysis one step further, I would suggest that the seven album leaves of paintings and calligraphy discussed above once formed part of an album composed on order of Emperor Li-tsung, who chose and wrote out the lines of poetry to be illustrated by court artists using familiar sites in the Imperial palace or the surrounding area.

14. According to Shinya Fujita, "It appears that a signature was once on the rock, but it is now damaged beyond recognition"; see Tokubetsu ten-Sodai no kaiga (Kyoto: Yamato Bunkakan, 1990), p. 53.

Concerning specific sites in the palace and around Hangchow, we know that the subject matter of *Ancient Pines and Buildings* corresponds to the imagery in the Po Chü-i poem transcribed by Emperor Li-tsung, entitled "Hall of Crape-Myrtle Blossoms." The poem reads:

> *Reading quietly in the Ssu-lun [Threads-of-Learning] Pavilion,*
> *I hear the echoes of beats from the clock tower become longer into the night.*

Sitting here alone, who is to keep me company,
But the Tzu-wei Star above and crape-myrtle (tzu-wei) blossoms below?

Here, it would be interesting to learn if the Ssu-lun Pavilion mentioned in the poem can be identified with the building depicted in the matching painting. Although an examination of Southern Sung texts has yet turned up a building by such a name, the following "Poem on Crape-Myrtle Blossoms" may be related to it:

In front of the Hsü-pai Hall in the prefectural compound [in Hangchow] during the [Northern] Sung grew two crape-myrtle trees, which, according to tradition, had been planted by Po Chü-i. When Su Shih was governor there, Emperor Shen-tsung [r. 1068–85] once wrote "Poem on Crape-Myrtle Blossoms," and presented it to him. Su Shih, likewise, composed a poem which read:

In front of the Hsü-pai Hall are [old] crape-myrtle trees,
They shine in the slanting rays of sunset on a windy autumn day.
Though many people know of [the beauty of] this place,
Their existence is limited while this will live on.[15]

15. See T'ien Ju-ch'eng, Hsi-hu yu-lan chih-yü, in Wu-lin chang-ku ts'ung-pien, collection 20 (Yangchow: Kiangsu Kuang-ling ku-chi, 1985), chüan 24, p. 11b.

16. Ibid., chüan 10, p. 17a.

Furthermore, there is mention of a Crape-Myrtle Pavilion (Tzu-wei t'ing) and a Crape-Myrtle Abode Built in the T'ang in the West Lake area.[16] These two sites would seem to accord with the imagery suggested in the last line of Po Chü-i's poem, especially that of a solitary figure sitting in a pavilion; but the multistoried building depicted in the album leaf is slightly different, making an exact match difficult.

Although I have yet been able to locate the sites depicted in *Retreat by a Lakeshore* and *Moon-viewing Terrace,* they both describe evening scenes with buildings that have shades similar to those seen in the building in *Ma Yüan's Banquet by Lantern Light,* in the National Palace Museum. This suggests to me that the scenes represented in these two leaves are based on the type of architecture found in the palatial compound or on actual scenes contained therein. Perhaps further research will reveal more about such sites in Sung imperial painting.

Another question related to these four album leaves is, Did Ma Lin paint them all? If, as I suggest above, they once belonged to the same album, perhaps these works should also be related stylistically. Indeed, the album leaves favor the one-corner composition associated with late Southern Sung imperial landscape painting. In terms of the use of brush and ink, there is a noticeable consistency; this, when combined with the similarity in construction of space and forms, such as the high-roofed pavilion and the moon in *Ancient Pines and Buildings,* and *Waiting for Guests by Candlelight,* implies Ma Lin as the unifying painter behind the works. Furthermore, the twisting yet ultra-refined "baroque"[17] treatment of the almost ornamental pine tree in *Ancient Pines and Buildings* in which the trunk and branches zig-zag and slant

17. See Suzuki Kei, Chugoku kaigashi, trans. Wei Mei-yüeh, Ku-kung wen-wu yüeh-k'an, no. 93 (October 1991), p. 134.

in the so-called Ma Yüan Pine[18] manner often found in gardens, as well as the technique of depicting distant mountains in *Retreat by a Lakeshore* by first outlining and then filling them in with light blue wash, are distinctive features of Ma Lin's style.

Finally, with regard to these album leaves, we should note that the *Ch'i-hsi* seal on Li-tsung's "Hall of Crape-Myrtle Blossoms" was associated with the court hall of the same name built in 1234,[19] suggesting the earliest date that this could have been executed. The integration of poetry and painting at the Sung court through inscribing works appears to have been the prerogative of the imperial family. The album that I propose once existed undoubtedly contained more than the four works described here, of which only *Waiting for Guests by Candlelight* was signed, as it may have been the last leaf in the set.

The Imperial Visage

In the collection of the National Palace Museum, Taipei, are two major works produced by Ma Lin as a court artist under Emperor Li-tsung, *Thirteen Sages and Rulers of the Orthodox Lineage*,[20] a set of thirteen paintings, five of which are extant (here, I will discuss the Portrait of Fu-hsi), and *Listening to the Wind in the Pines* (fig. 14.8). The former is a formal work espousing the ideology of the state for didactic purposes, while the latter conveys the poetic feeling of reclusion from court life. In this part of my paper, I would like to address the question of the real identity of the figures depicted in these works. When comparing the visages of the figures in these two works with the *Seated Portrait of Emperor Li-tsung* (fig. 14.6) in the National Palace Museum collection, I come away with the distinct impression that the former two present the dualistic nature of Li-tsung's personality—public and private—as idealized representations of a revered sage-ruler (fig. 14.7), on the one hand, and an untrammelled recluse (fig. 14.8), on the other.[21]

Concerning the visage of Li-tsung, Hu Ching wrote in his notes for "Seated Portrait of Li-tsung," in *Research on Portraits from the Nan-hsün Hall*, citing *Matters of Three Sung Reigns*, that Li-tsung "had a grand face and was nicknamed 'The Dark Grand Guardian (Wu T'ai-pao).'"[22] Furthermore, in *Additions to the West Lake Gazeteer*, it is recorded that "Li-tsung had a dragonlike complexion... When seated at court, he had the stern appearance of a deity."[23] These textual descriptions of the emperor match the appearance in the portrait and the two paintings.

In his *Secrets of Portraiture*, Wang I of the Yüan dynasty (1279–1368) made it clear that "In doing any portrait, one must understand [the laws of] physiognomy."[24] With regard to the appearance of Fu-hsi, the *Pai-hu t'ung (sheng-jen)* states, "Fu-hsi had a forehead as expansive as the sun, bony protuberances, large eyes, and a high nose with a visage like that of a dragon."[25] Ma Lin, in deifying the figure of Li-tsung as Fu-hsi, has departed from the tradition dating back to the Han dynasty of representing the bottom half of this mythological figure as a serpent. Moreover, ever since Ssu-ma Ch'ien's description of Emperor Kao-tsu of the Han dynasty in *Annals of the Historian* as having a "high nose and prominent eye-sockets," such facial qualities have become a convention for describing the visage of the emperor. Ma Lin, based upon the actual features of Li-tsung matching the traditional attributes of a

18. *T'ien Ju-ch'eng*, Hsi-hu yu-lan chih-yü, chüan 17, p. 7b.

19. *See Chu P'eng*, Nan-Sung ku-chi k'ao, in Wu-lin chang-ku ts'ung-pien, collection 26, chüan 1, 1881 edition (Yangchow: Kiangsu Kuang-ling ku-chi, 1985), pp. 214b-215a.

20. *In the present exhibition*, Splendors of Imperial China: Treasures from the National Palace Museum, Taipei, *this set of paintings is entitled* Confucian Sages and Worthies.

21. *Professor Li Lin-ts'an has suggested that the figure in* Listening to the Wind in the Pines *could be a representation of the Taoist figure T'ao Hung-ching; see* "Ts'ung Ma Lin te 'Ching-ting sung-feng' t'an ch'i," Ku-kung wen-wu yüeh-k'an, vol. 1, no. 6 (1983), pp. 95–101, and "T'ao Hung-ching yu Sung-feng ko," Ku-kung wen-wu yüeh-k'an, vol. 2, no. 10 (1985), pp. 51–54.

22. *See Hu Ching*, Nan-hsün-tien t'u-hsiang k'ao, in Hu shih shu-hua hui-k'ao san-chung (Taipei: Han-hua wen-hua kung-ssu, 1971), chüan 1, p. 317. *See also* "Sung Li-tsung tso-hsiang," in Nan-hsün-tien t'u hsiang, Ku-kung shu-hua lu, chüan 7, pp. 20–21. *Hu Ching follows Ch'en Chi-ju's attribution of the Li-tsung portrait (in his* T'ai-p'ing ch'ing-hua) *to a certain Kuo Hsiao-chai, who is unrecorded in art-historical texts. Although this may be a copy, it appears to be a faithful one. For the reference in* T'ai-p'ing ch'ing-hua, *see* Pi-chi hsiao-shuo ta-kuan, vol. 5, no. 4 (Taipei: Hsin-hsing shu-chu, 1974), p. 8b.

23. *T'ien Ju-ch'eng*, Hsi-hu yu-lan chih-yü, chüan 2, p. 25.

24. *For this line from Wang I's text, see* T'ao Tsung-i, Cho-keng-lu, chüan 11, p. 1b.

25. *Pan Ku*, Pai-hu t'ung, chüan 2, in Ying-yin Wen-yüan-ko ssu-k'u ch'üan-shu, vol. 850 (Taipei: Shang-wu yin-shu-kuan, 1983), p. 44.

ruler, has applied them to the representation of Fu-hsi (as well as other portraits in the series, such as that of Yao, Yü, T'ang, and Wu). And perhaps it is not a coincidence that the sage-rulers represented in this set of portraits also bear a marked resemblance to Li-tsung (fig. 14.9). Further research may bear this out, but the importance of physiognomy in Chinese portraiture stands without question.

Regarding the importance and associations of the "imperial visage," there exists a long history in China. Of the three examples that I would like to present from the Sung dynasty, the first reads:

> The deportment of Sung T'ai-tsu [r. 960–76] was as grand as that of a deity. People dared not look at his darkened face and expansive chin. When Li Yü [r. 961–75] was king of the Southern T'ang, a portrait of T'ai-tsu was sent to him. He took one look at it and with each passing day grew increasingly despondent, for he saw that T'ai-tsu [looked like] a real emperor.[26]

26. T'ien K'uang, Ju-lin kung-i, in Ying-yin Wen-yüan-ko ssu-k'u ch'üan-shu, vol. 1036 (Taipei: Shang-wu yin-shu-kuan, 1983), pp. 276–77.

27. Shao Po, Honan Shao-shih Wen-chian hou-lu, in Pi-chi hsiao-shuo ta-kuan, vol. 15, no. 2, chüan 1 (Taipei: Hsin-hsing shu-chu, 1974), p. 6b.

Another text reads:

> In the autumn of 1058, the ruler of the Liao kingdom fell prostrate when he saw the portrait of Emperor Jen-tsung [r. 1023–63], telling his subordinates, "This is truly a sage-ruler. If I had been born in the state of Sung, I would be no more than a servant worthy of holding his bridle or parasol."[27]

These two records, although perhaps somewhat exaggerated, serve to illustrate the importance of imperial physiognomy as an aspect of legitimacy. Yet another record mentions how Emperor T'ai-tsung (r. 976–97) was a firm believer in the art of physiognomy. He asked an expert, Ch'en Tuan (?–989), to advise him on which of his sons should be chosen as prince. Ch'en reported that "The guards of [the future] Chen-tsung [r. 998–1022] all have the countenances of great generals and ministers, so I did not even need to go in and see him to know that he will one day be a ruler."[28]

28. Shao Po, Shao-shih Wen-chien ch'ien-lu, in Pi-chi hsiao-shuo ta-kuan, vol. 15, no. 1, chüan 7, p. 10b.

The Thirteen Sages and Rulers of the Orthodox Lineage

Concerning the background of Ma Lin's *Thirteen Sages and Rulers of the Orthodox Lineage* and the paintings' inscriptions, Hu Ching, in his *Research on Portraits from the Nan-hsün Hall*, drew from the biography of Li-tsung in the *History of the Sung* as well as the *Yü-hai* to make the following observations:

> In the first lunar month of 1241, Li-tsung went to the National University (T'ai-hsüeh) and made sacrifices to Confucius by having the "Thirteen Eulogies of the Orthodox Lineage" done and presented to the Kuo-tzu-chien to serve as a model for students there. In the "Narrative to the Thirteen Eulogies of Sages [Done in] the Ch'un-yu [Period]," from Yü-hai, it says:

When Li-tsung was not busy with matters of state, he poured over ancient texts to try to determine the lineage of orthodoxy. [The thirteen figures] from Fu-hsi to Mencius had all served as either kings or officials and put their ideals into practice, or they were commoners who were able to influence others with their studies; they all merit being eulogized and depicted here...Particularly worth noting are Fu-hsi, Yao, Yü, T'ang, Wen, Wu, Chou, Confucius, Yen-tzu, Tseng-tzu, Tzu-ssu, and Mencius.

According to this list, the eulogies were composed by Li-tsung. He also ordered that the portraits be painted again and that a corresponding number of eulogies be written on them. Only five survive today.[29]

This provides some idea of when the set of portraits was produced, but what was the specific date? In his discussion of the portrait of Fu-hsi, Shih Shou-ch'ien relied on the writings of Pi Yüan (1730–1797) and others to arrive at the date of 1230.[30] Before considering why the portraits were made, perhaps we ought first to examine the reason why Emperor Li-tsung received such a posthumous name. According to the "Annals of Li-tsung" in the *History of the Sung*:

> From [the beginning of the 13th century], the proper and the improper could no longer be distinguished, and the policies of state fell into disarray. As a result, Li-tsung assumed the position of "Emperor Inheriting the Orthodox." He first removed the sacrificial tablets of Wang An-shih [1021–1086] from the Temple of Confucius and then elevated the position of scholars such as Chou Tun-i [1017–1073] and exalted the *Four Books* by Chu Hsi [1130–1200]. Subsequently, the spirit of the land changed greatly as the proscription of *tao-hsüeh* was lifted. Unfortunately, it was already late in the dynasty and his ambitions could not be fully achieved. When later scholars discuss the revival of the administration of state, they begin with Emperor Li-tsung's legitimizing, upholding, and glorifying *li-hsüeh*. It is thus only natural that he should have received the posthumous title of *li*.[31]

Sung Neo-Confucianism (*li-hsüeh*) was not officially recognized by the court as the "Orthodox Lineage" until the late Southern Sung. However, prior to this, the history of *li-hsüeh*, which involved education and the selection of scholars in general, was fraught with internal struggle. This is evident in the "Rise and Fall of Tao-hsüeh," a term found in the annals of the Southern Sung.[32] Although this subject has been treated in detail elsewhere, let me summarize some major events which led up to the production of Ma Lin's set of portraits. In 1197, Han T'o-chou (1151–1207) was in power as prime minister and instrumental in blacklisting the Ch'ing-yüan Party, which was associated with *li-hsüeh*. The official texts associated

29. *Hu Ching*, Nan-hsün-tien, chüan 1, pp. 1–2b (293–96).

30. Shih Shou-ch'ien, "Nan-Sung te liang-chung kuei-chien hua," I-shu hsüeh, vol. 1 (March 1987), pp. 7–40.

31. T'uo-t'uo et. al., comp., Sung shih, pen-chi, vol. 45 (Taipei: Ting-wen Ch'u-pan-she), p. 889.

32. "The Rise and Fall of Tao-hsüeh" (Tao-hsüeh ch'ung-tso) is a subtitle from Sung shih chi-shih pen-mo, chüan 8, Kuo-hsüeh chi-pen ts'ung-pien edition (Taipei: Shang-wu yin-shu-kuan, 1967), pp. 678–701. For a modern study of this topic, see Liu Tzu-chien (James T.C. Liu), "Sung-mo suo-wei tao-t'ung te chien-li," in Liang Sung shih yen-chiu hui-pien (Taipei: Lien-ching Ch'u pan shih-ye, 1987), pp. 249–82.

with this party gradually fell into disfavor. This development proved to be a political setback for the Chu Hsi School (also linked with *li-hsüeh*). In the late years of Ning-tsung's K'ai-hsi reign, Han fell out of power, and, in 1207, was assassinated, leading to the pardoning of the members of the Ch'ing-yüan Party. The derogatory term *tao-hsüeh* was changed to *li-hsüeh,* and, in 1212, Chu Hsi's *Annotated Edition of the Four Books* was established as an official text. In 1224, prime minister Shih Mi-yüan revised the imperial order of Li-tsung to resume the Orthodoxy and revere Confucian studies as a means to placate the Neo-Confucians, who, as members of the Tao-hsüeh Party, had already grown quite powerful. Thus, in the first year of Li-tsung's Tuan-p'ing rein, 1234, the Five Masters of the Northern Sung (Shao Yung [1011–1077], Chou Tun-i [1017–1073], Chang Tsai [1020–1077], Ch'eng I [1032–1085], and Ch'eng Yin [1033–1107]) were honored. Their places, along with that of Chu Hsi, were established in the Temple of Confucius. And, in 1241, Li-tsung visited the National University to perform sacrifices to Confucius, signaling the official recognition of the Thirteen Sages and Rulers of the Orthodox Lineage as the state ideology and the establishment of the Chu Hsi school as the Lineage of the Way.

Following an orthodox lineage is one of the cultural patterns found in Chinese history. And, in this case, Southern Sung theorists, keeping in mind the contention for legitimacy with the "barbarian" Chin in the north, naturally looked back to the Northern Sung as the true inheritors of Han civilization, thought, and legitimacy.

In the late Southern Sung, Wen Chi-weng (*chin-shih* 1253) wrote his "Colophon to the Portraits of Orthodox Lineage":

> While living in the capital and studying at the National University, someone did [a copy? of the] "Portraits of Orthodox Lineage" and sent it to the emperor. The portraits of rulers extended from that of Fu-hsi to Wu, with Emperor T'ai-tsu inheriting this lineage in the Sung. Portraits of sages extended from that of Confucius to Mencius, with Chou Tun-i inheriting the tradition in the Sung. [The latter two] truly were able to achieve the wonders of the tradition of sages.[33]

With his official sanctioning and establishment of the Orthodox Lineage, it should not be surprising that Li-tsung not only associated himself with these legendary rulers, but (more importantly, from the point of view of legitimacy) presented himself as a manifestation, even a reincarnation, of them as a sage-ruler.

In Chinese hagiography, the tradition of emperors assuming in their portraits the features and powers of Buddhist or Taoist deities is not uncommon. For example, sculptural representations of the Buddha in the Northern Wei (424–534) were often patterned after the facial features of the emperors.[34] And in the Sung dynasty, Emperor T'ai-tsu was considered a manifestation of the Dipamkara Buddha.[35] According to theorists of the Five Elements, the Sung dynasty was established on the basis of the Fire element.[36] Thus, in *Records of Experiences in Painting,* by Kuo Juo-hsü, there appears the following passage concerning Wu Tsung-yüan (?–1050):

33. Fu Tseng-hsiang, comp., Sung-tai Shu wen chi-ts'un, chüan 94 (Taipei: Hsin wen-feng Ch'u-pan-she, 1974), p. 195. For the biography of Wen Chi-weng, see Ming-kung wen-yin yun-chin, chüan 6, and Sung shih I, chüan 34.

34. Ting Chih-kuo and Ting Ming-I, "Yun-kang shih-ku k'ai-tso li-ch'eng," in Chung-kuo mei-shu ch'üan-chi, vol. 10 (sculpture) (Taipei: Chin-hsiu Ch'u-pan-she, 1989), pp. 2–3.

35. Chu Pien, Ch'u-wei chiu-wen, vol. 1, in Yin-ying Wen-yüan-ko ssu-k'u ch'üan-shu, vol. 863, p. 288.

36. Discussion of the Five Elements and the yin-yang relationship appears as early as the Spring and Autumn Annals (Lü-shih ch'un-ch'iu). Feng Yu-lan called the theory of the Five Elements and the yin-yang relationship a kind of "comedy of sanctity" (shen-sheng te hsi-chu); see Chung-kuo che-hsüeh shih, pp. 201–202. For more on the significance of the Five Elements, see certain passages in Chou Mi's Ch'i-tung yeh-yü.

[Wu Tsung-yüan] once painted the Thirty-six Heavenly Deities at the Shang-ch'ing Abbey in Lo-yang. He depicted the "Clear and Bright Emperor of the Fire Element" as Sung T'ai-tsung, because the Chao family [of the Sung] had conquered all under heaven through the Fire element. When Emperor Chen-tsung...stopped by Lo-yang and went to the Shang-ch'ing Abbey, he viewed the paintings there. Suddenly he saw the grand visage of one of them and said, "This truly looks like the late Emperor T'ai-tsung. Immediately prepare tables and incense for sacrifices!" He stood amazed in front of the painted image for quite a while. As it turns out, the Shang-ch'ing Abbey was an imperial temple dedicated in the T'ang dynasty to the sage-ruler Lao-tzu and once contained "Portraits of the Five Sages" by Wu Tao-tzu.[37]

The Five Sages here refer to the five emperors of the T'ang dynasty (Kao-tsu, T'ai-tsung, Kao-tsung, Chung-tsung, and Hsien-tsung), whose portraits were painted on the temple walls to receive sacrifices.[38] Another omen regarding physiognomy goes as follows:

Before T'ai-tsu became emperor, he passed through the town of Chang-wu, in Chin-chou, one day. In a temple, a Buddhist monk by the name of Shou-yen was intrigued by the physiognomy of T'ai-tsu and had someone record his image on the wall: an imposing man with a green cap and plain clothes. Now that he has become emperor, new attire has been painted on.[39]

Because Li-tsung was not in direct line to become emperor, the Mandate of Heaven had to be greatly emphasized in order to confer legitimacy to his succession as emperor. For example:

The moment before Li-tsung was born, his mother wished to return to her home. At that time it was not yet daylight, and the servant left and saw an armored guard standing at the gate. He went back to tell Li-tsung's father, who went out, but saw nothing. Just as they were about to board the boat, a large black serpent leapt into the boat, forcing them to abandon the trip. Not long afterwards, Li-tsung was born and his nickname as a youth was thus "the Dark Son."[40]

And in the "Annals of Li-tsung," it is recorded:

Li-tsung was born in 1205 in the Hung-ch'iao precinct of Shao-hsing. The night before, Li-tsung's father dreamt that a figure dressed in gold visited him. When he awoke, the room was filled with dazzling lights, and red light shining as if it were sunrise. For three days after the birth, household members often heard the sound of horses and carriages outside, but none were to be found upon further inspection. As a youth, Li-tsung was said to sometimes take on the appearance of a dragon with scales.[41]

37. Kuo Juo-hsü, T'u-hua chien-wen-chih, chüan 3, in Yu An-lan, Hua-shih ts'ung-shu, no. 1, pp. 104–105.

38. For Tu Fu's poem on this topic, see the Sung compilation by Kuo Chih-chien, Chiu-chia chi-chu Tu Fu, chüan 17, in Tu shih yin-te, vol. 2, Harvard-Yenching hsüeh-she yin-te t'e-k'an, no. 14 (Taipei: Ch'eng-wen Ch'u-pan-she, 1966), pp. 257–58.

39. Shao Po, Shao-shih chien-wen ch'ien-lu, chüan 1, p. 1a.

40. Chou Mi, Kuei-hsin tsa-shih, hou-chi, in Pi-chi hsiao-shuo ta-kuan, part 3 of third set, pp. 1a, b.

41. T'uo-t'uo et. al., Sung shih, vol. 41, "Li-tsung 1," p. 783.

The purpose of these stories was to illustrate Li-tsung's position in the direct line of descent within the orthodox lineage, and provide a popular foundation for the legitimacy of his rule. From our point of view, they might read like superstitious nonsense, but the frequent appearance of such stories in Sung dynasty writings, especially in connection with imperial figures, suggests that they played an important role. For example, all the Sung emperors, with the exception of Jen-tsung (r. 1023-63), Hui-tsung (r. 1101-25), Ch'in-tsung (r. 1126–27), and Kuang-tsung (r. 1190-94), had auspicious omens or spirits associated with their births in their biographies recorded in the *History of the Sung* as a means of proving that they had been "chosen" to inherit the Mandate of Heaven.[42] Representing Li-tsung as Fu-hsi, or, in other words, using a "figural mode of expression," is understandable in the context of this tradition.

In Ma Lin's painting of him, Fu-hsi is shown seated on a rock, which is rendered in the axe-cut texture strokes associated with the Ma-family style (fig. 14.7). Because it is a large painting, the brushwork appears rather coarse and the washes somewhat wet. Fu-hsi appears with long hair, seated on a deerskin. Below him are a turtle and the eight trigrams,[43] the pictorial meaning of which is rather easy to understand, for it is said that Fu-hsi was the inventor of the eight trigrams and that he derived the prognostication charts from the back of a divine turtle.[44]

In Max Weber's typology of the establishment and continuation of political control, he mentioned three kinds of central authority: rational, traditional, and charismatic.[45] The most problematic aspect of Chinese political history is the lack of a "rational" authority. For example, traditional authority achieved control through the use of labels, such as "orthodox" or Mandate of Heaven. Accounts of the Fire element would be considered "charismatic," because the transmission of political power is an idea based on personal or group belief, thereby placing the center of authority into a form that can be universally revered. Thus, on the surface, Li-tsung wanted to appear to revere *li-hsüeh* in order to win the support of the scholar-officials. In the name of the scholar-officials who promoted the cause of *li-hsüeh,* he formally pronounced the learning of the Ch'eng brothers of the Northern Sung as the "Orthodox Lineage." However, his citation of famous Confucian scholars did not entail awarding them any power or authority to enact changes, and, as such, created only the appearance of reverence, which he exploited for his own political ends.[46] As a result, the so-called Rational One (Li-tsung) turns out to be not so rational after all.

It is not possible nowadays to determine whether Ma Lin, like Wu Tsung-yüan, in the example mentioned earlier, was acting on his own to present a deity in the appearance of an emperor, or merely painting on the order of court. It is not inconceivable that Ma Lin would have known the story of Wu Tsung-yüan, or that he would have been working on imperial order. For example, in 1116, Emperor Hui-tsung personally instructed the Hall of Documents to record that "As Son of Heaven, I am the T'ai-hsiao sage-ruler, and I am to be known as the Emperor of the Taoist Faith."[47] In the same fashion, Li-tsung officially espoused the Orthodox Lineage as a state religion, but, for all intents and purposes, the deification of his

42. Ibid., *see biographical entries for individual emperors.*

43. *For more on the* Book of Changes, *see Tzu-hsia i-chuan, hsi-tz'u hsia, no. 8, in Ying-yin Wen-yüan-ko ssu-k'u ch'üan-shu, vol. 7 (Taipei: Shang-wu yin-shu-kuan, 1983), p. 105.*

44. *For a discussion of the interpretation of individual arrangements of the trigrams, see Ch'ien-tso-tu, chüan 1, pp. 3–4, as indexed in Feng Yu-lan, Chung-kuo che-hsüeh shih, p. 556.*

45. *The observations in this section are derived from Max Weber,* The Theory of Social and Economic Organization, *trans. A.M. Henderson and Talcott Parsons (New York: Oxford University Press 1947), p. 328. Also see, Chang Tuan-hui, "T'ien yü jen-kuei: Chung-kuo ssu-hsiang chung cheng-chih-ch'üan wei ho-fa-hsing te kuan-nien," in Chung-kuo wen-hua hsin-lun, ssu-hsiang 2, ed. Liu Tai (Taipei: Lien-ching Ch'u-pan shih-ye, 1982), pp. 97–155.*

46. *Liu Tzu-chien, "Sung-mo suo-wei tao-t'ung te chien-li," pp. 249–82.*

47. *See the Ming dynasty colophon appended to the end of Emperor Hui-tsung's* Auspicious Cranes, *in the Palace Museum, Beijing.*

imperial image was meant to aggrandize and centralize political power and respect for the emperor.

Listening to the Wind in the Pines

The title of Ma Lin's *Listening to the Wind in the Pines* is a translation of the four-character title written by Li-tsung in the upper right corner. Below the title are two seals, *p'ing-wu* and *yü-shu*. The editors of *Shih-chü pao-chi ch'u-pien* believed that the title was written by Emperor Ning-tsung. However, the editors of *Record of Paintings and Calligraphy* in the National Palace Museum, wrote:

> Two *ping-wu* years occurred in the Southern Sung, one during the reign of Hsiao-tsung, in 1186, and the other in that of Li-tsung, in 1246. The *ping-wu* seal that appears here apparently is that associated with Li-tsung, for if the calligraphy had been written by Hsiao-tsung, Ma Lin would have been only a youth at the time.[48]

48. Ku-kung shu-hua lu, *vol. 3,* chüan 5, p. 102.

The editors thus chose 1246 as the year in which the painting was executed. Moreover, the appearance of the *Ch'i-hsi-tien pao* seal in the lower left corner not only affirms the attribution of the calligraphy to Li-tsung's hand, but sets the earliest possible date for the execution of the painting to 1233, when the Ch'i-hsi Hall was built. At that time, Li-tsung was forty-one years old, and if we examine closely the physiognomy of the figure in this painting, we will note the resemblance to the figures in the portraits of Li-tsung and Fu-hsi. Perhaps this resemblance may be used as a means of dating the "Orthodox Lineage" portraits to around 1230. Finally, I believe that the figure depicted here is an idealized representation of Li-tsung as a recluse, for reasons I will discuss shortly.

With regard to Li-tsung's fondness for pines, we have a record stating that he enjoyed visiting the Tz'u-ching Temple, on the grounds of which was planted his "Pine of Imperial Favor (Yü ai sung)."[49] Although we do not have a description of this tree, Li-tsung was not the first Sung emperor to express a fondness for pines. An account in *Ancient Sites of the Southern Sung*, citing the "Palaces Section" of the *History of the Sung*, mentions a "Coiling Pine (P'an-sung)" in the imperial compound: "In the northern part of the Te-shou Garden is a twisting pine tree, also known as 'Bend-over Pine.' It was personally planted by Emperor Kao-tsung, and in the Ch'eng-hua era [1465–87] it was still there."[50] Unfortunately, the lack of other textual descriptions prevents exact identification of the site in Ma Lin's painting. It might be that the "Coiling Pine" of the Te-shou Palace was similar to the one shown in Ma Lin's painting, for both are noted for their unusually twisted branches and the "S" shape of their trunks. Indeed, it is not inconceivable that Ma Lin, as a court artist, would have based his interpretations of architecture and trees on actual examples found within the inner city.

The Chi-ch'ing Temple, according to the *Gazetteer of Touring West Lake*, "was built in 1241 and still has two hanging scrolls of Li-tsung, *Imperial Portrait* and *At Leisure*."[51] The subject matter of the latter is not specified, but it could very well

49. T'ien Ju-ch'eng, Hsi-hu yu-lan chih, chüan 3, p. 11a.

50. Chu P'eng, Nan-Sung ku-chi k'ao, chüan 2, p. 9a.

51. T'ien Ju-ch'eng, Hsi-hu yu-lan chih-yü, chüan 10, p. 5b.

have portrayed the emperor at leisure, as in *Listening to the Wind in the Pines*. The painting shows a figure seated on a pine trunk, listening and looking intently. That he represents the ideal of a recluse is first indicated by the transparent "T'ao Yüan-ming" gauze headdress with inner cap, recalling T'ao's line from "Ode on the Abode of Leisure," which reads, "Concealed in the deep shade of an evergreen." Similar in subject matter, and of the same period as Ma Lin, is the portrait of T'ao Yüan-ming, attributed to Liang K'ai (active first half of 13th century) and entitled *Noble Scholar of the Eastern Fence*, where T'ao is also shown wearing a similar gauze headdress, through which the inner cap is visible. This was commonplace attire in the Sung dynasty, the headdress having evolved from the type associated with T'ao Yüan-ming. Judging from the exposed chest and the light clothing of the casually attired figure cooling off by a stream, the fly-whisk on the ground, and the fan held by the servant, this would appear to be an early autumn scene.[52] Among Sung literati, the type of clothing depicted here was commonly known as informal rustic attire. The coloring in this painting is exceptionally refined, as seen, for example, in the flesh tones, clothing, rocks, pine needles, leaves, and trees. The distant mountains have been outlined with washes of light blue, to which Ma Lin has added his distinctive touches of mineral blues and greens. Indeed, the poetic, but difficult, representation of the act of listening to a sound has been successfully captured in this painting.

Also in the National Palace Museum is an album leaf attributed to Ma Yüan that is similar in composition and theme to Ma Lin's painting. In this work, *Pines, Stream, and Pair of Magpies* (figure 14.10), a scholar is dressed in typical Sung attire and holds a fly-whisk. A servant stands nearby, in a scene reminiscent of Ma Lin's *Listening to the Wind in the Pines*, except for the lack of wind and the pair of birds. The quick, loose brushwork and abbreviated depiction of forms (such as the bamboo leaves) indicate that this album leaf dates later than the Sung.[53] Despite the presence of a Ming dynasty *ssu-yin* seal, which would suggest that this painting came from the Yüan imperial collection, it may be a later copy or a pastiche based on an earlier work.[54] The magpies, for example, are similar to those found in Ma Yüan's *On a Mountain Path in Spring*. In any case, the custom among court artists of preparing drafts and making copies is a topic worth pursuing in another paper.[55] The general similarity of the figure depicted in this album leaf and the portraits of Li-tsung that we have been studying is worth remarking. However, whether this work represents a copy of a painting from the time of Li-tsung is an issue that awaits further research.

52. According to Ku Fu in his P'ing-sheng chuang-kuan, chüan 8 (Taipei: Han-hua wen-hua kung-ssu, 1971), p. 62, this painting is recorded as depicting "a tree in autumn."

53. Few members of the Ma family are recorded as having continued the painting tradition. See Li O, Nan-Sung yüan-hua lu, chüan 3, in Mei-shu ts'ung-shu, no. 4 of collection 4 (Taipei: I-wen yin-shu-kuan, 1975), pp. 179–80.

54. The ssu-yin seal here is similar to that on Fan K'uan's Travellers Amid Streams and Mountains in the National Palace Museum, Taipei.

55. For more information on this subject, see the entry "Hua-yüan" (Painting Academy), in Wen Chen-heng, Chang-wu chih, in I-shu ts'ung-shu (Taipei: Shih-chieh Ch'u-pan-she, 1968), p. 32.

Conclusion

In the field of art history, scholars have in recent years addressed not only issues relating to the physical features of works of art, but also factors associated with the background of their production, such as politics, economics, and culture. It goes without saying that art, especially painting, has often been stimulated by such external influences. This is all the more true for professional artists, who served and performed duties for the court and the imperial family. Although such artists have often gone unrecorded, or have been underrated, their relationship with the court provides an important understanding of how to appreciate their works in a new light. My proposals for the study of the works by Ma Lin suggest that these works can be analyzed within the physical and social context of the Southern Sung court at Hangchow.

Translated by Donald E. Brix

Figure 14.3
Anonymous (13th century), Ancient
Pines and Buildings. *Fan mounted as
an album leaf, ink and light color on
silk, 24.0 x 24.7 cm. Osaka Municipal
Museum of Art.*

Figure 14.4
Emperor Li-tsung (r. 1225–64), Po
Chü-i's Poem on Crape-Myrtle
Blossoms. *Fan mounted as an album
leaf, ink on silk, 24.0 x 24.7 cm. Osaka
Municipal Museum of Art.*

Figure 14.5
Ch'u Sui-liang (596–658), Copy of
Wang Hsi-chih's "Lan-t'ing t'ieh,"
from the Eight Pillars of the Lan-
t'ing t'ieh (second version). Detail of
section with yü-fu t'u-shu seal, T'ang
dynasty (618–907). Handscroll, ink on
paper, 24 x 88.5 cm. Palace Museum,
Beijing.

Figure 14.6
Anonymous (13th century), Seated
Portrait of Emperor Li-tsung .
Hanging scroll, ink and color on silk,
189 x 108.5 cm. National Palace
Museum, Taipei.

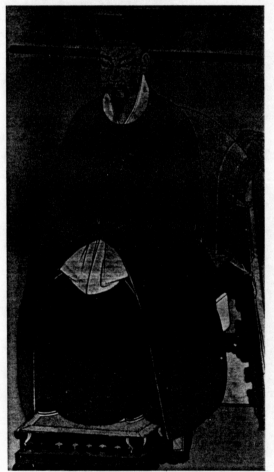

朕獲承
　祖
宗右文之緒祗通
燕謀日奉
慈極萬幾暇間博求載籍
推迹道統之傳自伏羲造
于孟子凡達而在上其道
行窮而在下其敎明採其
大指各為之贊難未能採
瞻精微姑以寫尊其所聞
之意云爾

必羲

繼天立極　　為百王先
法度聲建　　道德純全
八卦成文　　三墳不傳
無言而化　　至治自然

Figure 14.7
Ma Lin (ca. 1180–after 1256),
Portrait of Fu-hsi, from Thirteen
Sages and the Rulers of the
Orthodox Lineage. Hanging scroll,
ink and color on silk, 249.8 x 112 cm.
National Palace Museum, Taipei.

Figure 14.8
Ma Lin (ca. 1180–after 1256),
Listening to the Wind in the Pines.
Hanging scroll, ink and color on silk,
226.6 x 110.3 cm. National Palace
Museum, Taipei.

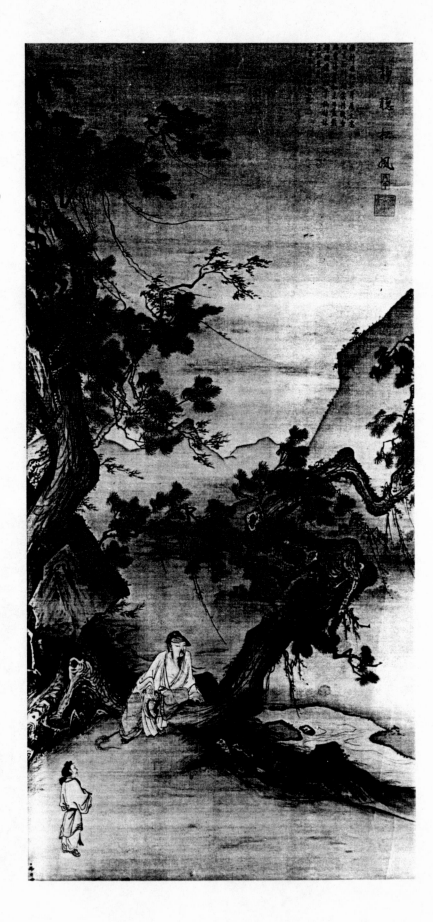

A

B

C

D

E

F

Figure 14.9
Details of faces: a) Seated Portrait o
Emperor Li-tsung; *b)* Fu-hsi; *c)* Ki:
Yao; *d)* King Yü of the Hsia Dynas
e) King T'ang of the Shang Dynast
f) King Wu of the Chou Dynasty (
from the set Thirteen Sages and the
Rulers of the Orthodox Lineage*);*
g) Listening to the Wind in the Pi:

Figure 14.10
Attributed to Ma Yüan (active late
12th–early 13th century), Pines,
Stream, and Pair of Magpies. Alb
leaf, ink and light color on silk, 26.
53.8 cm. National Palace Museum,
Taipei.

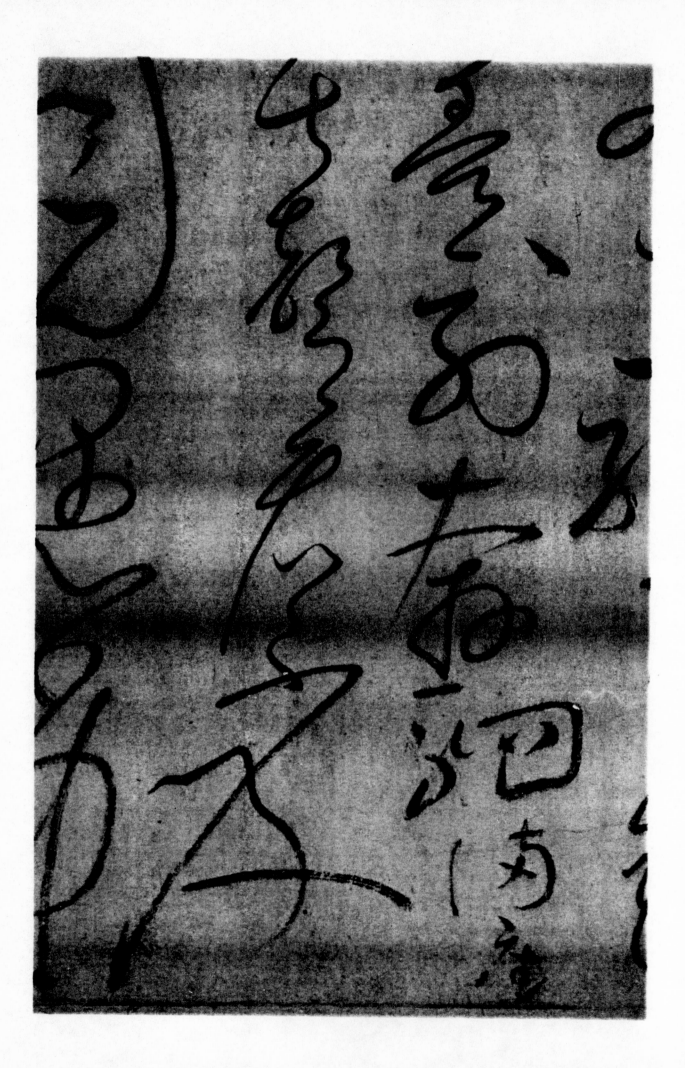

The Painting of Flowers and Birds in Sung-Yüan China

Maggie Bickford

Chao Tzu-ang asked Ch'ien Shun-chü, "What sort of thing is scholar painting (*shih-fu hua*)?" Shun-chü replied, "It is the painting of the *li-chia* (amateurs)." Tzu-ang said, "That is so, but I have inspected [works by] Wang Wei of the T'ang, Li Ch'eng, Kuo Hsi, Li Po-shih [Kung-lin] of the Sung; all were painted by high-minded scholars, and transmit the spirit of the thing [depicted], exhausting its subtleties. As for people of recent times who do scholar painting, how very misguided they are!"[1]

Much repeated and reviewed in traditional and modern literature on Chinese scholar painting, this apocryphal exchange between Chao Meng-fu (1254–1322) and Ch'ien Hsüan (ca. 1235–before 1307) is a blunt analytical instrument.[2] It has, however, the virtue of stating what observably is the situation during the late Sung-early Yüan period: scholar painting is what scholar-painters paint. If we survey the extant corpus, we see that Sung-Yüan scholars painted a wide range of subjects and did so through a wide range of styles. Moreover, the contemporary textual record attests to the stylistic heterogeneity of works that were esteemed by their peers.

The material and textual record, then, tells us that scholar painting is as much a matter of "who made it" as it is of "what it looks like" (although the former inevitably influences the impression of the latter). Asked what is the nature of scholar painting, Ch'ien Hsüan, as James Cahill observed long ago, "avoids any characterization which would distinguish it *stylistically* from other painting; he defines it only as that painting which is done by amateurs."[3] We have yet to get much beyond this tautological chestnut. And nowhere is this more apparent than in the case of the painting of flowers and birds, especially fine-style works. We acknowledge and contextualize the flower painting of such masters as Ch'ien Hsüan and Chao Meng-chien (1199–before 1267) (figs. 15.2, 15.3, and 15.5), but, despite the findings of many specialized studies,[4] we only are beginning to assimilate them into the general history of scholar painting.

Consider, for instance, flower paintings (figs. 15.1 and 15.2) by the contemporaries Cheng Ssu-hsiao (1239–1316) and Ch'ien Hsüan. Cheng's *Ink Orchid* (fig. 15.1) is an abbreviated monochromatic work that evokes its subject through a few swift brushstrokes. His subject—orchid—is associated with the culture-hero Ch'ü Yüan (343–278 B.C.), the slandered and exiled minister, who wandered the South disconsolately and drowned himself in the Mi-lo River. By Cheng's time, Ch'ü Yüan and his orchids were well-established symbols of the (self?-)righteous scholar unjustly scorned by a corrupt world. (Cheng would add his own loyalist link to this

1. "*Shih-fu hua*," in Ts'ao Chao, comp., Ko-ku yao-lun (*Essential Criteria of Antiquities*) (1388), chüan 1, p. 10a; *fasc. reprint of 1388 edn. in Sir Percival David*, Chinese Connoisseurship: The Ko Ku Yao Lun (*New York: Praeger, 1971), p. 335; same entry text collected in I-men kuang-tu, comp. Chou Lü-ching (1597; reprint) (Beijing: Shu-mu wen-hsien Ch'u-pan-she, n.d), chüan 1, p. 13a (vol. 1, p. 162A). This passage and variations of it have been translated many times. I have consulted the following translations: James Cahill, "Ch'ien Hsüan and His Figure Paintings," Archives of the Chinese Art Society of America 12 (1958), p. 14 (his translation reflects a version [collected in Mei-shu ts'ung-shu and elsewhere; see his note 24] that, among other variations, lists Hsü Hsi instead of Kuo Hsi); Sir Percival David, Chinese Connoisseurship, p. 16 (where "Kuo Hsi" in David's Chinese text appears as "Hsu Hsi"); Susan Bush, The Chinese Literati on Painting: Su Shih (1037–1101) to Tung Ch'i-ch'ang (1555–1636), Harvard-Yenching Institute Studies, no. 27 (Cambridge: Harvard University Press, 1971), p. 165; Susan Bush and Hsio-yen Shih, comps. and eds., Early Chinese Texts on Painting (Cambridge: Harvard University Press for the Harvard-Yenching Institute, 1985), p. 255; Wen Fong, Beyond Representation, Chinese Painting and Calligraphy 8th-14th Century (New York: The Metropolitan Museum of Art, 1992), p. 320. Cahill (pp. 14–16, 25–26, ns. 24, 29) discusses textual problems, other versions of this text, and other versions of the exchange.

2. For interpretation and review of historical usage of key terms see: Aoki Masaru, Chûka bunjinga-dan (*Talks on Chinese Literati Painting*) (Tokyo: Kôbundô, 1949); Cahill, "Ch'ien Hsüan

and His Figure Paintings," pp. 14–18; Wen C. Fong, "The Problem of Ch'ien Hsüan," The Art Bulletin 42, no. 3 (September 1960), pp. 181–84; Ch'i Kung, "Li-chia k'ao" (Investigation of [The Term] li-chia) (1963); reprinted in Ch'i Kung ts'ung kao (Ch'i Kung's Essays) (Beijing: Chung-hua shu-chü, 1981), pp. 139–48; Wang Wei, "Lun Ch'ien Hsüan ti hui-hua i-shu chi li-lun" (A Discussion of the Painting and Theory of Ch'ien Hsüan), Ku-kung po-wu-yüan yüan-k'an 2 (1985), pp. 57–58; Fong, Beyond Representation, pp. 319–20.

3. Cahill, "Ch'ien Hsüan and His Figure Paintings," p. 15 (his emphasis). Cahill (p. 26, n. 29) credits Aoki (Chûka bun-jinga-dan, p. 8) with being the first to correctly interpret the terms of this passage.

4. Among these are: Richard Edwards, "Ch'ien Hsüan and 'Early Autumn,'" Archives of the Chinese Art Society of America 7 (1953), pp. 71–83; Hsü Pang-ta, "Ts'ung 'Pai-hua t'u chüan' tsai lun Sung Yüan i-lai ti shui-mo hua-hui hua" (Once Again on Sung-Yüan monochromatic flower painting, with reference to "The Hundred Flowers Handscroll"), Wen-wu no. 2 (1959), p. 46; Hsieh Chih-liu, "Ts'ung Yang Pu-chih chih 'Ssu mei-hua t'u,' Sung-ren 'Pai-hua t'u' lun Sung Yüan chih-chien shui-mo hua-hui hua ti ch'uan-t'ung kuan-hsi" (A Discussion of relationships in the floral [painting] tradition between the Sung and Yüan periods, with reference to Yang Wu-ch'iu's "Four Views of Flowering Plum" and the Anonymous Sung "Hundred Flowers Painting"), in Chien yü tsa-kao (Hsieh Chih-liu's Miscellaneous Writings on Connoisseurship) (Shanghai: Shanghai Jen-min mei-shu, 1979), pp. 116–19; Toda Teisuke, "Kachôga ni okeru Kônanteki na mono" (Chiang-nan Elements in Flower-and-Bird Painting) in Chûgoku no kachôga to Nihon (Chinese Flower-and-Bird Painting and Japan), eds. Toda Teisuke and Ogawa Hiromitsu, vol. 10 of Kachôga no seikai (The World of Bird-and-Flower Painting) (Tokyo: Gakken, 1983), pp. 108–21; James Robinson, "The Vitality of Style: Aspects of Flower and Bird Painting During the Yüan Dynasty (1279–1368)" (Ph.D. diss., University

lofty orchid chain, as it was claimed that he painted rootless orchids because the Mongol conquerers had stolen the earth of China.)[5] Ch'ien Hsüan's subject (fig. 15.2) is Pear Blossoms, a motif whose literary traditions do not conspicuously bear associations comparable to Ch'ü Yüan's orchids. Here, the painter depicts his subject by defining each element with firm, pale outline that he fills in with opaque white and with green, gray, and brown dilute color washes.

If our operative category is "Sung loyalist painting," each of these paintings stands as a primary monument. Both scholar-painters lived through the fall of Southern Sung, an event that profoundly shaped the remainder of life during the aftermath that is the early Yüan. Both are entered in the i-min annals, their credentials as Sung loyalist survivors attested to by the facts of biography, by anecdotal apochrypha, and by the colophons added to their works by contemporaries and later men.[6] The shared status of these works in this context, then, is granted by virtue of the status of the maker. But what about the works themselves? If we change the operative category to "scholar painting," Cheng's Orchid remains secure in its niche, but Ch'ien's Pear Blossoms demands explanation—or, if we judge from the scholarly literature, it attracts special pleading. Why should this be so?

The self-evident "rightness" of Orchid as a scholar-painting monument arises from the degree to which it conforms to a combination of subject matter, media, and technique that, together with observable and attributed qualities or values, has come to be considered as the definitive categorial condition of scholar painting. Here we see fragrant virtue, embodied as orchid, presented in an image of extreme pictorial economy, executed in ink on paper, employing calligraphic brushwork that exhibits spontaneity and transparency of process, and that is strikingly displayed against a blank ground. Cheng's combined artistic choices announce his affiliation with the literati ink-painting lineage: they refer to a particular category—mo-lan (ink orchid)—that Cheng's contemporaries (and later men) recognize as belonging to the exclusive domain of the scholars, and which they define, in large part, through contradistinction to other subject matter and other artistic modes.[7]

Ch'ien Hsüan's Pear Blossoms, in contrast, is neither sketchy nor spontaneous. His brushwork per se is unassertive. His pleasure in craft is conspicuous. He applies outline and color with evident care and with cool tenderness. His image is finished and self-contained; it extends no invitation to participate in the re-creation of the processes through which it was made. It makes reference to the art of professional painters, in particular to the imperially sponsored flower painting of the Southern Sung Academy.

Ch'ien's choices here, and his unmistakable allegiance to features of professional and courtly flower painting, have proved embarassing sometimes to contemporary and modern admirers. They wish to save the artist for scholar-painting hagiography, but they have trouble accommodating his work within a system whose ethos conflates spontaneity with sincerity, harbors a deep distrust of craft, despises professionalism, and expects its loyalist scholar-painters to affirm Chinese cultural values under conditions of alien conquest through acts of considered archaism that, in their return to the past, stylistically repudiate the imperial art of Southern Sung

which lost China.[8] Ch'ien was, in fact, a professional, albeit of a peculiar kind. He was a scholar and a painter but not an amateur: he depended upon painting to make his living.[9] And if he had repudiated Southern Sung painting, that would have amounted to an act of artistic self-annihilation. If he stands as an exemplary loyalist survivor of the early Yüan period, he also is a late Sung scholar-painter. He was a middle-aged man by the time the Sung fell. His world was formed by late-Sung visual and literary culture. And in that world he was not a conservative artist, but one of a late-Sung literati avant-garde that included scholars who painted in fine styles, for instance Chao Meng-chien (figs. 15.3 and 15.5).[10]

If we wish to construct a historical narrative of Chinese scholar-painting that can accommodate Ch'ien Hsüan as well as Cheng Ssu-hsiao, we need to improve our understanding of late Sung literati culture. Despite the art-historical bleating that that culture is now unrecoverable, we know quite a lot about Southern Sung scholar painting and its visual context. Much of what we know is from fine-style flower painting. And the story that this evidence tells is, in significant ways, a story that is different from that told by Wang T'ing-yün's (1052–1102) *Secluded Bamboo and Withered Tree*,[11] a wonderful work that fulfills every desire of the dream of scholar painting, but one that, regretably, reinforces the old line that considers Chinese scholars under the Jurchen Chin to be the keepers of the flame of Northern Sung scholar-painting culture and that relegates their Southern contempories to the role of effeminate aesthetes. A review of the visual evidence is in order.

Southern Sung Flower Painting by Scholars and Others
1. Chao Meng-chien
Let us turn first to Chao Meng-chien, whose scholar-amateur credentials are impeccable. He was an eleventh-generation descendant of the Sung founder (Chao K'uang-yin; T'ai-tsu; r. 960–76). He passed the *chin-shih* examinations in 1226 and served in a number of posts in and around the Southern Sung capital. He was a poet, calligrapher, and painter, a collector and connoisseur. His contempories characterize him as a free spirit, absorbed in the arts, in friendship, and in wine, indulging in outrageous behavior, with suitably refined panache. His successors (unaware or forgetting that he died before the Mongol conquest) improved upon his life and established him apocryphally as a staunch Sung loyalist survivor.[12]

As a theorist and critic, it was Chao who first codified the orthodox lineage and technical repertory of the scholars' (then) modern art of ink-plum painting (*mo-mei*).[13] Yet his surviving works (figs. 15.3 and 15.5) conform neither to the conventions he ennumerates in his ink-plum treatises nor to the conventional desiderata of scholar painting that were current in his own time and that have been outlined above. The works themselves stubbornly remain mysterious. Nothing in the surviving corpus of scholar-amateur *or* Academy flower painting can account for them.[14]

Chao Meng-chien was famous for his ink paintings of orchid, plum, bamboo, and narcissi (the scholars' favorite botanical subjects). His *Narcissus* handscroll (fig. 15.3) brings the viewer close up to a dense bed of flowers, leading him through

of Michigan, 1984); Saehyang P. Chung, "An Introduction to the Changzhou School of Painting," 2 parts, Oriental Art n.s. 31, no. 2 (Summer 1985), pp. 146-60; n.s. 31, no. 3 (Autumn 1985), pp. 293-308; Robert E. Harrist, Jr., "Ch'ien Hsüan's Pear Blossoms: The Tradition of Flower Painting and Poetry from Sung to Yüan," Metropolitan Museum Journal 22 (1987), pp. 53–70; Roderick Whitfield, Fascination of Nature: Plants and Insects in Chinese Painting and Ceramics of the Yuan Dynasty (1279–1368) (Seoul: Yekyong, 1993); Maggie Bickford, "A Moment of Balance, a Moment of Choice," chap. 9 in Ink Plum, The Making of a Chinese Scholar-Painting Genre (New York: Cambridge University Press, 1996).

5. For orchid symbolism in Yüan painting, see Chu-tsing Li, "The Oberlin Orchid and the Problem of P'u Ming," Archives of the Chinese Art Society of America 16 (1962), pp 52–53.

6. For Cheng Ssu-hsiao, see Frederick W. Mote, "Confucian Eremitism in the Yüan Period," in The Confucian Persuasion, ed. Arthur F. Wright (Stanford: Stanford University Press, 1960), pp. 234–36, and Chu-tsing Li, "Cheng Ssu-hsiao," in Sung Biographies, Painters, ed. Herbert Franke, Münchener Ostasiatische Studien vol. 17 (Wiesbaden: Franz Steiner, 1976), pp. 15–23. For Ch'ien Hsüan, see Shih Shou-chien, "The Eremitic Landscapes of Ch'ien Hsüan (ca. 1235–before 1307)" (Ph.D. diss., Princeton University, 1984). For a recent survey of loyalist painting, see Yu Hui, "I-min i-shih yü Nan-Sung i-min hui-hua" (Descendant Ideas and The Paintings by the Descendants of the Southern Sung Dynasty), Ku-kung po-wu-yüan yüan-k'an, 11 (1994), pp. 50–68.

7. See, for instance, remarks by T'ang Hou (active ca. 1320), Hua-lun (Discourse on Painting), in I-shu ts'ung-pien (Collected Works on Chinese Art), comp. Yang Chia-lo (Taipei: Shih-chieh shu-chü, 1962), vol. 11, text no. 81, pp. 7, 9; trans., Bush, The Chinese Literati on Painting, pp. 126–27.

8. The issue of archaism looms large in the rationalizations developed for Sung and Yüan scholars who worked in fine styles and in attempts to assimilate fine-style works into the general history of literati art. This argument frequently is put forward with regard to Ch'ien Hsüan's figure painting and blue-green landscapes (see, for instance, Cahill, "Ch'ien Hsüan and His Figure Paintings"), but it cannot be applied persuasively to Ch'ien's flower paintings, as these clearly refer to (then) recent and contemporary styles.

9. See Wai-kam Ho's discussion of this issue in his entry on Flowers and Birds, cat. no. 71, in Eight Dynasties of Chinese Painting: The Collections of the Nelson Gallery–Atkins Museum, Kansas City, and The Cleveland Museum of Art (exhib. cat.) (Cleveland: The Cleveland Museum of Art, 1980), pp. 90–91.

10. I treat these issues in "Chao Meng-chien, Ch'ien Hsüan, and the Late Sung Literati Avant-Garde," monograph, in progress.

11. Handscroll, ink on paper, Fuji Yûrinkan, Kyoto; reproduced in Osvald Sirén, Chinese Painting: Leading Masters and Principles (New York and London: Ronald Press, 1956–58), vol. 3, pl. 320.

12. Chao's family came South in the aftermath of the fall of Northern Sung, when his great-grandfather, prince of An-ting, accompanied the future emperor Kao-tsung (Chao Kou; r. 1127–62) on his flight from the Jurchen conquerers. They settled in Kuang-ch'en, Chia-ho (modern Hai-yen, Chekiang), where Chao was born and grew up, apparently in straitened circumstances. For Chao's biography and evaluation of sources, see Chu-tsing Li, "Chao Meng-chien," in Sung Biographies, Painters, ed. Franke, pp. 2–7, and Ch'en Kao-hua, ed., Sung Liao Chin hua-chia shih-liao (Historical Source Materials on the Painters of the Sung, Liao, and Chin Dynasties) (Beijing: Wen-wu, 1984), pp. 742–43.

13. See Bickford, Ink Plum, pp. 149–52.

masses of petals and leaves that shimmer and stream across the long scroll. Chao achieves here a combination of free, sweeping movement and exquisite discipline of structure and execution that makes of the twisting, turning, intertwined leaves a rhythmic, lucid, progression that simply is unnerving. And this he sustains with unbroken consistency across some twelve feet of paper ground.

The nominally natural disarray is, in fact, engineered and patiently constructed with outstanding control, finesse, and skill. Mastery of brush and ink here does not refer to the outcome of practice internalized and then released in a spontaneous burst of calligraphic brushstrokes.[15] Mastery here is design and implementation. Technique is right up front. Whatever else it may be, Chao's creative act is one of technical tour de force and his pleasure in craft is candid.

Traditional and modern writers characterize Chao's painting as *pai-miao* (plain drawing) narcissi.[16] But, if we judge from this painting, that is a misnomer. Associated with the scholar-amateur exemplar Li Kung-lin (ca. 1041–1106), *pai-miao* was the only fine-style painting mode approved for literati use. I suspect that this is why the term is applied to the fine-style monochromes of Chao Meng-chien and others: its invocation was the only available way to gather such works into the categorical fold of scholar painting. But the essence of *pai-miao* painting is the primacy of line, and that is not what is going on here. In *pai-miao* painting (for instance Li Kung-lin's *Five Horses*),[17] line does the work and wash assists it. In Chao Meng-chien's *Narcissus* the roles of ink wash and line are reversed. This painting (literally) turns on tonal contrasts between light and darker washes, which form the inner and outer surfaces of the long, twisting leaves that are its basic formal unit, and between these washes and the reserved paper, which form their ribs. Chao applies fine, sharp lines to guide the laying down of these smooth washes. These lines are not calligraphic: they are strictly bound to the segment they outline; they are not developed internally as beginning, middle, and end; the brushstrokes do not twist, turn, or flare—the washed forms do. Sometimes he returns to sharpen edges with contour strokes. Most of the leaf tips are gently blunted; where they are sharp, their points are not formed by the play of the flexible tip of the brush (as Cheng Ssu-hsiao's single-stroke orchids [fig. 15.1] are) but, rather, are achieved through Chao's patient honing of the form with repeated applications of dark ink. If the viewer is propelled through this long scroll through wave on wave of a dominant impulse of rhythmic linearity, that is the effect of the long, twisting, turning, streaming leaves, not of the guide lines that help to construct them.

Chao Meng-chien's distinctive ink narcissi are reflected by many imitations and homages in later literati art. They remain, however, unprecedented in the history of Chinese flower painting. A proximate correlative may be found in fish painting, a genre that also develops an impression of pliant, rhythmic linearity through tonal contrasts among ink washes and between them and the reserved ground.

Consider, for instance, *Fish at Play* (fig. 15.4), attributed to Chao K'o-hsiung (b. ca. 1030). A military official, Chao K'o-hsiung was one of a number of members of the Sung imperial clan who painted fish in their spare time.[18] More than the waving water plants, the swimming fish evoke formal affinities with Chao Meng-

chien's flower painting: the smooth, dark washes along their dorsal contours, the display of their fluttering and flexing ink-wash fins and tails as they turn and move through the water. Like the windswept narcissi, these fish are in their element: the image again simultaneously evokes free, natural movement and exhibits exquisite artistic control. If we grant a general morphological analogy between K'o-hsiung's fish and Meng-chien's leaves and observe similar relationships in the work of wash and line in making forms, we can locate *Narcissus* developmentally at the late end of a fine-style ink-wash tradition associated with Sung imperial amateurs and with Sung court painting.[19] Chao Meng-chien develops this fine-style tradition toward scholar-amateur preferences by choosing paper rather than silk, by eliminating color, and by pursuing structural clarity through rigorous stylization and draftsmanship. What he does not do is abandon the imperial amateur's pleasure in elegance, refinement, and craft.

We do not know Chao Meng-chien's intention in choosing to paint narcissi in ink.[20] As a motif of scholar painting, narcissus was a latecomer, and Sung scholars were only beginning to pull together a body of enhancing allusions, to develop descriptives and themes, and to fashion an aesthetic for narcissus along the lines of plum blossoms and other flowers of pale purity. Whatever the artist's intentions and whatever the state of the motif during the late Sung, by the early Yüan, Chao's *Narcissus* provoked in Sung loyalist survivors passionate regret and longing for the fallen dynasty. Thus, it was not Chao Meng-chien who made ink narcissi into an enduring emblem of loyalty and purity; that, rather, was the contribution to literati iconography of loyalist survivors like Chou Mi (1232–98), and Ch'iu Yüan (1247–after 1327), who mourned the loss of Sung in their colophons to this painting. Provoked by this fine-style flower painting, their lamentations are as intense and moving as any of the colophons inscribed after Cheng Ssu-hsiao's calligraphic *Orchid*.[21]

Significantly, Chou and Ch'iu chose the form of *yung-wu tz'u* (song lyrics on objects) to make their responses to Chao's *Narcissus* scroll. Like Chao's painting, this poetic form is elaborately crafted; it exults in virtuosic display of technique, dazzling image, and in the generation of complex effect. Vigorously developed during the late Sung, it is a form in which writers focus on a single object (in this case narcissus), and use it as a location for constructing senusal, emotional, and symbolic situations of rich ambiguity through their manipulation of language, image, and allusion.[22] This capacity of *yung-wu* song lyrics to display and to conceal, to yield gradually new layers of interpretative possibility to those who can recognize recondite allusions and make connections proved to be useful to loyalist survivors who lodged passionate feelings in highly wrought forms. That is what Chou Mi and Ch'iu Yüan did in 1279, when they joined with a dozen loyalist poets who gathered to lament the desecration of the Sung imperial tombs, composing *yung-wu tz'u* on subjects such as white lotus, ambergris, and cicada.[23] And that is what Chou and Ch'iu are doing when they respond to Chao Meng-chien's *Narcissus* with their densely allusive song lyrics. For loyalist survivors like Chou Mi and Ch'iu Yüan, the refinement and finesse of *Narcissus* are not anomalies of literati culture; rather,

14. I have suggested that the closest analogues to Chao's peculiar images may be found in Sung decorative arts rather than in Sung painting. ("Luck and Virtue: 'The Three Friends of the Cold Season' in Song Material Culture, Literature, and Literati Painting," paper presented at the annual meeting of the Association for Asian Studies, Boston, 1994.) The inspiration for the continuous pattern of his Narcissus handscroll (fig. 15.3) and its tone-against-tone development may lie in weaving (especially damasks), metalwork, or lacquer. His emblem-like Three Friends album leaf (fig. 15.5) finds correlatives to its compression, clarity, and isolation in the small-repeat patterns of Sung textiles. I treat these relationships, as they develop from Sung through Ch'ing, in "The Three Friends of the Cold Season: Luck and Virtue Conjoined in Chinese Painting and the Decorative Arts," book, in progress. I suggest a more proximate source for some features of Narcissus below.

15. As in the semi-ecstatic state evoked by Su Shih in the famous poem in which he recalls painting bamboo and rock while intoxicated; trans., Bush, The Chinese Literati on Painting, p. 35.

16. For instance, Hsia Wen-yen, comp., T'u-hui pao-chien (Precious Mirror of Painting; preface dated 1365), chüan 4, in Hua-shih ts'ung-shu, ed. Yü An-lan (Shanghai, 1963; reprint [with Chung-kuo shu-hua yen-chiu tzu-liao she as comp.] Taipei: Wen-shih-che, 1974), vol. 2, p. 764; Li, "Chao Meng-chien," p. 5; Fong, Beyond Representation, p. 303.

17. Handscroll, ink on paper; collection unknown; reproduced in Sirén, Chinese Painting, vol. 3, pls. 191, 192.

18. For Chao K'o-hsiung, see Ch'ang Pi-te, ed., Sung-jen chuan-chi ts'ai-liao so-yin (Index to Biographical Materials of Sung Figures), vol. 4, p. 3484, where it is noted that he was the great-grandson of Chao Yen-mei (d. 984 aet. 38 sui); the entry on Chao Yen-mei (p. 3485) states that he was the younger brother of the emperor T'ai-tsung (Chao Kuei; r. 976–97). Entries on other great-grandsons of Yen-mei indicate birthdates in the 1030s and 40s.

The Hsüan-ho hua-p'u *editors found his painting tame, but were at pains to give it a suitable amateur context: "He liked to play with brush and ink; he never became mired in the opulent and aristocratic."* (Hsüan-ho hua-p'u [Catalogue of the Imperial Painting Collection During the Hsüan-ho Era; preface dated 1120], chüan 9; reprint, Yü Chien-hua, ed. and annot. [Beijing, 1964; reprint Hongkong: Wenfeng, n.d.], pp. 157–58.)

19. *If we take Chao K'o-hsiung's work as representing the art of imperial amateurs, we can make stylistic connections between them and painters at the academies of Shen-tsung (Chao Hsü; r. 1068–85) and Hui-tsung (Chao Chi; r. 1101–25) through the art of Liu Ts'ai, represented by the attribution* Fish Swimming Among Falling Flowers *(handscroll, ink and light color on silk, The Saint Louis Art Museum, 26:1927, see especially the opening section; reproduction and discussion in Steven D. Owyoung,* Chinese Paintings, The Bulletin of The Saint Louis Art Museum *n.s. 17, no. 3 [Summer 1985], pp. 4–5), and extend these to late Sung–early Yüan, represented by such works as* The Pleasures of Fishes, *dated 1291, by Chou Tung-ch'ing (active late 13th century), an associate of the loyalist Wen T'ien-hsiang (1236–83) (handscroll, ink and light color on paper, The Metropolitan Museum of Art, 47.18.10; reproduced in Fong,* Beyond Representation, *pls. 83, 83a. These paintings can be taken to span the period from late Northern Sung to early Yüan; beyond shared subject matter, they indicate significant formal affinities among fine-style ink-wash works by Academy and amateur painters.*

20. *Regarding his motivation in making this painting, Chao, in his short inscription (recorded and now lost), notes only that he painted it in response to a pressing request. Artist's inscription and complete colophons transcribed (under the title* Shui-mo shuang-kou shui-hsien ch'ang-chüan *[Long Scroll of Ink-Outlined Narcissi]) in Wang K'o-yü,* Shan-hu-wang hua-lu *(1643), chüan 6; reprint (n.p.: Ch'eng-tu ku-chi shu-tien, 1985), pp. 857–60; Chao's text, trans. (from another source) in Bush,* The Chinese Literati on Painting,

these are entirely appropriate attributes for a painting from the hand of an imperial amateur and for a relic of Sung literati culture. It is the appropriateness of these connections—evident in these and other colophons—that make fine-style painting both a flash point for loyalist response and a suitable vehicle for loyalist painters during the early Yüan.

Chao Meng-chien's famous *Three Friends of the Cold Season*, in the National Palace Museum, Taipei (fig. 15.5), also stands as a singular monument in the history of Chinese art.[24] This painting, one is tempted to assert, is a unique image. It is, I believe, the only surviving high-quality Sung painting devoted to pine, bamboo, and plum.[25] Its particular combination of theme, formal premises, and mode of execution remains unmatched in the Sung pictorial record. In conception and composition, and more evidently in media and technique, there is nothing like it in the "cut branch" (*che-chih*) sub-genre of Academy flower-and-bird painting. Some of its motifs and technical means can be found in extant works in the scholar-amateur genres of ink bamboo and ink plum, but there is no true match for it among extant Sung scholar paintings.[26]

Like other scholar-painters, Chao's pictorial premise is ideational, not naturalistic. One could not look out one's window and see what he has delineated here. Chao takes one spray of pine, one stalk of bamboo, one branch of plum and purposefully, patiently, weaves them into an inextricable three-in-one motif. Not only does this configuration not occur in nature, but, stylized severely and set in an extremely shallow pictorial space, these plants are implausible even as still life or study.

Chao works with established scholar-amateur conventions that had been developed specifically with reference to monochrome and that were designed as much to exploit the possibilities of ink and brush as to depict a nominal subject. This is most evident in his calligraphic bamboo and in his circled-petal plum blossoms. But he works these elements in a peculiar way, and toward an outcome distinctively different from other products of scholar-amateur art. In making *Three Friends*, Chao avails himself of formal solutions that had been adapted by scholar-painters from the art of writing; but Chao's is an art of linear exposition, not of calligraphic exploration. His brushwork is immaculate: the silvery, etched sharpness of needles and stamens, the pristine outlines of plum. To this clarity he brings refinements of wash: pale auras are lightly brushed about the petals; candy-cane stripes, laid down with elegant playfulness, form the bark of pine. Its monochrome, linearity, and significant stylization notwithstanding, the polished presentation and impeccable execution of Chao's work here exhibits deep affinities with and affection for the courtly art of flower painting. Where other literati make floral images (figs. 15.1 and 15.6) that are visually open-ended—exhibiting a technical transparency that prompts the imaginative reenactment of the painting process—Chao here (as also in *Narcissus*) makes a declarative visual statement. *Three Friends* displays the same self-possessed, now-and-forever pictorial finality that characterizes the finest work in the Academy tradition of poetic realism. This is perhaps how the emperor Hui-tsung (Chao Chi; r. 1101–25) would have painted ink flowers, if, like his younger

distant relation, he had at hand the devices developed by ink painters during the century that separates these imperial amateurs.[27]

We return now to the question of meaning.[28] Again, Chao left no textual evidence of his intention. We can see only that he has directed his incisive draftsmanship toward creating an isolated, emblematic image. But emblematic of what? We have become accustomed to reading *Three Friends of the Cold Season* as a triad of Confucian virtue, in which these botanical worthies that endure the depredations of winter—the pine, which is evergreen; the bamboo, which bends but does not break; and the plum, which blossoms amid snow and ice—are likened to the superior man who reveals his moral toughness by surviving with unimpaired integrity, while all about him succumb to the tribulations—the Cold Season—of troubled times. This reading accords comfortably with the aprocryphal image of Chao as loyalist exemplar. But whatever its honored place in the scholar's Iconography of Virtue, the Three Friends never was the exclusive property of loyalist survivors or high-minded hermits. The motif has held entirely auspicious associations in elite and in popular culture from Chao Meng-chien's time to ours, as attested by its ubiquitous presence in Chinese decorative arts.[29]

The only indisputably dated Sung visualizations of this three-in-one motif occur as delicate interlaceries of pine, bamboo, and plum woven into textiles excavated from the tombs of well-born women.[30] In its role as elegant ornament, gracing the garments of Chao's female contemporaries, the Three Friends motif is unlikely to stand for the indomitable virtue of the battered-but-unbowed Confucian scholar. Associated with New Year's and the coming of spring, The Three Friends appear in Sung genre painting, where sprays of pine, bamboo, and plum stick out of the headgear of street performers. In the same context, they regularly are deployed in "San yang k'ai t'ai" (Three *yang* bring on spring), "Chiu yang hsiao han" (Nine *yang* disperse the cold), or "Chiu-chiu hsiao han" (Nine nines disperse the cold) lucky rebus paintings and pictorial textiles that celebrate the return of the warm season.[31] The Three Friends also symbolize longevity, as attested to by Southern Sung and later song lyrics composed for birthdays. Typically, these birthday songs start off with a run of high-minded tropes, then turn to bring the Three Friends together in concluding sentiments like these: "What's more, see how it [plum] resists aging; In the cold season faithful friends pine and bamboo."[32]

Chao may have painted *Three Friends of the Cold Season* as an emblem of virtue, or as a New Year's token, or as a birthday keepsake. If we judge from the range of recipients of Three Friends song lyrics, he may have made it for a scholar in retirement, or for a favorite lady, or for a statesman. And if we judge from his recorded gifts of plum painting, he might have made it for his political patron Chia Ssu-tao (1213–1275), the Southern Sung minister (and art collector), who is reviled throughout Chinese history as traitor.[33] The case of Chao Meng-chien reminds us that, once we stop looking at Sung literati art from our default orientation in dominant Yüan outcomes, we know less than we think we do and can know much more than we now know about the multiplicity of painting styles, iconographic possibilities, and functions as social currency among the scholars of late Sung and their immediate successors.

p. 123. For complete documentation and publication record, see Wen Fong and Marilyn Fu, Sung and Yüan Paintings (exhib. cat.) (New York: The Metropolitan Museum of Art, 1973), cat. no. 12, pp. 143–44.

21. Colophons by Chou Mi and Ch'iu Yüan recorded (under the title Shui-mo shuang-kou shui-hsien ch'ang-chüan) in Wang K'o-yü, Shan-hu-wang hua-lu, chüan 6, p. 858; Chou's colophon, trans. (abridged) by Jonathan Hay in Richard Barnhart, Peach Blossom Spring, Gardens and Flowers in Chinese Painting (exhib. cat.) (New York: The Metropolitan Museum of Art, 1983), p. 39; Ch'iu's colophon, trans., Fong and Fu, Sung and Yüan Paintings, p. 71, and Fong, Beyond Representation, p. 306. Colophons to Cheng Ssu-hsiao's Orchid recorded in Shih-ch'ü pao-chi (Treasured Boxes of the Stony Moat [Catalogue of Painting and Calligraphy in the Ch'ien-lung Imperial Collection]; 1745), Wang Chieh et al., comps.; facs. reprint of an original ms. copy (Taipei: National Palace Museum, 1971), vol. 2, pp. 986B–88A.

22. For the development of yung-wu tz'u and late Sung literati culture, see Shuen-fu Lin, The Transformation of the Chinese Lyrical Tradition, Chiang K'uei and Southern Sung Tz'u Poetry (Princeton: Princeton University, 1978). Lin's work has stimulated art historians to speculate upon the implications of his findings for Sung-Yüan painting; such studies include John Hay, "Poetic Space: Ch'ien Hsüan and the Association of Poetry and Painting," in Words and Images, Chinese Poetry, Calligraphy and Painting, eds. Alfreda Murck and Wen C. Fong (New York: The Metropolitan Museum of Art and Princeton University Press, 1991), pp. 173–98; Harrist, "Ch'ien Hsüan's Pear Blossoms: The Tradition of Flower Painting and Poetry from Sung to Yüan"; and Bickford, Ink Plum. I develop these issues in "Chao Meng-chien, Ch'ien Hsüan, and the Late Sung Literati Avant-Garde."

23. See Lin, The Transformation of the Chinese Lyrical Tradition, pp. 191–93, and Kang-i Sun Chang, "Symbolic and Allegorical Meanings in

the Yüeh-fu pu-t'i *Poem Series*," *Harvard Journal of Asiatic Studies* 46, no. 2 (December 1986), pp. 353–85.

24. *The following discussion is adapted from my treatments of this work in "Luck and Virtue" and in* Ink Plum, *pp. 94–96, 155–56, and 158–59.*

25. *While Sung Academy paintings of winter and early spring themes frequently depict bamboo and plum (often combined with wild birds), I do not know of any that focusses on these three plants.*

26. *For scholar painting of the motifs, see Yang Wu-chiu's* Ink Bamboo *(album leaf, ink on paper, National Palace Museum, Taipei; reproduced,* Ku-kung ming-hua san-pai-chung [Three Hundred Masterpieces of Chinese Painting] *[Taichung: National Palace Museum and National Central Museum, 1959], pl. 93) and his* Four Views of Flowering Plum *(fig. 15.6). Appropriate comparative Academy images include* Birds in a Thicket of Bamboo and Plum, *unidentified artist, early 12th century. (hanging scroll, ink and color on silk, National Palace Museum, Taipei; reproduced,* Ku-kung ming-hua san-pai-chung, *pl. 136), and* Sparrows, Plum Blossoms, and Bamboo, *unidentified artist, late 12th century (fan mounted as an album leaf, The Metropolitan Museum of Art, 24.80.487; reproduced, Fong,* Beyond Representation, *pl. 47.*

27. *For a comparative discussion of this painting and Hui-tsung's* Four Birds [on Blossoming Branches and Bamboo] *(album leaves mounted as a handscroll, ink on paper, private collection), see Bickford,* Ink Plum, *pp. 94–96.*

28. *The discussion that follows is adapted from my "Luck and Virtue"; I develop these issues in "The Three Friends of the Cold Season: Luck and Virtue Conjoined in Chinese Painting and the Decorative Arts."*

29. *For a survey of Three Friends traditions in ceramics, see Mary Gardner Neill, "The Flowering Plum in the Decorative Arts," in Maggie Bickford,* Bones of Jade, Soul of Ice: The

2. Yang Wu-chiu (1097–1169) and Southern Sung Ink-Plum Painting

One of the most severe constraints that we impose upon our ability to understand flower painting is that we continue to observe the critical sanitary cordon that traditionally has protected scholar-amateur genres—ink bamboo, ink plum, ink orchid, among them—from contagion by contact with other other subject matter and other approaches to painting. This is not surprising, considering that theorists like Wu T'ai-su (active mid-14th century) were outraged at the very idea that ink plum could be classed with painting at all![34] But by honoring this prohibition we deny ourselves full access to the Southern Sung textual and visual record. If we examine these particulars carefully, we find that Southern Sung scholar-painters and their paintings look different than they appear to be when they are seen through the influential filter of Yüan critics, theoreticians, and practitioners. A reconsideration of the ink-plum master Yang Wu-chiu and the formative period of his genre is useful here.[35]

Lyricist, calligrapher, and painter, Yang was the most celebrated ink-plum master of his day. There are no reliable early biographies of this artist. Contrasts between Sung and Yüan characterizations reveal the typical and instructive slippage between proximate sources and post-Conquest sanitization and idealization. Southern Sung sources depict him as an elegant literatus and bon vivant, the sort who tipsily paints plums on the walls of his local brothel; Yüan sources (and accounts first recorded during the Yüan) present him as a man of principles, irony, and confrontational poise, who avoided office in protest against imperial pacificist policies. Thus, the Yüan scholars recast this Southern Sung rake in the image of the *Mo-mei* Master, making him into a worthy model for Chinese literati under alien rule.

Yang's *Four Views of Flowering Plum* (fig. 15.6), dated 1165, is the earliest extant masterwork in the ink-plum genre. Comprising Yang's painting and holograph song lyrics and postface, it also is an early instance of a self-documented, integrated pictorial/poetic program executed by an individual painter-poet-calligrapher. Thus it shows us what a major master painted at mid-twelfth century; it lets us read, in his own words, the poetic associations he generated to match his ink-plum images; and, because it conforms generally to characterizations of Yang's work in Sung sources, it provides a visual basis from which to assess the Southern Sung critical discourse.

According to Yang's postface, he made this work at the request of an associate who asked him to paint four stages in the life of plum blossoms and to compose a set of four song lyrics on the theme. The commission is thus designed to display Yang's mastery of the Three Perfections: poetry, calligraphy, and painting. Yang complies by painting four isolated images that depict plum in stages of growth from budding to decline, by inscribing four *tz'u* that recycle that theme, to which he adds his postface.

In *Four Views*, Yang translates his understanding of the botanical morphology of plum in nature into the linear structures of his ink-plum art. His capacity for naturalistic description and elegant lucidity owes much to accomplishments of fine-style

flower-and-bird painting. His significant stylization, which transforms monochromatic flower painting into the scholar's ink plum, arises from his experiences in calligraphy. This transformation is Yang's pivotal contribution to the development of the ink-plum genre.

The Southern Sung connoisseur Chao Hsi-ku (active ca. 1195–1242) located the excellence of Yang's work in the artist's ability to bring to his painting of plum the "vigor and incisiveness" of his calligraphy in the style of Ou-yang Hsün (557–641).[36] Looking at *Four Views*, we can see what Chao means. Yang's writing here (figs. 15.6 and 15.7b) follows Ou-yang's standard-script calligraphy (fig. 15.7a). Significant formal affinities between Yang's calligraphy and his plum painting (figs. 15.6 and 15.7c) are apparent. He paints plums the same way he writes characters: writing and painting are severe, rigorously structured, tense, attenuated, and angular; both are executed as a sequence of controlled flat brushstrokes that provide the long curves with a tough infrastructure, the articulated turns of Yang's Ou-yang-style calligraphy also forming the bony joints of plum limbs and branches. His placement and spacing of pictorial and written elements (fig. 15.6) also exhibit significant similarities: Like the branches of his ink plums, his calligraphy is isolated against an extensive ground, with ample internal spaces between each stroke and dot, between the elongated characters, and between each narrow column.

If we pursue the terms of Chao's praise in view of the observable evidence here, we see that what Chao, in the mid-thirteenth century, sees as "calligraphic" painting and "vigorous, incisive" brushwork looks different from our typical, Yüan-centered notion of those terms as manifested in monuments like the ink plums of Wu Chen (1280–1354; fig. 15.10) and Tsou Fu-lei (active mid-14th century).[37] Yang achieves in *Four Views* a balance between naturalistic description and calligraphic stylization, realized through rigorously structured draftsmanship, which rarely will be seen again. His calligraphic ink plums are abbreviated rather than abstract. His astute botanical rendering of plum reflects lessons learned from traditional flower painters who, during his lifetime, perfected the artist's capacity for observation and naturalistic description to a degree unprecedented in the history of Chinese art. Although the circles, strokes, and dots of Yang's painting came to constitute formal conventions that eventually permitted scholar-painters like Wu Chen (fig. 15.10) and Tsou Fu-lei literally to "write" their ink plums, Yang himself does not automatically transpose the brushstrokes and structures of calligraphy into painting. Rather, he pursues a calligraphic approach to terse naturalistic description: the exposed formal structures of his brushstrokes and the botanical morphology to which they refer with notable fidelity are exhibited with equal emphasis in a harmonious image, marked by the Southern Sung scholar-painter's taste for refinement and restraint.

It is a commonplace in the appreciation of calligraphy that a man's writing reveals his character, and that the choices that a man makes among available historical models reveals not only his taste but also his values, as it announces his admiration for the persona of the exemplary calligrapher as well as for the calligraphy exemplar that he copies. In *Four Views*, we encounter a situation in which the

Flowering Plum in Chinese Art (exhib. cat.) (New Haven: Yale University Art Gallery, 1985), pp. 194–204.

30. Pine-bamboo-and-plum patterned textiles have been excavated from the tombs of Huang Shen (d. 1243, aet. 17 sui) and Miss Chou (1240–74). For Huang Shen, see Fu-chien po-wu-kuan, eds., Fu-chou Nan-sung Huang Shen mu (Tomb of Huang Shen of the Southern Sung at Fu-chou) (Beijing: Wen-wu, 1982); her "Three Friends" jacket is reproduced (pl. 35; illegible) and its pattern illustrated in weave diagram (fig. 58) and line-drawing (fig. 59). For Miss Chou, see Kiangsi-sheng wen-wu k'ao-ku yen-chiu-so and Te-an-hsien po-wu-kuan, eds., "Kiangsi Te-an Nan-sung Chou-shih mu ch'ing-li chien-piao" (Preliminary Report on the tomb of Miss Chou of Southern Sung at Te-an, Kiangsi), in Wen-wu no. 9 (1990), pp. 1–13; the textile is reproduced as pl. 4.4.

31. For genre painting, see Picture of Driving Away Demons, unidentified Sung artist (hanging scroll, ink and color on silk, Palace Museum, Beijing; reproduced, Chu Chia-chin, Treasures of the Forbidden City [first publ. as Kuo-pao, 1983; trans., New York: Viking, 1986], pp. 106–107). Chu illustrates an eighteenth-century "Chiu-yang" tapestry, after a Sung painting (no. 98, p. 249).

32. Yao Shu-yao (d. after 1182), tz'u to the tune pattern "Nien-nu chiao" (The Charm of Nien-nu), in T'ang Kuei-chang, comp., Ch'üan Sung tz'u (Complete Sung tz'u) (Beijing, 1956; reprint, Taipei: Wen-kuang, 1983), vol. 3, p. 1550. Many examples of the type appear in this and other collections of song lyrics. Of particular interest with regard to scholar painting is Chang Chu's (1287–1368) "Inscribed on the Picture of Three Friends, Painted by Chao Yüan [d. after 1370] and Wang Mien [d. 1359] for Yang Kai [unidentified]," tz'u to the tune-pattern "T'a so hsing" (Treading on Sedge), in T'ang Kuei-chang, comp., Ch'üan Chin-Yüan tz'u (Complete Chin-Yüan tz'u) (Beijing: Chung-hua, 1979), vol. 2, pp. 1023–24.

33. Chu-tsing Li, "Chao Meng-chien," pp. 2–3. See also Ch'en Kao-hua, Sung Liao Chin hua-chia shih-liao, p. 743. Li and Ch'en note the suppression by later writers of Chao Meng-chien's close relationship with Chia Ssu-tao.

34. See Wu T'ai-su, comp., "Shu mei miao li" (On the Subtle Logic of Flowering Plum) and "Mo-mei ching-lun" (Discourse on Ink-Plum Essentials), in Sung-chai mei-p'u (Pine-Studio Plum Manual; ca. 1351), chüan 1; Shimada Shûjirô, ed., Shôsai baifu; facs. of Japanese ms. copy, Asano Collection, Hiroshima Central City Library (Hiroshima: Hiroshima chûô shiritsu toshokan, 1988), pp. 150 and 151–52; type-set transcription, p.266. Trans. and discussion, Bickford, Ink Plum, pp. 181–83.

35. For a full discussion of Yang Wu-chiu and his admirers, see Bickford, Ink Plum, pp. 131–46, from which the following discussion is adapted.

36. Tung-t'ien ch'ing-lu chi (Collection of Pure Happiness in a Cave Heaven), in I-shu ts'ung-pien, comp. Yang Chia-lo, vol. 28, text no. 247, pp. 272–73. Trans. and discussion in Bickford, Ink Plum, pp. 138–39, 141–43.

37. See Tsou Fu-lei, Breath of Spring, handscroll, ink on paper, Freer Gallery of Art, 31.1; reproduced, Sirén, Chinese Painting, vol. 3, pls. 364, 365.

38. Transcribed in T'ang Kuei-chang, comp., Ch'üan Sung tz'u, vol. 2, pp. 1205–6. Trans. and discussion in Bickford, Ink Plum, pp. 135–38. See also, Jao Tsung-i, "Tz'u yü hua, lun i-shu ti huan-wei wen-ti" (Tz'u Poetry and Painting: Transpositions in Art), in Ku-kung chi kan 8, no. 3 (1974), pp. 9–20, and eng. trans. by Louise Yuhas, pp. 11–21.

39. Datable to 1216 by Yang Mei-tzu's seal; hanging scroll, ink, color, and gold on silk, Palace Museum, Beijing.

40. "Yang Pu-chih tz'u-hua" (On Yang Wu-chiu's Song Lyrics and Painting), in Hou-ts'un hsien-sheng ta ch'üan chi (Collected Works of Liu Kezhuang),

Southern Sung writer uses the severe standard-script style of the upright T'ang calligrapher Ou-yang Hsün to transcribe song lyrics of lush, romantic longing. Yang's suite of Four Views tz'u not only traces the life-cycle of plum blossoms, but also recalls the course of a love affair from intoxicated infatuation to the lassitude of tristesse.[38] He eschews those popular flowering-plum conceits that link Plum-Blossom Beauties with purity, virtue, and transcendence or that embody eremitic ideals in the Flowering-Plum Recluse. His single plum allusion to political aspiration is so straightfoward and self-contained that it does not encourage extension as the governing theme of the set. That is to say, one can find little here to prompt an allegorical reading, which would bring his poetic intention to a loftier range of concerns. Typical of Yang's yung-wu tz'u on plum blossoms, those inscribed on Four Views are conspicuously erotic.

In view of the long-term development of ink plum as a mainstay of the scholars' Iconography of Virtue, it is significant that in this sole surviving work in which a Southern Sung ink-plum master celebrates plum blossoms in painting and poetry, he writes of "Tender buds tête-à-tête," "Sandalwood lips bashfully parting," "A whole night of deep fragrance," "Always lamenting it bloomed so late." In the record of extant inscribed Sung flower paintings, Yang's poetic images of romantic love, nostalgia, and transience find their closest echo in the mildly erotic quatrain that the empress Yang Mei-tzu (1162–1231) inscribed on the premiere monument of flower painting in the Academy tradition of poetic realism: Ma Lin's (ca. 1180–after 1256) Layer on Layer of Icy Thin Silk (fig. 15.8).[39] Moreover, during the Southern Sung, this eroticism formed one of the key attractions of Yang's work for literati admirers.

Liu K'o-chuang (1187–1269) undoubtedly was responding to a work very like Four Views when he composed his colophon for "Yang Wu-chiu's Tz'u and Painting." Liu begins his extravagant praise by including Yang among those very few persons who attained superb accomplishment in both poetry and painting: Wang Wei (700–61), Cheng Ch'ien (active 737), Wen T'ung (1018–79), and Li Kung-lin. He then praises Yang's song lyrics as the equal of those collected in Hua-chien chi (Among the Flowers) and Hsiang-lien chi (Fragrant Casket), and the best works of Yen Chi-tao (1030?–?1106) and Ch'in Kuan (1049–1100). He concludes by conferring upon the scroll the accolade "T'ao-ch'an's (Yang Wu-chiu) Three Perfections."[40]

Significantly, Liu locates Yang's accomplishment in two lineages: literati painting and literati love songs.[41] His admiration of Yang thus accomodates both scholar-painting values and an appreciation of celebrated sensuality. In Liu's mind, the ideals epitomized by Wang Wei, Wen T'ung, and Li Kung-lin sit comfortably with the delicacy and overt eroticisim, with the intention to stimulate pleasure and emotion rather than to affect moral consciousness, and with the resistance to allegorical interpretation, which are characteristic of the Hua-chien lyrics and are fundamental features of the suite of plum-blossom lyrics that Yang composed for and inscribed upon Four Views. Liu's remarks stand as a forceful reminder that at the moment when Yang Wu-chiu's painting is attaining the status of the classical ink-plum model, the terms in which his work is valued by scholar-connoisseurs are very dif-

ferent from the rhetoric of plum's "lonely and lofty, great and extraordinary moral fortitude" that will dominate ink-plum appreciation after the fall of Sung.[42]

Dismantling Southern Sung Stereotypes

The most effective way we can improve our understanding of Southern Sung scholar art is by making the observable evidence of Sung paintings the final arbiter of Sung art-historical reality. Here the case of ink plum is instructive. If we review the corpus of extant flowering-plum images of all kinds, we are forced to abandon two entrenched assumptions about literati painting: first, that scholar-painting genres evolve in a harmonious sequence of development through the linked practices, or stylistic lineages, of a succession of scholar-painters from Northern Sung through the Yüan period; second, that Southern Sung scholar-amateur painting and Academy painting stand "worlds apart." On reflection, we can understand that both presumed continuity and polarity are more rhetorical than real, more the formulations of writers than the practice of painters.

1. Southern Sung Ink-Plum Painting

Chao Meng-chien begins his treatise on how to paint ink plums by invoking the orthodox lineage: Chung-jen (d. 1123), Yang Wu-chiu, T'ang Cheng-chung (active ca. mid-12th to early 13th century). And traditional theorists and modern scholars continue to intone this ink-plum litany. Yet, if we review Southern Sung ink-plum paintings and texts, we see that the stylistic history of the genre during its formative period is not a sequence of organic developments, each generation refining and extending the accomplishments of its predecessor (as is the case after the Yüan). The products of the first three generations of ink-plum practioners represent, rather, disjuncture and repeated displacement.[43]

In traditional critical literature, the invention of ink-plum painting is given to the Ch'an monk Chung-jen, also known as Hua-kuang. If we judge from the ample textual evidence, his ink plums (and those painted by others during the first quarter of the twelfth century) did not look anything like what we, today, think of as ink-plum painting (for instance, fig. 15.10). Chung-jen's ink plums were blurry suffusions of wet ink washes on paper, which probably looked like Mu-ch'i's (mid–13th century) Hibiscus in Rain.[44]

Contemporaries were enchanted by early ink plums in which amorphous forms swam in and out of focus, like flowers seen through mist or rain. But the scholars who wished to capture ink plum for their emerging amateur practice had aesthetic and practical requirements that could not be met by the monk's inspired ink splashing. As this new group of practioners appropriated and adapted ink-plum painting, Chung-jen was displaced by Yang Wu-chiu. Yang's calligraphic conceptualization of plum (fig. 15.6) appealed to the scholar's taste for structure and brushwork. More important, Yang's solution to painting plum blossoms in ink could be understood and mastered as a systematic, repeatable method sufficient to sustain a class-practice among scholar-amateurs.

Yang's art is the point of origin for key conventions of the later ink-plum tradi-

chüan 107, Ssu-pu ts'ung-k'an edn., p. 934B. Trans. and discussion in Bickford, Ink Plum, pp. 142–43; see also Jao Tsung-i, "Tz'u yü hua, lun i-shu ti huan-wei wen-ti."

41. Hsiang-lien chi and Hua-chien chi are collections of erotic poetry. Hsiang-lien chi collects Han Wo's (844–923) romantic poetry on the theme of palace women; Shen Kua (1031–1095) (Meng-chi pi-t'an [Notes Written at Meng-ch'i], chüan 16; reprint with additions, Hu Tao-ching, annot., Meng-ch'i pi-t'an chiao-cheng [Beijing, 1957; reprint, [rev. and enlarged] Shanghai: Ku-chi, 1987] [entry no. 275], vol. 1, pp. 535–36) characterized it as yen-tz'u (erotic lyrics), others as "voluptuous, effeminate, paint-and-skirts poetry." Hua-chien chi, comp. Chao Ch'ung-tsuo (active mid-10th century), is the earliest anthology of literati song lyrics. See Beth Upton, "Han Wo," and Marsha Wagner, "Hua-chien chi," in Indiana Companion to Traditional Chinese Literature, ed. and comp., William H. Nienhauser (Bloomington: Indiana University Press, 1986), pp. 395, 441–42; and see Lois Fusek, trans. and annot., Introduction, Among the Flowers: The Hua-chien chi (New York: Columbia University Press, 1982).

42. The quotation is from Sung Lien (1320–81), "T'i Hsü Yüan-fu mo-mei" (Inscribing Hsü Yüan-fu's Ink-Plum Painting), in Sung Wen-hsien kung ch'üan-chi (Complete Works of Song Lian), chüan 3, Ssu-pu pei-yao edn., p. 77. The combination of elements in the terms of appreciation articulated by Liu K'o-chuang are apparent also in earlier Southern Sung praise of Yang and his ink plums. In Tu-hsing tsa-chih (Miscellaneous Writings of The One Who Alone is Sober, ca. 1175, in Chih-pu-tsu chai ts'ung-shu [Pai-pu ts'ung-shu chi-cheng edn.], chüan 4, pp. 1b–2a), Tseng Min-hsing records how Yang received the transmission of ink-plum painting from a direct disciple of the genre's founder, recounts how Yang used to paint plums on the walls of a brothel, and then compares the celebrity of Yang's "outstandingly noble" ink plums to the obscurity of inferior work by a morally superior contemporary who disapproved of Yang and would paint

plums only for worthy recipients. Chao Hsi-ku, who begins his praise of Yang by citing his ability to bring the brushwork of Ou-yang Hsün to plum painting (as discussed earlier), recounts an expanded brothel painting anecdote, pronounces Yang's poetry as "clear and fresh, without an iota of vulgarity," and laments that he never encountered men like Su Shih (1037–1101) and Huang T'ing-chien (1045–1105), exemplars of Northern Sung literati culture. (See above, n. 36.) Trans. and discussion, Bickford, Ink Plum, pp. 140, 141–42.

43. These developments are treated in detail and citation is made to primary sources and secondary literature in Bickford, "The Birth of the Ink-Plum Genre and its Early Development," pt. 3 of Ink Plum, from which the present discussion is adapted.

44. Undated; section of a handscroll (?) mounted as a hanging scroll, ink on paper, Daitoku-ji, Kyoto; reproduced, Bickford, Ink Plum, fig. 33.

45. See Hsü Yü-kung, Plum and Bamboo in Snow, handscroll, ink on silk, Liaoning Provincial Museum; reproduced, Yang Renkai and Dong Yanming, comps., Liao-ning po-wu-kuan ts'ang-hua (Liao-ning Museum Collection of Paintings; preface 1983; Shanghai: Shang-hai-shih jen-min mei-shu, 1986), pl. 17; Plum Blossoms in Moonlight, signature of Yen Hui, fan mounted as album leaf, ink on silk, The Cleveland Museum of Art, 78.49; reproduced, Eight Dynasties of Chinese Painting, cat. no. 90, p. 110; Yen-sou, Plum Blossoms, handscroll, ink on paper, Freer Gallery of Art, 31.2; reproduced, Sirén, Chinese Painting, vol. 3, pls. 366–67.

46. For extensive discussion, see Bickford, "A Moment of Balance, a Moment of Choice: The Flowering Plum in Southern Song Painting," ch. 9 in Ink Plum, from which the present treatment is adapted.

tion, from the mid-fourteenth century on. But Yang's immediate successors, the third generation of plum painters, retreated from Yang's structural clarity, rigorous draftsmanship, and astringent image. Towards the turn of the thirteenth century, a new tao-yün (reverse-saturation) ink-plum method, associated with Yang's nephew T'ang Cheng-chung, permitted Southern Sung scholar-painters to pursue formal drama and atmospheric effects that are typical of contemporary Academy landscape painting and entirely alien to Yang Wu-chiu's ink-plum aesthetic. Exploiting the contrast between ink washes and reserved silk ground, Yang's direct disciple Hsü Yü-kung (b. 1141?) paints a bold and emotional image of Plum and Bamboo in Snow, while the painter of Plum Blossoms by Moonlight (signature of Yen Hui; active late 13th–early 14th century) creates an evanescent, nearly brushless, evocation of a moonlight-bathed plum in bloom. Working the same method to an entirely different outcome, the scholar-official Yen-sou (active 13th century) brings unparalleled finesse and elegant lucidity to his tao-yün painting of Plum Blossoms.[45] Meanwhile, Chao Meng-chien, descendent of imperial amateurs and disciple of Yang Wu-chiu, reappraises fine-style possibilities at the end of Sung in his immaculate emblem of pine, bamboo, and plum (fig. 15.5).

It will be seen that this record of the first generations of ink-plum painters does not reflect a unitary line of stylistic development from representation toward calligraphic expression. It shows, instead, a healthy state of artistic flux, as painters explore the possibilities of a new scholar-painting genre. But, if the art of ink plum is to be granted scholar-painting status, this situation must be denied. It must be made to exhibit the particular pattern of continuity—transmission through the linked practices of orthodox masters—required of scholar-painting genres. That is why theorists, like Chao Meng-chien, fabricate the mask of lineage—Chung-jen, Yang Wu-chiu, T'ang Cheng-chung—to elide disjuncture and disguise diversity.

2. Amateur and Academy Painting: Abandoning the Bi-polar Model[46]

We tidy up Southern Sung visual culture by sweeping styles, social and institutional affiliations, and articulated (or imputed) aesthetic and other values into two neat piles. But the observable evidence of Southern Sung painting does not permit this: Late Sung was a period not only of prodigious art production, but also one of remarkable fluidity and creative mutual influence between amateur and Academy spheres of activity. In the case of flowering plum, as I have demonstrated elsewhere, if we array all extant images along lines of observable visual affinity, they will not fall into clearly defined amateur or Academy segments. Instead, the visual sequence thus formed will show interspersed amateur and Academy works that exhibit a modulated range of style and taste, preferences for color, light wash or monochrome, structural clarity or atmospheric ambiance, shifting proportions of naturalistic description and graphic or calligraphic abbreviation.

Southern Sung scholar-amateur monuments and Academy masterworks are joined by fundamental bonds of period style in its broadest sense—encompassing ways of seeing and thinking as well as ways of painting. Differences between Yang Wu-chiu's Four Views of Flowering Plum (fig. 15.6) and Ma Lin's Layer on Layer of Icy

Thin Silk (fig. 15.8) are obvious. Their deep underlying affinities are more interesting. They are instructive for understanding the Southern Sung situation and for understanding the extent to which that situation is deformed by routinely relegating such works to opposite poles of an amateur/Academy axis.

Literati theory prepares us to see Yang's calligraphic abbreviation; but, it obscures his sure botanical grasp and effaces his debt to courtly description. Academy stereotypes lead us to take as givens Ma's technical virtuosity and the dazzling allure of his image, but they distract us from the severity of his presentation, the toughness of his branch-work structures, and the incisiveness of his line. However simplified, neither Yang's image nor his brushwork is simple-minded or spontaneous; both are subtle, controlled and elegant. However gorgeous the surface, there is nothing fussy or sweet about Ma's plum blossoms.

As we reflect upon these artists' acts of selection, arrangement, and technique, we become aware that Yang's sketchy plums are more naturalistically descriptive than we might have thought they were; and that Ma's meticulous plum, for all its compelling sense of "reality," is, in fact, stylized and systematically conceptualized. Both outcomes result from a triangulation between an understanding of plum's botanical morphology and stylized visualization of flowering-plum ideals developed in literature. Each, in its own stylistic context, stresses whiteness, angularity, attenuation, and isolation, delicacy, refinement, and restraint. Each evokes transience visually and textually: through withering blossoms and scattered petals at the extremity of the pictorial image and through nostalgia evoked by poetic inscriptions.

In *Four Views of Flowering Plum*, Yang tempers angular brush strokes and structures with the nuance of rubbed washes and with the tenderness with which he draws the ruined flowers; he counters his astringent image and upright calligraphy with the lush longing of his plum song lyrics. In *Layer on Layer of Icy Thin Silk*, the genteel eroticism of the empress's quatrain and the delicate scintillation of gauzy blossoms and touches of rose, young green, and gold are countered by bony joints, skinny branches, jerky twigs, and sharp, black, line. Thus Yang and Ma (the latter in concert with his collaborator Yang Mei-tzu) work image, technique, and text to construct, upon their respective amateur and Academy platforms, the affective tension that is characteristic of Southern Sung plum appreciation: a refined *frisson* produced by simultaneous qualities of icy aloofness and inherent sensuality.

If we wish to appreciate fully how much these Southern Sung painters and paintings share, we need only look at Yang's *Four Views of Flowering Plum* (fig. 15.6) beside its late Yüan generic successor, Wu Chen's ink plum, painted in 1348 (fig. 15.10). In his accompanying art-historical inscription, Wu proclaims himself guardian of Yang Wu-chiu's orthodox tradition. But the painting that represents his understanding of his charge is an image Yang could never have envisioned, an image that, indeed, stands poles apart from Yang's *Four Views*. Yüan ink-plum painters who claimed a place in Yang's tradition through stylistic and textual allusion eschewed the elegant draftsmanship and love songs that Southern Sung scholars admired. And they swept aside Yang's restraint and discipline, his ordered lucidity, and his balance between naturalistic description and significant stylization—a classical vision Yang

shares with Ma Lin—as they practiced, promoted, and codified a scholar-painting genre that championed spontaneity and extroverted self-expression through aggressive calligraphic brushwork. The bottom line is, ink-plum pieties to the contrary, when Ma Lin goes so does Yang Wu-chiu.

3. Scholar Painting and Scholar Taste

If we return to our premise that scholar painting is as much a matter of "who made it" as "what it looks like," and apply it to the paintings we have reviewed, the critical importance of the artist's identity in securing scholar status for a work becomes clear. The place of *Three Friends of the Cold Season* (fig. 15.5) in the complement of Sung scholar painting is secured primarily by Chao Meng-chien's seal, impressed to the left of this exquisite fine-style monochrome of pine, bamboo, and plum. If that seal were effaced or if we doubted its authenticity, would we still identify this fastidious, elegant work as scholar painting? Would we give full weight to a symbolic reading of Three Friends as moral triad? Or, judging from ample evidence in the decorative arts, would we take this monochrome medallion simply to be an instance of auspicious ornament in the scholar taste? Similarly, the scholarly pedigree of Yen-sou's *Plum Blossoms* depends upon documentary, rather than pictorial, evidence: a contemporary colophon attests to the status of the unidentified artist as a bonafide scholar-official. Without this textual testimonial, the painting would remain undiminished, but we would be less likely to see it as a scholar-amateur work of remarkable delicacy and finesse, and more likely to take it as a reflection of the influence of scholar taste upon the work of a trained, professional flower painter. This brings us to *The Hundred Flowers* (fig. 15.9), a superb, fine-style monochrome that remains the most faithful reflection of Yang Wu-chiu's art.

Meticulously descriptive, overtly beautiful, lavish in display of craft, *The Hundred Flowers* takes its seasonal program, presentation, and techniques from the Academy flower-painting repertory. The painter then translates this polychromatic art into monochrome with unnerving effect: his ink wash and line both describe flowers with striking fidelity and suggest the artist's opaque pigments, as they simultaneously mime color in nature and in art. In this work that otherwise speaks consistently to Academy ideals of poetic realism, there occurs a spray of plum blossoms that is painted, unmistakably, in the Yang Wu-chiu style. What does this mean? At the very least it is evidence of the interpenetration of Academy and amateur modes; more ambitiously interpreted, its occurence in this context suggests that, for late Sung monochromists, the plums of Yang Wu-chiu had taken on the status of primary object: that is to say that the reality of flowering plum had become Yang's single-stroke branches and circled petals.

We don't know who painted *The Hundred Flowers*. We don't know for whom he painted, and we cannot begin to speculate upon his intentions. It seems to be the work of a trained professional working in the literati taste. But what if, hypothetically, we discovered contemporary colophons that attested to the status of its maker as a scholar-official whose character, calligraphy, and poetry were as refined as this consummately refined work of art? We no longer would regard the occurence of

Yang-type ink plums set among fine-style flowers as an odd intrusion. In the work of such a (fictive) man, we would consider them appropriate and purposeful. We might interpret the scroll's lavish floral program as a tribute to the former flourishing of the Sung. We might even speculate that the maker of *The Hundred Flowers*, like other loyalist lyricists and painters, used his elegant art to lodge his political message in flowers, translating brilliant color into monochrome in order to covertly express his grief at the the loss of Sung China to the Mongol barbarians—a loss that has drained all color from nature. Then, the unnerving effect of his meticulous monochromatic realism would be interpreted as a visual paradigm for the experience of the Sung loyalist who lives out his days in a world that appears to be the same but is drastically changed and deeply diministed. We would then take up the fine-style flower painting of the loyalist scholar-painter Ch'ien Hsüan (fig. 15.2) and make the connection. And (however fictive my hypothetical textual evidence) it would be the right connection. Ch'ien Hsüan's flower painting is clearly and closely related to *The Hundred Flowers*, as it is also to the monochromes of the imperial amateur Chao Meng-chien (figs. 15.3 and 15.5), and to Hui-tsung before him. Their art, in turn, cannot be severed either from Sung scholar-amateur painting or from Sung Academy traditions of flower-and-bird painting.

Is "The Problem of Ch'ien Hsüan" A Problem?

I have offered only a glimpse of the fertile and fluid visual culture that surrounded artists like Ch'ien Hsüan during the late Sung and early Yüan. Toda Teisuke has undertaken important investigations into the interaction of amateur and professional elements in the traditions of the P'i-ling school. More recently, Roderick Whitfield has introduced into the Ch'ien Hsüan discourse a dazzling fine-style handscroll, *Fascination of Nature*, by Hsieh Ch'u-fang, dated 1321, and carrying densely allusive literati colophons.[47]

The products of known Sung-Yüan scholar-amateurs, of unidentified artists working in the literati taste, and of professionals whose art served as flash points for loyalist response form a rich and revealing context for Ch'ien Hsüan's flower painting. *Pear Blossoms* remains haunting in its peculiar fusion of detached intellection and tender sensuality, but such paintings no longer can be considered isolated anomolies of scholar art. Challenged by the observable evidence of stylistic diversity in the literati visual culture of late Sung and early Yüan, the old-fashioned image of Ch'ien Hsüan standing alone at the margins of scholar painting seems, in the words of Wen Fong, "to be nothing but an art historical mirage."[48]

47. See Toda, "Kachôga ni okeru Kônanteki na mono," pp. 108–17 (I am grateful to Setsu Isao, who brought this to my attention in his seminar paper, "The Unity in the Aestheticism of the Literati and the Professional," Brown University, 1995) and Whitfield, Fascination of Nature: Plants and Insects in Chinese Painting and Ceramics of the Yüan Dynasty (1279–1368) (especially "The Question of Early Autumn," ch. 6). For stimulating discussions of Ch'ien Hsüan and fine-style monochromists, see Robinson, "The Vitality of Style: Aspects of Flower and Bird Painting During the Yüan Dynasty (1279–1368)."

48. Fong, "The Problem of Ch'ien Hsüan," p. 188, n. 68.

Figure 15.4
Attributed to Chao K'o-hsiung (great-grandson of Chao Yen-mei [d. 984 aet. 38 sui]), Fish at Play. Album leaf, ink and light color on silk, 22.5 x 25.1 cm. The Metropolitan Museum of Art.

Figure 15.5
Chao Meng-chien (1199–beofre 1267),
Three Friends of the Cold Season.
Album leaf, ink on paper, 32.2 x 53.4
cm. National Palace Museum, Taipei.

Figure 15.6
Yang Wu-chiu (1097–1169), Four
Views of Flowering Plum, *1165.*
Handscroll, ink on paper, 37 x 358.8
cm. Palace Museum, Beijing.

Figure 15.7
Ou-yang Hsün's Calligraphy and Yang
Wu-chiu's Calligraphy and Painting:

15.7a. Ou-yang Hsün (557–641),
Hua-tu-ssu Yung-ch'an-shih t'a-
ming, 631, detail. Rubbing, 21.8 x 10
cm. Ex-Weng Fang-kang Collection,
Otani daigaku Collection, Kyoto. After
Shodô zenshû, vol. 7, pl. 49.

15.7b. Yang Wu-chiu (1097–1169),
Four Views of Flowering Plum,
1165. Detail of inscriptions (fig. 15.6)

者三教殊源異軫類聚群

山洞徽砌其竁霧瑞崇其道

盖仁壽之和感山川無

盖閣人靈必資天家依憑

漸近青春試尋紅瑙經年踈隔小立

風前恍然初見情如相識爲伊只欲顛

狂猶自把芳心愛惜傳語東君一慑愁

宲不須要勒

嫩蘂商量無窮此恩如對新批此画欵

Figure 15.7c
Yang Wu-chiu (1097–1169), Four
Views of Flowering Plum, 1165.
Detail of painting (fig. 15.6)

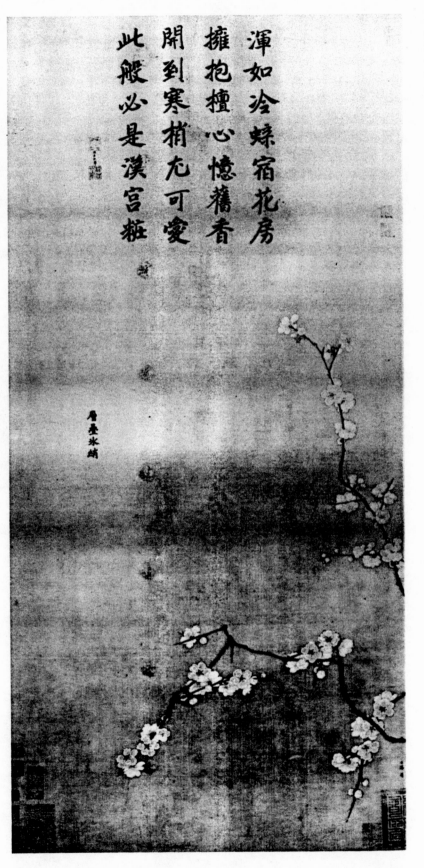

渾如冷蝶宿花房
擁抱檀心憶舊香
開到寒梢尤可愛
此般必是漢宮粧

臣馬麟

Figure 15.8
Ma Lin (ca. 1180–after 1256), Layer
on Layer of Icy Thin Silk, *1216.*
Hanging scroll, ink, color and gold on
silk, 101.7 x 49.06 cm. Palace
Museum, Beijing.

Figure 15.9
Anonymous (13th–14th century), The
Hundred Flowers. *Detail of a hand-*
scroll, ink on paper, 31.5 x 1693 cm.
Palace Museum, Beijing.

Figure 15.10
Wu Chen (1280–1354), Ink Plum,
1348. Colophon to Plum and Bamboo
in Snow *by Hsü Yü-kung (b. 1141?).*
Section of a handscroll, ink on paper,
29.6 x 35 cm. Liaoning Provincial
Museum. After Liao-ning po-wu-kuan
ts'ang-hua, *pl. 29.*

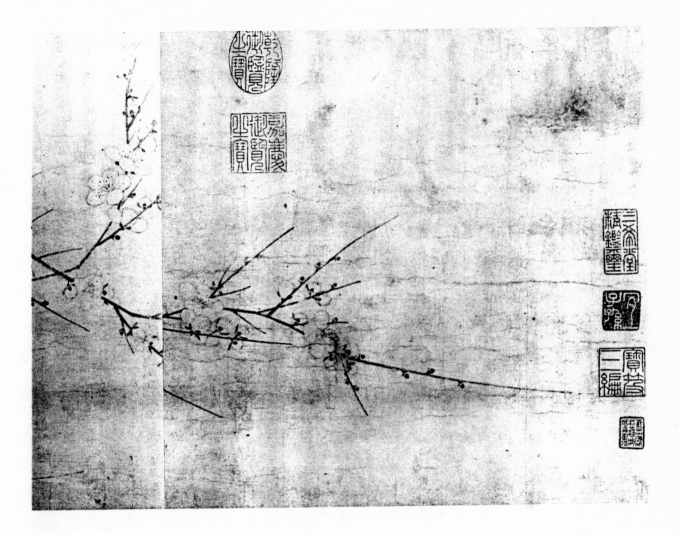

VI. Issues of Style and Meaning

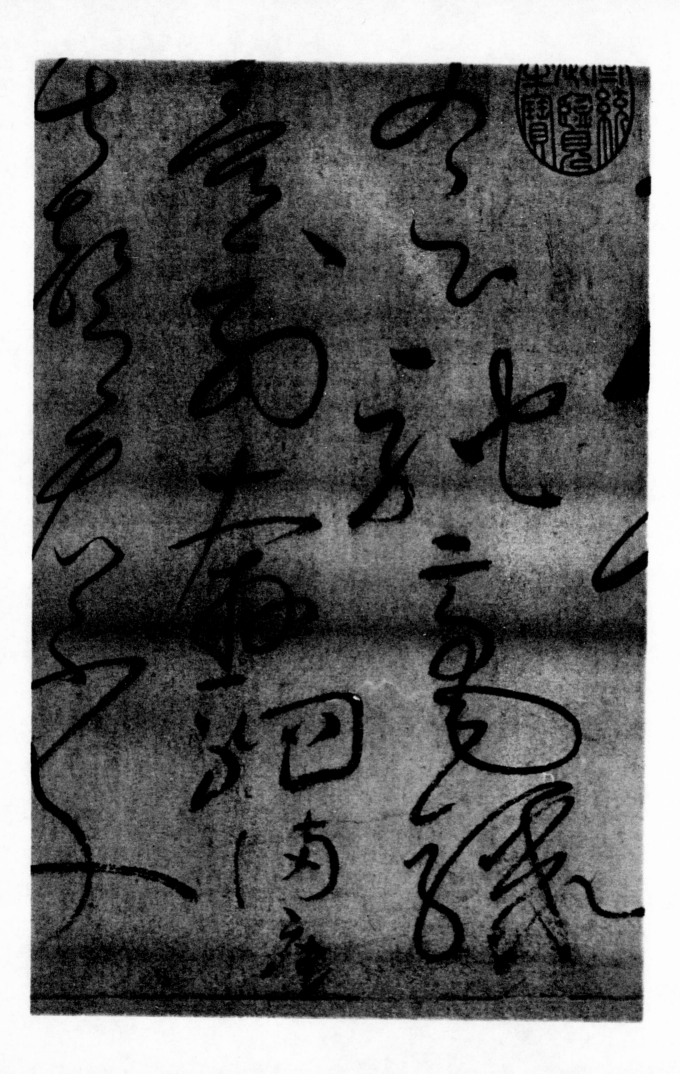

Screen Images:

Three Modes of "Painting-within-Painting" in Chinese Art

Wu Hung

This paper has a three-fold purpose. On the most basic level, it studies images of the painted screen, a physical object and a painting format which played an enormous role in ancient Chinese art but has become almost obsolete in modern Chinese life. The major function of a screen (*p'ing*) is "to shield": in the palace it surrounded the throne; in a household it set off the reception quarter; and in a bedroom it maintained privacy. In all these cases, the screen transformed *space* into *places* that were definable, manageable, and controllable. It also functioned as a kind of framed painting, displaying symbolic or representational images that were appropriate to the setting. When a painted screen is portrayed in a painting, however, what it defines and organizes is no longer architectural space but a pictorial one; its flat surface exhibits not just a painting, but a "painting-within-painting." It is therefore no coincidence that screen images became an invaluable means for ancient Chinese painters to structure pictures and to design visual metaphors. Logically, it can be expected that a close analysis of screen *images* will help reveal the artists' intentions and techniques.

Let us take a painting from this exhibition as an example. Titled *Enjoying Antiquities* and created by the Ming artist Tu Chin (active ca. 1465–ca. 1509), it offers a close-up of the activities on a tall terrace, a setting which is suggested by a series of railings and the floating clouds beyond them (fig. 16.1).[1] Two large standing screens continue and complete the zigzag outline initiated by the railings, dividing the picture plane diagonally from the lower left corner to the upper right corner. The two triangular spaces resulting from this division are then transformed into a solid earthen foreground and an empty background of clouds and mist. With its distinct structure and decoration, each screen also defines an individual place for portraying figures and events. The screen near the center is heavy and formal; ornate openwork patterns embellish its thick frame of rosewood. The clouds and waves painted on its central panel have a strong symbolic overtone (as they are often indicative of high official rank); their schematic forms echo the openwork patterns on the screen's frame. The man sitting in front of this screen is apparently the master of the terrace and the owner of the antiques displayed on a table beside him. Another man, perhaps a connoisseur of antiques, turns obediently towards him while examining the ancient vessels. Compared with this focal unit centered on a male master with his material possessions and status symbols, the second screen defines a feminine, submissive space. Thin, fragile, and without a strong and sculptured frame, its main feature is a landscape painting executed in broad inkwash. Positioned behind the first screen, its three leaves enclose a recessed space

1. This painting is executed with the superlative technical finish typical of Ch'iu Ying's style, so James Cahill suspects it to be Ch'iu's reworking of Tu's original design. Parting at the Shore: Chinese Painting of the Early and Middle Ming Dynasty, 1368–1580 *(New York: Weatherhill, 1978), p. 156.*

like a back chamber, in which two women, perhaps the master's concubines or maids, are wrapping and packing antiques—a *ch'in-lute,* handscrolls, albums, a vase, a *ting* tripod, and a tortoise-shell box.

The two screen images thus index time as well as space, since the women's activities conclude a narrative in the painting that consists of three consecutive events; the two earlier events being a boy servant bringing in a scroll painting to the master, and the master and his guest examining antiques. These three scenes are arranged along the zigzag line rising from the composition's lower left corner to its upper right corner. The master is thus the *focus* of both the spatial composition and the temporal narrative in the painting; and the two screens highlight the gender hierarchy in a traditional Chinese household. Thus the screens' images do not only play a formal role: as structural elements, they also map social, political, and intellectual fields of meaning in a painting.

We will learn later that these roles of screen images—to organize pictorial space, to construct a visual narrative, and to convey social and political messages—had been recognized long before Tu Chin, and this recognition had led to the invention of a number of basic modes of screen images. Tu's creativity lay in synthesizing these modes into a complex composition. The second purpose of this paper, therefore, is to reconstruct the historical moment when these basic modes of screen images were invented. In other words, what I want to do is to contextualize and historicize screen images. Instead of approaching them as individual pictorial formulas, I see them as linked solutions to some fundamental artistic tasks at a given historical moment. Artists responded to these tasks as well as to each other's responses to these tasks; their screen images reveal shared concerns as well as competition for originality and inventiveness.

We find this historical moment in the Southern T'ang, a local regime which lasted about forty years from 937 to 975 A.D. Relatively insignificant in Chinese political history, this short-lived dynasty contributed a great deal to the country's cultural legacy. In its small court, the twilight of the great T'ang empire gradually faded into a private refinement of the most exquisite elegance. Its last ruler, Li Yü (r. 961–75), was himself a celebrated poet and a famous connoisseur of all kinds of art. His court nourished a generation of influential artists, who were either native southerners or had fled from the north to find refuge in the more peaceful south. Students of Chinese art are familiar with their names: the landscape painters Tung Yüan and Chü-jan, the flower-and-bird painter Hsü Hsi, and figure painters Chou Wen-chü, Wang Ch'i-han, Ku Hung-chung, Wei Hsien, and Chao Kan. Some of them directly influenced Sung court art; others were later considered forebears of literati painting. Only very few of their works have survived, however. Even some "masterpieces" attributed to them have been proven to be later copies or reworkings; their value as reliable historical evidence has been seriously questioned. But instead of abandoning these copies and reworkings, I want to discover elements of the original works they preserve, as well as traces of the historical situations in which the originals were created. My method, as I have just proposed, is to identify pictorial motifs and compositions in these copies that reflect shared concerns as

well as artistic competition. The third purpose of this paper, then, is to test this method by reconstructing a significant aspect of Southern T'ang art largely based on later materials.

Mode 1: Screens in a Narrative Handscroll

The Night Entertainment of Han Hsi-tsai, a composition attributed to the Southern T'ang court painter Ku Hung-chung but probably refashioned in the Southern Sung, best illuminates how screen images help construct space, regulate a temporal sequence, and orient the gaze in a *handscroll* painting (fig. 16.2).[2]

In the painting's opening section, the host, Han Hsi-tsai, wearing a tall black cap, is seated on a dais with an honored guest in a red robe. The room is crowded; it is filled with people and is enclosed by furniture and painted wall-panels on all sides. Members of the company are rigid and formal; everyone's attention is concentrated upon a girl playing a *p'i-p'a*-guitar. A large screen separates this scene from the second section, which contains two episodes—a dance scene and a bedroom scene—smoothly connected by two female figures who have just left the living room to retire to a back chamber. The atmosphere becomes more relaxed. Han Hsi-tsai appears as a drummer in the dance scene, and is accompanied by four women on a huge couch-bed in the bedroom scene. The informality is further developed in the third section, which is enclosed by two screens on both sides. With his garment boorishly unbuttoned, Han Hsi-tsai is enjoying a musical performance and the display of feminine beauty. The change of mood again leads us to the fourth and last section, in which the contact between men and women becomes intimate, while Han Hsi-tsai stands in the middle watching. The room is now "empty"—from the first section to this last section, the furnishing has been gradually reduced while the intimacy between figures has been intensified. The illustrations gradually change from descriptive to implicit, and their message becomes increasingly ambiguous and open to interpretation. The painting gradually deepens in eroticism, transforming the spectator into a voyeur.

Although Osvald Sirén has asserted that "any attempt to formulate hard-and-fast rules for the spatial design in a picture like this would be futile,"[3] the painting clearly combines two modes of spatial representation, both utilizing the screen image as its chief compositional aid. The first mode serves to construct self-contained units (fig. 16.3a); the second mode aims to link these units into a continuum (fig. 16.3b). The artist boldly used large, flat screen panels to cut the horizontal composition; he also carefully hinted that such partitions are by no means absolute. We see that in the opening scene, a maid is emerging from behind a screen to peep at the party in front, and that each of the three screens which separate the four sections delicately overlaps with a figure belonging to the next section. Even more telling, between the last two scenes a woman is speaking to a man across a screen; she points in the opposite direction and seems to be beckoning him into the back quarter. These details create dynamism, linking isolated scenes into a continuous pictorial plane, just as in a musical composition, ties cross bar lines, connecting separated notes into a continuous melody.

2. *Hironobu Kohara considers this painting a "dependable" imitation of Ku Hung-chung's original work based on a comparison between its figurative types, costumes, and utensils with excavated Southern T'ang figurines and objects; see "An examination of the 'Night Entertainment of Han Hsi-tsai' 1," Kokka no. 884 (November 1965), pp. 5–10; pp. 9–10 (in Japanese). Yü Hui, however, argues that many details in the painting, especially the costumes, furniture, dances, and utensils, show typical Sung customs; see "On the dating of the handscroll painting 'The Night Entertainment of Han Hsi-tsai'," Ku-kung po-wu-yüan yüan-k'an 1993(4), pp. 37–56 (in Chinese).*

3. *Osvald Sirén,* Chinese Painting: Leading Masters and Principles, *7 vols. (New York: Ronald Press; London: Lund Humphries, 1956), vol. 1, p. 168.*

4. *Su Shih*, Su Tung-p'o ch'üan-chi
*(The Complete Work of Su Shih), Pao-
hua-an edition, 1909*, chüan 67, pp.
7b-8a; see Susan Bush, The Chinese
Literati on Painting: Su Shih
(1037–1101) to Tung Ch'i-ch'ang
(1555–1636) *(Cambridge, Mass.:
Harvard University Press, 1978), p.29.*

5. John Ellis, Visible Fictions, *revised
edition (London and New York:
Routledge, 1992), p. 45.*

6. *Freud notes that voyeurism always
keeps apart the object and the source of
the sexual drive.* "Instincts and their
Vicissitudes," *in* Standard Edition of
the Complete Psychological Works
of Sigmund Freud, *ed. J. Strachey, 24
volumes (London: The Hogarth Press,
1953–66), vol. 14, pp. 129–30. This
approach is summarized by Steve Neal:
"Voyeuristic looking is marked by the
extent to which there is a distance
between spectator and spectacle, a gulf
between the seer and the seen."*
"Masculinity as Spectacle," Screen 34.6
(Winter 1983). *Reprinted in* The
Sexual Subject *(London and New York:
Routledge, 1992). p. 283.*

7. *Christian Metz,* The Imaginary
Signifier: Psychoanalysis and the
Cinema. *Translated by C. Britton et al.
(Bloomington: Indiana University Press,
1982), p. 60.*

8. *It is therefore necessary to question
Metz's polarization of two kinds of art,
one relying on the "senses of distance"
(sight and hearing) and the other
depending on the "senses of contact"
(touch, taste, smell, etc.): "The main
socially acceptable arts are based on the
senses at a distance, and those which*

But these screens not only structure pictorial place; they also regulate a temporal viewing sequence by punctuating the spectator's motion of unrolling the picture surface. Properly viewed, the painting would be gradually unrolled and would exhibit only one section at a time. The spectator's experience is, quite literally, a journey into Han Hsi-tsai's deep mansion. He penetrates layers of screens to unveil the secrets they conceal. Ku Hung-chung's screens thus work perfectly with the handscroll format, an extreme form of what I call the "private medium" of visual art: only a single spectator can manipulate its movement and such physical manipulation depends on his psychological response to the painted images. Su Shih (1037–1101) once remarked on a handscroll of inferior quality: "One gets tired after looking at a painting like this for just a few feet!" [4] His words reveal an important impulse in refining the art of the handscroll: since a full presentation of a long handscroll depends on the spectator's enthusiasm and engagement (i.e., his desire to see the entire painting and hence his labor and patience to unroll the scroll to the end), the exposed images should always fulfill a dual function. On the one hand, these images should be expressive on their own; on the other, they should be "seductive" and stir the viewer's interest in the following section, which is still rolled up. The unspoken question—"What's next?"—is typical of a handscroll and can acquire endless variations, while the sense of suspense must always be achieved by dilation. Reviewed in this light, the screen images in *Night Entertainment* generate a sense of secrecy and suspense: they always exhibit and conceal at the same time, and always allude to things hidden and unseen.

Our analysis of the screen images in *Night Entertainment* gradually shifts from their structural roles in the painting to their psychological impact on the viewer—an impact that generates a voyeuristic gaze. For John Ellis, "The characteristic voyeuristic attitude in cinema is that of wanting to see what happens, to see things unrolling. It demands that these things take place for the spectator, are offered or dedicated to the spectator, and in that sense implies a consent by the representation (and the figures in it) to the act of being watched." [5] The same words can be said of *Night Entertainment*: the painting's handscroll format guarantees the privacy necessary for a voyeur; its moving surface has the potential to realize the desire of "wanting to see what happens, to see things unrolling." There is also a strong sense of separation between the spectator and the spectacle. The painted figures are all deeply absorbed in their own acts and never raise their eyes towards the onlooker. In this way, they consent to a silent performance for a secret watching eye.

It has been suggested that "distance" is essential for a voyeur as well as for a cinema spectator. [6] But in this argument "distance" is understood in a physical sense as an empty space separating the object and the eye; the spectator must "take care to avoid being too close to or too far from the screen." [7] This physical gulf is minimized, if not completely dismissed, in the viewing of a handscroll, which instead creates a tension between looking and touching. On the one hand, the painted scene in *Night Entertainment* rejects the viewer's direct participation; on the other, the viewer must physically handle the scroll which bears these scenes. [8] The distance required for voyeuristic looking thus has to be established by internal means in the

pictorial representation; and here we return to the screen motif. With its root definition of *p'ing* or "to shield," the screen is an ideal mechanism to separate not only individual scenes but also the viewer from the things being viewed. As *Night Entertainment* is unrolled the viewer's motion and vision are periodically stopped by screens with painted opaque panels, which constantly readjust the viewer's relationship to the picture—reasserting their distance, preventing excessive proximity, and creating concrete measures for the degree of attachment and detachment between the spectator and the picture. As in Wen T'ing-yun's (813?–870) poem "A Night Banquet," here a screen functions as a barrier, but a barrier that opens automatically upon receiving the voyeuristic gaze: "The long hairpins, a pair of dragonflies in her dangling locks; / Where the green fields end and hills slant, painted screens open..."[9]

The screens in *Night Entertainment* enclose both men and women, whose relationship gradually changes, and this changing relationship constantly redefines the subject and object of voyeuristic looking. Laura Mulvey's famous formula, "woman as image, man as bearer of the look,"[10] can be best applied to the painting's beginning section, in which Han Hsi-tsai and his male guests all fix their eyes on a female guitar player. Completely isolated, the musician passively receives and converges the intense looks from the male assembly. Consistent with the scroll's unrolling motion, this internal male gaze extends and directs the external gaze of the spectator. The following sections repeat this initial composition, but the active/passive heterosexual division is blurred. Han Hsi-tsai is no longer the "bearer of the look" but himself becomes part of the pictorial spectacle, either performing music or standing with his body exposed. This second representational mode is again reversed in the last scene, in which Han Hsi-tsai resumes his role as the "bearer of the look," but in a very different way from the beginning section. He now appears as a secret voyeur within the pictorial representation: standing among men and women engaged in intimate physical contact, his presence nevertheless goes unnoticed. There is clearly a psychological "distance" separating him as a watcher from the figures he watches. His position and gaze thus duplicate those of the spectator. On the other hand, he can never "mirror" the spectator, because he must continue to ignore the spectator in order to sustain the latter's voyeuristic gaze.

This reading finally brings us to the famous story which narrates the painting's creation:

> Ku Hung-chung was from south China and served the Southern T'ang emperor Li Yü (r. 961–75) as a court painter. A skilled artist, he was particularly good at portraying figures. At that time Han Hsi-tsai, who held the office of Internal Secretary, was illustrious and all his acquaintances were from the hereditary nobility. Han was obsessed with beautiful singing girls and held endless night drinking parties. He imposed no restraint on his guests, who mixed with his ladies, shouting in wild excitement. His reputation for indulgence spread both inside and outside the court.

depend on the senses of contact are often regarded as 'minor' arts (e.g., the culinary art, the art of perfumes, etc.). Ibid., p. 59. Both senses are involved in viewing a handscroll painting.

9. Translated by Paul F. Rouzer in Writing Another's Dream: the Poetry of Wen Tingyun (Stanford: Stanford University Press, 1993), p. 82.

10. Laura Mulvey, "Visual Pleasure and Narrative Cinema," reprinted in Visual and Other Pleasures (Bloomington and Indianapolis: Indiana University Press, 1989), pp. 14–26.

11. Hsüan-ho hua-p'u (The Hsüan-ho Painting Catalogue), I-shu tsung-shu (Collectanea of Writings on Art), ed. Yang Chia-lo, first series, vol. 9 (Taipei: Shih-chieh shu-chü, 1962), chüan 7, p. 193.

12. For different accounts of the painting's creation and the authors' varying agendas, see the section "Breaking Textual Enclosures" in my forthcoming book The Double Screen: Media and Representation in Chinese Painting (London and Chicago: Reaktion Books and University of Chicago Press).

Li Yü, the Southern T'ang emperor, valued Han Hsi-tsai's talent as a statesman and overlooked the matter, but he regretted not being able to see Han's famous parties with his own eyes. So he sent his court painter, Ku Hung-chung, as a detective to Han's night entertainments, instructing him to recreate everything he saw there based on his memory. The painting, the *Night Entertainment of Han Hsi-tsai*, was then made and presented to the throne.[11]

Written a century later, this record reconstructs the painting's creation from a particular point of view.[12] Instead of documenting true events, it personifies the voyeuristic gaze inherent to the painting as identifiable historical figures. Ku Hung-chung the artist and Li Yü the patron are both said to embody this gaze but in different ways. Ku peeped into Han Hsi-tsai's inner chambers; all images in his painting were supposedly "based on his memory." But Li was "able to see Han's parties with his own eyes" by looking at the picture. We also assume this second position.

Mode 2: The "Double Screen" and Pictorial Illusion/Illusionism

One of the most puzzling compositions in Chinese art history, the *Double Screen* (*ch'ung-p'ing*) was invented by Chou Wen-chü, a fellow artist of Ku Hung-chung in the Southern T'ang court. Chou's original painting has long disappeared and only later copies of it exist. In one of these copies, in the Freer Gallery of Art (fig. 16.4), four men comprise a circular cluster in the foreground and are playing or watching a game of chess; a servant-boy is standing alongside in attendance. Like *Night Entertainment*, this assemblage is centered on a bearded man wearing a tall black hat, whose identity as the host is suggested by his focal position, distinct costume, and rather severe expression. Behind him is a large, single-paneled screen, on which a domestic scene is presented: a bearded man, possibly the master in the reception hall, has now retired into a more relaxed atmosphere. Attended by four women, he is reclining on a platform couch. Two of the women are preparing his bed beside the couch; one is delivering a blanket; and the other is standing behind the master awaiting orders. This second group of figures is again framed by a screen, whose tripartite leaves are decorated with a landscape.

The designer deliberately confused the viewer, who is led to believe that the domestic scene painted on the screen is part of the real world portrayed in the painting. The consistent obliqueness of both "real" and "painted" furniture—platforms, beds, tables, and the chessboard—guide the viewer's gaze into the distance without interruption, and the reduced size of the "painted" figures and objects on the screen suggest their remoteness. The viewer, who is presumably positioned in the living room with the chess players and their audience, seems to see through the screen into an inner chamber, perhaps the master bedroom in the same house. Chou Wen-chü must have designed this visual trick very consciously: the two side panels of the tripartite screen inside the single-paneled screen differ in width, and the angle of their pivots is determined from the viewer's exact standpoint. This design is illogical because such diagonal pivoting could only be seen if this tripartite screen were a three-dimensional object rather than a flat image painted on the first screen, but this "mistake" makes sense because we are deceived by the trick.[13]

13. Based on this argument, another version of the "Double Screen" in Beijing's Palace Museum is a less faithful copy. The copier painted the tripartite screen with equal side-panels. Although this correction is totally logical, the clever copier has lost the whole point of the "illogicality" of the original design. As soon as this correction is made, the tripartite screen becomes static and opaque; the viewer's gaze is blocked, and the illusionism, which so strongly characterizes Chou Wen-chü's original work, is destroyed.

A number of ancient texts record that Chou Wen-chü too painted a version of *Night Entertainment of Han Hsi-tsai*—that he, like Ku Hung-chung, also received Li Yü's order to depict Han's private life.[14] Whether this record is reliable or not, it may shed light on the relationship between Chou's *Double Screen* and Ku's *Night Entertainment*. Reviewed in light of figs. 16.5a and 16.5b, the two paintings' subject matter is surprisingly similar. The difference lies mainly in representation: Ku's interlocking "frames" appear as superimposed "frames" in Chou's work. The male gathering at the beginning of Ku's painting is removed to the foreground in Chou Wen-chü's picture, against a "transparent" screen which allows the viewer to see the "bedroom" scene painted in the second section of the handscroll. The first two sections of Ku Hung-chung's handscroll are thus condensed into a single-frame picture. Technically, this transformation is achieved by changing the form and function of screen images. All screens in Ku Hung-chung's handscroll are solid pieces of furniture, placed perpendicularly to the painting's plane surface and bearing opaque painted panels. As such, these screens divide a horizontal space and regulate the motion of unrolling a handscroll. Chou Wen-chü's screens, on the other hand, are perfectly parallel to the picture plane, and no longer resist the spectator's gaze. In other words, to turn their painted faces into illusions these screens must sacrifice themselves as solid objects. They must become empty windows open onto empty windows; only their solid frames remain to differentiate the painted scenes and to separate the viewer from these scenes. While Ku Hung-chung's screens separate and link a series of frames in a moving picture, Chou Wen-chü's screens are themselves *frames* that index different systems of reference in a single representation.[15] Ku's picture requires physical handling; Chou's picture only encourages the penetration of the gaze. What Chou Wen-chü has transformed, therefore, include not only painted scenes but also the painting medium and the way of viewing.

In ancient Chinese writings, the "Double Screen," and in particular the first screen bearing female images, are referred to as *huan*, which has three different but interrelated meanings: illusion, illusionism, and magical transformation. When used in the sense of *illusion*, the term denotes verisimilitude in representation: the spectator feels he is seeing an actual object or space, but knows clearly what he is looking at is a picture. The underlying notion is therefore the dualism of *huan* and *chen* ("real" or "realness")—an illusory pictorial image mirrors reality and thus opposes reality. *Illusionism*, on the other hand, confuses and dismisses such distinctions: by employing certain media or techniques, the artist is able to deceive not only the viewer's eye but also his mind, at least temporarily. The viewer is persuaded to take the painted for the real. In literature, an illusionistic image often becomes the subject of a *magical transformation* that brings an inanimate figure to life.

Differing from many illusionistic paintings in Western art history which have been linked to pictorial realism,[16] illusionism never led to the dominance of representational art in imperial China. Rather, it remained an isolated artistic style frequently associated with two specific conventions: the screen as a "framing" device and the female image as the object being framed. Illusionism is thus often considered a property of a particular object or medium—the painted screen, especially

14. The Southern Sung art historian Chou Mi (1232–1309) first recorded this work, a painting on paper of seven to eight ch'i long which represented "lifelike figures that could have only come from Wen-chü's hand." Yün-yen kuo-yen lu (Paintings which have Passed before my Eyes), Tsung-shu chi-ch'eng (Collected Collectanea) no. 1553 (Ch'ang-sha: Shang-wu yin-shu-kuan, 1939), chüan 2, p. 32. Several decades later, in the early fourteenth century, the Yüan art historian T'ang Hou saw two versions of Chou's Night Entertainment and considered them "somewhat different in subject matter" from Ku Hung-chung's painting of the same title. Hua chien (Painting Connoisseurship), (Beijing: Jen-min mei-shu Ch'u-pan-she, 1962), p. 22. Hsia Wen-yen, another Yüan writer, stated in his T'u-hui pao-chien that "Chou Wen-chü and Ku Hung-chung both [or together?] painted the 'Night Entertainment of Han Hsi-tsai.'" chüan 3, p. 35.

15. A frame, according to Boris Uspensky, is both a prerequisite and a consequence of an "artistic text": "In a work of art, whether it be a work of literature, a painting, or a work of some other art form, there is presented to us a special world with its own space and time, its own ideological system and its own standards of behavior." The Poetics of Composition, trans. V. Zavarin and S. Wittig (Berkeley: University of California Press, 1973), p. 137. When an artistic text has internal divisions, as Susan Stewart observes, each smaller "text" is marked by a changing frame, as part of "a system of differences in relation to any other world. To step into the artistic text is to transform the external into the internal and the internal into the external. And each transformation opens up the possibilities of transformation itself." Nonsense: Aspects of Intertextuality in Folklore and Literature (Baltimore: The Johns Hopkins University Press, 1978), p. 23.

16. As John White proposes in his classic study of western perspective: "Illusionism is an ugly word in modern critical usage. Yet, to the early writers the illusionist effects that artificial perspective put

within the artist's reach were amongst the most praiseworthy, as well as the most revolutionary of its attributes. It is, indeed, the revolutionary aspect of the new realism that accounts for much of the emphasis laid upon it." The Birth and Rebirth of Pictorial Space (Cambridge, Mass.: Harvard University Press, 1987), p. 189.

17. A detailed discussion of the history of the "screen with women's images" is included in my forthcoming book, The Double Screen.

18. One such story relates that the T'ang dynasty scholar Chao Yen fell in love with a woman portrayed on a screen. The painter, actually a Divine Painter (Shen-hua), told him that the woman's name was Chen-chen (Doubly Genuine) and that she would come alive if Chao kept calling her name for a hundred days. The method worked and Chao married the woman. One year after the marriage, the woman gave birth to a boy. Chao's happiness was short-lived, however: one of his male friends warned him that the woman was a demon and gave Chao a magic sword to hang in his bedroom. That night the woman saw the sword. Sadly, she said to her husband: "Although I am not a demon, I can no longer stay here since you suspect me." So she again became a portrait on the screen. To Chao's amazement, a small boy now stood beside her in the painting. Quoted from Sung-ch'uang tsa-chi (Notes from the Pine Window). The most brilliant presentation of this theme is P'u Sung-ling's tale, "The Painted Wall." For a fascinating discussion of this tale, see Judith T. Zeitlin, Historian of the Strange: Pu Songling and the Chinese Classical Tale (Stanford: Stanford University Press, 1992), pp. 183-99.

19. For example, it is said that after Yen Yen-chih's (384–456) favorite concubine died, he was troubled by her memory one night. Suddenly he saw a woman emerging from the screen surrounding his bed. As she moved towards him, the heavy screen collapsed onto his body. After this nightmarish event Yan became ill and soon died. I yüan (The Garden of the Strange), cited in Chiang T'ing-hsi et al., Ku-chin t'u-shu chi-ch'eng, p. 2213.

the "screen with women's images" (shih-nü p'ing-feng).[17] A persistent theme in ancient Chinese tales is that a woman portrayed on a screen could come to life; the Chinese version of Pygmalion's myth was invented in this particular context.[18] Whereas in such stories the screen plays a central role in romantic love, in other tales the belief in the magic power of a painted screen invokes terror. The fear is that the owner of a screen might lose control over his illusionistic ladies. Since he possesses and controls these images only with his gaze, danger arises when he falls asleep and becomes temporarily powerless: the painted women come alive, not in a romance but in a nightmare.[19] Such a "dangerous" screen with women's images could even become a political portent to presage dynastic decline. Transmitted from one regime to another, it was always linked with nightmare, death, disorder, and especially female dominance over political affairs. Its poisonous influence threatened not only an individual gentleman but the patriarchal state.[20]

Whether romance or political satire, these tales reverse the relationship between a painted screen and the spectator, who has become extremely vulnerable to the bewildering power of the screen's illusionistic decoration. Consequently, different methods were imagined to exorcise a bewitched screen with women's images. The simplest method was to destroy it physically. Another method was to remove it from sight: by concealing it and locking it up, a man discards his role as spectator of the screen and therefore hopes to escape its evil influence. A third, more sophisticated strategy is to re-identify a painted image as an image. Thus some stories end with a counter-magical transformation: a woman who has come out of a screen painting resumes her original place on the screen's flat panel. Unfortunately, all three solutions are negative. In order to avoid the danger of a screen painting, one has to eliminate the painting itself—either its physical existence (destroying the screen), its visual impact (concealing the screen), or its illusionism (re-identifying the woman as a pictorial illusion).

There is one positive solution, but it is subject to a strict rule. When a painted woman becomes real in the viewer's imagination, she must still be confined in a sealed space and must not threaten the viewer's conventional territory. The result of this fantasy is a strange screen which, instead of being solid and opaque, has a "transparent" surface. It is said that King Sun Liang of Wu (r. 252–58) once ordered an extremely thin glass screen made for him. When he held parties on cool and clear nights, he would set the screen up in the moonlight and ask his four most favored concubines to sit inside. "Watching the ladies from outside," the anecdote goes, "there seemed no separation between them and the guests; only the women's perfume was sealed inside."[21]

We know that this kind of large glass screen could not have possibly existed in the third century. The question thus becomes why people imagined such a transparent screen: it did not block one's view and thus did not fulfill a screen's basic function of creating a practical enclosure. The answer must be that although the line between the male exterior space and the female interior space had become invisible, the separation between the two spaces was still there and could be mentally envisaged. The advantage of this screen was that it not only divided these two

spaces, but also allowed people to see into both of them. It was commonly under-
stood in traditional China that women in a household were not supposed to be
exposed on a public occasion, even in front of the master's male guests. This anec-
dote offers a compromise between this social restriction and private desire: Sun
Liang allowed his male guests to watch his ladies but be unable to "feel" them. But
what kind of thing can only be "seen" but not "felt"? The answer is clear: a painting.
In fact, what Sun Liang showed or intended to show to his guests were not his con-
sorts, but their "portraits" inside the screen's frame.

No matter whether Chou Wen-chü's painting was inspired by Sun Liang's
screen, it was designed to fulfill the same task. The painting's subject is the life of a
man, who is engaged in both the inner life of the boudoir and the male external
world. Of these two images, however, only his social presence is represented as
"reality" in the painting; his private life can only be shown as an illusion—a "paint-
ing-within-painting."

Mode 3: The Landscape Screen and the Image of the Mind

Our third Southern T'ang painting, *Collating Texts*, was made by Wang Ch'i-han, a
contemporary of Ku Hung-chung and Chou Wen-chü and also a "Painter-in-
Attendance" in Li Yü's court. *The Hsüan-ho Painting Catalogue*, however, distin-
guished him from the other two court painters and described him as a "scholar
artist": "He liked to paint mountain forests and deep valleys, hermits among cliffs
and reclusive diviners; [his works] bear no dust [of the human world] and have
nothing to do with the taste of an urban marketplace."[22] Unlike Ku Hung-chung
and Chou Wen-chü, who mainly painted portraits of their royal patrons and court
ladies, Wang Ch'i-han depicted subjects such as "A Lofty Gentleman" or "Ancient
Worthies."[23] His only surviving painting, *Collating Texts* in Nanjing University (fig.
16.6), reveals the same literati interest.

The painting's main figure is a scholar sitting behind a small desk at the lower
right corner of the composition. A pile of books, brushes, and an open scroll on
the desk seem to suggest that he is in the midst of writing. But instead of concen-
trating on his work, he is absorbed in the idle act of picking his ear (the painting is
therefore sometimes called *Man Cleaning his Ear*). A servant boy has just entered the
room and seems to be reporting some trivial matters to his day-dreaming master.
Both the awkward positioning and the mundane content of this scene de-emphasize
its importance. The focus of the painting are two juxtaposed images in the center
of the composition—an enormous screen stretching across the full width of the
picture and a large low table in front of the screen. The artist must have deliberate-
ly portrayed the scholar in fine brushwork, while using bold lines and dark ink to
delineate the screen's unusually thick frame and the table's strong and sturdy legs.
The dominance of the screen and the table is thus established by multiple factors:
their central position, size, weight, and the drawing style.

The significance of these two objects also lies in the images they bear. The table
supports books, scrolls, and a stringed musical instrument—all typical parapherna-
lia of a learned scholar. The screen, on the other hand, is painted with a panoramic

20. *The creation of one such screen,
called the Multi-colored Illusion,
which bore images of famous beauties in
Chinese history, coincided with the fall
of the Sui dynasty (581–604). When
the T'ang began to decline, it went to
Yang Kuei-fei (Yang T'ai-chen,
719–756), the celebrated consort of
Emperor Hsüan-tsung and the most
renowned femme fatale in Chinese his-
tory. Her older brother and the country's
de facto dictator, Yang Kuo-chung
(?–756), set it up to surround his bed.
As soon as he lay down, all the beauties
came off the screen and introduced them-
selves as the femme fatales who had
destroyed past dynasties. Paralyzed, he
lay there with eyes and ears open; only
after the last lady resumed her position
on the screen was he able to move. He
immediately sealed the screen up and
locked it in a dark chamber. But he
could not prevent the political turmoil
that followed his inauspicious dream: the
powerful warlord An Lu-shan rebelled
against the central government; the
emperor fled and Yang Kuei-fei was
killed. T'ai-chen wai-chuan (Informal
Biography of Yang Taizhen), cited in
ibid., pp. 2213–14.*

21. *Tangmo yishi, cited in Chian T'ing-
hsi, et al., Ku-chin t'u-shu chi-
ch'eng, p. 3128.*

22. *Hsüan-ho hua-p'u, chüan 4, p.
124. A similar statement is found in
Hsia Wen-yen, T'u-hui pao-chien,
chüan 3, p. 33.*

23. *Other titles of Wang Ch'i-han
paintings recorded in Hsüan-ho hua-
p'u include "Lofty Worthies," "A
Hermit," "In Reclusion Among
Mountains and Rivers," "Fishing and
Playing the Ch'in-lute," "A Gentleman
in Leisure," "A Literati Gathering in a
Wooded Pavilion," and "Elegant
Mountain Peaks." For lists of Ku Hung-
chung's and Chou Wen-chü's paintings
in the Sung royal collection, see Hsüan-
ho hua-p'u, chüan 7, pp. 186–89.*

landscape—verdant peaks soaring above lakes, willow trees growing on river banks, and a remote mountain range half-hidden in mists and clouds. The focal image of this landscape, a country villa on level ground at the foot of the high peaks, appears on the screen's central panel. The juxtaposition of the screen and the table offers a number of clues for reading the painting. It is possible that the two groups of images—those on the table and on the screen—highlight the two main aspects of the scholar's life: the books and musical instrument indicate his refined intellectual activities; the rural landscape and the thatched villa symbolize his retirement into the wilderness. It is possible that the landscape, which appears almost like real scenery behind the screen's "transparent" panels, reflects the scholar's mind: ignoring his routine "indoor" work, he imagines a place in the wilderness. It is also possible that these images imply a narrative. The scholar is about to take a journey: he has packed a few articles—some books and a musical instrument—on the table; he is sitting there waiting; the servant boy has come to report that the carriage is ready; and the destination of his journey is the villa painted on the screen.

Although it is difficult to decide which reading is closer to Wang Ch'i-han's original plan, all these readings result from his choice to forge a direct relationship between a scholar and a landscape screen. I say "choice" because he rejected two other contemporary modes of screen images exemplified by Chou Wen-chü's *Double Screens* and Ku Hung-chung's *Night Entertainment*. Although the screens in the *Night Entertainment* are painted with mountains and trees, these scenes are standard interior decoration without apparent relationship to the figures and events in the painting. Although one of the two screens in Chou Wen-chü's picture bears a landscape, this screen is secondary and serves as a backdrop for the gentleman and his ladies portrayed on the first screen. Wang Ch'i-han's choice, therefore, is to disassociate the image of a landscape screen from interior decoration, story telling, or illusionism, and to use it instead as a cultural symbol and a visual metaphor. It is symbolic because it signifies a scholar's individuality and spiritual freedom; it is metaphoric because it provides an unspoken message with a concrete pictorial form. This is exactly how this work was appreciated by its scholarly audience. Many distinguished literati added colophons to the painting. The three earliest writers, Su Shih (1036–1101), Su Ch'e (1039–1112), and Wang Hsien (1048–1104?), were all Sung leading scholars and noted advocates of literati arts. Their reading of the painting is characterized by intimacy and self-engagement. Wang Hsien, who happened to have had an earache earlier, identified himself with the painted scholar and found the landscape on the screen a metaphor for enlightenment.

Of course, Wang Ch'i-han was not the first person who perceived nature as the image of a lofty, scholarly mind—this idea had emerged as soon as the art of landscape painting began. To the Buddhist recluse Tsung Ping (375–443), mountains were sacred and embodied divine wisdom and moral principles, and freedom meant that his own spirit merged into them. When his infirmities no longer allowed him to meditate in real landscapes, Tsung Ping traveled in his mind through painted scenery. It is recorded in his biography that on the walls of his

chamber he depicted all the mountains that he had visited in his lifetime. He told his friends: "I strum my lute with such force because I want all the mountains to resound..."[24] Tsung Ping's chamber has long since disappeared. But a tomb excavated recently sheds light on his lost painting. Located at Lin-hsü in present-day Shantung Province, the burial is dated to 551 during the Northern Ch'i rule (550–577), though the deceased, Ts'ui Fen, spent most of his official life in the Eastern Wei court (534–550). The mural appears as a painted screen surrounding the tomb chamber, with its eight rectangular panels depicting a series of gentlemen (or manifestations of a single gentleman) in nature.[25] The chief landscape elements include strange rocks and tall trees, reminiscent of Tsung Ping's sacred landscape in which "grottoed peaks tower on high and cloudy forests mass in depth." But a more crucial factor connecting this screen with Tsung Ping's lost murals is the harmonious relationship between man, nature, literature, and music. Whether composing a poem or playing a lute, a figure portrayed on this screen finds peace in his arts as well as in the tranquil landscape. He is content and seems to be dreaming: his eyes are shut and his gentle facial expression reflects inward contemplation. Without much difficulty we can trace this image to the portraits of the *Seven Worthies of the Bamboo Grove*.[26] In both cases, a Chinese intellectual is represented as a refined individual who finds personal freedom in self-expression and unspoiled nature.

The tradition of the scholarly "landscape screen" continued into the T'ang and found its chief representative, not surprisingly, in the quintessential scholar painter Wang Wei (700–761). Wang's reputation as a poet and painter was inseparable from his passion for the Wang-ch'uan Villa, his country estate which he described repeatedly in both images and words. The T'ang art historian Chu Ching-hsüan (9th century) saw a version of Wang's Wang-ch'uan Villa painting in Ch'ang-an's Temple of a Thousand Blessings (Ch'ien-fu ssu), and considered its powerful landscape imagery a direct reflection of the artist's lofty mind: "Mountains and valleys, crowded close, turned this way and that, while clouds and water streamed by. His conceptions left the dusty, everyday world behind, and marvels grew from his brush-tip."[27] Chu did not document the painting's form, however. It is Chang Huai-kuan (active 713–741), a contemporary of Wang Wei, who recorded that the painting was painted on a screen in the temple's West Pagoda Precinct. [28]

While Wang Ch'i-han's *Collating Texts* clearly followed these precedents, it also inspired many later works of the same genre. The best of these portrays the famous Yüan literati painter Ni Tsan (1301–1374) in front of a landscape screen (fig. 16.7). The life of Ni Tsan has been well studied and need not be repeated here.[29] A more relevant issue is his painting style which, though also well known, provides a key to understanding this landscape screen. Rare among Chinese painters, Ni Tsan insisted on a single subject, a single style, and even a single composition throughout the later part of his life. The great majority of his paintings follow a simple pattern: a river bank in the foreground, surmounted by a few undernourished trees; a broad stretch of water; and earthy hills beyond. The result is a disjointed composition which destroys any sense of real space. When one of Ni Tsan's friends painted this portrait for him in the 1340s, he thus perceived the master and his art as two halves

24. Alexander C. Soper, Textual Evidence for the Secular Arts of China in the Period from Liu Sung through Sui *(Ascona, 1967), p. 16.*

25. *For a good reproduction of this mural, see* Zhongguo meishu quanji *(Treasures of Chinese Art), "Painting" 12 (Beijing: Wen-wu, 1989), pl. 59.*

26. *These portraits are studied in Audrey Spiro,* Contemplating the Ancients: Aesthetic and Social Issues in Early Chinese Portraiture *(Berkeley: University of California Press, 1990).*

27. *Chu Ching-hsüan,* T'ang ch'ao ming-hua lu, *p. 25.*

28. *Chang Huai-kuan,* Hua-tuan *(Opinions on Painting), cited in Hsü Sung,* T'ang liang-ching ch'eng-fang kao *(An Examination of the Components of the Two Tang Capitals) (Beijing: Chung-hua shu-chü, 1985), p. 114. The screen probably stood there until 845, when Emperor Wu-tsung waged a violent attack on Buddhism and destroyed the temple.*

29. *There are numerous studies of Ni Tsan's life and art. For a concise introduction, see James Cahill,* Hills Beyond a River: Chinese Painting of the Yüan Dynasty *(New York: Weatherhill, 1976), pp. 114–20.*

of a whole. He depicted the physical Ni Tsan as though he were thinking about composing a painting. Holding a brush in one hand and a piece of blank paper in the other, Ni Tsan is seated motionless, his face expressionless. His eyes are vacant and he gazes steadily before him; his mind has been transported to a place beyond the mundane world—a place reflected on the screen behind him. It is a landscape painted in Ni's unique style. Juxtaposed with Ni Tsan's physical likeness, it reveals Ni Tsan's inner and more essential existence.

Coda: The "Pure Screen"

This portrait of Ni Tsan, however, is also the last painting in which a landscape screen reflects an individual mind. A more general phenomenon from the Sung to Ming was that the landscape screen gradually lost its specific connections with literati. No longer an exclusive symbol of scholars, it was employed indiscriminately in representations of any figure: secular or sacred, scholar or commoner, man or woman. This pictorial motif was popularized and standardized; its meaning was "emptied" and reinvented. On the other hand, this process of proliferation forced scholar artists to try even harder to escape being assimilated into the general culture, for the essence of literati art lay in intellectualization and self-differentiation. The new images produced through such attempts, however, could never escape popularization and were inevitably adapted by painters outside literati circles.

It is no coincidence that when images of the landscape screen prevailed in society, amateur literati artists found attraction in a chaste, white screen (*su-p'ing*). Such screens appeared in the later works of Wang Meng (ca. 1301–1385) (fig. 16.8) and were also favored by his contemporaries such as Chao Yüan (d. after 1373), Chen Chü-yen (ca. 1331–before 1371), and Hsü Pen (active ca. 1372–1397). Some early Ming amateur painters continued this tradition, but it was Wen Cheng-ming (1470–1559) of the mid-Ming who made this image a firmly established pictorial convention in literati painting (fig. 16.9). Both Wang Meng and Wen Cheng-ming favored a pair of thatched huts, each containing a white screen. This image seems to deliberately echo a poem written by Po Chü-i in the ninth century, entitled "The Pure Screens":

> *I built a thatched hut under Incense Burner Peak;*
> *I placed two screens beside the east and west walls.*
> *Every night, they send the moonlight into my room;*
> *Every morning, they surround me like white clouds.*
> *Long have I cultivated a noble spirit;*
> *Inner and outer, my heart and you, the screen,*
> *reflect each other's brilliance.*

Oh, my screens, do you see that in the palace and the houses of great lords,
Screens are made of embroidered silk.
Those are decorated with chains of jewels, inlaid with mother-of-pearl,
with shining mica sheets attached.
Those are embellished with five metals and the Seven Treasures,
which mingle together and reflect one another.

The eyes of the rich are only delighted by such screens;
They can sleep peacefully only when surrounded by them.
But my pure screens—Oh, my screens—
Isn't it that things have their own nature and use?
You have nothing but wooden bones and a paper face,
Where can you stay but my thatched hut?

For Po Chü-i as well as for Wang Meng and Wen Cheng-ming, a pure screen is idealized as their soulmate or double. It is humble in appearance, and so it embodies a scholar's noble spirit; it is plain and white, and so it can reflect moonlight and resemble floating clouds, both traditional symbols of Nature. But could this literati "pure screen" escape the appropriation of popular culture? Some painters indeed tried to preserve its literati identity even when they themselves had gone commercial. Thus T'ang Yin (1470–1524) accompanied his "scholarly" self-portraits only with plain screens (fig. 16.10a). However, when he employed historical figures to allude to his love affairs with beautiful singing girls, he surrounded the figures with screens painted with colorful landscapes or flowers and birds (fig. 16.10b). For a professional artist such as Yu Ch'iu (active 2nd half of 16th century), however, a plain screen became a universal prop equally appropriate for depictions of scholarly gatherings and semi-erotic drawings of beautiful women. The image of the pure screen thus repeated the fate of the landscape screen to become a general property of Chinese culture. With its white, undecorated surface, it also put an end to the painted screen as a "painting-within-painting."

Figure 16.1
Tu Chin (ca. 1465–ca. 1509),
Enjoying Antiques. Hanging scroll,
ink and color on silk, 126.1 x 187 cm.
National Palace Museum, Taipei.

Figure 16.2
Ku Hung-chung (active 10th century),
Night Entertainment of Han Hsi-
tsai. Ink and color on silk, 12th-century
copy, 28.7 x 335.5 cm. Palace Museum,
Beijing.

Figure 16.3
Composition of the Night
Entertainment of Han Hsi-tsai. (a)
receding of furniture, (b) positions of
screen images.

Figure 16.4
Double Screen, *attributed to Chou Wen-chü, handscroll, ink and color on silk, 31.3 x 50.0 cm. Freer Gallery of Art, Washington D.C.*

Figure 16.5a
Sub-frames in the Double Screen *and* the Night Entertainment of Han Hsi-tsai.

Figure 16.5b
Viewing the Double Screen *and* the Night Entertainment of Han Hsi-tsai.

Figure 16.6
Wang Ch'i-han (10th century),
Collating Texts. *Handscroll, ink and*
color on silk, 28.4 x 65.7 cm. Nanjing
University Library, Nanjing.

Figure 16.7
Anonymous (14th century), Portrait of
Ni Tsan. *Handscroll, ink and color on*
paper, 28.2 x 60.9 cm. National Palace
Museum, Taipei.

Figure 16.8
Wang Meng (ca. 1301–1385),
Retreat at the Foot of Mount Hui.
Handscroll, ink on paper, 28.2 x 73.7
cm. Indianapolis Museum of Art.

Figure 16.9
Wen Cheng-ming (1470–
1559), A Study by Old Trees.
Hanging scroll, ink on paper, 52.4 x
31.3 cm. Collection Unknown.

Figure 16.10a
T'ang Yin (1470–1524), Talking to
Hsi-chou, ca. 1519. Hanging scroll,
ink on paper. National Palace Museum,
Taipei.

Figure 16.10b
T'ang Yin (1470–1524). T'ao Ku
Presents a Poem. Hanging scroll, ink
and color on silk, 168.8 x 102.1 cm.
National Palace Museum, Taipei.

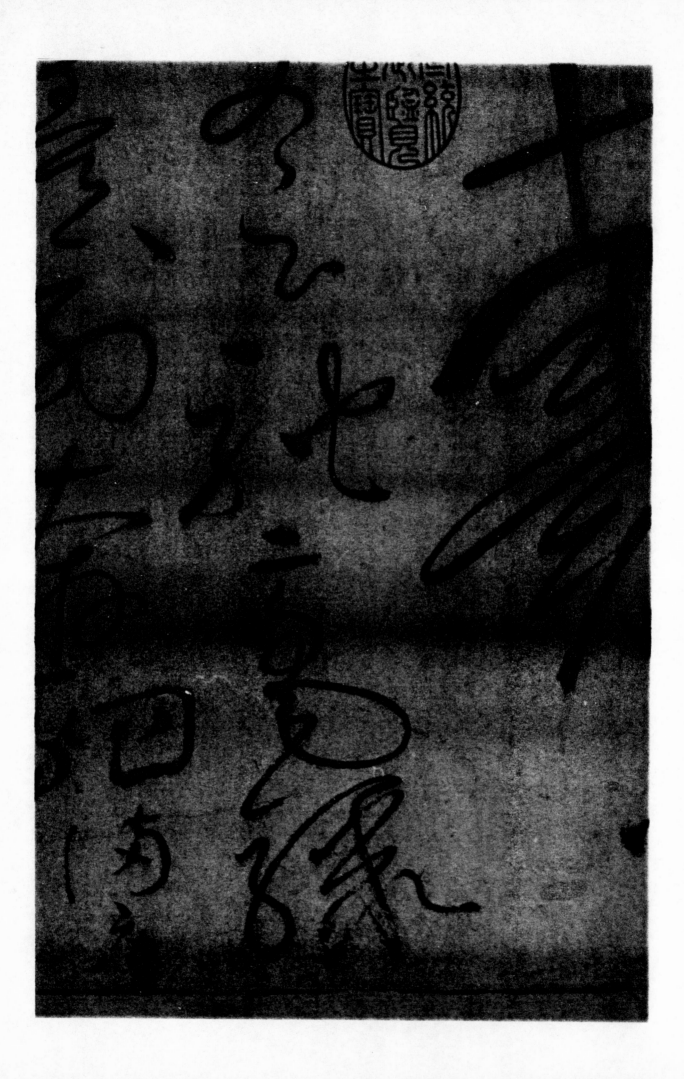

The Continuity of Spatial Composition in Sung and Yüan Landscape Painting*

Ogawa Hiromitsu

From the Continuity of Form to the Continuity of Spatial Composition

As I have argued elsewhere, new Sung and Yüan landscape paintings were sometimes created by rearranging preexisting compositional schemes, or by adopting sections of these schemes that contained expressive motifs. This applies especially to the masterpieces of Southern Sung landscape painting—Mi Yu-jen's (1074–1151) *Cloudy Mountains* handscroll, dated 1130, in the Cleveland Museum of Art, Mu-ch'i's (active 13th century) *Evening Glow over a Fishing Village*, in the Nezu Museum in Tokyo, and Li T'ang's (ca. 1070s–ca. 1150s) *Wind in the Pines Amid Ten Thousand Valleys*, dated 1124, in the National Palace Museum, Taipei, and his double hanging scroll *Landscapes*, in the Kôtô-in, in Kyoto.[1]

In this presentation I would like to expand on this thesis by demonstrating that this same phenomenon can be observed in an even broader range of Sung and Yüan landscape paintings. To carry this out, my paper necessarily adopts a more comprehensive viewpoint that takes into account the activities of Mi Yu-jen and Li T'ang's contemporaries in the second half of the twelfth century, including both literati and Academy painters. Commencing with a close analysis of the particular cases of Mi Yu-jen and Li T'ang, and then expanding to consider other painters, I hope to contribute to the establishment of an even more comprehensive scholarly thesis concerning the continuity of spatial composition in Chinese landscape painting.

Furthermore, I would like to expand on Toda Teisuke's thesis concerning figure painting, presented in his classic study "The Continuity of Form in Chinese Painting";[2] rather than apply it to the examination of individual formal elements in figure painting, however, I shift the focus to the spatial composition of landscape paintings, hoping in the process to obtain a new understanding concerning the role of imitation and originality in these works.

The Continuity of Spatial Composition in Chinese Landscape Painting—From the Five Dynasties Period Through the Northern and Southern Sung, Liao, and Chin to the Yüan Dynasty

Let us refer to the reproduction of Li T'ang's *Wind in the Pines Amid Ten Thousand Valleys* (fig. 17.1), where I have marked for emphasis seven important areas of the painting. To begin, the host peak merits close attention; we shall not consider for the time being the vegetation which crowns the peak. The same goes for the double hanging scroll *Landscapes* (fig. 17.2), disregarding the autumn and winter foliage. I would like to compare the two sides of this double hanging scroll. The base of the mountain in the right-hand scroll swells slightly outward, while creating a descent

* *Translator's note: "Continuity" translates the word denshô, which is usually translated as "transmission." In this case, "continuity" seems more appropriate, as the author is making reference to the continued use of the same method of spatial construction in landscape paintings; whereas "transmission" places more emphasis on the act of passing something down, "continuity" underlines the fact that a similar process is being employed. As mentioned in the body of the text, the word denshô makes reference to Toda Teisuke's concept of continuity in Chinese figure painting.*

1. See "Beiyûjin 'Unzanzukan' to sono keifu," Kokka 1096 and 1097 (1988), part I, pp. 5–28, part II, pp. 31–59; "The Relationship between Landscape Representations and Self-Inscriptions in the Works of Mi Yu-jen," in Words and Images: Chinese Poetry, Calligraphy and Painting, eds. Alfreda Murck and Wen C. Fong (New York and Princeton: The Metropolitan Museum of Art and Princeton University Press, 1991), pp. 123–40; "Ritô hitsu Bangakushôfûzu, Kôtôin sansuizu—sono sozai kôsei no kyôtsûsei ni tsuite," Bijutsushi Ronsô 8 (Tokyo daigaku bungakubu bijutsushi kenkyûshitsu, 1992), pp. 57–70. The original Japanese version of the article in English cited above can be found in Bijutsushigaku 8 (Tôhoku daigaku bigaku bijutsushi kenkyûshitsu, 1986), pp. 30–58.

2. Tôyô bunka kenkyûjo kiyô 57 (1972), pp. 1–30.

from the upper left-hand side of the scroll to the lower right. We can say the same for the base of the left-hand side of the mountain peak in the scroll on the left, which swells outward ever so slightly, concluding a descent of the mountainside from the upper right to lower left. The two sides of the mountain base form a central axis, which is slightly to the left of the division between the scrolls. Note the line symmetry on both sides of this central axis. Although the foot of the mountain base in the left-hand side of the scroll is obscured from view by the waterfall, we can surmise—judging from the angle of the slope right above the waterfall—that it continues to stretch itself outward like its counterpart on the right, together forming almost exactly the base of a trapezoid.

In addition, in the right-hand scroll, there is a line describing a mountain fold running parallel to the edge of the mountain. To its left there are two narrower, shorter lines describing mountain folds, which seem to run parallel to the mountain edge as well. And slightly to the left of these are another pair of lines, parallel to each other, that have been rotated slightly to the left (counterclockwise), on the upper left-hand portion of the central peak. Furthermore, the rock formation on which we find the two "lofty personages" to the right of the waterfall in the *Landscapes*, corresponds to the rock formation halfway up the host peak in *Wind in the Pines*. Thus, the compositional elements of the central peaks in both works correspond to each other. As I have argued elsewhere, this correspondence can also be illustrated in the six other marked sections of the central peak.[3]

3. "Ritô hitsu Bangakushôfûzu, Kôtôin sansuizu," pp. 58–59.

The double hanging scroll *Landscapes*, then, greatly enlarges the middle and background peaks of *Wind in the Pines*, while slightly reducing in scale the foreground pines, the rock base that supports them, and the precipice to the side of the waterfall. Compositional elements in *Wind in the Pines*, which emphasize the foreground much more than Fan K'uan's (d. after 1023) *Travelers Amid Streams and Mountains,* in the National Palace Museum, Taipei, are in turn brought closer to the foreground in the *Landscapes*. This is clearly a result of the plan by which the compositional motifs in these paintings are arranged.

Wind in the Pines firmly preserves the bilateral symmetry of the Fan K'uan tradition. The symmetry is evident starting from the central rock formation in the foreground to the precipices on either side, up through the central peak and the distant mountains on both the right and left. But in the *Landscapes*, despite its retention of a host peak, the bilateral symmetry breaks down. The *Landscapes* delicately rearranges a preexisting compositional scheme, and this helps us to understand better its affinity to the diagonal spatial arrangement of Southern Sung landscape painting.

Both paintings, then, while clearly retaining the host peak, share the idea of building up a landscape by arranging in their own way the individual expressive motifs. The very fact that the Kôtô-in *Landscapes* rearrange the expressive motifs of *Wind in the Pines*, or vice versa, implies the existence of a common underlying compositional model. To understand this model is to understand the close relationship of these two works.

Large, abstract axe-cut strokes, which are not really found in the *Landscapes*, are used in all the works in the handscroll series *Picking Herbs,* in the Palace

Museum, Beijing, thought to be a copy of Li T'ang. If this means that an inclination towards abstraction was already present in Li T'ang himself, then *Landscapes* cannot be dated too far apart from *Wind in the Pines* (as, for instance, some scholars have suggested).[4]

Li T'ang's compositional method, which constructs a landscape through various arrangements of its most important expressive elements—the host mountain, the pair of pine trees—had already found early theoretical expression in the painting treatise *Lofty Ambition in Forests and Streams* by Kuo Hsi (active 1054–87), the great master of the Northern Sung Hua-pei school of landscape painting and precursor to Li T'ang as court painter. This theory is put into practice in his *Early Spring*, of 1072, in the National Palace Museum, Taipei.[5]

There is also a method of landscape construction that consciously employs self-imitation* as a source of creativity; in this method, similar compositional schemes or portions of similar schemes are taken as a model, and the expressive substance of these is changed in various ways to produce a variety of landscape expressions. The *Cloudy Mountains* handscroll of Li T'ang's contemporary Mi Yu-jen is an example of this approach. Of the four equal compositional subdivisions (ABCD) in *Cloudy Mountains*, the second from the right (C) is reemployed in his ink painting *Distant Peaks and Clearing Clouds*, dated 1134, in the Osaka Municipal Museum.

An anonymous ink painting in the Tokyo National Museum, *Landscape with Tu Kuan-tao's Inscriptions*, adopts the middle two sections (BC) of *Cloudy Mountains* to the format of a pair of hanging scrolls. And, as mentioned above, Mu-ch'i's *Evening Glow over a Fishing Village*, a work that is very representative of ink landscape painting, exchanges the right two parts with the left two, adjusting them slightly in the process. Likewise, Mi Yu-jen's *Distant Peaks and Clearing Clouds* reverses and reduces in size the spatial composition of the *Hsiao I Steals the Lan-t'ing Preface*, in the National Palace Museum, Taipei, attributed to Chü-jan (active ca. 976–992), while appropriately rearranging the motifs. The former is not, however, simply an imitation of the latter, but instead creates something new out of the former's spatial composition.

In similar fashion, the later *Landscape with Tu Kuan-tao's Inscriptions* and *Evening Glow over a Fishing Village* are not simply imitations of Mi Yu-jen. Mi Yu-jen himself experimented in other works with the compositional structure of *Cloudy Mountains*; he produced color and ink variations on the fifty-six possible arrangements of its compositional scheme, in such paintings as *Distant Peaks and Clearing Clouds*. Other works that adopt these arrangements are *Landscape with Tu Kuan-tao's Inscriptions* and *Evening Glow over a Fishing Village*.[6]

Mi Yu-jen initially copied the works of Chü-jan for use as a base model, and from these created his own fifty-six variations on a landscape compositional scheme. These, in turn, were self-imitated, replacing Chü-jan as models for future works.

Li T'ang's *Wind in the Pines* and *Landscapes* follow Mi Yu-jen's method in *Distant Peaks and Clearing Clouds*, in that they rearrange the various elements in *Hsiao I Steals the Lan-t'ing Preface*; Li T'ang's works, in fact, self-imitate each other. Both paint-

4. See James Cahill, An Index of Early Chinese Painters and Paintings: T'ang, Sung, and Yüan (University of California Press, Berkeley, 1980), pp. 122–24.

5 See "Kakki hitsu Sôshunzu," Kokka 1035 (1980), pp.14–19.

* Translator's note: "Self-imitation" translates jikomohô. To be distinguished from dentômohô, it is translated here simply as "imitation," but literally means "imitation of tradition" or "copying of tradition."

6. Ogawa Hiromitsu, "The Relationship Between Landscape Representations and Self-Inscriptions in the Works of Mi Yu-jen," pp. 129–33.

* Translator's note: "Spatial matter" translates sozai kûkan, a term coined by the author to indicate both the subdivisions of compositional schemes that can be rearranged to form new paintings, and the combination of motifs upon which these spatial subdivisions are often based. The term "spatial matter" tries to make reference to the idea of space as subject matter and as a material that is manipulated to create new spatial compositions. I am inspired by Harold Rosenberg's coinage, "object matter," in his discussion of Minimalist Art.

7. Suzuki Kei, "Fûusansuizu, sansuizu kaisetsu" in Chûgokubijutsu Daiikkan Kaiga Ichi (Kôdansha, 1973), pp. 224–25.

8. Recently, Suzuki has ammended his thesis, judging the Tokyo National Museum landscape to be an original, and furthermore judging the Hikkôen album as well as the Boston piece to be copies. I follow his original thesis, however, and judge the Boston piece to be an original. See his Chûgoku Kaigashi Chûnoichi (Yoshikawa Kôbunkan, 1984), pp. 146–48. Furthermore, at the international symposium that took place at the National Palace Museum, Taipei, his dismissal of all Hsia Kuei attributions as copies was nicknamed the "No Original Hsia Kueis" thesis. In the roundtable discussion that followed, Max Loehr was convinced of the authenticity of the Boston Hsia Kuei. See Suzuki Kei's "Hsia Kuei and the Pictorial Style of the Southern Sung Court Academy," Proceedings of the International Symposium on Chinese Painting (National Palace Museum, Taipei, 1972), pp. 417–35.

9. Concerning the interrelationship of all of these paintings, see Watanabe Akiyoshi, "Den kakeihitsu sansuizu ni tsuite—Kakeiga ni kansuru nisan no nôto," Kokka 931 (1971), pp. 39–46.

10. See Moriyasu Osamu, "Den Kakeihitsu sansuizu," Kokka 1118 (1988), pp. 24–25.

11. As is well known, the second half of the scroll resembles the first half stylistically. Another work that shares stylistic similarities is the Twelve Views of a

ings, while appropriating the same models, come up with works of a completely different expressive nature, in the different media of color and ink.

However, between Mi Yu-jen, who completely reorganizes pictorial space, and Li T'ang, who does the same with motifs, there exists a considerable discrepancy when it comes to details. The nature of the artistic context from which this discrepancy emerged will be considered later on. For now, I would like to consider the pictorial space that derives from a certain prescribed subject matter and this covers a certain prescribed area of painting surface. The construction of pictorial space actually involves the rearrangement of intermediate elements—what I shall call "spatial matter"—to construct longer and larger pictorial spaces.*

I would like to analyze this process through a consideration of the works of Hsia Kuei (active ca. 1195–1230), who is something of an intermediary between Mi Yu-jen and Li T'ang. Hsia Kuei's fan painting Sailboat in the Rain, in Boston (fig. 17.3), serves as a starting point. Though a work in miniature format, Sailboat in the Rain is considered the only extant work definitely attributable to Hsia Kuei,[7] the only exception to Suzuki Kei's "No Original Hsia Kueis" thesis.[8] This round fan painting, it should be noted, shares a similar compositional scheme to other works attributed to Hsia Kuei, such as the Tokyo National Museum landscape painting, the leaf depicting a landscape from the Hikkôen album, also in the Tokyo National Museum, the Seikadô Bunko Art Museum's Moored Boat on the Lake,[9] and the recently introduced round fan painting Landscape, at the Okayama Prefectural Museum.[10]

This group of works, which constitutes a sizable portion of the total body of works attributed to Hsia Kuei, is extremely important because it employs the same compositional motifs as Li T'ang's paintings. If we take away the background mountain peaks of the right-hand scroll of Li T'ang's Kôtô-in Landscapes, reverse the direction in which the trees lean, keep the rock formation as is, while simplifying and inverting the whole, we end up with a compositional resemblance to this group of miniature Hsia Kuei-attributed works centered around Sailboat in the Rain.

Be that as it may, Hsia Kuei's originality cannot be directly linked to Li T'ang. Among the scenes depicted in the handscroll Twelve Views from a Thatched Cottage, in the Nelson-Atkins Museum of Art, famous for its variety of expression, there is the Mist-Shrouded Village, Returning Sail. This scene resembles formalistically a portion of the background from the first half of Hsia Kuei's handscroll Streams and Mountains, Pure and Remote, in the National Palace Museum, Taipei.[11] From the beginning to about the middle of the handscroll, the foliage and rock formations which connect the scenes Mountain Market, Clear with Rising Mist and Returning Sail off Distant Shore are about the same shape as their counterparts in Sailboat in the Rain. If we consider the fact that the entire background portion of the first half of the Streams and Mountains handscroll is similar to the River Abode (included in the Tôyôbijutsu Taikan),[12] that the scene depicting the bridge around the middle portion of the handscroll is similar to the Hatakeyama Memorial Hall Landscape, and that the rock formation that immediately follows the bridge scene resembles Sailboat in the Rain, we realize that these paintings in miniature format such as Sailboat in the Rain, River Abode, and the Hatakeyama Landscape are not simply surviving fragments of a por-

tion of a long handscroll, nor simply imitations of such portions.

It is entirely appropriate to consider as originals those Hsia Kuei attributions that share similar spatial matter with the handscrolls *Twelve Views* and *Streams and Mountains*. They demonstrate that Hsia Kuei adopted a painting method that constructed long handscrolls by connecting, one by one, these intermediary units or clusters of motifs that I am calling spatial matter. This method, by which a proto-typical spatial composition is rearranged to produce new works, and which is also employed in Hsia Kuei's lost *Eight Scenes of the Hsiao and Hsiang Rivers*,[13] can also be discerned in Liang K'ai's (active first half of 13th century) *Snowy Landscape*, in the Tokyo National Museum; it is, in fact, a characteristic feature of the Southern Sung Painting Academy.[14]

In fact, both of these painters lie somewhere between Mi Yu-jen, who rearranges the entire spatial composition, and Li T'ang, who rearranges individual motifs. By pairing down and rearranging their subject, both Hsia Kuei and Liang K'ai represent an extension of the approaches of Mi Yu-jen and Li T'ang. In following the lead of these latter two, they enrich their material. Living up to the proverb "One-corner Ma," both the *Twelve Views* and *Streams and Mountains* handscrolls actually develop from the diagonal compositional method. We can call this a consistent feature of Southern Sung academic landscape painting: basing spatial composition on this diagonal plan, while eclectically borrowing from the compositional schemes of both Li T'ang and Mi Yu-jen.

Even though they were originally trained in the techniques of the Hua-pei landscape tradition, Hsia Kuei and the Southern Sung academic painters, as time passed, came to absorb the Chiang-nan landscape painting tradition, and thus combined their original training with a technique that goes back to both Li T'ang and Mi Yu-jen, thereby creating their own individual approaches. The one who realized this most radically was none other than Hsia Kuei. Moreover, that is why, among the four great Southern Sung masters, in contrast to Li T'ang, Liu Sung-nien, and Ma Yüan—all of whom displayed facility in figure and landscape paintings, as well as color and ink paintings—it was Hsia Kuei alone, who, despite being a pure ink landscape painter, was esteemed so highly for so long.

Now I would like to consider two *Red Cliff* handscrolls: one thought to be a work of the Chin dynasty and attributed to the Southern Sung painter Yang Shih-hsien, in Boston (fig. 17.4),[15] and another in Taipei (fig. 17.5),[16] the only extant work of Wu Yüan-chih, a late twelfth-century literati painter also of the Chin dynasty. Let us divide the Yang Shih-hsien handscroll into four equal parts and take parts 2, 3, and 4 from the right, reverse them and have them constitute a separate picture, and at the head of the scroll add foreground, rearranging the material appropriately as we go along. The end result resembles fairly closely the composition of the Wu Yüan-chih painting. This observation is important not only for the history of Red Cliff paintings, but also for the light it sheds on the phenomenon of continuity in spatial composition.

Now compare the pine foliage of the cliff in the middle section of the Yang Shih-hsien scroll with its counterpart at the end of the Wu Yüan-chih scroll. The trees

Landscape *handscroll at Yale. Works by other artists that also bear a stylistic affinity to* Streams and Mountains, Pure and Remote, *include Ma Yüan's landscape at the Freer and Hsia Kuei's landscape in the Li Shu Nien collection. The compositions of these four paintings are based on similar units of spatial matter, and in this sense are not irrelevant to the two works being discussed here, but for the sake of brevity I leave them out.*

12. See Yamashita Yûji, "Kakei to Muromachi sansuiga" in Nihon bijutsushi no suimyaku (Perikansha, 1993), pp. 801–33.

13. See Richard Barnhart, "Shining Rivers: Eight Views of the Hsiao and Hsiang in Sung Painting," in Chung-hua min-kuo chien-kuo pa-shih nien Chung-kuo i-shu wen-wu t'ao-lun-hui lun-wen chi/shu-hua (National Palace Museum, Taipei, 1992), pp. 45–95.

14. See Toda Teisuke, "Ryûshônen no Shûhen," Tôyôbunka kenkyûjo kiyô 86 (University of Tokyo, 1981), pp. 337–66.

15. Suzuki Kei was the first to date this to the Chin period, and Richard Barnhart and Ching I-han follow this dating as well. See Suzuki Kei's "Zensekihekifuzu kaisetsu," in Chûgoku bijutsu, Vol 1. Painting 1 (Tokyo: Kôdansha, 1973), pp. 219–20; Richard Barnhart, "Sôkin ni okeru sansuiga no seiritsu to tenkai," in Bunjinga suihen, vol 2, (Tokyo: Chûôkôronsha, 1977), p. 121, and Ching I-han, "Shi-erh shih-jie ti san fu mu-ming-k'uan shan-shui ku-shih hua," National Palace Museum Quarterly 14, no. 1 (1979), p. 54.

16. Concerning the dating of the career of Wu Yüan-chih, see my "Bugenchoku no katsuyakunendai to sono seisaku-kankyô ni tsuite," Bijutsushi Ronsô 11 (1995), pp. 67–75.

look like mirror images of each other. The make-up of the tree clusters is similar: one pine leans over the water surface, while its neighbor stands perpendicular to it, and standing a short distance apart from both is a third tree, also in a perpendicular position. The two handscrolls also have in common the way the rock formations—the ones that connect the Red Cliff to the distant mountains—are largely divided into three groups.

While the distant mountains at the end of the Yang Shih-hsien scroll are tall, those at the head of the Wu Yüan-chih scroll are lower, making the sealine visible. This difference between the two is thought to be due to the fact that the mountains in the latter represent the introductory portion of the scroll and in the former its concluding section. Again, the rock formation placed at the very end of the Wu Yüan-chih handscroll, which towers above and hides from view the flow of the Yangtze River, corresponds to the middle portion (that juts out slightly) of the Red Cliff in the Yang Shih-hsien handscroll. The Yang Shih-hsien scroll reverses the flow of the Yangtze. And finally, in the Wu Yüan-chih work, the lower edge at the end of the scroll is descriptively vague.

The two Red Cliff compositions, at first glance, do not resemble each other. When observed closely, however, the portion of the cliff that stands perpendicular to the Su Shih boat party in the Yang Shih-hsien painting, and the upper rectangular portion of the same cliff face, correspond to a similar cliff formation in the Wu Yüan-chih painting (in the latter work, the section in question has been transferred to the middle of the scroll). From this we know, then, that even after Mi Yu-jen, the practice of subdividing the entire compositional scheme into halves and quarters was carried out in the Chin dynasty; and thus we also know that this practice coexisted alongside Li T'ang's method of rearranging motifs.

The feature that most sets the Wu Yüan-chih painting apart from its counterpart, that is to say, the foreground land mass at the right, can therefore be explained with reference to the Mi Yu-jen/Li T'ang method: it has inverted and slightly reduced in size the foreground at the left of the scroll, appropriately rearranging the material to make it blend in with its surroundings.

Both scrolls, however, mix Li T'ang's texture strokes and mountain shapes with those of Tung Yüan (d. 962)—in their use of axe-cut strokes that are produced with the tip of the brush drawn out like hemp-fiber strokes; in the precipice split down the middle that occupies all of the middle ground; and in the slightly rounded mountain shapes in the background.

This mélange is much more noticeable in the Wu Yüan-chih handscroll, and there is no doubt that both of these are modeled on Li T'ang. In fact there are two more works based on the Li T'ang style, that, like these two handscrolls, do not employ precise axe-cut strokes: *Small Views of Rivers and Mountains* and *Ten Thousand Trees, Marvelous Peaks*, attributed to Yen Wen-kuei, both in the National Palace Museum, Taipei. The former is especially important because the tall weeds found at the roots of the trees in the foreground can be found among the foreground pines of the Yang Shih-hsien scroll and in the fore- and background pine trees of the Wu Yüan-chih painting as well.

At the foot of the waterfall in Li T'ang's *Wind in the Pines*, we also find the white-green undergrass painted with delicate brushwork. The difference here in texture strokes and rendering of the undergrowth is simply a matter of whether it stands out or not; both features link the two handscrolls to Li T'ang. But rather than place them in the same group as *Wind in the Pines* and the Kôtô-in *Landscapes*, we know they belong to the group that counts *Small View of Rivers and Mountains* and the *Ten Thousand Trees, Marvelous Peaks* among its members.

Compositionally, however, the relationship between the Yang Shih-hsien and Wu Yüan-chih paintings is irreversibly one-way. The latter can conceivably come out of the former, but not vice versa. In other words, even if the Yang composition can be dated later than the Wu painting, compositionally it is closer to a prototypical Red Cliff painting that surely served as a model for both.

Another possibility is that even though both were subject to the influence of Li T'ang, there remained, between the Southern Sung and Chin regional cultures, quite a discrepancy in the availability of Li T'ang's works. As with Yen Wen-Kuei's *Small View of Rivers and Mountains* and *Ten Thousand Trees, Marvelous Peaks,* it should have been easier for Chin painters also to have access to early interpretations of the Li T'ang style. The original on which the Yang and Wu Red Cliff paintings are based could have been from the hand of Li T'ang himself. We can conjecture that this original was a Red Cliff composition composed during the Northern Sung period, and that it can be grouped with *Small View* and *Ten Thousand Trees*.[17]

The extant Yang Shih-hsien is executed in ink and color, however, while the Wu Yüan-chih is an ink painting. Perhaps the landscape expression that Li T'ang pursued in both ink and color was also sought in the slightly different genre of narrative landscape. The paintings by Yang Shih-hsien and Wu Yüan-chih transmit Li T'ang's endeavor to us faithfully, but not before further combining it with the techniques of Mi Yu-jen. In other words, the creativity that Mi Yu-jen based on systematic self-imitation (as witnessed in *White Clouds of the Hsiao and Hsiang Rivers*, in the Shanghai Museum, and *Miraculous Views of the Hsiao and Hsiang Rivers*, in the Palace Museum, Beijing), was employed by later artists to investigate the limits of landscape expression.

Developing in a different direction from the earlier *Cloudy Mountains* and *Distant Peaks and Clearing Clouds*, Mi Yu-jen rearranged both spatial composition and motifs at the same time in an attempt to arrive at a more diverse landscape expression. Li T'ang, on the other hand, tended to rearrange the elements within a similar spatial scheme and developed a method not founded on Mi Yu-jen's. And this creativity based on self-imitation, systematized by Mi Yu-jen and Li T'ang, was continued everywhere throughout the Southern Sung and Chin dynasties. Developing in many different directions, in some cases it was transformed into strict copying, but in others it was used to produce more creative rearrangements of the subject matter and spatial composition.

Just what kind of painting tradition lay at the origin of the Mi Yu-jen and Li T'ang method? Examining this tradition should help to clarify how the considerable difference in method between the two painters originated.

17. Unfortunately, there remains no textual evidence that Li T'ang ever painted the Red Cliff theme.

I shall approach this issue first by considering Master Li's *Dream Journey through the Hsiao and Hsiang Rivers*, of about 1170, in the Tokyo National Museum. This handscroll is thought to preserve the ancient Chiang-nan landscape painting tradition that predates Mi Yu-jen. In connecting a variety of preexisting motifs and unique spatial composition in order to construct a new pictorial space, the painting shares the same approach as the two Hsia Kuei handscrolls, *Twelve Views from a Thatched Cottage* and *Streams and Mountains, Pure and Remote*. The *Dream Journey* borrows the unique spatial matter—which contributes to the X-shaped compositional plan—found in such stylistic predecessors as *Awaiting a Ferry at the Foot of the Mountain in Summer*, *Wintry Groves and Layered Banks*, and *Residents of the Capital City*, all attributed to the tenth-century Chiang-nan landscape painting master Tung Yüan. This new method of constructing pictorial space can also be discerned in Huang Kung-wang's (1269–1354?) *Dwelling in the Fu-ch'un Mountains*, in the National Palace Museum, Taipei.[18]

18. See Kunigô Hideaki, "Shôshô gayû zukan shôkô—Tôgen no sansuiga to no kankei ni tsuite," Bijutsushi Ronsô 6 (1990), pp. 41–57.

19. See Richard Barnhart, Marriage of the Lord of the River: A Lost Landscape by Tung Yüan (Ascona: Artibus Asiae, 1970).

Moreover, among works from a later period, Mu-ch'i's *Mist-Shrouded Temple, Evening Bell* (from the *Eight Views of the Hsiao and Hsiang Rivers* handscroll at the Hatakeyama Memorial Hall) contains a section in the vicinity of the mist-shrouded temple which depicts similar spatial matter. As has already been noted,[19] if we consider these paintings in relation to Tung Yüan's three landscape compositions, this type of painting method is then not limited to *Dream Journey through the Hsiao and Hsiang Rivers*, but must have been adopted broadly during the Sung and Yüan periods, among both the Chiang-nan landscape painters and those continuing the Huapei tradition in Chiang-nan.

The no-longer extant *Marriage of the Lord of the River* was copied and transmitted by both *Awaiting a Ferry*, which employs the X-shaped compositional format, and the *Hsiao and Hsiang Rivers* scroll in the Beijing Palace Museum collection, which does not. Now, if we link the two extant works we can get a sense of what the original looked like; it probably did not depict a naturalistic space, but, rather, a pictorial space in which the motifs are freely chosen, like the pictorial space of the *Dream Journey*, in which various spatial subjects are arranged together in the composition of a long handscroll.

This original is thought to be a condensed version of Mi Yu-jen's *Cloudy Mountains*, whose compositional scheme is constructed around the limited material of the small island and the opposing bank, connected by a small bridge. However, if of the four equal subdivisions of *Cloudy Mountains*, the second from the right has as its model Chü-jan's *Hsiao-I Steals the Lan-t'ing Preface*, then the method witnessed in *Dream Journey*, *Marriage of the Lord of the River*, *Awaiting a Ferry*, and the Beijing *Hsiao and Hsiang Rivers*, despite these paintings' different dates, also lies at the origin of Mi Yu-jen's systematized compositional method.

Mi Yu-jen does not depict a naturalistic space, but a pictorial one, which can be cut off voluntarily at any place, and divided into four equal subdivisions that can be joined to form a new compositional arrangement. This can be thought of as a strict subdividing, as opposed to the comparatively loose subdividing observed in *Awaiting a Ferry* and *Hsiao and Hsiang Rivers*. The *Awaiting a Ferry* handscroll ends, for

example, where the boat is about to leave the space of the handscroll. If we look at the way the *Hsiao and Hsiang* handscroll ends, we can understand that this type of cropping of the picture plane does not come from the imitation of a model, but is the result from the very beginning of an intent to create a pictorial space. It further demonstrates that we need to rethink these works as an attempt to base the construction of handscroll pictorial space upon the subdividing method of Tung Yüan himself.

The method employed during the Southern Sung and Chin periods, both in north and south China, can be directly linked to Li T'ang and indirectly to Mi Yu-jen, and, if we go back even further, to Tung Yüan. With the exception of Hsia Kuei, the compositional problems of both color and ink landscape painting were inseparable. If we go back to the period before that, already with Tung Yüan and his school we witness this inseparability. In other words, it is probable that even in the Hua-pei school, which was the source of Li T'ang's method that so overwhelmed the Chiang-nan school of landscape painting during the Northern Sung, color and ink painting were both pursuing the same compositional style.

This is what we see being attempted in the late tenth-century ink and color landscape painting recently excavated from a Liao Dynasty tomb (fig. 17.6), now in the Liaoning Provincial Museum, and the *Mt. K'uang-lu* (fig. 17.7) in the National Palace Museum, Taipei, attributed to Ching Hao. Furthermore, another pair of ink paintings, *The Min Mountains* (fig. 17.8), in the National Palace Museum, thought to be by an anonymous late-twelfth-century follower of Kuo Hsi, and the *Wind and Snow in the Fir Pines*, in the Freer Gallery, Washington D.C., attributed to the literati painter Li Shan (active late 12th to early 13th century), can be related to the first pair both in terms of spatial composition and texture strokes.

Varying the perspective of the painting from slightly nearer to slightly farther away, these four landscapes of the Hua-pei tradition, whether they be copies or originals, have in common the placement of a central peak to the left, distant mountains in the upper right, and the main body of trees on the lower right. They also, in the order named, gradually open out spatially on their right.

Let us now look at the recently excavated Liaoning *Landscape* and *Mt. K'uang-lu*, which have no dates assigned to them but are traditionally grouped close to each other. We see that they share similar texture strokes. The main peak rises up out of coiling rocks, which are executed in texture strokes in which the brush tip is basically dropped down vertically. Such a peak can also be observed in a painting attributed to Ching Hao's (active ca. 870–ca. 930) direct disciple, Kuan T'ung (active ca. 907–23), *Autumn Mountains at Dusk*, in the National Palace Museum. This peak is thought to be a feature that derives from Ching Hao himself.

Compared to *Mt. K'uang-lu*, the Liaoning *Landscape* narrows the pictorial space on the right, and in the lower right places the foliage too close to the central peak. We can guess that the paintings were derived from some model of similar spatial composition; both contain portions of the right side of the central peak that jut out slightly, and both place buildings on the middle left-hand side of the central peak, as well as underneath the precipice. The Liaoning *Landscape* and *Mt. K'uang-lu* share

similar spatial composition and texture brushstrokes, and both are probably based on a Ching Hao work. Though the Liaoning tomb painting slightly alters the expression of this model by constructing mountain folds out of texture strokes, it has not yet hardened into the stylized vertical outlines of varying ink tones that we find in *Mt. K'uang-lu*; the Liaoning work is thus closer to the original. Compared to *Mt. K'uang-lu*, the Liaoning *Landscape* simplifies subject matter; it is distant from the original in showing a considerable degree of stylization, but is close to it compositionally, adding to Ching Hao's work the larch pines that pepper contemporary Northeast China.

In the Liaoning painting, vermilion is used for the pavilion, and for the distant mountains white pigment and greenish-white, according to a color-perspective scheme in which red is used as the foreground color and blue for distance. Ching Hao was steeped in landscape painting color theory and painted such traditional themes as Kuan-yin.[20] The technique of the Liaoning *Landscape*, in which color is applied not just to the pavilions and the distant mountains but to the figures as well, can be directly connected to the technique of Ching Hao himself, which in turn was elaborated in both color and ink paintings. The white and greenish-white of the distant mountains combined with the ink of the rocks is unique, and if changed to indigo, it resembles the ink and color landscape painting techniques of Ma Yüan and the other Southern Sung academic painters.

The texture strokes of *Wind and Snow in the Fir Pines* and *The Min Mountains* share nothing in common with those of the Liaoning *Landscape* and *Mt. K'uang-lu*. *The Min Mountains*, which imitates Kuo Hsi's texture strokes, is nevertheless more straightforward than Kuo Hsi's *Early Spring* in emphasizing volume, and in painting mountains and rocks that are like clouds; however, it does not place them in a unified spatial expression full of light and air. In this respect it takes to the extreme the billowing cloudlike rocks that go back to Li Ch'eng (919–967).

Wind and Snow in the Fir Pines applies everywhere the same technique used for the distant mountains, in which the contours of the mountain remain vague. No attempt is made to distinguish between the brushwork of the fore, middle, and backgrounds. Even the three-dimensionality of the mountain forms of *The Min Mountains* has been abandoned in favor of an emphasis on surface plane.

Let us then examine in detail *Mt. K'uang-lu* and *The Min Mountains*. The composition of the two paintings is essentially the same. One of the biggest differences is that, in *The Min Mountains*, the trees in the lower right are placed so that they connect with the road and bridge which run along the rock formation in the middle foreground. In addition, the building between the two waterfalls on the far left has been omitted. The lower of the two waterfalls on the left has furthermore been divided in two, where it pours out into the river, and it has been positioned directly below the other waterfall.

They have in common the position of the buildings at the base of the host peak and under the trees in the lower right. Furthermore, the buildings in both paintings form a T- or L-shaped right angle where they join together. The two works also arrange mountains in similar fashion, with distant mountains to the left of the host

20. Liu Tao-chun's Wu tai ming hua pu-i, *under the heading of Ching Hao (in the "divine painters" category of the chapter on landscapes), mentions the following: "Ching Hao painted a mural painting of Kuan-yin at the Shuang-lin Yüan Temple on Mt. Luo-chia." It is furthermore known that he often painted the Buddhist landscape theme of Kuan-yin sitting amidst Mt. Pu-tuo-luo. Moreover, in his* History of Painting, *Mi Fu writes, "Wang Shen studied Li Ch'eng's texture strokes, and he used the golden grain [archaic style]. It looks like all of the depictions, past and present, of the Kuan-yin at Mt. Pu-tuo-luo." If this is indeed the case, then the Kuan-yin falls into the category of a color landscape painting.*

mountain, and on the right small mountains that gradually turn into distant ones. To the right of the pavilion is a mountain cluster that connects to the small and distant mountains to the right of the central peak. Moreover, to the left of the mountains which descend in succession toward the viewer from the host peak, there is a waterfall, and to the right is a pavilion which appears and then disappears. This group of mountains descending from the host peak, in response to the change in position of the waterfall below, connects onto the rock formation which bears the mountain path to the right.

The Min Mountains is qualitatively the better painting. Due to the bifurcation of the waterfall, however, the way in which the water flows is irrational compared to Mt. K'uang-lu, which shows that The Min Mountains was copied in a freer manner. Both paintings have further elements in common: the chain of rocks that stretches from the right to the upper left of the mouth of the lower waterfall, and the trees standing where the pavilion and rock formations connect at the base of the central peak (which run up diagonally to the upper right). The Min Mountains has completely changed the texture strokes of the model for Mt. K'uang-lu, and at first glance represents an entirely different landscape expression. It echoes Mi Yu-jen's painting method, which deals with both ink and color paintings, through a mixture of imitation and self-imitation. It does what Mi Yu-jen's Distant Peaks and Clearing Clouds does with Chü-jan's Hsiao I Steals the Lan-t'ing Preface, inverting and reducing the spatial plan while rearranging the motifs accordingly. Mi Yu-jen's method, in turn, could not have arisen had there not been a precedent that goes back to Ching Hao.

Mi Yu-jen's method doubles as proof of the existence of a similar method governing The Min Mountains and Mt. K'uang-lu (similar composition, varied expression). If such a simplified method did not exist, then Li T'ang's approach would not have been conceivable either. In sum, if this method that goes back to the Hua-pei tradition of Ching Hao and Tung Yüan's Chiang-nan tradition had never come about, then the techniques of Hsia Kuei and Wu Yüan-chih, let alone those of their forebears Mi Yu-jen and Li T'ang, would not have been conceivable.

In this way, the attempts made by Mi Yu-jen and Li T'ang are not simply grounded in their employment of the extremely radical technique of the Hua-pei landscape school based on Kuo Hsi. They are based just as much on their use of the more widespread technique of the Chiang-nan school. What is more, in Li Kung-nien's Landscape, 1110–1114, in The Art Museum, Princeton University, the billowing cloudlike rocks in the foreground and the angular shape of the central peak of the Hua-pei landscape painting master Li Ch'eng are thought to have been subject to the influence of the Chiang-nan landscape master Chü-jan.[21]

If we also see Chü-jan's influence in the shape of the distant mountains in the Kôtô-in Landscapes, we can begin to map out the following genealogy of landscape painting: The Hua-pei tradition for a long time nurtured a method in which each one of the individual expressive motifs has been clearly grasped in the construction of landscape composition, and this was combined with the remarkable technique of Kuo Hsi. This in turn was absorbed by Mi Yu-jen's technique based on self-imitation, which was practiced over and over, within a given spatial construct in which

21. See Odashima Shun and Ogawa Hiromitsu, "Rikônen hitsu sansuizu," Bijutsushigaku 13 (1991), pp. 79–96

expression was varied; this consequently allowed for a whole range of landscape expressions. When the resulting style combines with that of the Chiang-nan school, in which traditional subject matter is reemployed and new pictorial space is constructed, all three come together in the person of Li T'ang, after his move to the south. They come to fruition in his *Wind in the Pines Amid Ten Thousand Valleys* and Kôtô-in *Landscapes*.

Or rather, like Mi Yu-jen's *Cloudy Mountains* and *Distant Peaks*, there was a profusion of paintings bearing multiple aspects, varying from rough to delicate, simplified to precise. Li T'ang's *Wind in the Pines* and *Landscapes* are important examples of one aspect of this variety, and as such occupy a position comparable to Mi Yu-jen's *Cloudy Mountains* and *Distant Peaks*.

T'ang Ti (1247–1355) also sheds light on aspects of Sung dynasty painting.[22] As is known, his *Fishermen Returning on a Frosty Bank*, dated 1338 (fig. 17.9), in The National Palace Museum, and *Returning Fishermen*, 1342, in The Metropolitan Museum, employ the same compositional scheme. These two works "imitate" each other. I will demonstrate that they also imitate the Taipei *Small Wintry Grove* (fig. 17.10),[23] and that they are therefore the result of a method that combines imitation with self-imitation. I also hope to consider T'ang Ti's position within the history of the development of spatial composition.

There are portions of these paintings that follow Kuo Hsi's technique of using the brush in a flat way to create rocks like clouds. *Small Wintry Grove*, however, retains the older brushwork of Li Ch'eng as well.[24] Keeping this in mind, let us observe closely the details of the composition and the brushwork of *Small Wintry Grove*. There is a cluster of three trees, consisting of a dry, crooked tree with branches extending to the left, another dry tree in the middle with a branch extending vertically beyond the edge of the picture plane, and on the right, a wide-leafed tree which stretches its branches outward to the right. *Fishermen Returning on a Frosty Bank* and *Returning Fishermen* employ this arrangement as well, and scatter, in addition, three or four wide-leafed shrubberies. The former places a withered tree in front of a pair of pines, and the latter places one it behind it.

There is a big change, however, from the brushwork of Li Ch'eng, which is not very remarkable, to that of Kuo Hsi, whose brushwork really stands out. Even though the "Li-Kuo style" groups the two painters together, compared with Li Ch'eng, who died an untimely death and ended up with only a small output, Kuo Hsi lived a long life, painted prolifically, and had a much greater influence on later generations. Just as we saw in the comparison of *Mt. K'uang-lu* and *The Min Mountains*, new paintings were being created by applying radically different brushwork to similar compositional schemes.

In fact, Taipei's *Fishermen Returning* and the Metropolitan's *Returning Fishermen* are concrete examples of works that come out of Kuo Hsi. The groups of three trees and three fishermen have counterparts in the lower right-hand portion of the abovementioned *Min Mountains*. The cluster that, in the former two, includes broad-leafed shrubbery added to the withered tree and pair of pines, divides, in the latter, to become two separate pairs of pine trees. The direction of the group of

22. *In the absence of an established theory concerning T'ang Ti's dates, I follow those assigned to him by Shih Shou-ch'ien. See his "Yu-kuan T'ang Ti (1287–1355) chi Yüan-tai Li-Kuo feng-ko fa-chan chih jo-kan"* I-shu hsüeh 5 *(1991), pp. 83–131.*

23. Small Wintry Grove *bears the seal of the Hsüan Wen Hall Imperial Library, indicating that it was in the collection of the Kuei Chang Hall, which had been moved to the Hsüan Wen Hall in 1341. See Fu Shen,* Yüan-tai huang shih shu hua shou ts'ang shih-lue *(Taipei: National Palace Museum, 1981), pp. 63–67. The Bureau Seal (a half seal) at the lower right indicates that it was already in use during the Yüan Dynasty. Furthermore, during the reign of Jen-tsung, T'ang Ti was transferred to Peking, and was assigned to the Chi Hsian Yüan Academy (see Chang Yü's epitaph for T'ang Ti in the Wu-hsing Gazetteer [vol. 12] by Tung Ssu-chang). The fact that he maintained such close relations with the Yüan court, combined with the time period during which* Small Wintry Grove *was kept at the Yüan Imperial Library, serves as evidence that* Small Wintry Grove *was a model for* Fishermen Returning on a Frosty River Bank *and* Returning Fishermen.

24. *As this painting employs some of the brushwork of Kuo Hsi mixed in with other styles, it has been dated to the latter half of the eleventh century, as a product of the Li Ch'eng school. I follow this dating.*

three fishermen is reversed and they now move towards the right. In the group that depicts the two lofty gentleman on horseback followed by the walking manservant, the pose of the gentleman at the head, who is turning around to look back, remains the same. However, because it puts the withered tree behind the pair of pines and closes off the space on the right side, *Returning Fishermen* is closer to *The Min Mountains* than *Fishermen Returning*. Both *Fishermen Returning* and *Returning Fishermen* schematize the section in *Early Spring* in which the trunks and branches of the trees are extended to cover the fisherman household. They transform the three treetops so that they form a strong arc and something of a halo over the heads of the three fishermen. Their presence is thus emphasized and approaches the lower right portion of *The Min Mountains*. Both *Fishermen Returning* and *Returning Fishermen* follow portions of both the small-scale *Small Wintry Grove* and the larger *Min Mountains* to produce an imitative work in large scale, while imitating each other at the same time. There is no way to verify definitively if T'ang Ti saw *The Min Mountains*, which bears no official Yüan seal. (In contrast, *Small Wintry Grove* does bear a Yüan Imperial Library seal, which means T'ang Ti did indeed see it.)

It has been pointed out that Chu Te-jun (1294–1365), in his *Playing the Zither Under the Grove*, in the National Palace Museum, also reverses the right-hand portion of *The Min Mountains*.[25] *The Min Mountains* represented, then, a standard work in the Kuo Hsi tradition not just to T'ang Ti but to all of the Yüan dynasty followers of the Li-Kuo tradition. In other words, there is a strong possibility that this work is not from the Chin or Southern Sung, but from closer to Kuo Hsi's time, sometime during the Northern Sung. Other than *Fishermen Returning* and *Returning Fishermen*, T'ang Ti's *Travelers in the Autumn Mountains, After Kuo Hsi*—like *Playing the Zither Under the Grove*—takes the left three of the four equal subdivisions of spatial composition in *The Min Mountains* and adjusts the motifs accordingly. The distant mountains to the left of the main peak are brought closer, and those on the right are brought down to the lower right-hand part of the composition. The little mountain that resembles the face of a dog is brought to the left of the host peak and is altered to resemble the silhouette of a dog's face in profile.

The buildings at the base and left-hand side of the host peak, however, are positioned differently from their counterparts in *The Min Mountains*. This difference might bear a trace of Ching Hao's *Mt. K'uang-lu*. The series of mountains that descend continuously from the main peak and the waterfall at lower left might echo the Ching Hao painting as well. The rock formation at the lower right is retained but has become very faint. The path on the lower right has been turned into a broad, flat space, and the small rock formation to its right is retained at the very right edge of the picture frame. Of the cluster of trees at the lower right corner of *The Min Mountains*, T'ang Ti keeps only the ends of branches of the withered and broad-leafed tree inside the picture. On the path below, one finds a string of travelers, and if we return to the left, there is a building. This rather complicated building shares with its counterpart a T-shape structure.

Transporting the rock formation and building in the foreground to the bottom center of the painting represents a big change. This move counterbalances the posi-

25 See Nishigami Minoru, "Shutokujun to Shinzô," Bijutsushi 104 (1978), pl. 29.

tion of the host mountain, which, while taking up three-quarters of the painting surface, has been positioned in the center. The composition of *Playing the Zither Under the Grove* resembles the inverted right half of *The Min Mountains*, and reveals a lingering of the diagonal compositional format of the Southern Sung. In contrast to this, T'ang Ti returns to the centered peak compositional format of the Northern Sung Hua-pei school, all the while retaining something of the diagonal compositional format. This is no doubt a result of his borrowing and simplifying the left three-quarters of the compositional format of *The Min Mountains*, which is related to the Southern Sung diagonal compositional scheme.

Li Sheng's *Parting at Lake Tien*, dated 1346, in the Shanghai Museum, roughly contemporary to T'ang Ti's *Fishermen Returning* and *Returning Fishermen*, adopts the same spatial plan in the main peak and lower half of the surrounding area. Li Sheng's work should be thought of in connection to the Li-Kuo painters of the Yüan, as following the same models: the landscape paintings of the Hua-pei school. Li Sheng adopted this for part of his handscroll; the present painting adapts the coloring technique of the Chiang-nan school to a large format. The fifth chapter of the *Tu hui pao chien* points out the connection between Sheng Mou and the Southern Sung Academy painters, primarily of the Hua-pei school. Sheng changes the spatial composition a little bit, adds the line variation of the ink painting and creates a new artwork. This shows that he is continuing the method of Li T'ang and Hsia Kuei.

The difference in expression between *Parting at Lake Tien* and *Enjoying the Fresh Air in a Mountain Retreat* parallels the difference between Mi Yu-jen and Li T'ang, who take the same composition or simplified scheme and make expressive changes. T'ang Ti, in *Fishermen Returning* and *Returning Fishermen*, takes the subject matter of *Small Wintry Grove* and *The Min Mountains* and freely keeps or discards elements in making an enlarged copy.[26] It is entirely in keeping with the Hua-pei tradition, which includes both Li T'ang and Ching Hao. *Travelers in the Autumn Mountains, After Kuo Hsi*, being a three-quarters imitation of *The Min Mountains*, belongs to the Chiang-nan landscape tradition that goes back through Mi Yu-jen to Tung Yüan. And, like Sheng Mou, this method freely picks and chooses from among the traditions of the north and south.

T'ang Ti, Sheng Mou, and the Yüan landscape painters are trying both the strict and freer techniques of the northern and southern landscape traditions, and in the process establishing a base for the study in the Ming and Ch'ing of ancient landscape styles. These five paintings, T'ang Ti's and those of the Northern Sung that served as his models, reveal consistently the same compositional process, and surely served as fine examples for the landscape painters of the Ming and Ch'ing.

Conclusion: Towards a Systematic Consideration of the Continuity of Spatial Composition in Landscape Painting

The composition of a landscape painting involves three categories of elements. The first category consists of expressive motifs. The second consists of the units of spatial matter that are composed from these expressive motifs and that are used to fill a certain area of prescribed painting surface. The third consists of the units of pic-

26. Among Yüan painters of the first rank, T'ang Ti is relatively unique in that he painted the Lung Hsiang Temple mural and the Chia Hsi Hall folding screen as well. As a painter who must have been used to painting in both large and small formats, the problem of enlarging the scale of a painting when making a copy must have been easily managed.

torial space derived from a combination of the expressive material and the spatial matter; they can sometimes fill up large areas of the picture plane. These three elements are arranged and rearranged to create a landscape painting.

These elements and their combinations are not so numerous, like those used for other genres, such as the six cranes of birds-and-flower paintings,[27] or the twelve water scenes in landscape painting,[28] which fall into the first and second category of elements. They number no more than ten at most: the small islands and boats that belong to the first category; the small units of spatial matter—small island and bridge, or a boat and hills—that fall into the second category; and, finally, the units of pictorial space that are composed when all of these elements are brought together, such as a mountain range that is connected to an island by a bridge, all of which wall off a certain water surface upon which a tiny boat floats, and so forth.

The process that employs these elements predictably becomes reified and schematized by certain artists and artistic schools. Invested with an authority like that commanded by the classics of literature, it is passed on unchanged to future generations. Corresponding to these three categories of elements are the three stages in their reemployment: their separation, redistribution, and joining together. These three stages can in fact be likened to the initial stage of picture construction itself. As such, they represent a reenactment of the creative artistic process.

If we consider the development of Mi-style landscape painting,[29] and remember that certain motifs (the island, bridge, and boat) from the *Cloudy Mountains* handscroll are recycled in later compositions, then certain landscapes can be classified as employing the Mi-method of landscape construction.

This recycling can be considered the first of three types of continuity. It involves the intentional, creative repetition of one's own earlier work. The works that exemplify this among Mi Yu-jen's own oeuvre include *White Clouds on the Hsiao and Hsiang Rivers*, and *Miraculous Views of the Hsiao and Hsiang Rivers*, which represent the early stages of this process of continuation. Among the works of others, *Verdant Peaks Above the Clouds*, dated 1309, by Kao K'o-kung (1248–1310) is representative.

The second type of continuity of landscape composition involves units of spatial matter, which must cover a prescribed painting surface and are derived from motifs such as islands, rivers, and bridges. It is represented by Mi Yu-jen's *Cloudy Mountains*, in The Metropolitan Museum of Art, which is thought to represent a fragment of a much longer handscroll, and Fang Ts'ung-i's (ca. 1301–after 1378) *Cloudy Mountains*, in the Shanghai Museum.

There is, furthermore, a third type of continuity in which not just motifs or units of spatial matter, but the entire pictorial space of *Cloudy Mountains* itself is transmitted. Among examples that typify this type are two paintings mentioned earlier, Mi Yu-jen's *Distant Peaks and Clearing Clouds* and Mu-ch'i's *Evening Glow over a Fishing Village*. Within this category, all of Mi Yu-jen's own works are of course based on self-imitation and everybody else's would be imitation of past masters. Self-imitation, however, does not limit itself *strictly* to the imitation by a painter of his own works, but can be combined with an imitation of older works by other

27. Concerning the six cranes, see my "Sesshoku rokkakuzu byôbu kô—Shôsoin nansô hôbutsu urushibitsu ni egakareta sômokutsuruzu ni tsuite," Tôyô bunka kenkyûjo kiyô 117 (University of Tokyo), pp. 179–214, and also "Kôsen rokkakuzu hekiga to sono keifu (part 1)," Kokka 1165 (1992), pp. 7–22.

28. For the twelve water scenes, there is of course Ma Yüan's version in the Beijing Palace Museum collection.

29. See Ogawa Hiromitsu, "Beiyûjin 'Unzanzukan' to sono keifu."

artists. *Distant Peaks* is, in this sense, both imitative and self-imitative. Differing from the first type of continuity, which concerns such things as the brushwork used to depict the trees and so forth, the second and third types can also encompass works that, while adopting a compositional scheme very similar to the Mi school, deviate stylistically from Mi-school landscape painting. Chü-jan's *Hsiao I Steals the Lan-t'ing Preface*, for example, in serving as one of the artistic models for *Distant Peaks*, illustrates this process.

There are, in addition, many works, outside of the Mi-school sphere, that illuminate discussion of the continuity of landscape composition. Tung Yüan's *Awaiting a Ferry at the Foot of the Mountain in Summer* and *Hsiao and Hsiang Rivers*, for instance, reemploy the pictorial space of his lost *Marriage of the Lord of the River*. In what corresponds to the third type of continuity, they "cut-and-paste" the spatial units of the lost painting, varying in the degree to which they adhere to its original compositional plan. In the same way, *Mt. K'uang-lu*, the excavated Liaoning *Landscape, The Min Mountains*, and Li Shan's *Wind and Snow in the Fir-Pines* transmit Ching Hao's pictorial space. Of these four paintings, however, the former two (*Mt. K'uang-lu*, Liaoning *Landscape*) stylistically follow Ching Hao, while the style of the latter two (*The Min Mountains, Wind and Snow*) point to the very different Kuo Hsi. By adapting a certain compositional plan to a completely different stylistic expression in this way, then, these paintings parallel the similar development occurring in Mi-style landscapes.

Li-sheng's *Dream Journey through the Hsiao and Hsiang Rivers* is of the second type of continuity, which employs the spatial matter of Tung Yüan's *Summer Mountains, Wintry Grove in Layered Banks*, and *Residents of the Capital City*. Another work that belongs to this second type is Hsia Kuei's *Streams and Valleys, Pure and Remote*, that employs the spatial matter of his other works. Li Kung-nien's *Landscape*, which eclectically mixes Chü-jan's angular mountains with Li Ch'eng's cloudlike rocks, illustrates the first type of continuity. This first type is not very widespread among Sung and Yüan dynasty landscapists, as already pointed out in the case of the Mi landscape school. It becomes common, however, among ancient landscape painters in the Ming and Ch'ing periods.

Continuities of the second and third type, however, are rather frequent in Sung and Yüan. They are not always, of course, accompanied by an awareness that old landscape styles are being specifically used as models. Rather, certain landscape compositions and expressive elements come to prevail, become "tradition," and tend to be priviledged as models over others. Take for example the case of the late Sung literati artist Sung Ti, who painted the genre-founding *Eight Views of the Hsiao and Hsiang Rivers*. He was a contemporary of Kuo Hsi, who clearly grasped the most important expressive elements of landscape painting. In similar fashion, Sung Ti limited the expressive elements and motifs used in landscape painting to a certain prescribed sphere.

On the other hand, of the remaining four of Mu-ch'i's *Eight Views of the Hsiao and Hsiang Rivers, Evening Glow over a Fishing Village* consciously bases itself on Mi Yu-jen's spatial composition, thus falling into the third category of continuity. The

same holds for the temple roof peaking out of the foliage in *Mist-Shrouded Temple, Evening Bell*.

Distant Shore, Returning Sail, by employing the spatial matter made up of such motifs as the shore and the sailboat, falls into the second category. The addition of fishermen's nets would have turned it into a continuity of the first type, based on *Evening Glow over a Fishing Village*.[30] However, *Geese Alighting on a Shore*, in the Idemitsu Museum, in employing only the subject of the "descending geese," falls into the first category. The limitation of subject matter in the Eight Views of Hsiao and Hsiang Rivers genre reflects the development of the transmission of composition of landscape paintings as a whole. By exclusively promoting traditional elements, it radically hastens its development and transformation. Of course, looked at the other way, it was also strongly influenced by landscape composition.

The development of spatial composition in landscape painting, regardless of the Hua-pei and Chiang-nan traditions of landscape painting, was continuous, and, up through the Yüan dynasty, was taken up by individual painters as a choice of either imitation of past models or self-imitation. Yet either choice was adopted with the aim of continuing traditional compositional schemes. Starting with the Ming dynasty, however, the following of tradition by individual painters who studied a variety of traditional styles became directly linked to originality, and this led to the drastic increase of self-imitation within the whole genre of landscape painting, bringing about a complete break with the past.

While continuing to imitate past models, Mi Yu-jen and Li T'ang, in order to arrive at their own creative landscape expression, developed, in addition, a method of close self-imitation. Pursuing this method in both color and ink, the two worked from a fixed compositional scheme. In this respect, they differed from the looser, more general imitation of later painters.

Li T'ang, rather than place emphasis strictly on self-imitation, highlighted aspects of the tradition that were worth following within his own work; he imitated with the aim of creating new works through the free copying of tradition. He thus anticipated the kind of creative imitation that would characterize Ming and Ch'ing painting.

Contrary to Li T'ang, Mu-ch'i devoted himself to the type of traditional imitation where all of the layers of the compositional scheme of one work were explored. Yet he succeeded in achieving a pictorial expression that did not expose this imitative quality. This demonstrates that the methods of Mi Yu-jen and Li T'ang were already branching off into the diverse methods of a diverse group of painters.

Another such example is Li Jung-chin, who employs a similar compositional scheme in *Summer Palace of Ming-huang*, in the Osaka Municipal Museum, and the *Han Palace* (which bears a fake seal of Kuo Chung-shu), in the National Palace Museum, Taipei. These works are purposefully self-imitative. Like T'ang Ti, Li Jung-chin is thought to have copied Kuo Chung-shu.

There is also Ch'ien Hsüan (1235–1301), who, in *Dwelling in the Mountains*, in the Palace Museum, Beijing, considerably expands the foreground small island on the left half of Mi Yu-jen's *Cloudy Mountains*, and pushes the middle ground moun-

30. *To get an idea of what exactly the guidelines were for each scene of the* Eight Views, *see Hisamatsu (now Nagaoka) Yumiko, "Gyomotsu Kaihô Yûshô hitsu aboshizu byôbu—Shôshô hakkei kara no dokuritsu to sono jidaisei," Bijutsushi 123 (1988), pp. 1–20.*

tain form into the distant background. Imitating in this way, he achieves a style that has in fact nothing to do with imitation. And, finally, we have Huang Kung-wang (1269–1354), who, in *Dwelling in the Fu-ch'un Mountains*, employs an X-shaped compositional scheme—which goes back to Tung Yüan—as spatial matter to construct a new pictorial space, a space that does not attempt to reconstruct atmosphere or light. The Yüan dynasty was full of such diverse painters, not all of whom can be treated adequately here.

Wu Wei (1459–1508), a painter of the Zhe school of the middle period of the Ming dynasty, bases his *The Pleasures of the Fishermen*, in Beijing, on Tung Yüan's color painting *Residents of the Capital City*. The landscape is painted in ink, with light color applied to the figures. Therefore, while thoroughly grasping the ink-painting technique for landscape and figures employed by Tung Yüan in *Wintry Grove, Layered Banks* and so forth, he continued the endeavors of Mi Yu-jen and Li T'ang to explore the differences of expression between painting in color and in ink.

There is also the case of Sôami (d. 1525), the Japanese painter roughly contemporary with Wu Wei, who served as official connoisseur and advisor to the Muromachi shogunal family. On the right panel of his sliding-door painting *Eight Views of the Hsiao and Hsiang Rivers* in the Myôshin-ji, in Kyoto, he inverts the compositional scheme of Mi Yu-jen's *Cloudy Mountains*, condensing or expanding the expressive material where appropriate. In this way he adapted the primarily small-scale Mi-landscape style to a much larger format.

On the right panel of his folding screen *Four Seasons Landscape*, in The Metropolitan Museum, furthermore, he self-imitates this earlier model, subduing the outlines. We know, then, that even through the Ming and Muromachi periods, when the development of landscape composition took a turn in a different direction, the very strict approach to composition was maintained. And even after the Muromachi period—when handscrolls were cut up in order to adapt them to the vertical hanging scroll format used for display during the tea ceremony—a connection to the Chinese method of landscape composition was maintained. In fact, the painters of this period had a complete knowledge of its fundamental rules, and followed them faithfully.

The continuity of landscape composition is not just a phenomenon belonging solely to China or Japan. Nor is it simply a historical issue. Rather, it is something that involves all of East Asia, including Korea; much more than in Europe or in the Islamic world or any other area of the globe, it is something that throughout the ages has framed the way the world is viewed. It still has meaning in today's world, by exposing the profound human ability to recognize patterns in the perception of space.

As can be gathered from this discussion, imitation in landscape painting is different from imitation in figure painting, in that it is not always directly linked to form or outline. Rather, through both imitation and self-imitation, the mastery of many different kinds of compositional methods leads to the expanding of the boundaries of expression. Outlines can dim or sharpen. This continuation does not

just develop in one specific direction. This is especially true of the process of self-imitation, which has no built-in directionality at all.

Take the case of Ching Hao and his imitators. Comparing *Mt. K'uang-lu* with what we assume to be the appearance of the original Ching Hao work, we can see that the outlines of the rock formations are emphasized, while variation in ink tonality is lost. Thus, the traditional theory concerning copies would apply here. But in works such as the excavated Liaoning *Landscape, Wind and Snow in the Fir Pines*, and *The Min Mountains*, it does not apply. And in Mi Yu-jen's *Cloudy Mountains* and *Distant Peaks and Clearing Clouds*, as I have tried to show here, there is no point in discussing which painting imitates which, as more traditional approaches would tend to do.

Figural painting is not very helpful when pursuing these kinds of problems of landscape painting. Even more irrelevant are the morphological and iconographical considerations often brought to bear in the study of European Christian art. Even if, in Kuo Hsi's *Early Spring*, we understand the three-generational, six-member family of fishermen as a reflection of the literati idealization of the concept of "Three Generations Under One Roof," it will not help us to grasp the most essential feature of the landscape expression in this painting. And even if T'ang Ti in his *Fishermen Retuning* and *Returning Fishermen* uses his three fishermen to echo the three lofty gentlemen in *Small Wintry Grove*, it does not contribute to the important achievements in landscape composition that these three paintings represent.

Traditional scholarship on Chinese painting bases itself solely on texture strokes, that is, the rendering of trees and so forth. Though this approach transcends the traditional divisions between the Hua-pei and Chiang-nan schools, it is still insufficient. What is needed, in addition, is an approach that bases itself on landscape painting, not figural painting, and that furthermore considers landscape painting *consistently*. We await an approach that includes not just morphology and iconography, but also traditional Chinese scholarship; we await a methodology that systematically considers the continuity of compositional schemes in landscape painting: something like a "composition theory."

Translated by Yukio Lippit

Figure 17.1
Li T'ang (ca. 1070s–ca. 1150s), Wind
in the Pines Amid Ten Thousand
Valleys, *dated 1124. Hanging scroll,*
ink and color on silk, 188.7 x 139.8
cm. National Palace Museum, Taipei.

Figure 17.2
Li T'ang (ca. 1070s–ca. 1150s),
Landscapes. Pair of hanging scrolls, ink
on silk, each 98.1 x 43.3 cm. Kôtô-in,
Daitoku-ji, Kyoto.

Figure 17.3
Hsia Kuei (active ca. 1195–1230),
Sailboat in the Rain. *Album leaf, ink*
and slight color on silk, 23.9 x 25.1 cm.
Museum of Fine Arts, Boston.

Figure 17.4
Attributed to Yang Shih-hsien, The Red
Cliff. *Handscroll, ink and color on silk,*
30.9 x 128.8 cm. Museum of Fine Arts,
Boston.

Figure 17.5
Wu Yüan-chih, The Red Cliff. *Hand-scroll, ink on paper, 50.8 x 136.4 cm. National Palace Museum, Taipei.*

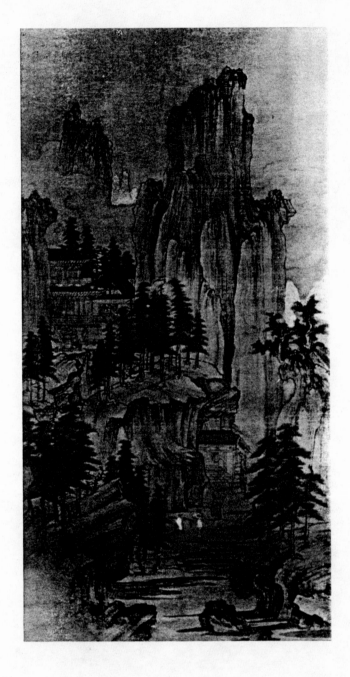

Figure 17.6
Anonymous, Landscape excavated
from the Liao dynasty tomb at
Yemaotai. *Hanging scroll, ink and*
color on silk, 154.2 x 54.5 cm.
Liaoning Provincial Museum.

Figure 17.7
*Attributed to Ching Hao, Mt. K'uang-
lu. Hanging scroll, ink on silk, 185.8 x
106 cm. National Palace Museum,
Taipei.*

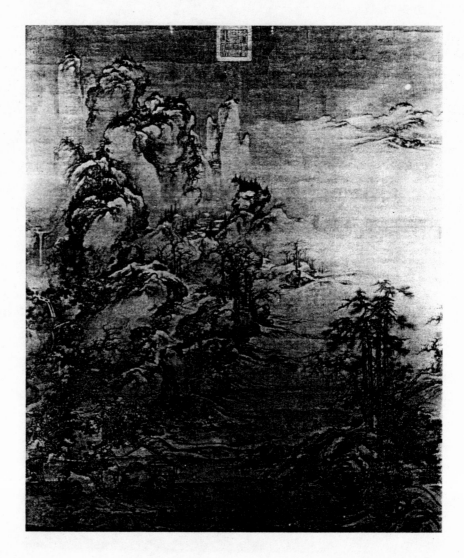

Figure 17.8
Anonymous, Clearing after Snow in
the Min Mountains. *Hanging scroll,
ink on silk, 115.1 x 100.7 cm.
National Palace Museum, Taipei.*

Figure 17.10
Anonymous, Small Wintry Grove.
Hanging scroll, ink on silk, 42.4 x 49.3
cm. National Palace Museum, Taipei.

A-cha-li 阿吒力
A-ts'o-yeh kuan-yin 阿嵯耶觀音
An-fei 安妃
An Jen-yü 安仁裕
An Lu-shan 安祿山 (d. 757)

chan 盞
Ch'an-yüan treaty 澶淵之盟
Chang Chih 張芝 (active second half of
 2nd century)
Chang Chih-ho 張志和 (active ca. 730-
 ca. 830)
Chang Hsü 張旭 (active early 8th century)
Chang-huai 章懷 (T'ang prince, Li Hsien,
 d. 684)
Chang Huai-kuan 張懷瓘 (active 713-14)
Chang Hung 張洪 (active mid-3rd century)
Chang Kung-yu 張恭誘
Chang Kuo Lao 張國老
Chang Sheng-wen 張勝溫 (active late
 12th century)
Chang Ssu-lang 張四郎
Chang Tao-ling 張道陵
Chang T'ung-chih 張同之
Chang Yen-yüan 張彥遠 (9th century)
Ch'ang-an 長安
Ch'ang-e 嫦娥
ch'ang-tzu 場子
Chao-chuang t'ing 照妝亭
Chao Hsi-ku 趙希鵠 (active ca. 1230)
Chao Hung 趙竑
Chao Kan 趙幹 (active ca. 961-75)
Chao K'o-hsiung 趙克夐 (active early 12th
 century)
Chao Ling-jang 趙令穰 (active ca.1080-
 1100)
Chao Meng-fu 趙孟頫 (1254-1322)
Chao Yen-mei 趙延美
Chao Yüan 趙原 (active ca. 1350-75)
Chao Yün 趙昀 (Sung emperor, r. 1225-
 64)
Ch'ao Pu-chih 晁補之 (1053-1110)
chen 眞
Chen-jiang 鎮江

chen-mu-shou 鎮墓獸
chen-mu-wen 鎮墓文
Chen-tsung 眞宗 Emperor (r. 998-1022)
ch'en 臣
Ch'en Chi-ju 陳繼儒 (1558-1639)
Ch'en Chih-kung 陳直躬
Ch'en Hung 陳閎 (active ca.725-50)
Ch'en-liu 陳留
Ch'en T'uan 陳搏 (active 976-83)
Cheng-chou 鄭州
Cheng-ho 政和
cheng-kuei wen-tzu 正規文字
Cheng Shao-fang 鄭紹方
Cheng Ssu-hsiao 鄭思肖 (1239-1316)
cheng-t'i-tzu 正體字
Cheng Wen-pao 鄭文保
ch'eng-ch'i 盛器
ch'eng huang chü lü 橙黃橘綠
ch'eng-ni 澄泥
ch'eng weng 盛甕
Ch'i 齊
Ch'i-hsi 緝熙
Ch'i-hsi-tien pao 緝熙殿寶
Ch'i-hsi-tien shu 緝熙殿書
Ch'i-tan 契丹
Chia-hsing 嘉興
chia-ku-wen 甲骨文
chia-shan 假山
Chia-yu-kuan 嘉峪關
Chiang Ch'i 蔣祁
Chiang-p'u 江埔
chiao-ssu 郊祀
Chiao-t'an-hsia 郊壇下
Chien-ch'uan 劍川
Chien-k'ang 建康
chien-t'i-tzu 簡體字
Chien-yeh wen-fang chih yin 建業文房
 之印
Ch'ien-fo ssu 千佛寺
Ch'ien Hsüan 錢選 (ca. 1235-before 1307)
Ch'ien-hsün pagoda 千尋塔
Ch'ien-lung 乾隆 Emperor (r. 1736-95)
Ch'ien Ming-i 錢明逸 (active ca. 1050)
Ch'ien Wei-yen 錢惟演 (d. ca. 1033)

Ch'ih-feng 赤峰
Ch'ih-ming yang-ho t'ien-ti 赤明陽和天帝
chin-chan 進盞
Chin-fu t'u-shu 晉府圖書
chin-t'i-tzu 今體字
chin-wen 金文
Ch'in K'uai 秦檜 (1090-1155)
Ch'in Kuan 秦觀 (1049-1100)
Ch'in Shih Huang 秦始皇 (246-210 B.C.)
Ching Hao 荊浩 (active ca. 870-ca. 930)
Ching-hsing 井陘
Ching-shih 京師
Ching-te-chen 景德鎮
ching-t'ing sung-feng 靜廳松風
ch'ing 青
ch'ing-ch'i 青器
ch'ing-ch'i yao 青器窯
Ch'ing-liang ssu 清涼寺
Ch'ing-ling chen 青嶺鎮
ch'ing-pai hua ch'i 青白花器
ch'ing-pai hua tz'u-ch'i 青白花瓷器
ch'ing-pai hua wan 青白花碗
ch'ing-pai tz'u 青白瓷
ch'ing-pai wan 青白碗
ch'ing p'an 青盤
ch'ing-t'an 清談
Ch'ing-tso chiang 青作匠
ch'ing tz'u-ch'i 青瓷器
ch'ing tz'u hua wan 青瓷花碗
ch'ing weng ch'i 青甕器
Ch'ing-yao tso 青窯作
chiu p'ing 酒瓶
Ch'iu Ying 仇英 (ca. 1495-1552)
ch'iu-yüeh 秋月
cho-tsun 著尊
Chou Chih-kao 周執羔
Chou Mi 周密 (1232-1298)
Chou Wen-chü 周文矩 (ca. 940-75)
Chu Ch'i-niang 朱七娘
Chu Ching-hsüan 朱景玄 (b. ca. 787)
Chu Hao-ku 朱好古 (active Yüan
　　dynasty)
Chu Hsi 朱熹 (1130-1200)
Chu Kang 朱棡 (1358-1398)
Chu Kuan 朱貫 (ca. 960s-1050s)
chu-wei 麈尾
ch'u-hsiang 出香
Ch'u Sui-liang 褚遂良 (596-658)
Chü-jan 巨然 (active ca. 976-93)
ch'ü-chih 屈卮

Ch'ü Ting 屈鼎 (active first half of 11th century)
Ch'ü Yüan 屈原 (343-278 B.C.)
ch'üan-chen 全眞
ch'üan-ching 全景
Ch'üan-chou 泉州
Chuang-tzu 莊子 (399-295 B.C.)
chüeh 爵
ch'un 春
Chung-li Ch'üan 鐘離權
Chung Yu 鐘繇 (151-230)
Ch'ung-sheng Temple 崇聖寺
Confucius 孔夫子 (551-479 B.C.)

Fa-k'u 法庫
Fan K'uan 範寬 (active ca. 990-1030)
Fan Tzu-an 範子安
fang 坊
fang-ch'un yü-chi 芳春雨霽
fei-pai 飛白
Feng-ch'en k'u 奉宸庫
Feng-hsien ssu 奉先寺
feng-liu 風流
fu 簠
fu 幅
Fu-hsi 伏羲
Fu-ma Tseng 駙馬贈
fu-tzu 父子

Hai-t'ang shih 海棠詩
Han Cho 韓拙 (active early 12th century)
Han Chü 韓駒
Han Hsi-tsai 韓熙載
Han Hsiang-tzu 韓湘子
Han Ko 涵閣
Han Shih-hsün 韓師訓
Han T'uo-chou 韓侂胄
Han Yü 韓愈 (768-824)
He Chih-chang 賀知章
He Hsien-ku 何仙姑
He-lan ch'i-chen 賀蘭棲眞
He Tzu-chen 賀自眞
Ho Ch'ung 何充
Ho-lin-ko-erh 和林格爾
Ho-yao chiang 合藥匠
Hou-yüan tsao-tsuo so 後苑造作所
hsi 洗
Hsi-ch'üeh 喜鵲
hsi-tsun 犧尊
Hsia Kuei 夏圭 (active ca. 1195-1230)
hsiang-ch'iu 香球

hsiang-ho 香盒
hsiang-lu 香爐
Hsiang-ting li-i so 詳定禮儀所
hsiang-tsun 象尊
hsiao-chou 小軸
hsiao-chuan 小篆
hsiao-hua 小畫
hsiao-kuan 小罐
hsiao-lien 小奩
hsiao-pi 小筆
Hsiao-tsung 孝宗 Emperor (r. 1162-89)
Hsiao Tzu-yün 蕭子雲 (486-548)
hsiao-yao ching 逍遙巾
hsieh-chen 寫眞
hsieh-ch'in fang-yu 攜琴訪友
Hsieh K'un 謝鯤
Hsien-chü fu 閑居賦
Hsing-tsung 興宗 Emperor (r. 1031-55)
Hsiu-nei-ssu 修內司
Hsü Ching 徐兢
Hsü-chou 徐州
Hsü Hsi 徐熙 (d. before 975)
Hsü Hsüan 徐鉉 (917-92)
Hsü Pen 徐賁 (d. ca. 1379)
Hsü Shen 許慎 (ca. 58-ca. 147)
Hsü Shou-hsin 徐守信
Hsü Tao-ning 許道寧 (ca. 970-1053)
Hsü Yu 許由
hsüan-hu tzu 懸壺子
Hsüan-hua 宣化
Hsüan-tsang 玄奘 (active mid-7th century)
Hsüan-tsung 玄宗 Emperor (r. 712-56)
hu 壺
Hu-lü Ch'e 斛律徹
hu-pin you-chü 湖濱幽居
hua-teng tai-yen 花燈待宴
hu-tsun 壺尊
hua wan 花碗
Huai-jen 懷仁 (active early 7th century)
Huai-su 懷素 (ca. 735-ca. 799)
huan 寰
Huang Ch'uan 黃荃 (ca. 905-65)
Huang Chü-ts'ai 黃居寀 (10th century)
Huang Fu-jan 皇甫冉
Huang Kung-wang 黃公望 (1269-1354)
Huang T'ing-chien 黃庭堅 (1045-1105)
Huang-yüeh-ling 黃悅嶺
Hui-tsung 徽宗 Emperor (r. 1101-25)
hun 魂
hun-tun 渾沌

i 彝
i ku wei hsin, i su wei ya 以古爲新，
　　　　以俗爲雅
I-li chü 儀禮局
I-nan 沂南
I-te 懿德
I Yüan-chi 易元吉 (1001-1065)

jen 仁
jen-ch'ing 人情
Jen-tsung 仁宗 Emperor (r. 1023-63)
Jen-wu 壬午
Jen-yün t'ang 任運堂
Jih 日
Ju yao 汝窯
Jung 戎

K'ai-feng 開封
K'ai-shu 楷書
Kao Jun 高潤
Kao K'o-ming 高克明 (ca. 1007-49)
kao-shih ching 高士巾
Kao-tsung 高宗 Emperor (r. 649-83)
Kao-tsung 高宗 Emperor (r. 1127-62)
Kє yao 哥窯
Ko-luo-feng 閣羅鳳
K'ou Chun 寇準 (961-1023)
Ku Hung-chung 顧閎中
Ku K'ai-chih 顧愷之 (ca. 344-ca. 406)
ku-sung lou-ko 古松樓閣
ku-t'i-tzu 古體字
Ku-tu kung-tien 古都宮殿
ku-wen 古文
Kuan yao 官窯
Kuan-yin 觀音
Kuang-tsung 光宗 Emperor (r. 1189-94)
kuei 簋
k'un-kua 坤卦
k'un-ning 坤寧
kung-yü 供御
kuo 過
Kuo Chung-shu 郭忠恕 (d. 977)
Kuo Hsi 郭熙 (ca. 1000-ca. 1090)
Kuo Juo-hsü 郭若虛 (active early 1080s)
Kuo-tzu-chien 國子監

Lan-t'ing chi-k'o 蘭亭集刻
Lan-t'ing hsü 蘭亭序
Lan-t'ing t'ieh 蘭亭帖

p'ing-feng 屏風
P'ing-ching fu 平京府
Po Chü-i 白居易 (772-846)
p'o 魄
pu-p'ing erh ming 不平而鳴
P'u-chin (Pujin) 蒲京

San-li-t'u 三禮圖
San-t'ai-shan 三臺山
san-ts'ai 三彩
sha-teng-ch'ing 沙登箐
shan-ching ch'un-hsing 山徑春行
shan-lei 山罍
Shang-ch'ing-kung 上清宮
Shang-hsiang 商鄉
shang-hua 賞花
Shang-shih chü 尚食局
Shao-hsing fu 紹興府
Shao Yung 邵雍 (1011-1077)
Shen Kua 沈括 (active ca. 1086-93)
Shen-tsung 神宗 Emperor (r. 1068-85)
Sheng-lo-p'i 盛羅皮
Sheng-tsung 聖宗 Emperor (r. 983-1031)
shih 士
Shih Chih-lien 石志廉
Shih-chung-shan 石鐘山
shih-fu-hua 士夫畫
Shih Kung-i 史公奕
shih-lang 施浪
shih-lung 世隆
Shih Mi-yüen 史彌遠
shih-nü p'ing-feng 仕女屏風
shih-ta-fu 士大夫
Shou-ning tien 壽寧殿
shu 書
shu 數
shu-hua 書畫
shui ch'eng 水丞
shui t'an 水罈
Ssu-ma Ch'ien 司馬遷 (145-ca. 90 B.C.)
Ssu-ma Chin-lung 司馬金龍
Ssu-ma Kuang 司馬光 (1019-1086)
ssu-yin 司印
Su Ch'e 蘇轍 (1039-1112)
Su Hsün 蘇洵 (1034-1101)
Su Shih 蘇軾 (1037-1101)
Su Shun-ch'in 蘇舜欽 (1008-1048)
Su Yi-chien 蘇易簡 (957-995)
Sui-hsien 隨縣
Sun Liang 孫良

sung-ch'üan shuang-hsi 松泉雙溪
Sung Li-tsung tso-hsiang 宋理宗坐像
Sung Tao 宋道
Sung Ti 宋迪 (active 11th century)
Sung Yüan ts'e-yeh 宋元冊頁

ta-hsiao ch'eng 大小盛
ta-hsiao ch'eng weng 大小盛甕
ta-hsiao shui kuan 大小水罐
Ta-hu t'ing 打虎亭
Ta-kuan 大觀
Ta-li 大理
ta lien 大奩
ta weng 大甕
Tai Fu 戴孚
Tai-tsung 代宗 Emperor (r. 763-79)
t'ai-hsieh yüeh-yeh 台榭月夜
T'ai-hsüeh 太學
T'ai-miao 太廟
T'ai-tsu 太祖 Emperor (r. 907-27)
T'ai-tsu 太祖 Emperor (r. 960-76)
t'ai-tsun 太尊
T'ai-tsung 太宗 Emperor (r. 626-49)
T'ai-tsung 太宗 Emperor (r. 976-97)
t'ang-chan 湯盞
T'ang Lan 唐蘭
T'ang Yin 唐寅 (1470-1524)
tao 道
Tao-t'ung shih-san tsan-t'u 道統十三贊
　　　圖
T'ao Ch'ien 陶潛 (d. 427)
T'ao Hung-ching 陶宏景
T'ao Ku 陶穀 (903-970)
t'ao-wen 陶文
T'ao Yüan-ming 陶淵明
te-shou 德壽
Te-tsung 德宗 Emperor (r. 780-804)
teng 登
Teng Ch'un 鄧椿 (active ca. 1167)
tien 典
Tien-ts'ang-shan 點蒼山
T'ien-pao 天寶
Ting-hsien 定縣
Ting-wu lan-t'ing 定武蘭亭
tou-kung 鬥拱
Tou Wan 竇綰
Ts'ai Hsiang 蔡襄 (1012-1067)
Ts'ai Ssu 蔡四
Ts'ai T'ao 蔡絛
ts'ai-t'ao 彩陶

Ts'ai Yung　蔡邕 (132-192)
Ts'ang-chieh　倉頡
Ts'ang-shan　蒼山
Ts'ao Kuo-chiu　曹國舅
Ts'ao Pa　曹霸 (active mid-8th century)
Ts'ao T'ang　曹唐
Tseng Hou　曾侯
Tseng Liu Ch'ing-wen shih　贈劉清文詩
Tseng-tzu　曾子
Tsu-wei-t'ing　紫微亭
ts'u wan　粗碗
Tsui-t'ai-p'ing　醉太平
Ts'ui Hao　崔顥 (d. 754)
Ts'ui Po　崔白 (active ca. 1060-85)
tsun　尊
Tsung Ping　宗炳 (375-443)
tu　度
Tu Chin　杜菫 (active ca. 1465-ca. 1509)
Tu Fu　杜甫 (711-770)
tu-le　獨樂
Tu Mu　杜牧 (803-ca. 852)
Tu Yen　杜衍 (978-1057)
t'u-hsing wen-tzu　圖形文字
t'u-hua wen-tzu　圖畫文字
Tuan Chih-hsing　段智興 Emperor
　　　　　(r. 1172-1200)
Tuan Chih-hsüan　段志玄 (d. 643)
tui　敦
Tun-huang　敦煌
Tung Chung-shu　董仲舒 (ca. 193-179
　　　　　B.C.)
Tung-hsi pa-tso ssu　東西八作司
tung-li kao-shih　東籬高士
tung-t'ien　洞天
Tung Yüan　董源 (d. 962)
Tzu-ch'i　子蓁
Tzu-chin　子晉
Tzu-ssu　子思
Tzu-wei-hua kuan　紫微花觀
Tzu-yun lou　紫雲樓
tz'u　詞
Tz'u-ch'i k'u　瓷器庫
Tz'u-hsien　磁縣
Tz'u-yao shang-shui-wu shih　瓷窯商稅
　　　　　務使

wa t'an　瓦鐔
wa weng　瓦甕
Wang An-shih　王安石 (1021-1086)
Wang Ch'i-han　王齊翰 (active ca. 961-75)

Wang Chin-hsi　王晉錫
Wang Ch'in-jo　王欽若
Wang Chu　王著 (d. 990)
Wang Hsi-chih　王羲之 (ca. 303-ca.361)
Wang Hsien-chih　王獻之 (344-388)
Wang Hui-chih　王徽之 (d. 388)
Wang Hung　王洪 (active ca. 1131-61)
Wang I　王繹 (active 1360s)
Wang Kung　王鞏 (active late 11th century)
Wang Meng　王蒙 (d. 1385)
Wang P'u　王普
Wang Shen　王詵 (ca. 1048-after 1104)
Wang T'ing-yün　王庭筠 (1151-1202)
Wang Wei　王維 (ca. 699-ca. 761)
Wang Ying-lin　王應麟 (1223-1296)
Wang Yüan-ch'i　王原祈 (1642-1715)
Wei-ch'ih Ching-te　尉遲敬德 (585-658)
Wei Hsien　魏賢
Wen-ch'ang　文昌
Wen Cheng-ming　文征明 (1470-1559)
Wen-ch'eng　魏文成帝 (Wei Emperor)
Wen-ssu yüan　文思院
Wen T'ung　文同 (1018-1079)
weng　甕
Wu Chen　吳鎮 (1280-1354)
Wu Chü　吳琚
Wu I　吳益
Wu Li　吳歷 (1632-1718)
Wu T'ai-pao　烏太保
Wu-ting　武定
Wu Tse-t'ien　武則天 (r. 684-755)
Wu Tsung-yüan　武宗元
Wu-yüeh　吳越

Yang Ku　楊穀
Yang Mei-tsu　楊妹子 (Sung empress,
　　　　　1162-1232)
Yang Ning-shih　楊凝式 (873-957)
Yang Shih　楊石
Yang Tz'u-shan　楊次山
Yao　堯
Yao-tzu tso　窯子作
Yao-wu　窯務
Yao-yü　藥玉
Yeh-lü A-pao-chi　耶律阿保機 (Emperor,
　　　　　see T'ai-tsu)
Yeh-lü Lung-hsü　耶律隆緒 (Emperor, see
　　　　　Sheng-tsung)
Yellow Emperor (Huang-ti)　黃帝
Yen Chen-ch'ing　顏眞卿 (709-785)

Yen Hui 顏輝 (active late 13th-early 14th
 century)
Yen Li-pen 閻立本 (d. 673)
Yen-shih 偃師
Yen-tzu 顏子
Yen Wen-kuei 燕文貴 (active ca. 970-
 1030)
Yen-yu t'u 讌游圖
yin 陰
Yu-sheng chen-wu ling-ying chen-chun
 佑聖眞武靈應眞君
Yu-sheng-kuan 佑聖觀
Yü (of the Hsia) (夏)禹
yü-ch'ih 玉池
Yü-fu t'u-shu 御府圖書
yü-jung 玉容
yü-li 漁利
Yü Shih-nan 虞世南 (558-638)
yü-shu 御書
Yü-shu chih pao 御書之寶
Yü Yün-wen 俞允文 (1511-1579)
Yüeh-chou 越州
Yüeh Shou 岳壽
Yung-le 永樂
Yung-t'ai 永泰
yung-wu 詠物

zhen-ching 眞精